"We, and all others
who believe in freedom
as deeply as we do,
would rather die on our feet
than live on our knees."

Franklin Delano Roosevelt

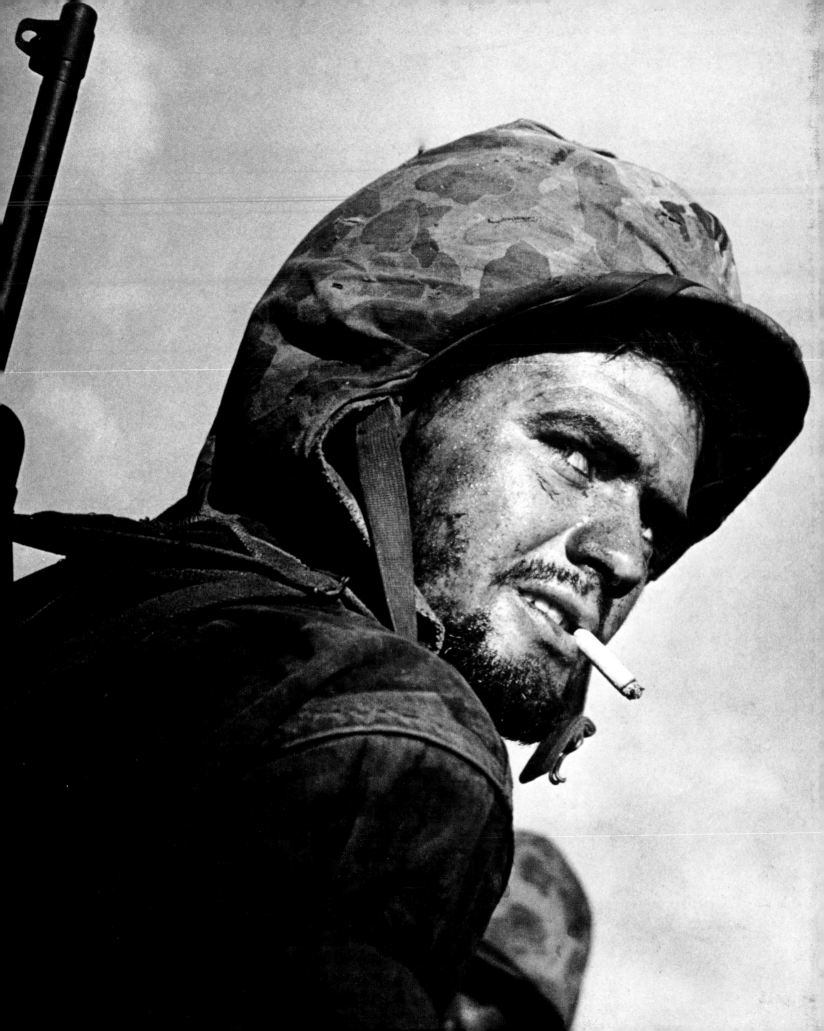

EYEWITNESS TO WORLD WAR II

Unforgettable Stories and Photographs From History's Greatest Conflict

NEIL KAGAN ★ STEPHEN G. HYSLOP

NATIONAL GEOGRAPHIC

WASHINGTON, D.C.

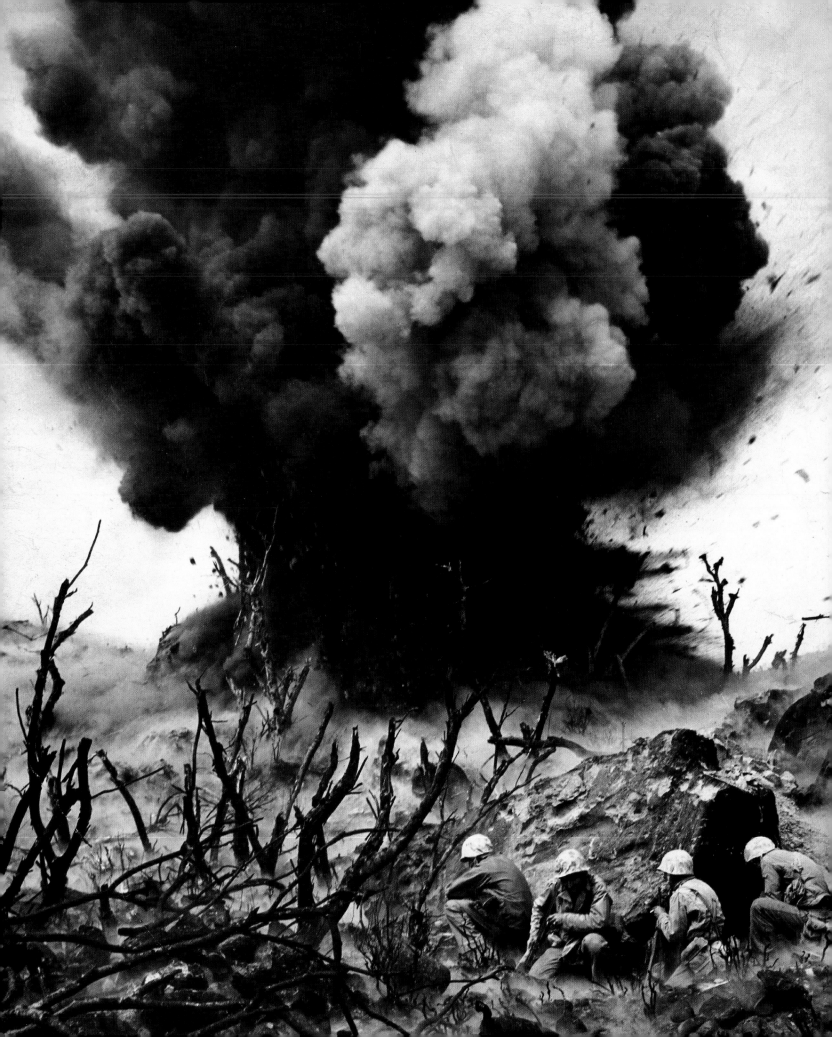

> "Secure this lousy piece of real estate
> so we can get the hell off it."
>
> Lt. Col. Charles Shepard
> 28th Marine Regiment, Iwo Jima

Foreword by Hugh Ambrose 6

Through the Lens | A World Gone Mad | 8

CHAPTER 1
Seven Days in December ★ 30

Through the Lens | Home Front U.S.A. | 64

CHAPTER 2
Striking Back at Japan ★ 82

Through the Lens | Face-Off in the Desert | 118

CHAPTER 3
War in the Mediterranean ★ 134

Through the Lens | A War of Wills | 178

CHAPTER 4
Island Fighting ★ 190

Through the Lens | The Battle of the Atlantic | 232

Through the Lens | Air War Over Europe | 242

CHAPTER 5
Victory Over Germany ★ 252

Through the Lens | Holocaust | 296

CHAPTER 6
Victory Over Japan ★ 308

Additional Reading 344 | Illustrations Credits 344 | Text Rights and Permissions 345 | Index 346

Cover: American soldiers prepare to land in New Guinea, where fighting between Allied and Japanese forces raged from 1942 to 1944.
Endpapers: A crewman on the U.S.S. *Enterprise* directs a plane in the Pacific *(front)*; American soldiers and servicewomen celebrate V-J Day *(back)*.
Page 2: A battle-weary GI smokes a cigarette during the invasion of Saipan in 1944, which brought U.S. bombers within range of Tokyo.
Opposite: U.S. Marines take cover after triggering an explosion at the mouth of a cave occupied by Japanese troops on Iwo Jima in February 1945.

SACRIFICE AND REMEMBRANCE

They still remember. People around the world still honor those young Americans who helped secure their liberty by ending the tyranny of Hitler, Hirohito, and Mussolini. Schoolchildren on Guam sing songs of tribute to the Marines who stormed their beaches in 1944 and freed that island from Japanese occupiers. The youngsters of Normandy wave American flags on June 6 to commemorate D-Day. The good people of Melbourne have not forgotten the U.S. troops who defended Australia by fighting and dying on land, at sea, and in the air in the struggle for Guadalcanal. In my travels to those battlefields, I have seen the locals offer both solemn memorials and spontaneous expressions of gratitude to the visiting veterans, honors received with tears and heartfelt thanks by the elderly soldiers, sailors, Marines, Coast Guardsmen, merchant mariners, and airmen.

People around the world also remember the evils against which the Allies fought. Visiting Manila in 2000, I had the honor of accompanying a group of elderly American veterans known as the Battling Bastards of Bataan, whose determined and courageous but ultimately futile struggle to hold off Japanese invaders ended in a death march to nightmarish prison camps. A Filipino guide accompanying our tour bus had the driver stop at a low statue cut from dark rock, a memorial easily missed on the busy city street. The guide told us this was a monument to all those civilians in his country who died in the war—hundreds of thousands of men, women, and children, many of them killed, he said, by Japanese troops. It was a stark reminder of what those American veterans and their allies had been

> ## "He lay there with his hands clenching and unclenching. Finally he brought his hands together in a position of prayer."
>
> W. EUGENE SMITH,
> COMBAT PHOTOGRAPHER,
> OKINAWA

Prayer for Deliverance A wounded GI awaits evacuation on Okinawa, where nearly 50,000 U.S. soldiers and sailors were killed or wounded in the spring of 1945.

fighting against. Their struggle was a "good war," not because the combat they engaged in was any less brutal than others, nor because their generation was better than others, but because it was a war that had to be fought, against aggressors who had to be defeated. After vanquishing Nazi Germany and imperial Japan, America helped right those countries and transform them into democratic allies, thereby winning not just the war but the peace.

That peace remains a great gift, paid for by soldiers whose sacrifices must never be forgotten. This book commemorates their struggle, using their own words as well as the eyewitness accounts of civilians and correspondents—and the riveting, visual testimony of frontline war photographers like W. Eugene Smith, who took the picture at right on Okinawa in 1945 as American troops gathered around a wounded comrade. "Although he was in great pain, they did not give him morphine because of the head wound," Smith wrote. "He lay there with his hands clenching and unclenching. Finally he brought his hands together in a position of prayer."

This book focuses on the trials, prayers, and sacrifices of Americans in World War II, while also providing a global overview of that great conflict, from the rise of Nazi Germany to the fall of Imperial Japan. In keeping with the mission of the National Geographic Society, it relates America to the world and reminds us of the vital role Americans played on the world stage when they joined with their allies on distant shores to uphold freedom and democracy.

— **HUGH AMBROSE,** author of *The Pacific*

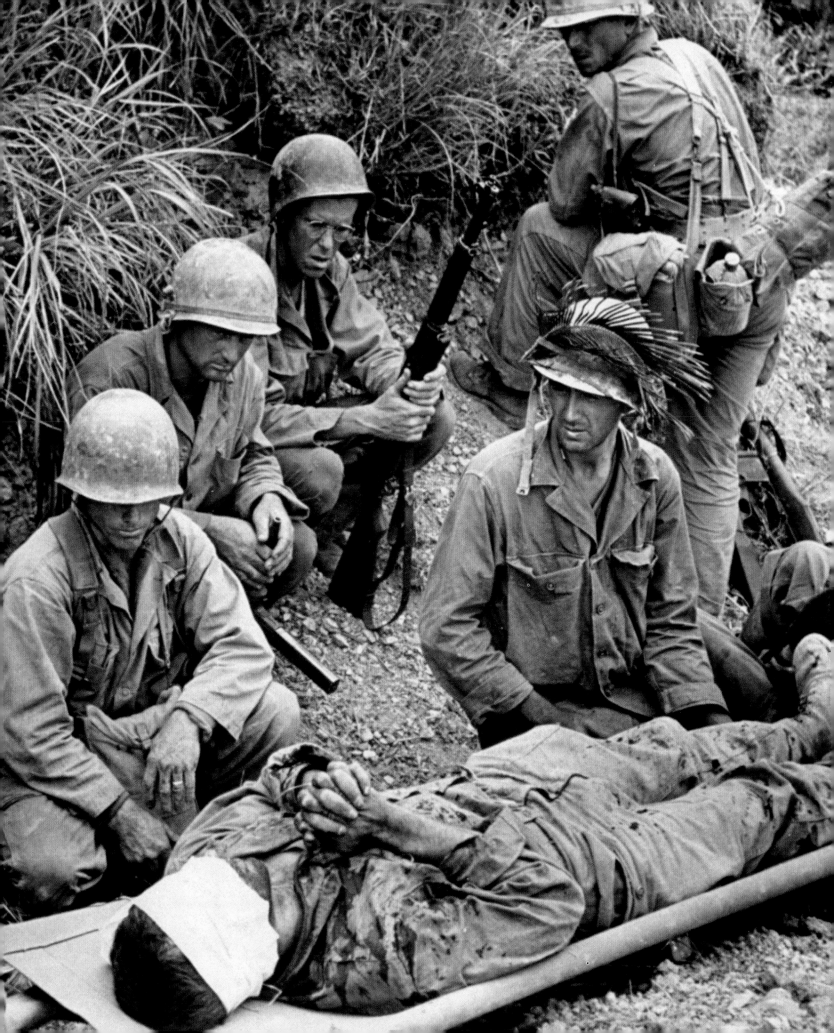

I N 1939, A QUARTER CENTURY AFTER ENLISTING TO FIGHT FOR Germany in the calamitous First World War, Adolf Hitler triggered an even greater global catastrophe by invading Poland. For millions who had endured that earlier conflict, the Second World War came all too soon. But for Hitler, warfare was welcome. Any peace lasting "more than 25 years is harmful to a nation," he insisted. "Peoples, like individuals, sometimes need regenerating by a little bloodletting." He was prepared to spill more than a little blood to regenerate the German Reich, an empire of medieval origins that rose anew in 1871 but collapsed in 1918 while Hitler was recuperating after being blinded in battle. When he was told of Germany's defeat, Hitler wrote, "Everything went black before my eyes again." ★ Hitler regained his eyesight but emerged with a warped view of the world. German commanders bore responsibility for losing World War I, but Hitler blamed communists and Jews and vowed to purge them from the Third Reich, which he forged by promising to restore order to a nation convulsed by the Great Depression. Appointed chancellor in 1933, Hitler assumed emergency powers, crushed opposition to his Nazi Party, and became Germany's unchallenged Führer (leader), backed by an expansive new Wehrmacht (armed forces). He was "our savior, bringing light into darkness," said a devotee at one of the mass rallies where Hitler whipped followers into a frenzy. His incendiary words and deeds sparked conflagrations at home and abroad as like-minded dictators joined him in fanning the flames. By December 1941, the war Hitler started had engulfed the world, causing bloodletting of unprecedented proportions. ∎

A World Gone Mad:

THE CAUSES OF WORLD WAR II

Rising to Power Flanked by Nazi storm troopers holding swastika banners, Adolf Hitler ascends to the podium during a rally at Bückeburg, Germany, in October 1934. Hundreds of thousands flocked to such gatherings to celebrate the dawn of what Hitler called his "Thousand-Year Reich."

Rome's New Caesar

Benito Mussolini was Hitler's paragon and precursor, hailed by Italians as Il Duce ("the Leader") a decade before Germany's Führer seized power, but he was destined to be overshadowed by the Nazi dictator. Rising to prominence in the chaotic aftermath of World War I when Italy's democratic system was unraveling, Mussolini posed as a modern-day Caesar. Like Roman rulers of old, he received stiff-arm salutes from his adoring Blackshirts, known as Fascists for fasces—bundles of rods with ax heads attached that symbolized Roman authority. Granted emergency powers temporarily in 1922, Mussolini became Italy's permanent strongman. "We have buried the putrid corpse of liberty!" he declared in 1934 after abolishing elections, banning labor unions, and crushing dissent.

In 1935, Rome's new Caesar invaded Ethiopia. Great Britain threatened action and the League of Nations imposed sanctions, but Mussolini remained defiant, accusing the British and other imperial rivals of denying Italians "their place in the sun." He touted his campaign as a "war of civilization and liberation," but his forces brutally overpowered the lightly armed Ethiopians by bombing, strafing, and gassing them. With victory in his grasp, the British backed down and the League caved in, despite an impassioned plea from Ethiopian ruler Haile Selassie, who foresaw further aggression if Italy went unpunished. "It is us today," he warned. "It will be you tomorrow."

Hitler, who had withdrawn from the League of Nations in 1933, was glad to see it discredited as a peacekeeping body. He was gearing up for war, and Nazi Germany had much greater military and industrial potential than Fascist Italy did. By 1939, when he forged his Pact of Steel with Mussolini, Il Duce was very much the junior partner in that alliance. He would continue to seek victories over vulnerable opponents, but as one Italian official said, his posturing as a great Roman conqueror was "a bluff, a fraud." ■

A Losing Battle Ethiopian soldiers, shown here entering combat in early 1936, fought bravely but had little chance against the Italian invaders, backed by artillery and warplanes.

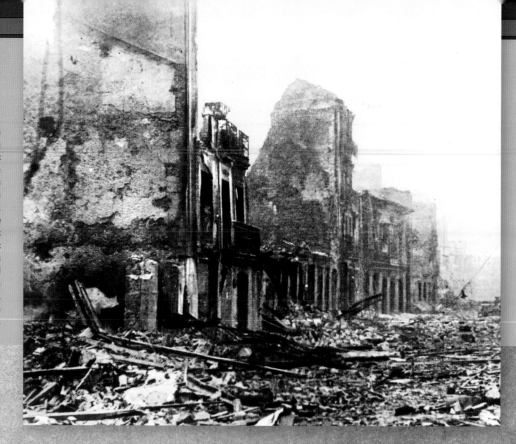

Republic in Ruins The devastation inflicted by German bombers in 1937 on Guernica *(right)* forecast the ultimate fate of the Spanish Republic, toppled by Franco's rebellious Nationalists with support from Hitler and Mussolini. Republican troops like the soldier below, pictured in his last moments by photographer Robert Capa, suffered mounting casualties as the Spanish Civil War dragged on and met defeat in 1939 when Madrid fell to Nationalist forces, hailed by supporters with fascist salutes *(opposite)*.

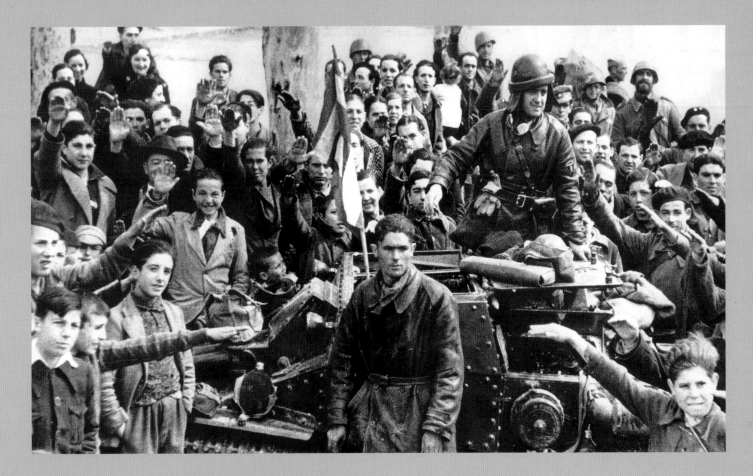

Showdown in Spain

War returned to Europe in 1936 when Spanish Nationalists led by Gen. Francisco Franco assailed Republicans and their democratically elected government. Both sides in the Spanish Civil War had extremists within their ranks, including communists among the Republicans and fascists among the Nationalists. The struggle intensified when Hitler and Mussolini backed Franco and Soviet dictator Joseph Stalin aided the Republicans. Britain, France, and the United States remained neutral, but thousands of foreigners volunteered to fight Franco. Among them was British author George Orwell, who found that war for a lofty cause was still a nasty business. "Here we are, soldiers of a revolutionary army, defending Democracy against Fascism," he wrote, "but the details of our life are just as sordid and degrading as it could be in prison . . . Bullets hurt, corpses stink, men under fire are often so frightened that they wet their trousers."

For Hitler and his commanders, Spain was a proving ground for new weapons and tactics. In

Boy Soldiers **Youngsters in Nationalist uniforms bear arms in Zaragoza, seized by Franco in late 1936.**

April 1937, warplanes of Germany's Condor Legion demonstrated the fearsome impact of strategic bombing by blasting the town of Guernica in Republican-held territory and killing more than 1,500 people. Such attacks drew fervent protests, but moral indignation did not halt Hitler's forceful intervention on behalf of the Nationalists, who took Madrid in 1939 and installed Franco as Spain's dictator.

Orwell emerged from the struggle contemptuous of communism, which tainted the Republican cause, but convinced that Western democracies were inviting disaster if they failed to oppose Hitler. "When one thinks of the cruelty, squalor, and futility of war," he wrote, "there is always the temptation to say, 'One side is as bad as the other: I am neutral.'" In this war, Orwell concluded, neutrality weakened the democracies and left his complacent homeland "sleeping the deep, deep sleep of England, from which I sometimes fear that we shall never awake till we are jerked out of it by the roar of bombs." ∎

Mayhem in China

While fighting in Spain intensified, foreshadowing the eruption of World War II in Europe, the Japanese invaded China in 1937 and set the stage for further convulsions in the Far East that would draw the United States into the conflict. Like Germany, Japan was hit hard by the Depression, which undermined its constitutional government. Parliamentary leaders who favored peace were attacked, and commanders intent on expanding the Japanese Empire gained the upper hand. In 1931, Japan seized Manchuria, from which its troops began infiltrating China. In July 1937, fighting erupted near Peking (Beijing) between Japanese soldiers and Chinese Nationalists, whose leader, Chiang Kai-shek, vowed not to yield "one more inch of our territory." Military chiefs in Tokyo then authorized a punitive expedition "to chastise the outrageous Chinese" for acts "derogatory to the prestige of the Empire of Japan."

Far from enhancing its prestige, Japan's long and brutal war on China disgraced its armed forces. In December, they attacked Nanking (Nanjing), Chiang's capital. He and his officials fled, but many Chinese soldiers were trapped there and removed their uniforms to avoid detection by Japanese troops, who had been told to take no prisoners. The invaders began killing men indiscriminately, and soon they were assaulting women, thousands of whom were raped, and attacking children. Japanese officers failed to restrain their soldiers, some of whom used bayonets on civilians. This provided a "finishing touch to training for the men and a trial of courage for the officer," one commander said. "After that, a man could do anything easily." More than 200,000 people may have died in the Nanking massacre.

The atrocity alarmed Americans, as did the Japanese bombing of a U.S. gunboat in Chinese waters. President Franklin Roosevelt proposed a "quarantine" on foreign aggressors. Not until Japan joined Germany and Italy to form the Axis and expanded its offensive, however, would he impose tough sanctions and force Tokyo to choose between renouncing its imperial ambitions or defying America. ∎

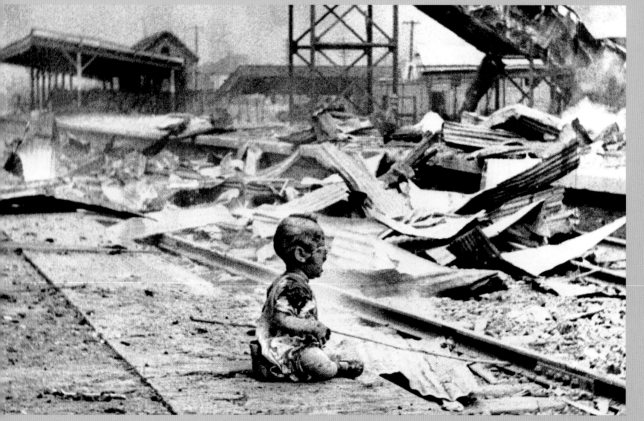

Infamous Attack The shocking photo (left), showing a wounded infant abandoned in a bomb-blasted railroad station in Shanghai in 1937, drew international attention to Japan's devastating assault on China. Later in the war, Japan used poison gas against Chinese troops—after preparing civilians at home to withstand such attacks by donning gas masks like those worn by Japanese monks (above).

A Living Death Japanese troops execute Chinese prisoners of war near Nanking in December 1937 by burying them alive in a pit. One Japanese diplomat who learned of such atrocities remarked: "My God, is this how our Imperial Army behaves?"

"Peace for Our Time"

Before Hitler went to war in 1939, he won territorial concessions in Europe by exploiting the desire of the French and British to avoid conflict and inducing them to yield without a fight. He won his first bloodless victory in March 1936 when he sent troops into the Rhineland, an industrial zone bordering France that had been demilitarized at the end of World War I. Hitler's forces were not yet overpowering and had orders to withdraw if French troops opposed their advance. But France would not act alone and could not get Britain to join in a military response. Hitler's gamble succeeded, and German generals who were plotting to overthrow him backed down. Nazi storm troopers celebrated by parading in Berlin and chanting: "Today we own Germany and tomorrow the entire world."

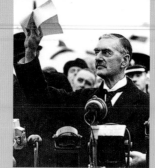

False Optimism **Neville Chamberlain proudly waves the 1938 peace accord, which Hitler shredded within months.**

Hitler went on to annex Austria, an ethnically German country where his troops were greeted in March 1938 with banners proclaiming "One People, One Reich, One Führer!" When leaders in London and Paris let that provocation pass unchallenged, Hitler then threatened Czechoslovakia, where ethnic Germans were a minority, concentrated in the Sudetenland along Germany's border. Hitler's growing military strength made France and Britain all the more cautious. British prime minister Neville Chamberlain was so intent on avoiding war that he ended up encouraging German aggression.

Meeting with Hitler at Munich in September 1938, Chamberlain and French premier Édouard Daladier agreed to let German troops occupy the Sudetenland, placing all of Czechoslovakia at risk. Hitler's one concession was to sign what the Führer deemed a meaningless "scrap of paper," stating that the Munich accord signaled the desire of Germany and Britain "never to go to war again." Chamberlain returned home touting the deal as "peace with honor . . . peace for our time." Hitler doubted his resolve and soon broke the peace by overrunning the rest of Czechoslovakia. Britain and France then pledged to fight if Germany invaded Poland. Appeasement had failed, and war was imminent. ∎

Hostile Takeover **Police restrain angry Czechs as German troops enter Prague and occupy the capital on March 15, 1939. The Czech government yielded after Hitler threatened to bomb the city.**

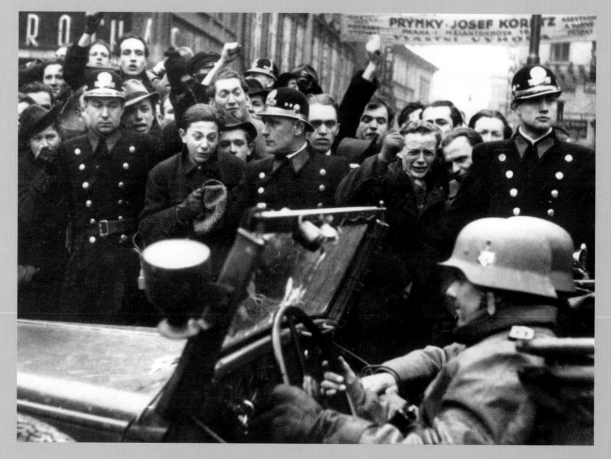

Tearful Salute An overwrought woman raises her arm dutifully as German occupation forces enter the Sudetenland in October 1938. The occupiers were greeted joyfully by many ethnic Germans there but were dreaded by some other inhabitants, who saluted only because they felt compelled to.

Blitzing Poland

The fate of Poland was sealed on August 24, 1939, when Germany and the Soviet Union concluded their Nonaggression Pact. A temporary truce between Hitler and Stalin, the pact allowed those two ruthless dictators from opposite ends of the ideological spectrum to pursue the one goal they had in common—wiping Poland off the map. Hitler could now expand his Reich by seizing central and western Poland, including the capital, Warsaw, and the Polish Corridor separating East Prussia from the rest of Germany. Stalin would then enlarge his empire by occupying eastern Poland. With the Soviet leader as his new comrade-in-arms, Hitler had Poland cornered and doubted that Britain and France would intervene to save that country. "Our enemies are little worms," he told his generals. "I got to know them at Munich."

On September 1, German ground forces swept into Poland while Stuka dive-bombers and other warplanes of their formidable Luftwaffe struck military as well as civilian targets. Britain and France declared war two days later and began mobilizing to fight, but could do little to prevent Poland from being overrun by Hitler's army, which advanced so rapidly in tanks, trucks, and other vehicles that reporters coined the term *blitzkrieg* ("lightning war") to describe the

campaign. "The Germans have proceeded not only with might and speed, but with method," wrote *New York Times* war correspondent Otto Tolischus, "and this bids fair to be the first war decided not by infantry, 'the queen of all arms,' but by fast motorized divisions and, especially, by the air force."

By month's end, the Germans had captured Warsaw and seized the bulk of Poland, while Soviet forces claimed their share to the east. Hitler's quick victory did not bode well for his opponents in western Europe. In upcoming campaigns, German forces would refine their blitzkrieg tactics and combine swift armored thrusts with precise air strikes to achieve stunning breakthroughs. ■

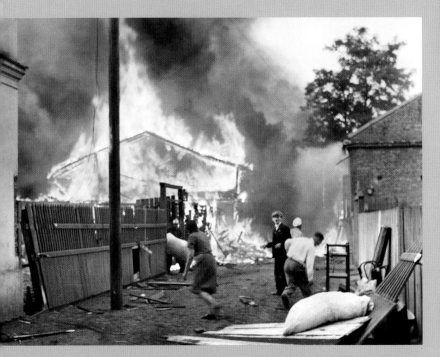

Under Fire Residents of Warsaw flee houses hit by firebombs dropped on the Polish capital by the Luftwaffe. For precision bombing, the Germans relied on the Junkers Ju-87 Stuka *(left)*, equipped with a siren that wailed eerily as the dive-bomber descended. Although hailed as a blitzkrieg, the German conquest of Poland also involved slower devices such as horse-drawn artillery and methodical advances by foot soldiers like the infantryman at right, hurling a stick grenade.

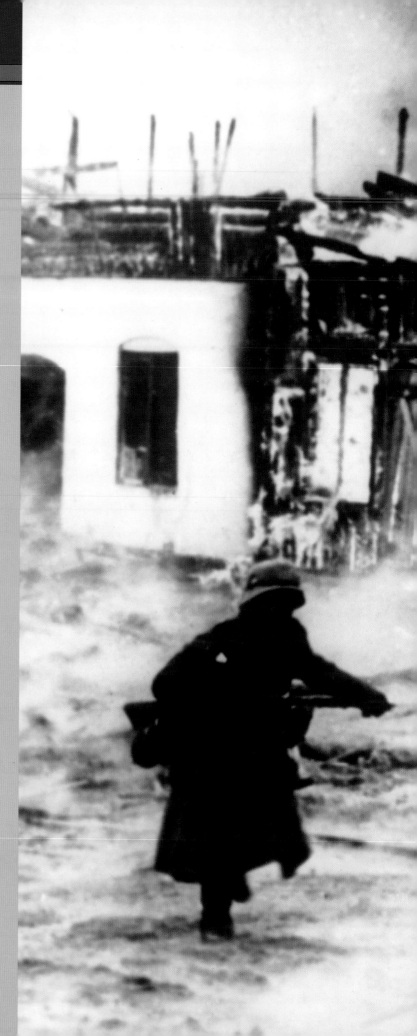

Breakthrough in the West

After conquering Poland, Hitler prepared to settle scores with France and Britain. He was surprised but not dismayed when they declared war as promised. Now that the battle lines were drawn, he saw an opportunity to defeat France "in one gigantic knockout blow" that would leave the British isolated and force them to come to terms. Before launching that strike, Hitler secured his northern flank by invading Denmark and Norway in April 1940 and neutralizing Sweden. By May, he was ready to slug it out with the western powers.

The path of least resistance for German forces invading France, whose border with Germany was shielded by the formidable Maginot Line, lay through the vulnerable Low Countries to the north. On May 10, one German army group invaded Holland, luring French troops and the British Expeditionary Force (BEF) northward into Belgium to meet that threat. Meanwhile, the armored divisions of a second army group were moving furtively through Luxembourg and the forested Ardennes, mistakenly considered impenetrable by tanks. On May 13, they stunned French forces at Sedan, crossed the Meuse River, and raced toward the English Channel, driving a wedge between Allied forces in Belgium and those still in France. When one French general learned of that devastating breakthrough, he "burst into tears," an aide recalled. "He was the first man I had seen weep during this campaign. Alas, there were to be others."

On May 24, fearing that his fast-advancing panzers (German tanks and armored units) were overextended and vulnerable to a counterattack, Hitler halted them near the French port of Dunkirk, just south of the Belgian border, until infantry could catch up. The pause allowed the imperiled BEF to fortify Dunkirk and hold out long enough for an improvised fleet to ferry nearly 340,000 troops across the Channel to safety. That "miracle at Dunkirk" encouraged the British to defy Hitler and keep fighting. But many Allied soldiers were cut off and captured when Dunkirk fell in early June, leaving France vulnerable to the Germans, who began bearing down on Paris. "The new advance will not be very arduous," wrote Maj. Gen. Erwin Rommel as his panzers turned southward. "The sooner we get on with it, the better." ∎

Path of Destruction German troops storm a burning Norwegian village in the spring of 1940. Similar scenes unfolded as Hitler's Wehrmacht blazed its way through the Low Countries and France.

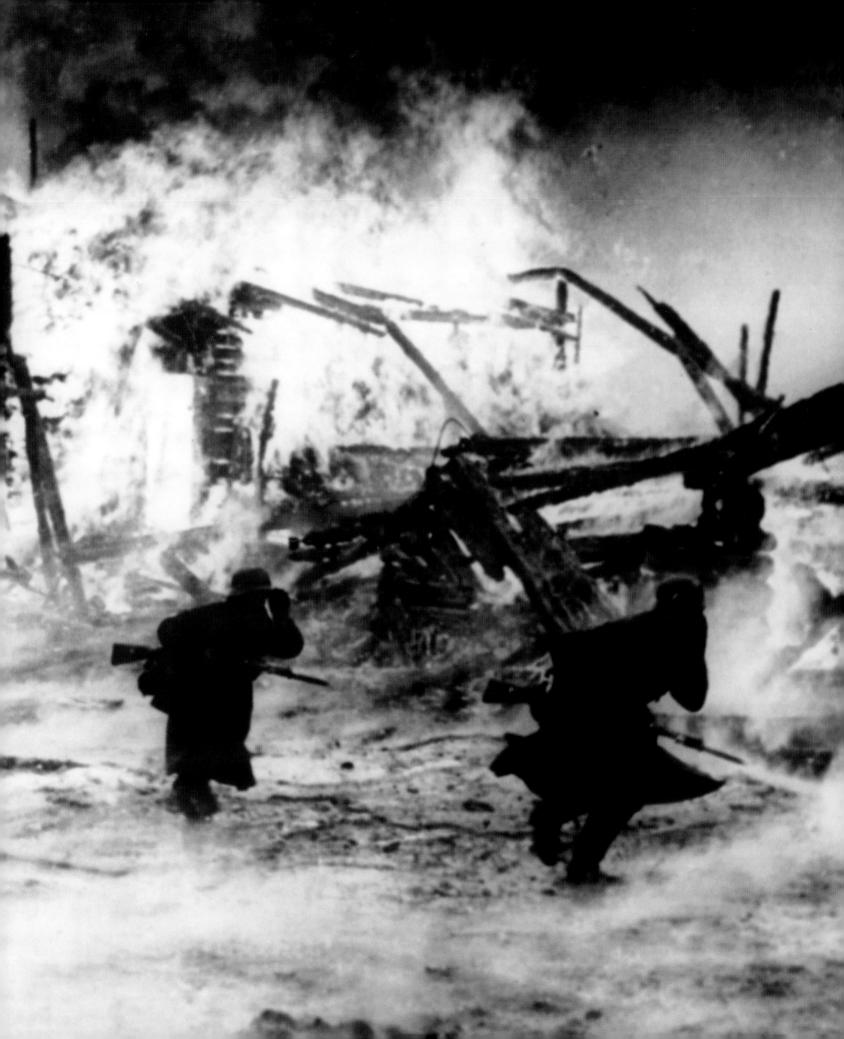

Triumphal Tour Hitler pauses before the Eiffel Tower with Albert Speer *(left)* on June 23, 1940, soon after his troops occupied Paris. Hitler "stood at the height of his triumphs," Speer wrote, but decided against staging a victory parade. "We aren't at the end yet," he said.

The Fall of France

The climactic battle for France began on June 5, 1940, when German forces crossed the Somme River, the site of prolonged trench warfare during World War I. The French commander, Gen. Maxime Weygand, urged his countrymen to stand fast as they did in 1914 when they stopped the Germans short of Paris. "The battle on which the fate of the country depends will be fought, without thought of withdrawal, from the position that we now occupy," Weygand declared. "All officers . . . must be filled with the grim desire to fight to the death." This time, however, there would be no holding back the German invaders, whose mobile forces were primed to wage blitzkrieg and avoid the deadlock that exhausted their country in the last war. General Rommel's tanks were among the first to punch through Weygand's static defenses. "All quiet forward," he reported that evening, "enemy in shreds." French officials abandoned

Paris on June 10 and declared the city open, or undefended, to spare the populace. A week later, 84-year-old Marshal Philippe Pétain took charge of the government and announced to the nation: "With a heavy heart, I tell you today that it is necessary to stop the fighting." Gen. Charles de Gaulle denounced Pétain for yielding and fled to London as self-proclaimed leader of the Free French.

On June 21, Hitler imposed an armistice on French commanders in the same railway car where German officers had conceded defeat in 1918. His terms confined Pétain's compliant Vichy-based administration to southern France and placed the rest of the country under German occupation. Afterward, Hitler toured Paris with his chief architect, Albert Speer, and told him that he had been considering destroying that majestic capital. Instead, he had decided to transform Berlin into the world's greatest city. "Paris will be only a shadow," he said. "So why should we destroy it?" ■

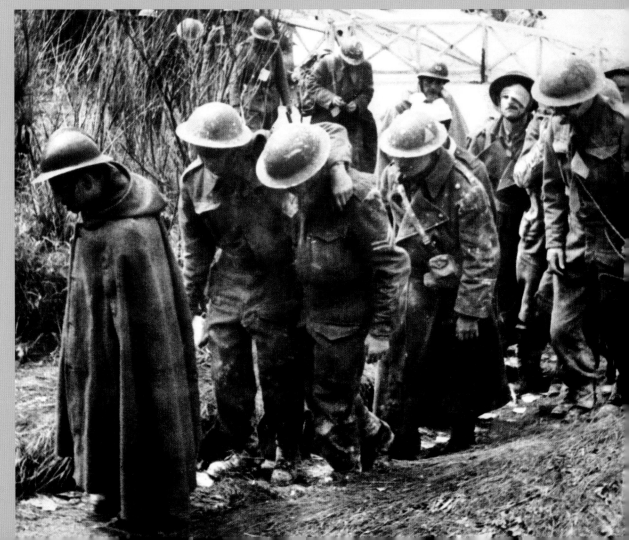

Bitter Losses These downcast British soldiers, captured at Dunkirk, were among more than a half million Allied troops seized by the Germans before the Wehrmacht crossed the Somme in early June. A million more were captured before the fighting ended, most of them French forces, who remained in detention for the duration of the war under the armistice imposed by Hitler. French regimental flags were salvaged and taken south to Marseilles, in Vichy territory, where citizens like the tearful man pictured above watched mournfully as the flags flew one last time before being shipped for safekeeping to Algeria, governed by Vichy officials like other French colonies.

The Battle of Britain

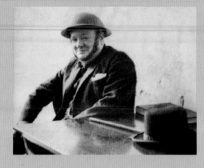

Winston Churchill succeeded Neville Chamberlain as prime minister on May 10, 1940, the same day Hitler launched the offensive that defeated France and left Britain alone to oppose Nazi Germany. A fervent critic of appeasement, Churchill ruled out coming to terms with Hitler and pledged continued defiance. "We shall fight on the seas and oceans," he vowed in June, "we shall fight with growing confidence and growing strength in the air, we shall defend our island, whatever the cost may be. We shall fight on the beaches . . . we shall fight in the hills; we shall never surrender."

Churchill's confidence in British air power was well founded, for the Royal Air Force (RAF) possessed an unrivaled radar network to detect attacks and superb warplanes, flown by skilled pilots. Hitler could not risk crossing the Channel and fighting the British on their beaches without first defeating the RAF. The numerically superior Luftwaffe launched the Battle of Britain in July and came close to

victory by pounding RAF bases and depleting its corps of trained pilots. Goaded by the British bombing of Berlin, Hitler then vowed to "eradicate their cities."

That aerial "blitz" was appalling for civilians— who took shelter in London's Underground as bombs rained down—but allowed the RAF to repair its airfields and replenish its squadrons. Strategic bombing "makes headlines, kills people, and smashes property," radio correspondent Edward R. Murrow reported from London in September. "But it doesn't win wars," he concluded, and "will not cause this country to collapse." Hitler scrapped plans to invade Britain as winter approached. For the first time, an opponent had withstood his threats and assaults by resolving, in Churchill's words, never to give in, never to yield "to the apparently overwhelming might of the enemy." ∎

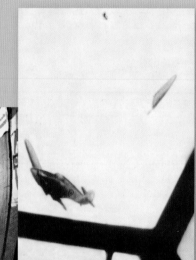

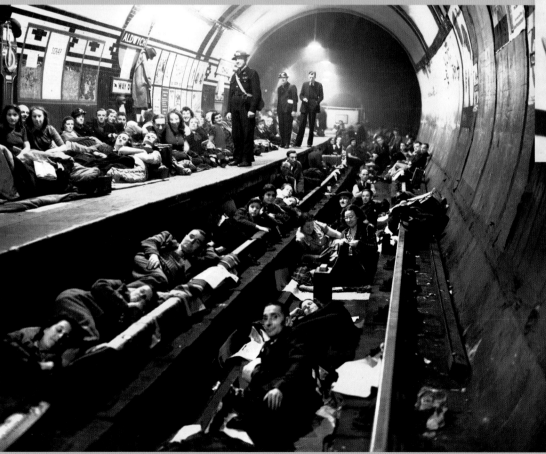

Enduring the Blitz Londoners huddle in the Underground (*left*), whose stations became bomb shelters at night. Churchill himself exchanged his bowler for a steel helmet and took shelter during air raids, while smiling confidently for the photographer who snapped the picture at top. The RAF lost more than 900 aircraft in the Battle of Britain, including the Hawker Hurricane above, photographed from the cockpit of a Luftwaffe fighter moments after the Hurricane's wing was shot off and the pilot bailed out. RAF pilots downed nearly twice as many German warplanes, however, and denied Hitler the air superiority he needed to attempt an invasion.

Smoldering Ruins Firefighters douse flames in a bombed-out section of London on New Year's Day, 1941. The Blitz continued through the winter and left nearly 100,000 people dead or wounded.

War in the Balkans

Hitler was drawn into the treacherous Balkans—a region of forbidding terrain and fierce ethnic rivalries—by his faltering Axis partner, Mussolini. In October 1940, seeking to rival Hitler's conquests, Mussolini ordered troops in Albania, occupied by Italy in 1939, to invade Greece. The Greeks routed the Italians and strengthened ties with Britain, which sent troops to bolster Greece and urged Yugoslavia to resist Germany and its allies in the region, including oil-rich Romania. When Yugoslav officers hostile to the Axis took charge in Belgrade in April 1941, Hitler invaded their country and ordered the Luftwaffe to "destroy the city." At least 17,000 people died in that attack, described by one German general as "a matter of Hitler's vanity, his personal revenge." By month's end, Axis forces had overrun both Yugoslavia and Greece, and British troops had withdrawn to Crete. In May, the Germans launched an airborne assault on that island, killing or capturing some 15,000 British soldiers.

Conquering the Balkans proved easier than pacifying that fractious region. Serbs in Yugoslavia had long been at odds with Croats, a rift the Germans exploited by setting up a puppet Croatian state, led by fascists called Ustase. Opposing them were partisans led by Josip Broz, a communist who took the name Tito. A Croat himself, Tito forged a multiethnic resistance movement, which incorporated many Serbs but clashed with Serbian monarchists called Chetniks, who began collaborating with occupation forces. Churchill set aside his aversion to communism and aided Tito's partisans because they were doing the "most harm to the Germans." Hitler responded by boosting his forces in the Balkans to 100,000 and ordering the execution of 100 Yugoslavs for every German killed. That vicious conflict was an added burden for his Wehrmacht, already severely strained by the huge task he undertook in late June 1941—the invasion of the Soviet Union, delayed for several weeks by the distracting Balkans campaign. ∎

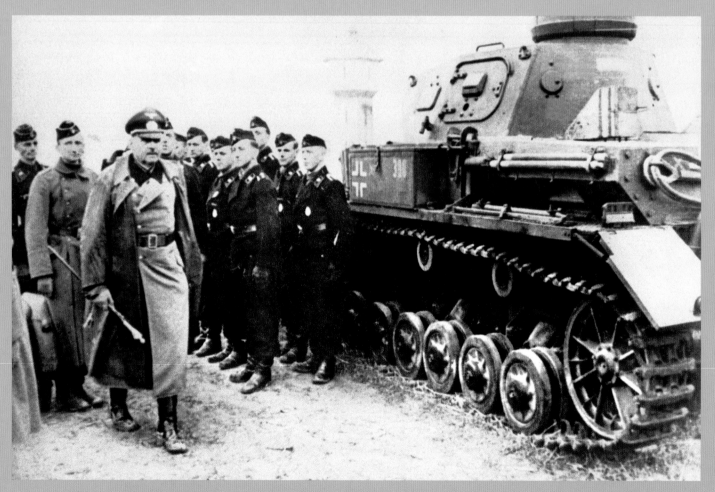

Ready for Action Field Marshal Wilhelm List inspects a panzer division in Bulgaria shortly before German tanks and troops invaded Yugoslavia in April 1941.

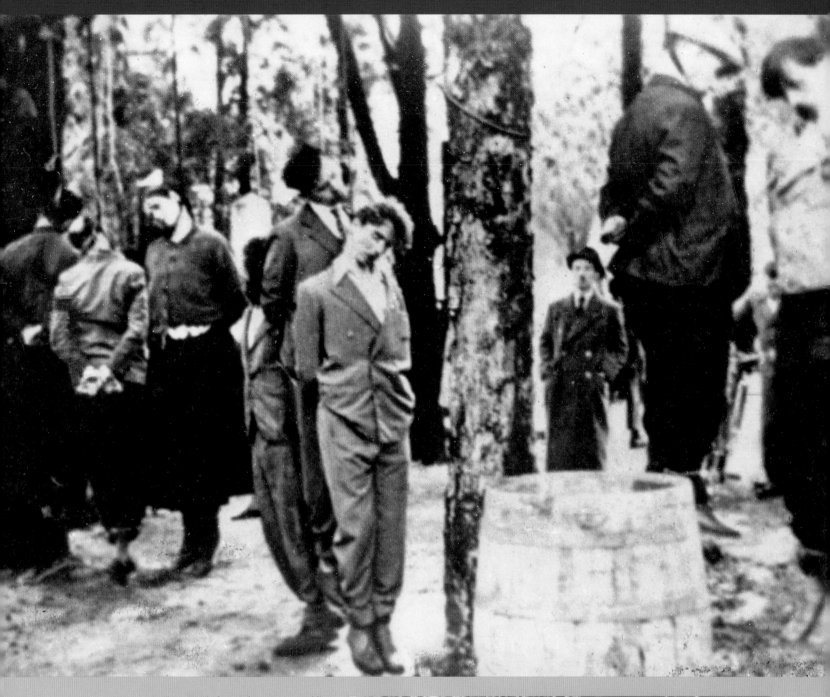

Fierce Reprisals At right, a German soldier shoots suspected partisans in Pančevo, Yugoslavia, in retaliation for sniper attacks that killed two Germans there in late April 1941. In this case, a German military tribunal condemned to death 36 men found to be carrying weapons. On other occasions, Axis occupation forces in the Balkans responded to assaults by rounding up civilians indiscriminately and executing them by firing squad or by hanging (above).

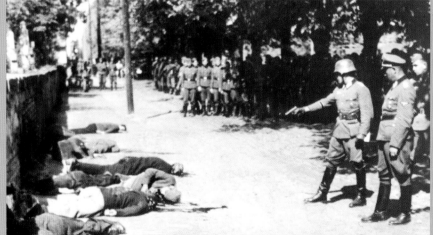

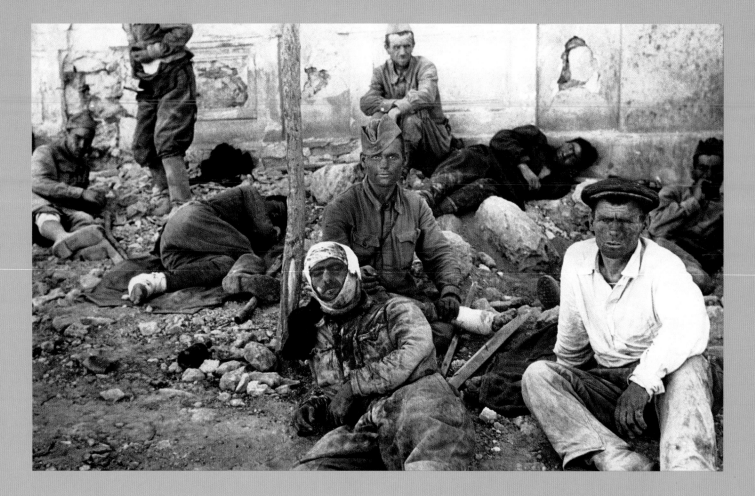

Taking on Russia

Hitler's decision to break his pact with Stalin and invade the Soviet Union in June 1941 was a fateful choice—one whose consequences for World War II were rivaled in magnitude only by the decision of his Axis partner Japan to attack the United States six months later. Like Japan's leaders, Hitler threw caution aside and exacerbated an ongoing conflict by challenging a nation far larger than his own. A safer course for Germany would have been to go all out to defeat British forces around the Mediterranean, seizing the Suez Canal and other vital links between Britain and its colonies while subjecting that island nation to relentless submarine warfare. But Hitler had always considered fighting the British to be of secondary importance—a mere prelude to his grand scheme, which was to advance eastward against the Soviets and fulfill his twin obsessions: living space for Germans and degradation or death for Slavs, Jews, and others defined as subhuman by Nazi zealots, who had a

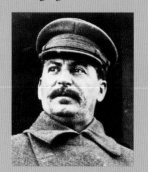

Hitler's Nemesis Stalin was staggered by the German invasion but struck back hard at Hitler.

method to their madness that made them all the more dangerous. This would be a "war of extermination," warned Hitler, who told his generals to ignore international law and act with "unprecedented, unmerciful, and unrelenting harshness."

Beginning on June 22, three million German troops invaded Russia in a blistering offensive code-named Operation Barbarossa that caught Stalin and his Red Army off guard. One-fourth of the Soviet Air Force was destroyed that first day, much of it on the ground. Huge gains by German armored columns in the opening weeks seemingly confirmed Hitler's prediction that Stalin's regime would soon collapse under attack. The Soviet dictator had deep reserves, however. If the Germans smashed a dozen divisions, "the Russians simply put up another dozen," wrote Gen. Franz Halder in August. "We have underestimated the Russian colossus," he concluded. Hitler's Japanese allies would soon make the same miscalculation in taking on the American colossus. ∎

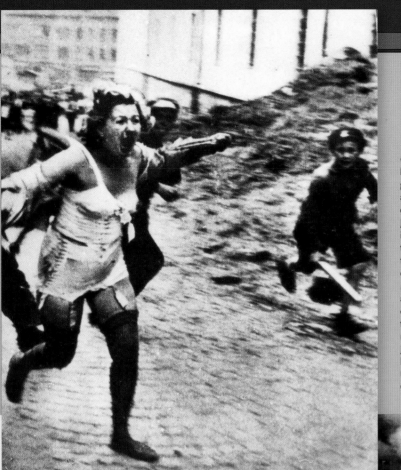

Conquest and Carnage Below, smoke billows from a burning farmhouse as panzer grenadiers—infantrymen with German armored units—dash forward to clear out enemy sharpshooters near Smolensk in July 1941. Millions fell victim to the German invasion, including vast numbers of Soviet troops who were killed or captured like the forlorn prisoners shown here amid the rubble of German-occupied Sevastopol in 1942 *(opposite)*. Many of those prisoners perished, as did countless civilians when Nazi officials dispatched death squads to murder Jews by the thousands or incited pogroms—orchestrated mob violence whose targets included the Jewish woman at left, fleeing in terror from her tormentors in Lviv, a city in what is now Ukraine that the Germans seized soon after Operation Barbarossa began.

Honolulu Star-Bulletin 1st EXTRA

Evening Bulletin, Est. 1882, No. 11278
Hawaiian Star, Vol. XLVIII, No. 15203

8 PAGES—HONOLULU, TERRITORY OF HAWAII, U. S. A., SUNDAY, DECEMBER 7, 1941—8 PAGES

★ PRICE FIVE CENTS

WAR !

(Associated Press by Transpacific Telephone)

SAN FRANCISCO, Dec. 7.—President Roosevelt announced this morning that Japanese planes had attacked Manila and Pearl Harbor.

OAHU BOMBED BY JAPANESE PLANES

SIX KNOWN DEAD, 21 INJURED, AT EMERGENCY HOSPITAL

Attack Made On Island's Defense Areas

By UNITED PRESS

WASHINGTON, Dec. 7.—Text of a White House announcement detailing the attack on the Hawaiian islands is:

"The Japanese attacked Pearl Harbor from the air and all naval and military activities on the island of Oahu, principal American base in the Hawaiian islands."

Oahu was attacked at 7:55 this morning by Japanese planes.

The Rising Sun, emblem of Japan, was seen on plane wing tips.

Wave after wave of bombers streamed through the clouded morning sky from the southwest and flung their missiles on a city resting in peaceful Sabbath calm.

According to an unconfirmed report received at the governor's office, the Japanese force that attacked Oahu reached island waters aboard two small airplane carriers.

It was also reported that at the governor's office either an attempt had been made to bomb the USS Lexington, or that it had been bombed.

CITY IN UPROAR

Within 10 minutes the city was in an uproar. As bombs fell in many parts of the city, and in defense areas the defenders of the islands went into quick action.

Army intelligence officers at Ft. Shafter announced officially shortly after 9 a. m. the fact of the bombardment by an enemy but long previous army and navy had taken immediate measures in defense.

"Oahu is under a sporadic air raid," the announcement said.

"Civilians are ordered to stay off the streets until further notice."

CIVILIANS ORDERED OFF STREETS

The army has ordered that all civilians stay off the streets and highways and not use telephones.

Evidence that the Japanese attack has registered some hits was shown by three billowing pillars of smoke in the Pearl Harbor and Hickam field area.

All navy personnel and civilian defense workers, with the exception of women, have been ordered to duty at Pearl Harbor.

The Pearl Harbor highway was immediately a mass of racing cars.

A trickling stream of injured people began pouring into the city emergency hospital a few minutes after the bombardment started.

Thousands of telephone calls almost swamped the Mutual Telephone Co., which put extra operators on duty.

At The Star-Bulletin office the phone calls deluged the single operator and it was impossible for this newspaper, for sometime, to handle the flood of calls. Here also an emergency operator was called.

HOUR OF ATTACK—7:55 A. M.

An official army report from department headquarters, made public shortly before 11, is that the first attack was at 7:55 a. m.

Witnesses said they saw at least 50 airplanes over Pearl Harbor.

The attack centered in the Pearl Harbor, Army authorities said:

"The rising sun was seen on the wing tips of the airplanes."

Although martial law has not been declared officially, the city of Honolulu was operating under M-Day conditions.

It is reliably reported that enemy objectives under attack were Wheeler field, Hickam field, Kaneohe bay and naval air station and Pearl Harbor.

Some enemy planes were reported short shot down.

The body of the pilot was seen in a plane burning at Wahiawa.

Oahu appeared to be taking calmly after the first uproar of queries.

ANTIAIRCRAFT GUNS IN ACTION

First indication of the raid came shortly before 8 this morning when antiaircraft guns around Pearl Harbor began sending up a thunderous barrage.

At the same time a vast cloud of black smoke arose from the naval base and also from Hickam field where flames could be seen.

BOMB NEAR GOVERNOR'S MANSION

Shortly before 9:30 a bomb fell near Washington Place, the residence of the governor. Governor Poindexter and Secretary Charles M. Hite were there.

It was reported that the bomb killed an unidentified Chinese man across the street in front of the Schuman Carriage Co. where windows were broken.

C. E. Daniels, a welder, found a fragment of shell or bomb at South and Queen Sts. which he brought into the City Hall. This fragment weighed about a pound.

At 10:05 a. m. today Governor Poindexter telephoned to The Star-Bulletin announcing he has declared a state of emergency for the entire territory.

He announced that Edouard L. Doty, executive secretary of the major disaster council, has been appointed director under the M-Day law's provisions.

Governor Poindexter urged all residents of Honolulu to remain off the street, and the people of the territory to remain calm.

Mr. Doty reported that all major disaster council wardens and medical units were on duty within a half hour of the time the alarm was given.

Workers employed at Pearl Harbor were ordered at 10:10 a. m. not to report at Pearl Harbor.

The mayor's major disaster council was to meet at the city hall at about 10:30 this morning.

At least two Japanese planes were reported at Hawaiian department headquarters to have been shot down.

One of the planes was shot down at Ft. Kamehameha and the other back of the Wa- *Turn to Page 2, Column 1.*

Hundreds See City Bombed

Hundreds of Honolulans who hurried to the top of Punchbowl soon after bombs began to fall, saw spread out before them the whole panorama of surprise attack and defense.

Far off over Pearl Harbor the white sky was polka-dotted with anti-aircraft smoke.

Rolling away from the navy base were billowing clouds of ugly black smoke. Sometimes a burst of flame reddened the black sources of the smoke.

Out from the silver-surfaced mouth of the harbor a flotilla of destroyers streamed into battle, smoke pouring from their stacks. *Turn to Page 2, Column 2.*

Names of Dead and Injured

The city emergency hospital reported at 10:30 a list of 4 killed and 21 injured.

The complete list will be verified later. Here is a partial list:

Peter Lopez, 24, of 2641 Kamanaiki St., was reported at 9:25 a. m. to be in serious condition from wounds in the upper abdomen.

Bernice Gonvela, 12, 2768 Kalihi St., is suffering from a mangled thigh, lacerations on the right leg and left arm.

A Portuguese girl, unidentified, 18 years old, died on arrival from puncture wounds.

Another victim who died on arrival was Frank Ohashi, 25, 3765 Kamanaiki St., from puncture wounds in the chest.

Cecilia Broadly, 28, Moanalua gardens, was released from the hospital after treatment for lacerations.

Three were reported injured and one reported killed from the bomb that fell at Fort and School Sts.

Schools Closed

All schools on Oahu, both public and private, will remain closed until further notice, Edouard L. Doty, territorial director of civilian defense, announced at 11 a. m. today. This does not apply elsewhere in the territory.

Editorial

HAWAII MEETS THE CRISIS

Honolulu and Hawaii will meet the emergency of war today as Honolulu and Hawaii have met emergencies in the past—coolly, calmly and with immediate and complete support of the officials, officers and troops who are in charge.

Governor Poindexter and the army and navy leaders have called upon the public to remain calm; for civilians who have no essential business on the streets to stay off; and for every man and woman to do his duty.

That request, coupled with the measures promptly taken to meet the situation that has suddenly and terribly developed, will be needed.

Hawaii will do its part—as a loyal American territory. In this crisis, every difference of race, creed and color will be submerged in the one desire and determination to play the part that Americans always play in crisis.

BULLETIN

Additional Star-Bulletin extras today will cover the latest developments in this war move.

Breaking News This extra edition of the *Honolulu Star-Bulletin* appeared soon after the attack on Pearl Harbor, which was far costlier than first reported.

30 ★ EYEWITNESS TO WORLD WAR II

O n Monday, December 1, 1941, Japan's military and political leaders gathered at the Imperial Palace in Tokyo for a war conference presided over by Emperor Hirohito, who sat above them on a platform in front of a golden screen. A slight, unassuming figure with thick glasses, the 40-year-old Hirohito did not look like a man who held Japan's destiny in his hands. Yet he was in fact the nation's commander in chief. He was being asked to approve an offensive that would set Japan against the United States—which was still at peace—and its embattled ally Great Britain. He did not seek that conflict, but he bore ultimate responsibility for exposing his people to the huge risks it entailed. ★ Hirohito, whose constitutional duties as emperor included appointing Japan's prime minister, had recently entrusted that high office to Gen. Hideki Tojo. A staunch advocate of imperial expansion, Tojo expected to continue on the aggressive course he and other Japanese officers had set when they invaded China in 1937 and maneuvered their country into the Axis alliance with Germany and Italy in 1940. That defensive pact did not require Japan to join its Axis partners in their war against Britain. But Tojo and his fellow militants, who dominated the government, hoped to exploit the fact that many European countries were now under German occupation or attack by seizing vulnerable British, French, and Dutch colonies in Asia—lands rich in oil, rubber, and other militarily vital resources that Japan lacked. The urge to grab those assets increased when the U.S. responded to the Japanese occupation of French Indochina in July 1941

Seven Days in December:

THE WEEK THAT CHANGED THE WORLD

■ **December 1, 1941** Emperor Hirohito approves Japanese attacks on the U.S. and its allies.

■ **December 5, 1941** Soviet forces counterattack German troops near Moscow and begin driving them back.

■ **December 6, 1941** President Franklin D. Roosevelt sends a message to Hirohito seeking peace.

■ **December 7, 1941** Japanese attack Pearl Harbor and launch a far-reaching offensive in Asia and the Pacific.

■ **December 8, 1941** Japanese attack American bases in the Philippines; U.S. Congress declares war on Japan.

■ **December 11, 1941** Adolf Hitler declares Germany at war with the U.S.

> **"Across the four seas all are brothers. In such a world why do the waves rage, the winds roar?"**
>
> EMPEROR HIROHITO, QUOTING A POEM COMPOSED BY HIS GRANDFATHER, EMPEROR MEIJI

by imposing an oil embargo on Tokyo. War planners there shelved plans to join Germany in its ongoing invasion of Russia, a traditional enemy of Japan, and settled instead on a sweeping offensive that included attacks on British Malaya and Singapore and the Dutch East Indies as well as American bases in the Philippines and Hawaii, where the U.S. Pacific Fleet lay sheltered at Pearl Harbor.

Tojo could not launch those attacks without the consent of Hirohito, who served not just as commander in chief but as Japan's national idol, revered as a living god who watched kindly over his people. As such, the emperor tried to remain above the fray and hold out hope for peace even as his officers prepared for war. Shortly before appointing Tojo prime minister, Hirohito had prompted one last effort to resolve the crisis diplomatically by quoting a poem composed by his grandfather, Emperor Meiji: "Across the four seas all are brothers. / In such a world why do the waves rage, the winds roar?" Japanese envoys in Washington entered into talks with Secretary of State Cordell Hull that continued into late November. By then, however, Tojo had set the offensive in motion, with the understanding that forces on their way to battle would be recalled if a diplomatic breakthrough occurred. Prospects for peace dwindled when American officials learned that a Japanese convoy was carrying tens of thousands of troops toward Malaya, an invasion the U.S. would not tolerate. Secretary Hull, who doubted that a government headed by Tojo could be trusted, saw no point in negotiating under the threat of imminent hostilities and made a final offer to Tokyo: Washington would lift the embargo and offer Japan economic incentives if it nullified the Tripartite Pact and withdrew its forces from China and Indochina.

Whether to retreat and make peace or press ahead and wage war was the great issue facing the imperial conference on December 1. Hirohito hosted the meeting, but did not speak. He left it to the head of his privy council, Yoshimichi Hara, to question Tojo and other officials and deliver the verdict. To yield to the American demands, Hara concluded, would threaten the "existence of our empire." Tojo understood that this was Hirohito's conclusion as well. "Once His Majesty decides to commence hostilities," he stated, "we will all strive to meet our obligations to him, bring the government and the military ever closer together, resolve that the nation united will go on to victory, make an all-out effort to achieve our war aims, and set His Majesty's mind at ease."

Throughout the conference, Hirohito "displayed not the slightest anxiety," one witness reported. "He seemed to be in a good mood. We were filled with awe." He may have taken comfort in the thought that he had exhausted the possibilities for peace before embarking on war. But by appointing as prime minister the militant General Tojo—and by allowing warships and troop transports to be launched menacingly while negotiations in Washington were under way—Japan's commander in chief had undermined those talks. Soon after the conference ended, Hirohito affixed his seal to a document approving the offensive. To bow to Washington, he remarked, would be humiliating.

Hirohito and his officers, already embroiled in a punishing conflict with China, were taking a big gamble by widening their war to include the United States. Among those who harbored doubts about the outcome was Adm. Isoroku Yamamoto, commander of the Combined Fleet (incorporating most of Japan's naval forces), who planned the assault on Pearl Harbor by a formidable naval task force, including six aircraft carriers of the First

Air Fleet. Yamamoto had spent several years in the U.S. as a student and naval attaché and marveled at its industrial might. He knew that Japan could not match American war production if the conflict lasted long. But he was a gambler by nature who loved poker and other games of chance, and he was prepared to risk all on a surprise attack on Pearl Harbor. If it succeeded as he hoped, America might be left without the will or means to wage a costly war in the Pacific while also defending against Germany in the Atlantic. If his bid failed, however, and the U.S. retained the strength and determination to strike back, he had little hope of prevailing in the long run. "If I am told to fight, I shall run wild for the first six months or a year," he remarked, "but I have utterly no confidence for the second or third year."

On December 2, Yamamoto learned that Hirohito had approved the offensive and signaled Vice Adm. Chuichi Nagumo, commanding the task force destined for Pearl Harbor, to attack there as planned, early on Sunday morning, December 7. The events of this momentous week would transform the war that began in Europe in 1939 into a truly global conflict—by far the largest and most destructive armed struggle ever waged. Hirohito's decision in Tokyo, and other steps taken in the U.S. and Europe during these seven days, would alter not just the course of the war but the fate of the world. Axis leaders who hoped to dominate the globe would now have to contend with the lingering might of the British Empire and the growing strength of the world's two emerging superpowers: the United States and the Soviet Union. Yet Japanese forces were far better prepared for conflict in Asia and the Pacific than their Allied foes and saw a golden opportunity to achieve supremacy there. No one in December 1941 could be sure of the war's outcome, but one thing was certain: There would be terrible sacrifices on both sides before the greatest conflict of all time reached its shattering conclusion.

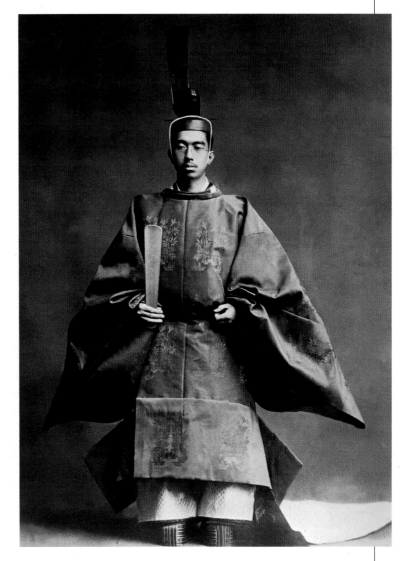

Divine Leader **Wearing traditional court dress, Japanese emperor Hirohito poses for a formal portrait at the time of his enthronement in 1928, which included a ceremony deifying him. As Japan moved toward war with the U.S., Hirohito upheld the policies of the militarist faction that dominated the government and armed forces.**

WARNINGS IN WASHINGTON

While Hirohito was settling on war, President Franklin D. Roosevelt was returning to the White House from his retreat at Warm Springs, Georgia, where he shared Thanksgiving dinner with children at a rehabilitation center he founded for those afflicted with polio as he was. Paralyzed from the waist down in 1921 at the age of 39, he had overcome that setback to become the only American ever elected to three terms as President. Roosevelt had faced many trials since his first inauguration in the depths of the Great Depression in January 1933, but nothing as dire as the crisis that confronted him now in Washington. On his desk when he got back was a message broadcast in code by radio from Tokyo to Lt. Gen. Hiroshi Oshima, the Japanese ambassador in Berlin. Intercepted

and deciphered by the U.S. Army's Signal Intelligence Service (SIS), the dispatch warned that "there is extreme danger that war may suddenly break out between the Anglo-Saxon nations and Japan through some clash of arms and that the time of the breaking out of this war may come quicker than anyone dreams."

This was the latest of many alarming messages decoded by an SIS team led by William Friedman, a brilliant cryptanalyst who had succeeded in reproducing the electronic circuitry of a machine known as Purple, which the Japanese used to encode and decipher their diplomatic communications. The treasure trove of intelligence produced by Friedman's team was called Magic and allowed Roosevelt and others in high positions in Washington to read the minds of their counterparts in Tokyo. A recent Magic intercept had revealed that if the talks with Secretary of State Hull did not yield a settlement by November 29, "things are automatically going to happen." That hostilities were imminent was confirmed by the message to Oshima, indicating that one or both of the "Anglo-Saxon nations," meaning the U.S. and Great Britain, might be attacked by Japan at any time.

No one in Washington knew of the impending assault on Pearl Harbor, though, because Tokyo did not inform diplomats of its specific war plans, and the Japanese Navy had its own code for radio signals. That code was changed shortly before the attack on Pearl Harbor, and the strike force approaching Hawaii observed radio silence, leaving U.S. Navy cryptanalysts with no clue as to its whereabouts or intentions. The SIS did gather intelligence suggesting that Pearl Harbor was a likely target, but those clues were overlooked. One message sent from Tokyo to the Japanese consul in Honolulu on December 2 requested daily reports on the presence in Pearl Harbor of aircraft carriers and other warships and asked whether they were "provided with antitorpedo nets." A reply sent to Tokyo on December 3 contained a report on the Pacific Fleet by a naval intelligence officer at the consulate, Ens. Takeo Yoshikawa. The SIS passed those messages along to the U.S. Navy's cryptographic bureau, where a linguist new to the staff, Dorothy Edgers, translated the Japanese text into English. She was alarmed by the dispatches and brought them to the attention of her chief, but he set them aside until the following week, when he would have more time to review her work. "We'll get back to this on Monday," he told her.

Certain that Japan would soon attack, but unsure when or where the blow would fall, Roosevelt found himself in an unenviable position as commander in chief. To win the war he knew was coming, he felt compelled to let the nation's enemies strike the first blow. A preemptive attack on Japan would cast the U.S. as the aggressor and upset American isolationists, who would support war only if their country was forced into it. Furthermore, Army and Navy chiefs hoped to avoid conflict with Japan long enough to allow them to build up strength in the Pacific. There was little they could do now that war appeared likely except place American bases on alert. Army chief Gen. George Marshall stated the government's position in a warning sent to commanders in the Pacific after negotiations ended: "Japanese future action unpredictable but hostile action possible at any moment. If hostilities cannot, repeat cannot, be avoided the United States desires that Japan commit the first overt act. This policy should not, repeat not, be

"Japanese future action unpredictable but hostile action possible at any moment. If hostilities cannot, repeat cannot, be avoided the United States desires that Japan commit the first overt act."

ARMY CHIEF GEORGE MARSHALL IN A WARNING SENT TO AMERICAN COMMANDERS IN THE PACIFIC

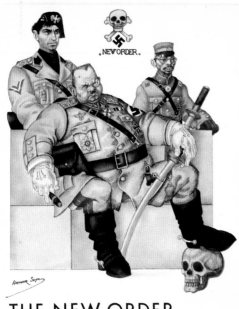

THE NEW ORDER
BY ARTHUR SZYK

Sinister Allies **The grotesque figures of a Japanese imperialist *(right)*, German Nazi *(center)*, and Italian Fascist adorn the title page of *The New Order*, by Polish-born artist Arthur Szyk. His book lampooning the Axis powers appeared in 1941, one year after Japan, Germany, and Italy concluded their Tripartite Pact.**

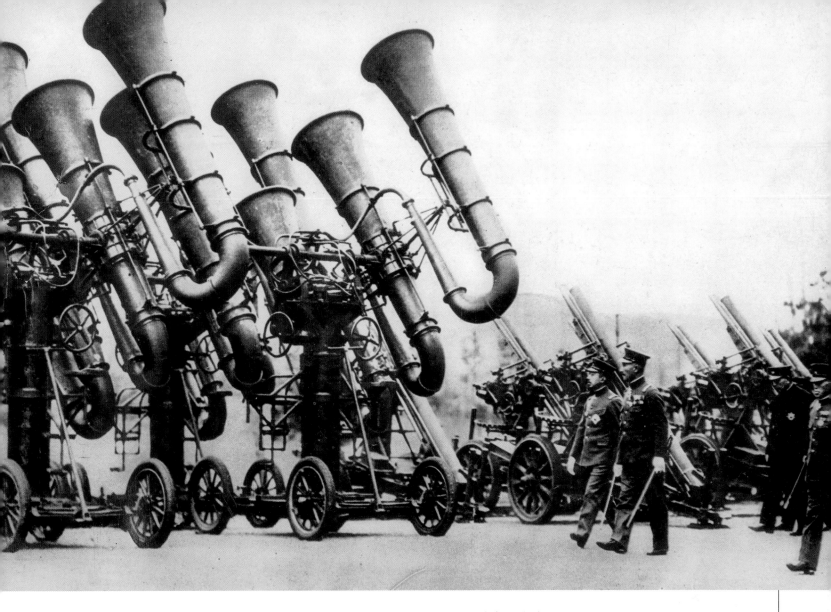

construed as restricting you to a course of action that might jeopardize your defense." The last thing Marshall or Roosevelt wanted was for U.S. forces to be caught napping and suffer heavy losses. A Japanese attack rebuffed by alert defenders would be ample justification for war—and far better for American morale than a costly defeat.

In choosing not to initiate hostilities with Japan, Roosevelt was supported not just by his military chiefs but also by British prime minister Winston Churchill. Roosevelt was aiding Britain against Germany and shared Churchill's conviction that war in Europe should have priority over war in the Pacific if a showdown with Tokyo could not be avoided. "It seems to me that one important method remains unused in averting war between Japan and our two countries," Churchill wrote Roosevelt, "namely a plain declaration, secret or public as may be thought best, that any further act of aggression by Japan will lead to the gravest consequence." The British would make a similar declaration, added Churchill, who closed on a personal note: "Forgive me, my dear friend, for presuming to press such a course upon you, but I am convinced that it might make all the difference and prevent a melancholy extension of the war."

Roosevelt responded by issuing a private appeal to Hirohito. On Saturday, December 6, he sent a radiogram urging the emperor to withdraw his forces from Indochina, a gesture

Listening for the Enemy Hirohito, accompanied by senior military officers, inspects massive acoustic locators used by Japan in the 1930s to defend against air raids. Resembling giant tubas, the passive listening devices pivoted to locate the engine noise of approaching planes and direct the fire of the antiaircraft guns in the background.

A Spy at Pearl Harbor

In the early hours of December 7, 1941, a diplomat known as Tadashi Morimura was eating breakfast at the Japanese Consulate in Honolulu when the first bomb fell on Pearl Harbor. Upon hearing the explosion, he switched on a shortwave set tuned to Radio Tokyo. As more explosions rocked the area, Morimura listened attentively to a news broadcast for the repetition of a seemingly innocuous phrase, "east wind, rain," inserted into a weather report. It was a coded message that the Imperial Navy had attacked Pearl Harbor. Outside, Morimura recalled, "bombs were falling and black smoke was clearly visible, hanging in a pall over the harbor."

Tadashi Morimura was the cover name for naval officer Takeo Yoshikawa, a gifted intelligence agent who helped commanders plan the surprise attack. Yoshikawa, who graduated from the Imperial Naval Academy at the top of his class, trained on surface ships and submarines before joining the Intelligence Division of the Navy General Staff, where he became an expert on the U.S. Pacific Fleet and its bases.

In late March 1941, traveling under a false diplomatic passport, Yoshikawa sailed for Hawaii to serve under cover at the consulate in Honolulu. His mission was to collect "legal intelligence" on Pearl Harbor and the Pacific Fleet, which meant conducting surveillance without breaking any laws to avoid being apprehended as a spy. He chose to

War Game Japanese naval officers used a model of Pearl Harbor similar to this one to plan their attack, aided by reports from 27-year-old Ens. Takeo Yoshikawa *(right)*, spying in Honolulu under diplomatic cover.

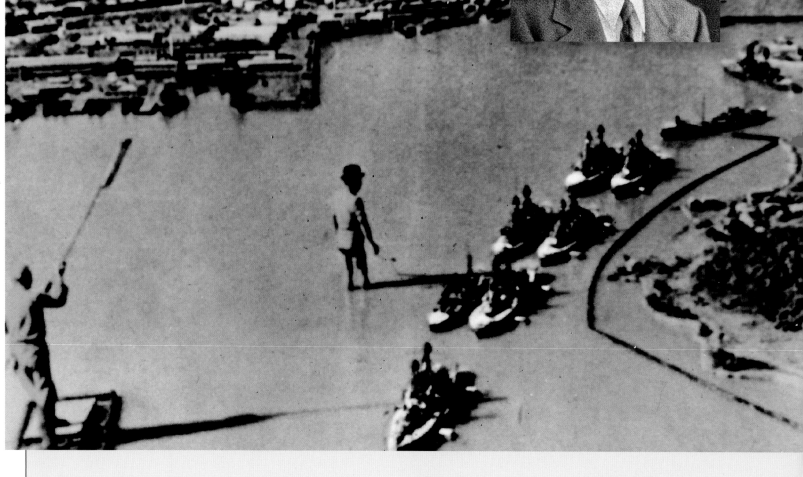

operate alone. "My superiors in Tokyo had cautioned me severely as to the vital nature of the mission," Yoshikawa recalled, "and I was never to find anyone whom I could trust sufficiently to assist me in its accomplishment." Although not told the exact purpose of his assignment, he understood that he was paving the way for an attack on U.S. naval facilities.

> ## "For a moment, at least, I held history in the palm of my hand."
> ### ENS. TAKEO YOSHIKAWA

The young consular official rented a second-story apartment in Honolulu overlooking the harbor and worked tirelessly, gleaning information about the military bases around Pearl Harbor and their security procedures, taking photographs of ships, and recording their movements. Posing as a carefree diplomat with few duties and plenty of leisure time, he took rides on tugboats, listened to gossip in bars and restaurants, and rented small aircraft for sightseeing flights over Honolulu to observe the military airfields. A strong swimmer, Yoshikawa joined tourists on Oahu's beaches to examine underwater obstructions, time the tides, and examine beach gradients. He made almost daily strolls through Pearl City with its clear view of the Ford Island airfield and Battleship Row and hiked up slopes overlooking Pearl Harbor to observe the comings and goings of the fleet.

Yoshikawa's favorite observation point provided excellent cover. He frequented the Shuncho-ro tearoom, a traditional Japanese geisha establishment perched above Pearl Harbor's East Loch. Yoshikawa always requested a table with a view from which he could observe ships in the harbor. He occasionally questioned the restaurant's geisha, who often entertained U.S. naval personnel, but never took them into his confidence, aware that most of Hawaii's Japanese population was loyal to America.

Yoshikawa sent a steady stream of intelligence reports to Tokyo, detailing the number and type

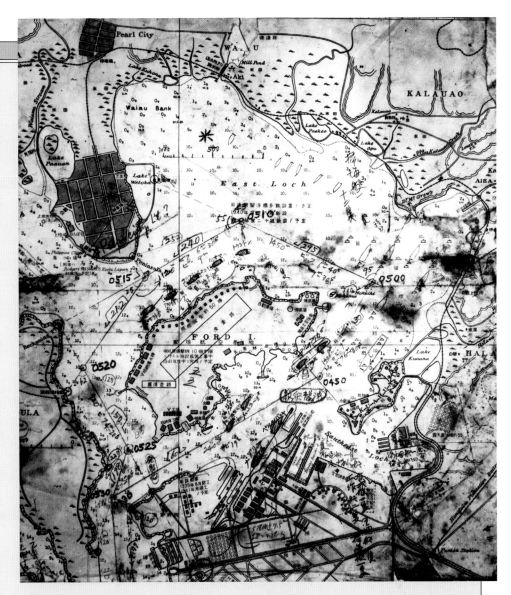

Charting an Attack **Intelligence supplied by Yoshikawa and others went into the handwritten notes on this chart of Pearl Harbor, recovered from the Japanese two-man submarine *HA-19*, which failed in its attempt to enter the harbor and target a U.S. warship on December 7.**

of ships present, the location of fuel and ammunition depots, and fleet dispositions within the anchorage. His messages were enciphered using the Japanese Foreign Ministry's J-19 diplomatic, or "Purple," code. That code had been broken, but U.S. intelligence officers gave communications from the consulate in Hawaii low priority and overlooked Yoshikawa's reports.

On September 24, Yoshikawa's superiors requested that all intelligence he provided be of "immediate tactical significance." Then in late November, Lt. Cmdr. Suguru Suzuki arrived in Honolulu aboard the Japanese liner *Taiyo Maru*,

disguised as a steward. Suzuki delivered a list of detailed questions concerning Pearl Harbor, to which Yoshikawa replied that same day. He knew that an attack was imminent when he was ordered to submit daily reports placing all ships in a grid system and was asked whether they were protected by antiaircraft defenses or antisubmarine nets. Yoshikawa sent his final message on December 6, reporting that the aircraft carriers "*Enterprise* and *Lexington* have sailed from Pearl Harbor."

On December 7, as the attack drew to a close, Yoshikawa and others in the consulate were arrested by FBI agents, who found no evidence of espionage. Eight months later, he was quietly repatriated to Japan in a diplomatic prisoner exchange. American officials did not know that they were releasing a spy who had proudly contributed to the attack. "For a moment, at least," he wrote afterward, "I held history in the palm of my hand." ∎

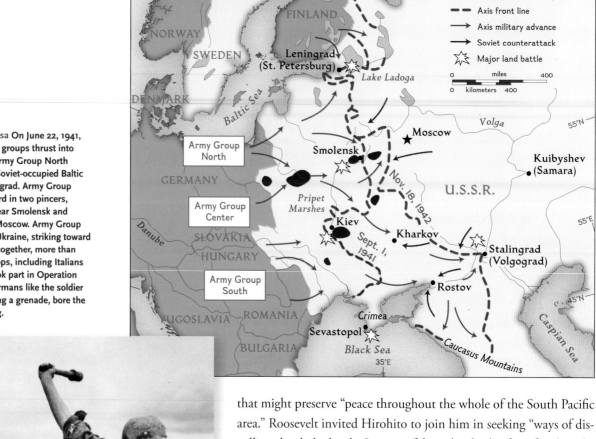

The Eastern Front
June 1941–November 1942

Axis territory June 1941
Trapped Soviet troops
Axis front line
Axis military advance
Soviet counterattack
Major land battle

Operation Barbarossa On June 22, 1941, three German army groups thrust into the Soviet Union. Army Group North drove through the Soviet-occupied Baltic states toward Leningrad. Army Group Center swept forward in two pincers, which converged near Smolensk and later advanced on Moscow. Army Group South lunged into Ukraine, striking toward Kiev and Rostov. Altogether, more than 4.5 million Axis troops, including Italians and Romanians, took part in Operation Barbarossa; but Germans like the soldier below, shown hurling a grenade, bore the brunt of the fighting.

that might preserve "peace throughout the whole of the South Pacific area." Roosevelt invited Hirohito to join him in seeking "ways of dispelling the dark clouds. I am confident that both of us, for the sake of the peoples not only of our own great countries but for the sake of humanity in neighboring territories, have a sacred duty to restore traditional amity and prevent further death and destruction."

Roosevelt doubted that this message would sway Hirohito. He had good reason to believe that Japan was now firmly set on a destructive course. Even in the darkest hours, however, he retained his innate optimism and keen sense of humor. After dispatching his last-ditch appeal to the exalted emperor, Roosevelt remarked to his wife, Eleanor, and guests who had joined her that evening at the White House: "Well, this son of man has just sent his final message to the Son of God."

That same day, officials in Tokyo began transmitting a long message in code to the Japanese ambassador in Washington, Adm. Kichisaburo Nomura, to be delivered to Secretary Hull at 1 p.m. on Sunday, December 7—a time chosen by the Japanese to coincide with the onset of the attack on Pearl Harbor. The dispatch, which constituted Tokyo's official response to Hull's final offer in the recent peace talks, was in 14 parts, but transmission of the last part was held back until Sunday. The SIS deciphered the first 13 parts and delivered the transcript to the White House around 9:30 p.m. on Saturday. Roosevelt and his trusted advisor Harry Hopkins read the harsh statement with deep concern. They feared that the delayed 14th part of the message would mean war. If so, Hopkins asked, why not strike the Japanese first? "No, we can't do that," Roosevelt replied. "We are a democracy and a peaceful people."

"Just kick in the door, and the whole rotten structure will collapse."

ADOLF HITLER, BEFORE THE INVASION OF RUSSIA

The long and shameful record of Nazi aggression—perpetrated by a dictator who loathed democracy, spurned peace, and always struck first—was much on Roosevelt's mind as war loomed. Like Churchill, he believed that relentless aggression would come back to haunt the Axis powers as they plowed ahead and took on an ever larger and more determined field of opponents, thus sowing the seeds of their own destruction. Such a reckoning was in fact just now unfolding in Europe. While Roosevelt waited anxiously in Washington on December 6 for distant shots to be fired that would ultimately recoil against Japan with devastating impact, German troops dispatched eastward by their Führer in search of "living space" were meeting death at the frigid outskirts of Moscow, where Soviet forces garbed in white were sweeping down on them like a blizzard.

A WAR OF ANNIHILATION

As winter descended on the Wolf's Lair, Hitler's head-quarters in East Prussia, it became painfully clear that his all-out war on Russia, which he had hoped to win before the first snow fell, was far from over. So confident had he and his aides been of quick victory when Operation Barbarossa began on June 22, 1941, that few German troops were furnished with wool overcoats and other winter gear. Having conquered France in six weeks, Hitler figured that Soviet resistance would crumble within three months. Russia's Slavs were an inferior race, he believed, and Joseph Stalin had weakened the Red Army by purging thousands of its most experienced officers. "Just kick in the door," Hitler assured one general before the invasion began, "and the whole rotten structure will collapse."

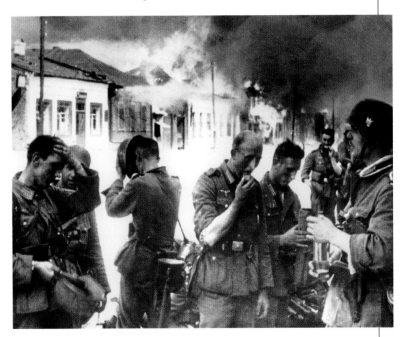

Scorched Earth **Buildings blaze in the captured city of Vitebsk in July as German soldiers pause to eat and drink before resuming their campaign against the Russians in July 1941. Soviet troops set fire to Vitebsk before they withdrew to prevent anything of value from falling into enemy hands. The damage caused by that scorched-earth policy was compounded by German forces, which bombarded towns and burned settlements occupied by partisans or Jews.**

Despite inflicting massive casualties on the ill-prepared Soviets—nearly six million of whom were killed or captured by the end of 1941—German troops faced mounting opposition as the year wore on. Having rejected an advance on Moscow in late August in favor of operations in Ukraine, the Soviet breadbasket, Hitler belatedly unleashed the armored divisions of Army Group Center against the Russian capital in October. By then, the dazzling German blitzkrieg he envisioned earlier had been reduced to a painstaking slog along muddy roads, which froze hard in November, briefly allowing vehicles to make headway before snow began falling in drifts and the nights grew so cold that tank crews had to light fires under their engines in the morning to get them started.

The Double Life of Richard Sorge

Richard Sorge was one of the most successful secret agents of World War II. Born in 1895 in Baku, Russia, to a Russian mother and a German mining engineer, he served in the German Army during World War I, suffered severe wounds in 1916, and recuperated in Berlin, where he studied economics and became a Marxist. After the war, Sorge joined the German Communist Party and spent several years in Russia, where he was recruited by the GRU (Soviet military intelligence).

In 1929, Sorge returned as a spy to Germany with instructions to join the Nazi Party. Traveling abroad as a reporter, he settled in Japan in 1933 and assembled an extensive network of agents and informants, including German diplomats—who confided in him believing that he was indeed a Nazi—and journalist Hotsumi Ozaki, an advisor to Japan's prime minister. In May 1941, Sorge signaled Moscow that Hitler would soon invade the Soviet Union—a warning that Stalin refused to believe. In the fall of 1941, Sorge again secured vital intelligence, reporting to his superiors that Japan was planning to wage war on the United States and had no intention of attacking Russia in the Far East. This time, Stalin trusted his master spy and shifted nearly 40 divisions from Siberia to reinforce battered Soviet forces defending Moscow.

Japanese authorities arrested Sorge on October 18, 1941, and later offered him to return him to Moscow in a prisoner exchange, but the Soviets declined. "The man named Richard Sorge is unknown to us," they claimed. After three years in prison, he was hanged on November 7, 1944. ■

More than 100,000 lightly clad German troops were disabled by frostbite. Soldiers slept huddled close together in huts or dugouts and risked death by exposure if they went out to relieve themselves. More than a few men perished "while performing their bodily functions," noted Maj. Gen. Heinz Guderian, a pioneer of blitzkrieg tactics. His armored columns had punctured Allied defenses in Belgium and France with startling speed in 1940 but were stalled now by arctic weather and Soviet forces far better equipped for winter warfare. Among those foes were rugged Siberian troops, summoned to defend Moscow after Stalin learned from a master spy in Tokyo named Richard Sorge that Japan would attack British and American bases rather than advance from Manchuria into Siberia. As Guderian recalled: "Only he who saw the endless expanse of Russian snow during this winter of our misery, and felt the icy wind that blew across it . . . who drove for hour after hour through that no-man's land only at last to find too thin shelter, with insufficiently clothed half-starved men; and who also saw by contrast the well-fed, warmly clad and fresh Siberians, fully equipped for winter fighting; only a man who knew all that can truly judge the events which now occurred."

Hitler himself was in a poor position to judge what his forces were up against. He seldom left the Wolf's Lair, a dreary command post ringed by barbed wire and minefields. One visitor likened the place to a concentration camp—whose inmates were not foes of the Third Reich but its top generals, subject to the whims of their overbearing Führer, a former corporal who considered himself a military genius. By imposing his will on his chiefs, he flouted the proud traditions of the German General Staff, which had once been the envy of the world. Critical thinking and vigorous debate at headquarters gave way to the Führer principle—the idea that Germans of all ranks must bow to Hitler's superior judgment and follow their leader. Officers who defied that principle and questioned his assumptions and pronouncements risked being sacked like the army's chief, Field Marshal Walther von Brauchitsch, who opposed Hitler's August decision to postpone the drive on Moscow and became a scapegoat when troops failed to take the city in December. Hitler relieved him and assumed personal command of the army. "Anyone can do the little job of directing operations in war," claimed the Führer, who would no longer have someone else to blame when those operations went awry.

As late as December 4, Hitler thought that he might still be able to lash the faltering Army Group Center into taking Moscow. German forces had advanced to the north and south of the city in pincers that threatened to close around the capital. Some units were within a dozen miles of Moscow, and their commander, Field Marshal Fedor von Bock, reportedly got close enough to see the spires of the Kremlin through his field glasses. But his troops were now dangerously overextended and vulnerable to a counterattack. Guderian and other officers took it upon themselves to pull back to more defensible positions. Hitler's view of the situation at the front

"does not correspond in any way with reality," wrote Guderian's chief of staff, who added that "we are too weak to defend ourselves."

In rare moments of candor, Hitler conceded that things were not going well. "We started a month too late," he confided to an aide. The grim precedent of Napoleon's disastrous invasion of Russia in 1812, when the icy blasts of "General Winter" doomed the French army, was too obvious for him to ignore. But he never considered turning back, for this was a war of annihilation that would bring terrible retribution on Hitler and Germany if his army was repelled. He had violated the cardinal rule of military conduct by committing systematic atrocities against civilians, using not only the dreaded Schutzstaffel—the black-shirted SS security forces who carried out his murderous racial policies—but also regular German troops. The invasion of the Soviet Union unleashed the Holocaust, whose victims included millions of Jews as well as members of other groups defined by Nazis as subhumans or enemies of the Reich, including communists—lumped together with Jews by Nazis as part of a supposed "Jewish-Bolshevist" conspiracy—and Slavs in occupied areas like Ukraine, who starved when the Germans instituted a policy of feeding their own troops and civilians at Russia's expense. The ultimate goal of the invasion, remarked SS chief Heinrich Himmler, was to "decimate the Slavic population by thirty millions" and make room for German settlers.

SS death squads, which rounded up Jews and other victims in Russia and shot them by the thousands, were abetted by some German generals, including Field Marshal Erich von Manstein, who wrote that the "Jewish-Bolshevist system must now and forever be destroyed." Manstein's one concern was that his subordinates not be present when civilians were massacred, for he considered that spectacle "unworthy of a German officer." Death squads excavated trenches to serve as mass graves for their victims, who were often forced "to lie face down inside the trench and were then shot in the side of the head," testified one SS executioner. "The next batch of victims always had to lie down on the corpses of those who had just been killed before," he added. Even when those "corpses had been covered with sand and chalk, the next victims often saw them, because body parts would frequently be jutting out of the thin layer of sand or earth." German soldiers and police sometimes assisted the SS in carrying out such massacres and also shot suspected partisans or communists. In many cases, the mere suspicion that a detainee was Jewish was considered grounds for execution. By December, an SS report stated, Army Group Center had put to death 19,000 "partisans and criminals, that is, in the majority, Jews."

If Hitler's war of annihilation faltered, those and other atrocities would be exposed, including the brutal neglect of Russian prisoners of war, more than half of whom died in captivity. Defeat or retreat would subject German soldiers and civilians to similar abuse at the hands of vengeful Soviets and reveal Hitler's war for what it was: a monumental crime that claimed countless lives on both sides. Only by holding the line and demanding more sacrifices from German soldiers could he achieve a victory large enough to cover that crime—a triumph he believed would vindicate all the destruction wrought to achieve it. "This land,

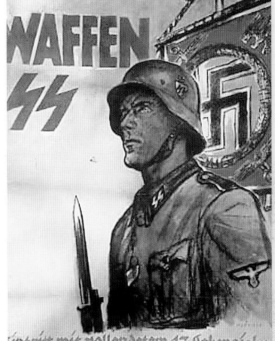

Hitler's Legions A poster issued in 1941 by the Waffen SS—the military branch of that ruthless Nazi organization—calls for recruits to "enlist at the end of your 17th year." Some Waffen SS units committed atrocities against civilians or prisoners of war.

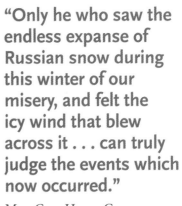

"Only he who saw the endless expanse of Russian snow during this winter of our misery, and felt the icy wind that blew across it . . . can truly judge the events which now occurred."

Maj. Gen. Heinz Guderian

MAJOR ROESLER
HOLOCAUST BY BULLETS

In July 1941, a German officer identified as Major Roesler of the 52nd Reserve Infantry encountered an SS death squad, assisted by German police, in action near Zhitomir in Ukraine and reported the massacre to superiors.

The notification from the Infantry Reserve Regiment 52 concerning "Conduct with regard to the Civilian Population in the East" causes me to submit the following report:

Towards the end of July 1941, I.R. 52, of which I was in command, was on its way from the West to Zhitomir, where it was to move into a rest camp. On the day of our arrival, in the afternoon, when I had moved into the Staff Quarters together with my Staff, we heard salvoes of rifle fire at regular intervals, fired at no great distance, and followed by pistol shots after a little while.

I decided to investigate this matter and with my Adjutant and Ordnance Officer (1st Lt. v. Bassewitz and Lt. Mueller-Brodmann) set out in the direction of the rifle fire. We soon received the impression that some cruel show must be taking place here because after a while we saw numerous soldiers and civilians streaming towards a railway embankment in front of us; we were informed that executions were being carried out continuously behind it. Throughout this time we were unable to see across the railway embankment to the other side, but at regular intervals we heard the sound of a trilling whistle and then a salvo of about 10 rifle shots, followed after a certain interval by pistol shots.

When we finally climbed up the railway embankment a sight was revealed to us on the other side of a horrible cruelty that was bound to shake and disgust anyone who came face to face with it unprepared. A pit had been cut in the ground, about 4 m. wide and 7–8 m. long, and the excavated earth had been piled up on

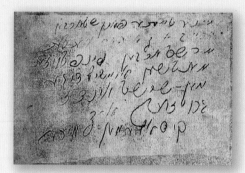

"My dearest,
Before I die,
I am writing a few words,
We are about to die,
five thousand innocent people,
They are cruelly shooting us,
Kisses to you all,
Mira"

The note above, hastily written in Yiddish, was discovered in the clothing of a Jewish woman executed with many others by SS Einsatzkommando 3a near Antanase, Lithuania.

one side. This mound and the side of the pit beneath it were stained all over with streams of blood. The pit itself was filled with human corpses of all kinds and both sexes in such numbers that it was difficult to estimate them; it was not possible to judge the depth of the pit.

Behind the mound of excavated earth a Police Commando was lined up with a Police Officer in command. The uniforms of the commandos were stained with blood. In a wide circle stood countless soldiers of troop units already stationed there, some as spectators, dressed in swimming trunks, as well as many civilians with women and children.

I stepped right up to the pit to obtain a picture that I have not been able to forget until this day. Among others there was an old man with a long white beard lying in the grave, with a little walking stick still hooked over his left arm. As this man still gave signs of life by his stertorous breathing, I requested one of the policemen to kill him off, but he answered with a laugh: "I fired seven shots into his belly, he'll croak on his own." The persons who had been shot were not placed in the grave in any order, but stayed there lying as they had fallen from the wall of the pit after they were shot. All these persons had been killed by shots in the back of the neck and then finished off with pistol shots from the top. I did not acquire any excessive sensitivity of the emotions during my service in the World War and in the French and Russian campaigns of this war; and experienced much that was more than unpleasant when I was active in the volunteer units in 1919, but I cannot recall ever having witnessed a scene such as that I have described here. ■

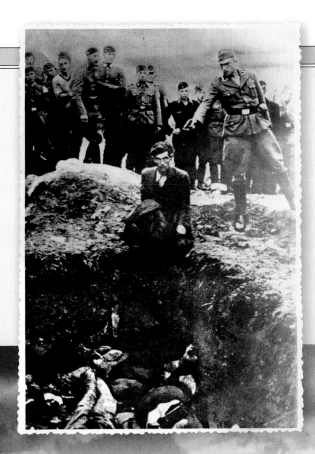

Mass Murder An SS noncommissioned officer, watched by German police and Wehrmacht personnel, prepares to shoot a Jewish man kneeling before a mass grave near the Ukrainian town of Vinnytsya in 1942. Below, a woman is overcome with grief upon finding the body of a loved one in a killing field near Kerch in the Crimea. A Russian photographer recorded the scene after Soviet troops liberated the area in December 1941.

> "This land, which we have conquered with the blood of German sons, will never be surrendered. Millions of German peasant families will be settled here in order to carry the thrust of the Reich far to the east."
>
> ADOLF HITLER

Red Review Soviet cavalrymen parade in Moscow's Red Square on November 7, 1941, to commemorate the 24th anniversary of the Bolshevik Revolution. The review was held while German armies were advancing on the city.

which we have conquered with the blood of German sons, will never be surrendered," he said of Russia. "Millions of German peasant families will be settled here in order to carry the thrust of the Reich far to the east." That conquest was far from complete, however, and Soviet troops were about to parry Hitler's thrust with a strength and determination he did not know they possessed.

CRISIS IN MOSCOW

Comrade Joseph Stalin was a changed man. Since the invasion of his country began in June, this brutal tyrant long dreaded by Russians had himself lived in mortal fear of defeat and destruction. Having ignored warnings that Hitler was about to turn on him and violate their cynical Nonaggression Pact—which set World War II in motion in 1939 by allowing the two dictators to carve up eastern Europe and terrorize its inhabitants—Stalin was aghast when three million German troops crossed the frontier and shattered Soviet defenses. He retreated from the Kremlin to his dacha outside Moscow, where he paced the floor at night, unable to sleep. A week after the invasion began, he was visited there by officials of the Politburo, the Communist Party's ruling council, which Stalin had dominated since the death of Vladimir Lenin in 1924. "Why have you come?" he asked nervously, suspecting that they intended to arrest him. Instead, they asked him to take charge of a newly formed national defense committee.

Three days later, Stalin broadcast his first speech to the nation since it was thrust into war, urging Russians to lay waste to their country rather than surrender anything of value

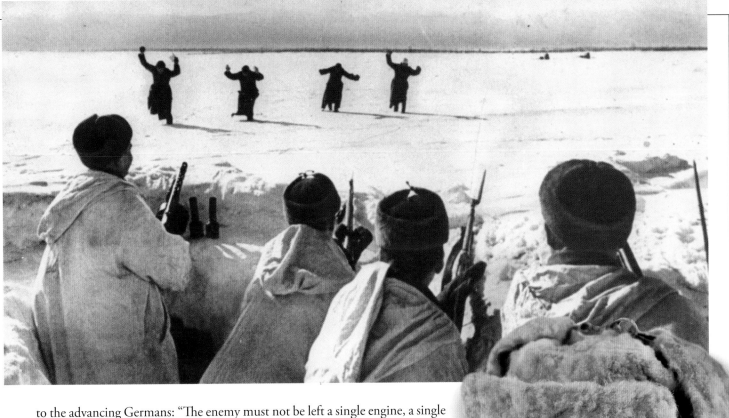

to the advancing Germans: "The enemy must not be left a single engine, a single railway car, a single pound of grain or a gallon of fuel." At first, Soviets at the front were overrun too quickly to carry out that policy, but in time they made good on Stalin's stratagem. Entire factories were disassembled and shipped eastward by rail to sustain the production of guns, tanks, and aircraft on which the war effort depended. What could not be moved was destroyed.

Despite Stalin's defiant tone, he and his commissars feared that Russian resistance might collapse under the German onslaught, and they stopped at nothing to make their men fight to the death. Commanders who faltered and soldiers who fled were shot. Officers who surrendered or let themselves be captured alive brought down official punishment on their wives, who were subject to arrest. Stalin's eldest son, Yakov, was taken prisoner by the Germans in 1941—a "crime" for which his wife spent two years in a Soviet labor camp while he languished and died in enemy hands. Stalin, of course, was exempt from the harsh rules he imposed to keep others from retreating. He made plans to abandon Moscow before deciding to remain at the Kremlin as winter closed in. Addressing the public on November 9, the anniversary of the Bolshevik Revolution, he set aside the usual Communist rhetoric and appealed instead to Russian patriotism and hatred of the invaders. "If they want a war of extermination, they shall have it!" he vowed. "Our task now will be to destroy every German, to the very last man!" By shifting his deadly aim from domestic foes to foreign enemies, Stalin emerged as a grimly effective war leader.

He was strengthened in his determination to hold Moscow by one of the few Soviet commanders bold

Coming In From the Cold German soldiers surrender to Russian troops wearing white snow-camouflage suits and fur hats similar to the officer's cap above, known as an *ushanka*. Far better equipped than the invading Germans for cold weather, the Soviets also wore *valenki*: traditional Russian wool-felt winter footwear *(below, left)*.

"If they want a war of extermination they shall have it!"

JOSEPH STALIN

enough to stand up to him—Gen. Georgi Zhukov. Despite long and faithful service in the Red Army and Communist Party, Zhukov had narrowly escaped the fate of other officers who were liquidated in the mid-1930s by the morbidly suspicious Stalin. Those purges left many survivors cowed by their dictator, but Zhukov remained self-assured and outspoken. When Stalin angrily rejected his recommendation that the doomed Ukrainian capital of Kiev be abandoned to the Germans, he asked to be relieved. Such defiance might have cost him his freedom or his life in earlier times, but Stalin desperately needed the strong-willed

General Winter A Red Army propaganda poster from January 1941 exhorts Soviet citizens with the message "Let's Fight for Moscow!" At right, German soldiers retreat from Moscow through near-blizzard conditions in a photograph taken on December 7, 1941, as a major Soviet counteroffensive unfolded, backed by reserve divisions transferred from Siberia.

Zhukov. He was sent to organize the defenses of Leningrad (St. Petersburg), which would withstand a long and punishing siege by the Germans. Then as winter approached, he was summoned to the capital. "Are you certain we can hold Moscow?" Stalin asked him in mid-November. "Speak the truth, like a Communist." Zhukov was not yet sure that his troops could save the city, but steadied the anxious Stalin by exuding confidence: "We'll hold Moscow without a doubt," he promised.

By month's end, the German advance on the capital had stalled, and Zhukov came to the Kremlin to offer his plan for a counterattack. Accompanying him was Maj. Gen. Pavel Belov, who had not seen Stalin since 1933 and found the 61-year-old dictator much altered. "In eight years, he seemed to have aged 20," Belov noted. "His eyes had lost their old steadiness; his voice lacked assurance." Hitler's stunning offensive had shaken Stalin and forced him to lean on a proven commander like Zhukov and trust in his judgment. It was a lesson that Germany's 52-year-old Führer had yet to learn and would never entirely absorb. Stalin quickly approved Zhukov's plan and sent him on his way.

The counterattack began on December 5 and intensified the next day. Elusive Soviet ski troops cloaked in white found gaps in the enemy lines and slipped behind their startled foes, who were immobilized by the bitter cold while Russians advanced in winterized tanks that kept churning in the deepest of freezes. Soon the Germans were falling back and in danger of being cut off by their swarming opponents. Some units lost cohesion and retreated in disarray. As one German officer observed, it was every man for himself: "More and more soldiers were making their own way west, without weapons, leading a calf on a rope, or drawing a sledge with potatoes behind them—just trudging westward with no one in command. Men killed by aerial bombardment were no longer buried."

Hitler averted disaster in weeks to come by forbidding any further withdrawals and insisting that his officers stand fast at all costs. German troops paid heavily in blood, but the price would have been even higher had they continued to give way. As they dug in and held out, Stalin's hopes for a smashing victory faded. But Moscow was saved, and Hitler now faced a

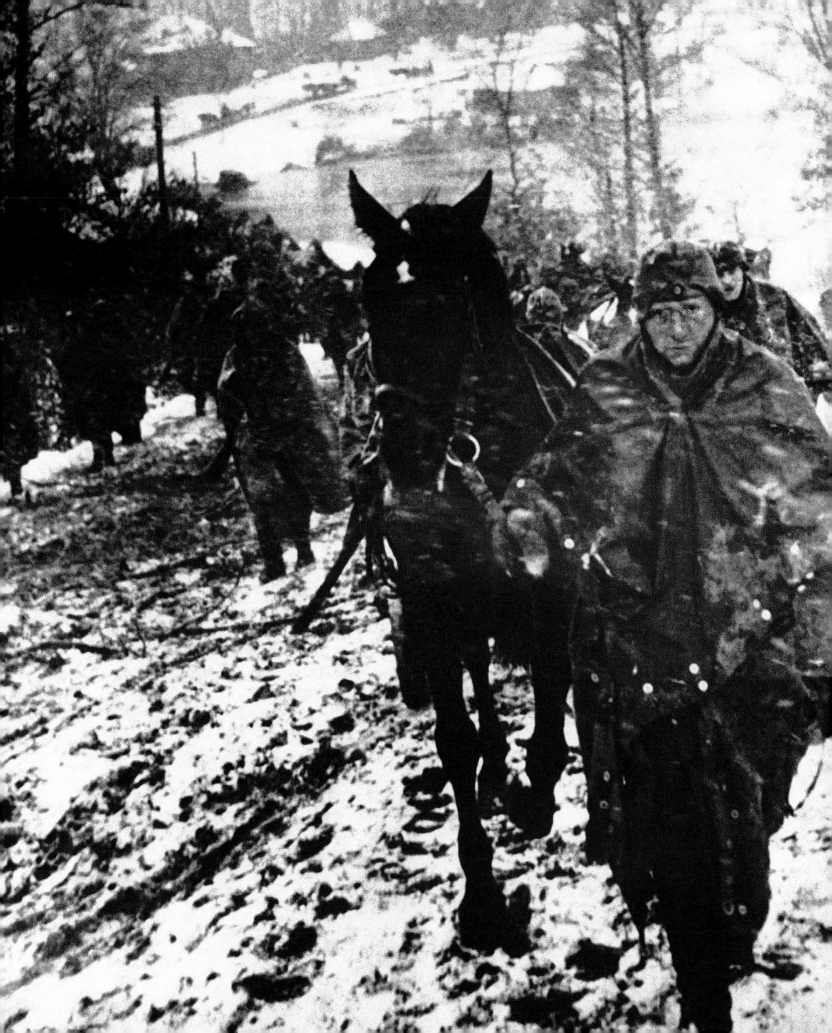

long and desperate struggle against foes whose ranks swelled enormously in 1941. When the year began, the world's two largest industrialized nations, the United States and the Soviet Union, were sleeping giants who had yet to awake to the peril they faced. Unwilling to let the potentially formidable Soviets rest easy, Hitler roused them from their slumber in late June and suffered the consequences in early December—just days before his Japanese allies shattered the peaceful dreams of Americans and caused them to bring their vast resources to bear against the Axis.

DAY OF DESTINY

Up well before dawn on Sunday, December 7, naval aviators aboard the aircraft carriers of Admiral Nagumo's task force sat down to a ceremonial breakfast of rice and red beans and took sips of sake before setting out to attack the U.S. Pacific Fleet at Pearl Harbor. These warriors did not have to wait until they had achieved victory to celebrate their mission. They believed that a man who entered battle for his beloved country and its divine emperor was blessed, whether he prevailed or perished. "I shall die only for the emperor," sang cadets at Japan's naval academy. "I shall never look back." Cmdr. Mitsuo Fuchida, chosen to lead the attack, spoke for many in the strike force when he recalled his feelings that morning. "Who could be luckier than I?" he asked himself. In risking his life for what he held sacred, he remarked, "I fulfilled my duty as a warrior."

Fuchida and his men felt no qualms about carrying out a surprise attack on Americans. Their great military icon was Adm. Heihachiro Togo, who launched Japan's triumphant war against imperial Russia in 1904 with a surprise attack and secured victory a year later by smashing the Russian fleet at Tsushima. The idea of knocking out a larger but less agile opponent with a sudden, stunning blow was cherished by those who practiced Japanese martial arts such as kendo, among them the architect of the Pearl Harbor assault, Admiral Yamamoto, who hoped to match Admiral Togo's success against the Russians by catching Americans off guard. What many Americans found contemptible—a sneak attack—was viewed by the Japanese as heroic when used against great powers that tried to thwart their imperial ambitions.

As dawn approached around 6 a.m., the first wave of 183 fighters, bombers, and torpedo planes took off from Nagumo's six carriers, 230 miles north of Pearl Harbor. A second wave of nearly equal strength would follow a short time later. Storm clouds had helped Nagumo's ships evade detection as they crossed the North Pacific, but rough seas made conditions hazardous now for Fuchida and his aviators, whose heavily laden planes came perilously close to the wave tops before gaining altitude. Ascending above the clouds, they saw golden light glimmering on the eastern horizon—a good omen for men whose imperial emblem was the rising sun. Fuchida worried that cloud cover would obscure their target but was reassured when

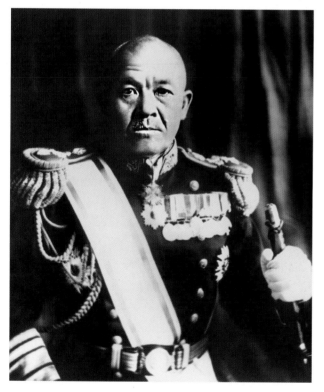

Strike Commander **Vice Adm. Chuichi Nagumo commanded the six aircraft carriers of the Japanese Imperial Navy's First Air Fleet in the attack on Pearl Harbor. Warplanes dispatched by Nagumo on December 7 struck American bases on Oahu in two waves, as shown here on the map** (opposite, top).

Japanese Air Assault on Oahu

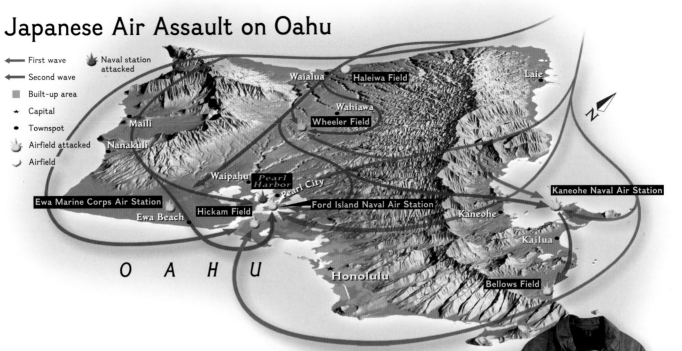

Legend:
- First wave
- Second wave
- Naval station attacked
- Built-up area
- Capital
- Townspot
- Airfield attacked
- Airfield

Waialua · Haleiwa Field · Laie · Wahiawa · Wheeler Field · Maili · Nanakuli · Waipahu · Pearl Harbor · Pearl City · Kaneohe Naval Air Station · Ewa Marine Corps Air Station · Hickam Field · Ford Island Naval Air Station · Kaneohe · Ewa Beach · Kailua · OAHU · Honolulu · Bellows Field

he picked up a weather forecast from Honolulu on his radio, promising clear skies. He understood English and used the broadcast to home in on Honolulu. Residents there were waking to what looked like another placid Sunday in paradise. But they had less than two hours of peace left.

This was one of several attacks on American and British targets carried out by Japanese forces on what was December 7 in Hawaii and the continental U.S. and December 8 in Asia. But none of those assaults came as more of a shock than the raid on Pearl Harbor, thought to be safely beyond Japan's reach. Despite warnings that Tokyo was preparing for hostilities, many American officers believed that their base on the island of Oahu and their country at large remained secure against attack. "The Japanese will not go to war with the United States," insisted Vice Adm. William Pye on December 6. "We are too big, too powerful, and too strong." Pye's superior, Adm. Husband Kimmel, commander in chief of the Pacific Fleet, assured a reporter that same day that the Japanese would not risk conflict with the U.S. as long as their old enemy, Russia, remained undefeated by Germany and capable of attacking them. "I don't think they'd be such damned fools," Kimmel was quoted as saying.

If Japan did strike, Kimmel assumed that the first blow would fall elsewhere. Neither he nor Lt. Gen. William Short, the U.S. Army commander in Hawaii, had received intelligence indicating that Pearl Harbor was a likely target. Like their chiefs in Washington, they thought that the main threat was to American forces stationed closer to Japan at bases in the Philippines and on sparsely defended Wake and Midway Islands. Accordingly, Kimmel had recently dispatched the aircraft carriers U.S.S. *Enterprise* and U.S.S. *Lexington* to deliver fighter planes to Wake and Midway. The Pacific Fleet's only other carrier, the U.S.S. *Saratoga*, was in San Diego Harbor on December 7 after being overhauled. Aircraft carriers were the greatest assets any modern navy possessed, and Japanese commanders were deeply disappointed to learn from agents in Honolulu that Kimmel's flattops were not at

Fliers' Gear Japanese naval aviators had two flying suits—a lighter one for warm weather (above) and a heavier outfit for colder conditions.

CAPTURED PHOTOS

With more than 420 aircraft on its decks, Vice Adm. Chuichi Nagumo's First Air Fleet was the most powerful carrier task force that had ever been assembled. The Japanese Imperial Navy was eager to record Nagumo's historic attack on the U.S. Pacific Fleet at Pearl Harbor and assigned photographers and motion-picture cameramen to document the action. When the first wave of warplanes took off shortly before sunrise on December 7, it was too dark for cameras to be of much use. Most of the pictures taken aboard the Japanese carriers record the launching of the second wave of warplanes later that morning.

Some of the attacking aircraft carried aerial observers, equipped with bulky F-8 oblique cameras with glass plates or smaller handheld Type 99 aerial cameras with rolls of film. Their assignment was to record the damage done to American ships and port facilities for naval intelligence analysts. Copies of those pictures were distributed to the fleet about three weeks after the attack. Japanese propaganda officials did not use the actual film footage produced by cameramen who accompanied Nagumo's fleet. Instead, they

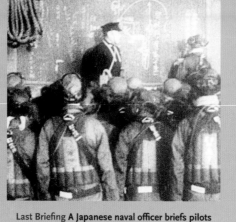

Last Briefing A Japanese naval officer briefs pilots before the attack on Pearl Harbor in a scene recorded by a motion-picture cameraman. A photographer in a warplane attacking in the first wave took the picture opposite.

contrived their own newsreel in 1942, which simulated the attack on Pearl Harbor using prewar stock footage and scale models.

Many pictures taken by the Japanese on December 7 were later captured by Americans when they struck back at Japan. In August 1943, the U.S. reclaimed the Aleutian island of Kiska, which had been occupied by Japanese troops for more than a year. Left behind there by those forces was motion-picture film taken on the carrier *Akagi* during the attack on Pearl Harbor. Aerial reconnaissance photos shot during and shortly after the attack were later discovered in Japanese military archives when the war ended. Some photos were probably destroyed along with Japanese intelligence files before American occupation officials gained access to those archives. Among the surviving images, however, are remarkable shots of the assault, including a stunning picture taken from a Japanese aircraft as it approached Ford Island and Battleship Row *(opposite)*, showing a geyser of water produced when a torpedo struck a battleship, probably the U.S.S. *Oklahoma*. Below and at right are other pictures taken by the Japanese on that infamous day. ■

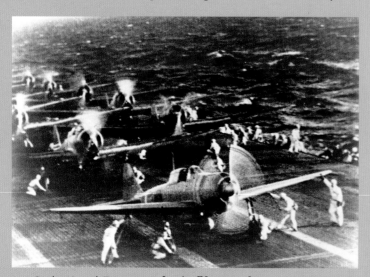

Ready to Launch Zeros prepare for takeoff from one of Nagumo's carriers in a photo found after the Japanese abandoned Attu Island in the Aleutians.

Sunrise Sendoff A navy Type 97 torpedo bomber races down a carrier deck in the early morning light as crewmen wave their caps in tribute.

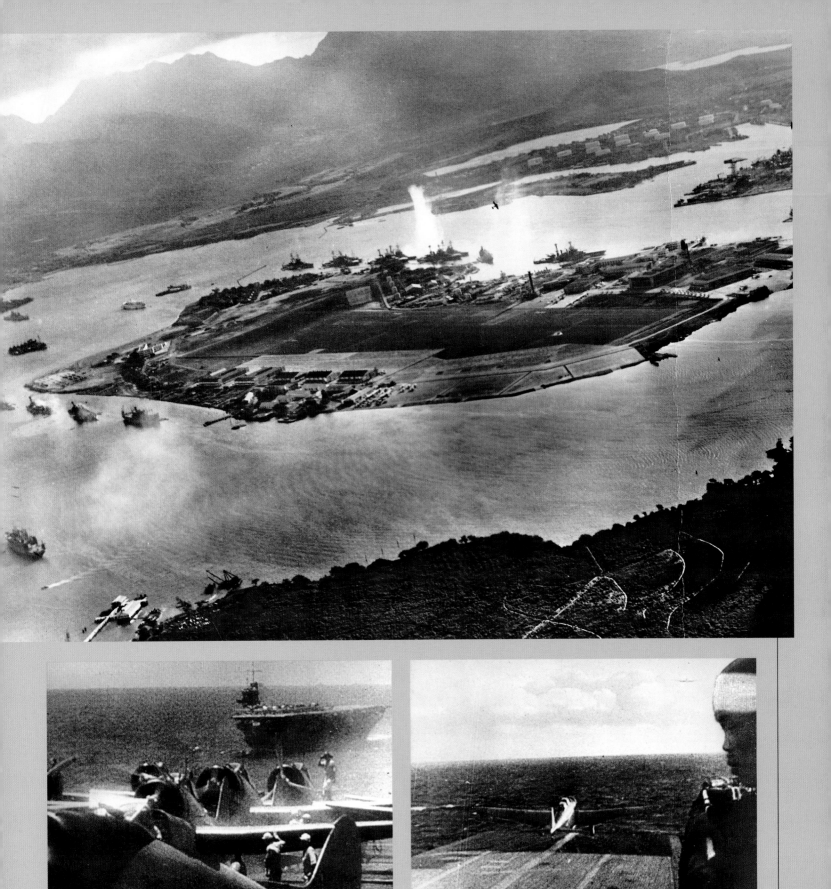

Strength in Numbers Navy Type 99 dive-bombers rev up on one flattop while another, the large fleet carrier *Soryu*, lurks in the background.

Bound for Pearl Taking off into the wind, a Type 99 dive-bomber leaves the flight deck of the carrier *Shokaku* en route to Pearl Harbor.

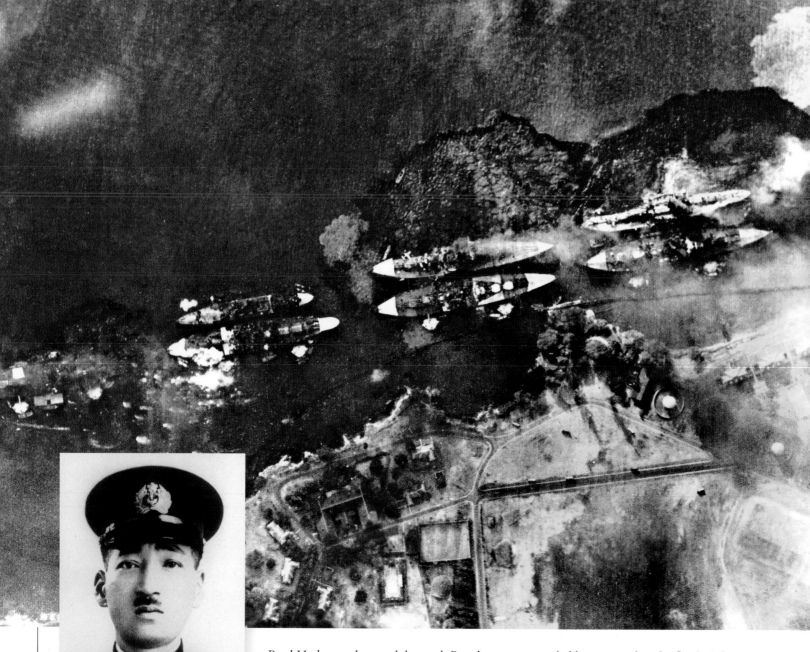

Bombs Away At top, a Japanese photograph shows U.S. battleships under attack on December 7. The *Nevada* is at far left, behind the *Arizona*, which is moored alongside the smaller *Vestal* and has just been hit by a bomb near the stern. Cmdr. Mitsuo Fuchida *(above)* led the first wave of warplanes and observed the attack on Battleship Row through a peephole in the cockpit floor. "I watched four bombs plummet toward the earth," he recalled. "The target—two battleships moored side by side . . . two tiny puffs of smoke flashed suddenly on the ship to the left, and I shouted, 'Two hits!'"

Pearl Harbor as the attack loomed. But they were consoled by reports that the fleet's eight battleships were now docked there, along with dozens of cruisers and destroyers. Pearl Harbor's defenses included antiaircraft batteries and squadrons of fighters and bombers at several surrounding air bases. Aerial reconnaissance was intermittent, however, and neither pilots, soldiers, nor sailors were placed on high alert. The one threat they were actively guarding against was sabotage by Japanese residents of Honolulu. Warplanes were parked close together on runways, which made them easier to protect against saboteurs but more vulnerable to air strikes.

So ill prepared were Pearl Harbor's defenders for war that two clear warnings of an imminent attack failed to reach Kimmel and Short between the time Fuchida and his men took off and when they reached their target shortly before 8 a.m. At 6:45, Lt. William Outerbridge, captain of the destroyer U.S.S. *Ward,* dropped depth charges on an odd-looking submarine lurking near the narrow entrance to Pearl Harbor. Operated by a two-man crew and armed with a single torpedo, the midget Japanese sub was one of five assigned to slip furtively into the shallow harbor—where the larger submarines that hauled and released them could not

safely go—and target American warships. (All five midget subs were lost in those missions.) Outerbridge promptly reported the startling incident, but communications were slow on a Sunday morning. It took an hour for his report to work its way up the chain of command to Kimmel, by which time Fuchida and his men had Pearl Harbor in sight.

The second warning came around 7:15 a.m. when Pvt. Joseph Lockard, operating a mobile radar station near Kahuku Point at the northern end of Oahu, reported an "unusually large flight" of aircraft approaching the island at a distance of less than 100 miles. "Don't worry about it," replied Lt. Kermit Tyler, the watch officer of the Army Air Forces' 78th Pursuit Squadron. Tyler assumed that the planes were friendly B-17 bombers, expected in from California that morning for a stopover at Pearl before they continued on to the Philippines. No fighters were dispatched, and no word of Lockard's report reached General Short before the attack began.

At 7:40 a.m., Fuchida was looking anxiously through breaks in the clouds for sight of land. "Suddenly a long white line of breaking surf appeared directly beneath my plane," he recalled. "It was the northern shore of Oahu." As he approached Pearl Harbor on the island's south shore, the skies cleared as forecast. He saw "ships riding peacefully at anchor. One by one I counted them. Yes, the battleships were there all right—eight of them!" At 7:49, he signaled for the attack. "No enemy fighters were in the air," he noted, "nor were there any gun flashes from the ground." Breaking radio silence, which was no longer necessary, he informed Admiral Nagumo that surprise was complete by repeating three times the code word "Tora!" (Tiger!). Born in the Year of the Tiger, Fuchida was now fulfilling his destiny by pouncing like a cat on the unsuspecting Americans.

The attackers' first objective was to pound airfields around Pearl Harbor and destroy U.S. warplanes on the ground. Japanese commanders had studied the blitzkrieg tactics of Germany's Luftwaffe, whose preemptive strikes had shattered opposing air forces by destroying hundreds of planes before they could take off. Within minutes of Fuchida's signal launching the attack, the naval air station on Ford Island, amid Pearl Harbor, and the army air bases at nearby Hickam and Wheeler Fields were engulfed in smoke and flames as dive-bombers blasted hangars, barracks, and scores of aircraft parked wingtip to wingtip. The initial reaction of most men on the ground was disbelief. Harry Mead, a radio operator on Ford Island, assumed that the air raid was a training exercise. When he saw the first explosion, he figured that someone was going to catch hell "for putting live bombs on those planes." Moments later, a petty officer standing near Mead recognized the distinctive Japanese rising-sun emblem on the dive-bombers and let loose a burst of profanity echoed by many men at Pearl Harbor when the truth hit them: "Them [expletive deleted] bastards are bombing us!"

Smoke was billowing from Ford Island when Lt. Cmdr. Shigeharu Murata led a squadron of 40 Japanese torpedo planes against the big ships on Battleship Row. On the battleship U.S.S. *Nevada*, a Navy band had assembled on deck to play the national anthem as the flag went up. Like Mead, band leader Oden McMillan figured that the explosions on Ford

Flying Samurai A Japanese magazine cover promotes the war effort by portraying a heroic young aviator beside his mother.

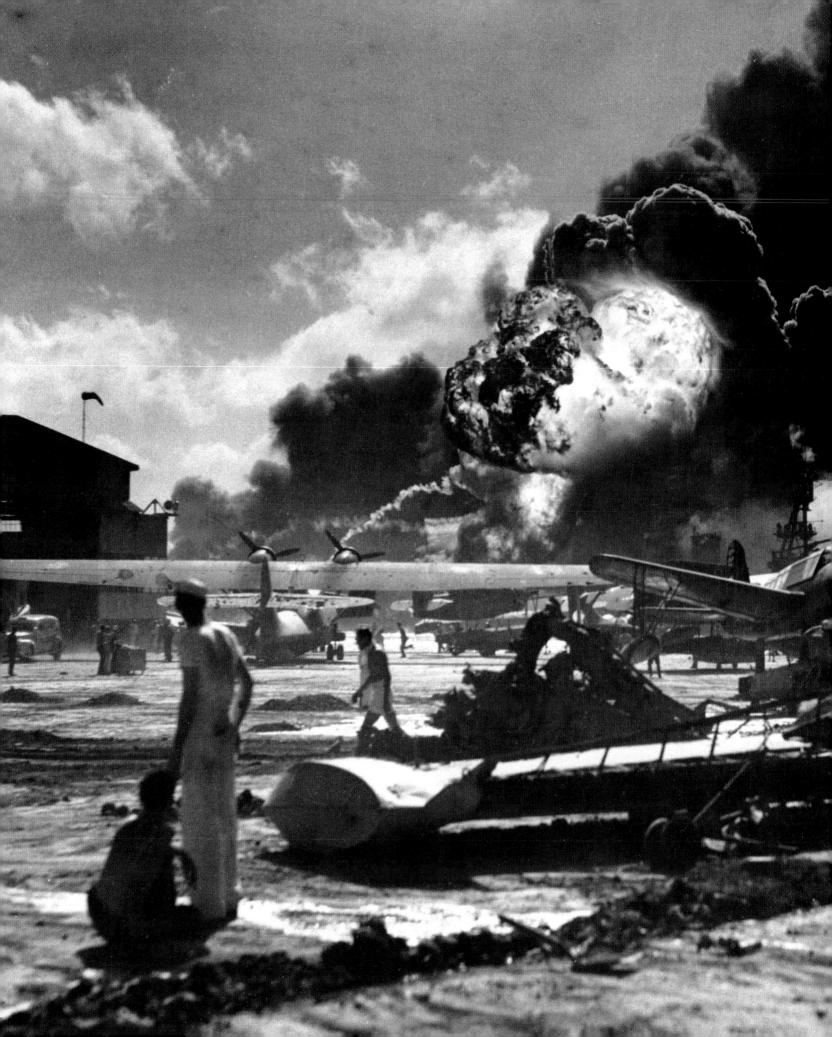

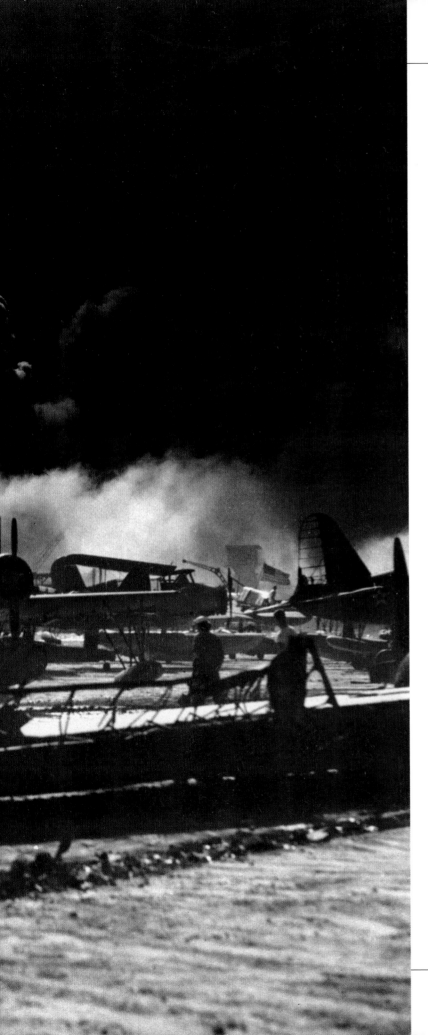

"Them [expletive deleted] bastards are bombing us!"

HARRY MEAD,
RADIO OPERATOR ON FORD ISLAND

Island were part of a drill, so he launched into the anthem at eight o'clock sharp—just as the first torpedo planes swooped in. Standing watch on the *Nevada* was Ens. Joseph Taussig, who thought the approaching aircraft must be U.S. Navy planes practicing torpedo runs. Pearl Harbor is only about 40 feet deep, and any torpedoes dropped by the incoming planes would, he assumed, sink harmlessly to the harbor floor. To his astonishment, the planes dropped torpedoes that were equipped with stabilizers to run in shallow waters. One of them struck the battleship U.S.S. *Oklahoma,* docked near the *Nevada,* which was strafed by the attackers as they flew over. McMillan and his band dutifully stood their ground long enough to finish the anthem, then scrambled for cover as Taussig sounded the general alarm and shouted over the loudspeaker: "This is no drill!" A short time later, a torpedo slammed into the *Nevada*. During the attack, Taussig was severely wounded in his left leg, which was later amputated, but he remained at his post directing antiaircraft fire until the burning ship was abandoned. As he recalled: "I was placed in a cab and driven to the harbor hospital, bleeding all over this poor man's taxi."

The damage done by the torpedoes was compounded by bombs dropped at high levels that crashed through the decks of warships before exploding. Around 8:20 a.m., a bomb penetrated the forward magazine of the battleship U.S.S. *Arizona* where gunpowder was stored, triggering a volcanic blast that killed hundreds of men instantaneously and knocked sailors off the decks of neighboring vessels. Fuchida, who was directing bombers at an altitude of nearly 10,000 feet, felt the shock wave buffet his plane and looked down to see smoke and flames leaping skyward. "It was a hateful, mean-looking red flame," he remarked, "the kind that powder produces, and I knew at once that a magazine had exploded." Of the nearly 1,400 men aboard

Shocking Blast A sailor standing near the wreckage of a PBY Catalina flying boat and other seaplanes on Ford Island watches a violent explosion on the destroyer **U.S.S. Shaw** in Pearl Harbor. American officials delayed the publication of photos like this one detailing the disaster.

the *Arizona* that morning, fewer than 300 survived. Among them was John Rampley, a gunner's mate in the only turret that remained intact. "We felt a tremendous jolt, as if the ship had been lifted up and slammed back down," he recalled. "Rivets popped from the steel walls and flew about." When the call came to abandon ship, he climbed down from the turret onto a deck strewn with charred and shattered bodies: "They lay crumpled like broken dolls who had been picked up in the air and slammed against the structures of the ship . . . All around, the air was filled with the smell of burning oil and burning flesh." Menacing patches of flaming oil coated the water into which Rampley and others leaped. He managed to swim to Ford Island, but many wounded men who abandoned the *Arizona* and other stricken ships were too weak to save themselves and drowned or were burned to death.

For those at Pearl Harbor who remained unscathed, shock and disbelief gave way to the urge to strike back at the enemy with any weapon at hand. U.S. Marines camped near the harbor rushed from their tents when the attack began and shot at low-flying warplanes. Among them was Cpl. James Jenkins. "Most of us were in our underwear," he recollected, "and had our old World War I helmets on." Their outdated bolt-action rifles posed little threat to the attackers. One Marine grabbed a machine gun and began firing wildly, doing more harm to his own side than to the Japanese, who flew by so close that Jenkins "could see the goggles on the pilots' heads." When the shooting stopped, he was sent to stand guard at the docks, where Navy boats began "bringing in burned bodies and throwing them at my feet." He could see the smoldering hulks of several battleships, including the *Oklahoma,* which had capsized.

By the time the last wave of Japanese bombers departed around 9:45, all eight battleships and a dozen other warships had gone down or been severely damaged. Most would eventually be salvaged, but the *Arizona* and *Oklahoma* were shattered beyond repair and accounted for nearly three-fourths of the Navy's casualties on this bloody Sunday. Losses among members of the other services and civilians brought the day's toll to just over 2,400 killed and nearly 1,200 wounded. Pvt. Melvin Faulkner, who helped bury the dead at the Army's Schofield Barracks, where some 200 soldiers were laid to rest, never forgot that solemn ceremony: "I wondered how many more Americans would lose their lives before the war was over and prayed that I wouldn't be one of those buried so far from home."

Relic of Battle Stained with blood and oil, this U.S. Navy white dress jumper was worn by an enlisted man serving as a pharmacist's mate while he tended the wounded in the clinic of the Ford Island Naval Air Station on December 7.

"They lay crumpled like broken dolls who had been picked up in the air and slammed against the structures of the ship."

JOHN RAMPLEY, GUNNER'S MATE, U.S.S. *ARIZONA*

GEORGE D. PHRANER

SURVIVOR, U.S.S. *ARIZONA*

Machinist's Mate First Class Phraner, a member of a 5-inch gun crew on the U.S.S. Arizona, *was at breakfast aboard his ship on December 7, 1941, when the Japanese struck.*

I looked across the bow of the ship and could see large plumes of smoke coming up from Ford Island. At first, we didn't realize it was a bombing. It didn't mean anything to us until a large group of planes came near the ship and we could see for the first time the rising sun emblem on the plane wings. The bombing was becoming heavier all around us and we knew this was REALLY IT! . . .

It was then that general quarters sounded over the speaker and everything became automatic. My battle station was on a forward 5-inch gun and it was standard practice to keep only a limited amount of ammunition at the guns . . . the gun captain pointed at me and said, "You go aft and start bringing up the ammunition out of the magazines." The aft magazines were five decks below.

A few moments later I found myself deep below the water line in a part of the ship I normally would never be in. I remember getting these cases of ammo powder and shells weighing about 90 pounds each. I had begun lifting shells into the hoist when a deafening roar filled the room and the entire ship shuddered. It was the forward magazine. One and a half million pounds of gunpowder exploding in a massive fireball disintegrating the whole forward part of the ship. Only moments before I stood with my gun crew just a few feet from the center of the explosion. Admiral Kidd,

> **"I could feel myself losing the battle to save my own life. I hung to the ladder, feeling good. I felt that it was all right for me to let go."**

Captain Van Velkenburg, my whole gun crew was killed . . .

Seconds after the explosion the lights went out and it was pitch black. Almost immediately a thick acrid smoke filled the magazine locker and the metal walls began to get hot. In the dark and not being able to breathe, we made

our way to the door hatch, only to find it shut and locked. Somehow we were able to open the hatch and start to make our way up the ladder. I was nauseated by the smell of burning flesh, which turned out to be my own as I climbed up the hot ladder . . .

After a while I began to get weak and lightheaded. I could feel myself losing the battle to save my own life. I hung to the ladder, feeling good. I felt that it was all right for me to let go. At that moment I looked up and could see a small point of light . . . It gave me the strength to go on. After what seemed to me like an eternity, I reached the deck gasping and choking. ■

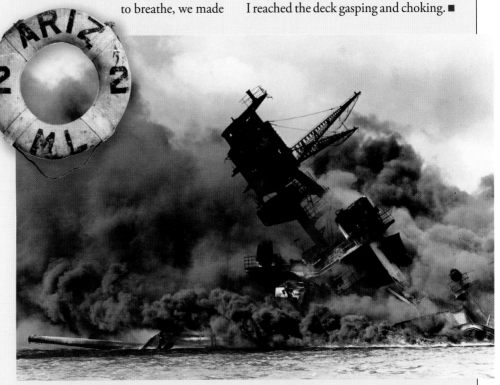

Fiery Aftermath Sunk to its deck, the *Arizona* smolders in the aftermath of the attack, which claimed the lives of most of the battleship's crew. The life preserver above was recovered from the wreck.

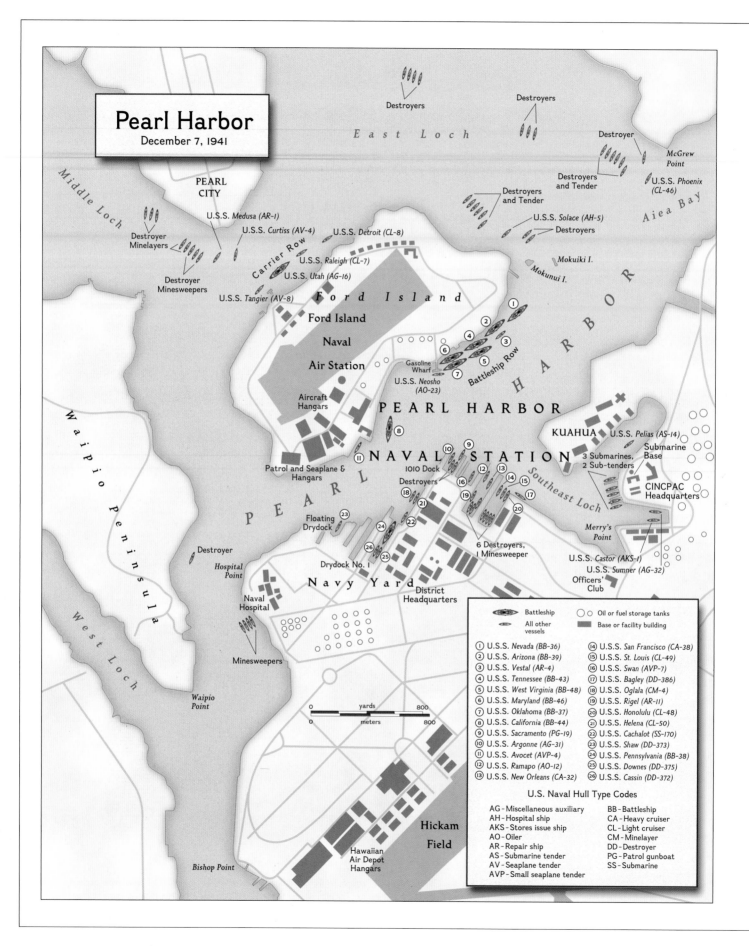

Pearl Harbor
December 7, 1941

East Loch

Destroyers

Destroyers

Destroyer

McGrew Point

PEARL CITY

Middle Loch

Destroyers and Tender

U.S.S. *Phoenix* (CL-46)

Aiea Bay

Destroyer Minelayers

U.S.S. *Medusa* (AR-1)

U.S.S. *Curtiss* (AV-4)

U.S.S. *Detroit* (CL-8)

Destroyers and Tender

U.S.S. *Solace* (AH-5)

Destroyers

Destroyer Minesweepers

Carrier Row

U.S.S. *Raleigh* (CL-7)

U.S.S. *Utah* (AG-16)

Mokuiki I.

U.S.S. *Tangier* (AV-8)

Mokunui I.

Ford Island

① ② ④ ③ ⑥ ⑤ ⑦

Battleship Row

Ford Island Naval Air Station

Gasoline Wharf

U.S.S. *Neosho* (AO-23)

HARBOR

PEARL HARBOR

Aircraft Hangars

KUAHUA

U.S.S. *Pelias* (AS-14)

Submarine Base

⑧

Waipio Peninsula

⑩ ⑨

NAVAL ⑪ **STATION**

1010 Dock

Destroyers

⑫ ⑬ ⑭ ⑮

⑯

3 Submarines, 2 Sub-tenders

CINCPAC Headquarters

Patrol and Seaplane Hangars

⑱ ⑲ ⑰

Southeast Loch

⑳

Floating Drydock

㉓

② ㉒

㉑

6 Destroyers, 1 Minesweeper

Merry's Point

Destroyer

㉖

㉔

⑳

Hospital Point

㉕

U.S.S. *Castor* (AKS-1)

U.S.S. *Sumner* (AG-32)

Officers' Club

Naval Hospital

Drydock No. 1

Navy Yard

District Headquarters

West Loch

Minesweepers

Waipio Point

yards	800
meters	800

Hickam Field

Hawaiian Air Depot Hangars

Bishop Point

Legend

Symbol	Description
〰 Battleship	◯◯ Oil or fuel storage tanks
～ All other vessels	▪ Base or facility building

① U.S.S. *Nevada* (BB-36)
② U.S.S. *Arizona* (BB-39)
③ U.S.S. *Vestal* (AR-4)
④ U.S.S. *Tennessee* (BB-43)
⑤ U.S.S. *West Virginia* (BB-48)
⑥ U.S.S. *Maryland* (BB-46)
⑦ U.S.S. *Oklahoma* (BB-37)
⑧ U.S.S. *California* (BB-44)
⑨ U.S.S. *Sacramento* (PG-19)
⑩ U.S.S. *Argonne* (AG-31)
⑪ U.S.S. *Avocet* (AVP-4)
⑫ U.S.S. *Ramapo* (AO-12)
⑬ U.S.S. *New Orleans* (CA-32)

⑭ U.S.S. *San Francisco* (CA-38)
⑮ U.S.S. *St. Louis* (CL-49)
⑯ U.S.S. *Swan* (AVP-7)
⑰ U.S.S. *Bagley* (DD-386)
⑱ U.S.S. *Oglala* (CM-4)
⑲ U.S.S. *Rigel* (AR-11)
⑳ U.S.S. *Honolulu* (CL-48)
㉑ U.S.S. *Helena* (CL-50)
㉒ U.S.S. *Cachalot* (SS-170)
㉓ U.S.S. *Shaw* (DD-373)
㉔ U.S.S. *Pennsylvania* (BB-38)
㉕ U.S.S. *Downes* (DD-375)
㉖ U.S.S. *Cassin* (DD-372)

U.S. Naval Hull Type Codes

AG – Miscellaneous auxiliary	BB – Battleship
AH – Hospital ship	CA – Heavy cruiser
AKS – Stores issue ship	CL – Light cruiser
AO – Oiler	CM – Minelayer
AR – Repair ship	DD – Destroyer
AS – Submarine tender	PG – Patrol gunboat
AV – Seaplane tender	SS – Submarine
AVP – Small seaplane tender	

As Fuchida and his men returned to their carriers, the elation they felt at catching their foes off guard drained away. Their losses were less than many of them had feared: 29 planes downed by antiaircraft batteries or American fighters, few of which made it into the air. That was a small figure compared with the more than 250 U.S. warplanes destroyed in the attack. For all the harm done at Pearl Harbor, however, the Pacific Fleet had not been incapacitated. The oil depots and repair yards on which it depended had suffered little damage, and officers urged Admiral Nagumo to launch another strike against those vital facilities and the undamaged warships. But the cautious Nagumo would not risk sending his warplanes out again while carriers of the Pacific Fleet were somewhere at sea and posed a potential risk to his own vessels. "The attack is terminated," his chief of staff announced that afternoon. "We are withdrawing." When Admiral Yamamoto learned of the results at his headquarters, he saw little reason for celebration. There was no glory, he wrote, in

> **"I wondered how many more Americans would lose their lives before the war was over and prayed that I wouldn't be one of those buried so far from home."**
> PVT. MELVIN FAULKNER

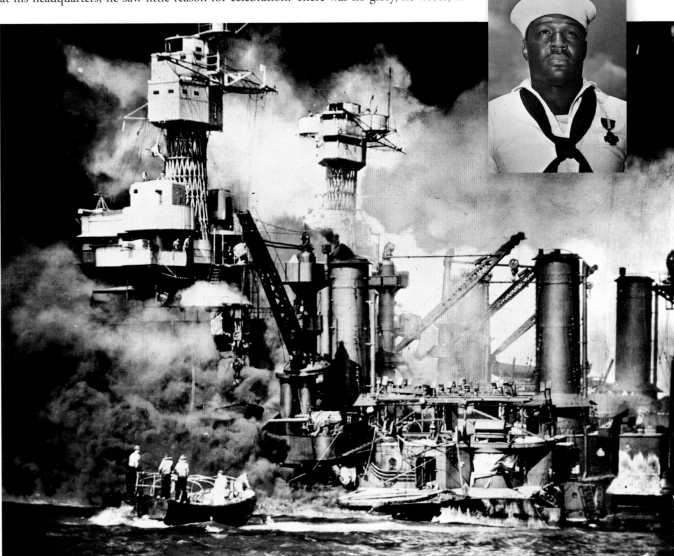

Battered Fleet The map at left shows where U.S. Navy warships were anchored in Pearl Harbor on the morning of December 7 and the location of targeted military facilities such as the U.S. Army's Hickam Field. In the rare color photograph above, sailors man a motor launch to rescue survivors from the stricken battleship U.S.S. *West Virginia*. Doris "Dorie" Miller *(inset)*, a 22-year-old mess attendant aboard the *West Virginia*, was awarded the Navy Cross for heroism in defending his ship and aiding survivors. The first African American so honored, Miller was later lost in action aboard the carrier U.S.S. *Liscome Bay*, torpedoed by a Japanese submarine in 1943.

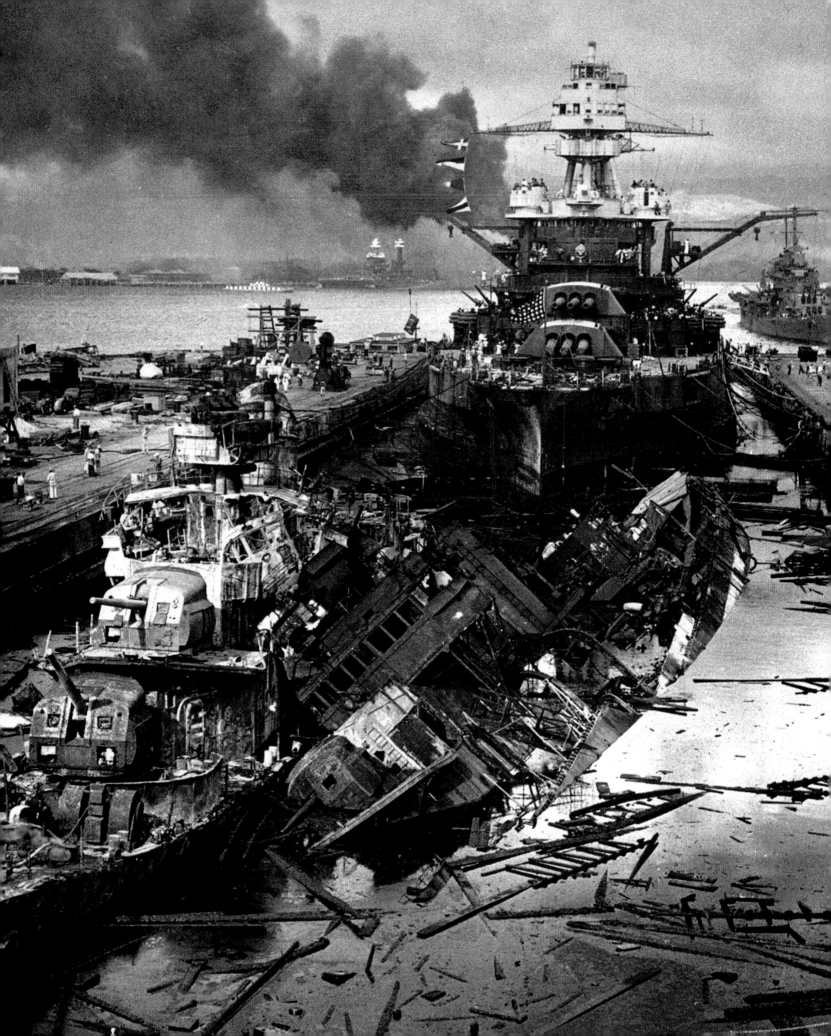

"We're all in the same boat now."

PRIME MINISTER WINSTON CHURCHILL

mauling "a sleeping enemy" who was now wide awake and capable of striking back. "Angered and outraged, he will soon launch a determined counterattack," warned Yamamoto, who understood that the tide might turn against him if he did not complete the task his forces left unfinished on December 7.

A WORLDWIDE CONFLICT

Within hours of the attack on Pearl Harbor, Japanese forces hit several other targets up to 6,000 miles away. It was the broadest offensive ever launched at one time by a single nation, and it transformed World War II into the first genuinely worldwide conflict—far bigger in scope than World War I, which had left most of Asia unscathed. As bombs fell at Pearl Harbor, Japanese troops landed on the Malay Peninsula and began advancing southward toward the British stronghold of Singapore. Elsewhere in Southeast Asia and the western Pacific, Japanese warplanes pounded Allied defenses to clear the way for invasions that would follow in the days and weeks to come. Among the American targets bombed on the first day of the offensive and later seized by Japanese troops were bases on Guam, Wake Island, and the Philippines, where 18 B-17 bombers and dozens of fighters were destroyed on runways at Clark Field around noon on December 8 (11 p.m. on December 7 in Washington). Gen. Douglas MacArthur and his officers in the Philippines knew by then that Japan was waging war on the U.S., but they were no better prepared for the onslaught than the commanders at Pearl Harbor. For Filipinos, who had been promised independence by the U.S. within five years, the prospect of Japanese occupation was appalling. In Manila, young Antonio Quintos was sent home from school early when news of war broke on December 8. He and his brother came upon two distraught American soldiers in the street. "They were crying like kids," he recalled. "We were too scared to cry."

Back in Washington, President Roosevelt got little sleep that night. He spoke by phone with Prime Minister Churchill, who promised to seek a declaration of war against Japan in London the next day as Roosevelt did the same in Washington. Churchill told the President: "We're all in the same boat now." Then in the early hours of December 8, Roosevelt met with correspondent Edward R. Murrow at the White House. Their talk was not broadcast, and Roosevelt felt free to speak his mind. Like many Americans, he was angry and ashamed that U.S. forces had been caught by surprise. Speaking of how American warplanes were blasted like sitting ducks, he pounded his fist on the table and exclaimed: "On the ground, by God, on the ground!" When he went before Congress at noon on December 8, however, he set aside any misgivings he had about America's readiness to fight and focused his anger on the Japanese and their "unprovoked and dastardly attack." He expressed "confidence in our armed forces" and promptly received the congressional declaration of war he requested.

Salvaged from Ruin The tattered flag above, from the battleship U.S.S. *California*, was recovered shortly after the Japanese attack. The badly damaged *California* was later salvaged and rebuilt, as was the destroyer U.S.S. *Cassin*, shown at left leaning against the destroyer U.S.S. *Downes* in a dry dock at Pearl Harbor. The battleship U.S.S. *Pennsylvania*, to their rear, was in the facility for maintenance and came under attack but escaped major damage.

DRAFT No. 1 December 7, 1941.

PROPOSED MESSAGE TO THE CONGRESS

Yesterday, December 7, 1941, a date which will live in ~~world history~~ *infamy*

the United States of America was ~~simultaneously~~ *suddenly* and deliberately attacked

by naval and air forces of the Empire of Japan

The United States was at the moment at peace with that nation and was

still in ~~continuing the~~ conversations with its Government and its Emperor looking

toward the maintenance of peace in the Pacific. Indeed, one hour after

Japanese air squadrons had commenced bombing in ~~the island of Oahu~~ *Oahu*

the Japanese Ambassador to the United States and his colleague delivered

to the Secretary of State a formal reply to a ~~former~~ *recent American* message. ~~from the~~

~~Secretary.~~ *While* This reply ~~contained a statement~~ *stated* that diplomatic negotiations *it seemed useless*

~~must be considered at an end,~~ *it* contained no threat ~~and no~~ hint of ~~armed~~ *or war or*

armed attack.

It will be recorded that the distance ~~of Hawaii, and especially~~ of

Hawaii from Japan makes it obvious that the attack ~~was~~ *was* deliberately

planned many days *or even weeks* ago. During the intervening time the Japanese Govern-

ment has deliberately sought to deceive the United States by false

statements and expressions of hope for continued peace.

To secure America and its place in the world, Roosevelt knew that he would have to join Churchill in opposing not just Japan but the Axis as a whole. But there was little support in Congress or the country at large for widening the war against Japan to include Germany and Italy. How to rally reluctant Americans against those European belligerents was a vexing problem for the President.

On December 11, 1941, Hitler solved it for him by declaring war on the U.S., a step that Germany's defensive pact with Japan did not require. In a rambling speech before the Reichstag—the powerless parliament from which he had eliminated all opponents of his regime—Hitler portrayed Roosevelt as a warmonger who sought "unlimited world dictatorship." Under no circumstances, he vowed, would he allow such an enemy "the opportunity to strike first." True to his aggressive principles, Hitler struck first by joining Japan in its war on the United States.

Germany's impulsive Führer was trying to assure his listeners that he was still in command of events. For the past two years, this had been essentially Hitler's war—a conflict he instigated and expanded until it embraced much of Europe and the Mediterranean. Now, however, he was caught up in something larger: a global struggle over which he had limited control. Instead of calling the shots as he did before, he would spend much time and energy responding to the initiatives of his foes in Washington, London, and Moscow, whose collective resources were greater than those of the Axis. "Today I stand at the head of the mightiest army in the world, the most powerful air force, and a proud navy," Hitler boasted on December 11. Within the past week, however, Soviet forces had pushed his vaunted army back from Moscow. And now he was taking on America, a colossus that he and his Axis partners antagonized at their peril.

State of War **President Franklin D. Roosevelt stands before both houses of Congress as he delivers his request for a declaration of war against Japan on Monday, December 8, 1941, the day after the Japanese attacked Pearl Harbor. In Roosevelt's hand-edited draft of his message to Congress (opposite),** he altered his description of December 7 from "a date which will live in world history" to "a date which will live in infamy," a memorable term that branded the attack as shameful and intolerable.

"Yesterday, December 7, 1941—a date which will live in infamy—the United States of America was suddenly and deliberately attacked by naval and air forces of the Empire of Japan."

PRESIDENT
FRANKLIN D. ROOSEVELT,
DECEMBER 8, 1941

THE SENSE OF OUTRAGE AT THE JAPANESE ATTACK ON Pearl Harbor united Americans against their foes. Never in its history had the nation so swiftly and vigorously mobilized its human and material resources for a single purpose—to achieve victory overseas. "There is one front and one battle where everyone in the United States—every man, woman, and child—is in action," President Roosevelt declared. "That front is right here at home, in our daily lives, and in our daily tasks." ★ The first and foremost task on the home front was transforming millions of civilians into soldiers at induction centers and training camps. The U.S. Army alone grew from under 200,000 men in 1939 to over eight million personnel in 1945. That huge call-up transformed American society by expanding opportunities for women and minorities in the various armed forces and in war industries. By 1945, as many as three million women worked in defense plants. ★ Tens of millions of Americans who were not directly involved in the war effort contributed in other ways—by planting "victory gardens" to expand food stocks, purchasing war bonds, and conducting scrap drives to collect metals, rubber, and other strategic materials. All those contributions helped make America the most dynamic and productive society ever to wage war. Within a year of the attack on Pearl Harbor, the U.S. was turning out more tanks, aircraft, and other munitions than Japan, Italy, and Germany combined. ■

Home Front U.S.A.:

AMERICANS MOBILIZE FOR WAR

On the aircraft:

SINCE PEARL HARBOR THE 5,000th *Boeing* BUILT *Flying Fortress*

5,0,0,0

Building Bombers **Workers** at a Boeing plant in Seattle stand proudly beside B-17 Flying Fortress number 5,000, covered with placards bearing their signatures. Women filled many jobs at such factories as men were drafted or enlisted in response to appeals like the U.S. Navy poster at left.

Called Up Wearing his hat and little else, an Army draftee is inoculated for smallpox and typhoid simultaneously by medical officers during his induction at Fort Dix in December 1940. To encourage enlistment, U.S. authorities resuscitated old Uncle Sam by reissuing artist James Montgomery Flagg's famous World War I recruiting poster (below).

Answering the Call

In September 1940, as Germany attacked America's close ally Great Britain, Congress passed the Selective Training and Service Act, instituting the nation's first peacetime draft. The act required all men between 21 and 35 to register for the draft and authorized conscription of 900,000 to serve for one year. After Pearl Harbor, men as young as 18 were drafted to serve for the duration of the war plus six months. More than ten million men were called up by 1945. Another six million Americans, including some 300,000 women, volunteered for service.

Nearly one million African Americans entered the armed forces. Segregated in the Army throughout the war and accepted only as mess attendants in the Navy when the conflict began, blacks had to overcome prejudice at home before they could fight enemies abroad. Gen. George S. Patton doubted that they were ready for combat until he saw the African-American 761st Tank Battalion excel at training

maneuvers. "I would never have asked for you if you weren't good," he told them when they joined his forces in France. "I have nothing but the best in my army."

Whatever their background, recruits were treated alike at induction centers, where they were poked, prodded, and inoculated. Some induction centers, like Fort Dix in New Jersey, also served as training camps, where soft enlisted men were hounded and hardened by drill sergeants. "He roared at us from the moment we appeared until the moment we left," one Marine wrote of his boot camp sergeant. "Our bare existence, for which we were humbly apologetic, plagued him, and sent him into spasms of rage." Not until they faced far worse ordeals in combat did men fully appreciate the lessons drilled into them in camp—the necessity of obeying orders, working as a team, and practicing skills needed to survive in battle repeatedly until they became automatic. ∎

Shoving Off Shouldering their seabags, sailors prepare to ship out from San Diego in June 1942. More than three million Americans joined the U.S. Navy during World War II, swelling its ranks tenfold.

Sorrowful Send-Offs

World War II hit Americans where they lived, making and breaking marriages and separating loved ones. The draft encouraged some couples to marry and have children, because most fathers were deferred by draft boards until military manpower demands increased in 1943. Another incentive for marrying was the emotional pressure couples felt when men were about to leave for a war from which they might not return. That sometimes led people to make commitments they found hard to keep. "I've told him I don't love him," a young woman confided to an interviewer after a serviceman proposed to her. "But he's an aviator and he says I should marry him anyhow and give him a little happiness. He says he knows he'll be dead in a year." When separated by war, couples who wed or became engaged for such reasons often had trouble sustaining their relationships,

Longing won't bring him back sooner...
GET A WAR JOB!
SEE YOUR U. S. EMPLOYMENT SERVICE
WAR MANPOWER COMMISSION

some of which ended with "Dear John" letters to servicemen abroad.

Most marriages survived the long wartime separations, but life was not easy for the wives of men in uniform. Military families often tried to stay together while the husband remained Stateside. Wives and children followed servicemen from base to base, riding overcrowded trains and living in rented rooms or cramped military housing. When husbands went overseas, their wives received small monthly allotments from the government to pay for basic necessities, but many took jobs or went to live with their parents to make ends meet.

Parting was doubly painful for servicemen who left both a wife and child behind, often for a year or two—and sometimes forever. But lengthy separations did not stop couples from starting families. Birth rates rose, anticipating the baby boom of the postwar era. ∎

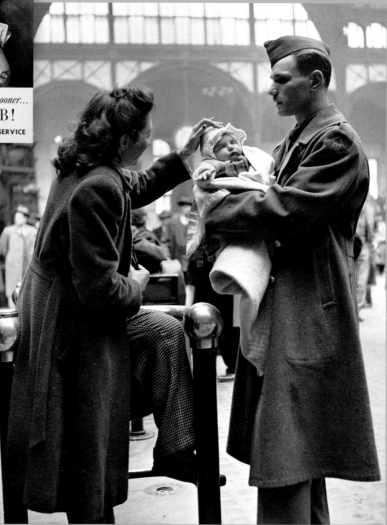

Sad Farewells Above, a distraught woman stands in New York City's Pennsylvania Station, watching her soldier boyfriend return to active duty, in a picture taken by photographer Alfred Eisenstaedt in 1943. On the same morning, Eisenstaedt also photographed a serviceman lingering momentarily at the station with his wife and infant *(right)* and a soldier and his girlfriend sharing a parting embrace *(opposite)*. Work offered wives and fiancées of distant servicemen consolation and financial support, but women with children to care for found it harder to heed the poster above and hold a war job.

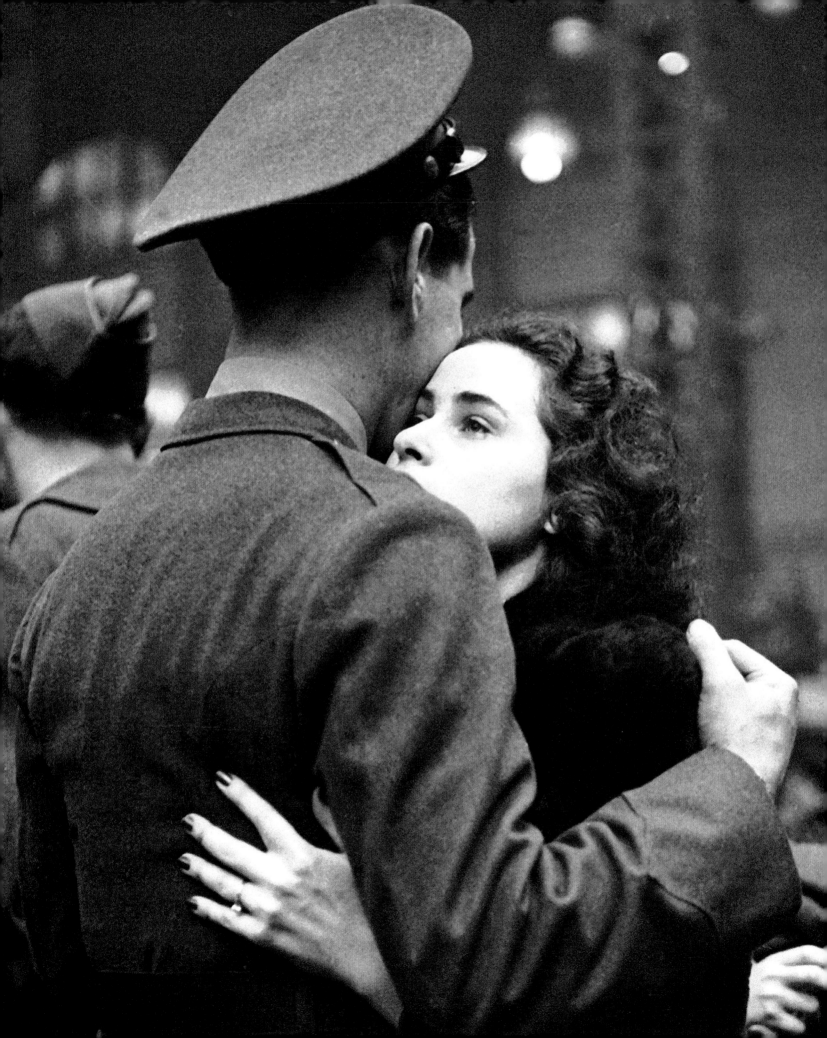

Back in Style Free at last from wartime restrictions, Ruth Cregan of Washington, D.C., proudly dons a pair of nylon stockings on a sidewalk in October 1945. When the war ended and a local department store advertised a shipment of scarce nylons, Cregan was the first in a long line of eager shoppers, who had been denied nylon for years when it was reserved for military uses,

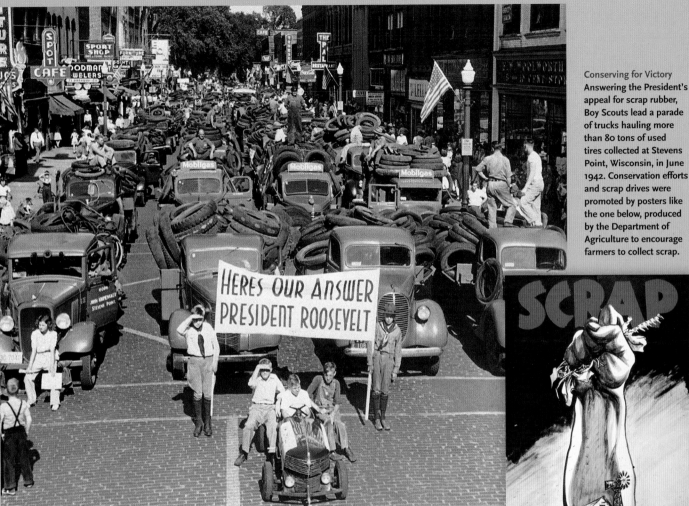

Conserving for Victory
Answering the President's appeal for scrap rubber, Boy Scouts lead a parade of trucks hauling more than 80 tons of used tires collected at Stevens Point, Wisconsin, in June 1942. Conservation efforts and scrap drives were promoted by posters like the one below, produced by the Department of Agriculture to encourage farmers to collect scrap.

HERES OUR ANSWER PRESIDENT ROOSEVELT

SCRAP

Conservation and Sacrifice

Americans on the home front felt the pinch as the nation shifted from producing consumer goods to arming and equipping millions of U.S. and Allied troops—including Soviet forces, who received more than 400,000 American-made trucks and jeeps. To further that massive war effort, officials in Washington urged citizens to sacrifice for the common good. One poster exhorted the public to "Produce and Conserve, Share and Play Square."

Beginning in May 1942, the government froze prices on nearly all consumer goods and rationed items considered essential, including sugar, coffee, butter, meat, shoes, and gasoline. Nylon, needed to make parachutes, was denied to the public, forcing women to do without fashionable stockings. One-third of all cigarettes made in the U.S. were allocated to the armed forces, and new car production was halted so that auto plants could manufacture military vehicles. Not all Americans were content to share and play square. Black markets emerged, with restricted items sold at steep prices, and ration coupons for gasoline were counterfeited and used to purchase as much as 5 percent of the domestic fuel supply by 1944.

Most people responded generously, however, when asked to aid the war effort. After Japan seized most of the world's rubber supply, President Roosevelt called for a scrap drive, which brought in nearly 500,000 tons of used rubber within a month. Much of it proved ill suited for recycling, but the government successfully conserved rubber by limiting the use of gas, autos, and tires. Other public scrap drives brought in an array of materials to be used for munitions, from iron and steel to the glycerin in kitchen fats. One man donated his beat-up old car to a scrap drive—no small sacrifice when new cars were unavailable—and placed a sign on the window playing on a favorite World War II song: "Praise the Lord, I'll Soon Be Ammunition." ∎

Ringing Up Contributions

Americans on the home front made a big investment in the war effort by opening their pocketbooks and buying government savings bonds, known as "war bonds" after the attack on Pearl Harbor. Authorized by the U.S. Treasury to finance the war effort and curb inflation by reducing the amount of currency in circulation, war bonds were issued in denominations ranging from $25 to $10,000 and offered a modest annual return of 2.9 percent. Typically, they were purchased at a discount of 25 percent and redeemed at full face value ten years later, leaving the cash in the Treasury's coffers for the duration of the war and then some. Patriotic youngsters purchased war savings stamps worth as little as 10 cents, which they pasted in a book until they had enough to buy a bond. In 1944 alone, the stamps and bonds purchased by American schoolchildren more than covered the cost of building nearly 3,000 aircraft and 44,000 jeeps.

War bond poster campaigns, featuring artwork by such renowned artists as Norman Rockwell, encouraged people to purchase a "share in America." Composer Irving Berlin contributed a theme song entitled "Any Bonds Today?" for the National Defense Savings Program. High-profile bond drives featuring celebrities such as Bette Davis and Rita Hayworth toured three hundred cities and towns. One nationwide series of "Stars Over America" rallies sold a prodigious $838,540,000 worth of bonds. Screen stars Hedy Lamarr and Lana Turner raised millions by promising kisses to those who bought high-priced bonds. Singer Kate Smith, renowned for her rendition of "God Bless America," hosted a marathon radio broadcast that rang up $40 million in bond sales in 16 hours. By the time the fighting ended, more than 85 million Americans had bought bonds worth a total of $135 billion—more than a third of the cost of financing the war, estimated at $340 billion. ■

Don't Let That Shadow Touch Them
Buy WAR BONDS

Liberty Loans At right, a swing band occupies a stage resembling a gigantic cash register, erected in New York's Times Square for a war bond drive in 1944. Another attraction at war bond rallies was the Japanese midget submarine *HA-19 (opposite)*, recovered at Pearl Harbor. The poster above, by artist Lawrence Beall Smith, promoted the purchase of war bonds as a way to protect children from America's enemies, symbolized here by a shadowy swastika.

5TH WAR LOAN

$18,300,000

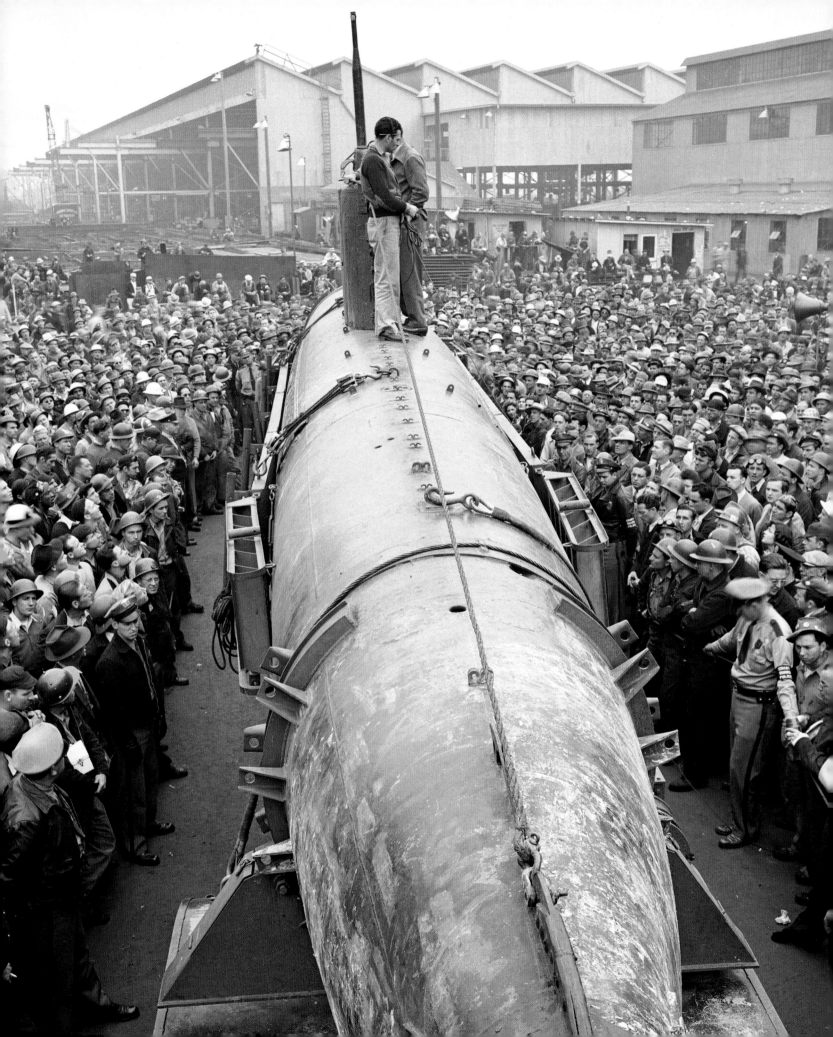

This Woman's Army

On May 27, 1942, more than 10,000 volunteers jammed recruiting centers to become the first to enroll in the new Women's Army Auxiliary Corps (WAAC). In New York City, the line stretched for blocks, and women waited up to eight hours to enlist. Although destined for noncombat duty, they underwent basic training that included running obstacle courses under a tear-gas barrage and other trials similar to those men faced in boot camps. "If the guys can take it," one woman said, "so can I."

Initially most WAACs, as they were called, worked as typists and clerks. But as more men were sent overseas, women in uniform took on various duties at bases in the U.S., where they served as mechanics, cryptographers, radio operators, and air traffic controllers. In November 1942, WAACs went overseas to serve in North Africa, where they faced new hazards. Five women on their way to join Gen. Dwight Eisenhower's staff in Algiers were rescued after their ship was torpedoed and were later commended by Ike for their "skill, spirit, and determination." In July 1943, they and other auxiliaries officially became WACs in the newly designated Women's Army Corps, which was now an integral part of the U.S. Army.

Women of the Army Nurse Corps were deployed in every theater of the war and often served in field hospitals just behind the front. More than 200 were killed in action during the conflict. Women of the Navy Nurse Corps were not sent to combat zones until the close of the war, but many served on hospital ships. Like WACs, those who enlisted in the Navy as WAVES (Women Accepted for Volunteer Emergency Service) were first confined to clerical work but later took on technical tasks. ∎

Call to Duty Oveta Culp Hobby, director of the Women's Army Auxiliary Corps, inspects recruits at Fort Des Moines, their training center in Iowa, on June 1, 1942. By 1944, when the poster above appeared, women were serving in four U.S. services—the Army, Navy, Marine Corps, and Coast Guard—and acquiring skills that would prove useful to them after the war.

Top-Flight Trainees At left, WAAC recruits crowd into an Army truck on their way to Fort Des Moines, where many of the first trainees were officer candidates. In September 1942, the U.S. Army Air Forces formed a separate unit for pilots, the Women's Auxiliary Ferrying Squadron, whose duties included shuttling military aircraft around the country and transporting cargo. Known later as WASPs (Women Air Force Service Pilots), those accepted for training already had some experience as pilots and were soon flying solo like the woman above, operating a Fairchild PT-19A trainer at Avenger Field in Sweetwater, Texas.

Hosting the Boys in Uniform

When the United States went to war, existing volunteer organizations like the American Red Cross stepped up efforts to aid service members at home and abroad. During the conflict, the Red Cross collected 13.4 million pints of blood—which was converted to life-saving plasma and shipped abroad—and sent more than 27 million food and medical parcels to Allied prisoners of war held overseas.

In 1941, a new volunteer group, the United Service Organizations (USO), arose to meet the emotional needs of lonely recruits. At that time, nightspots near military bases consisted largely of raucous bars and dismal, disease-ridden brothels. What the USO offered instead at canteens set up near many camps was wholesome entertainment, provided mostly by young women who volunteered to talk and dance with servicemen but knew where to draw the line. A volunteer at the USO near Camp Kilmer, New Jersey, recalled that she and others were escorted there by bus. "At the end of the night," she added, "you

got right back on the bus." There was no rule against hostesses corresponding with guests when they went overseas. "We would write to the boys," another volunteer remarked, "especially boys who had no one to write to them."

Celebrities helped entertain servicemen at USO events around the world and at nightclubs founded by other organizations like the Stage Door Canteen in New York's theater district, which offered guests food, nonalcoholic drinks, and a rare chance to meet and dance with headliners like Dorothy Maguire *(right)*. But the real stars were the everyday volunteers who kept servicemen entertained and were treated by them in return as someone special. As one USO hostess said, "You felt like the belle of the ball, one soldier after another would cut in to dance with you!" ∎

Dancing with a Star Actress Dorothy McGuire jitterbugs with a soldier at Manhattan's Stage Door Canteen, which was so successful that others like it opened in several cities. The USO recruited Donald Duck to promote its volunteer efforts for servicemen in the poster above.

Woman's Work When men were called to duty, female welders like those shown here replaced them at Carnegie–Illinois Steel's armor plate plant in Gary, Indiana. Impressive images such as this photo and the poster below, issued by the Westinghouse Corporation to boost morale among female employees, refuted those who claimed that industrial labor was not woman's work.

We Can Do It!

WAR PRODUCTION CO-ORDINATING COMMITTEE

Fighting the Production War

America had not yet overcome the Great Depression when it entered World War II. Good work was hard to find, particularly for minorities and women. In the six months following the attack on Pearl Harbor, roughly 750,000 women sought well-paid jobs in defense plants. Only about one in ten was accepted. There were still lots of men seeking work, and they had priority.

Soon, however, Americans were fighting on two fronts, and there were not enough able-bodied men to meet the needs of both the armed forces and booming war industries. Employers who once thought women too delicate for tasks like welding and riveting found them well suited for such work and faced a new challenge—attracting women to jobs considered unfeminine. Artists and photographers helped out by altering the image of the American woman. The character "Rosie the Riveter," popularized in a 1942 hit song by bandleader Kay Kyser, became an icon and inspired depictions

of strong working women like the poster above. When asked why even more women did not join the workforce, one who knew what it took to raise a family responded: "Because they don't have wives."

The wartime industrial boom also allowed African Americans to find skilled jobs from which they had long been barred. Aided by the Fair Employment Practices Commission, blacks made up 7.5 percent of the workers in war industries by 1944. Among them were women who had been relegated to domestic work before the war. As one woman put it: "Hitler was the one that got us out of the white folks' kitchen."

By mobilizing all its human and technological resources, the U.S. overwhelmed its enemies materially and won the production war, turning out some 1,500 naval vessels, 5,600 merchant ships, 80,000 landing craft, 100,000 tanks and armored vehicles, 300,000 aircraft, 20 million small arms, and 41 billion rounds of ammunition. ■

Arsenal of Democracy **Below, women at a defense plant in Long Beach, California, polish off their work under bright lights reflected in the translucent noses of Douglas A-20B bombers. Leading photographers contributed to the war effort by producing inspiring portraits of the nation's diverse workforce for magazines. The women welders at right—two of the 1.5 million black war workers employed during World War II—were photographed by Margaret Bourke-White at a factory producing military supplies in New Britain, Connecticut.**

Industrial Triumph **The submarine U.S.S. *Robalo* hits the water with a huge splash during its launching on May 9, 1943, at the Manitowoc Shipbuilding yards in Wisconsin. The narrow Manitowoc River made it necessary to launch submarines sideways; they then entered Lake Michigan and were towed from Chicago through inland waterways to the Mississippi River and the Gulf of Mexico. Ensuring that such companies had the workers they needed— and retained highly skilled men who might otherwise have been drafted—was the task of the War Manpower Commission, which issued the poster above in 1943 to celebrate the achievements of an integrated workplace.**

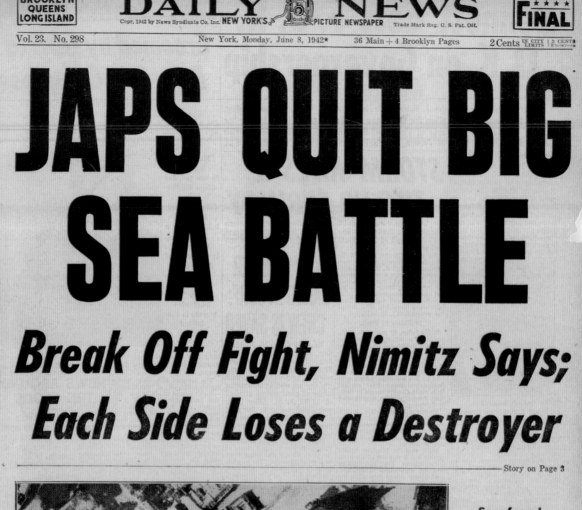

JAPS QUIT BIG SEA BATTLE

Break Off Fight, Nimitz Says; Each Side Loses a Destroyer

— Story on Page 3

Scarfaced
Cologne

RAF reconnaissance plane brought back this foto of a section of the German city of Cologne showing the scars caused by the 1,000-plane raid. The famous Cathedral (top right) appears to have escaped with superficial damage and shadows cast by the great spires show that they still stand. Street running from left to top right of foto is the Hohestrasse, described in Baedeker's guide book as the busiest thoroughfare in Cologne. Section of the city shown in this picture is shaded and marked (1) in map of Cologne on page 18. Saturday night hundreds of RAF bombers battered Emden, Germany's great U-boat base.

—*Story on page 3; other picture on page 18.*

(Associated Press Cablefoto **SENT HERE YESTERDAY** from London)

BROOKLYN QUEENS LONG ISLAND

DAILY NEWS

Copr. 1942 by News Syndicate Co. Inc. NEW YORK'S PICTURE NEWSPAPER Trade Mark Reg. U. S. Pat. Off.

FINAL

Vol. 23. No. 298 New York, Monday, June 8, 1942★ 36 Main + 4 Brooklyn Pages 2 Cents IN CITY LIMITS 3 CENTS ELSEWHERE

Hinting at Victory The New York *Daily News* ran this headline before the U.S. Navy revealed the full extent of its triumph at Midway in June 1942.

O N December 23, 1941, Gen. Douglas MacArthur took a step he had been dreading ever since the Philippines came under attack two weeks earlier. Japanese troops on the main island of Luzon were now approaching the capital of Manila from north and south. MacArthur's forces, consisting of 22,000 Americans and a larger number of Filipinos, many of them poorly trained, had no chance of holding the city. U.S. warplanes at Clark Field and other bases had been all but wiped out, and the Japanese had command of the air and the sea. In order to spare civilians, MacArthur announced, he would have to declare Manila "an open city, as was done in the case of Paris," which fell without a fight when the French abandoned it to German invaders in June 1940. A proud and aggressive commander who had earlier scrubbed a defensive plan calling for his troops to withdraw to the remote Bataan Peninsula as soon as the Japanese attacked, MacArthur would now have to conduct that retreat with the enemy in hot pursuit. ★ MacArthur would be remembered as a great American general. But for him as for other accomplished Allied commanders, World War II began disastrously. Like many top Army officers when the conflict began, the 61-year-old MacArthur was molded by his experiences in World War I, a struggle that unfolded in slow motion compared with the lightning-quick offensives launched by Germany and Japan in this conflict. The startling speed and destructive impact of modern combat, fueled by dramatic advances in aviation and weaponry since 1918, stunned MacArthur and other American officers in

Striking Back at Japan:

FROM THE BATTLE OF BATAAN TO MIDWAY

- **December 23, 1941** Gen. Douglas MacArthur abandons the Philippine capital of Manila to the Japanese and withdraws American and Filipino troops to the Bataan Peninsula and Corregidor.

- **March 11, 1942** MacArthur escapes from besieged Corregidor to command Allied forces in Australia.

- **April 9, 1942** U.S. forces trapped on Bataan surrender and begin a forced march to Japanese prison camps.

- **April 18, 1942** Maj. James Doolittle leads a raid on Tokyo by bombers launched from the aircraft carrier U.S.S. *Hornet*.

- **May 4–8, 1942** Battle of the Coral Sea

- **June 3, 1942** Japanese Imperial Navy launches diversionary attacks on U.S. bases on the Aleutian Islands before assaulting Midway Island.

- **June 4–6, 1942** Battle of Midway

> **"Stand and fight, slip back and dynamite. It was savage and bloody, but it won time."**
>
> GEN. DOUGLAS MACARTHUR, DESCRIBING HIS WITHDRAWAL FROM MANILA

December 1941—as it did Polish, French, British, and Russian commanders who had been overwhelmed by German blitzkriegs in the two years preceding the Japanese onslaught.

In MacArthur's case, the crisis was aggravated by his deep personal attachment to Manila, where his esteemed father, Gen. Arthur MacArthur, had served as military governor following the U.S. occupation of the Philippines during the Spanish-American War. Arthur MacArthur's stellar military record—which included a Medal of Honor for his daring charge up Missionary Ridge as a 19-year-old Union lieutenant during the Civil War—inspired his son to similar acts of heroism as a colonel with the American Expeditionary Force in France in 1918. Douglas MacArthur's reluctance to retreat from Manila in 1941 stemmed in part from devotion to his father's memory. "You know, I feel Dad's presence here," he remarked. Among the traits he shared with his father was a self-assurance bordering on arrogance. An officer who knew both generals remarked that "Arthur MacArthur was the most flamboyantly egotistical man I had ever seen, until I met his son." Douglas MacArthur's combative pride caused him to spurn the idea of withdrawing to Bataan until that retreat could no longer be avoided—a fallback for which he failed to make adequate preparations. One Army depot near Manila contained enough rice to nourish his men for years, but none of it was shipped to the Bataan Peninsula before they withdrew there and went hungry.

MacArthur's faults were inseparable from his strengths as a commander. His giant ego, which could make him overbearing and overconfident, also made him an inspirational leader in dire circumstances. No one was more aware of MacArthur's flaws than Lt. Col. Dwight D. Eisenhower, who served under him for several years. "He'd like to occupy a throne room surrounded by experts in flattery," Eisenhower wrote in his diary before leaving MacArthur's staff in 1939. "Will I be glad when I get out of this!" Yet when "Ike" later achieved prominence as a general, he paid his exasperating old boss a rare tribute. "If that door opened at this moment," he told reporters, "and General MacArthur was standing there, and he said, 'Ike, follow me,' I'd get up and follow him."

After grudgingly abandoning Manila, MacArthur and his officers executed a skillful, fighting retreat to Bataan. Bridges were held just long enough for the troops to cross over, then destroyed to slow the oncoming enemy. MacArthur described the withdrawal succinctly: "Stand and fight, slip back and dynamite. It was savage and bloody, but it won time." His second in command, Maj. Gen. Jonathan Wainwright, fought a valiant delaying action at a vital bridge over the Pampanga River, northwest of Manila, before crossing with his rear guard on New Year's Day, 1942, and demolishing the span behind him. By mid-January, some 80,000 Filipino and American troops and 25,000 civilians were holed up behind fortified lines on Bataan, situated across Manila Bay from the capital. MacArthur made his headquarters on Corregidor, a small island off the southern tip of the peninsula. Sheltered there, in a tunnel blasted out of volcanic rock, with his staff, his wife and young son, and Filipino president Manuel Quezon, he appealed by radio to Washington for aid and reinforcements. Army Chief of Staff Gen. George Marshall hailed him for his "splendid resistance" and

promised support. But it soon became clear that neither the Army nor the Navy, still reeling from its losses at Pearl Harbor, could break the Japanese stranglehold on the Philippines.

MacArthur's stranded forces did not yield easily to their Japanese foes. Lt. Col. Philip Fry, the American commander of an elite regiment of Filipino Scouts, recalled how his troops repulsed the initial attack by Lt. Gen. Masahura Homma's overeager troops, who advanced across a minefield into murderous machine-gun fire: "A great shout of 'Banzai!' came from the front and the Japs started an old Civil War charge . . . It was slaughter. All of our guns had been carefully sighted for mutual support and the Japs were caught by terrific fire both frontal and flanking." Homma's next assault was more careful and effective. "This time the enemy brought up his tanks and hit us hard," Fry related. The big guns used by MacArthur's men to combat those tanks fired sporadically, Fry added, because "we had World War I ammunition and averaged about six duds out of every ten rounds fired." Antiquated or deficient weapons, including faulty hand grenades and torpedoes, greatly hampered U.S. forces in the Pacific at the start of this conflict, exposing gaps in the nation's defenses caused by two decades of peacetime complacency and neglect.

Both sides in the grueling battle for Bataan suffered from tropical diseases, festering wounds, and paltry rations. But Homma received thousands of reinforcements in early 1942 and MacArthur received none. "It was Japan's ability to bring in fresh forces and America's inability to do so that finally settled the issue," he wrote. After visiting his troops on the peninsula in January and assuring them that help was on the way—a pledge he made in good faith but could not fulfill—MacArthur returned to Corregidor and remained there. Soldiers mocked their distant commander, calling him "Dugout Doug." He fared better at headquarters than his famished troops did in the field, but life was no picnic on Corregidor, which was constantly under bombardment. The sickening realization that his men on Bataan were trapped gnawed at MacArthur and left him unable to face them again. As their strength ebbed away and their hopes dwindled, they found solace in gallows humor. "We're the battling bastards of Bataan," they chanted, "No mama, no papa, no Uncle Sam . . . And nobody gives a damn."

In truth, their stubborn resistance heartened Americans on the home front and surprised the Japanese, who expected to secure the Philippines by February 1 and were still counting their losses and pouring in reinforcements a month later. By then, Bataan's "battling bastards" were among the last Allied forces in the region holding out against Japanese invaders. In the western Pacific, lightly defended American bases on Guam and Wake Island had

Commanding in Style Pictured above late in the war, Gen. Douglas MacArthur smokes his trademark Missouri meerschaum corncob pipe, shown opposite along with two other stylish accouterments he was seldom without—sunglasses and a gold-embroidered version of the U.S. Army's standard tropical service cap, which he designed while serving in the 1930s as military advisor to the Philippines with the local rank of field marshal.

HENRY CLAY HENDERSON
DEFENSE OF THE PHILIPPINES

Henderson was serving as a fireman—responsible for operating and maintaining a ship's boilers—on the submarine tender U.S.S. Otus *when the Japanese bombed Cavite Navy Yard near Manila on December 10, 1941. Left behind when most U.S. naval forces departed for Australia, he was captured on Corregidor.*

Dec. 12, 1941 Fri. morning. I went to the Cavite Navy Yard to try to salvage any submarine spare parts or torpedoes. GOD what a sight. Dead bodies everywhere. Dog, cats, chicken, and pigs were eating the flesh of these bodies. It was a scramble to find a place to put my foot down without stepping on someone or some dismembered part of a body . . .

Jan 2, 1942. All flag personnel were assembled on the USS *Canopus* for assignment to submarines that would ultimately take them to Australia. This included everyone except submarine spare parts personnel. When the Submarine Officers left the area, us so called stragglers were fair prey for any and all dirty details the ARMY could come up with . . .

Mar 1, 1942. . . . The USS *Canopus* was eventually bombed and had to be scuttled. This crew, as well as all of us stragglers were put in the Beach Defense Sectors, serving under the US ARMY. The US MARINES also suffered this same fate. They were put in charge of training us in the use of the rifle, bayonet, pistol, hand grenades, knife, garrote, and hand to hand combat. BOY!!! They made MARINES out of us in short order. I got so adept with the Enfield rifle that during the invasion of Corregidor, when I got one of the enemy in my sights, he was a downed man . . .

> **"GOD what a sight. Dead bodies every where. Dog, cats, chicken, and pigs were eating the flesh of these bodies."**

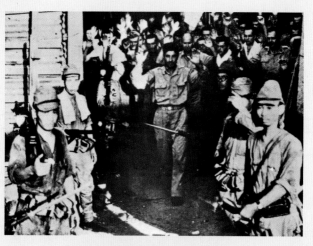

Hands Up Captured Japanese infantrymen of the 14th Imperial Army accept the surrender of U.S. troops at the north entrance of the Malinta Tunnel on Corregidor on May 9, 1942.

March 15, 1942. I was transferred to the Beach Defense Sector on Monkey Point on Corregidor with the Marines and other stragglers like myself. Being the Junior Chief, I was put in charge of this group. This was a sorry lot, each of us knew just exactly what we were, Cannon Fodder . . .

May 5, 1942 Wed. 2230hrs. The alert was sounded to repel boarders. The Japanese had landed and where? Right on top of us stragglers. Now I know this was

not planned, but none the less, it happened that way. The battle raged until we were told the next morning to resist until NOON, strip our guns and dispose of them and surrender. However, by 1000 hrs. this morning, we knew the end had come, after all my Enfield was no match for the TANKS that had followed the Infantry ashore and stomped us into the ground. As all of this was happening, a big shell dropped in on top of us. A small piece of shrapnel hit my left ankle and the concussion stunned me . . . I don't know how long I was in this stupor, some time later, I came to. My rifle had been fired for so long and so many times, that the protective wood around the barrel showed signs of being charred by the heat of this rapid firing. A Japanese soldier was nudging me with his bayonet and pointing in the direction of the 92nd Field Artillery garage. I didn't think I could, but he convinced me otherwise. We were all moved to this location to await further developments . . . The shrapnel in my ankle was killing me by this time. A Corpsman from the USS *Luzon,* a river boat from China, removed this sliver from my ankle with a pair of needle nose pliers. He sewed up the wound, using needle and thread from a sewing kit one of my friends had on him. ■

been overwhelmed not long after the attack on Pearl Harbor. In Southeast Asia, the British lost Hong Kong in late December and suffered a staggering defeat in February when Singapore fell to Japanese troops heavily outnumbered by the hapless defenders of that strategic city at the southern tip of the Malay Peninsula. Winston Churchill, who had sent the battleship H.M.S. *Prince of Wales* and the battle cruiser H.M.S. *Repulse* to defend Singapore and lost both to Japanese bombers, called the surrender of that stronghold the "worst disaster and greatest capitulation of British history."

In Malaya, as in Burma, where the capital Rangoon fell to Japanese troops in early March, the invaders moved furtively through the jungle and outflanked British forces defending roads and junctions. The British were further hampered by resistance to imperial rule in their Asian colonies. By posing as liberators and promising to forge a Greater East Asian Co-Prosperity Sphere, the Japanese attracted sympathizers not just in British colonies like Burma—where many nationalists sided with the Japanese against Britain—but also in the oil-rich Dutch East Indies, which were occupied with ease after the Japanese shattered a motley Allied fleet in the Java Sea in late February.

Southeast Asians who endured Japanese occupation soon discovered, however, that their new rulers were more ruthless imperialists than their old European masters. Before World War II erupted, Japan had colonized Korea and Manchuria (reorganized as the puppet state of Manchukuo) and occupied much of China, often subjecting their fellow Asians in those lands to harsh treatment. Ba Maw, a collaborator who served as prime minister of Burma under the Japanese, later denounced what he called the "Korea clique"—Japanese officers who had learned in Korea, Manchuria, and China to behave like "the master race in Asia and to deal with the other Asian races on that footing." They saw "only one destiny for the East Asian countries," he added—"to become so many Manchukuos or Koreas tied to Japan forever." As the new imperial masters of the region, the Japanese siphoned off the natural resources of countries they occupied and forced men to labor for them and women to serve as prostitutes for their soldiers.

Japanese authorities did little to restrain brutal acts by soldiers against civilians or Allied prisoners of war. To the contrary, army officers hardened troops to brutality by beating subordinates and allowing them to do the same to men under their command. Many Japanese soldiers were also steeped in a crude version of the ancient samurai code of *bushido* ("way of the warrior"), which encouraged them not just to be brave and loyal and to die rather than surrender but also to regard those who surrendered to them as cowardly and contemptible. During the fighting on Bataan, Japanese planes dropped leaflets aimed at Filipino troops, blaming their plight on the U.S. and urging them to abandon their American allies: "Give up all your weapons at once and surrender to the Japanese force before it is too late, then we shall fully protect you." Few Filipinos were taken in by such appeals. They knew what

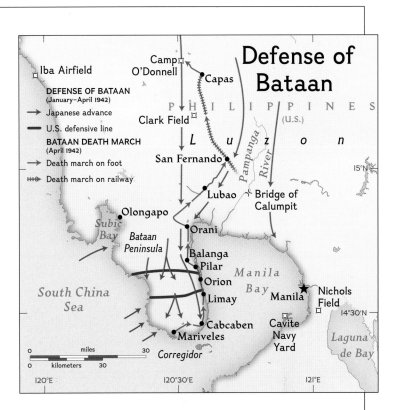

Embattled Island The map above shows the capital, Manila, and other sites on the Philippine island of Luzon where Japanese forces challenged American and Filipino troops. An American protectorate destined for independence, the Philippines had its own army, whose insignia included the water buffalo device of the 12th Infantry Division *(below)* and the arms of the Philippine General Staff *(bottom)*.

"We're the battling bastards of Bataan. No mama, no papa, no Uncle Sam... And nobody gives a damn."

SOLDIERS' SONG ON BATAAN

Japanese occupation meant for Korea and China—and recognized that those promises of protection were not worth the paper they were printed on.

THE BATAAN DEATH MARCH

On March 11, 1942, MacArthur left Corregidor with his family and staff aboard a swift PT boat, which evaded Japanese patrols and reached the distant Philippine island of Mindanao, where they boarded a B-17 for Australia. In making this escape, MacArthur was following orders from General Marshall and President Roosevelt, who did not want him killed or captured by the Japanese and sent him to command Allied forces in Australia. "The President of the United States ordered me to break through the Japanese lines," he declared when he arrived there, "for the purpose, as I understand it, of organizing the American offensive against Japan, a primary object of which is the relief of the Philippines." Then he offered a memorable pledge to the Filipino people and the troops stranded on Luzon. "I came through, and I shall return," he vowed. The War Information Office in Washington asked MacArthur's permission to change the "I" to "we" before releasing the story to the press. "We shall return" would signal that Americans as a whole were determined to defeat the Japanese and liberate the Philippines. But MacArthur would not allow his statement to be altered. Reclaiming the Philippines was his personal crusade, and he believed that Filipinos had more trust in him than in the U.S. government, which had seemingly abandoned them to the enemy.

Many American soldiers left behind on Luzon felt abandoned by their commander as well as their government. Some men like pilot Sam Grashio thought that it made sense for MacArthur to carry on the fight elsewhere rather than "fall into the hands of the enemy," but Grashio noticed that others were scornful: "His departure occasioned some bitter remarks about 'Dugout Doug' from men who had long envied the Corregidor garrison for what they presumed was the easier life of the latter or who blamed MacArthur for the inadequate defenses of the Philippines." Morale dropped when he departed, recalled Col. Clifford Bluemel, who assured his troops that MacArthur would indeed return: "Help is going to come. He's going to bring it back." But privately, Bluemel doubted that help would arrive in time to save them. "I had to lie a little bit," he admitted. "I didn't believe it." Hunger and disease had weakened the troops, and they could not keep up the fight much longer. In late March, Homma's

You're a long way from home, boys, in hostile territory. But don't worry, boys; your lives are not in immediate danger. Why? Because we'll not bother with you small fry. It's much simpler to isolate you by cutting your life-line. So fire away, boys, to your hearts' content!

PHILIPPINES

Cut Off The Japanese propaganda leaflet above was meant to demoralize U.S. troops on the Philippines by showing how easily their lifeline could be severed. After holding out for months without being resupplied or reinforced, Americans and Filipinos yielded, first on Bataan and then on Corregidor, where a photographer recorded the surrender of hundreds of men *(opposite)*, many of them wearing helmets like the bullet-damaged M1917A-1 at top.

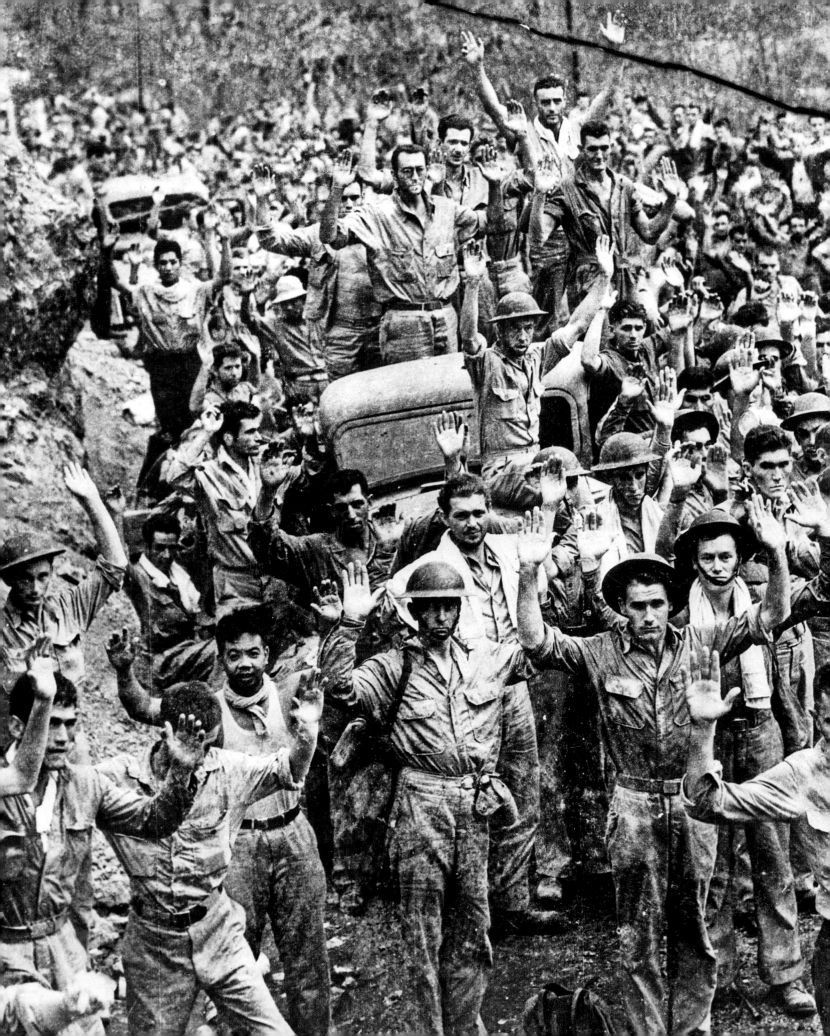

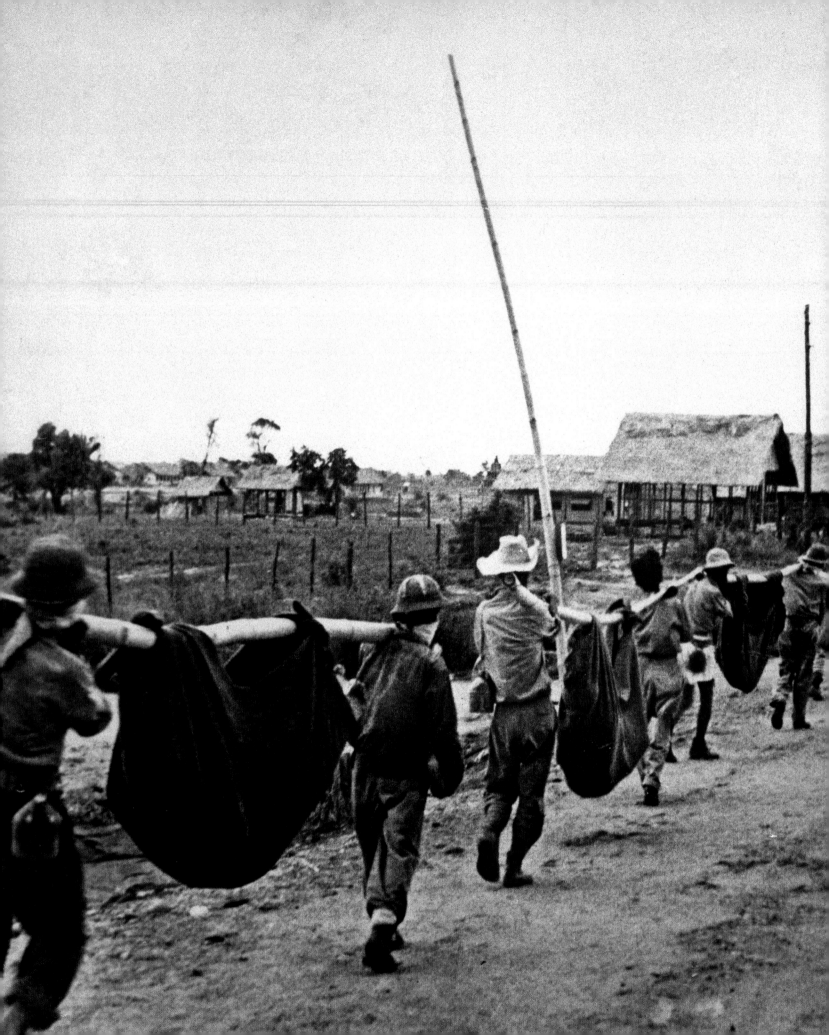

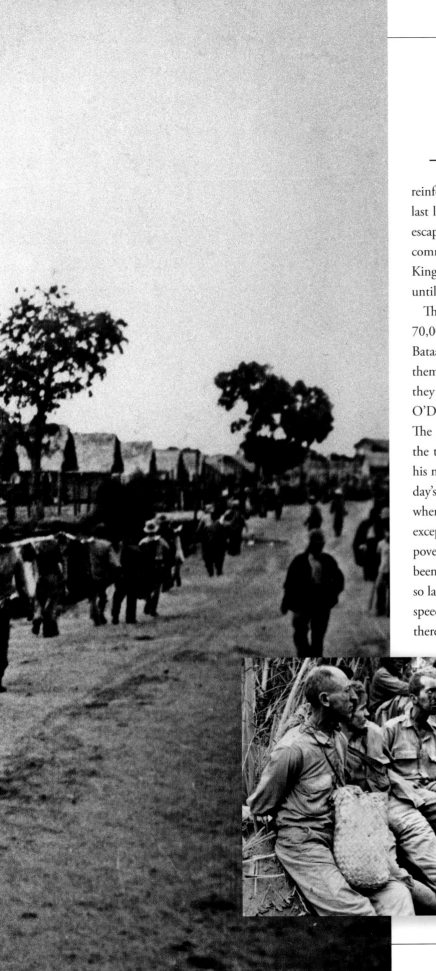

"You take a little walk to Balanga. Maybe you get food there."

JAPANESE SOLDIER TO STARVING PRISONERS

reinforced army launched fresh attacks and broke through their last lines of defense. A few thousand Americans and Filipinos escaped to Corregidor, where General Wainwright had taken command, but the rest were rounded up when Gen. Edward King surrendered Luzon on April 9. Wainwright would hold out until early May before surrendering the Philippines as a whole.

The Japanese were not prepared to handle the more than 70,000 prisoners of war they seized at the southern tip of the Bataan Peninsula in April. Hasty plans were made to march them nearly 70 miles north to the nearest railroad station, where they would be crowded into boxcars and shipped to Camp O'Donnell, a captured Allied base converted into a prison camp. The prisoners were wary of the Japanese, but few anticipated the terrible ordeal that lay ahead. When Maj. Alva Fitch and his men reached the town of Mariveles at the end of their first day's march, they "expected to find food and transportation to wherever we were going," he said. Instead, "we found nothing except several hundred Americans, as bewildered, hungry, and poverty stricken as ourselves. We were herded into what had been the public square and thoroughly searched." An hour or so later, Fitch added, "a Jap climbed up on a truck and made a speech: 'You take a little walk to Balanga. Maybe you get food there.' Balanga was about 40 kilometers [25 miles] away. I didn't think we could make it, but I was no longer in a position to dispute with the Imperial Japanese Armed Forces."

Many of the prisoners were in poor shape when the march began. Those who lagged behind or fell out were

March of Death American prisoners of war at Camp O'Donnell on Luzon carry remains of the dead for burial there. The brutal trek to the camp left POWs weak and emaciated like the three men from the 31st Infantry Regiment shown here *(inset)*, sitting with their hands bound during an infrequent halt on the long march. By the time the survivors reached their destination, recalled Cpl. John Love, men were "dying faster than we could dig graves."

Amateur Codes to Beat Prison Camp Sensors

Not all the codes and ciphers used during World War II were authorized by official intelligence organizations. Many were applied or devised by individuals, particularly prisoners of war, to evade censorship. In one case, Lt. Frank G. Jonelis, held in a prison camp in Japan, managed to send a postcard addressed to "Mr. F. B. Iers" in Los Angeles. Japanese censors did not understand the reference in the address and permitted the note to pass. The postcard reached an alert FBI agent, who recognized that the contents (transcribed below) contained a null code—in which certain words are given as "nulls" to be eliminated—and deciphered the message.

Other POWs established more sophisticated methods of exchanging coded messages with relatives through the Red Cross mail system. Generally, these codes had been prearranged between a soldier and his wife, friend, or relative in order to slip personal information past military censors, but they could also provide valuable information to Allied intelligence services.

Capt. Geoffrey Stibbard, a British officer captured in Greece in 1941, was held in Oflag VB, an officers' prison camp in Germany. Stibbard managed to send hundreds of coded letters to British intelligence officers via his mother. His letters appeared to be normal correspondence but in fact concealed an elaborate code, which he had arranged with her before leaving for service overseas. Intelligence officers first tried to break the code on their own, but they were unable to decipher the messages until Stibbard's mother helped them out. ▪

AUGUST 29, 1943

DEAR IERS:

AFTER SURRENDER, HEALTH IMPROVED **FIFTY PERCENT**. BETTER FOOD ETC. **AMERICANS LOST** CONFIDENCE **IN PHILIPPINES**. AM COMFORTABLE **IN NIPPON**. MOTHER: INVEST **30%, SALARY**, IN BUSINESS. LOVE

Frank G. Jonelis

Hidden Meaning This null-code message was deciphered by removing all but the first two words in each line (shown in bold type above). Decoded it read: "After surrender, fifty percent Americans lost in Philippines. In Nippon 30%."

beaten by guards or prodded back into line with bayonets. Those who collapsed were often shot or stabbed and left to die. As Fitch and his fellow prisoners approached Balanga, they noticed "an increase in the number of corpses along the road"—victims who had preceded them on the march and failed to reach that town, where there were in fact no provisions. Nor were there any sanitary facilities at Balanga, Fitch recalled: "This did not concern most of us much, as we had been three days without food and could never get enough water to spare for urine. There were two small spigots at Balanga and it was necessary to stand in line for several hours to get your canteen filled." Fitch managed to dig a few turnips out of the ground with a stick. That helped sustain him, but others in his company were unable to keep up when the march resumed: "I helped Chaplain Duffy along until he quit trying. I then commended him to his maker and left him to the gentle mercies of the Japanese." Fitch later tried to help a fellow officer named Vaughn back on his feet when he fell: "I couldn't get him up and a Jap came along and told me to move on. I tried to explain to him but he jabbed me in the butt with his bayonet. Then he shot Vaughn in the chest."

More than 7,000 Filipino and American prisoners perished on that murderous death march, which concluded with a suffocating train ride from San Fernando to Capas, a few miles from Camp O'Donnell. Up to a hundred men were jammed into each boxcar. "Too crowded to sit, much less lie, they watched the doors slam shut," related one survivor, Capt. John Olson. "Then began three to four hours of excruciating sweltering in this fetid sweat box. Some collapsed, the weakest died. Even the Japanese guards suffered."

The prisoners' ordeal continued when they reached Camp O'Donnell, which Olson likened to Andersonville, the filthy Confederate compound where thousands of Union prisoners died of disease and malnutrition during the Civil War. In fact, the plight of many prisoners of war during World War II was even worse than that of inmates at 19th-century hellholes like Andersonville and Fort Delaware, where Confederate captives died in droves. In this conflict as in the Civil War, many prisoners perished because their captors lacked enough food, medicine, and other supplies to sustain them or were unwilling to expend those vital resources on captured enemies. But the toll during World War II was magnified by fierce national rivalries and racism, which led some guards and officers who oversaw camps not just to neglect prisoners but to despise them and hasten their death. Captured Allied troops suffered worse treatment from imperial Japan—whose soldiers were taught to disdain those of all opposing nations or races

who yielded to them—than from Nazi Germany, where Anglo-Saxons like the British and Americans were considered worthy foes while Russians and other non-Aryan adversaries were classified as subhuman and treated terribly. When scarce resources combined with the hostility and fanaticism of prison guards and commandants, as happened all too often during World War II, those who survived confinement sometimes envied the dead.

Major Fitch thought he had endured the worst his captors had to offer when he reached Camp O'Donnell, but he soon learned otherwise: "I was damn glad to arrive, little knowing that the name O'Donnell would make the Black Hole of Calcutta seem a Sunday school picnic." Another prisoner recalled the chilling words of the commandant who greeted them. They were enemies, he told them, and always would be. His only concern as their enemy was "how many of you are dead every morning." Those who had perished on the Death March, he added, were "the lucky ones." The camp was so crowded and chaotic that no precise casualty count was kept during the war, but roughly half of those held there died there.

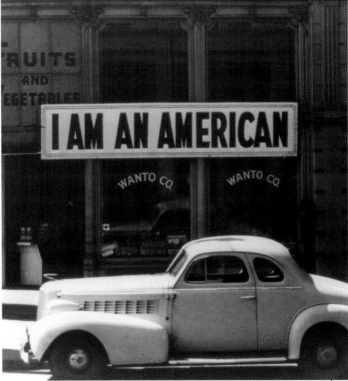

Patriotic Plea In a desperate appeal for tolerance, a Japanese-American store owner placed this sign in the window of his Oakland, California, grocery on December 8, 1941.

AMERICA'S LOYAL "ENEMY ALIENS"

In the bitter aftermath of the attacks on Pearl Harbor and the Philippines, Americans were inclined to distrust and disdain all Japanese, including those so-called enemy aliens on American soil, many of whom were in fact proud U.S. citizens. Few people realized that Japanese Americans were among the nation's first war victims on December 7, 1941, when flak from antiaircraft guns went astray in Honolulu and crashed into their homes, killing some and maiming others. Sifting through the rubble in search of survivors that morning was 17-year-old Daniel Inouye, a Japanese-American Red Cross volunteer who would later represent Hawaii in the U.S. Senate. An American citizen by birth, he had no sympathy for imperial Japan. Although only a "generation removed from the land that had spawned those bombers," Inouye wrote later in his memoir, *Journey to Washington,* he looked up at the warplanes and cursed those Japanese. Even as he did so, however, he knew that similar curses would be aimed at him and other loyal Japanese Americans by people who saw them as enemies. No matter how much they did to support and defend their country, he realized, "there would always be those who would look at us and think—and some would say it aloud—'Dirty Jap!' "

Unlike Japanese Americans on the West Coast, who were sent to internment camps in early 1942, most of those in Hawaii were spared that ordeal. They made up nearly 40 percent of Hawaii's 400,000 inhabitants and were too important to its economy to be removed or isolated. Some influential Anglo-Americans vouched for them, including John Burns, a police captain in Honolulu and future governor who expressed "complete confidence in Hawaii's Japanese Americans." Eighteen-year-old Yoshiaki Fujitani was among those Nisei (Japanese born in America) who enrolled in the Reserve Officer Training Corps (ROTC)

"Hawaii is our home, the United States is our country. We know but one loyalty and that is to the Stars and Stripes."

JAPANESE-AMERICAN VARSITY VICTORY VOLUNTEERS, PETITIONING TO SERVE THEIR COUNTRY

SATO HASHIZUME
JAPANESE-AMERICAN INTERNMENT CAMPS

Hashizume was born in Japan in 1931 and immigrated with her family to Portland, Oregon, as an infant. In 1942, she and her family were sent to the Minidoka internment camp in Idaho.

The people in our apartment house were extremely loyal. After awhile, there used to be an FBI agent who stood across the street from our apartment house. As people left our apartment house, he would question them and say, "Do they have short-wave radio or Japanese flags?" or, "Do they have anything that would suggest loyalty to Japan?" They would say, "No! No! They are Americans! They are born here in the United States! What are you saying?" . . .

We were concerned that they would take away my father or they would think that we were doing something subversive. And so we . . . were going through everything, magazines, our albums, and found the Japanese flag, we went and took

> **"We were concerned that they would take away my father or they would think that we were doing something subversive."**

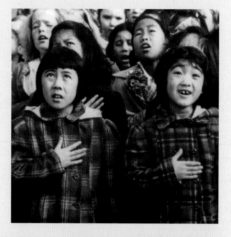

them downstairs and burned them in the furnace, to try to get rid of anything that suggested that we may have some loyalties to Japan . . . My father had some books and things that he rather cherished, and he thought, "Well, maybe those should go be burned as well." So, we have gaps in our album where we threw some pictures away that we thought might be incriminating . . . We didn't receive a notice until shortly before we had to leave. At that point, my father had to sell the business . . . so a woman came and gave him an offer that he took and it was way below market value, but we had no choice.

So then we got a notice that said, "This is what you can take, and this is what you must leave behind." . . . They told us that we needed to take our bedding; we needed to take our sheets—not the mattresses or anything like that—but our sheets, and pillows. Then, the other thing that we were supposed to take was one plate, one cup, a knife, fork, and spoon, and our toiletries and then only what we could carry in terms of our clothes . . . We couldn't take any cameras; certainly we couldn't take any pets. I had a cat that I had to get rid of. My sister found a home for it and that was heartbreaking to me . . . Well, we each had a suitcase, and so we filled it—and we didn't know whether we were going to be there for years or days . . . We knew we were going to the assembly center, but from there, we didn't know where we were going to go. ■

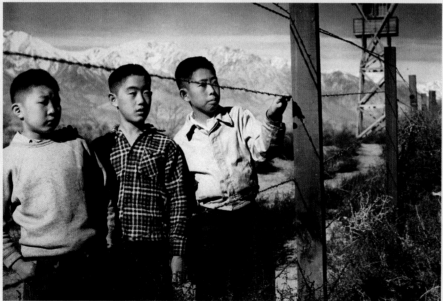

Fenced In These boys, confined at the Manzanar Relocation Center in California, were among thousands of young Japanese Americans sent with their parents to internment camps. Many had pledged allegiance to the U.S. in school like the girls above.

Patriotic Internees Posing with an American flag at the Colorado River Relocation Center in Arizona, the Hirano family displays a photograph of a son who served in the U.S. Army while they remained interned. The mother of George Matsushita, a soldier with the 442nd Regimental Combat Team, made the Senninbari vest below in the Amache internment camp in Colorado. Senninbari traditionally featured 1,000 embroidered knots, each stitched by a different person to ensure the wearer good fortune.

Bleak Confines Windblown dust envelops the Manzanar camp below the Sierra Nevada, one of many relocation centers situated in remote areas in the west.

"Tell Nimitz to get the hell out to Pearl and stay there until the war is won."

President Franklin D. Roosevelt

at the University of Hawaii. After the attack on Pearl Harbor, they were inducted into the newly formed Hawaiian Territorial Guard and issued rifles. When they went out on patrols, Fujitani recalled, some people "looked at us very suspiciously . . . to them, we sure looked like the enemy." He and other Nisei were sent to patrol the docks. They joked about what a Marine might say if he arrived there by ship with his buddies to defend Pearl Harbor and saw Japanese guards waiting on shore with guns in hand: "Hey, Mac, we're too late."

Their service in the Hawaiian Territorial Guard lasted only about a month. In late December 1941, Japanese submarines surfaced off Hawaii and shelled port facilities and oil storage tanks. Little damage was done, but the attacks increased concerns in Washington about security in Hawaii and heightened hostility toward Japanese Americans there. In January, Fujitani and his fellow guards "were told that we were going to be inactivated." Rumor had it that they were being cast aside because they "looked like the enemy." Their suspicions were confirmed when the Hawaiian Territorial Guard was reactivated a short time later without them. Although most Japanese Americans in Hawaii remained free, more than a thousand people were arrested as suspected enemy sympathizers. Many of them were Isei (U.S. residents born in Japan) who clung to the traditions of their ancestral land by teaching Japanese or preaching Buddhism. Others of Japanese birth or heritage in Hawaii had their homes searched and their shortwave radios removed or disabled to prevent them from receiving broadcasts from Tokyo. Collectively, they faced hostility and humiliation that few German Americans or Italian Americans with ancestral ties to Axis countries experienced.

Desperate to prove their loyalty, Fujitani and other Nisei at the University of Hawaii formed a group called the Varsity Victory Volunteers and appealed to Lt. Gen. Delos Emmons, the new Army commander at Pearl Harbor and military governor of Hawaii, which was now under martial law. "Hawaii is our home, the United States is our country," they wrote Emmons. "We know but one loyalty and that is to the Stars and Stripes. We wish to do our part as loyal Americans in every way possible and we hereby offer ourselves for whatever service you may see fit to use us." In February 1942, they were assigned to the Army Corps of Engineers as a volunteer labor battalion. They carried no weapons and wielded only hammers, picks, and shovels as they quarried rocks, dug ditches, and built roads and barracks. It was dirty, thankless work, but most of them stuck with it. One exception was Fujitani, who resigned in April after learning that his father, a Buddhist minister, had been arrested. "I've been a pretty good American," he thought. "Why should they take my dad? . . . I decided, well, I am not going to cooperate anymore . . . I sort of lost my feeling for America." Unpaid as a

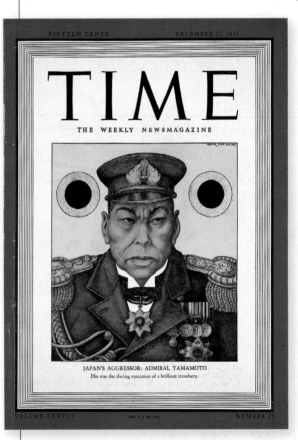

Face of the Enemy This grim portrait of Japanese admiral Isoroku Yamamoto, by artist Arthur Szyk, appeared on the cover of *Time* on December 22, 1941, two weeks after the attack on Pearl Harbor, which Yamamoto masterminded.

volunteer, he went to work to support his mother and siblings but later served in the U.S. Military Intelligence Service as a translator in occupied Japanese territory.

The Varsity Victory Volunteers were ultimately rewarded for their efforts. They and other Nisei in Hawaii formed the nucleus of the 442nd Regimental Combat Team, organized in early 1943 when the U.S. Army began inducting Japanese Americans as soldiers. Some of them went directly from internment camps to Army training camps. Others like Daniel Inouye who were not interned jumped at the chance to fight for their country. He had recently enrolled as a premedical student at the University of Hawaii when the ROTC commander addressed Nisei in the auditorium there and informed them that they were eligible to enlist. The officer later told Inouye "that he had a little pep talk all prepared for us, how we now had a chance to do our duty as patriotic Americans, but it was about as necessary as telling those Navy gunners on December 7 to open fire." They burst from the hall and ran to the draft board three miles away. Some who volunteered that day later died in action. Others, like Inouye, were severely wounded and carried the scars of battle with them ever after as living proof that they were neither enemies nor aliens but true Americans, more faithful to their country than their country had been to them.

REVIVING THE FLEET

Tell Nimitz to get the hell out to Pearl and stay there until the war is won." With those words, Franklin Roosevelt entrusted the battered Pacific Fleet to Adm. Chester Nimitz. He had never commanded a ship in battle, but there was no one better suited to restore confidence to officers haunted by the disastrous events of December 7. A mortifying mishap early in his career—when as a 23-year-old ensign in 1908 he took command of a destroyer and ran it aground—taught Nimitz to cope with failure and use it as an incentive to improve and excel. When he arrived at Pearl Harbor a few weeks after the attack there, he commiserated with the commander he was sent to replace, Adm. Husband Kimmel, and assured him: "The same thing could have happened to anybody." Kimmel would soon be dismissed from the Navy for dereliction of duty, but Nimitz did not blame him or his aides for America's collective failure to prepare for war in the Pacific. Staff officers who expected to be sacked by the new fleet commander were stunned when he told them that they had been assigned to Pearl Harbor because they were first-rate and he still considered them so. He would try to accommodate those who wished to leave, but he hoped to preserve continuity and there were some officers he would insist on keeping.

No one was more surprised or heartened by Nimitz's words than Lt. Cmdr. Edwin Layton, Kimmel's chief intelligence officer. Layton felt that he had let Kimmel down and assumed that he would be let go by his successor. But failure to foresee the enemy's first strike made Layton all the more determined to anticipate his next move, and Nimitz kept him on. He proved so valuable that Nimitz later denied his request for duty at sea. "You can kill more enemy working at your desk," Nimitz told him, "than if you commanded a division of cruisers."

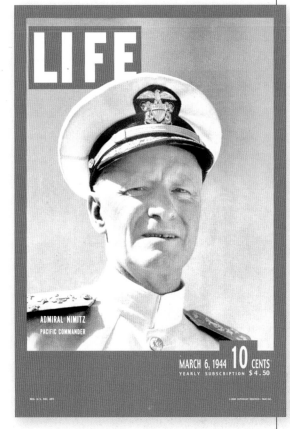

Fleet Commander Appointed commander in chief of the Pacific Fleet shortly after the Pearl Harbor disaster, Adm. Chester Nimitz, shown here on the cover of *Life* in 1944, struck back at Japan in the Battle of the Coral Sea and the pivotal Battle of Midway.

Eavesdropping on the Enemy

At Pearl Harbor, the task of obtaining vital intelligence on the Japanese fleet fell to Station Hypo, which monitored and analyzed radio messages that were enciphered by the Japanese and broadcast as groups of numbers in Morse code. Radio listeners transcribed those cryptic numbers and passed them along to Station Hypo's combat intelligence unit, whose assignment was to break JN-25, the Japanese Imperial Navy's operational code. Overseeing that daunting task was Lt. Cmdr. Joseph Rochefort, a seasoned cryptanalyst fluent in Japanese who assembled a dedicated team of code breakers, mathematicians, linguists, and traffic analysts (specialists who used various techniques to determine the origin and destination of a message). A sign above the desk of one staff member summed up the nerve-racking nature of their efforts: "You don't have to be crazy to work here, but it helps."

Rather than relying on mechanical coding machines, the Imperial Navy used printed codebooks and cipher tables. The JN-25 codebook consisted of more than 30,000 five-digit numbers, each representing a word, phrase, letter, or numeral. To disguise the codes for frequently repeated words such as "battleship" or "attack," each five-digit code number in a message was altered by adding on a different five-digit number from the cipher table, which had 100,000 possible combinations. The sender then transmitted the message along with a numerical key, indicating the location of the cipher numbers in the table. To decipher the message, the officer receiving it used an identical cipher table and codebook to reverse the process. This system should have been unbreakable,

JAPANESE CODE JN-25	
The Japanese Imperial Navy used codebooks filled with five-digit numbers representing words such as those below. The code numbers shown here were then altered using a cipher table, so that when a word appeared a second time in the message, it was represented by a different five-digit number.	
attack (ing, ed)	73428
battleship (s)	29781
cruiser (s)	58797
destroyer (s)	36549
enemy	38754

but it had flaws. The Imperial Navy often used the same codebooks and cipher tables for several months before distributing new ones to its far-flung fleet. Before those changes were made, telltale repetitions occurred. Some careless operators used the same sequence of numbers from the cipher table time and again. Rochefort's team employed mathematical analysis, assisted by punch-card tabulating machines, to look for such

repetitions, strip away the cipher numbers, and reveal the underlying five-digit codes.

Clues to the meaning of frequently repeated code numbers were provided by traffic analysis. Using radio direction finders in two locations, traffic analysts could triangulate readings and determine the location of a ship, which might then be identified by reconnaissance aircraft. Japanese ships could also be distinguished by the idiosyncrasies of their telegraphers. One telegrapher aboard the aircraft carrier *Akagi*, for example, pressed the key so hard it sounded like he was hitting it with his foot. Knowing which ship was sending a message and its location helped Rochefort's team decode routine information such as the ship's name and coordinates. That in turn helped them decode other details of vital significance such as a ship's destination and when it would arrive there. By April 1942, the combat intelligence unit was able to read about a third of the JN-25 code words and make educated guesses about Japanese naval plans.

The big breakthrough came in May 1942 when the team decoded references to a major operation whose objective was designated "AF." Rochefort and Capt. Edwin Layton, Admiral Nimitz's chief intelligence officer, concluded that "AF" stood for Midway Island. To make sure, Layton instructed the base commander at Midway to send an uncoded message stating that the island's water-distillation plant had failed and fresh water was needed. A short time later, Rochefort's team decoded a Japanese message stating that "AF is short of water." Nimitz then sent the bulk of his fleet to Midway to intercept Japanese carriers bearing down on that island. ∎

Covert Cryptanalyst Joseph Rochefort led the Navy's team of code breakers at Pearl Harbor who deciphered Japanese intentions at Midway—a top-secret coup that went largely unrecognized for decades.

Indeed, intelligence was the secret weapon that allowed Nimitz to risk battle against a Japanese fleet far larger than his own. He was less concerned by the severe damage done on December 7 to the Pacific Fleet's battleships, which were old and slow, than by the fact that he had just three aircraft carriers to contend with seven big Japanese carriers and four smaller ones. Only by knowing where those carriers were and where they were headed could he gain the advantage of surprise and lessen the odds against his fleet. Using aerial reconnaissance alone to search for enemy warships across the vast Pacific was like seeking needles in a haystack. More effective were the techniques employed by Layton, who had studied in Japan and understood the language, methods, and mentality of Japanese officers. The task he performed for Nimitz was to read the enemy's mind.

Layton did not practice telepathy. His conclusions were based largely on briefings he received from Lt. Cmdr. Joseph Rochefort, who had studied with him in Japan and ran Pearl Harbor's secret combat intelligence unit, locked behind steel doors in a windowless basement. Listeners there at Station Hypo and elsewhere transcribed Japanese naval radio signals and code breakers analyzed them with the help of IBM tabulators that were forerunners of the first electronic computers, designed for military use later in the war. Unlike Japanese diplomatic communications—enciphered using a machine that the U.S. Army's Signal Intelligence Service had succeeded in duplicating—Japanese naval communications were enciphered the old-fashioned way, using codebooks and cipher tables that were changed periodically to frustrate enemy cryptanalysts. One such change had occurred shortly before the December 7 attack, and the Japanese strike force had taken extra precautions by observing radio silence. Like Nimitz, Rochefort did not blame his staff for failing to detect that assault. Forget about it, he told them, "and get on with the job!" Bolstered by fresh recruits—including band members from the sunken battleship *California* whose musical training suited them well for code breaking—they worked 12-hour shifts seven days a week. Rochefort lived like a troll, seldom emerging from the unit's cramped, subterranean office. "For weeks the only sleep he got was on a field cot pushed into a crowded corner," wrote one aide. "Always nearly fully dressed, he was ready at a moment's notice to roll out and jump into carpet slippers and an old, red smoking jacket."

He and his team were helped by the fact that the Japanese grew more confident and less careful in early 1942 as their stunning early triumphs instilled in them what they later called "victory disease." Changing codebooks was not easily done once their navy was widely dispersed in wartime, and so they relied on the same codes for months on end. That allowed Rochefort's team to detect patterns and begin unlocking the hidden content of those messages. It was a slow process of trial and error. When Admiral Nimitz first visited Rochefort and his team in January 1942, they could read only about 10 or 15 percent of any given message—not enough to reveal enemy plans. Within a few months, however, they would double their capacity to read those messages, and Nimitz would come to rely mightily on intelligence provided by Rochefort, whose goal was "to tell the commander in chief today what the enemy is going to do tomorrow."

Seeking Vengeance America's determination to avenge December 7—signaled by this poster published by the U.S. Office of War Information in 1942—was especially strong among men of the Pacific Fleet, who took the attack on Pearl Harbor personally.

"You can kill more enemy working at your desk than if you commanded a division of cruisers."

Adm. Chester Nimitz to intelligence officer Lt. Cmdr. Edwin Layton

Until his cryptanalysts achieved that goal, any offensive operations Nimitz conducted with his few aircraft carriers risked exposing them to a superior fleet whose movements he could not yet anticipate. At first, all he dared attempt was hit-and-run raids on enemy bases on the Marshall Islands and other targets at the outskirts of the Japanese-occupied zone, which embraced roughly the western half of the Pacific Ocean. American newspapers touted those attacks as revenge for Pearl Harbor, but Nimitz and his staff knew better. As one officer who took part in the raids remarked, "The Japs don't mind them any more than a dog minds a flea." One thing they *would* mind and find shocking was a carrier-launched air strike on Tokyo. When that option was first proposed, Nimitz rejected it as too risky because his bombers had a range of only about 300 miles, and any carrier that got close enough to Japan to launch and retrieve those aircraft would likely be spotted and sunk. Lt. Col. James Doolittle of the U.S. Army Air Forces overcame that objection, however, by training pilots to take off from an aircraft carrier in B-25 bombers, which had a range of nearly 1,200 miles. They were too heavy to land on a carrier, but Doolittle, who would lead the raid himself, hoped to reach China after the attack and find refuge among friendly forces fighting the Japanese invaders there.

Assigned to haul the 16 B-25s and their crews to within range of Tokyo was the U.S.S. *Hornet,* a new flattop due to join the Pacific Fleet along with the U.S.S. *Yorktown,* transferred from the Atlantic Fleet. With five carriers, Nimitz would have been greatly strengthened, but he lost the recently overhauled *Saratoga* when it was

Doolittle's Raiders **In a group portrait taken aboard the U.S.S.** *Hornet,* **Lt. Col. James Doolittle stands at left beside the carrier's commanding officer, Capt. Marc Mitscher, surrounded by bomber pilots and crewmen who would soon launch a daring raid on Tokyo, carrying 500-pound bombs like that in the foreground. At bottom, sailors watch as one of 16 B-25B Mitchell bombers involved in the Doolittle Raid takes off from the** *Hornet* **on the morning of April 18, 1942.**

"Before we're through with them, the Japanese language will be spoken only in hell."

VICE ADM. WILLIAM "BULL" HALSEY

torpedoed by a Japanese submarine and returned to the West Coast for repairs. And he would have to commit a second carrier to the risky Doolittle raid because the heavily loaded *Hornet* had no room for the fighters or reconnaissance aircraft needed to guard against an attack. To escort the *Hornet,* Nimitz chose the *Enterprise* and its pugnacious captain, Vice Adm. William "Bull" Halsey, who made no secret of his hatred for the enemy. "Before we're through with them," he remarked, "the Japanese language will be spoken only in hell."

On April 18, Doolittle and his airmen took off from the deck of the *Hornet* in rough seas 670 miles from Tokyo and embarked on what Halsey called one of the "most courageous deeds in military history." The odds against them appeared steep, but they achieved complete surprise and dropped their payloads on military targets in and around Tokyo before continuing on. One crew landed in Vladivostok, where Russian authorities who were now officially their allies detained them for more than a year before they escaped. The rest reached China as planned, where they crash-landed or bailed out. Doolittle and 70 others found shelter among friendly Chinese and survived. Nine airmen were captured by the Japanese, who executed three of them in flagrant violation of the Geneva Convention, which war leaders in Tokyo refused to recognize even though it protected their own prisoners taken by the Allies.

Japanese authorities dismissed the attack on Tokyo as trivial and issued statements in English mocking it as the "do-little" or "do-nothing" raid. In truth, they were stung by the assault. "Even though there wasn't much damage," declared fleet commander Adm. Isoroku Yamamoto, "it is a disgrace that the skies of the Imperial capital should have been defiled without a single enemy plane being shot down." The Doolittle Raid lent impetus to a sprawling new offensive proposed by Yamamoto, which called for attacks on American bases on the Aleutian Islands and on Midway Island, situated some 1,300 miles northwest of Honolulu and that much closer to Tokyo. Yamamoto's objective was to extend Japan's defensive perimeter in the Pacific—and perhaps lure the American carriers into a decisive battle against his larger force.

By late April, Nimitz had a rough idea of Japanese intentions, thanks to advances by Rochefort's team, aided by another combat intelligence unit in Australia. He knew that Yamamoto was preparing for a big push in the mid-Pacific, although just where he would attack was not yet clear. Nimitz also learned that three of Yamamoto's flattops—the light carrier *Shoho* and the big carriers *Shokaku* and *Zuikaku*—had recently been detached from the fleet to conduct a separate offensive against Port Moresby, New Guinea, situated dangerously close to Australia. If the Japanese seized that port, they could sever the maritime

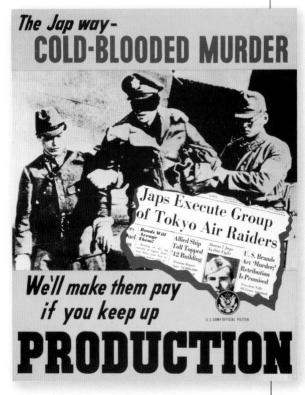

Captives' Plight A 1943 poster urging American workers to keep up war production shows Lt. Robert Hite in Japanese custody after the Doolittle Raid. Hite, copilot of a B-25 dubbed *Bat Out of Hell,* landed in China and was captured and imprisoned in Shanghai, where three of his fellow POWs were executed. Hite survived and was liberated at war's end.

supply line between the U.S. and Australia and bottle up MacArthur's forces there. Nimitz dispatched a task force led by the carriers *Lexington* and *Yorktown* to meet that threat in the Coral Sea, knowing as he did so that if they were lost in action he would have little chance of repelling Yamamoto's main thrust.

The Battle of the Coral Sea was unprecedented. For the first time, a naval contest was decided by aircraft launched from opposing warships that never came within sight of each other. On May 7, dive-bombers and torpedo planes launched from the *Yorktown* and *Lexington* scored the first coup in this new form of combat by sinking the *Shoho.* "Scratch one flattop!" radioed a jubilant American squadron leader, Lt. Cmdr. Robert Dixon, as the ship foundered. In carrier warfare, hunters who make a kill announce their presence to the enemy and often become the hunted. Such was the case in this battle, which intensified on May 8 when warplanes from the *Shokaku* and *Zuikaku* swooped down on their prey, damaging the *Yorktown* and rupturing the fuel lines of the *Lexington,* which exploded and sank that evening after its crew was rescued by other ships in the task force. As the battle drew to a close, the *Shokaku* was hit as well, and the *Zuikako* lost so many pilots that both Japanese carriers were

Fatal Blast Above, the aircraft carrier *Lexington* is rocked by a massive explosion resulting from Japanese air strikes on May 8, 1942, the last day of the Battle of the Coral Sea. The force of the blast hurled aircraft off the flight deck, one of which is silhouetted against the fireball. The map at right shows where the *Lexington* and other ships stricken during the battle went down, including the U.S.S. *Neosho,* an oil tanker servicing the Pacific Fleet; its escort, the destroyer U.S.S. *Sims;* and the Japanese aircraft carrier *Shoho.* Not shown are other ships engaged in the battle, including the Japanese carriers *Shokaku* and *Zuikaku,* which were put out of action for months, and the carrier U.S.S. *Yorktown,* which was repaired in time to take part in the Battle of Midway.

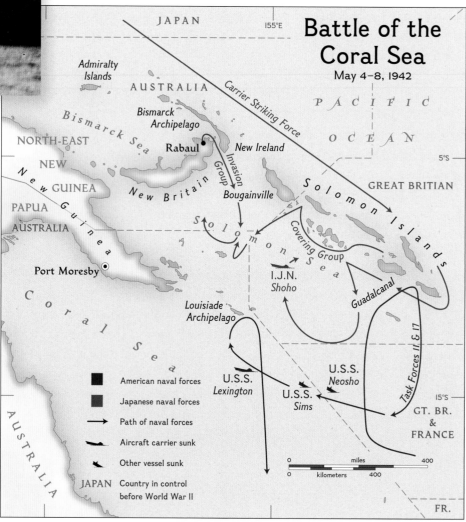

Battle of the Coral Sea
May 4–8, 1942

JAPAN 155°E
Admiralty Islands
AUSTRALIA
Bismarck Archipelago
Bismarck Sea
NORTH-EAST
NEW
Rabaul
New Ireland
NEW GUINEA
PAPUA
New Guinea
New Britain
AUSTRALIA
Bougainville
Port Moresby
Solomon
Coral Sea
Louisiade Archipelago
AUSTRALIA
PACIFIC OCEAN
5°S
GREAT BRITIAN
Solomon Islands
Carrier Striking Force
Invasion Group
Covering Group
Solomon Sea
Guadalcanal
I.J.N. Shoho
Task Forces 11 & 17
15°S
GT. BR. & FRANCE
U.S.S. Neosho
U.S.S. Lexington
U.S.S. Sims
FR.

■ American naval forces
■ Japanese naval forces
→ Path of naval forces
⬎ Aircraft carrier sunk
⬎ Other vessel sunk
JAPAN Country in control before World War II

0 miles 400
0 kilometers 400

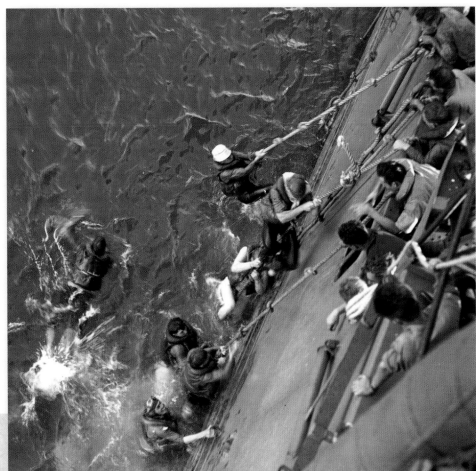

"Scratch one flattop!"

Lt. Cmdr. Robert Dixon,
after the sinking of the *Shoho*

Lost and Found Below, crewmen abandon the burning U.S.S. *Lexington* by scrambling down ropes on the afternoon of May 8. At left, survivors wearing life vests are pulled aboard the cruiser U.S.S. *Minneapolis,* one of several ships of the task force involved in the rescue effort, which saved most of the *Lexington*'s crew.

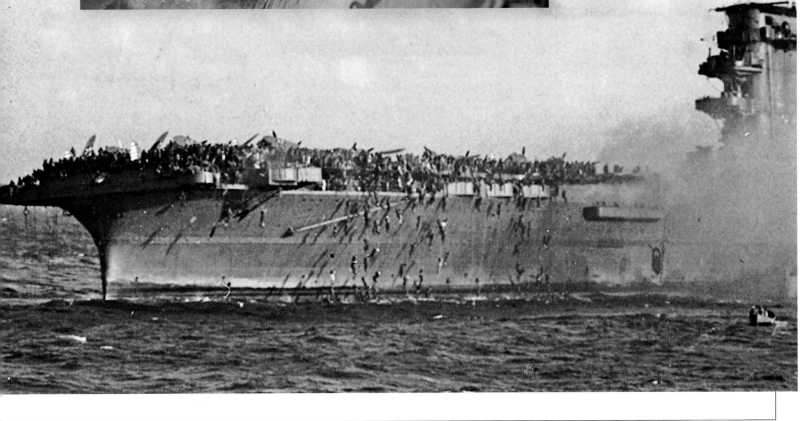

ARTFUL WARNINGS TO SEAL LOOSE LIPS

To keep Americans from disclosing secrets to spies, the U.S. Office of War Information distributed posters warning of the consequences of careless talk. Produced by leading graphic artists, they were designed to catch viewers' eyes and seal their lips. Some were considered too artistic by critics, who cited a survey in which factory workers thought the poster entitled "He's Watching You," showing a helmeted Nazi, referred to their boss. But most people heeded these warnings and got the message. ■

put out of action for months, easing the threat to Port Moresby and depriving Yamamoto of two large carriers he was counting on for his main offensive.

In late May, the battered *Yorktown* entered Pearl Harbor, trailing a long slick of oil caused by a bomb that detonated deep in its hull. The crew had been at sea for three months and was looking forward to extended shore leave while the carrier underwent repairs, which would surely take weeks. But when Nimitz inspected the damage, he told the officers in charge of the task: "We must have this ship back in three days." The tone of his voice made it clear to them that something big was up—and that there could be only one response to his seemingly impossible demand: "Yes, sir."

DESTINATION MIDWAY

Confidence ran high as Admiral Yamamoto's fleet set out on May 28, 1942, to complete the task left unfinished on December 7, 1941. Yamamoto fully expected that the U.S. Pacific Fleet would come out to defend Midway with its aircraft carriers, whose absence at Pearl Harbor on the first day of the Pacific war had enabled his foes to keep up the fight. His plan designated June 7, 1942—precisely six months after that opening attack—as N-Day, the date on which Midway would be invaded and his fleet would be poised to achieve a decisive victory. Yamamoto did not take the Americans lightly. The closely fought Battle of the Coral Sea demonstrated that they could hold their own in a contest where the two sides were of roughly equal strength. But even after the losses his fleet suffered there, Yamamoto had eight operational aircraft carriers to contend with just three opposing flattops, including the damaged *Yorktown.* He had far more cruisers and destroyers than his foe and could deploy more than a dozen battleships, while Nimitz had not one that was fit to fight. As Capt. Yoshikawa Miwa wrote in his diary at sea on May 31: "Everybody in the fleet from its head down to the men entertains not the least doubt about a victory."

What Yamamoto and his forces did not anticipate was that the great advantage of surprise, which had been theirs in December, would be seized by their opponents. Nimitz's situation as battle loomed was the opposite of his predecessor's six months earlier. Kimmel had been utterly in the dark as to the movements and intentions of the enemy, but Nimitz had intelligence that cast a floodlight on Yamamoto's plan and exposed it in sharp detail. During the last week of May, he received precise forecasts from Rochefort and Layton, who informed him that the Japanese would commence attacks on the Aleutians on June 3 and begin blasting Midway with carrier-launched bombers on June 4 in preparation for an invasion. On the basis of the latest intercepts, Layton predicted that those carriers would approach from the northwest at a bearing of 315 degrees and would be 175 miles from Midway at 6 a.m. on June 4.

Skeptics considered those startling revelations too good to be true. Officers who knew of Rochefort's code-breaking operation worried that the Japanese were sending out false signals to divert the Pacific Fleet and disguise what could be another attack on Pearl Harbor. Others figured that such secrets could come only from a spy in Japan, peddling material that might be bogus or genuine. "That man of ours in Tokyo is worth every cent we pay him," remarked an officer aboard the *Enterprise,* which returned to Pearl Harbor

> **"Everybody in the fleet from its head down to the men entertains not the least doubt about a victory."**
>
> CAPT. YOSHIKAWA MIWA, BEFORE THE BATTLE OF MIDWAY

on May 26, around the same time as the *Yorktown*. Nimitz put great trust in the intelligence he received and saw flaws in Yamamoto's plan to exploit. By committing two aircraft carriers and other warships to the Aleutian offensive, which Nimitz recognized as a diversion, Yamamoto was dispersing his forces across a wide area. Furthermore, his plan assumed that Nimitz would not dispatch his carriers from Pearl Harbor until Midway came under assault on June 4. If, however, they were lurking nearby when that attack began, their air squadrons might surprise Japanese carriers while they were engaged in offensive operations against Midway.

By May 28, Nimitz was ready to implement his own plan. He dispatched some cruisers and destroyers to defend the Aleutians, but reserved the rest for two carrier task forces bound for Midway. One, which left Pearl Harbor that day, included the *Hornet* and was led by its escort the *Enterprise,* whose commander, Admiral Halsey, had been hospitalized and replaced by Rear Adm. Raymond Spruance, an officer as cool and calm as Halsey was fiery. Nimitz likened Spruance to the imperturbable Ulysses S. Grant, noting that he "thought things through very carefully . . . and then when he decided to strike, struck hard."

The other task force was led by Rear Adm. Frank Fletcher, who sailed with Capt. Elliott Buckmaster aboard the *Yorktown,* which departed on May 30 after 72 hours of frantic repair

Diversion in the North Smoke rises from a damaged merchant ship in Dutch Harbor, on Unalaska Island in the Aleutians, after an air raid by Japanese carrier-based warplanes on June 3, 1942. The raids and subsequent landings in the Aleutian Islands (U.S. possessions within Alaska) were carried out by Rear Adm. Kakuji Kakuta's light carrier strike force as a diversion to screen the Japanese attack on Midway. The fighting knife patch *(inset)* was worn by members of the Kiska Task Force, consisting of American and Canadian troops who reclaimed Kiska and Attu Islands in 1943.

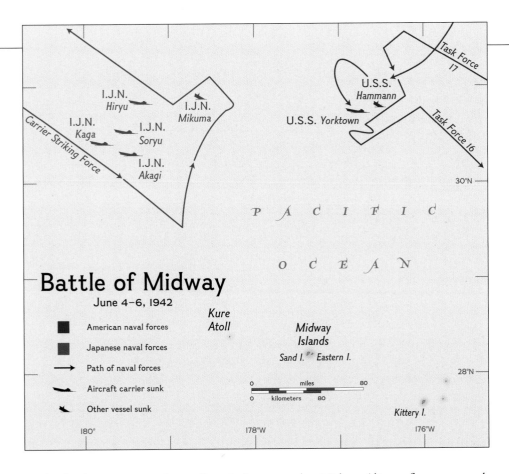

Battle of Midway
June 4–6, 1942

- ■ American naval forces
- ■ Japanese naval forces
- → Path of naval forces
- ⌁ Aircraft carrier sunk
- ⌁ Other vessel sunk

Carrier Striking Force

I.J.N. *Hiryu*
I.J.N. *Kaga*
I.J.N. *Soryu*
I.J.N. *Akagi*
I.J.N. *Mikuma*

U.S.S. *Hammann*
U.S.S. *Yorktown*

Task Force 17
Task Force 16

PACIFIC OCEAN

Kure Atoll

Midway Islands
Sand I. Eastern I.

Kittery I.

0 — miles — 80
0 — kilometers — 80

30°N
28°N
180° 178°W 176°W

Turning Point in the Pacific **Beginning** on June 4, 1942, American and Japanese naval forces clashed in the pivotal Battle of Midway, shown on this map charting the losses suffered by both sides. The opposing fleets launched air strikes that cost Japan four big carriers—*Akagi, Kaga, Hiryu,* and *Soryu*—with the loss of only one American carrier, U.S.S. *Yorktown.* On June 6, the last day of the battle, a Japanese submarine finished off the stricken *Yorktown* and sank one of its escorts, U.S.S. *Hammann,* while U.S. Navy pilots attacked and sank the Japanese cruiser *Mikuma.*

work. Fletcher was assigned overall tactical command at Midway (distant fleet commanders like Nimitz had to delegate that authority to a trusted subordinate destined for battle). Some in Washington thought Fletcher unequal to the task and faulted him for the loss of the *Lexington,* but Nimitz gave him a fair hearing when he returned from the Coral Sea and concluded that he had shown "superior judgment." Nimitz saw the *Yorktown* off and wished Fletcher and crew "good luck and good hunting." By June 2, the two task forces had linked up northeast of Midway, ready to pounce on the approaching Japanese carriers.

Early on June 3, an American base at Dutch Harbor in the Aleutians came under attack. Nimitz was pleased to learn that Yamamoto's offensive was unfolding as anticipated. Although Japanese forces would succeed in occupying a few islands at the far end of the Aleutian chain, they were strategically insignificant compared with Midway, where Nimitz had positioned the bulk of his fleet. Around six the following morning, a Catalina PBY scout plane spotted Japanese carriers and other warships approaching Midway from the northwest at a bearing of 320 degrees and a distance of 180 miles. "Well," Nimitz told Layton, "you were only five miles, five degrees, and five minutes off."

The approaching armada was Yamamoto's First Carrier Striking Force, commanded by Vice Adm. Chuichi Nagumo, who had unleashed the attack on Pearl Harbor. This force was similar to Nagumo's earlier one, with a crucial exception: Rather than six carriers, Nagumo now had just four—his flagship *Akagi,* along with the *Kaga, Hiryu,* and *Soryu.* Awaiting them were the three U.S. carriers as well as several squadrons of fighters and bombers on Midway, which Nimitz had reinforced in recent weeks and planned to use, in effect, as a fourth carrier from which strikes would be launched. With part of Yamamoto's fleet up north attacking the Aleutians and other parts off to the south and west, Nagumo was on his own

"Good luck and good hunting."

Adm. Chester Nimitz,
before the Battle of Midway

for now. Armed with accurate intelligence, Nimitz had negated Yamamoto's advantage and achieved virtual parity with the enemy at Midway. His forces were determined to avoid a repetition of the disaster on December 7—and make June 4, 1942, a day that would live in infamy for Japan.

A Decisive Battle

This time, there would be no American warplanes caught on the ground. Anticipating an attack, the airmen at Midway were up well before dawn and ready for takeoff when radar detected incoming planes from Nagumo's carriers and the siren sounded. By 6:15 a.m., they were all aloft and the airstrip was clear. Advance warning gave them a fighting chance, but they were ill equipped to contend with their Japanese foes. Many of the fighter pilots on Midway were flying stodgy Brewster F2A-3 Buffalos, nicknamed "Flying Coffins." Within a matter of minutes, they came up against swift, agile Mitsubishi Zeros and were thoroughly outclassed. More than a dozen Buffalos were gunned down in the ensuing dogfight. Capt. Herbert Merrill, who bailed out and survived, offered a scathing assessment afterward. "The F2A-3 is *not* a combat aeroplane," he wrote. The Zero could run circles around it, and any commander who sent a Buffalo out to fight "should consider the pilot as lost before leaving the ground."

Shielded by the Zeros, most of the Japanese bombers reached Midway unscathed, but the pilots were disappointed to find the airstrip bare. They set oil tanks ablaze and blasted hangars, barracks, and a power station but did little damage to the runway or Midway's big guns. Around 7 a.m., Lt. Joichi Tomonaga ordered the raiders back to their carriers and signaled Nagumo: "There is need of a second attack wave." Nagumo was considering whether to launch that second attack when bombers from Midway appeared on the horizon. He had no radar to warn of such raids, but his carriers were well shielded. Zeros prowled the skies above while battleships, cruisers, and destroyers guarded the perimeter and peppered the incoming torpedo planes with flak. "Black bursts of antiaircraft fire blossomed all around them, but none of the raiders went down," observed Cmdr. Mitsuo Fuchida, who had hoped to lead the first wave today as he did on December 7 but had fallen ill. "As *Akagi's* guns commenced firing," he added, "Zeros braved our own antiaircraft fire and dove down on the Americans," destroying three of those planes. Others released their torpedoes before crashing or darting off, but none of the weapons hit home. The greatest threat to Nagumo's flagship, Fuchida recalled, came from a stricken B-26 bomber that flew "straight over the *Akagi*, from starboard to port, nearly grazing the bridge" before bursting into flames. The doomed pilot may have been trying to hit the carrier. His heroism impressed his foes and

Headgear This flight mechanic's cap was typical of that worn by sailors in the Japanese Imperial Navy.

"Zeros braved our own antiaircraft fire and dove down on the Americans."

Cmdr. Mitsuo Fuchida, at the Battle of Midway

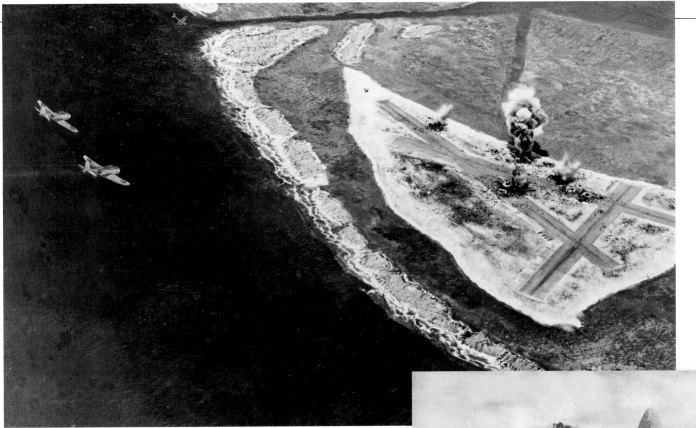

caused Nagumo's chief of staff to offer a silent prayer for him as he plunged into the sea.

The attack convinced Nagumo to launch a second wave of warplanes against Midway. Those aircraft were meant to carry torpedoes against enemy warships, but would be rearmed with bombs instead. At 8:30, after repelling further attacks by bombers from Midway, Nagumo learned that at least one enemy carrier had been sighted by aerial reconnaissance. He faced an agonizing decision. His second wave was ready to attack Midway, but the American carrier force was now his primary target. He could send the planes his mechanics had fitted with bombs against those ships, but they would be more effective with torpedoes, for which they were designed. In addition, they would have to proceed without fighter escorts, because Nagumo's Zeros had been aloft for hours and needed to land and refuel—as did the warplanes of the first wave returning from Midway. Nagumo decided to clear the decks for those landings by lowering the planes that were about to take off to the hangar deck below, where they would be rearmed with torpedoes for a concerted assault on the enemy carrier force.

"Nagumo's reasoning was logical enough," Fuchida wrote afterward, but his decision ignored the crucial time factor, which favored commanders who were "quicker to act boldly and decisively to meet unforeseen developments." That advantage went to Admirals Fletcher and Spruance, who acted swiftly and surely while Nagumo proceeded as if his foes would allow him all the time he needed to reconfigure his attack.

At about six that morning, Fletcher had received a message from a scout plane, which reported spotting two Japanese carriers northwest of Midway. He promptly signaled Spruance to pursue them with the *Enterprise* and *Hornet:* "Proceed southwesterly and attack

Zeroing In The realistic photograph at top, produced using a diorama created by industrial designer Norman Bel Geddes for the U.S. Navy, depicts Japanese warplanes attacking Midway's Eastern Island airfield on the morning of June 4, 1942. Japanese Navy Model 21 Zeros, like the one shown above, taking off from the carrier *Akagi*, were the principal fighters deployed against American forces at Midway.

LT. COMMANDER C. WADE MCCLUSKY
DESTRUCTION OF THE *KAGA* AND *AKAGI*

*McClusky led two squadrons of aircraft, Scouting Squadron Six and Bombing Squadron Six,
from the U.S.S.* Enterprise *in a devastating attack on the Japanese carrier force at Midway on June 4.*

Peering through my binoculars which were practically glued to my eyes, I saw dead ahead about 35 miles distant the welcome sight of the Jap carrier striking force...I then broke radio silence and reported the contact to the *Enterprise*. Immediately thereafter I gave attack instructions to my group. Figuring that possibly the *Hornet* group commander would make the same decision that I had, it seemed best to concentrate my two squadrons on two carriers...Picking the two nearest carriers in the line of approach, I ordered Scouting Six to follow my section in attacking the carrier on the immediate left and Bombing Six to take the right-hand carrier. These two carriers were the largest in the formation and later were determined to be the *Kaga* and the *Akagi*...It was 1222 [10:22 a.m. local time] when I started the attack, rolling in a half-roll and coming to a steep 70 degree dive. About halfway down, anti-aircraft fire began booming around us— our approach being a complete surprise up to that point. As we neared the bomb-dropping point, another stroke of luck met our eyes. Both enemy carriers had their decks full of planes which had just returned from the attack on Midway... the planes on deck were being refueled and rearmed for an attack on our carriers...

In the meantime, our bombs began to hit home. I leveled off at masthead height, picked the widest opening in their screen and dropped to deck level,

> **"As we neared the bomb-dropping point, another stroke of luck met our eyes. Both enemy carriers had their decks full of planes which had just returned from the attack on Midway."**

Badge of Honor **Wade McClusky,** shown as a captain wearing naval aviator's wings like the badge pictured below, was awarded the Navy Cross for valor at Midway.

figuring any anti-aircraft fire aimed at me would also be aimed at their own ships...With the throttle practically pushed through the instrument panel, I was fortunate in avoiding a contact with death by slight changes of altitude and varying the getaway course to right and left.

It was quick work to figure the return course, and as I raised my head from the plotting board, a stream of tracer bullets started chopping the water around the plane. Almost immediately my gunner, W. G. Chochalousek, in the rear seat, opened fire. Then a Jap Zero zoomed out of range ahead of me. A hurried glance around found another Zero about 1000 feet above, to the left and astern, about to make another attack. Remaining at 20 feet above the water, I waited until the attacking plane was well in his dive, then wrapped my plane in a steep turn toward him...Then ensued about a 5-minute chase, first one Zero attacking from the right, then the second from the left. Each time I would wrap up toward the attacker with Chochalousek keeping up a constant fire. Suddenly a burst from a Jap seemed to envelop the whole plane. The left side of my cockpit was shattered, and I felt my left shoulder had been hit with a sledgehammer. Naturally enough it seemed like the end, we sure were goners. After two or three seconds, I realized there was an unusual quietness except for the purring engine of the old Dauntless. Grasping the inner phone, I yelled to Chochalousek, but no answer. It was difficult to turn with the pain in my left shoulder and arm, but I finally managed and there was the gunner facing aft, guns at the ready and unharmed. He had shot down one of the Zeros...and the other decided to call it quits. ∎

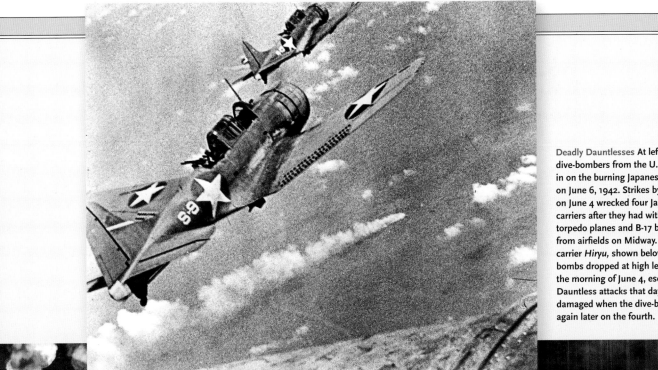

Deadly Dauntlesses At left, SBD Dauntless dive-bombers from the U.S.S. *Hornet* close in on the burning Japanese cruiser *Mikuma* on June 6, 1942. Strikes by Dauntlesses on June 4 wrecked four Japanese aircraft carriers after they had withstood attacks by torpedo planes and B-17 bombers launched from airfields on Midway. The Japanese carrier *Hiryu*, shown below turning to avoid bombs dropped at high levels by B-17s on the morning of June 4, escaped the first Dauntless attacks that day but was fatally damaged when the dive-bombers struck again later on the fourth.

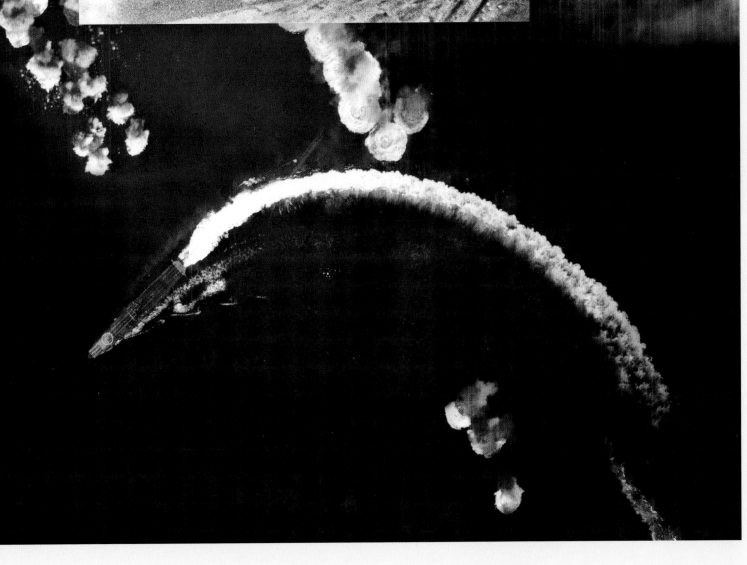

"He went just as straight to the Jap fleet as if he'd had a string tied to them."

LT. GEORGE GAY, SOLE SURVIVOR OF LT. CMDR. JOHN WALDRON'S SQUADRON

enemy carriers when definitely located." Fletcher was waiting for his scout planes to return to the *Yorktown,* and he suspected from intelligence reports that there were more than two enemy carriers nearby. By sending Spruance's task force ahead, he prudently held his own force in reserve until he knew better where those other carriers were and also guarded against an enemy attack that would catch all his flattops together and set them ablaze—a risk that Nagumo ran by bunching his carriers and compounded by pausing to rearm his aircraft before launching them.

Spruance, for his part, wasted no time before clearing his decks. He and his chief of staff, Capt. Miles Browning, figured that the first wave of Japanese attackers would return from Midway to Nagumo's carriers by 9 a.m. "We felt that we had to hit him before he could launch his second attack," Browning remarked, "both to prevent further damage to Midway and to ensure our own safety." Spruance was also keenly aware that if his bombers caught Japanese planes as they were refueling and rearming for another attack, the results would be explosive. That meant launching his aircraft promptly, before his carriers were close enough to their targets to ensure that his heavier, short-range bombers would return safely. Furthermore, the bombers would have little protection, because many of the fighters would

Doomed Heroes This group photograph of the pilots of Torpedo Squadron Eight was taken on the deck of the U.S.S. *Hornet* a month before Lt. Cmdr. John Waldron led the squadron's 15 TBD-1 Devastators against Japanese carriers at Midway. Only Lt. George Gay, front row center, survived.

be held back to shield the carriers, as ordered by Nimitz. He and Spruance were no more eager to send pilots to their death than were Yamamoto and Nagumo. But a fierce resolve, fueled by bitter memories of the attack on Pearl Harbor, drove Americans of all ranks to make fearful sacrifices in pursuit of victory at Midway. One squadron leader on the *Hornet,* Lt. Cmdr. John Waldron, summed up that fighting spirit in a message he delivered to his men the night before the battle: "I want each one of us to do his utmost to destroy our enemies. If there is only one plane left to make a final run-in, I want that man to go in and get a hit."

As it happened, Waldron's squadron of 15 Douglas TBD-1 Devastator torpedo planes was the first from Spruance's task force to attack Nagumo's carriers, intercepting them around 9:20. Other squadrons had lost track of the enemy because Nagumo had altered course to get closer to the opposing warships before launching his strike. Waldron anticipated that move. "He went just as straight to the Jap fleet as if he'd had a string tied to them," recalled Lt. George Gay, who like others in the squadron was entering battle for the first time. Coming in alone, their lumbering, low-flying Devastators made easy targets for Japanese antiaircraft batteries and the recently refueled Zeros. Before long, there was in fact only one plane left, piloted by Gay, who released an errant torpedo at the *Soryu* and then flew right over the carrier. He found himself staring "down the gun barrel of one of those big pom-poms up forward" but managed to remain aloft until Zeros clipped his wing and sent the plane tumbling. Fished out of the sea by friendly forces after the battle as he clung to an inflatable raft, he was the sole survivor of Waldron's squadron.

Such sacrifices were not in vain. The desperate and seemingly futile assaults by torpedo planes from Spruance's task force, 37 of which went down in about an hour, delayed the rearming and refueling of Nagumo's bombers and brought the Zeros down from the lofty heights where they usually patrolled. At 10:20, Nagumo was at last ready to launch his warplanes when a new threat appeared high overhead—squadrons of Douglas SBD Dauntless dive-bombers from the *Enterprise* and *York-town,* launched from that carrier by Fletcher, who had decided to join in the attack.

"One remarkable fact stood out as we approached the diving point," recalled Lt. Cmdr. C. Wade McClusky from the *Enterprise:* "Not a Jap fighter plane was there to molest us." Before the low-flying Zeros could rise to this unforeseen challenge, the rugged Dauntlesses bore down like eagles and released bombs that triggered titanic explosions on carrier decks loaded with planes primed to detonate. Fuchida survived the blasts on the *Akagi,* which left "a huge hole in the flight deck," he wrote. "Planes stood tail-up, belching livid flame and jet-black smoke. Reluctant tears streamed down my cheek as I watched the fires spread."

The *Akagi* was doomed, as were the *Soryu* and *Kaga,* whose surviving crewmen were strug-gling to save the burning ship when the submarine U.S.S. *Nautilus* surfaced and fired three

Savoring Victory **Recuperating at Pearl Harbor Naval Hospital after the Battle of Midway, a smiling George Gay receives news of the Pacific Fleet's smashing victory. Like other American servicemen wounded in action, he received a Purple Heart** *(left).*

LT. JOSEPH POLLARD
ABANDONMENT OF THE U.S.S. *YORKTOWN*

Pollard, a flight surgeon on the U.S.S. Yorktown, *treated the wounded aboard that stricken carrier on June 4 until Capt. Elliott Buckmaster gave the order to abandon ship.*

Battle Dressing Station #1 rapidly overflowed into the passageway, into the parachute loft and into all other available spaces. I called for stretcher bearers to get the more seriously wounded to the sick bay where they could receive plasma, etc., but the passageways had been blocked off due to the bomb hits. So we gave more morphine, covered the patients with blankets, and did the best we could. Many patients went rapidly into shock. All topside lights were out and I never realized that flashlights gave such miserably poor light. There was no smoke in Battle Dressing Station #1, which was fortunate...

I went up to the flight deck... Blood was everywhere. I turned forward and saw great billows of smoke rising from our stack region. We were dead in the water and it suddenly dawned on me how helpless we were lying there...

The fire by this time was discovered to be in the rag locker and was under control. This stopped the billowing column of smoke which gave away our position and made us so susceptible to a second attack. Suddenly, there was a great burst of steam from our stack, then another, and amid cheers from all hands we got underway...

About 1600 [2:00 p.m. local time] our radar picked up enemy planes at 40 to 60 miles coming in fast. We had just begun to gas five F4F-4s that we had succeeded in landing just before the previous attack. Some had only 25 gallons aboard. Nevertheless, they took off post haste. We were just hitting 22 knots but they took a long run and made it off. Just as the last one left the deck I made a dive for Battle Dressing Station #1 and again the AAs [antiaircraft guns] began as before. By the time I could find an unoccupied place on

> **"One torpedo hit had occurred... Then another sickening thud and the good ship shuddered and rapidly listed hard to port. I knew we were completely helpless but did not want to admit it. Just then word came over the speaker, 'Prepare to abandon ship.'"**

the deck there was a sickening thud and rumble throughout the ship and the deck rose under me, trembled and fell away. One torpedo hit had occurred... Then another sickening thud and the good ship shuddered and rapidly listed hard to port. I knew we were completely helpless but did not want to admit it. Just then word came over the speaker, "Prepare to abandon ship."...

We listed more and more to port until it was almost impossible to stand on the slick deck. We searched frantically for life preservers for the wounded, taking some from the dead. Our stretchers had gone below to the sick bay and we had difficulty finding enough for our wounded. All who could possibly walk did so. I went up on the flight deck and walked along the starboard edge being very careful not to slip and skid the width of the ship and off the port side. The ship rolled slowly with the swells but the water was not rough and after each roll she returned to her former position...

The speakers were dead and when word was passed to abandon ship, it did not get to me. Several life rafts were in the water but the lines over the side were not long enough to reach the water. Lieutenant Wilson and I tied some lines together and lowered some wounded. Meanwhile the sick bay wounded were being lowered from the hanger deck. Captain Buckmaster came up and said to abandon ship...

I chose a big line and went over the side. I stopped at the armor belt for a rest. It was at least 75 feet from the deck to the water and I still had some 20 feet to go. I worked along the armor belt to a spot which was immediately above a life raft. The line there was a small one and soon after I started down a corner of my life jacket got inside my grip and I began slipping. The fingers of both my hands were rather badly burned before I realized it. Then I released the line and dropped the remainder of the way into the water and swam through the oil to the raft." ■

Body Blow Surrounded by bursts of antiaircraft fire, the carrier *Yorktown* is struck amidships by the second of two torpedoes fired by aircraft from the Japanese carrier *Hiryu* on June 4, 1942. Hit earlier by Japanese dive-bombers, the *Yorktown* listed heavily after the torpedoes struck, and sailors struggled to maintain balance on the flight deck *(below)*. Fearing the ship would capsize, Captain Buckmaster ordered the *Yorktown* abandoned that afternoon. He returned later with a salvage crew and tried in vain to save the ship, but it went down on June 6 after being torpedoed by a Japanese submarine.

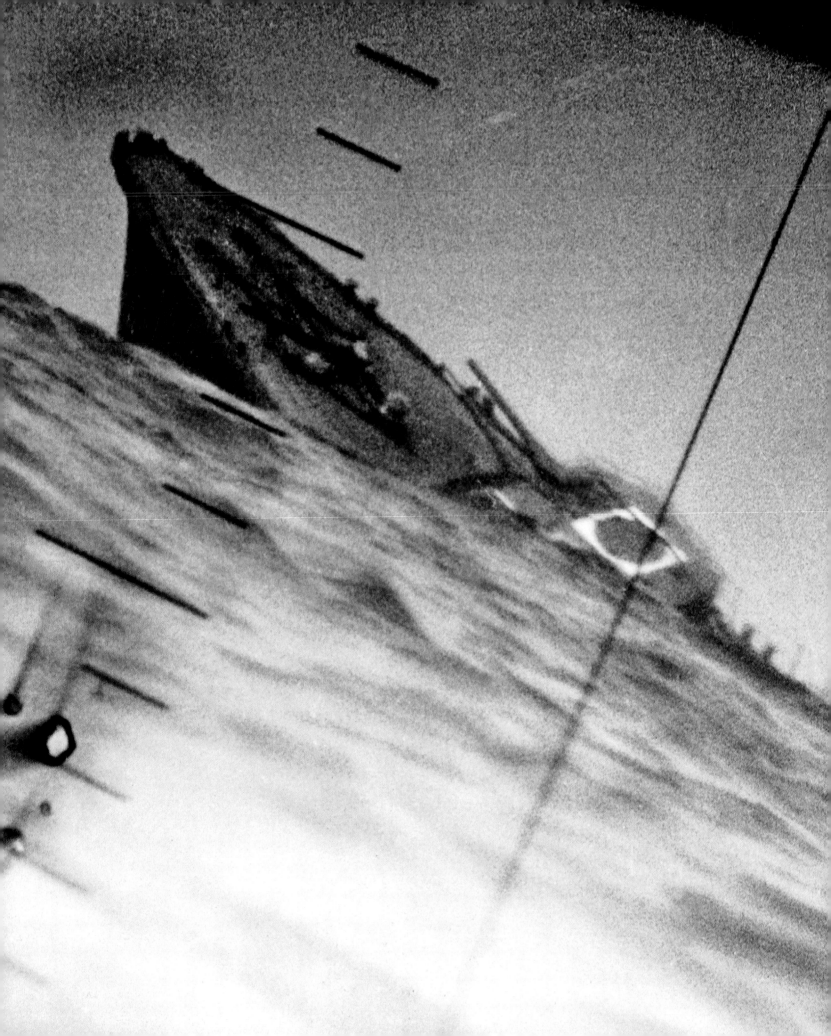

Torpedoed The Japanese destroyer *Yamakaze* goes down, in a photo taken from the submarine U.S.S. *Nautilus*, which sank the ship a few weeks after taking part in the Battle of Midway. Navy submariners like the officer looking through a periscope here took a heavy toll on Japanese ships.

torpedoes, one of which plowed into the carrier but broke apart without detonating. That reprieve allowed the smoldering *Kaga* a few more hours of life before the ship was abandoned and went down. Nagumo's fourth carrier, *Hiryu,* escaped the dive-bombing attack and succeeded in launching its warplanes, which found the *Yorktown* around noon and set it ablaze. Fletcher yielded overall command to Spruance and transferred his flag as task force commander to the cruiser U.S.S. *Astoria.* Captain Buckmaster remained on the *Yorktown,* which was attacked again a few hours later. The carrier eventually sank, but not before its captain and surviving crew had transferred safely to other ships of the task force. A different fate awaited Rear Adm. Tamon Yamaguchi when bombers dispatched by Spruance blasted his surviving carrier, the *Hiryu,* late on June 4 and left it in flames. Yamaguchi chose to go down with his ship. "I have no words to apologize for what has happened," he said in a parting message to Admiral Nagumo, who was dissuaded by staff officers from going down with the *Akagi.* "I only wish for a stronger Japanese Navy—and revenge."

Many Americans felt that they had achieved revenge with their stunning victory at Midway, which forced Yamamoto to withdraw and altered the course of the war in the Pacific. But Nimitz knew how close the battle had been, and how much remained to be done. "Pearl Harbor has now been partially avenged," he declared. "Vengeance will not be complete until Japanese sea power is reduced to impotence . . . Perhaps we will be forgiven if we claim that we are about midway to that objective." Midway was in fact roughly halfway between the West Coast and Japan. But U.S. forces would find the second half of that journey far longer, harder, and bloodier than the first.

> ## "Vengeance will not be complete until Japanese sea power is reduced to impotence."
>
> ADM. CHESTER NIMITZ

W

HEN U.S. TROOPS LANDED IN NORTH AFRICA in November 1942, they were entering an arena that had been hotly contested by Allied and Axis forces for some time. The struggle began there in 1940 when troops of the Italian Tenth Army led by Marshal Rodolfo Graziani crossed from Libya into Egypt, defended by British forces, including men from various British dominions and colonies. Graziani was acting on orders from Mussolini, who hoped to expand Italy's empire in North Africa—which included Libya and Ethiopia—by seizing Egypt and the Suez Canal, Britain's lifeline to Middle Eastern oil and the Far East (see map, page 141). The campaign unfolded in the Western Desert, where extreme temperatures, sandstorms, and sporadic flash floods tested men and machines to the utmost. The one serviceable road ran along the narrow Mediterranean coastal plain, where forces were vulnerable to attack. Inland, a steep escarpment rose to the Libyan Plateau, which could be reached by tanks and trucks at strategic Halfaya Pass, located in Egypt near the Libyan border. ★ On September 13, 1940, Graziani sent 80,000 of his 200,000 troops into Egypt, where they pushed back a British covering force and seized Halfaya Pass before halting at Sidi Barrani, some 65 miles beyond the border. Graziani's supply lines were overextended, and many of his unreliable Fiat-Ansaldo tanks had broken down. He would soon face a blistering British counterattack that would eventually draw Germany into the campaign, transforming North Africa into a major theater of World War II. ■

Face-Off in the Desert:

THE STRUGGLE IN NORTH AFRICA

Desert Raiders British commandos of the Special Air Service—so called because it originally consisted of paratroopers—prepare for a raid on Axis lines of communication in the Western Desert riding modified American Lend-Lease Jeeps bristling with Vickers aircraft machine guns. Among the devices employed in desert warfare were periscopic binoculars *(inset)*, used here by a German officer at an observation post to direct artillery fire while remaining under cover.

Routing the Italians

In late 1940, Gen. Archibald Wavell, the British commander in chief in the Middle East, authorized Operation Compass, a raid designed to push Marshal Graziani's troops at Sidi Barrani back toward Libya. Led by Lt. Gen. Richard O'Connor with 30,000 troops of his Western Desert Force, the attack was launched at dawn on December 9 with close support from the Royal Air Force and the Royal Navy, which shelled Italian coastal positions. British tanks of the Seventh Armored Division, backed by two Indian brigades, overran enemy camps and seized Sidi Barrani, capturing nearly 40,000 Italians. One British commander estimated that vast haul at "five acres of officers, 200 acres of other ranks." O'Connor's raid soon turned into an all-out assault on Graziani's army, much of which remained in Libya. After reclaiming Halfaya Pass in mid-December, the British crossed the border and captured the fortified Libyan town of Bardia, where the "Desert Rats" of the Seventh Armored

Division and the Australian 16th Infantry Brigade bagged another 40,000 prisoners in early January 1941.

Ahead lay the strategic port city of Tobruk, which Graziani relied on for supplies. Neither O'Connor nor Wavell had any thought of seizing that prize when the campaign began, but they were urged on now by Prime Minister Churchill. "Seek, and ye shall find," he wired Wavell in Cairo, quoting scripture; "knock, and it shall be opened to you." Supported by massed field guns, Australian infantry broke through at Tobruk and took the city on January 22, corralling an additional 17,000 POWs. O'Connor's troops pursued the remnants of Graziani's army westward across Libya and trapped most of them in early February. In two months, the victors had advanced 500 miles and annihilated the Italian Tenth Army, capturing 130,000 prisoners, 380 tanks, and 845 artillery pieces. Their victory so embarrassed Mussolini and the Axis that Hitler felt compelled to intervene. ■

Soldiers of the Empire Visiting Egypt in 1940, Anthony Eden, British secretary of state for the Dominions, inspects the Fourth Indian Division, which helped beat the Italians.

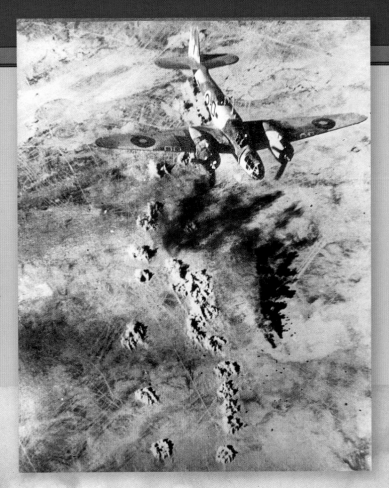

New and Old The diverse British forces that campaigned in North Africa used modern vehicles as well as time-honored modes of transportation. At right, an American-made Martin Maryland II bomber of the South African Air Force attacks an Italian transport column during Operation Compass in December 1941. Below, troopers of the First Cavalry Division, the British Army's last horse cavalry division, conduct maneuvers in the Western Desert, where they were employed for noncombat purposes.

Captive Legions Long columns of Italian POWs, captured by British forces at Bardia, Libya, during Operation Compass, cross the desert to a holding camp on January 6, 1941. As indicated by their clothing, troops in North Africa had to endure cold spells in winter and chilly nights even in seasons when it was brutally hot in the daytime.

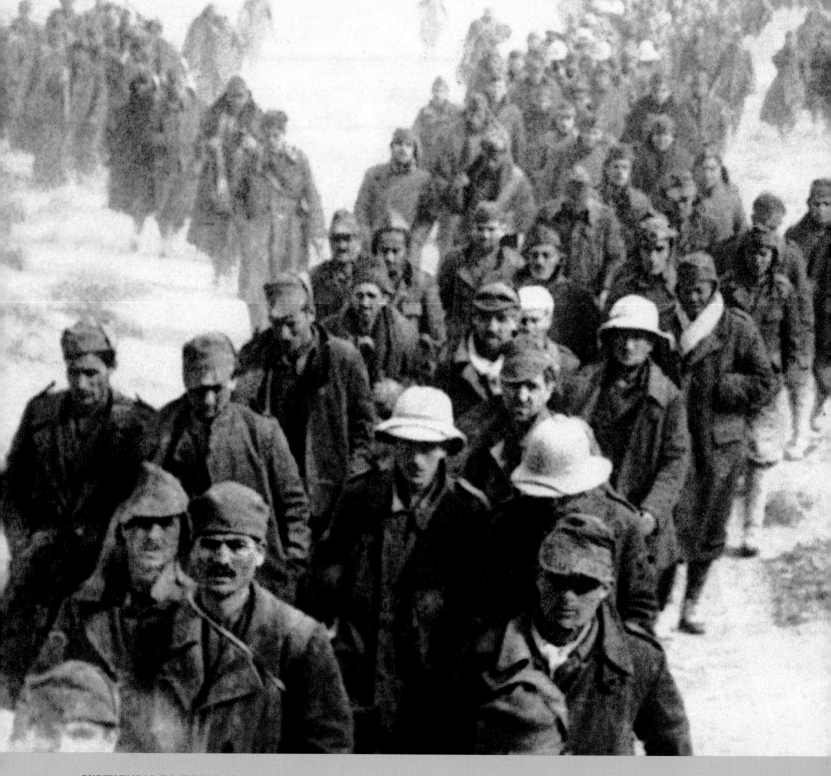

The Desert Fox

On February 11, 1941, a small convoy of Italian freighters docked at Tripoli in far western Libya and began offloading men and vehicles. They were the lead elements of the newly created Afrikakorps, two panzer divisions dispatched at Hitler's order to bolster his faltering Italian allies.

Commanding the Afrikakorps was Lt. Gen. Erwin Rommel, who had demonstrated his mastery of armored warfare during the blitzkrieg in France. Rommel realized that success in desert combat depended on the daring use of mobile mechanized columns to disrupt and destroy enemy troop concentrations. Despite orders to remain on the defensive, the aggressive general soon attacked. The sudden advance by Rommel's German and Italian forces startled British troops in Libya, who hastily withdrew toward Egypt with their foes in hot pursuit. "The British are falling over each other to get away," wrote Rommel.

On April 7, a German patrol captured General O'Connor and the officer sent to relieve him, Lt. Gen. Philip Neame. General Wavell then decided to hold the port of Tobruk in eastern Libya to deny Rommel a supply base. Wavell entrusted its defense to Australian troops led by Maj. Gen. John Lavarack. Unable to break through there, Rommel laid siege to Tobruk, but the Royal Navy had control of the Mediterranean and shipped supplies and reinforcements to the besieged port.

Meanwhile, much of the Afrikakorps had bypassed Tobruk and crossed into Egypt to occupy Halfaya Pass—known to the British as Hell Fire Pass for the hot battles fought there. Wavell's attempts to dislodge those Germans and relieve pressure on Tobruk failed. Churchill then replaced him with Gen. Claude Auchinleck. The methodical Auchinleck prepared at length for Operation Crusader, a massive armored offensive by the newly formed British Eighth Army, which broke through to Tobruk in November 1941 at a steep cost in men and tanks. Rommel, short on supplies and unable to replace lost armored vehicles, withdrew westward and dug in around the Libyan port of El Agheila in December. But the wily general known as the "Desert Fox" would not wait long before striking again. ∎

Panzer Commander Gen. Erwin Rommel, wearing a pair of captured British dust goggles, crosses the desert in eastern Libya with a unit of the 15th Panzer Division. One of Rommel's dress caps is shown above.

Rapid Fire At left, a soldier in the sidecar of an Afrikakorps motorcycle wields an MG 34 light machine gun during a patrol by a reconnaissance unit of the 21st Panzer Division in January 1942. Below, a German machine-gunner and loader man their MG 34 in a rocky emplacement in the Western Desert.

Mobile Forces Riding a German jeep, men of the Afrikakorps follow deep tracks in the desert in 1942. Rommel relied heavily on vehicles that could leave roads and negotiate rugged terrain. His ground forces were supported by Luftflotte 2, an air fleet that reached North Africa in December 1941 and included Ju-87B2 Stuka dive-bombers such as those shown being fueled below. The Afrikakorps cuff title above, worn on the left sleeve, was authorized in July 1941.

A Break in the Action

There were occasional lulls in the fighting in North Africa, but there was no respite for soldiers from the rigors of life in this harsh environment. Men on both sides struggled to maintain their health and morale. Temperatures in the desert ranged as high as 120°F under the summer sun, but could plummet overnight, leaving soldiers chilled to the bone. Their food was seldom fresh or appetizing. The rations issued to German troops consisted heavily of beans, zwieback, olive oil, sardines, and universally detested Italian canned meat. The British made do largely with preserved food, consisting of crackers and canned items such as cheese, fish, and "bully beef," which was "anything but solid," Pvt. Henry Foster of the West Yorkshire Regiment recalled: "with the intense heat, it was quite liquefied." Drinking water was almost always in short supply and often had to be transported over long distances. It was

Combating Pests Heads swathed in netting to repel flies, crewmen of a British Bren gun carrier write letters home.

carried by the Germans in sturdy five-gallon containers, dubbed "Jerry cans" by the British, who called the old gasoline cans they used to hold water "flimsies." Bathing and shaving had to wait until sufficient water was available.

More irritating than flies or other pests was the powdery desert sand and dust that reduced visibility, irritated the eyes and sinuses, and fouled weapons, vehicles, and optical equipment. Military operations often came to a standstill when stiff winds stirred up *ghiblis:* blinding sandstorms that engulfed men and vehicles, made breathing difficult, and disrupted radio signals. Helmuth Orschiedt, an artilleryman serving with Rommel's 15th Panzer Division, recalled those maddening desert storms: "Sand and dust everywhere, even inside wristwatches," he wrote. "We wrapped our heads in clothes and laid down. Nothing else could be done to survive." ■

Desert Treats In rare moments of relaxation, a British soldier bathes in a canvas basin *(above)* and Afrikakorps officers gather for a song at a commandeered piano *(right)*.

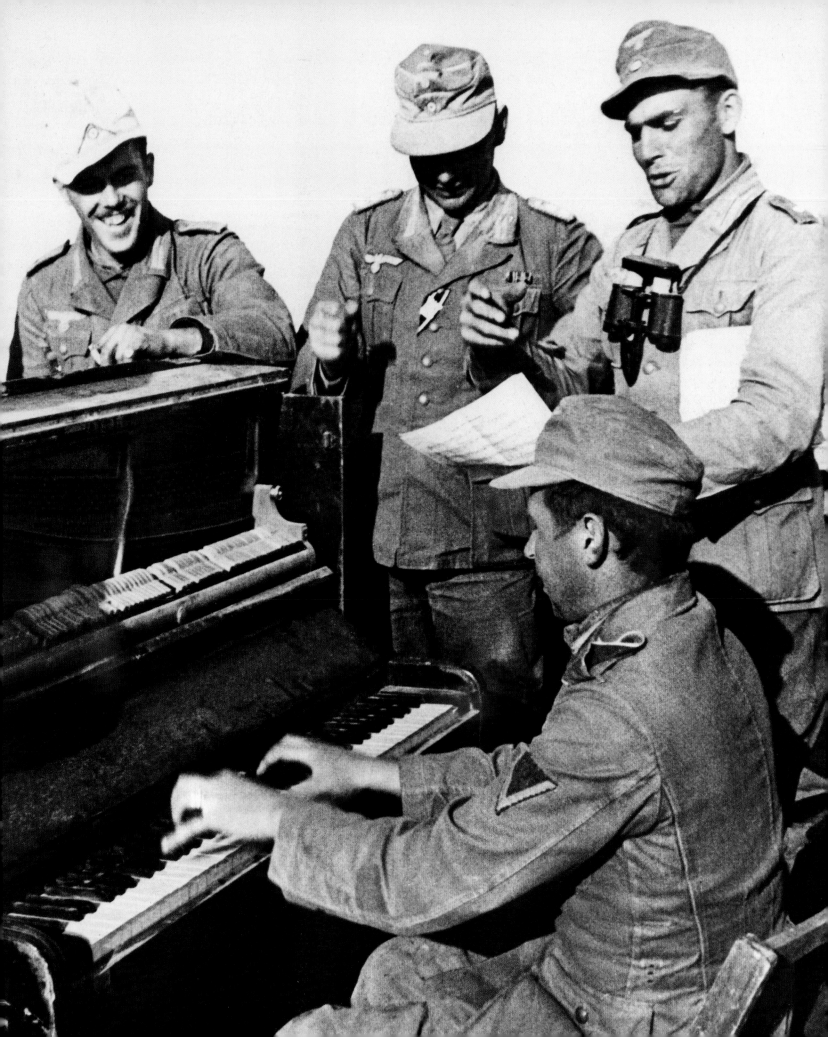

The Final Push

Bolstered with fresh supplies and reinforcements, Rommel left El Agheila in late January 1942 and resumed the offensive. His forces, redesignated the Panzerarmee Afrika, drove the British Eighth Army back almost 300 miles before Rommel halted short of Tobruk to rest and fortify his troops for the next big push. In late May, they forged ahead, breaching Allied lines and capturing Tobruk in June, after which Rommel was promoted to field marshal. Churchill called Tobruk a "shattering and grievous loss" and soured on General Auchinleck, who withdrew to El Alamein in Egypt, only 150 miles west of Cairo. There the British dug in, using the Mediterranean to the north and the impassable Qattara Depression to the south to shield their flanks. In August, Auchinleck was replaced by Lt. Gen. Harold Alexander, who entrusted the Eighth Army to the supremely confident Lt. Gen. Bernard "Monty" Montgomery. "We will finish with Rommel once and for all," Monty vowed.

In planning his attack on Rommel's opposing army at El Alamein, Montgomery made excellent use of intelligence reports obtained by intercepting and decoding messages sent by enemy commanders. The attack began on the night of October 23 with a powerful artillery bombardment that opened gaps in the German defenses for a massed infantry assault. Rommel was away, receiving medical treatment in Germany, and flew back on the 25th to find his forces hard pressed. The British had taken heavy losses advancing through German minefields, however, and the outcome at El Alamein remained in doubt until November 2 when British armored divisions achieved a decisive breakthrough.

Defeated in one of the war's pivotal battles, Rommel fell back slowly across Egypt and Libya to Tunisia, where his diminished army would encounter new foes—Americans who had landed in North Africa just days after Monty's smashing victory. ∎

Monty's Show **General Montgomery watches the fighting at El Alamein** *(top)*, **where he relied on heavy guns like the 25-pounder above, pulled by a Morris "Quad" artillery tractor.**

Pursuing Rommel Below, British artillerymen use BL 5.5-inch medium guns to target retreating Axis forces along the coastal road in Libya in early December 1941, after the Battle of El Alamein. At left, the commander of a British armored unit details operational plans to his subordinates on a relief map of the area around Tobruk.

Image of Defeat **Hands raised in surrender**, a crewman of an immobilized German Panzer III tank surrenders to British infantrymen during the early stages of the Battle of El Alamein, which proved to be the one of the worst defeats Germany had yet suffered in the war.

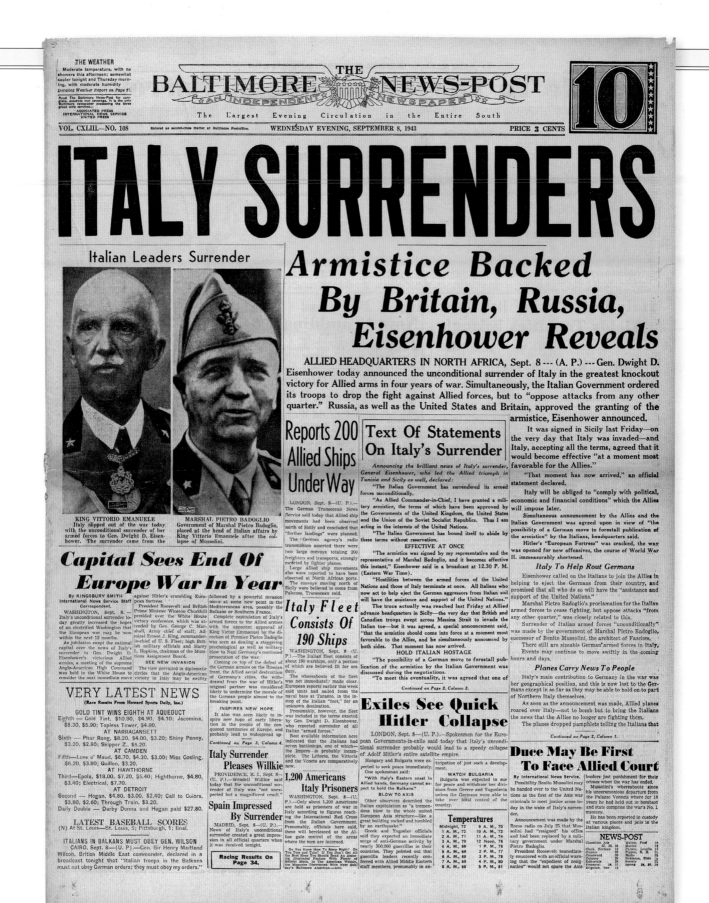

No Respite Hailed by the press, the surrender of Italy on September 8, 1943, did not prevent fierce fighting there between German and Allied troops.

Maj. Gen. George S. Patton could not wait to enter combat. "All my life I have wanted to lead a lot of men in a desperate battle," he wrote before embarking from Norfolk, Virginia, with more than 30,000 troops in late October 1942. They would be among the first American soldiers to cross the Atlantic and wage war. Their objective was not Europe, however, but North Africa, and the opponents awaiting them were not Germans or Italians but French forces serving the Vichy government, which collaborated with the Axis but remained officially neutral. As much as Patton longed for action, this was not a contest he relished. He and others who had fought as allies of France in World War I found it unsettling to be pitted against their old comrades-in-arms. "I cannot stomach fighting the French if there is a way to avoid it," he remarked aboard the U.S.S. *Augusta,* the flagship of Rear Adm. Henry Hewitt, as their task force of more than 100 warships and troop transports approached the coast of French Morocco in early November. ★ Whether French forces in North Africa would actively oppose this Allied invasion was uncertain. Some of them felt little loyalty to their Vichy rulers, who had come to terms with Hitler in June 1940 following the German occupation of northern France and retained control of southern France and the French colonies. Adm. Jean-François Darlan, commander of all Vichy armed forces, met secretly in Algiers on the eve of the invasion with a U.S. official who urged him to yield without a fight. Darlan would bow to the Allies and order a cease-fire—but not soon

War in the Mediterranean:

FROM NORTH AFRICA TO THE FALL OF ROME

CHRONOLOGY

- **November 8, 1942** American and British troops land in Morocco and Algeria.

- **January 14–24, 1943** Roosevelt and Churchill meet at Casablanca and agree to invade Sicily after securing North Africa.

- **May 7, 1943** Axis forces surrender in Tunisia, ending the conflict in North Africa.

- **July 10, 1943** Allied troops invade Sicily.

- **July 25, 1943** Mussolini falls from power.

- **September 3, 1943** British Eighth Army lands at Reggio di Calabria, launching Allied invasion of Italy.

- **September 8, 1943** Italy surrenders; German troops take control there.

- **September 9, 1943** U.S. Fifth Army lands at Salerno, Italy.

- **June 5, 1944** Rome falls to Allied troops.

"All my life I have wanted to lead a lot of men in a desperate battle."

MAJ. GEN.
GEORGE S. PATTON

Leading the Way Packed into a landing craft, American soldiers prepare to hit the beach near Oran, Algeria, during Operation Torch in November 1942. U.S. troops who fought in North Africa wore M1 helmets like the one above, covered with camouflage netting. Some were later issued the M3 fighting knife, shown here with its sheath.

enough to prevent bloodshed between two countries whose bonds of friendship went back to the American Revolution.

As Patton and Hewitt approached Morocco, two other Allied task forces prepared to land in Algeria. Altogether, nearly 110,000 troops—three-quarters of them Americans and the rest British—took part in this invasion, known as Operation Torch, commanded by Lt. Gen. Dwight D. Eisenhower. His objective was to advance eastward from Algeria into Tunisia and trap Field Marshal Erwin Rommel's Panzerarmee Afrika, which was being pursued westward by the British Eighth Army of Gen. Bernard "Monty" Montgomery, which had defeated Rommel at El Alamein, Egypt. Before taking on that larger challenge, however, the troops involved in Operation Torch would have to snuff out any French resistance they encountered.

Patton and Hewitt had to reckon with the French naval base at Casablanca, where forces were on guard against another deadly attack like that launched by the British against the Vichy fleet in July 1940 to prevent French warships from falling into German hands. Wary French gunners manning a big coastal battery at Casablanca opened fire as soon as Hewitt's warships drew within range on November 8.

Patton was standing on the deck of the *Augusta* when an incoming shell splashed into the water nearby and drenched him. He was less concerned for his own safety than for the loss of his landing craft, which was shattered by concussion when the *Augusta* returned fire and spilled his belongings into the sea. Turning to his aide, he burst out: "Goddamit, I hope you have a spare toothbrush with you I can use to clean out my foul mouth." Any further curses the profane Patton had to offer were soon drowned out by a deafening battle between American naval forces, which included warplanes from the aircraft carrier U.S.S. *Ranger,* and the outmatched Vichy fleet. Several French ships went down at a cost of nearly 500 lives in a clash that the Americans, who suffered few casualties, would rather have avoided. Those defiant Frenchmen in Morocco were not Patton's preferred foes, but the fight was on, and he entered it with gusto. Wading ashore north of Casablanca, he found his forces in chaos after a rough landing and had to whip them into shape before he could whip the enemy. "The beach was a mess and the officers were doing nothing," he noted. One frightened man found cringing in the sand received a swift kick in the rear from his commander. "If I see another soldier lying down on this beach," he vowed, "I'll court-martial him." Heavy surf delayed the landing of tanks and other equipment. Patton's troops were not in position to assault Casablanca until November 11, his 57th birthday, by which time French resistance in neighboring Algeria had collapsed. "Dear Georgie," Ike wrote him, "Algiers has been ours for two days . . . The only tough nut left is in your hands. Crack it open quickly."

That morning Darlan's cease-fire order took effect, sparing Patton the necessity of assaulting Casablanca. As a Christian, he was glad no more blood would be spilled, he said, "but as a soldier I would have given a good deal to have the fight go on." He had not yet had a chance to distinguish himself—nor would he until the raw recruits he and other American

PVT. LEO INGELSBY

LOST IN NORTH AFRICA

*Ingelsby's 509th Parachute Regiment took part in the U.S. Army's first-ever airborne assault.
His C-47 transport plane went off course en route from England, missed its drop zone in Algeria, and landed on
November 8, 1942, near a French fort, where he and others were briefly detained.*

It was nearly midnight by the time the plane was aloft ... The flight plan was to take us across the Bay of Biscay, then south across Spain ... and over the Mediterranean to our destination beyond Oran, the Tafaroui airfield ... Even before Gibraltar, a heavy ground fog set in, and a promised and clandestine radio direction beam never was picked up ... Within the hour, the plane encountered violent turbulence. The pilot told us that during the turbulence his visibility was absolutely zero, and his altimeter was descending at a rate of a thousand feet per minute.

Gradually, the plane settled back to normal as it flew through the storm and as the darkness gave way to dawn. By the pilot's reckoning, we could be almost anywhere except where we ought to have been. The storm had blown him in every direction; he had never been more lost ... After a short while the message came back to us that his gas was getting so low that it would be safer for us to jump rather than risk a crash landing on that rocky surface. Accordingly, we gathered up our gear and hooked up our static lines to the overhead cable. As we started to shuffle toward the mid-cabin exit door, the co-pilot yelled for us the hold up.

> **"Our captors were a detachment of, as they called themselves, Le Legion Étrangères—or, as known to old Laurel and Hardy fans, the French Foreign Legion."**

From the open door we could see why he shouted. There below us ... was a square-shaped high-walled fortress-like structure flying at its corner the tri-colored flag of France. The pilot made out the outlines of a landing strip, banked the plane sharply, and glided in for a smooth and bumpless landing.

We didn't have to wait long before the gate of the fort opened. There emerged a heavy-set mustachioed senior non-com who strolled up to the open door. Greeting him was the only member of the planeload that spoke French, Private Rosario Cyr, our assigned medic. Our pilot, the senior officer aboard, told Cyr to tell him that we were on a training flight and got lost. To which the non-com just grunted. He told us we were to be prisoners, to leave all weapons in the plane and follow him ... Our captors were a detachment of, as they called themselves, Le Legion Étrangères—or, as known to old Laurel and Hardy fans, the French Foreign Legion. ∎

Divided Loyalties These French Foreign Legionnaires from Syria served with the British Eighth Army. In Algeria, however, Foreign Legion units served the pro-Axis Vichy government, led in 1942 by Pierre Laval, depicted by a cartoonist riding a swastika-shaped hobby horse *(inset)*.

officers led became true soldiers. They were lucky to have met with only sporadic opposition from foes with little incentive to fight. "Had the landings been opposed by Germans," Patton observed, "we never would have gotten ashore."

Ike's Difficult Debut

The man who led Operation Torch was a prodigious military planner, but he had as much to learn about high command as the green American troops who stumbled ashore in North Africa did about fighting. Born in 1890, Eisenhower did not enter West Point until he was nearly 21 and missed out on World War I, which ended before the tank brigade he was training at Gettysburg, Pennsylvania, could enter action. He served for some time as a staff officer under the temperamental Douglas MacArthur before Army Chief of Staff George Marshall called him to Wash-

High Command **Gen. Dwight D. Eisenhower** *(left)*, supreme commander of Allied forces in North Africa, stands beside his Western Task Force commander, Lt. Gen. George Patton.

ington and groomed the little-known Eisenhower for greatness. Arriving in North Africa, he found himself overseeing strong-willed generals who far surpassed him in reputation and experience. Even the celebrated Monty, the hero of El Alamein, would become Ike's subordinate when he reached Tunisia with his army in early 1942. "Good chap—no soldier!" Montgomery said of his new boss. "He knows nothing whatever about how to make war or fight battles; he should be kept right away from all that business if we want to win this war." Gen. Alan Brooke, the British army chief, echoed that scathing assessment: "Eisenhower as a general is hopeless! He submerges himself in politics and neglects his military duties."

Politics in fact took up more of Eisenhower's time than he wished. One of his first official acts was to cut a deal with Admiral Darlan, which left that Vichy turncoat, who now pledged loyalty to the Allies, in charge of Morocco and Algeria and freed Ike to concentrate on fighting Axis troops in Tunisia. The deal outraged Gen. Charles de Gaulle, who had fled to Britain when Germany invaded his country in June 1940 and proclaimed himself leader of the Free French. Others joined de Gaulle in blasting Eisenhower for embracing an officer who had collaborated with the enemy. "Are we fighting Nazis or sleeping with them?" asked Edward R. Murrow. Ike defended his pact with Darlan as necessary to achieve Allied military objectives, as did President Roosevelt, who cited an old Balkan proverb to justify such unsavory deals: "My children, you are permitted in time of great danger to walk with the Devil until you have crossed the bridge."

The assassination of Darlan in December brought a more acceptable French officer to power and relieved some of the political pressure on Eisenhower. Yet he still had to devote much attention to a task that was more diplomatic than military: strengthening the fragile Anglo-American alliance. More than a few British officers doubted the fighting capacity of the Yanks and the fitness of their commander. Many American officers likewise had misgivings about their British counterparts, who were suspected of being more concerned with preserving their own empire than shattering Hitler's Reich. General Marshall worried that Americans were being drawn into a long and costly diversion in the Mediterranean that might

"Good chap— no soldier! He knows nothing whatever about how to make war or fight battles; he should be kept right away from all that business if we want to win this war."

Gen. Bernard Montgomery on his new boss, General Eisenhower

> "My children, you are permitted in time of great danger to walk with the Devil until you have crossed the bridge."
>
> PRESIDENT ROOSEVELT, CITING AN OLD BALKAN PROVERB TO JUSTIFY UNSAVORY DEALS

Fighting Back **German Panzer III F tanks of Heavy Panzer Battalion 501 move into position to counterattack Allied forces near Tébourba, some 20 miles west of Tunis. The fighting at Tébourba, between November 29 and December 4, 1942, left the Germans in control there and dealt a setback to Eisenhower, who suspended the Allied advance on Tunis a few weeks later.**

serve British interests there but would do little to hasten the defeat of Nazi Germany. Ike was a true Anglophile, however, and believed that British and U.S. interests were inseparable. He would not allow American officers to speak ill of their allies and expected his Yanks to serve as faithfully under British superiors as under their own countrymen. "Every subordinate throughout the chain of command," he insisted, "will execute the orders he receives without even pausing to consider whether that order emanated from a British or American source." That was too much to ask of Patton, who felt that American generals should be calling their own shots and complained that Ike was "more British than the British."

The strains in this alliance would ease when Americans proved themselves in battle, but the trials awaiting them in Tunisia were severe. Alarmed by Operation Torch and Darlan's defection, Hitler occupied southern France and heavily reinforced the ports of Tunis and nearby Bizerte, which if captured by the Allies would sever the enemy supply line and doom Axis troops in North Africa. Ike's headquarters at Algiers was 500 miles from Tunis, and the forces he dispatched to seize that objective moved slowly along muddy roads. American soldiers who had expected to find Africa warm and dry encountered torrential winter rains, fierce winds, and frigid nights. Patton, raised in California, called Tunisia the "coldest damn place I have ever seen" and found it "very hard on the men."

Any hope Ike had of achieving a quick victory ended in December when his ill-equipped troops were stopped short of Tunis by punishing German counterattacks. American light tanks like the M3 Stuart proved no match for the hefty German Mk IV, whose armor-piercing 75-mm gun made the Stuart's 37-mm weapon seem like a pistol by comparison.

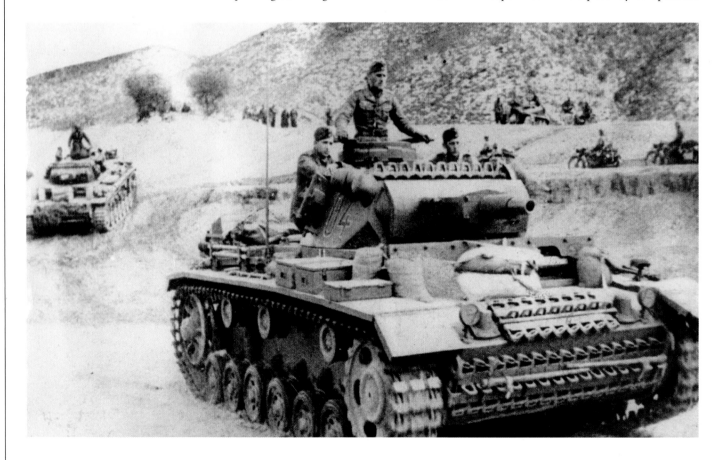

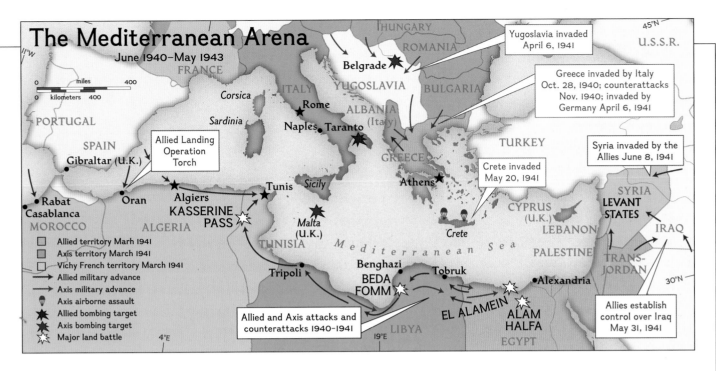

The Mediterranean Arena
June 1940–May 1943

PORTUGAL

SPAIN

Gibraltar (U.K.)

Rabat
Casablanca
MOROCCO

Oran

Algiers
KASSERINE PASS

ALGERIA

Allied Landing Operation Torch

Corsica

Sardinia

Rome

Naples • Taranto

ITALY

FRANCE

HUNGARY

ROMANIA

Belgrade

YUGOSLAVIA

BULGARIA

ALBANIA (Italy)

GREECE

Athens

TURKEY

| Yugoslavia invaded April 6, 1941 |

| Greece invaded by Italy Oct. 28, 1940; counterattacks Nov. 1940; invaded by Germany April 6, 1941 |

| Crete invaded May 20, 1941 |

| Syria invaded by the Allies June 8, 1941 |

Tunis

Sicily

Malta (U.K.)

Crete

CYPRUS (U.K.)

SYRIA
LEVANT STATES

LEBANON

IRAQ

Mediterranean Sea

TUNISIA

PALESTINE

TRANS-JORDAN

Tripoli

Benghazi
BEDA FOMM

Tobruk

• Alexandria

EL ALAMEIN

ALAM HALFA

LIBYA

EGYPT

| Allies establish control over Iraq May 31, 1941 |

| Allied and Axis attacks and counterattacks 1940–1941 |

U.S.S.R.

miles 400
kilometers 400

☐ Allied territory March 1941
☐ Axis territory March 1941
☐ Vichy French territory March 1941
→ Allied military advance
→ Axis military advance
⛴ Axis airborne assault
★ Allied bombing target
✦ Axis bombing target
✧ Major land battle

Even the more powerful M4 Sherman was at a disadvantage against the heavily armored Mk IV or the huge German Tiger tank. American armored units took savage beatings when they dashed recklessly into battle—a tactic favored by commanders who approached armored assaults like cavalry charges—and fell into traps laid for them by the savvy Germans. During one tank battle in Tunisia, an American lieutenant found his men so shocked by the pounding they were taking that they could barely move. "I walked from tank to tank trying to make them fire and retire," he recalled. "They seemed petrified." The lieutenant "cursed and insulted, climbing on tanks and shouting," but he could not get them to budge and fell wounded. No less petrifying for the Allies were shrieking Stuka dive-bombers that so dominated the skies over one blood-soaked battleground west of Tunis that it became known as Stuka Valley.

In late December, Eisenhower suspended the offensive in Tunisia until his troops there were bolstered and better equipped. It was a gloomy Christmas for the Allied commander, who was as tough in assessing his own performance as his British critics were. Thus far, he wrote, the campaign in North Africa had "violated every recognized principle of war." When told that he might receive a Medal of Honor for the Torch landings, he objected that he had done nothing to earn the medal. "I don't want it and if it is awarded I won't wear it," he said. "I won't even keep it."

In January 1943, Franklin Roosevelt and Winston Churchill met at Casablanca with military chiefs from their two countries. When Eisenhower conferred privately there with the President, he thought he was about to be sacked and said that he was "ready to take the rap for whatever went wrong." Roosevelt was looking beyond the problems of the moment to the Allies' next big step, however, and asked him when he would have in Tunisia in hand. "May 15," Ike replied, committing himself to a deadline he was not sure he could meet.

If the Allies secured North Africa by then, they could challenge Axis forces on their own turf that summer by landing in Sicily, which in turn might be used as a stepping-stone to invade mainland Italy. That plan was favored by the British but opposed by Marshall, who

Endgame in North Africa The map above charts major actions around the Mediterranean prior to Operation Torch in November 1942. By the time President Roosevelt and Prime Minister Churchill met at Casablanca in January 1943 *(below)*, the situation in North Africa had changed. The former Vichy French territories of Morocco and Algeria were now under Allied control, and Montgomery's British Eighth Army had driven Rommel's army out of Libya, confining Axis forces to Tunisia.

Solving the Enigma

When Gen. Bernard Montgomery took charge of British forces in North Africa in 1942, he told his troops that he knew what Rommel was up to. That was no idle boast, for the British were decoding German wireless communications and reading their plans.

German commanders went to war in 1939 confident that those communications were absolutely secure. They relied heavily on an intricate electronic coding machine called Enigma, which evolved from a less sophisticated device produced in the 1920s as a way for businesses to hide their secrets from competitors. The Germans vastly improved on that prototype and rendered their coded messages seemingly impenetrable to foes.

When an Enigma operator pressed a letter on the keyboard, an electronic impulse traveled through multiple rotors in turn, each of which had 26 settings for its contact points, and lit up a different letter on a panel atop the machine. The combination for the rotor settings was known only to the sender and the receiver, who typed the encrypted message—a meaningless stream of letters transmitted in Morse code or by teletype—into an Enigma machine set to that combination, reversing the process and unscrambling the text.

The first serious breach in Enigma's security occurred in the early 1930s when a clerk in the German cipher bureau sold Enigma operating instructions and settings to French agents, who shared the intelligence with their allies in the Polish cipher bureau. That helped Polish mathematician Marian Rejewski and other inspired cryptanalysts solve Enigma's puzzles and reconstruct the machine. They then integrated several Enigma rotors into a device called a "bombe," which raced through countless settings until it found a combination matching that used by German operators on any given day.

In 1938, as war loomed, the Germans improved Enigma by increasing the number of rotors from

"The geese who laid the golden eggs— and never cackled."

WINSTON CHURCHILL, ON THE
BLETCHLEY PARK CODE BREAKERS

Enigma in Action Watched over by Maj. Gen. Heinz Guderian, radiomen in a panzer half-track send messages encoded on an Enigma machine (foreground) during the invasion of France in 1940.

three to four or more and adding additional cables, which could be inserted into a plugboard in various ways, further scrambling the message. Frustrated and fearing attack by Germany, Polish code breakers shared what they had accomplished with their Western allies. In August 1939, they bequeathed their Enigma, bombes, and other breakthroughs to the British Code and Cipher School at Bletchley Park, north of London.

Teams of mathematicians—including the brilliant Alan Turing, a pioneering computer theorist—joined intelligence analysts, linguists, and technicians at the Bletchley campus to crack the

improved Enigma codes. Turing and fellow mathematician Gordon Welchman developed a more powerful bombe that could cope with the increasing number of Enigma combinations. Under the direction of Cmdr. Alastair Denniston, Bletchley Park expanded to include legions of clerks and typists who handled thousands of intercepts. "Secrecy was so great that at the end of a watch we never spoke about what we did," recalled Royal Navy code clerk Betty Warwick Boyd, "nor did we talk to those in other huts or know what they did." Churchill referred to them as "the geese who laid the golden eggs—and never cackled."

By 1943, the code-breaking teams were processing up to three thousand messages a day. The workload overwhelmed Bletchley's bombes, leading to the development of a revolutionary electronic computer called Colossus at a research station near London. Colossus could even decipher messages encoded by the 12-rotor machine used by Hitler and the German General Staff.

Intelligence gathered by decoding Enigma messages was classified as "Ultra" secret. Ultra decrypts were used carefully, to prevent the Germans from realizing that their codes had been broken. Ultra contributed greatly to Allied successes in North Africa, the Battle of the Atlantic, and the D-Day landings, leading ultimately to defeat for those who devised Enigma and placed too much trust in it. ∎

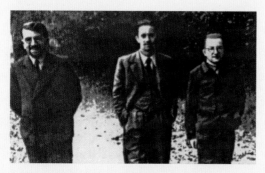

Polish Exiles After fleeing German-occupied Poland, Marian Rejewski (right) strolls in France with two other cryptanalysts who helped solve Enigma, Henryk Zygalski (left) and Jerzy Różycki.

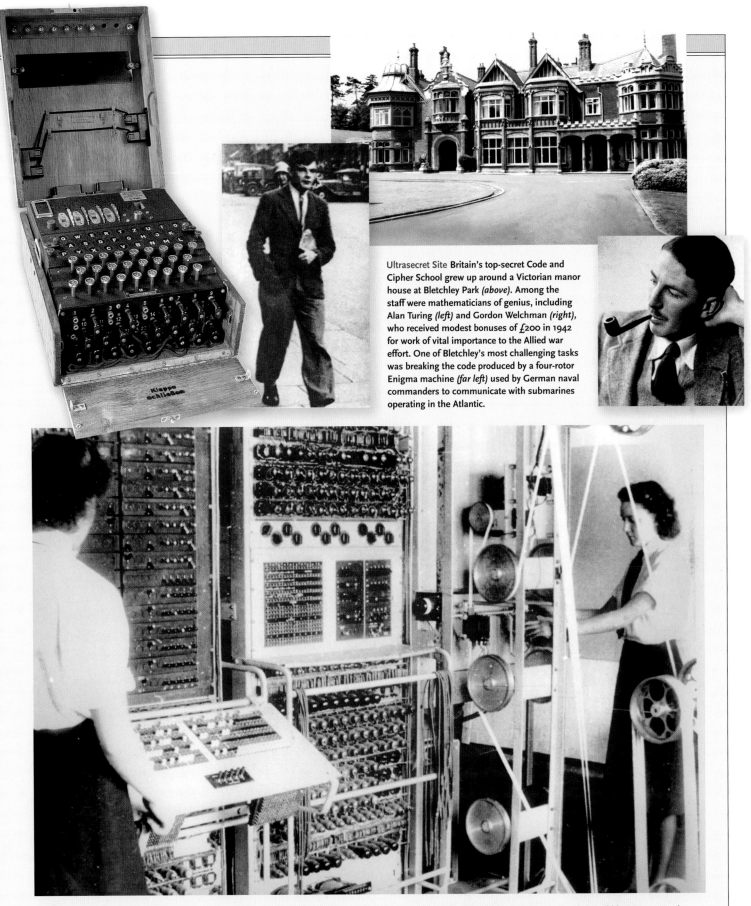

Ultrasecret Site Britain's top-secret Code and Cipher School grew up around a Victorian manor house at Bletchley Park *(above)*. Among the staff were mathematicians of genius, including Alan Turing *(left)* and Gordon Welchman *(right)*, who received modest bonuses of £200 in 1942 for work of vital importance to the Allied war effort. One of Bletchley's most challenging tasks was breaking the code produced by a four-rotor Enigma machine *(far left)* used by German naval commanders to communicate with submarines operating in the Atlantic.

Crunching Code Members of the Women's Royal Naval Service, known as Wrens, operate Colossus, the first electronic digital computer that could be programmed.

considered the Mediterranean "a blind alley to which American forces had only been committed because of the President's insistence that they should fight the Germans somewhere." Taking Italy would be a long and costly struggle, he reckoned, and even a hard-won victory there would pose no direct threat to Germany, which was shielded from Italy by neutral Switzerland and the forbidding Alps. The surest and quickest route to Germany lay through northern France or the Low Countries, Marshall insisted, and the sooner the Allies pursued that course the better. Marshall's British counterpart, General Brooke, was against risking such an invasion in 1943, citing the disastrous results of an Allied raid across the English Channel against the German-occupied port of Dieppe in August 1942. The Allies could not afford a repetition of that debacle, and they would not be equipped to undertake a massive cross-Channel invasion with any confidence until 1944. In the meantime, Allied forces in North Africa could be used to knock Hitler's partner Mussolini out of the war and keep German troops tied down in Italy while the big push across the Channel unfolded.

The British won that argument by securing approval for an invasion of Sicily at Casablanca and clearing the way for an invasion of Italy at another Allied conference later in the year. Eisenhower accepted the decision. What worried him was the new command structure adopted at Casablanca, which entrusted ground operations in Tunisia to his British deputy, Gen. Harold Alexander. Eisenhower admired Alexander, but British commanders were also placed in charge of naval and air forces. Ike rightly suspected that his allies doubted his ability and were distancing him from the campaign. As Brooke wrote in his diary: "We

Canada's Bloodiest Day Wounded Canadians lie near a disabled tank of the 14th Canadian Tank Regiment following a disastrous Allied amphibious raid on the German-occupied port of Dieppe, France, on August 19, 1942. Canadians made up most of the 6,000 troops who landed there, more than 4,000 of whom were killed, wounded, or captured. The bitter setback prompted Allied commanders to delay an invasion of France until 1944 and concentrate on operations in the Mediterranean.

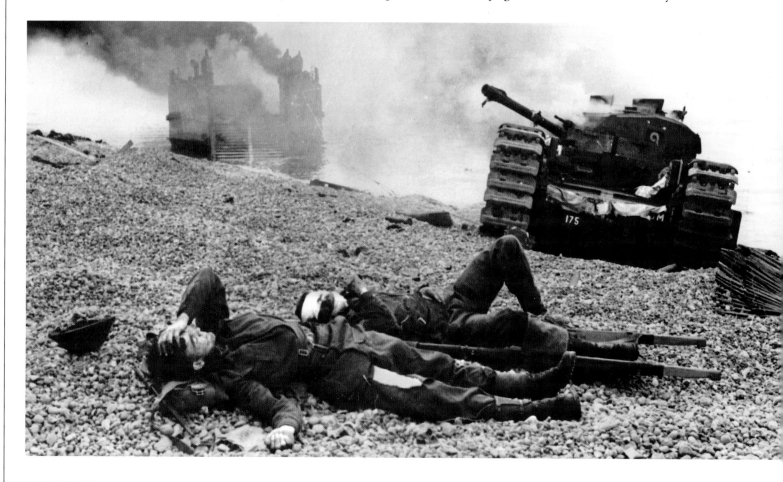

were pushing Eisenhower up into the stratosphere and rarified atmosphere of a supreme commander, where he would be free to devote his time to political and inter-allied problems, whilst we inserted under him our own commanders to deal with the military situations and to restore the necessary drive and coordination which had been so seriously lacking of late!"

Eisenhower—who was promoted to full, four-star general to match Alexander's rank—praised the new command structure publicly, but inwardly he was seething. Marshall worried about Ike's health and the pressures that had been on him ever since the Darlan deal. "He may think he has troubles so far," Marshall said, "but he will have so many before this war is over that Darlan will be nothing."

Those words proved grimly prophetic as fighting resumed in Tunisia. Eisenhower remained responsible for appointing American officers in North Africa and replacing those who were not up to task. In February, he drove to the front to confer with Maj. Gen. Lloyd Fredenhall, commander of the U.S. II Corps. Fredenhall's engineers were excavating a deep bunker to shelter him and his staff. His forces, meanwhile, were widely dispersed on the Allies' southern flank—a dangerous spot as Rommel's Panzerarmee approached from the south to link up with the army of Gen. Hans-Jürgen von Arnim, who had arrived in Tunisia in December. One officer under Fredenhall, Brig. Gen. Paul Robinett, told Eisenhower that II Corps was in an "impossible" position. Fredenhall had ignored Ike's advice to keep a large mobile force in reserve, and if his front collapsed, he would be hard-pressed to hold the vital Kasserine Pass, which the enemy could use to wreak havoc behind Allied lines.

Fredenhall was clearly a liability. But Eisenhower hesitated to remove an officer recommended by his boss, Marshall, and thought there was no imminent threat to II Corps, having received intelligence that the Germans would attack up north. In fact, Rommel was about to launch an assault in the south—a step he took with some misgivings. If it were up to him, his battle-worn forces would have been withdrawn from Africa to save them for decisive campaigns in Europe. But neither Hitler nor his commander in the Mediterranean, Field Marshal Albert Kesselring, would stand for that. So Rommel decided to attack II Corps before Montgomery's trailing Eighth Army could catch up and trap him. Kesselring added two of Arnim's divisions to the offensive and vowed: "We are going to go all out for the total destruction of the Americans."

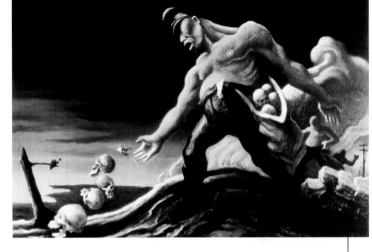

Fascist Nightmare A demonic Axis soldier casts skulls into furrows in this 1942 painting by American artist Thomas Hart Benton entitled "The Sowers," one in a series of works produced by Benton to bring "the bloody actual realities of this war home to the American people." The U.S. Office of War Information sponsored an exhibition of the paintings, but closed it early amid concern about the disturbing nature of Benton's images.

"We are going to go all out for the total destruction of the Americans."

FIELD MARSHAL ALBERT KESSELRING, APPROVING AN ATTACK ON THE U.S. II CORPS IN TUNISIA

RETREAT AND REDEMPTION

Perched on a hill with men of his 168th Infantry Regiment, Col. Thomas Drake watched helplessly as Stuka dive-bombers and German armor shattered American defenses around the Tunisian town of Sidi bou Zid on the morning of February 14. Sherman tanks—known to the troops as "Ronsons" because they ignited so quickly—lay blasted and burning in the valley below, and artillerymen of the U.S. First Armored Division were abandoning their guns on a distant hill and fleeing. Drake called Brig. Gen. Raymond McQuillin at his command post near the town and told him that his forces were giving way.

Turnaround in Tunisia After being defeated at Kasserine Pass, American forces in Tunisia rallied and struck back at their foes along with the British, who outflanked Axis troops along the Mareth Line in March 1943 and forced them to retreat to Tunis, leaving behind shattered tanks like the Panzer III L above, lost in action by the 15th Panzer Division. The Allies secured Tunisia in May and seized vast hordes of Axis troops, including the Italians at top, streaming out of Tunis on their way to prison camps.

"You don't know what you're saying," McQuillin responded. "They're only shifting positions." Drake assured him otherwise. "I know panic when I see it," he insisted. If so, McQuillin shot back, Drake should "take command and stop it." How Drake's lightly armed infantrymen were supposed to stop this rout if American armor and artillery could not was left unexplained. A short time later, Drake learned that McQuillin was pulling out and asked to do the same. McQuillin contacted II Corps headquarters, 80 miles to the rear. Fredenhall, who had positioned his units too far apart to cope with this attack, replied that it was "too early to give Drake permission to withdraw."

Left stranded in what was now enemy territory, the regiment held out under fire for 36 hours before Drake's request was finally granted: "Fight your way out. Time and place yours." Leaving behind their dead and wounded, they escaped in the night with other men of the 34th Infantry Division, only to be overtaken by German troops the next day. "We were young, dumb, outgunned, outmaneuvered, and outsmarted," recalled Capt. Billy Bingham. "By the time the Germans caught up with us we were in poor condition, dead tired," he added. "It was more like a roundup than a battle." Drake told an officer who demanded his surrender to "go to hell," but he and his men had little choice but to yield. More than a thousand Americans were captured. As the prisoners were led away under guard, Bingham stated, "we saw Arabs tearing the uniforms off dead soldiers. Dogs were gnawing on the bodies of those killed on the 14th, the wreckage of a terrible battle."

By February 19, another terrible battle loomed at Kasserine Pass. Rommel's attack there was delayed as he debated whether to push westward through that pass against II Corps and attack the big enemy supply base at Tébessa, Algeria, or to advance northward against other Allied targets in Tunisia. He chose to divide his forces and pursue both options, reckoning that he would not need all his strength to overcome Fredenhall's troops at Kasserine Pass. Stunned by the German onslaught, Fredenhall pleaded for reinforcements. "I haven't got a damn bit of reserve," he said, a situation for which he bore some responsibility. Eisenhower sent troops, but few of them would arrive in time to defend the pass. So Fredenhall called on Col. Alexander Stark, commander of the 26th Infantry Regiment, back near Tébessa. "Alex," he said, "I want you to go to Kasserine right away and pull a Stonewall Jackson. Take over up there."

Like Jackson, Stark was a Virginian, but there the resemblance ended. A former military surgeon who had been decorated for bravery in the last world war but seemed out of his depth in this one, he arrived at the pass early on February 19 to find American engineers with minimal combat training occupying the low ground, leaving the heights to be occupied by the oncoming Germans. Stark had little chance of making a heroic stand here but was slow to recognize how perilous the situation was. He had things "well in hand," he told a British officer, who concluded that Stark "had completely lost control of events." On February 20, Stark was overwhelmed as Rommel's tanks challenged the Americans head-on while German infantrymen, who had seized the high ground, poured down flanking fire on the forlorn defenders. Hundreds fell dead or wounded before resistance collapsed that afternoon and the survivors fled.

Eisenhower sent Maj. Gen. Ernest Harmon to prop up the hapless Fredenhall and restore order. On his way to the front, Harmon had to force his way through retreating Yanks. "It

was the first—and only—time I had ever seen an American army in rout," he wrote. "Jeeps, trucks, wheeled vehicles of every imaginable sort streamed up the road toward us . . . It was obvious there was one thing only in the minds of the panic-stricken drivers: to get away from the front, to escape to some place where there was no shooting." Had Rommel committed all his forces to a swift thrust through Kasserine Pass, he might have shattered the demoralized II Corps. But as it was, American and British artillery units were able to waylay German tanks as they advanced through rugged terrain on separate paths. On February 22, Rommel and Kesselring conferred and called off the offensive, which achieved no lasting gains but cost the Americans more than 6,000 casualties and destroyed nearly 200 tanks.

The results seemed to confirm the low opinion in which the inexperienced Americans were held by British officers like Alexander. "They simply do not know their jobs as soldiers," he wrote, "and this is the case from the highest to the lowest." But the fault lay not just with the Yanks but with the entire, ill-coordinated Allied operation in North Africa. "One would have to search all history to find a more jumbled command structure," concluded General Robinett, who felt that II Corps had not been well served by Fredenhall, by his British superior Lt. Gen. Kenneth Anderson, or by their supreme commander, Eisenhower.

Fortunately, Ike and the Americans under him learned far more from their failures in Tunisia than from their easy success in Morocco and Algeria. Poor officers were eased out and promising ones promoted. Eisenhower rehabilitated II Corps by placing it first under the stern hand of General Patton—who took on that task temporarily before resuming preparations for the Sicily campaign—and then under the firm grip of Ike's old friend at West Point Maj. Gen. Omar Bradley. He and Eisenhower overcame British qualms and insisted that II Corps be given an important role to play when the Allies launched an all-out attack on their Axis foes in April.

Desert Air Power A C-47 of the U.S. Air Transport Command, carrying supplies for Allied forces in North Africa, flies over the famous Egyptian Pyramids at Giza in 1943. The patch above was worn by members of the Western Desert Air Force, a separate combat command that included British, South African, Australian, Polish, and American units.

Operation Mincemeat

On April 30, 1943, a fisherman trolling in the Atlantic off the Spanish port of Huelva recovered what appeared to be the body of a British officer floating in the sea, seemingly one more victim of a war that had already claimed countless lives. In fact, the body was that of a man who had taken his own life, little knowing that his remains would be used in Operation Mincemeat, one of the most successful deceptions of World War II. The macabre plot was carried out by MI-5, Britain's counterintelligence agency, to conceal the upcoming Allied invasion of Sicily.

MI-5 entrusted the mission to Flt. Lt. Charles Cholmondeley of the Royal Air Force and Lt. Cmdr. Ewen Montagu of Naval Intelligence. Their goal was to place false documents in the hands of German commanders indicating that Allied forces massing in North Africa across from Sicily were destined for two other targets—German-occupied Greece and Sardinia. The documents would be carried by a corpse disguised as a deceased military courier who had apparently drowned after his aircraft crashed off the Spanish coast. Although officially neutral, Spanish officials cooperated with German authorities and could be expected to bring such sensitive documents to their attention.

Cholmondeley obtained a suitable dead body from a London coroner—that of a 34-year-old drifter named Glyndwr Michael who had committed suicide by taking rat poison, leaving no marks on his body inconsistent with drowning. "In life he had done little for his country," Montagu wrote, "but in death he did more than most could achieve by a lifetime of service."

The officers established a backstory for their fictitious courier, whom they dubbed Maj. William Martin of the Royal Marines. Secretaries at MI-5 composed romantic letters from Martin's fiancée and provided a charming photograph of her. Cholmondeley carried the letters in his wallet, repeatedly folding and unfolding them

> ## "In life he had done little for his country, but in death he did more than most could achieve by a lifetime of service."
>
> Lt. Cmdr. Ewen Montagu, on Glyndwr Michael

to add authenticity before placing them on the dead man once he was suitably clothed. Other convincing items in Martin's pockets included a bank overdraft notice, a military identification card, theater tickets, receipts, matchbooks, and keys. His briefcase included a letter from Lt. Gen. Archibald Nye of the Imperial General Staff to Gen. Harold Alexander in Tunisia that detailed Allied plans for an invasion of Greece and referred to a second operation, which another letter in the briefcase suggested was Sardinia.

The body was then packed in dry ice to retard decomposition and placed aboard the submarine H.M.S. *Seraph* for the voyage to Spain. Only its commander knew the true nature of the mission. Before dawn on April 30, the *Seraph* surfaced off

Huelva and Major Martin, with briefcase chained securely to him and life vest inflated, was slipped into the sea.

The body was quickly found by the fisherman and turned over to local authorities, who passed the remains along to the British consulate for burial but sent the contents of the briefcase to Spanish Naval Headquarters in Madrid. There, an officer allowed agents from the German Embassy to open the letters and make photographs. Code breakers at Bletchley Park monitored communications by the Abwehr (German military intelligence) and confirmed that information from Martin's briefcase had been sent to Berlin. On May 12, the German High Command directed that measures for the defense of Greece and Sardinia "take precedence over everything else." So successful was Operation Mincemeat in diverting enemy attention and troops to those other targets that only two German divisions were in Sicily to support its demoralized Italian defenders when the Allies landed there in July. ■

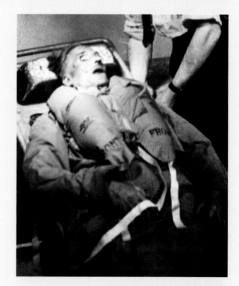

Finishing Touches The body of Glyndwr Michael, disguised as Maj. William Martin, receives final preparation from an MI-5 officer in this top-secret photograph made shortly before the remains were transported by submarine to be left floating in a life vest off the coast of Spain.

TELEPHONE Nº MAYfair 6261 (2 LINES)
TELEGRAMS EUCLASE WESDO LONDON

113 New Bond Street
London W.1. 19th April 1943.

Major W. Martin R.M.,
Naval & Military Club,
94, Piccadilly. W.1.

To S. J. Phillips
Sole of E. (Phillips
Silversmith.
Jewels, Antique Plate.

15th April. 1943. Single diamond ring sma
shoulders plat? (pre purchas

Engraving "P.L. from W.M. "

Telephone :
WHitehall 9777

21st April,
1943.

Dear Admiral of the Fleet,

I promised V.C.I.G.S. that Major Martin would
arrange with you for the onward transmission of a
letter he has with him for General Alexander. It is
very urgent and very "hot" and as there are some
remarks in it that could not be seen by others in the
War Office, it could not go by signal. I feel sure
that you will see that it goes on safely and without
delay.

I think you will find Martin the man you want.
He is quiet and shy at first, but he really knows his
stuff. He was more accurate than some of us about the
probable run of events at Dieppe and he has been well
in on the experiments with the latest barges and
equipment which took place up in Scotland.

Let me have him back, please, as soon as the
assault is over. He might bring some sardines with him -
they are "on points" here!

Yours sincerely

Louis Mountbatten

Admiral of the Fleet Sir
Commander in Chief Med
Allied Force H.Q.,
Algiers.

Elaborate Deception Carefully crafted to make an imaginary staff officer appear genuine, the personal possessions of "Major Martin" included his naval identity card and an expired pass for Combined Operations Headquarters (below), along with a picture of his fiancée Pam, a bill from a jewelry store for an engagement ring, and two ticket stubs for a show the couple supposedly attended together (above). The cover letter at left, introducing Martin to Adm. A. B. Cunningham at Allied headquarters in Algiers, was signed by Admiral Lord Louis Mountbatten himself and refers slyly to "sardines," meant to be interpreted by the Germans as alluding to Sardinia.

PASS No. 649.
COMBINED OPERATIONS HEADQUARTERS
On presentation of this Pass the holder
Major W. Martin, R.M.
is authorised to enter on official duty
Combined Operations Headquarters.

Kenneth
Secretary.

Not valid after 31st MARCH, 1943.

Issued in lieu of Nº 09650 lost.

Page 3
Navy Form S.1511
NAVAL
IDENTITY CARD No. 148228

MARTIN
William
(me of issue) CAPTAIN, R.M.
(ACTING MAJOR)
of issue) H Q
COMBINED OPERATIONS
CARDIFF
1907

May 1943.

Signature of Bearer
W. Martin

Visible distinguishing marks
NIL.

War correspondent Ernie Pyle returned to North Africa shortly before that battle began and noted how Americans there had been hardened by combat. "The most vivid change is the casual and workshop manner in which they now talk about killing," he wrote. Few of them had started out hating Germans, but their losses at Kasserine Pass and elsewhere left them with the same burning desire to destroy the enemy that Americans serving in the Pacific felt after Pearl Harbor. As Pyle observed, soldiers in North Africa were now eager "to see the Germans overrun, mangled, butchered in the Tunisian trap."

By the time the final battle for North Africa began on April 23, Rommel had returned to Germany on sick leave and Montgomery's Eighth Army had rolled in and sealed off the Axis troops. They were trapped with their backs to the sea, prey to relentless Allied air strikes. Bradley's II Corps, assigned to take Bizerte while other Allied forces targeted Tunis, advanced with newfound determination against Germans who were in no mood to surrender. The biggest obstacle in Bradley's path was Hill 609, bristling with mortars and machine-gun nests. "Get me that hill," he ordered Maj. Gen. Charles Ryder, whose 34th Infantry Division had been mauled and maligned in recent months. "Take it and no one will ever again doubt the toughness of your division." In contrast to earlier battles, the infantry here was closely supported by armor and artillery. Bradley asked his artillery chief, Brig. Gen. Charles Hart, to throw all he had at the stubborn defenders of Hill 609. "We'll give them a serenade," Hart replied, "and sweeten it with everything we've got."

On April 29, Ryder's infantry advanced up the hill behind a phalanx of Sherman tanks, overwhelming foes who were shaken by Hart's barrage and shocked to see armor ascending the slope. The taking of Hill 609 opened the way to Bizerte for Bradley's men, who seized that port on May 7, the same day Tunis fell. Nearly 250,000 Axis troops were captured by the Allies in the worst defeat for Hitler since the disaster at Stalingrad earlier that year. Eisenhower, who met his deadline for securing North Africa with a week to spare, displayed the tough new American stance toward the enemy by refusing to speak with the defeated Axis commander, General Arnim. Ike did not "trust his reactions before a representative of the Prussian and Nazi regime," explained his chief of staff. "The only German generals I'm interested in," said Eisenhower, "are the ones we haven't captured yet."

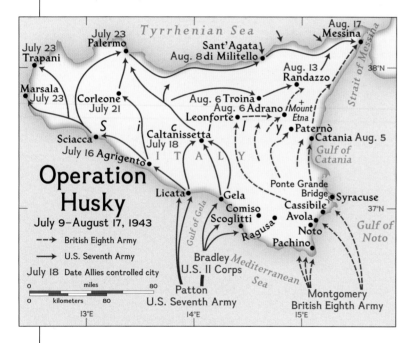

Tyrrhenian Sea

July 23 Palermo
July 23 Trapani
Sant'Agata
Aug. 8 di Militello
Aug. 17 Messina
Marsala July 23
Corleone July 21
Aug. 13 Randazzo
Aug. 6 Troina
Aug. 6 Adrano
Leonforte
Mount Etna
Sciacca
Caltanissetta July 18
Paternò
Catania Aug. 5
July 16 Agrigento
Gulf of Catania
Strait of Messina
38°N

Operation Husky
July 9–August 17, 1943

Licata
Gela
Comiso
Scoglitti
Ragusa
Ponte Grande Bridge
Syracuse
Cassibile
Avola
Noto
Pachino
37°N
Gulf of Noto

---→ British Eighth Army
—→ U.S. Seventh Army
July 18 Date Allies controlled city

miles 0 — 80
kilometers 0 — 80

13°E 14°E 15°E

Bradley U.S. II Corps
Patton U.S. Seventh Army
Montgomery British Eighth Army
Mediterranean Sea

Operation Husky As shown on this map, U.S. troops landed on the south coast of Sicily, to the west of the British Eighth Army, then advanced northward to Palermo before fighting their way eastward to Messina. British troops advanced slowly up Sicily's east coast from Syracuse against stout German defenses and reached Messina shortly after the Americans did.

"The most vivid change is the casual and workshop manner in which they now talk about killing."

WAR CORRESPONDENT ERNIE PYLE, OBSERVING HOW AMERICAN SOLDIERS HAD BEEN HARDENED BY COMBAT IN NORTH AFRICA

STORMING SICILY

Bernard Montgomery did not mince words. The Allied plan for Operation Husky—the code name for the invasion of Sicily—was, he said, a "hopeless mess." A firm believer in concentrating one's forces, he rejected a proposal for far-flung landings there and wanted them confined to a narrow stretch of Sicily's south coast and placed under his command. "I should be running Husky," he wrote. Officially, Eisenhower was running the show, but operational command of ground forces remained with his British deputy,

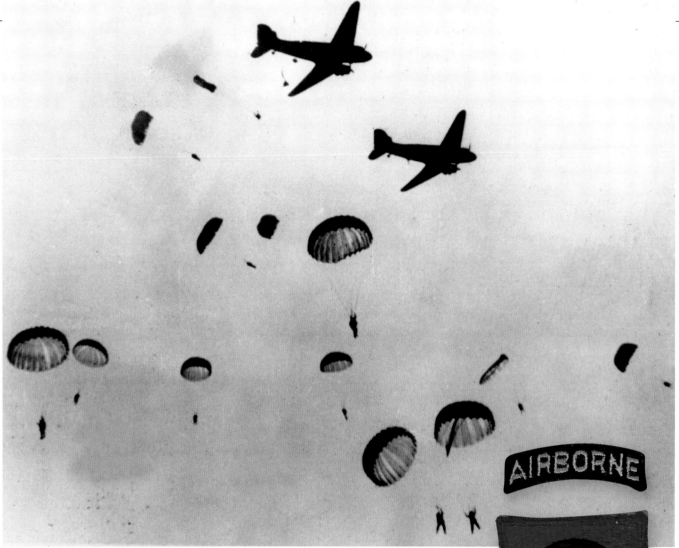

Alexander, who trusted in Monty's judgment. Ike, too, saw merit in Montgomery's plan, but placed the American troops bound for Sicily under Patton. Monty's Eighth Army would land near Syracuse and advance on Messina, at Sicily's northeastern tip, where they hoped to cut off Axis forces before they escaped across the strait to the Italian mainland. Patton's Seventh Army would land farther from Messina and guard the British flank and rear. Patton did not like playing second fiddle, but fell into line when Ike backed the revised plan. "I've been in this army 30 years," Patton said, "and when my superior gives me an order I say 'Yes, sir!' and then do my god-damnedest to carry it out."

No soldiers involved in Operation Husky had a more perilous task to carry out than the airborne troops assigned to land in Sicily on the night of July 9, 1943, and seize roads, bridges, and other objectives that could be used by the enemy to assail Allied forces as they came ashore early on July 10. "Many lives will be lost in a few hours," predicted Col. James Gavin of the U.S. 82nd Airborne Division, which was entering combat for the first time. The C-47 aircraft carrying Gavin's men and other regiments were scattered by heavy winds and dropped most of the paratroopers far from their designated landing zones.

"Each aircraft was more or less on its own," recalled Lt. Robert Piper of Gavin's 505th Parachute Infantry Regiment. "We finally picked up the Sicilian coast and were flying up

Descending on Sicily American paratroopers involved in Operation Husky descend from C-47 transports on July 10, 1943, shortly after the first airborne landings on Sicily occurred before dawn. Paratroopers of the U.S. 82nd Airborne Division wore the sleeve patch above.

"When I said 'Hi,' they responded with 'Heil Hitler.'"

Lt. Robert Piper, 505th Parachute Infantry Regiment

the Strait of Messina over near the British sector when the pilot admitted he wasn't sure where he was. I asked him to turn westerly and give me the green light when we were again over land." Piper and his men were less than four hundred feet above ground when they jumped. He landed in an olive tree and managed to free himself. Other paratroopers came down hard that night and broke bones or drifted over enemy positions and were shot before they reached the ground.

The first concern for those who landed unscathed was to find comrades and form companies, using passwords to distinguish friend from foe in the dark. (The call sign for paratroopers in Gavin's regiment was "George," to be answered by "Marshall.") Piper gathered up about a dozen men. Reckoning that they had landed east of their intended drop zone, they "immediately started moving west over rugged, rocky and barren country." Spotting a group of soldiers who were approaching in the gloom, he and his company had only a few seconds to identify and deal with them before becoming targets themselves. "When I said 'Hi,' they responded with 'Heil Hitler,'" Piper recalled, "and there was a brief firefight, which they lost!"

Most of the paratroopers in the 82nd were far from their objectives that morning, but they fared better than the British airborne forces, who landed in gliders, many of which were released too far from shore and plowed into the sea, drowning more than 200 men. Despite such calamities, small, determined groups of Allied airborne troops seized targets such as the Ponte Grande, a vital bridge in the British sector, and caused confusion among opposing forces inland as the greatest amphibious assault yet attempted unfolded on the coast. Seven Allied divisions (two

Traffic Jam British soldiers push a driverless jeep across a Sicilian beach while comrades form a chain to unload a landing craft. Hauling hundreds of vehicles and vast amounts of equipment through soft, deep sand on Sicily's shores was a slow business that delayed the Allied advance.

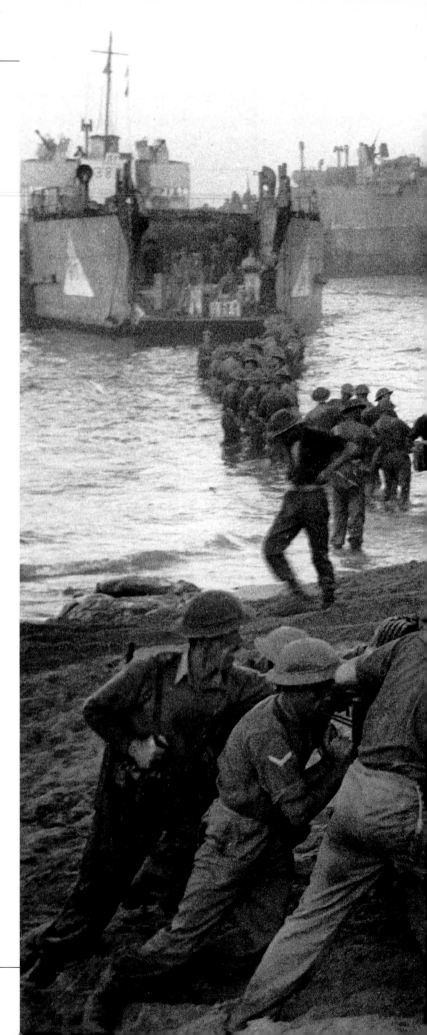

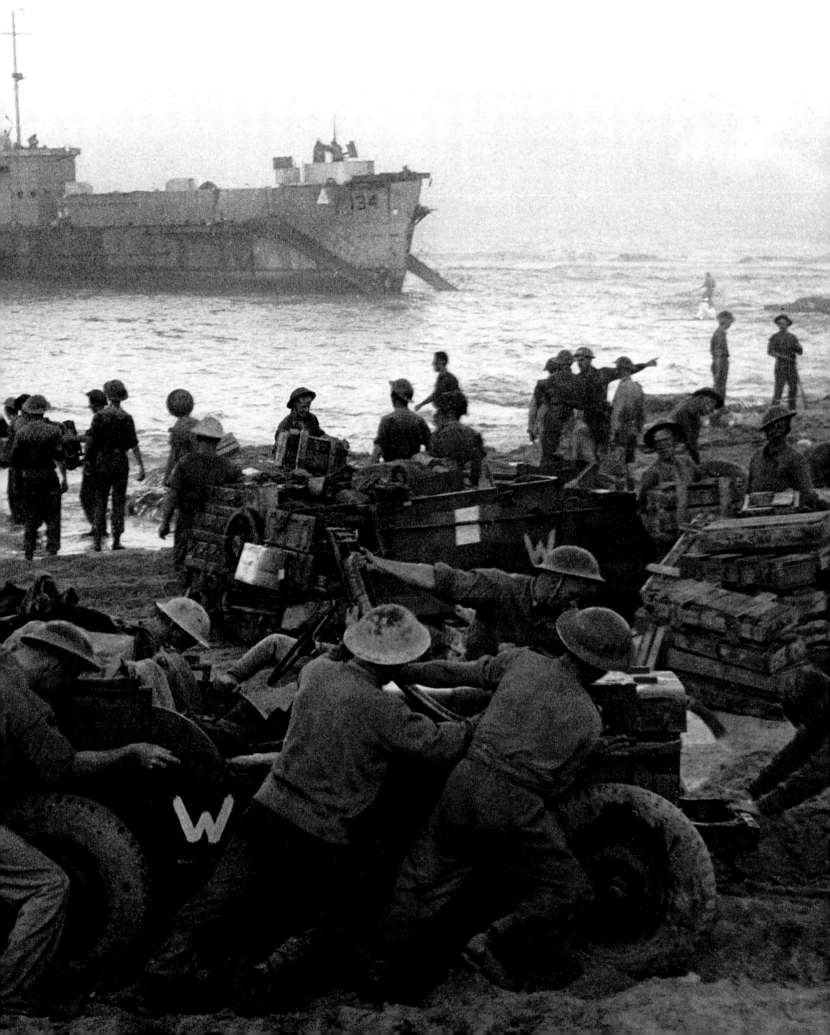

more than would later land at Normandy on D-Day) comprising more than 80,000 men were transported from North Africa, along with 600 tanks and thousands of other vehicles, by an armada of more than 3,000 ships and landing craft, including newly designed DUKWs that operated as boats at sea and trucks on land. That immense fleet "resembled a distant city" on the horizon, wrote Ernie Pyle. "It covered half the skyline . . . I hope no American ever has to see its counterpart sailing against us."

Heavy surf made the Allied landings on July 10 nauseating and treacherous. Enemy air strikes and land mines took their toll as the troops came ashore, but resistance on the beaches was lighter than Eisenhower had feared. Credit for that went partly to Allied intelligence officers, who could not hide the huge buildup for Operation Husky in North Africa but conducted ingenious deception campaigns that kept their foes guessing as to where the blow would fall. One such deception, known as Operation Mincemeat, used false papers planted on a corpse to suggest that the Allies would target Sardinia or Greece. Other ruses conducted shortly before the invasion began, when the threat to Sicily was obvious, indicated that the invaders would come ashore near the island's western tip, a long way from the actual landing zones. On July 10, one of the two German divisions in Sicily was far off to the west awaiting a possible invasion there. The other was closer

Medic in Action **Pvt. Harvey White,** a medic with the U.S. 3rd Infantry Division, administers blood plasma to Pvt. Roy Humphrey, wounded by shrapnel during the fighting on Sicily in August 1943. Army medical personnel wore an armband marked with a red cross *(below)*. In early 1945, those serving with infantry units in combat were awarded the Combat Medical Badge *(right)* in recognition of the risks they faced—and were paid an extra ten dollars a month.

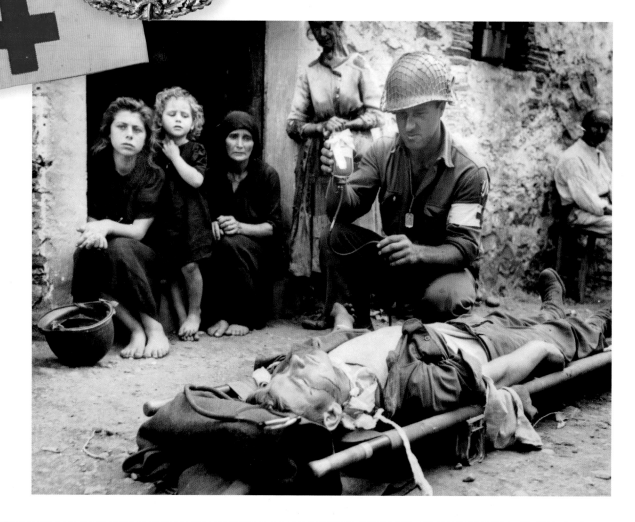

to where the Americans came ashore, but arrived there too late to disrupt the initial landings.

Some Italian troops fought the Allies intently, but many others were ill equipped and demoralized, having lost faith in Mussolini, now widely disdained by his own people as Hitler's lackey. Italians were soon surrendering in droves to the Allies, who could not handle them all at once. Sgt. Bill Mauldin of the 45th Infantry Division, who won fame for his wartime cartoons, wrote of those willing captives: "It's hard to work up a good hate for soldiers who are surrendering so fast you have to take them by appointment."

American troops and supplies were still coming ashore around the town of Gela on the morning of July 11 when the Hermann Göring Panzer Division—named for the chief of the Luftwaffe, to which their outfit was attached—attacked in force and advanced to within a half mile of the beach. "Situation critical. We are being overrun by tanks," reported an officer in the First Infantry Division, known proudly to its troops as the "Big Red One" for the scarlet number on their shoulder patch. Their commander, Maj. Gen. Terry Allen, appealed for armor to meet the threat, but many of the Seventh Army's tanks were stuck with other vehicles in thick sand on the beach. With only a few Shermans to throw into the battle, Allen relied mightily on his antitank gunners, who had honed their skills against panzers in North Africa. When an aide suggested withdrawing the division's hard-pressed troops, Allen shot back: "Hell, no. We haven't begun to fight. They haven't overrun our artillery yet." By midday, the Germans were being pounded by a lethal combination of artillery fire—including blasts from fearsome 155-mm Long Toms that could fire 95-pound projectiles up to 15 miles or pulverize tanks at short range—and salvos from Admiral Hewitt's warships offshore. The Germans "wisely concluded that the 26-ton Mark IV is no match for a cruiser," wrote Allen's corps commander, Bradley. The attackers soon took to their heels, leaving nearly half of their 60 tanks behind in flames.

The hardest losses for U.S. forces in Operation Husky occurred that night as C-47s flew in over Gela with another wave of paratroopers and were mistaken for enemy aircraft. Nearly two dozen planes were shot down, and several hundred men were killed or wounded. The sad fact was that another airborne assault was not needed to secure the beachhead or allow forces there to advance inland. It soon became clear that the Germans were shifting to a defensive stance that eased pressure on the American sector while making it harder for the British to advance toward Messina. On July 11, Field Marshal Kesselring flew to Sicily from mainland Italy to confer with his generals. An agile and adaptable commander, Kesselring recognized that the Allies were now too well established to be driven back into the sea. But with an additional 20,000 Germans troops, who began arriving that evening, his forces could make a stand around towering Mount Etna in northeastern Sicily and shield Messina.

Montgomery found his direct route to Messina—a narrow corridor between Mount Etna and Sicily's east coast—blocked by stout German defenses near Catania. So he sent his XXX Corps on a wide sweep to the west around that volcanic peak, which brought those troops into the path of Patton's forces as they advanced inland along Rte. 124, the only serviceable road for tanks and trucks in the area. Montgomery prevailed on General Alexander to shunt

Aid and Comfort This magazine cover shows a compassionate British medic carrying a Sicilian baby to an aid station to be weighed and fed. Many Sicilians went hungry and large numbers were injured as fighting raged across the island.

"It's hard to work up a good hate for soldiers who are surrendering so fast you have to take them by appointment."

SGT. BILL MAULDIN, 45TH INFANTRY DIVISION, AS ITALIAN TROOPS SURRENDERED IN DROVES

A Comic Look at GI Life

Sgt. Bill Mauldin drew on his own experiences as an infantryman in Sicily and Italy to produce cartoons that captured the essence of the private soldier's war. Mauldin's uncompromising look at the harsh and sometimes humorous existence of the ordinary GI—a term that originally meant "government issue" but came to signify any enlisted man—endeared him to millions of soldiers, who relished his sardonic sketches in the Army newspaper *Stars and Stripes*.

Born in New Mexico in 1921, Mauldin studied at the Academy of Fine Arts in Chicago.

After joining the National Guard, he became part of the 45th Infantry Division and drew cartoons for its newspaper. He served with the 45th in the Mediterranean until 1944, when he went to work full-time for *Stars and Stripes*. His most memorable cartoon characters were two bedraggled soldiers named Willie and Joe. "I drew pictures for and about the soldiers because I knew what their life was like and understood their gripes," Mauldin recalled. "I wanted to make something out of the humorous situations which come up even when you don't think life could be any more miserable." ■

"*Fresh, spirited American troops, flushed with victory, are bringing in thousands of hungry, ragged, battle-weary prisoners . . .*"
(*News item*)

The GI's View Bill Mauldin, pictured above sketching during the war, published an acclaimed account of soldier life, *Up Front (left)*, illustrated with cartoons he drew for *Stars and Stripes*. He won the Pulitzer Prize for his cartoons in 1945.

"Just gimme a coupla aspirin. I already got a Purple Heart."

"Damn fine road, men!"

"We must take Messina before the British."

LT. GEN. GEORGE S. PATTON

the Americans aside. "Monty wants the road right away," a deflated Patton told Bradley, whose corps would have to backtrack toward their landing zone to comply with Alexander's directive. "General Bradley executed this preposterous order silently and skillfully," wrote an aide, "but inwardly he was as hot as Mount Etna."

Unwilling to wait idly in the wings while Monty stole the show, Patton persuaded Alexander to "take the wraps off" and let his forces advance on Palermo, a major port in northwestern Sicily. That quick dash to Palermo, seized on July 23, brought Patton's army more Italian prisoners and a major supply base. But otherwise, wrote Bradley, "there was little to be gained in the west. Certainly there was no glory in the capture of hills, docile peasants, and spiritless soldiers."

Greater glory lay in beating Monty to Messina—a contest that unfolded when the British Eighth Army failed to crack the enemy's formidable Etna Line in the east. Belatedly, Alexander committed both armies to that task, with the Americans advancing along Sicily's north coast while the British pressed forward to their south. "This is a horse race in which the prestige of the U.S. Army is at stake," Patton declared. "We must take Messina before the British." That so-called race often slowed to a crawl, however, as the Germans fought fiercely and withdrew stubbornly, wrecking bridges and blocking tunnels behind them. It cost the First Infantry Division five hundred casualties and the better part of a week to pierce the Etna Line at Troina, Sicily's highest town. There was little left of the place when they got there, a reporter wrote, except weeping civilians, "torn streets, heaps of rubble that had been houses, grief, horror and pain."

On August 17, American troops entered Messina, arriving there a few hours ahead of the British. The Yanks had won the race by a nose. Yet the Allies had gained less through competition than they could have achieved through cooperation and coordination. In recent days, Kesselring had managed to evacuate more than 100,000 Axis troops and 10,000 vehicles across the Strait of Messina to the mainland. As Bradley

STAFF SGT. CHARLES BEARDSLEY
THE LONG ROAD TO PALERMO

Beardsley served with the 30th Regiment of the 3rd Infantry Division as Patton's troops crossed the rugged terrain of western Sicily at a grueling pace and captured Palermo.

As the day wore on water became more and more of a problem [and] by 5 p.m. we were starting to drink water from the horse troughs along the side of the road . . . As the night darkened the temperature lowered and it became a little more comfortable, but fatigue was a problem. We were now already down to less than half strength since many soldiers had dropped out from heat exhaustion, blisters and other foot problems.

From 10 p.m. on, every time we took a rest break, I fell asleep as soon as my butt hit the ground . . . At around 11 p.m. the men were dropping out from just pure exhaustion. The next day I saw a couple

> **"As the day wore on water became more and more of a problem [and] by 5 p.m. we were starting to drink water from the horse troughs along the side of the road."**

of men that were leading a mule carrying a heavy machine gun and ammo, which weighed around 250 pounds. They used up three mules this way. I saw the first one go down around noon . . .

About three miles down the road . . . the bridge had been blown. Everyone had to

climb down into a deep canyon about 300-feet deep to cross a dry riverbed and then climb up the other side. The enemy must not have realized they could have held us up for hours with just a couple machine guns properly placed. We continued on to our objective which we reached at 2 a.m. after twenty hours. The battalion started out with 800 men and by the time our objective was reached there were only 200 left since so many of the soldiers fell apart physically . . .

Now [a] town had to be taken, but fortunately there were only Italian soldiers there so it was just a matter of walking through, taking cover as you went and firing a few rounds that bounced off the stone walls. In 20 minutes the town was ours. When I reached the other side of town I was so completely exhausted there wasn't an ounce of strength left in me. My bones ached and even my skin was tired. I collapsed between the rows in a vineyard and didn't know a thing until the next morning . . .

The next day when we moved out we hiked through the area and we saw the destruction. There were many dead lying around bloated and smelling like something that would gag a maggot. It was my first real smell of rotting bodies on a battlefield but not to be the last . . . About four days later we reached Palermo meeting little resistance which was agreeable to us. We had covered 150 miles in six days and we needed a rest. ■

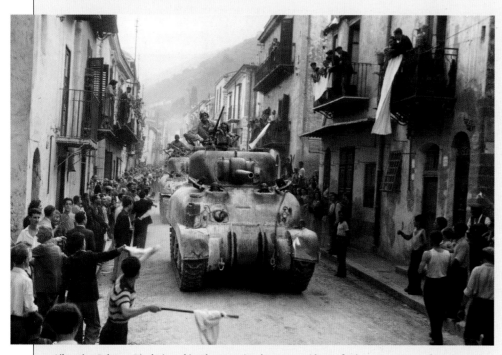

Liberating Palermo Displaying white sheets to signal a truce, residents of Palermo greet men of U.S. Second Armored Division, arriving in M4 Sherman tanks after Axis troops abandoned the city on July 23, 1943.

"You name them; I'll shoot them."

observed, this promising Allied campaign had come to an "unspectacular end"—one that allowed too many of their enemies to escape and fight again another day.

Patton basked briefly in glory after taking Messina, but was soon mired in scandal. Two soldiers in his army were charged with massacring Axis prisoners of war and court-martialed. Both men admitted to the deeds, but stated in their defense that Patton had urged them in pep talks to be merciless to their foes. As one soldier recalled, he told them "to kill the enemy wherever we found him . . . and not to fool around with prisoners. He said that there was only one good German and that was a dead one." One of the defendants was acquitted, and both cases were hushed up by the Army to shield American POWs from reprisals.

Another scandal involving Patton became public, however, when it was revealed that he had insulted and slapped two hospitalized soldiers in Sicily whom he considered shirkers. Patton called one of those men—suffering from what was then labeled shell shock—a "yellow son-of-a-bitch" and waved a pistol at him. "You ought to be lined up against a wall and shot," he railed. "I ought to shoot you myself right now, goddamn you!" Patton could have been court-martialed for that outburst, but Eisenhower chose instead to reprimand him and require him to make apologies. He later cut Patton down a notch by placing him under his temperamental opposite, Bradley, who remarked that for all Patton's skills as a commander, "he had not yet learned to command himself." To win this brutal war, however, Ike needed men like Patton, who told him on one occasion: "You name them; I'll shoot them."

THE COLLAPSE OF IL DUCE

Had Sicily been defended only by Italian troops, it would have fallen much sooner. The ease with which those disheartened soldiers yielded to the Allies signaled that Mussolini, who had ruled Italy with an iron fist for more than two decades, was losing his grip. From the start, he had been the junior partner in his so-called Pact of Steel with Hitler. When he tried to rival German conquests by invading the Balkans and North Africa, Il Duce had stumbled badly, forcing the Führer to bail him out. Heavy losses in those campaigns and in Russia had embittered Italians, who felt less affection for Germany—their foe in the last war—than for America, home to many Italian immigrants. "In Italy, we can rely only on the Duce," warned Hitler, who feared that Mussolini would be overthrown and made plans, if that happened, to seize control of Italy, an operation code-named Alaric after the Germanic chieftain who sacked Rome.

On July 25, 1943, six days after the first Allied bombing raid on Rome, Mussolini met with King Victor Emmanuel III, who had been reduced to a ceremonial role when Il Duce

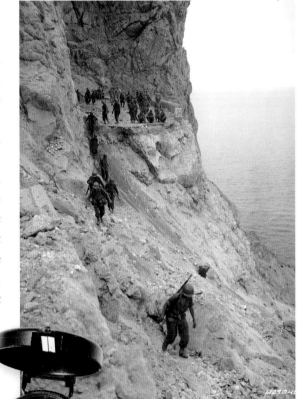

Sidetracked **Soldiers of the Third Infantry Division pick their way down a steep cliff after German engineers used explosives to block the highway along Sicily's north coast and slow Patton's advance toward Messina. For cross-country navigation during World War II, the U.S. Army relied mainly on the Model 1938 lensatic compass (inset).**

> ## "At this moment, you are the most hated man in Italy."
>
> KING VICTOR EMMANUEL III
> TO BENITO MUSSOLINI

Despised Leader A bullet-riddled portrait of Italian dictator Benito Mussolini hangs pinned to tree by a bayonet soon after the Allied invasion of Sicily, which led to Mussolini's downfall. Many Sicilians chafed under Fascist rule and resented the intruding Germans, who placed their stamp on Italy by installing their own road signs.

seized power but remained popular in Italy. Mussolini expected the king to back him in his feud with the Fascist Grand Council, which had turned against him. But Victor Emmanuel told the faltering dictator that it was time for him to step down. "At this moment, you are the most hated man in Italy," he said. "You have not a single friend left, except me." Mussolini was arrested that evening and replaced by Field Marshal Pietro Badoglio, who pledged that Italy would remain loyal to Germany but entered into secret peace talks with the Allies. Hitler was not fooled and set Operation Alaric in motion while those talks were under way in August. Eight divisions led by Erwin Rommel would occupy northern Italy, where Mussolini would later be installed as a Fascist figurehead after German commandos freed him from prison in September. Other German forces led by Kesselring, including troops withdrawn from Sicily, would patrol the country from Rome southward and guard against Allied landings there.

In making plans to invade mainland Italy, Eisenhower had to reckon with strong German resistance. His task was further complicated by preparations in Britain for Operation Overlord—a cross-Channel invasion of France in 1944—which limited the number of troops, landing craft, and other resources committed to Italy. Ike and his staff considered ways of expediting the Italian campaign, including an airborne assault on Rome that would spare troops from having to fight their way to that city from Italy's toe, 300 miles away. But any quick leap to Rome was rejected as too risky. Instead, Allied troops would land in southern Italy, closer to their staging grounds.

On September 3, Montgomery's Eighth Army came ashore virtually unopposed at Reggio di Calabria, just across the Strait of Messina. The U.S. Fifth Army, which was led by Lt. Gen. Mark Wayne Clark and included some British forces, would land six days later at Salerno, roughly halfway up the coast to Rome. The plan called for Montgomery's and Clark's forces to link up, take Naples, and advance on Rome, but no one knew what the Allies would do next if and when they seized Italy's capital.

"Before we embark on major operations on the mainland of Europe, we must have a master plan," objected Montgomery, who concluded that there was no such plan. Like many costly campaigns during World War II, this one was launched not because the territory at stake was crucial or the strategic objective was clear but simply because the enemy was there in strength and showed no signs of yielding until he was defeated on all fronts and his strength was gone.

Few of the soldiers who embarked on this long and painful Italian venture knew what they were in for. On the evening of September 8, as Clark's forces prepared to land at Salerno, they learned that Italy had surrendered. Unaware that German troops had stepped into the breach and were ready to fight them tooth and nail, they began celebrating. "The war is over," cheered sailors on the destroyer U.S.S. *Mayo*. Gleeful soldiers of the Second Battalion Scots Guards asked their bagpiper to compose a tune for their victory march through Naples. "I never again expect to witness such scenes of sheer joy," wrote an aide to Clark. "Speculation was rampant, and it was all good . . . We would dock in Naples harbor unopposed, with an olive branch in one hand and an opera ticket in the other." Officers

who knew better tried to bring men to their senses. "Stop it, you bloody fools," yelled one British captain, who foresaw bloody days ahead. Maj. Gen. Ernest Dawley, commander of the U.S. VI Corps, told troops that they would have to fight like "Comanches if we mean to get ashore and stay there."

STRUGGLE AT SALERNO

It was dark as hell, and we were just waiting out there," recalled an American soldier whose landing craft lurked offshore as the first wave of troops hit the beach at Salerno before dawn on September 9. "If we thought we were going to sneak ashore, we were nuts," he told author and war correspondent John Steinbeck. "They had machine guns in the sand dunes and 88's [artillery] on the hills." As he and other troops in the landing craft waited their turn to enter the fight, they saw soldiers stumble onto the beach—illuminated by tracer fire and bursting shells—and collapse. It was like watching a war movie in a dark theater. "Then all of a sudden it came on me that this wasn't a moving picture," he said. "Those were guys getting the hell shot out of them . . . I was just getting real scared when

Dictator's Reprieve Benito Mussolini prepares to board a German Fieseler Storch liaison aircraft in September 1943 after being freed from captivity at the Campo Imperatore Hotel in Italy's Abruzzi mountains by German commandos, who conducted a daring glider-borne rescue mission on Hitler's orders. Installed as Hitler's puppet in German-occupied northern Italy, Mussolini was seized by Italian partisans in April 1945 and executed.

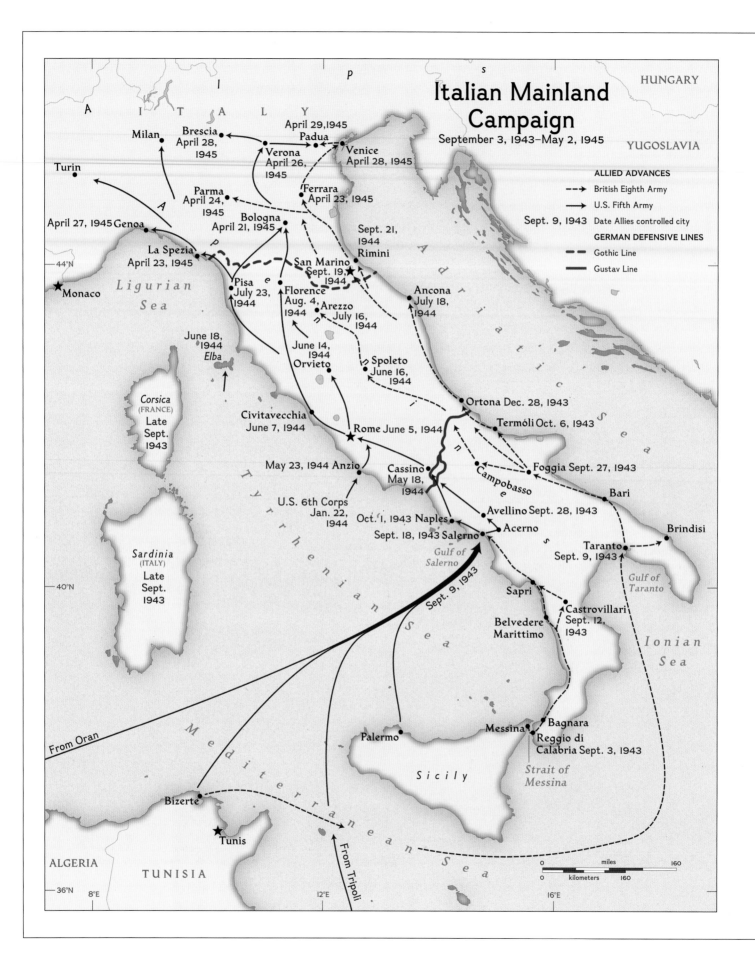

Italian Mainland Campaign

September 3, 1943–May 2, 1945

ALLIED ADVANCES

- – – – British Eighth Army
- ——→ U.S. Fifth Army
- Sept. 9, 1943 Date Allies controlled city

GERMAN DEFENSIVE LINES

- – – – Gothic Line
- —— Gustav Line

HUNGARY

YUGOSLAVIA

I T A L Y

Alps

Milan
Brescia April 28, 1945
April 29,1945 Padua
Verona April 26, 1945
Venice April 28, 1945

Turin

Parma April 24, 1945
Ferrara April 23, 1945

Sept. 21, 1944
Rimini

Genoa April 27, 1945

La Spezia April 23, 1945

San Marino Sept. 19, 1944

Apennines

Bologna April 21, 1945

Pisa July 23, 1944
Florence Aug. 4, 1944
Arezzo July 16, 1944

Ancona July 18, 1944

Monaco

Ligurian Sea

June 18, 1944 *Elba*

June 14, 1944 Orvieto

Spoleto June 16, 1944

Corsica (FRANCE) Late Sept. 1943

Ortona Dec. 28, 1943

Civitavecchia June 7, 1944

Rome June 5, 1944
Termóli Oct. 6, 1943

May 23, 1944 Anzio

Cassino May 18, 1944
Campobasso

Foggia Sept. 27, 1943

Sardinia (ITALY) Late Sept. 1943

U.S. 6th Corps Jan. 22, 1944

Oct. 1, 1943 Naples
Avellino Sept. 28, 1943
Acerno

Bari

Tyrrhenian Sea

Sept. 18, 1943 Salerno

Gulf of Salerno

Brindisi

Taranto Sept. 9, 1943

Gulf of Taranto

Sapri

Adriatic Sea

Ionian Sea

Sept. 9, 1943

Belvedere Marittimo

Castrovillari Sept. 12, 1943

From Oran

Mediterranean Sea

Palermo

Messina
Bagnara
Reggio di Calabria Sept. 3, 1943

Strait of Messina

Bizerte

Sicily

From Tripoli

Tunis

ALGERIA

TUNISIA

| 0 | miles | 160 |
| 0 | kilometers | 160 |

we got the order to move in, and I swear that is the longest trip I ever took, that mile to the beach. I thought we'd never get there . . . Then we bumped the beach and the ramps went down and I hit the water up to my waist."

Unlike the landings on Sicily, the invasion at Salerno was anticipated by the Germans, who had one armored division ready to greet the Allies when they arrived that morning and more on the way. Soldiers who made it ashore unscathed like the man Steinbeck interviewed remained at great risk as the day dawned. Enemy gunners perched on slopes above the beach continued to pound the incoming Allies, who were divided by the Sele River as it entered the sea, separating the Americans to the south from British forces to the north. In the morning light, they made conspicuous targets for German warplanes and tanks, which caused havoc before DUKWs delivered artillery to help deal with them. Once again, as in Sicily, Allied warships brought their big guns to bear and blasted enemy positions, clearing paths for troops on the beach, who advanced a few miles inland by nightfall. They made further progress over the next two days, but Germans clung to the high ground overlooking the Salerno plain and prepared to counterattack. Earlier in the month, Patton had reviewed plans for the invasion and predicted where that blow would fall. "Just as sure as God lives," he said, pointing to the Sele on a map, "the Germans will attack down that river."

Patton's recent problems kept him away from the action at Salerno. It was Clark, an officer of lofty ambition but little battle experience, who decided to land troops on both sides of the river. The risks involved in doing so did not fully dawn on him until he came ashore in the American sector on September 12 and established his headquarters at a villa near the Sele River and its tributary, the Calore. The corridor between those two rivers seemingly offered a path by which his troops could advance and break out, but instead the Germans used it as a path to break in.

By evening, elements of several panzer divisions were bearing down on the American sector, forcing Clark to withdraw to a hastily improvised command post near the beach. The counterattack intensified the next day as armored columns overran exposed units of the 36th Infantry Division, made up largely of inexperienced soldiers from the Texas National Guard. One battalion lost more than 500 men captured or killed in a matter of hours. Those who withstood frontal and flank attacks had to watch their rear as they pulled back. "Tonight, you're not fighting for your country," one officer told his men bluntly as Germans enveloped them, "you're fighting for your ass."

Heavy artillery fire halted the panzers that evening, but Clark feared that they would soon renew their advance along the Sele and reach the sea, driving a wedge through his forces with dire results. He asked Admiral Hewitt to prepare to remove troops from the threatened American sector and ferry them northward to the British sector. But Hewitt—who had a new German threat to contend with in the form of radio-guided glide bombs that badly damaged several warships—worried that using landing craft to extract troops would prove disastrous and was relieved when other measures eased the pressure on Clark. On the night

"It was dark as hell, and we were just waiting out there . . . I was just getting real scared when we got the order to move in, and I swear that is the longest trip I ever took, that mile to the beach."

AN AMERICAN SOLDIER, AFTER LANDING AT SALERNO

Operation Avalanche **Antiaircraft fire from Allied warships lights the sky over Salerno in September 1943 to shield troops who landed on the beach there from German warplanes. The German Army patch above was retrieved near Salerno by a soldier of the U.S. 34th Infantry Division after the Germans withdrew from Salerno to the Winter Line, also known as the Gustav Line** *(shown on map, opposite),* **from which they later retreated to the Gothic Line.**

"We'll stay here until hell freezes over if necessary."

Lt. Col. William Darby
at Chiunzi Pass

of September 13, Maj. Gen. Matthew Ridgway, commander of the 82nd Airborne, sent in a battalion of 1,300 paratroopers, who landed safely among the American soldiers, offering them hope that more help would soon be on the way. Morale improved further the next day when the Allies renewed the naval bombardment and air strikes that had helped push back the enemy several days earlier and would do so again now. On September 18, the Germans began withdrawing from Salerno before Montgomery's army could arrive from the south and place them in an even worse bind.

No U.S. troops who fought at Salerno fared better against their tough foes than Lt. Col. William Darby's Rangers. Trained rigorously by British commandos, they seized the Chiunzi Pass, on the Allied left flank, on the first day of the battle and held it tenaciously. "We'll stay here until hell freezes over if necessary," Darby vowed. In late September, the Germans abandoned attempts to reclaim that pass, and the Allies proceeded northward to Naples. Entering that city on October 1, Clark found windows shuttered and the streets empty. Some Neapolitans came out later to cheer the troops, but many were left speechless by the damage done to their city after Italy surrendered and the Germans became their enemies. Some of the actions taken by German occupiers before they abandoned Naples could be justified on military grounds—such as wrecking railroads and port facilities to deny them to Allied forces—but other measures served mainly to punish the populace, including destroying the water and sewage systems in Naples and torching libraries filled with rare books and manuscripts. (Elsewhere, Germans looted public and private art collections and hauled their treasures away.) Hundreds of structures in Naples were demolished to block streets, and bombs were placed in public buildings and timed to detonate after the Germans departed. One blast shattered the city's main post office on October 7, killing or wounding

Battered and Looted Above, a boy embraces a crippled companion in the streets of war-torn Naples after German occupiers left parts of that city in a shambles. At right, German soldiers display a painting taken from the Uffizi Museum in Florence, Italy. The Germans looted more than 800 paintings and sculptures from Italian collections.

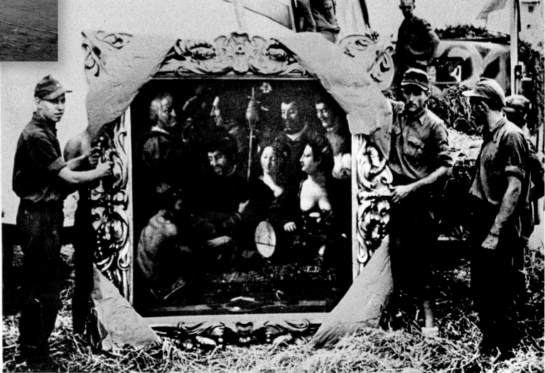

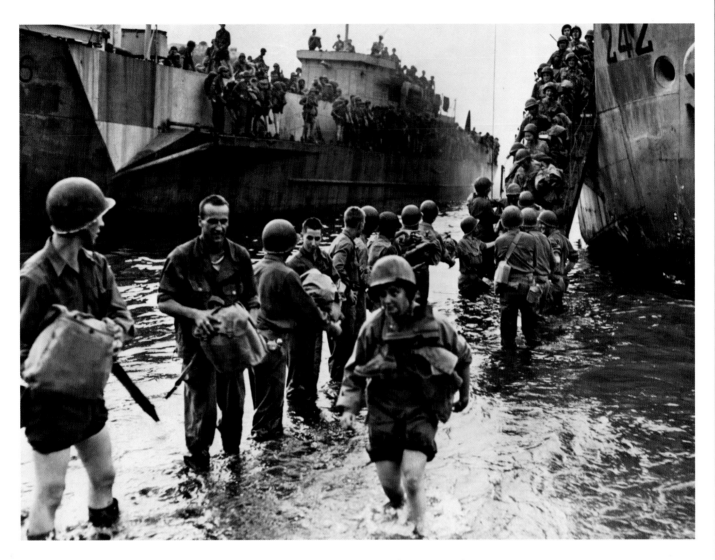

scores of civilians and soldiers. "The first two floors were blown completely away," said one witness. "Chunks of steel and marble were thrown as far as 100 yards."

The devastation in Naples was part of a larger German campaign to make Italy and its people pay dearly for abandoning the Axis. More than a million Italian troops were detained by German authorities. Most refused to fight for the Germans and were classified as military internees rather than prisoners of war, thus denying them any rights under the Geneva Convention. Nearly 700,000 of those internees ended up as slave laborers in German camps, along with millions of other captives, many of them civilians seized in eastern European countries. Other victims of the German occupation included Italian Jews, who had not been rounded up under Mussolini but were now at risk of being seized by Nazi agents and sent to concentration camps. Nearly 10,000 Italian Jews suffered that fate, but many more were harbored by sympathetic neighbors, priests, and officials who risked their own lives to save them.

The Allied war effort brought misery and death to many civilians, including hundreds of thousands of people who perished in massive bombing raids on German and Japanese cities. But Allied commanders like Eisenhower firmly believed that they were engaged in a

Beached at Naples A U.S. Army nurse wades ashore from a British landing craft at a beach near Naples as other nurses descend the gangplank and hand their packs to troops standing by to assist them. The demolition of the city's docking facilities by the Germans meant that all supplies and personnel had to land on the beaches, but hardworking Allied construction and salvage crews repaired the docks within four days.

PRIMO LEVI
DEPORTATION FROM ITALY TO AUSCHWITZ

Italian chemist Levi was arrested by Italian Fascists as a partisan in 1943 and deported by Germans with other Jews to the concentration camp at Auschwitz in February 1944.

They loaded us on to the buses and took us to the station of Carpi. Here the train was waiting for us, with our escort for the journey. Here we received the first blows—and it was so new and senseless that we felt no pain, neither in body nor in spirit. Only a profound amazement—how can one hit a man without anger?

There were twelve goods wagons [freight cars] for six hundred and fifty . . . in mine we were only forty-five, but it was a small wagon. Here then, before our very eyes, under our very feet, was one of those notorious transport trains, those which never return, and of which, shuddering and a little incredulous, we had so often

> **"Two young mothers, nursing their children, groaned night and day, begging for water . . . the hours of darkness were nightmares without end."**

heard speak . . . closed from the outside, with men, women and children pressed together without pity, like cheap merchandise . . .

The doors had been closed at once, but the train did not move until evening. We had learnt of our destination with relief, Auschwitz—a name without significance for us at the time, but it at least implied some place on this earth.

The train traveled slowly, with long unnerving halts. Through the slit, we saw the tall pale cliffs of the Adige Valley and the names of the last Italian cities disappear behind us . . . We suffered from thirst and cold—at every stop we clamored for water, or even a handful of snow, but we were rarely heard—the soldiers of the escort drove off everybody who tried to approach the convoy. Two young mothers, nursing their children, groaned night and day, begging for water. Our state of nervous tension made the hunger, exhaustion and lack of sleep less of a torment. But the hours of darkness were nightmares without end . . .

Through the slit, known and unknown names of Austrian cities, Salzburg, Vienna, then Czech, finally Polish names. On the evening of the fourth day the cold became intense—the train ran through interminable black pine forests, climbing perceptibly. The snow was high. It must have been a branch line as the stations were small and almost deserted, during the halts, no one tried any more to communicate with the outside world—we felt ourselves by now "on the other side."

There was a long halt in open country—the train started up with extreme slowness, and the convoy stopped for the last time, in the dead of night, in the middle of a dark and silent plain. That dark and silent plain was Auschwitz. ■

Destination Auschwitz Italian Jews peer from the narrow window of a German boxcar in late 1943. They were among more than 2,000 Jewish men, women, and children turned over to the Germans by Italian Fascist authorities for transportation to Auschwitz. Others Jews in Italy were rounded up by German authorities.

necessary struggle against an evil far greater than any harm done by their own forces. "We are told the American soldier does not know what he is fighting for," Ike said late in the war when the full magnitude of Nazi war crimes came to light. "Now, at least, he will know what he is fighting *against.*"

TENSIONS AT TEHRAN

As 1943 drew to a close, the Allies had yet to draw up a master plan for winning the war in Europe. American and British forces were now cooperating closely in Italy, but the Russians were waging their own bitter struggle against German invaders, who were falling back but remained in Soviet territory. President Roosevelt and Prime Minister Churchill were in constant communication, but the two did not confer jointly with Joseph Stalin until the Big Three, as they were known, met on November 30, 1943, in the Iranian capital of Tehran—a site chosen because Iran had sided with the Allies after being occupied by British and Soviet troops.

A vast gulf separated Stalin from the two Western leaders at that conference. He feared that they would postpone Operation Overlord—allowing Hitler to throw more troops against the Soviets—and might even make a separate peace with Germany, despite Roosevelt's declaration that the Allies would accept no terms other than unconditional surrender. Roosevelt

"We are told the American soldier does not know what he is fighting for. Now, at least, he will know what he is fighting *against.*"

GEN. DWIGHT EISENHOWER, AFTER NAZI WAR CRIMES CAME TO LIGHT

Big Three Stalin, Roosevelt, and Churchill sit side by side in the Iranian capital of Tehran after gathering there to discuss Allied strategy on November 28, 1943. Churchill wears the uniform of a Royal Air Force air commodore and Stalin the uniform of a marshal of the Soviet Union.

"I believe man might destroy man and wipe out civilization."

WINSTON CHURCHILL AT TEHRAN

and Churchill were concerned that if Russians pushed the Germans back to Berlin and occupied Poland and other countries, Stalin would make a mockery of their stated purpose, which was to defeat totalitarianism and defend democracy. As Roosevelt declared before the United States entered the conflict, America's goal was to help build "a world founded upon four essential freedoms": freedom of speech, freedom of worship, freedom from want, and freedom from fear. Nothing in Stalin's past suggested that he would promote or preserve those freedoms in any country under his control.

The simmering tensions boiled over at dinner on the second night of the conference. Stalin taunted Churchill by suggesting that his reluctance to launch Overlord stemmed from his "secret affection" for Germany. Churchill let that pass but was appalled when Stalin declared that when the war ended, "at least 50,000 and perhaps 100,000 German commanders must be physically liquidated." Churchill knew for a fact that Soviet agents had executed 10,000 Polish officers and buried them in a mass grave after Stalin and Hitler carved up that country as part of their short-lived Nonaggression Pact in 1939. "The British parliament and public," Churchill told Stalin, "will never tolerate mass executions." Stalin reiterated that 50,000 German officers must be shot, to which Churchill replied: "I would rather be taken out into the garden here and be shot myself than sully my own and my country's honor by such infamy." Unlike the outspoken Churchill, Roosevelt often disguised his true thoughts and feelings behind a mask of geniality. He chose to treat Stalin's threat as a joke and remarked that perhaps they could compromise by shooting only 49,000 officers. But others at the dinner shared Churchill's impression that Stalin was in earnest. Churchill knew of secret American efforts to develop an atomic bomb and came away from his confrontation with Stalin fearing the consequences if this conflict did not end hostilities between the world's great powers. "There might be a more bloody war," he told his physician that night. "I believe man might destroy man and wipe out civilization."

The one bond holding the Big Three together was their mutual determination to defeat Hitler. Before leaving Tehran, they agreed that Operation Overlord would be conducted in the spring of 1944. "Who will command Overlord?" Stalin asked. "Nothing will come out of the operation unless one man is made responsible." The decision lay with Roosevelt because the U.S. would commit most of the troops and supplies needed to liberate France and invade Germany. He put Stalin off and left Tehran undecided as to who would be supreme commander of that supreme effort. The leading candidate was U.S. Army Chief George Marshall. Roosevelt did not want to part with Marshall, a highly respected figure in Washington with great influence in Congress. At the same time, he thought that Marshall

Loaded for Combat Most American soldiers in Italy wore a standard U.S. Army field jacket like the one shown here and were armed with the semiautomatic .30-caliber M1 rifle or the lighter-weight M1 carbine *(above)*. The carbine was carried by many officers and paratroopers and by infantrymen who had bulky weapons to haul such as machine guns or mortars. U.S. troops on the move were often heavily loaded, like the men of the African-American 92nd Infantry Division *(opposite)*, shown advancing through Italy's Apennine Mountains in early 1945.

LT. CLARENCE "LUCKY" LESTER

A TUSKEGEE AIRMAN OVER ITALY

Lester was among the Tuskegee Airmen in the 99th Fighter Squadron, 332nd Fighter Group, 15th Air Force. On July 18, 1944, he downed three German fighters within six minutes over Italy.

We were flying a loose combat formation, 200 feet apart and zig-zagging. The flight leader commanded "hard right turn and punch tanks" . . . I saw a formation of Messerschmitt Bf 109s straight ahead, but slightly lower; I closed to about 200 feet and started to fire. Smoke began to pour out of the 109 and the aircraft exploded. I was going so fast I was sure I would hit some of the debris from the explosion, but luckily I didn't.

As I was dodging pieces of aircraft, I saw another 109 to my right, all alone

> **"I looked down to see the enemy pilot emerge from his burning aircraft. I remember seeing his blonde hair as he bailed out at approximately 8,000 feet."**

on a heading 90 degrees to mine, but at the same altitude. I turned onto his tail and closed to about 200 feet while firing. His aircraft started to smoke and almost stopped. My closure was so fast I

began to overtake him. When I overran him, I looked down to see the enemy pilot emerge from his burning aircraft. I remember seeing his blonde hair as he bailed out at approximately 8,000 feet.

By this time I was alone and looking for my flight mates when I spotted the third 109 flying very low, about 1,000 feet off the ground. I dove to the right behind him and opened fire . . . as I did a diving turn, I saw the 109 go straight into the ground." ∎

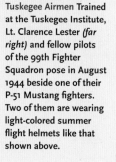

Tuskegee Airmen Trained at the Tuskegee Institute, Lt. Clarence Lester *(far right)* and fellow pilots of the 99th Fighter Squadron pose in August 1944 beside one of their P-51 Mustang fighters. Two of them are wearing light-colored summer flight helmets like that shown above.

deserved the chance to win fame as a commander abroad. As Roosevelt said to Eisenhower when he stopped to visit him on his way to Tehran: "Ike, you and I know who was the chief of staff during the last years of the Civil War, but practically no one else knows." Roosevelt was referring to Henry Halleck, who oversaw the Union Army in Washington while Ulysses Grant and William Sherman won lasting glory in the field. Roosevelt did not want his Army chief to end up like Halleck: "I hate to think that 50 years from now practically nobody will know who George Marshall was."

The President shared those thoughts with Eisenhower because he would be called on to serve as acting chief in Washington if Marshall became supreme commander in Britain. Marshall, who had raised Ike to prominence and knew that his command experience in the Mediterranean qualified him to take charge of Overlord, scrupulously declined to campaign for that prestigious appointment. He told Roosevelt that "the issue was too great for any personal feelings to be considered" and that he would honor the President's decision. Roosevelt chose Eisenhower to be supreme commander, in part because he was more acceptable and more attuned to the British than Marshall was, but also because he valued his chief so highly. "I feel I could not sleep at night with you out of the country," Roosevelt told him. As it turned out, Marshall would long be remembered, not just for all he did in Washington to win the war but for his inspired Marshall Plan, which helped rebuild postwar Europe.

Nisei GIs **Lt. Gen. Mark Wayne Clark inspects Japanese-American soldiers of the 442nd Regimental Combat Team in northern Italy in 1944. The 442nd was composed of Nisei (Japanese Americans born in the U.S.), who proved their loyalty by fighting with distinction in Italy, southern France, and Germany.**

HARD ROAD TO ROME

Eisenhower's departure from the Mediterranean in December did not bode well for Allied operations there. Joining him soon in Britain to prepare for Overlord would be other accomplished commanders—including Patton, Bradley, and Montgomery—as well as seven Allied divisions, which left Italy at a time when the Germans were being reinforced and strengthening their defenses. Since pulling back from Salerno in September, Field Marshal Kesselring had formed a forbidding barrier known as the Winter Line, which snaked across the mountainous Italian peninsula north of Naples and barred the way to Rome. "Don't worry," said General Clark, who remained in Italy as commander of the Fifth Army, "I'll get through the Winter Line all right, and push the Germans out." But smashing that line would make the battle at Salerno seem like a skirmish by comparison.

Depleted by the demands of Overlord, Clark and his British superiors—General Alexander and Field Marshal Henry Maitland Wilson, Ike's successor in the Mediterranean—needed all the help they could get. Help soon arrived from various forces who joined the Allies in a broad coalition known as the United Nations (today's UN was not founded until war's end). Clark's army was bolstered by the French Expeditionary Corps, consisting of Algerians, Moroccans, Tunisians, and French North Africans who cast their lot with the Allies when the Vichy regime collapsed. Led by Gen. Alphonse Pierre Juin, an Algerian-born French patriot, they were adept at mountain warfare and accompanied by tribesmen

> ## "Don't worry, I'll get through the Winter Line all right, and push the Germans out."
>
> LT. GEN. MARK CLARK,
> COMMANDER OF THE
> U.S. FIFTH ARMY

"We never take prisoners. After all, they started it."

AN OFFICER IN THE POLISH II CORPS ON THEIR GERMAN FOES

called Goumiers who relished close combat with knife in hand. The British Eighth Army, now commanded by Gen. Oliver Leese, had long been a multicultural force, whose recruits included Rajputs from India, Ghurkas from Nepal, and Maoris from New Zealand, among others. Joining them for the punishing assault on the Winter Line were Canadians, South Africans, and more than 50,000 Polish troops. The Poles' leader, Lt. Gen. Wladyslaw Anders, had been captured when Russia invaded eastern Poland in 1939 and detained for more than a year in Moscow's dreaded Lubyanka Prison before being released to fight the Germans, whom Anders hated for devastating his homeland even more than he did the Soviets. "We never take prisoners," said one officer in Anders's Polish Corps of their German foes. "After all, they started it."

U.S. forces fighting in the Mediterranean were ethnically diverse as well, including Hispanics in the 36th Infantry Division, several of whom were cited for bravery at Salerno, and Native Americans from various western tribes in the 45th Infantry Division, known as the "Thunderbirds." The 442nd Infantry Regiment, made up of Japanese Americans, would enter combat in Italy in the summer of 1944, as would the African-American 92nd Infantry Division. Black troops of the Second Cavalry Division had arrived earlier in North Africa, but were relegated to noncombat duty, as were many other black units in an Army that remained racially segregated and riddled with prejudice.

Among the African Americans who defied doubters and proved themselves in battle were the Tuskegee Airmen of the 99th Fighter Squadron, who trained at the Tuskegee Institute in Alabama and flew missions in Sicily and Italy with the 15th Army Air Force. Their commander, Lt. Col. Benjamin Davis, had endured more than the usual hazing at West Point. During his four years at the academy, white classmates refused to speak to him. He and his fellow airmen were at first given little opportunity to test their skills against enemy pilots by commanders, one of whom stated that the "negro type has not the proper reflexes to make a first-class fighter pilot." When Lt. Gen. Ira Eaker took charge of Allied air forces in the Mediterranean in late 1943, however, he overruled such objections. Thrown into the thick of the fighting over central Italy in January 1944, the 99th Fighter Squadron downed more than a dozen German warplanes in two days.

Air power was crucial to Allied success in the Mediterranean and in Europe at large. From bases in southern Italy, bombers struck targets vital to the German war effort, including heavily defended oil refineries at Ploesti, Romania, which were blasted repeatedly in raids that cost the lives of thousands of airmen but reduced the flow of oil to German factories and armed forces substantially. When crews learned in the briefing room that Ploesti was their target, one bomber pilot in the 15th Air Force recalled, they reacted with "half-stifled

German Skullduggery **The Anzio beachhead is portrayed as a death trap in this German propaganda leaflet, air-dropped to Allied troops to break their morale. The text states, "The Beach-Head has become a Death's Head. It is welcoming you with a grin, and also those who are coming after you across the sea for an appointment with death."**

War Trophy **British and South African troops show off a Nazi flag captured at Cassino as bulldozers clear a path through the rubble of the bombed-out town in May 1944, shortly after German troops retreated.**

groans" and shifted in their seats "as if to move out of harm's way . . . The man beside me leaned forward and muttered, 'Oh, Christ, here we go.' " Ploesti missions were so perilous that each one counted as two in the number required for airmen to complete their tour of duty until mid-1944. By then, the German fighter squadrons defending the refineries had been degraded, but airmen continued to suffer heavy losses to antiaircraft batteries at Ploesti and challenged the presumption at headquarters that the mission was now less hazardous. After one costly raid, members of the 449th Bomber Group invited their general "to visit Ploesti on our next mission—single sortie! No flak vest will be issued."

Allied fighters and bombers also flew numerous missions against enemy bases and supply lines in Italy. Close air support of ground troops attacking the Winter Line was hampered by bad weather, however, and often failed to dislodge entrenched German defenders. Before leaving Italy to join Eisenhower in Britain, Montgomery expressed skepticism about trying to overcome those stout enemy defenses in a season when frequent storms reduced roads to mud and flooded rivers. "I do not think we can conduct a winter campaign in this country," he wrote. "If I remember, Caesar used to go into winter quarters—a very sound thing to do!" But this was a war without letup, and those left in charge of the Italian campaign had little choice but to continue seeking ways of puncturing the Winter Line, come hell or high water. It was a grueling process of trial and error, and the errors were costly. By January 1944,

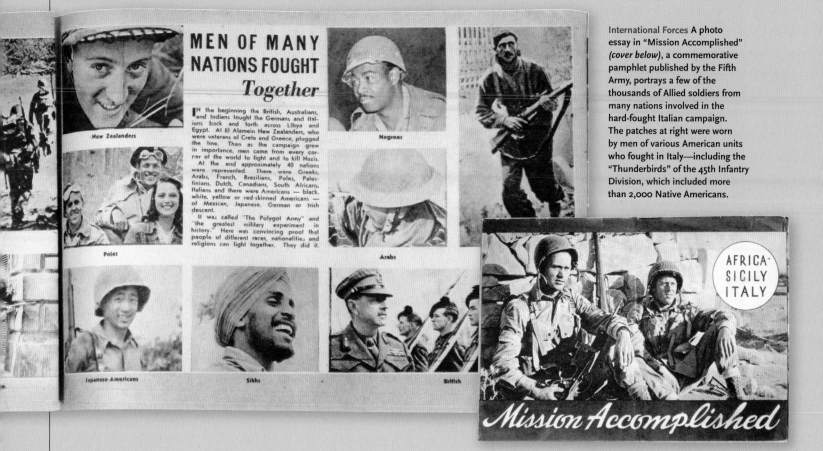

MEN OF MANY NATIONS FOUGHT *Together*

IN the beginning the British, Australians, and Indians fought the Germans and Italians back and forth across Libya and Egypt. At El Alamein New Zealanders, who were veterans of Crete and Greece, plugged the line. Then as the campaign grew in importance, men came from every corner of the world to fight and to kill Nazis.

At the end approximately 40 nations were represented. There were Greeks, Arabs, French, Brazilians, Poles, Palestinians, Dutch, Canadians, South Africans, Italians and there were Americans — black, white, yellow or red-skinned Americans — of Mexican, Japanese, German or Irish descent.

It was called "The Polyglot Army" and "the greatest military experiment in history." Here was convincing proof that people of different races, nationalities and religions can fight together. They did it.

New Zealanders

Poles

Japanese-Americans

Negroes

Arabs

Sikhs

British

International Forces A photo essay in "Mission Accomplished" *(cover below)*, a commemorative pamphlet published by the Fifth Army, portrays a few of the thousands of Allied soldiers from many nations involved in the hard-fought Italian campaign. The patches at right were worn by men of various American units who fought in Italy—including the "Thunderbirds" of the 45th Infantry Division, which included more than 2,000 Native Americans.

AFRICA· SICILY ITALY

Mission Accomplished

LEGIONS OF THE "UNITED NATIONS"

When Lt. Gen. Mark Clark's Fifth Army was activated in French Morocco on January 5, 1943, it adopted a badge that included the blue silhouette of a mosque to evoke its exotic place of origin. That foreign symbol proved prophetic. During its 602 days of sustained combat on the Italian peninsula, the Fifth Army—made up largely of American armored and infantry divisions—was augmented by a wide assortment of troops from other countries and became a microcosm of the United Nations, as the Allies were known during World War II.

The first non-American unit attached to the Fifth Army was the British X Corps, which landed with Clark's forces at Salerno in September 1943 and fought alongside the Americans that winter at Cassino. In the spring of 1944, the X Corps was relieved by the French Expeditionary Corps, led by Gen. Alphonse Pierre Juin. Organized in North Africa, it consisted of a Free French motorized infantry division and three divisions

of infantry from Algeria and Morocco, including tribesmen called Goumiers. When the French Expeditionary Force broke through the enemy line in May 1944, General Clark reported that "knife-wielding Goumiers swarmed over the hills...and General Juin's entire force showed an aggressiveness hour after hour that the Germans could not withstand."

In the summer of 1944, Clark was reinforced by the Sixth South African Armored Division. Later that year, his forces were joined by men of the Brazilian Expeditionary Force, including three regimental combat teams and artillery. By then, the U.S. Fifth Army—which had included Native Americans from its inception—had both African Americans and Japanese Americans among its ranks. As a multiethnic, multinational force, it was rivaled only by the British Eighth Army, whose troops included Canadians, Poles, Italians, South Africans, Indians, New Zealanders—and in early 1945 the Jewish Brigade, consisting of more than 5,000 Jewish volunteers recruited in Palestine. ■

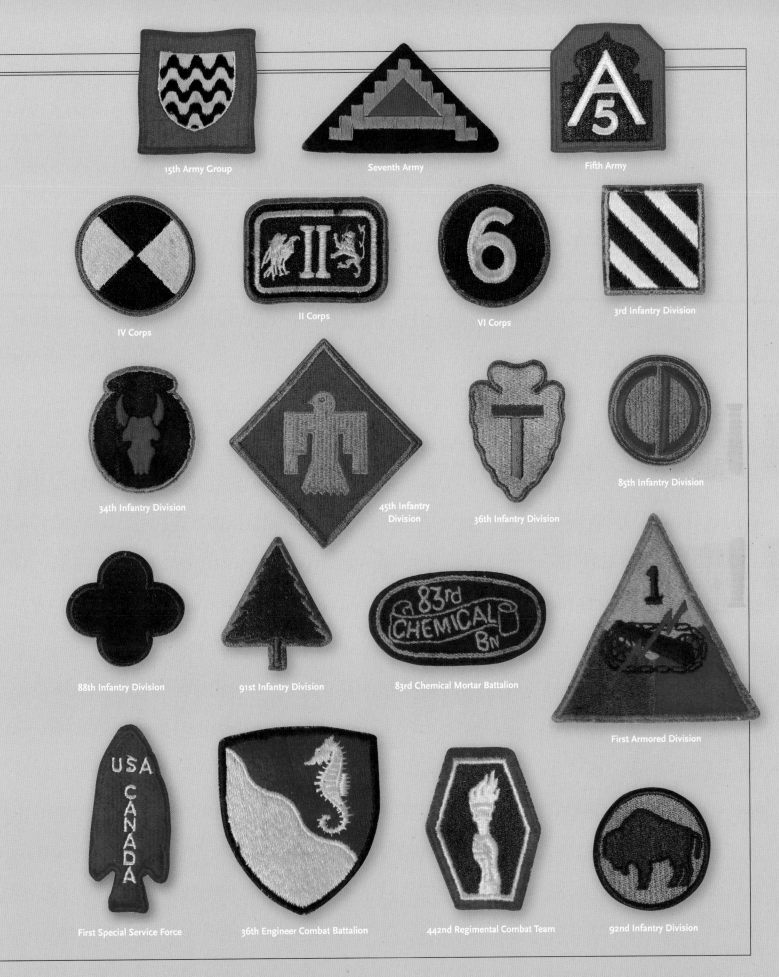

15th Army Group

Seventh Army

Fifth Army

IV Corps

II Corps

VI Corps

3rd Infantry Division

34th Infantry Division

45th Infantry Division

36th Infantry Division

85th Infantry Division

88th Infantry Division

91st Infantry Division

83rd Chemical Mortar Battalion

First Armored Division

First Special Service Force

36th Engineer Combat Battalion

442nd Regimental Combat Team

92nd Infantry Division

Allied planners had concluded that an amphibious landing at Anzio, on Italy's west coast north of the Winter Line, might succeed in unhinging German defenses and lead to the capture of Rome. Churchill strongly favored that option and managed to secure enough landing craft—most of which were being diverted to Britain for Overlord—to bring at least two divisions ashore at Anzio in late January. That would be a smaller force than landed at Salerno, and it would be at considerable risk unless Allied troops put renewed pressure on the Winter Line and kept Germans there from being diverted to Anzio. In mid-January, French, British, and American forces attacked the heart of the Winter Line, around the town of Cassino, where the main highway to Rome crossed the rain-swollen Rapido River. The French advanced north of town near the ancient Benedictine monastery of Monte Cassino but made little progress in that mountainous terrain. The British fared better initially to the south, but bogged down at the Garigliano River, into which the Rapido flowed.

That left the Americans, assigned to cross the Rapido River between the British and French, in a bind. Their task would have been difficult even had their allies on either flank succeeded, but was all but impossible now. Clark nevertheless decided that he "must make this attack, fully expecting heavy losses," and sent the 36th Infantry Division into battle on January 21. "We had the feeling we were being sacrificed," said Sgt. Billy Kirby, "but we'd give it our damnedest." Even hardened veterans of Salerno had never seen anything as desperate as this fight. Germans firing from the rubble of the bombed-out town of Sant'Angelo on the far bank gunned down many of them as they struggled across a mine-strewn bog to reach the Rapido. Others perished in the river when the rubber rafts or wooden boats they launched were blown apart. Kirby was among the remnant that made it across the Rapido before he, too, fell wounded. "Just about everyone was hit," he recalled. "I didn't have a single good friend in the company who wasn't killed or wounded." Some men in the 36th never forgave Clark for ordering the futile attack, but commanders caught up in this grinding war of attrition often felt compelled to demand such sacrifices with little assurance of success.

More trials and errors lay ahead for the Allies, who proceeded with the landing at Anzio despite their setbacks at the Winter Line. The troops who came ashore there on January 22 achieved almost complete surprise and met with little opposition initially. Their commander, Maj. Gen. John Lucas, had orders to advance inland and cut roads linking the Winter Line to Rome, which was only about 30 miles from Anzio. But Lucas hesitated to break

Triumph Touted **Troops of the Fifth Army receive a jubilant welcome as they enter the Italian capital in these scenes from "Road to Rome," a booklet commissioned by their publicity-conscious commanding general, Mark Clark, and distributed to soldiers free of charge.**

out of the beachhead until he had all his men and equipment ashore. Clark had warned him not to stick his neck out, and he heeded that advice by refusing to be rushed by higher-ups like Churchill who hoped for a daring stroke that would end the stalemate in Italy. "I will not be stampeded," Lucas vowed. By the time he was ready to advance at month's end, Kesselring had him hemmed in. Clark sent reinforcements, but the Germans remained stronger and

launched a furious assault in mid-February led by hulking Tigers, the largest tanks in their arsenal. The hard-pressed 45th Infantry Division was nearly driven back into the sea, but Lucas withstood the attack with help from the dynamic Maj. Gen. Lucian Truscott, who then took his place. Lucas had long expected to be treated as a sacrificial lamb. They would put him ashore "with inadequate forces," he predicted before the operation began, then saddle him with the blame. Kesselring agreed that Anzio as conceived was a weak "halfway measure."

Allied commanders miscalculated again in March when they launched another assault at Cassino, preceded by bombing raids that shattered the historic mountaintop monastery, killing scores of monks and civilians sheltered there. Contrary to Allied suspicions, the Germans were not using Monte Cassino as an observation or command post, but they occupied the ruins soon after the bombing ceased and found them better suited for defensive purposes than intact buildings. Troops from New Zealand and India launched determined attacks on the defenders but were unable to oust them from the rubble of the ruined monastery or the battered town of Cassino. "Almost every building or stump of a building contained a sniper's or a machine gunner's post," stated the New Zealanders' battle report. When the fighting ended in late March, the Allies were no closer to their goal, and Cassino had earned the title "Little Stalingrad."

The costly struggles of international forces who battered the Winter Line without breaking it were not entirely in vain. German casualties were steep, and defenders who escaped injury were worn down by persistent air and ground assaults. Allied commanders learned from their mistakes and stopped fixating on Cassino. In May, they attacked on a broad front, seeking out the enemy's weak spots, one of which proved to be well south of Cassino where North African troops threaded steep mountain passes and outflanked the Germans. Other breakthroughs followed as the line buckled. The final blow was delivered by Polish troops, who took Cassino at a cost of 4,000 casualties and buried their dead on a hill overlooking the ruined town. In an inscription addressed to the people of Italy, they honored their fallen Polish comrades, who died "for our freedom and yours."

In late May, Truscott's troops broke out of the Anzio beachhead and linked up with others in Clark's Fifth Army who had breached the Winter Line. Truscott had a chance to cut off large numbers of German troops before they escaped northward to take up new defensive positions, but Clark was intent on taking Rome before the British got there and circumvented orders from his British superior, Alexander, by diverting most of Truscott's forces to that city. As Clark put it, he wanted people back home to know that it was his American-led Fifth Army that "did the job," when in fact the British-led Eighth Army had contributed significantly to this hard-won victory.

Critics charged that Clark neglected his duty to pursue the enemy and instead pursued fame in Rome. If so, his triumph was appropriately short lived. His entry into the Eternal City on June 5, 1944, was overshadowed in less than 24 hours by a greater sensation—the Allied landings in Normandy on June 6. "How do you like that?" Clark said when he heard the news. "They didn't even let us have the newspaper headlines for the fall of Rome for one day."

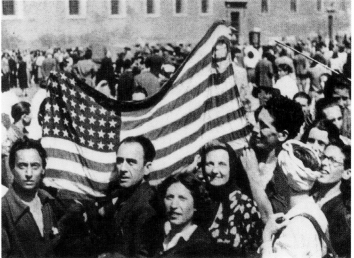

Banner Day **Italians in Rome's Piazza Venezia display an American flag as they celebrate the liberation of their city on June 5, 1944.**

"How do you like that? They didn't even let us have the newspaper headlines for the fall of Rome for one day."
Lt. Gen. Mark Clark

THE CONTEST BETWEEN ALLIED AND AXIS FORCES IN the Mediterranean was costly for both sides, but the toll was far greater for those engaged in the death struggle between Germany and the Soviet Union. In December 1941, the German Army suffered its first significant defeat of the war when it was driven back from Moscow. Stalin then ordered Gen. Georgi Zhukov to step up the pressure, using Red Army troops far better prepared than their foes to fight in the bitter Russian winter. As German troops of Army Group Center retreated from Moscow, Soviet forces swept around their flanks and tried to trap those invaders near Smolensk (see map, page 38). But they heeded Hitler's stand-fast order and rallied, preventing Soviet pincers from closing around them. ★ In the spring of 1942, Russian troops counterattacked Army Group South and advanced 60 miles with deceptive ease before they were stopped below Kharkov and cut off by the German Sixth Army, losing over 300,000 men killed or captured. Meanwhile, two vital Russian cities remained under siege—Leningrad, which held out against Army Group North; and Sevastopol, which fell to the Germans in mid-1942 after Soviet efforts to relieve that Black Sea port failed. By then, Hitler was back on the offensive, but his forces had suffered so many losses to the enemy and the elements over the winter that he could no longer attack along the entire front. ■

A War of Wills:

RUSSIA RESURGENT IN THE EAST

Spirit of Resistance Russian soldiers fight amid the rubble of Stalingrad, where Hitler's renewed offensive in 1942 came to a grinding halt. During the war, Soviet authorities reached deep into Russia's past to inspire resistance to the German invaders, as shown by the poster at left, portraying three renowned warriors— the medieval prince Alexander Nevsky, the Napoleonic-era general Aleksandr Suvorov, and the Red Army hero Vasily Chapayev—urging Soviets on to victory.

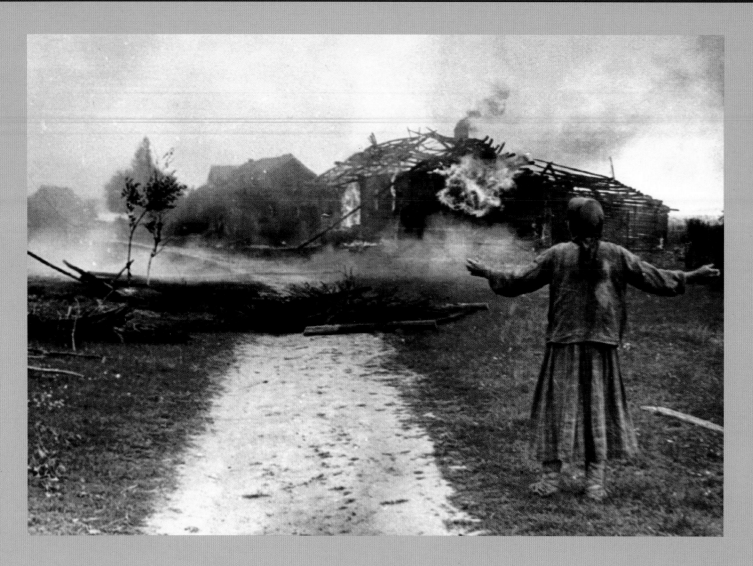

A Landscape of Fire and Ice

The Russian counteroffensive that drove Hitler's forces back from the gates of Moscow was conducted during an unusually harsh winter that proved excruciating even for the better-equipped Soviets. Automatic weapons jammed when gun oil froze. Shells fell short when fired from cold artillery barrels. Defensive minefields were all but useless when covered by thick blankets of snow. Drifts and subzero cold also limited the movement of men, horses, and motor vehicles, which ran sluggishly at best and consumed large amounts of fuel covering little ground. Motor oil congealed to a tar-like consistency in crankcases, and men who wanted their engines to start promptly had to keep fires kindled under them all night.

Conditions were especially brutal for the poorly equipped Germans, and Stalin made life even harder for them with his scorched-earth policy, which reduced villages to ashes and left the invaders little shelter in occupied Russia other than isolated sheds or hovels. With nighttime temperatures falling as low as – 49°F, exposure took a steep toll on the Germans. By the end of that terrible winter of 1941–42, the number of frostbite victims in their ranks exceeded a quarter of a million. Thousands more were stricken by pneumonia, influenza, and trench foot. The "infernal cold," stated Field Marshal Wilhelm Keitel, had "catastrophic results for our troops, clad as they were only in improvised winter clothing." Many obtained warmer clothing eventually, but by then some men had suffered lasting damage. One German soldier wrote in his diary that winter: "My hands are done for, and have been ever since the beginning of December. The little finger of my left hand is missing and—what's even worse—the three middle fingers of my right one are frozen . . . The best thing I can do with the little finger is to shoot with it." ■

Fighting the Elements At left, a German motorcycle dispatch rider bundled in a fleece-lined leather suit wears a gas mask to protect his face against blowing ice and snow. Below, ice-encrusted horses haul German supply wagons through a driving blizzard. Stalin's scorched-earth policy denied shelter not only to Germans but also to Russians like the woman pictured opposite, raising her hands helplessly as her village burns.

Defending the Motherland

Despite harsh conditions and horrendous loss of life, the struggle that Russians called the "Great Patriotic War" united their country and filled people with nationalist fervor. Soviet propaganda downplayed communism and stressed patriotism, calling on Russians to defend their motherland against the brutal German invaders. Religion, which had been suppressed under Stalin, was now officially embraced to rally the faithful behind the war effort. Posters and newspaper articles extolled ordinary citizens who risked death or gave their lives to save Russia from defeat and destruction.

Russian women shouldered their share of the war effort by driving trucks, operating railroads, and toiling in munitions plants, shipyards, and aircraft factories, filling jobs vacated when men joined the Red Army. Many women replaced men on collective farms and worked the fields, feeding more than 11

Call to Arms **"Mother Russia"** holds the Soviet military oath in a poster entitled **"The Motherland Is Calling!"**

million soldiers and 80 million civilians. Still others enlisted and joined the fight.

As many as 800,000 women entered the Soviet armed forces during the war, serving not just as nurses or clerks but as combatants, including snipers, machine gun teams, tank crew members, and partisans fighting in German-occupied territory. Red Army sniper Natasha Kovshove described her motivation in a letter to her family: "My hatred for the cursed fascist beast grows stronger every day, with every battle . . . I will shoot the vermin point blank. I will pump bullet after bullet into their foul skulls, stuffed with insane thoughts about our Moscow and of ruling over us, a free, proud, and bold people." The Soviet Union was the first nation to allow women pilots to fly combat missions. Three regiments of women aviators flew a combined total of more than 30,000 combat sorties, and two of those pilots became fighter aces. ■

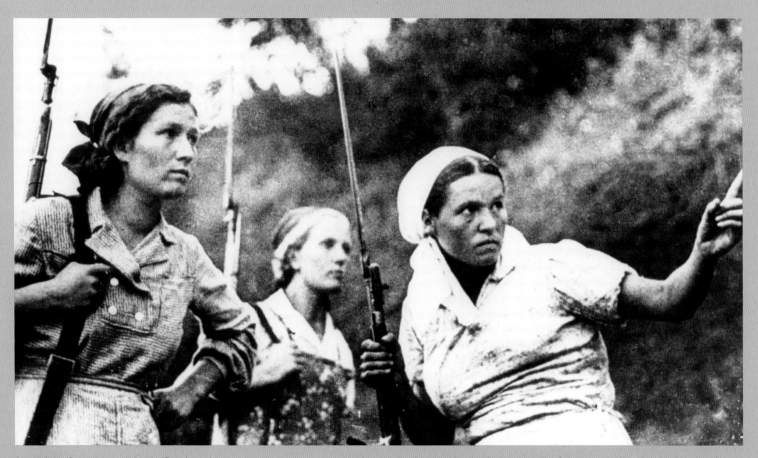

Fighting for Russia Armed with rifles, these three partisans were among many Russian women who joined bands of Soviet guerrillas fighting surreptitiously behind German lines.

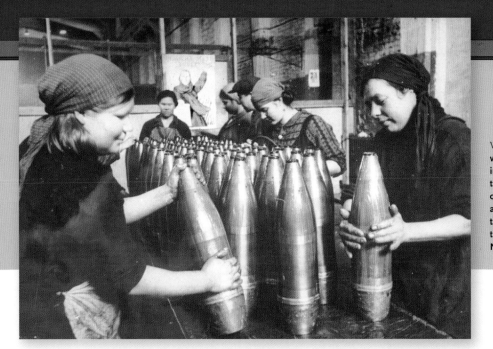

War Work At left, Russian women grease artillery shells in a room decorated with the same war poster shown opposite. Below, women dig antitank ditches to shield their city from attack during the siege of Leningrad in November 1941.

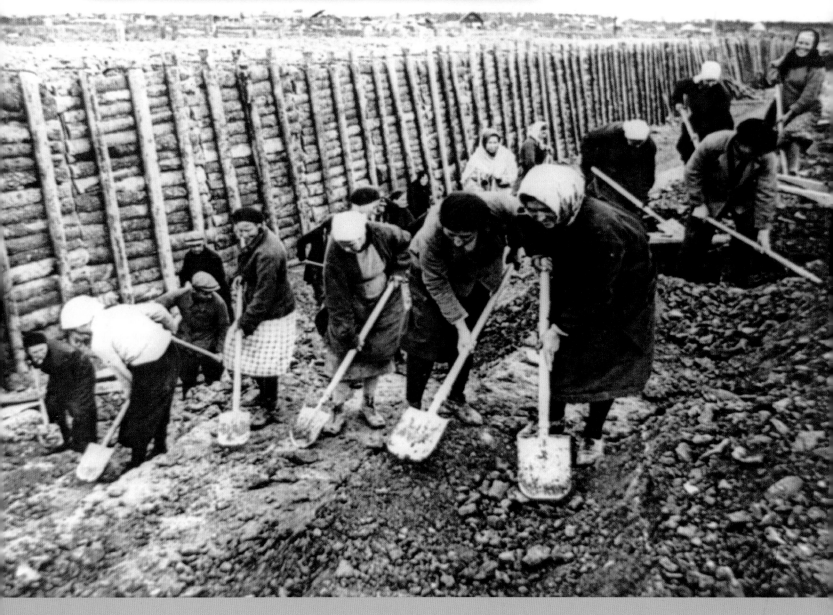

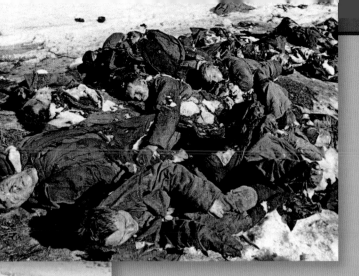

Beleaguered City Below, residents draw water from a broken main in besieged Leningrad. At left, a truck with its door open to allow the driver to escape if the vehicle breaks through the ice crosses slushy Lake Ladoga on the "Road of Life" in the spring of 1942. When Russian forces broke the siege by recapturing the town of Schlüsselburg, which offered access to Leningrad from the east, they discovered the bodies of 38 Soviet soldiers (above), who had been executed by the Germans.

The Siege of Leningrad

In September 1941, German troops of Army Group North outflanked Soviet defenders and encircled Leningrad. In addition to the soldiers manning its fortifications, the besieged city had nearly 2.5 million residents and was harboring more than 100,000 refugees. Their only link to the outside world was a fragile lifeline that opened when winter set in—a two-hundred-mile-long track called the "Road of Life" that crossed the frozen surface of Lake Ladoga to the east of Leningrad and remained open only as long as the ice was thick enough to support vehicles. Truck convoys brought in a mere hundred tons of fuel and food a day—not enough to provide for all those in need. Food was strictly rationed, with small daily allotments for soldiers and factory workers. Office workers, dependents, and children received even less; by January 1942, they were limited to only a quarter of a pound of bread per day. To stretch short stocks of flour, it was mixed with cottonseed or cellulose.

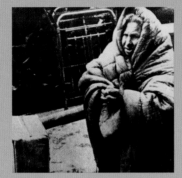

Homeless **An elderly woman huddles under a quilt amid the ruins of her home in besieged Leningrad.**

German air raids destroyed public transport and damaged the city's water system. Oil and coal supplies dwindled, and the use of electricity in private homes was banned to provide power to industry and the armed forces. People used wood to heat their homes, burning furniture and scraps of lumber scrounged from bombed-out buildings.

By March 1942, more than 200,000 people had died in Leningrad of cold and starvation. Frozen corpses piled up in the city streets and parks, left there by people too exhausted to bury them. "Many a time I saw a man suddenly collapse on the snow," a staff officer in the Leningrad garrison recalled. "There was nothing I could do. One just walked on." Leningrad held out against the Germans, but the ordeal took a terrible toll on its populace and defenders. More than 640,000 Russians died there before the siege was finally broken in January 1943. ∎

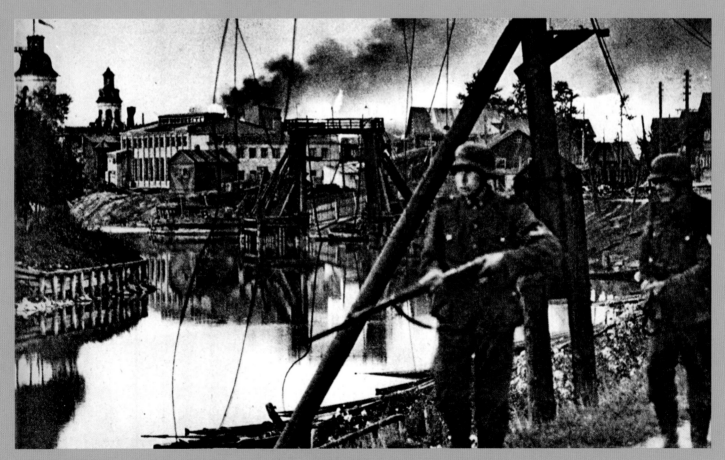

Cutting Off the Source **Soon after surrounding Leningrad in September 1941, German soldiers patrol the Neva River in Schlüsselburg—Leningrad's main source of fresh water.**

The Battle of Stalingrad

In 1942, unable to advance along the entire front, Hitler resolved to seize Soviet oil fields in southern Russia. Designated Operation Blue, the German offensive was launched on June 28 by Army Group South, which pushed east toward the Volga River to secure its flank before advancing southward through the Caucasus Mountains to oil-rich Baku on the Caspian Sea. In mid-July, an overconfident Hitler decided to expand the offensive and split Army Group South in two. Army Group A was assigned to capture Baku while Army Group B attacked Stalingrad, a sprawling industrial city on the Volga crucial to Stalin and the Soviet war effort.

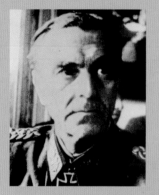

Defeated **This photo of Field Marshal Friedrich Paulus was taken after he surrendered at Stalingrad.**

Hitler assigned armored forces and Luftwaffe squadrons to bolster Gen. Friedrich Paulus's Sixth Army at Stalingrad. That buildup came at the expense of Army Group A, which stalled in the Caucasus in September as the battle for Stalingrad intensified. Ordered by Stalin to stand fast, Gen. Vasily Chuikov's Soviet 62nd Army fought desperately as German artillery and bombers blasted the city. "We moved back, occupying one building after another, turning them into strongholds," a Soviet officer recalled. "A soldier would crawl out of an occupied position only when the ground was on fire under him and his clothes were on fire."

On November 19, the Soviets launched a massive counteroffensive and drew a noose around Stalingrad, trapping the Sixth Army and other German and Axis troops, who suffered from hunger and exposure as the winter deepened. Efforts to supply them by air failed, as did an attempt by Field Marshal Erich von Manstein to break the siege. On January 22, General Paulus sought permission to surrender, but Hitler refused, ordering him to fight "to the last soldier and the last bullet." To discourage Paulus from yielding, Hitler promoted him to field marshal on January 30. When Soviet forces closed in on his headquarters the next day, however, Paulus gave up. The defeat left 91,000 Axis prisoners in Russian hands, few of whom survived. ■

Tightening the Noose **Soviet soldiers enter a ruined factory to clear out Germans holed up there during the final stages of the Battle of Stalingrad in January 1943.**

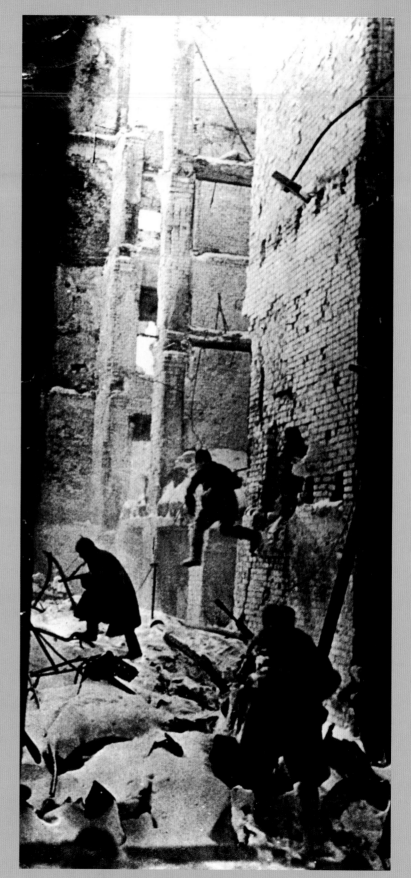

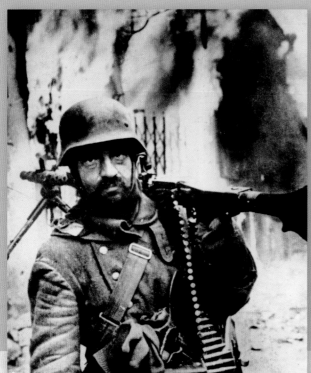

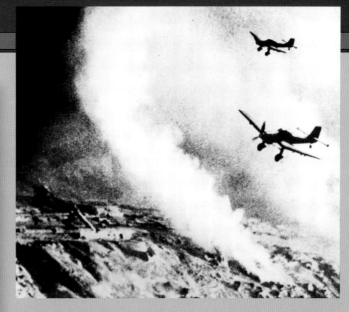

A Searing Struggle Below, a German soldier cautiously investigates a burning Soviet armored car during the Battle of Stalingrad. Savage street fighting left soldiers like the German machine-gunner at left dazed and exhausted. By January 1943, the Stuka dive-bombers above were flying over a city largely reduced to rubble. "Animals flee this hell," one German soldier there wrote; "the hardest stones cannot bear it for long; only men endure." The crushing defeat of German Army Group B at Stalingrad exposed Army Group A in the Caucasus to a counterattack, which nullified most of the gains made by the Germans since mid-1942.

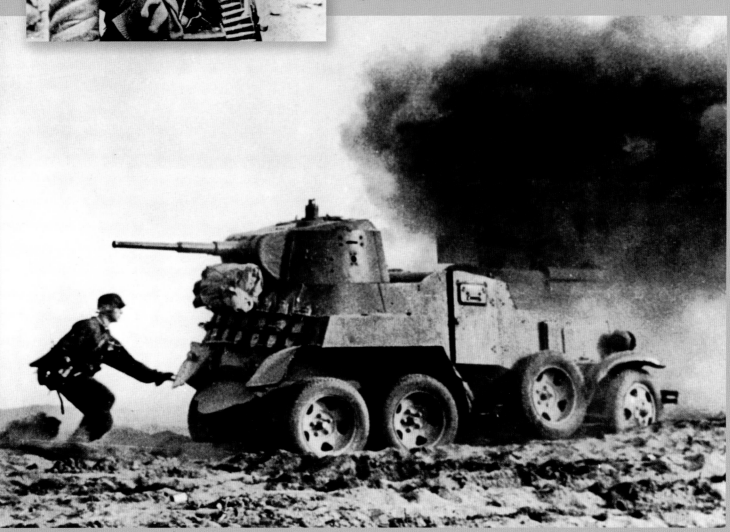

A Clash of Titans

Following their victory at Stalingrad, Soviet forces advanced in February 1943 and liberated Kharkov, one of Russia's largest cities. Field Marshal Manstein then bolstered his Army Group South with German forces withdrawn from the Caucasus and recaptured Kharkov in March. North of the city, however, Russians gouged a 90-mile-long bulge in the front and held out there. To eliminate that menacing Soviet salient, Hitler authorized Operation Citadel, which called for armored pincers to advance from north and south and close on the enemy near Kursk, amid the bulge.

In preparation for that attack, the Germans massed 900,000 men, 10,000 big guns, and 2,700 tanks, including hefty new Panzer V Panthers and Panzer VIB King Tigers, built to contend with sturdy Soviet tanks like the T-34. Awaiting them in the bulge were more than a million Russian troops and 3,600 tanks, shielded by minefields, tank traps, and other forbidding defenses. The stage was set for the greatest battle ever waged between armored forces.

The attack opened at dawn on July 5 as Gen. Hermann Hoth's Fourth Panzer Army, supported by the Luftwaffe, struggled forward in the south under intense Soviet artillery fire. Hoth's battle-weary forces paused on July 10 after advancing only 20 miles. In the north, armored units of the German Ninth Army advanced only eight miles. On July 12, Hoth unleashed the powerful II SS Panzer Corps, which collided near the village of Prokhorovka with Gen. Pavel Rotmistrov's Fifth Guards Tank Army. For eight hours, German and Soviet tanks—more than a thousand in all—fought each other to a standstill, leaving the battlefield littered with broken and blazing vehicles.

On July 13, Hitler called off Operation Citadel. As German forces began withdrawing from the Kursk salient, the Russians counterattacked, reclaiming Kharkov permanently in August. Soviet casualties in the titanic Battle of Kursk—which involved more than 2 million men, 6,000 armored vehicles, and 4,000 aircraft—were far

ВПЕРЕД! НА ЗАПАД!

higher than German losses. But the Russians had deeper reserves and prevailed, dooming the invaders to a defensive struggle that would not end until they were driven back to Berlin. ∎

Turning Point Backed by a Tiger tank, SS panzergrenadiers advance during the Battle of Kursk. After repulsing the Germans there, Russians fulfilled the words on the poster above: "Forward! To the West!"

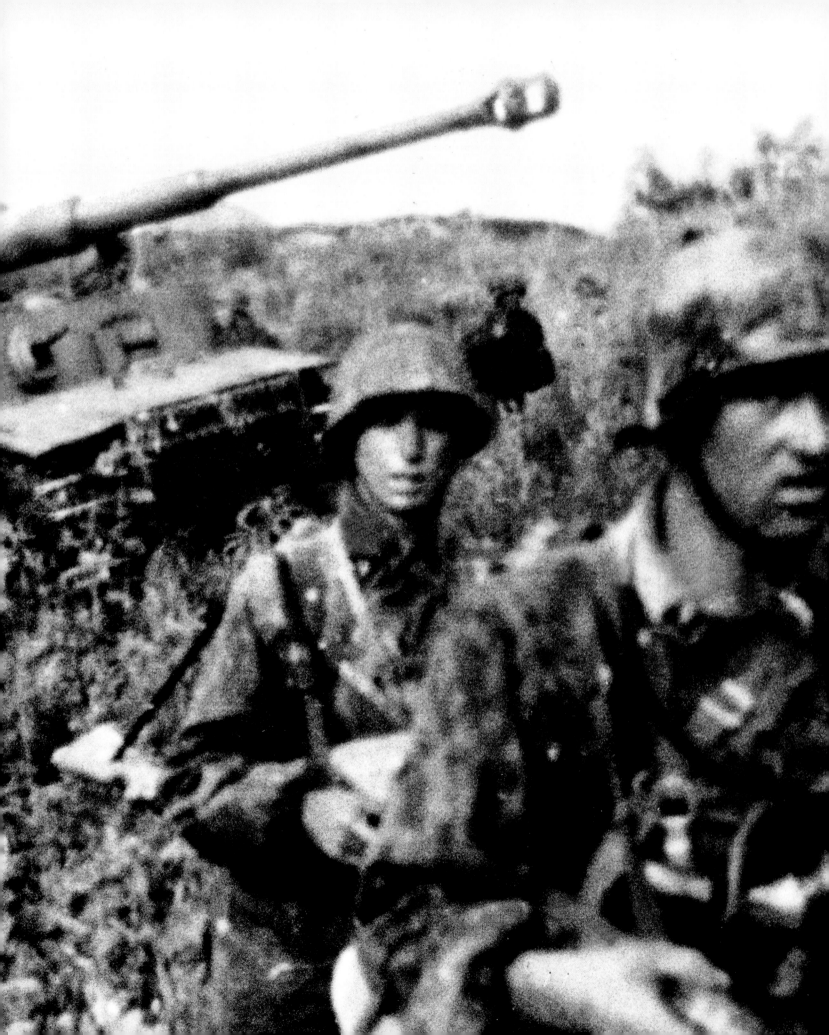

Yanks Gain on Cherbourg

WAR EXTRA

Los Angeles Examiner

CHARACTER QUALITY · AMERICA FIRST · ENTERPRISE ACCURACY

AN AMERICAN PAPER FOR THE AMERICAN PEOPLE · THE GREAT NEWSPAPER OF THE GREAT SOUTHWEST

Examiner Telephone RIchmond 1212 · Examiner Building, 1111 S. Broadway

VOL. XLI—NO. 188 · LOS ANGELES, FRIDAY, JUNE 16, 1944 · ©PCC · Two Sections—Part I—FIVE CENTS

TOKYO AFLAME!

Super-Forts Hit Other Big Cities

U. S. Invades Isle Near Japan

YANKS REPORT GAIN IN DRIVE ON CHERBOURG

Troops Within Six Miles of German Escape Lifeline; Other Allied Advances Revealed

STOCKHOLM, June 15.—(P)—Aftonbladet dispatches from Berlin today said new Allied landings at Calais and Ostende were expected momentarily.

SUPREME HEADQUARTERS ALLIED EXPEDITIONARY FORCE, June 16 (Friday).—(P)—American troops slashing westward from Carentan on a 10-mile front have reached firm ground within six miles of La Haye du Puits, junction of the last German-held rail-highway lifeline to the Port of Cherbourg, and within four and a half miles of the secondary junction point of St. Sauveur-Le-Comte in what was officially described today as "steady progress."

In the developing drive to cut off and capture the Cherbourg Peninsula, similar steady advances were reported in a midnight communique from supreme headquarters for a less clearly-defined thrust through the lowlands between the Vire and Elle Rivers southeast of Carentan.

This advance appeared to be aimed towards St. Jean De Daye, on the highway linking St. Lo and Carentan. Extent of the gain was not disclosed officially, but it appeared probable that the road already had been cut about five miles west of Lison.

NEW BEACH OUTLET

On the extreme right flank of the Allies' beachhead in Normandy, American capture of the coastal village of Quineville and surrounding territory was declared to have provided "a valuable new outlet from the beaches."

On the eastern, or left, wing of the beachhead, held by British and Canadian forces, violent German armored counterattacks were repulsed with what the Al—

(Continued on Page 2, Cols. 2-4)

BUTADIENE PLANT. Opening for Water Tender, Fluid Repairman, Oiler and Guard. Ages 18 to 55. Availability Certificate Required, Apply Personnel Dept., 1st Floor Bldg. 600, Flower street, SOUTHERN CALIFORNIA GAS COMPANY.—Advertisement.

INVADED BY YANKS—This is Saipan, Jap stronghold in the Marianas, only 1500 miles southeast of Tokyo, where American amphibious forces are smashing their way ashore against strong opposition. Saipan, largest of the Marianas group, has a good harbor at Magicienne Bay, and is 1100 miles west of the Marshalls.

FDR Gives Blueprint for Postwar World Peace

By Robert G. Nixon

WASHINGTON, June 15.—President Roosevelt today made public the American blueprint for preservation of peace in the postwar world through the creation of a council of nations and a court of international justice led by the United States, Great Britain, Russia and China.

The Chief Executive's plan envisions an armed world in which member nations would maintain "adequate forces" to prevent future wars and to make it impossible for any nation to prepare deliberately for war in the future.

These forces, Mr. Roosevelt said, would be called upon for "joint action when necessary."

Mr. Roosevelt declared that the plan does not call for the creation "of a superstate with its own police forces and other paraphernalia of coercive power."

Instead, he said, "the maintenance of peace and security must be" the joint task of all peace loving nations" and the future peace of the world would be maintained through effective agreements between all the member nations.

The World Council, the President said, would be elected annually by the representatives of all the participating nations.

The American proposal, as outlined by President Roosevelt, was made public by the White House in a presidential statement following a long conference this morning with the President and his Postwar Policy Committee.

At the conference were Secretary of State Cordell Hull, Undersecretary of State Edward R. Stettinius Jr., Dr. Isaiah Bowman, presidential adviser, and

(Continued on Page 6, Cols. 4-7)

STRATEGIC ISLANDS—Saipan, which is but a few miles from her sister island, Tinian, is 150 miles from Guam, 675 miles from Truk, 1500 miles from the Philippines, 1375 miles from Japan.

20th Bomber Units Strike Nippon Heart

NEW YORK, June 15.—(AP)—The Tokyo radio in a broadcast heard tonight by C. B. S. claimed to have downed six American planes during today's raid on Japan.

WASHINGTON, June 14.—(A. P.)—Japan was bombed today by America's new super-planes, the B-29s, and Congress heard that Tokyo suffered "great destruction."

The War Department disclosed at 10:39 p. m., Pacific War Time, that the long-secret flying giants had gone into action. The announcement said:

"B-29 Super Fortresses of the United States Army Air Forces 20th Bomber Command bombed Japan today."

To this was added some time later that the planes flew to the attack from the China-India-Burma theater.

'Great Destruction' in Tokyo

Then Representative Starnes (Democrat), Alabama, arose in the House to tell his colleagues that the target of the raid was Tokyo proper. A good source informed him, he said, that a large number of American planes were causing "greatest destruction" in Tokyo.

(Editor's note: Simultaneous with this announcement the War Department made public details of the new "Gasoline-Jelly" ignition bomb. It was also disclosed that a large percentage of bomb loads is made up of this devastating weapon which undoubtedly was used on the flimsy construction of Tokyo).

It was the second American bombing of Japan, but the first announcement of action by the B-29s.

House, Senate Halt Sessions

House and Senate sessions were halted for announcement of the news. Senator Pepper (Democrat), Florida, told his colleagues he was "sure the heartfelt thanks of Congress and the country go out" to those who made the attack possible.

Representative Mahon (Democrat), Texas, said the news vindicated the wisdom of Congress in furnishing funds for the giant new bombers.

Representative Manasco (Democrat), Alabama, said the War Department advised him the B-29s "bombed several large cities" on the mainland of Japan but there was no information yet on the results.

Manasco said the assumption could be that the reference was made to Tokyo and Yokohama.

"It is now officially confirmed that America's Super Fortresses flying from remote bases have

(Continued on Page 2, Column 1)

Yanks Land on Saipan, Key Base

By Richard V. Haller
Staff Correspondent International News Service

PEARL HARBOR, June 15.—Strong United States amphibious forces have invaded Saipan Island, one of the Key Japanese strongholds in the Marianas 1500 miles from Tokyo, Admiral Chester W. Nimitz announced today.

Assault troops have established a beachhead under protection of a powerful force of carrier-based planes and warships.

"Landings are being continued against strong opposition under cover of supporting bombardment by our air and surface forces," said the communique from the commander in chief of the Pacific Fleet.

"Initial reports indicate that our casualties are moderate."

Announcement of the bold invasion of Saipan, located in the strategic inner circle of enemy defenses, came after a four-day battering of that base and four others—Guam, former American possession; Tinian, Rota and Pa-

(Continued on Page 2, Column 1)

WOMEN DESIRING work downtown close to home apply for splendidly positions at Van de Kamp's Bakeries! Ideal work ing conditions, good hours. Apply downtown, 811 Garfield Bldg., 8th and 10th; or plant, 3939 Fletcher Drive at San Fernando Rd.—Advertisement.

★ BACK THE INVASION ★ BUY A BOND TODAY ➤

Half-true As reported here, Americans landed on Saipan in June 1944—but B-29s did not in fact bomb Tokyo until months after Saipan was secured.

WHILE U.S. TROOPS AND THEIR ALLIES WERE ADVANCING ON THE HISTORIC CITY OF ROME, others were fighting on obscure islands in the Pacific that few Americans had heard of before the conflict began. Officially, President Roosevelt gave the war against Germany priority over that remote struggle against Japan. But unlike Hitler, Roosevelt did not dictate to his commanders. His stated policy of "Europe First" did not prevent the U.S. Navy or Army from launching counteroffensives to halt menacing Japanese advances in the Pacific before Americans entered battle across the Atlantic. Gen. Douglas MacArthur, after escaping from the Philippines in March 1942 and taking charge of Allied forces in Australia, insisted that the best way to shield that country from invasion was to oust Japanese troops from nearby New Guinea, which he hoped to use as a stepping-stone to reclaim the Philippines. "We must attack, attack, attack!" MacArthur declared. In Washington, meanwhile, Adm. Ernest King, chief of the U.S. Navy and Marine Corps, was pressing for swift retaliation against Japan. ✳ The Pacific Fleet's stunning victory at the Battle of Midway in June set the stage for the first American ground assault on Axis troops, launched in August 1942 against the Japanese on Guadalcanal, situated east of New Guinea near the southern tip of the Solomon Islands. Although Guadalcanal lay farther from Australia than New Guinea, it offered the Japanese a platform for air strikes on Australia's maritime supply lines. For troops engaged on Guadalcanal and other Pacific islands in months to come, and for many Americans following their strenuous campaigns back home, beating Japan was the nation's first order of business. In fact, not until mid-1944 would there be more Americans fighting in Europe than in the Pacific. ✳ The American assault on Guadalcanal was launched from New Zealand, situated two thousand miles

Island Fighting:
GUADALCANAL TO THE INVASION OF SAIPAN

CHRONOLOGY

- **August 7, 1942** U.S. Marines land on Guadalcanal, launching American ground campaign against Japanese forces in the Pacific.

- **September 1942** Gen. Douglas MacArthur sends U.S. troops to Papua New Guinea to join Australians fighting the Japanese there.

- **January 1943** American forces secure Guadalcanal and Buna in Papua New Guinea.

- **November 20, 1943** American forces land on Makin and Tarawa Atolls in the Gilbert Islands.

- **June 14, 1944** U.S. Marines land on Saipan in the Mariana Islands.

- **June 19–20, 1944** Battle of the Philippine Sea

- **August 3, 1944** Allied troops led by Lt. Gen. Joseph Stilwell defeat Japanese forces in Burma at Myitkyina.

Battle Honor This sleeve insignia of the First Marine Division, issued in early 1943, honors the division for its service at Guadalcanal, where it spearheaded the first American invasion of Japanese-occupied territory.

from Japanese-occupied territory and at less risk of attack than Australia. The First Marine Division, led by Maj. Gen. Alexander Vandegrift, began arriving there in late June 1942 and was supposed to undergo at least a half year of training before entering combat. That same month, however, a British resident on Guadalcanal who served as a Coastwatcher—assigned to spy on enemy movements for the Allies—reported by radio that the Japanese were building an airfield there. The urgent task of seizing that base before it became operational fell to Vandegrift and his Marines. "I didn't even know the location of Guadalcanal," he recalled. "I knew only that my division was spread over hell's half acre, one-third in Samoa, one-third in New Zealand, and one-third still at sea." Vandegrift had less than five weeks to assemble his division of nearly 20,000 men and prepare for the mission. Their training consisted of brief landing exercises, which he described as "a complete bust."

The Marines who approached the Solomons in early August, like many later assault forces in the Pacific, found such tropical islands seductive from afar and sickening up close. Guadalcanal "was beautiful when seen from the sea," recalled Pvt. Robert Leckie, who landed there with Vandegrift's division and later chronicled the campaign. "She was beautiful, but beneath her loveliness, within the necklace of sand and palm, under the coiffure of her sun-kissed treetops with its tiara of jeweled birds, she was a mass of slops and stinks and pestilence; of scum-crested lagoons and vile swamps inhabited by giant crocodiles; a place of spiders as big as your fist and wasps as long as your finger . . . She was sour with the odor of her own decay, her breath so hot and humid, so sullen and so still, that all those Marines who came to her shores on the morning of August 7 cursed and swore to feel the vitality oozing from them in a steady stream of enervating sweat."

At first, Vandegrift's men met with little opposition on Guadalcanal. Japanese construction crews abandoned the half-finished airstrip there to the Marines, who dubbed it Henderson Field for a pilot who had died in action at Midway. Most of the fighting occurred initially on Tulagi, a small island north of Guadalcanal where some two thousand Japanese troops were stationed. "Enemy force overwhelming," their commander reported that morning. "We will defend our posts to the death." They did just that. In three days of savage combat, not one Japanese soldier surrendered willingly, and only two dozen were captured alive. The rest perished, many of them in desperate attacks that left scores of Marines dead.

Taking Tulagi and Henderson Field offered small comfort to Vandegrift, who faced mounting opposition at sea and in the air. Before dawn on August 9, Japanese warships surprised an Allied task force between Guadalcanal and nearby Savo Island and sank four cruisers, killing more than a thousand sailors. That same day, Vice Adm. Frank Fletcher, a veteran of Midway, withdrew the three aircraft carriers shielding the landing forces. Those were the Navy's most precious assets, and Fletcher and his commander in the South Pacific, Vice Adm. Robert Ghormley, were unwilling to risk them at Guadalcanal any longer. Without close support from the carriers and their warplanes, vulnerable transports also had to be withdrawn, taking with them nearly 1,400 Marines, heavy artillery and equipment, and other essential supplies on ships that had not yet been unloaded. "God only knew when we could expect aircraft protection," remarked Vandegrift, who told his officers to break the bad news to their men but assure them that there would be no repetition on Guadalcanal of the recent disaster at Bataan. Since the birth of their corps in 1775, "Marines had found

themselves in tough spots," Vandegrift said. "They had survived and we would survive—but only if every officer and man gave his all to the cause."

The Navy did not abandon the Marines on Guadalcanal. Cruisers, destroyers, and PT boats continued to patrol the waters offshore—known as Iron Bottom Sound for the many vessels sunk there as the campaign intensified—and the carriers remained out at sea, where they were less exposed to attack but close to enough to launch air raids on enemy warships around the Solomons. Japanese skippers were adept at evading detection at night, however, and brought troops in under cover of darkness so swiftly and successfully that their sorties became known as the Tokyo Express.

Fortunately for Vandegrift and his men, their foes underestimated their strength and determination. Many Japanese officers, in the wake of their dramatic advances in the Pacific, suffered from "victory disease" and assumed that pampered American soldiers were no match for their own dedicated warriors. According to a Japanese training manual, "Westerners—being very haughty, effeminate and cowardly—intensely dislike fighting in the rain or

"All those Marines who came to her shores on the morning of August 7 cursed and swore to feel the vitality oozing from them in a steady stream of enervating sweat."

Pvt. Robert Leckie, on the landing at Guadalcanal

Storming the Beach Assault troops of the First Marine Division rush ashore from a landing craft onto Guadalcanal's "Beach Red" on August 7, 1942.

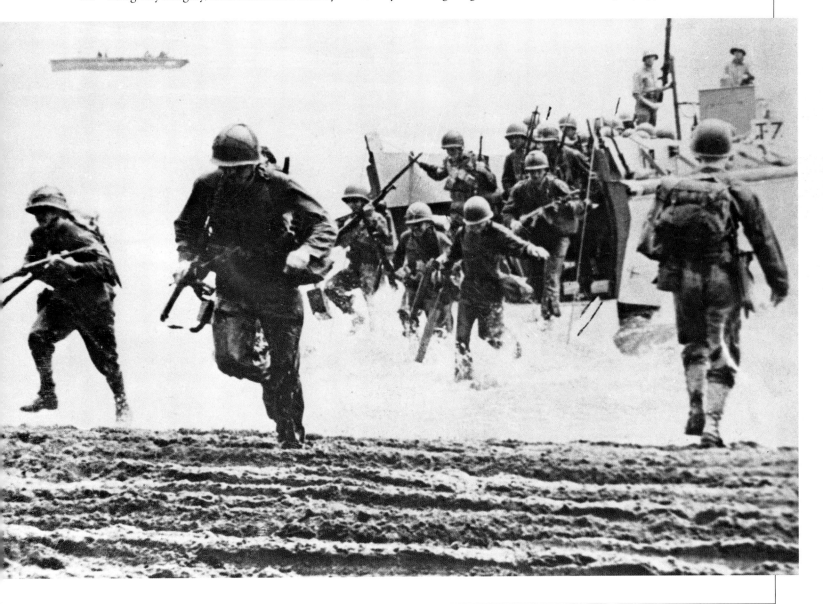

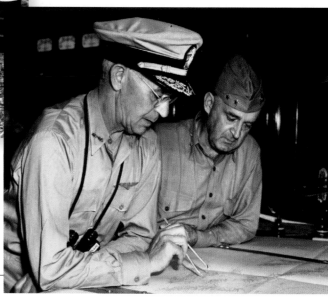

"Westerners—being very haughty, effeminate and cowardly—intensely dislike fighting in the rain or mist or in the dark."

JAPANESE TRAINING MANUAL

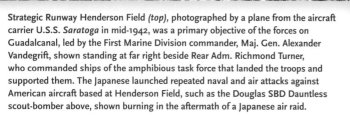

Strategic Runway Henderson Field *(top)*, photographed by a plane from the aircraft carrier U.S.S. *Saratoga* in mid-1942, was a primary objective of the forces on Guadalcanal, led by the First Marine Division commander, Maj. Gen. Alexander Vandegrift, shown standing at far right beside Rear Adm. Richmond Turner, who commanded ships of the amphibious task force that landed the troops and supported them. The Japanese launched repeated naval and air attacks against American aircraft based at Henderson Field, such as the Douglas SBD Dauntless scout-bomber above, shown burning in the aftermath of a Japanese air raid.

mist or in the dark. They cannot conceive night to be a proper time for battle—though it is excellent for dancing. In these weaknesses lie our great opportunity."

When Col. Kiyano Ichiki landed on Guadalcanal with nine hundred troops in mid-August, he was overconfident and did not wait for reinforcements. On August 21, he launched a reckless nighttime assault near the Tenaru River and his troops were scythed down by artillery and machine-gun fire from Marines warned of their approach by Coastwatchers. Ichiki committed suicide, and Vandegrift wiped out lingering resistance by sending in tanks, which crushed men under their tracks. "The rear of the tanks looked like meat grinders," he reported. The attack cost the Japanese "some 800 dead with only a handful escaping to the jungle," Vandegrift added. "Our own casualties came to 100 with 43 dead."

By late August, Henderson Field had been completed by a naval construction battalion—designated CB and staffed by hardworking men known as Seabees. That allowed fighters and bombers to land on Guadalcanal and strengthened Vandegrift's position. But there was no respite for the Seabees who maintained the runway or the Marines who defended the field, which was subject to repeated air and ground attacks as the Tokyo Express funneled more Japanese troops and artillery to Guadalcanal. On the night of

Deadly Waters Dubbed "Iron Bottom Sound" by American sailors, the strait separating Guadalcanal from small islands to its north was the site of explosive engagements between Allied and Japanese warships, beginning with the Battle of Savo Island in the early hours of August 9, 1942. In that battle, the Australian cruiser H.M.A.S. *Canberra* was destroyed along with three American cruisers—U.S.S. *Vincennes*, U.S.S. *Astoria*, and U.S.S. *Quincy*, pictured in flames at bottom, illuminated by Japanese searchlights. The map below shows where those vessels and other Allied and Japanese warships went down.

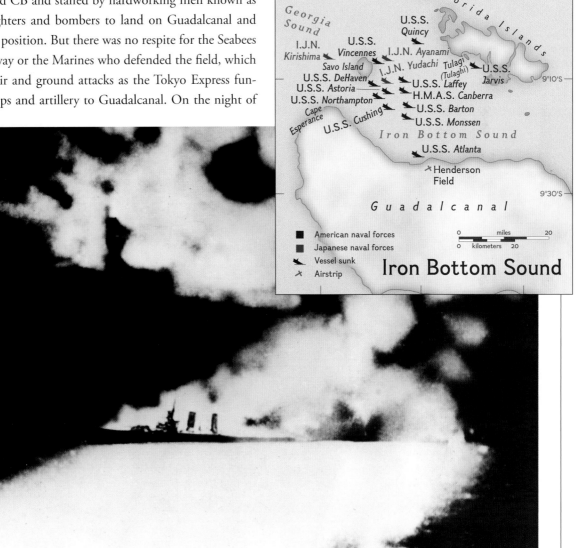

Iron Bottom Sound

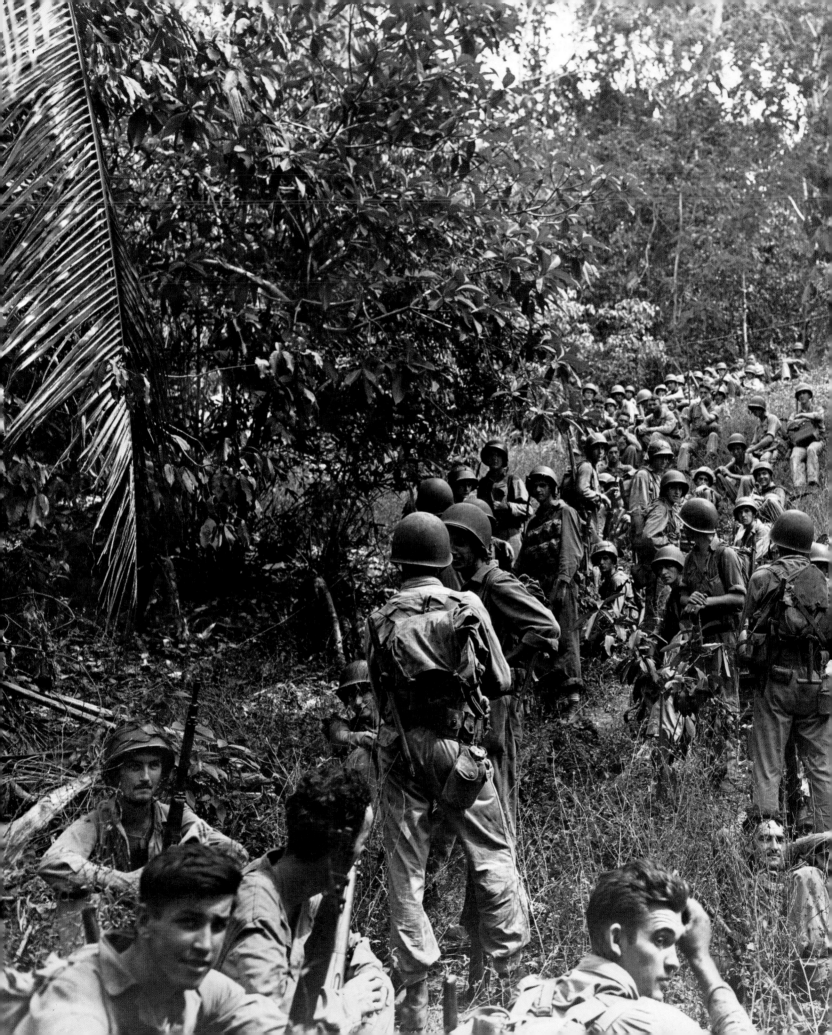

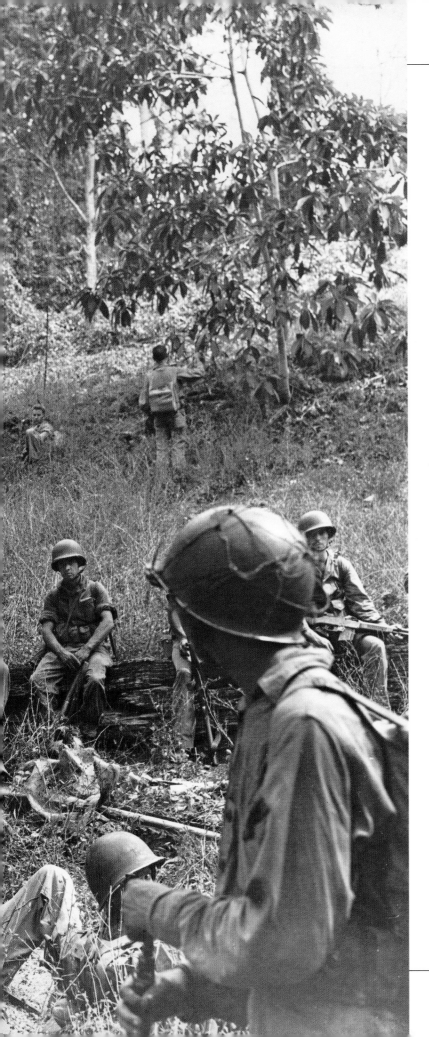

"U.S. Marines be dead tomorrow!"

JAPANESE SOLDIERS DURING
THE BATTLE ON BLOODY RIDGE

September 12, a fierce battle erupted on Bloody Ridge, over-looking Henderson Field. Several thousand Japanese soldiers attacked there, shouting in broken English: "U.S. Marines be dead tomorrow!" Lt. Col. Merritt Edson urged the commandos of his First Marine Raider Battalion to stand fast. "There is only us between the airfield and the Japs," he told them. "If we don't hold, we will lose Guadalcanal." After being forced back to within a half mile of the airstrip, they repulsed the enemy at dawn with support from Col. William McKennon's battalion, whose machine-gunners shredded the attackers. "When one wave was mowed down—and I mean mowed down—another followed it into death," McKennon recalled. Once again, the Japanese lost more than ten men for every Marine they killed and gained no ground.

Unwilling to concede defeat, Japanese commanders commit-ted still more naval power and some 20,000 additional troops to the long-running battle for Guadalcanal. Vandegrift received reinforcements as well, but Japanese warships menaced his sup-ply lines and pounded Henderson Field mercilessly, rendering it almost useless for the few warplanes that survived the bombard-ment. "I can hold," Vandegrift told his superiors, "but I've got to have more active support than I've been getting."

At Pearl Harbor, Adm. Chester Nimitz concluded that his Pacific Fleet was losing the campaign and replaced the cautious Ghormley with the aggressive Vice Adm. Bull Halsey. "Jesus Christ and General Jackson!" Halsey exclaimed when he received his orders. "This is the hottest potato they ever handed me." Soon after he took command in the South Pacific in mid-October, the aircraft carrier U.S.S. *Hornet* went down off Santa Cruz Island, east of Guadalcanal, in a bruising battle that damaged another carrier, U.S.S. *Enterprise,* and knocked two Japanese flattops out of action. Undeterred, Halsey had the *Enterprise* hastily repaired and committed his only available carrier to what Admiral King later called "one of the most furious sea battles ever fought."

Into the Jungle Men of the Second Battalion, First Marine Regiment, rest in a jungle clearing shortly after landing on Guadalcanal on August 7. On August 21, these men annihilated Japanese troops who attacked them near the Tenaru River.

PFC. JAMES A. DONAHUE

TO HELL AND BACK: A GUADALCANAL JOURNAL

*In his journal, 21-year-old Private Donahue of the Second Battalion, First Marine Regiment,
described the Japanese frontal assault on his entrenched position near the Tenaru River on August 21.*

It all started about 3 a.m. in the morning. However, we were warned about 11 o'clock to "Stand by your guns." . . . Was this going to be the real test? All of a sudden our listening posts reported troops moving toward us . . . The point was heavily fortified. I don't mean with big guns, but we had a platoon of machine gunners there and a 37mm gun crew . . . The Japs still came across and we kept knocking them off. Their machine guns would throw up a barrage for them but their field of fire was limited. They finally succeeded in getting a machine gun across, which was set up right below. Len Beer threw a hand grenade, which silenced it . . . The 37mm gun did plenty of damage with its canister shot. The Japs brought up their field pieces and started laying them into the line . . . soon our 105's silenced them. Japs were using rifle grenades and mortars. After about two hours, reinforcements came up. They sent two light machine guns, which were mounted between Bottles' and my position and Beer's and Dignan's. Within ten minutes the whole two crews were shot up, this due to the fact that they were not below the deck.

At this point, Sgt. Muth picked up a gun and started running down the line. He would stop, fire a few good bursts and then take off to a new posi-

**About five minutes later,
I said to Bottles,
"Why the hell don't he fire?"
Murray said slowly,
"He's dead."
I said, "Are your sure?"
And he said, "Here is his
blood; feel his pulse."**

**Back Home James Donahue—shown
here in a 1945 photo, sitting at left with his
wife Cass and war buddy Art Dignan—kept the
Pacific diary pictured above.**

tion. J. moved up behind Murray, and I and he had a BAR [Browning automatic rifle]. He shouted if there was room for him in the foxhole. There wasn't, so we

had to make room. He would be killed if he stayed on the deck. A machine gun had been mounted in an abandoned alligator [amtrac] and they were throwing plenty of lead our way. J crept as close as possible and made a dive for our hole. He landed okay and Murray and I continued our fire. About five minutes later, I said to Bottles, "Why the hell don't he fire?" Murray said slowly, "He's dead." I said, "Are you sure?" And he said, "Here is his blood; feel his pulse." But we couldn't determine whether he was alive. We couldn't move an inch either, for the Japs were really spraying our lines. So I reached over and felt his pulse. His face was sunken and there was no pulse. The blood began to fill the hole, so we fixed a poncho so that the blood would stay on the other side. The next morning I saw that he had been hit in the head and chest.

While our artillery was finding the Japs' range, they landed three in our lines so close to us that we were covered with dirt . . . We thought that the next one would land square on top of us. Another Jap machine gun was set up on our side of the river. Bottles said, "Let's go down and get them." I said he was crazy. It was suicide to go down that bank. We had no grenades, so we called to Dignan to heave a pineapple [grenade]. He did and another crew was wiped out. ▪

Casualties were steep on both sides in that pivotal Naval Battle of Guadalcanal. By the time the smoke cleared on November 15, the U.S. Navy had lost nine warships and more than a thousand lives, but the Japanese toll was even steeper, including two battleships, a heavy cruiser, three destroyers, and no fewer than ten troop transports, which went down with thousands of soldiers aboard. "We've got the bastards licked!" exulted Halsey. In the words of his opponent, Rear Adm. Raizo Tanaka, Japan's "last large-scale effort to reinforce Guadalcanal" had ended in failure.

Halsey received a hero's welcome when he visited the Marines on Guadalcanal in the wake of that victory. The fighting was not over, but the flow of Japanese troops and supplies to the embattled island had been reduced to a trickle. The Marines loved Halsey's combative posture and his well-publicized contempt for the enemy, signaled by a sign he erected at the naval base on Tulagi, which proclaimed in large letters: "KILL JAPS. KILL JAPS. KILL MORE JAPS." He sometimes referred to Japanese soldiers as "monkeys," one of many disparaging terms applied by American fighting men in the Pacific to enemies they loathed as much as they did the dense jungle. Some soldiers claimed the body parts of dead Japanese soldiers as trophies. One of the men who fought at Guadalcanal recalled that when they overran a Japanese encampment there, they found "pictures of Marines that had been cut up and mutilated on Wake Island. The next thing you know there are Marines walking around with Jap ears stuck on their belts with safety pins . . . We began to get down to their level."

The same war that dehumanized men and brought out the worst in them also inspired remarkable acts of courage and devotion. Battle-hardened officers like Lt. Col. Evans

> "The next thing you know there are Marines walking around with Jap ears stuck on their belts with safety pins . . . We began to get down to their level."
>
> A MARINE ON GUADALCANAL

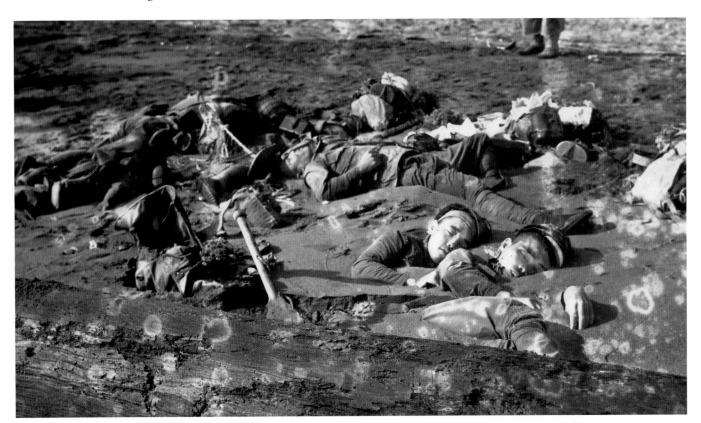

Swept Away Corpses of Japanese soldiers lie half-buried in the sand near the mouth of the Tenaru River after the disastrous assault by Col. Kiyano Ichiki's forces.

NATIONAL GEOGRAPHIC'S WARTIME MAPS

When the United States entered the war, commanders were sorely in need of accurate maps of remote areas where fighting was taking place. U.S. agencies such as the Army Map Service and the Navy's Bureau of Navigation worked to fill that gap, but detailed maps produced by the National Geographic Society also proved helpful to many people involved in the war effort, including the nation's commander in chief. Soon after the attack on Pearl Harbor, President Roosevelt read a military dispatch referring to Simatang, a tiny Indonesian island in the Celebes Sea. Unable to find Simatang on any map at hand, Roosevelt turned to National Geographic, which fulfilled his request and later presented him with a cabinet containing exhaustive, large-scale maps of the world's regions on retractable panels. A similar cabinet was provided to Winston Churchill.

Men of all ranks sent to the Pacific used the National Geographic map shown at right to orient themselves. The U.S. government distributed more than 20,000 copies of this map, containing 73 insets detailing Pacific islands, atolls, harbors, and reefs. Early in the war, ships of the U.S. Asiatic Fleet relied on it when navigating Australian waters, for which they lacked charts. In 1942, Adm. Chester Nimitz was on his way to Guadalcanal *(below)* when the navigator of the B-17 in which he was flying lost his bearings in a storm, grabbed this map from under his seat, and used it to get back on course. ∎

Islands in Detail National Geographic's wartime map of the Pacific, reduced in scale at right, was 38 by 31 inches and represented strategic islands such as Guadalcanal within the framework of the ocean and in a detailed inset *(enlarged above)*, which aided navigators.

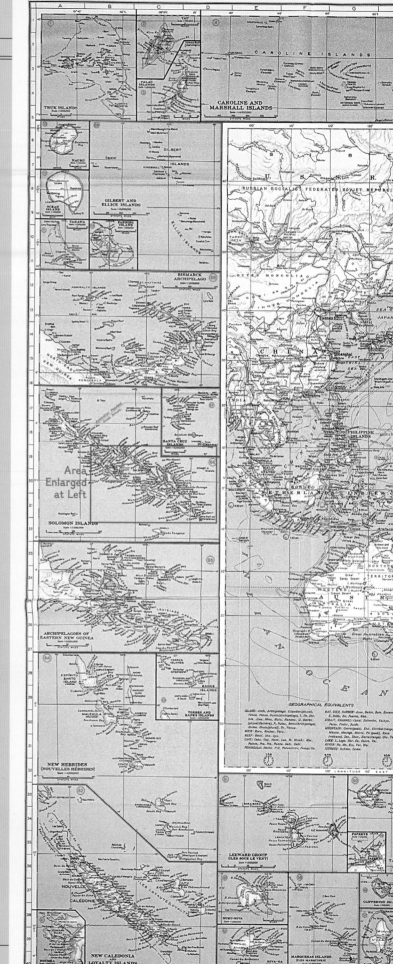

PACIFIC OCEAN

Compiled and Drawn in the Cartographic Section of the
National Geographic Society for

THE NATIONAL GEOGRAPHIC MAGAZINE

GILBERT GROSVENOR, EDITOR

Scale 1:35,000,000 or 552.4 miles to 1 inch at the Equator

Mercator Projection
(Border maps are on Conic Projection)

Albert H. Bumstead, Chief Cartographer. Culture by James M. Darley; Physiography by Charles E. Riddiford.

WASHINGTON
DECEMBER
1936

the five Sullivan brothers
'missing in action' off the Solomons

THEY DID THEIR PART

Fighting Sullivans A wartime poster salutes the five Sullivan brothers—from left to right, Joseph, Francis, Albert, Madison, and George. All were lost when their ship, the light cruiser U.S.S. *Juneau,* was torpedoed and sunk by a Japanese submarine on November 13, 1942, after being severely damaged during the Naval Battle of Guadalcanal. To avoid such tragedies in the future, the U.S. Navy and other services took measures to prevent all the sons in large families like the Sullivans from being killed in action.

Carlson, commander of the Second Marine Raider Battalion, combined utter ruthlessness toward the enemy with selfless dedication to their fellow fighting men. "We never take a prisoner," Carlson said of the commandos he drilled in guerrilla warfare and led in perilous missions against the Japanese on Guadalcanal and elsewhere. "That's not our job. I tell my men to kill every Jap they meet—lame, halt, and well . . . They're too treacherous, for one thing. They killed most of our medical corpsmen who tried to help them, so we take no chances." At the same time, Carlson practiced and preached the heroic team spirit called "gung ho": a Chinese concept meaning "work in harmony" that he witnessed in action while observing Mao Zedong's Communists in China in the 1930s. What he admired was not their ideology but their tireless dedication to their cause and their comrades. "He tried to make Chinese out of us," recalled one of Carlson's men. "He'd say that the Chinese could march 50 miles in a day on nothing but a handful of rice, so that's what we had at Guadalcanal." Traveling light and moving furtively through the jungle, Carlson's Raiders wiped out stubborn pockets of Japanese resistance on Guadalcanal in late 1942 and dispelled any lingering notion among their foes that Americans were too soft to succeed at the nasty business of jungle warfare.

Stereotypes of the Japanese held by American troops could be just as misleading. Not all Japanese soldiers felt compelled to die rather than surrender. One reason that so few yielded to the Americans is that neither side expected mercy if they surrendered. Some Japanese, including fleet commander Adm. Isoroku Yamamoto, saw nothing dishonorable in retreating to fight again another day and considered officers who sacrificed themselves and their men when faced with defeat foolhardy. By early 1943, the surviving Japanese troops on Guadalcanal were starving, and many were suffering from tropical diseases. Instead of

Stricken Carrier Splinters fly as a dud Japanese 500-pound bomb smashes through the flight deck of the U.S.S. *Enterprise* on August 24, 1942. Although the bomb did not explode, it punched a ten-foot hole in the deck, disabled an elevator, and killed or wounded several crewmen. The attack occurred during the Battle of the Eastern Solomons, waged against Japanese aircraft carriers by Vice Adm. Frank Fletcher's carrier task force, which continued to shield U.S. forces at Guadalcanal after withdrawing from its exposed position near Iron Bottom Sound earlier in August.

Coastwatchers Behind Japanese Lines

On May 18, 1942, Martin Clemens, who served as district commissioner for the British Solomon Islands Protectorate, left his post at the village of Aola on the north coast of Guadalcanal and traveled to the tree-covered high ground near Lunga Point. He had received radio reports that a Japanese naval task force was on its way to the southern Solomons. From his vantage point, Clemens watched troops of Japan's elite Special Naval Landing Force come ashore on the nearby islands of Tulagi and Gavutu-Tanambogo.

Clemens's interest in the Japanese operation was not simply that of a civilian official. The 27-year-old Scotsman was a volunteer in the British Solomon Islands Protectorate Defense Force and held a reserve commission as a lieutenant in the Royal Australian Navy. His primary wartime duty was to act as part of a far-flung network of coastwatchers, who remained behind Japanese lines to spy for the Allies in the southwest Pacific. If apprehended by the Japanese, he and others conducting such surveillance were subject to execution.

Recruited from among colonial officials, planters, and missionaries, the coastwatchers were organized into a network of field stations by Lt. Cmdr. Eric Feldt of the Royal Australian Navy. By mid-1941, Feldt had established 64 coastwatcher stations, equipped with radio sets capable of both Morse code and voice communications. By 1942, Feldt's network numbered around 800 agents across an area of more than 500,000 square miles. Coastwatchers like Clemens on Guadalcanal were supported by scouts native to the area, including men of the police or local defense forces who blended in with the populace and attracted little attention as they monitored Japanese movements.

Clemens promptly reported the arrival of the Japanese expedition on Guadalcanal, relaying his message through a chain of stations in the northern Solomon Islands and Papua New Guinea to Allied intelligence officers in Australia. Clemens and his scouts established an observation post

> **"The coastwatchers saved Guadalcanal, and Guadalcanal saved the Pacific."**
>
> ADM. WILLIAM HALSEY,
> U.S. NAVY COMMANDER,
> SOUTH PACIFIC

above Lunga Point to observe enemy warships and watch activity at the new Imperial Navy seaplane base on Tulagi. On July 1, 1942, he reported that the Japanese had begun work on an airstrip at Lunga Point—a warning that led American forces to invade Guadalcanal and transform that threatening airstrip into Henderson Field.

As enemy activity increased, Clemens withdrew deeper into the jungle to avoid detection. The Japanese soon became aware that a clandestine radio was operating on the island, and Clemens had to move frequently, shifting his bulky radio and batteries. No longer able to observe progress on the airstrip, Clemens sent scouts to join the labor force there and report back to him.

Shortly after U.S. Marines landed on Guadalcanal, the gaunt, bearded Clemens and his ragged band of his scouts entered the American camp carrying a British flag. Throughout the campaign, they continued to provide vital intelligence to General Vandegrift at First Marine Division headquarters. "We relied heavily on information brought to us by Martin and his charges," wrote Vandegrift, who credited them with providing the "margin of victory" in some instances. Admiral Halsey offered even higher praise. "The coastwatchers saved Guadalcanal," he stated, "and Guadalcanal saved the Pacific." ▪

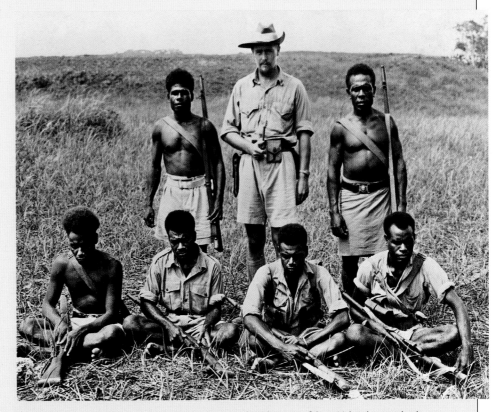

Allied Agents Coastwatcher Martin Clemens *(center)* stands with scouts of the British Solomon Islands Protectorate Defense Force who helped him spy on the Japanese on Guadalcanal, including Andrew Langabaea and Daniel Pule *(standing, left and right)*, and Olorere, Gumu, Chaparuka, and Chaku *(seated, left to right)*.

COMBAT ARTIST

Howard Brodie was an accomplished sports illustrator for the *San Francisco Chronicle* when news arrived of the attack on Pearl Harbor. He enlisted in the U.S. Army and was training as a message center clerk at Camp Crowder, Missouri, when his talents were recognized and he was assigned as a military artist to the newly created Army magazine *Yank.* The goal of the illustrated weekly was to provide a publication by and about the average American soldier. Unlike *Stars and Stripes,* which had a largely civilian staff, *Yank* was produced entirely by enlisted men.

Brodie's first assignment in combat came when he was sent with writer Mack Mor-

Artist in Uniform **Dressed in combat fatigues, Howard Brodie finishes a drawing on an improvised sketch board in his tent on Guadalcanal.**

riss to cover U.S. Army troops dispatched to reinforce the Marines on Guadalcanal. Brodie sketched men of the 25th "Tropic Lightning" Division during the fighting on Mount Austen, one of the last Japanese strongholds on the island, which fell to the Americans in early January 1943. Working in artillery positions and aid stations just behind the front lines, Brodie used pencil, crayon, and pen and ink to depict soldiers alone or in teams, performing tasks as strenuous as that of the athletes Brodie portrayed before the war but in surroundings far more dangerous and oppressive. In a 1943 interview, Brodie stated, "I wouldn't have missed Guadalcanal for anything. But I was damned glad to leave the place." ■

Impressions of Combat **These sketches, drawn by Howard Brodie on Guadalcanal, include portraits of individual soldiers—one of which appeared on the cover of *Yank*—as well as scenes of a howitzer in action on the slopes of Mount Austen *(right)* and litter bearers struggling to evacuate a wounded soldier under fire from enemy snipers *(opposite).***

The stench of dead Japs was nauseating — Inf. on the road to Kokumbona — Guadalcanal — sketched between air alarms.

S/Sgt Howard Brodie Guadalcanal '43

PROP OF U.S.

SKETCHED PVT. MERLE "JUDGE" HARDY TIRED & HOT COMING IN FROM A PATROL AT THE FRONT — HOWARD BRODIE GUADALCANAL YANK STAFF ARTIST

EVERETT GINTHER OREGON (BAKER. B-17 Radio Operator "CARROLL CUTIES" RAIDS OVER UPPER SOLOMONS —

HOWARD BRODIE GUADALCANAL

GUYS THAT DESERVE EVERY CREDIT HERE — LITTER BEARERS ON A JUNGLE TRAIL AT THE FRONT — THEY'RE UNDER SNIPER FIRE TOO & FEW ARE ARMED

SGT HOWARD BRODIE GUADALCANAL

SENDING THIS ALONG FOR RECORD'S SAKE OF WHAT A JUNGLE TRAIL AT THE FRONT LOOKS LIKE — THESE ARE NATIVES WHO HAVE DONE A GREAT JOB BRINGING SUPPLIES UP TO OUR BOYS — HOWARD BRODIE YANK STAFF ARTIST

CAPTURED JAPANESE DIARY
THE FATE OF IMPERIAL SOLDIERS ON GUADALCANAL

This diary, found on the dead body of an unidentified noncommissioned officer of the 38th "Nagoya" Division on Guadalcanal, records the suffering of Japanese troops as the battle drew to a close.

25 December 1942 Today is Christmas, a very important day for the enemy. Artillery bombardment is a terrible thing. Again I became sick with malaria and my temperature began to rise, so I fell asleep in the trench. I prayed for a complete recovery, because this is the third time that I had this fever.

26 December 1942 Corporal Abe found some sweets on a dead enemy and divided them . . .

27 December 1942 I went with Corporal Abe to get some more meat, because it was so good yesterday. It was to be eaten by the company. It was buried in the company cemetery to keep it secret. However, maggots had started to develop in it.

1 January 1943 Gave 3 banzai for the Emperor and sang the national anthem. We toasted with whiskey. We are fortunate to drink whiskey on this island. A number of shells burst around the position at about 1400. It is surprising how many shells the enemy has.

5 January 1943 Sergeant Takeya is missing. It is not possible for an active NCO to desert.

12 January 1943 I ran out of ink, so I shall have to write in pencil from now on. I reconnoitered the enemy situation in front of the 3rd Battalion.

14 January 1943 Men are dying one after another, and now the company roster

> **"The enemy does not come close enough that we can kill them and get their rations. I am very hungry. I wonder if this is how it is when a man is starving."**

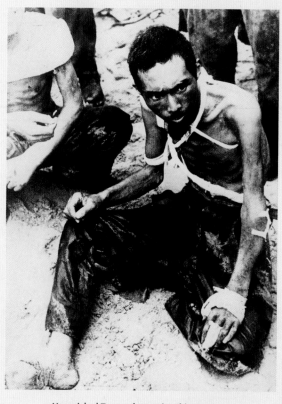

Vanquished Too weak to resist, this starving Japanese soldier was captured by American troops at a strongpoint on Mount Austen.

has 20 men, besides the company commander. The enemy keeps firing from distance, so we shall have to be careful of stray bullets. The enemy does not come close enough that we can kill them and get their rations. I am very hungry. I wonder if this is how it is when a man is starving. Rice cakes and candies appear in my dreams. I must train myself to suppress these desires.

16 January 1943 I heard one of the enemy talking busily in Japanese over a loud speaker. He was probably telling us to come out. What fools the enemy are! The Japanese Army will stick it out to the end. This position must be defended with our lives. There was no artillery shelling because of the broadcast . . . It will probably have no effect at all.

19 January 1943 Ant nests are good to eat when one is starving. I received some meat from battalion headquarters. My orderly is sick, so I had to cook it myself. Enemy artillery began to fire about 1100, and there was an enemy attack in front of the 8th Company about 1300. We fired on them with light machine gun, and I believe they got a surprise . . . I felt very dazed and only semiconscious because of my empty stomach. At 1330, I prepared my equipment to put it in my haversack so that it can be packed on a moment's notice. It will be so heavy that I don't know whether I'll be able to carry it or not, because of my run-down condition . . . Only my spirit keeps me going. ■

abandoning them to their fate, Japanese sailors risked their own lives and rescued 13,000 emaciated soldiers from the island. As shown by such devotion to duty, the gung ho spirit was confined to no one nation or corps engaged in a struggle as heroic as it was horrific.

MacArthur Strikes Back

We'll defend Australia in New Guinea," General MacArthur declared in August 1942 as the American campaign on Guadalcanal unfolded. At the time, Japanese troops in New Guinea were advancing on Port Moresby in the Australian-administered territory of Papua (now Papua New Guinea). That was one of the worst places on Earth to wage war. Swollen rivers descended from the towering peaks of the Owen Stanley Range through dense jungle infested with pythons, crocodiles, leeches, and a maddening host of disease-bearing insects. Allied forces in Australia needed strengthening, and committing them to a counteroffensive in forbidding New Guinea was risky. "MacArthur without fear of criticism might have remained on the defensive until sufficient forces could be made available," remarked his air commander, Maj. Gen. George Kenney. "A lesser general might even have considered the abandonment of Port Moresby, his only base in New Guinea." Instead, MacArthur set out to drive enemy troops from New Guinea as the first step toward his goal of liberating the Philippines and defeating Japan.

Interservice rivalry lent some urgency to MacArthur's campaign. After much wrangling, the Joint Chiefs of Staff in Washington had narrowed his theater of operations in the southwest Pacific slightly and expanded that of the Navy and Marines to allow them to launch their offensive in the Solomons. MacArthur was eager to match them stride for stride to justify his repeated appeals for more troops and supplies. Adept at public relations, he used reporters to press his case that resources should be diverted from Admiral Nimitz's theater to bolster his own efforts and hasten victory over Japan. Such infighting could be counterproductive, but MacArthur's boss, Gen. George Marshall, and Navy chief King managed to reach an accommodation that kept competition between their services from undermining the war effort. Army troops relieved battle-weary Marines on Guadalcanal and joined in many later Pacific campaigns under Nimitz's jurisdiction. In return, Nimitz provided a fleet to support MacArthur, who required warships and transports for amphibious landings.

Although MacArthur seldom got along with anyone whose ego and reputation rivaled his own, he took a liking to the prominent Admiral Halsey and invited him to command his fleet. "If you come with me, I'll make you a greater man than Nelson ever dreamed of being," promised MacArthur, referring to Horatio Nelson. Halsey chose to remain as naval commander in the South Pacific under Nimitz, but he and MacArthur made a powerful tandem as their respective forces closed in on the big Japanese base at Rabaul, situated on the island of New Britain, between New Guinea and the Solomons.

Trophies of Battle At top, U.S. Army troops proudly display a Japanese flag captured on Guadalcanal in late December 1943. Hardened by the horrific nature of the fighting there, some soldiers took enemy body parts as trophies, like the severed head above, placed by a member of the Fifth Marine Regiment on a disabled Japanese tank for his friends to photograph.

MacArthur's offensive began inauspiciously in September 1942 when he sent raw American troops to reinforce the Australians who were defending Port Moresby. Many of those Aussies were battle tested and succeeded in driving Japanese troops —who had landed at Buna on the east coast of Papua and crossed the rugged Owen Stanley Range—back toward Buna and nearby Gona, where the Japanese dug in and held fast. The Australians were assigned to take Gona, while soldiers of the U.S. 32nd Infantry Division stormed Buna—a daunting task for which they were ill prepared. Their corps commander, Lt. Gen. Robert Eichelberger, a former superintendent at West Point, wrote that they were "in no sense ready for jungle warfare" and were "not sufficiently trained to meet Japanese veterans on equal terms." Like other American soldiers rushed into combat in 1942, they would have to learn to fight in the line of fire.

Eichelberger remained with MacArthur in Australia to train the rest of the corps while Maj. Gen. Edwin Harding led the division into battle in New Guinea. One regiment flew to Port Moresby and trekked over the mountains toward Buna on a trail so narrow and tangled that men had to hack their way through the brush with machetes. Others had an easier trip, landing at an airfield closer to Buna, but the rainy season had begun and few soldiers were in that sweltering jungle for long before contracting dysentery, malaria, or other maladies. Attacking in mid-November, they made little progress amid hostile terrain and fierce Japanese resistance. "Everywhere men cursed, shouted, and screamed," reported one American lieutenant whose platoon reached the outskirts of Buna and tried to break through there. "Brave men led and others followed. Cowards crouched in the grass, frightened out of their skins." When the offensive stalled, MacArthur sent in Eichelberger with instructions that left no room for retreat: "Bob, I want you to take Buna, or not come back alive."

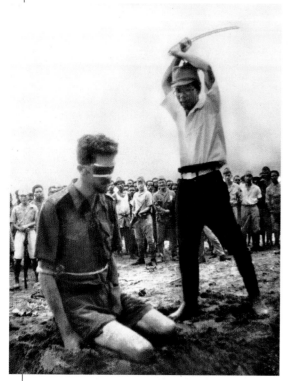

"We'll defend Australia in New Guinea."

Gen. Douglas MacArthur

Brutality and Mercy Above, Japanese officer Yasuno Chikao uses his sword to execute Sgt. Leonard Siffleet, a captured Australian commando, at Aitape Harbor in Papua New Guinea on October 24, 1943. Japan did not observe the Geneva Conventions and showed no mercy to uniformed commandos like Siffleet found operating behind enemy lines. Australian soldiers were often aided and sheltered, however, by compassionate islanders like the Papuan shown opposite helping a blinded Australian infantryman along a road near the Buna-Gona battlefront.

Eichelberger found the troops in disarray: "Their clothing was in rags," his inspectors reported. "They were receiving far less than adequate rations and there was little discipline or military courtesy." Units were badly jumbled, and some officers had lost touch with their men. Eichelberger called a halt to the fighting while he restored order and replenished the division's supplies. Morale improved when the men were well fed and well led. Honoring the age-old maxim that "a commander must be seen by his troops in combat," Eichelberger visited the front soon after the offensive resumed in December and urged on companies that were bogged down near Buna. Although officers there had taken to removing their insignia because it exposed them to sniper fire, he wrote, "I was glad on that particular day that there were three stars on my collar which glittered in the sun. How else would those sick and cast-down soldiers have known their commander was in there with them?"

Generals could inspire men by appearing up front, but the task of leading soldiers in battle fell largely to lowly sergeants and lieutenants, who often took even greater risks in combat than the troops they watched over. The first significant American breakthrough at Buna was achieved by Staff Sgt. Herman Bottcher, an exile from Germany who had fought against fascists during the Spanish Civil War before enlisting in the U.S. Army. On December 5, Bottcher led his platoon of fewer than 20 men through a gap in the enemy

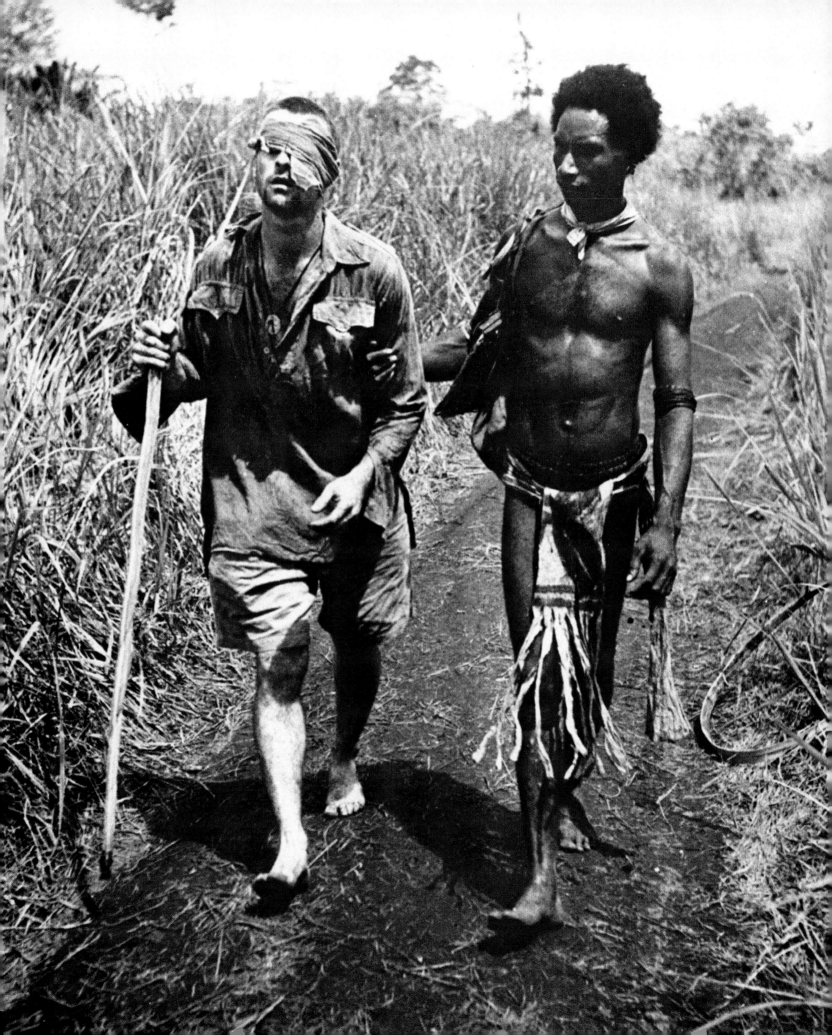

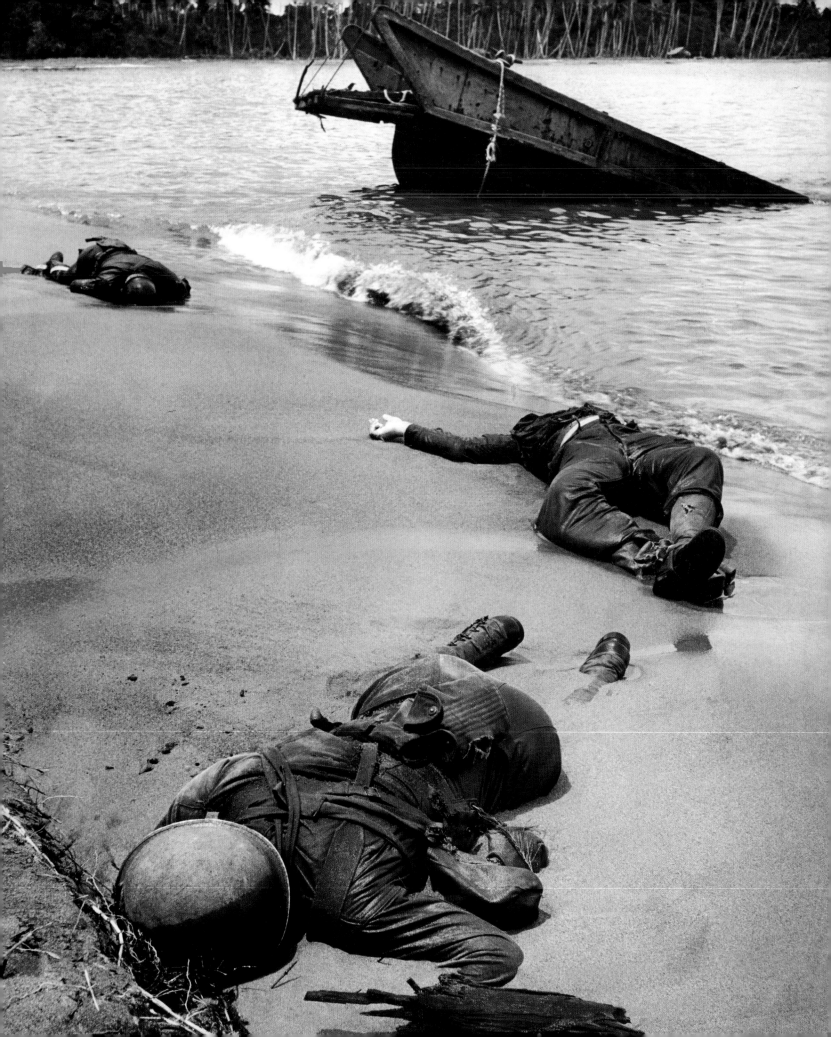

line above Buna and reached the beach, where they dug in and used their rifles and a single machine gun to repulse swarming attackers, inflicting on them more than 120 casualties. "With his hand on the hot machine gun, Bottcher was able to mow them down like wheat in a field," Eichelberger related. "For days after, the evidence of Sergeant Bottcher's victory rolled in and out with the tide . . . drifting bodies of Japanese soldiers." Wounded, Bottcher earned his first Distinguished Service Cross (DSC) in that battle. He won his second DSC two weeks later when he offered himself as a target to draw enemy fire away from his men and again fell wounded. The award that meant most to him, however, was U.S. citizenship, which he had been denied for fighting in Spain but was granted by an act of Congress several months before he died in action in the Philippines in late 1944.

By January 1943, American and Australian troops had crushed enemy resistance at Buna and Gona, where the victors found corpses piled high in Japanese bunkers. "Rotting bodies, sometimes weeks old, formed part of the fortifications," a British correspondent reported. "The living fired over the bodies of the dead, slept side by side with them." Eichelberger's men uncovered the diaries of Japanese soldiers, which recorded their thoughts as their plight worsened and no help arrived. "Now we are waiting only for death," wrote one man. "The news that reinforcements had come turned out to be a rumor . . . Even the invincible Imperial Army is at a loss. Can't anything be done? Please, God." Spectacular early triumphs in the Pacific had tempted the Japanese to expand their conquests and threaten Australia. Now they were overextended and lacked the resources to cope with simultaneous Allied assaults on their bases in New Guinea and the Solomons.

Eichelberger knew better than to risk MacArthur's wrath by seeking renown for the victory at Buna. He turned down a request to be interviewed for a cover story in *Time,* but stories about him appeared in other magazines and earned him a scolding from his boss, who did not want anyone overshadowing him. "Do you realize I could reduce you to the grade of colonel tomorrow and send you home?" MacArthur asked Eichelberger, who heeded those words and told a public relations officer: "I would rather have you put a rattlesnake in my pocket than to have you give me any publicity."

MacArthur was hard on his subordinates, but he was even harder on the Japanese. Throughout 1943, he and Halsey confounded opposing commanders by circumventing enemy bases where attacks were anticipated and defenses were well prepared and striking more vulnerable targets instead. By "island hopping," leapfrogging over one Japanese position to strike another, they covered more ground at less cost. Some battles were unavoidable, however, and left thousands dead, maimed, or broken in spirit. From Guadalcanal, Halsey's

A Costly Victory Lt. Gen. Robert Eichelberger *(above)* was ordered by General MacArthur to take charge of the demoralized U.S. 32nd Infantry Division in Papua New Guinea in late 1942 and attack Japanese-held Buna while Australians assaulted nearby Gona. Eichelberger's forces achieved victory at a steep price. Among the casualties were three slain soldiers of the 32nd Infantry Division, photographed near the wreckage of a Japanese landing craft on a beach near Buna in January 1943 *(opposite)*. This grim photo was not approved for publication by the War Information Office until September 1943, when it appeared in *Life* with a note from the editors, who wrote that it was time for Americans to come directly "into the presence of their own dead."

"Bob, I want you to take Buna, or not come back alive."

GENERAL MACARTHUR TO GENERAL EICHELBERGER

forces leapfrogged to New Georgia, midway up the Solomons chain, where another Japanese airfield was under construction. Soldiers of the 43rd Infantry Division, most of them former National Guardsmen from New England with little combat training, found the dense jungle there appalling. Many were wounded by friendly fire from troops unnerved by strange noises in the night. "Some men knifed each other," one report stated. "Men threw grenades blindly in the dark." Hundreds of soldiers cracked under the strain each week on that embattled island and were hospitalized with combat neuroses. Ultimately, more than 50,000 U.S. Army troops and Marines were needed to subdue fewer than 10,000 Japanese defenders on New Georgia.

> "Upon passing over the target, the element of surprise is lost, so it is best to pull all power you can and make a hurried departure."
>
> PILOT OF THE FIFTH ARMY AIR FORCE, DESCRIBING SKIP-BOMBING TACTICS

HELP FROM ABOVE

Crucial to Allied success in pushing back the determined Japanese was General Kenney's Fifth Army Air Force, which supported MacArthur's offensive and supplemented naval air power as Halsey's Solomons campaign intensified. A resourceful and inventive commander, Kenney found a way of making air raids on enemy warships and transports more accurate and less dangerous. Hitting moving ships with bombs released at high altitude was a long shot that seldom paid off. Dive-bombers like the SBD Dauntless were far more accurate in that role, but were vulnerable to attack because of their slow cruising speed and proximity to enemy antiaircraft guns as they swooped down and pulled up. Naval aviators joked that SBD stood for "slow but deadly" and achieved success with the Dauntless by "helldiving"—dropping down abruptly from high altitude and catching Japanese defenders off guard, a tactic used with devastating impact at Midway. The Dauntless lacked sufficient range and speed for Kenney's purposes, however. Using longer-range B-25s, he perfected a tactic called skip-bombing, developed in 1941 by Italian pilot Giuseppe Cenne. The B-25s came in low and released their bombs a few hundred feet above the water and a few hundred yards away from their target. The bombs skipped like stones toward their mark while the pilot pulled up and over the enemy ship. "Upon passing over the target, the element of surprise is lost," one pilot warned, "so it is best to pull all power you can and make a hurried departure." Flying mostly at night, Kenney's 43rd Bombardment Group, known proudly as "Ken's Men," achieved a "high percentage of hits" through skip-bombing in 1943 and reported "no losses to date."

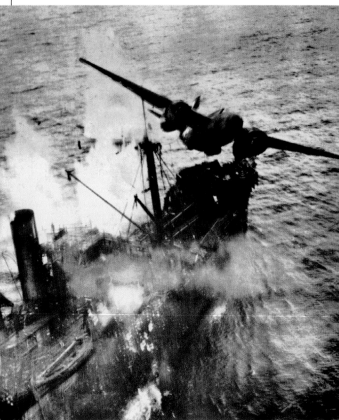

Narrow Escape A Douglas A-20G Havoc bomber of the Fifth Air Force's 89th Attack Squadron barely clears a Japanese merchant ship moments after a successful skip-bombing attack off Wewak, New Guinea, in March 1944.

Another asset for Kenney's fliers was the Lockheed P-38 Lightning fighter, which entered service in the Pacific in late 1942. With a top speed surpassing 400 miles per hour and plenty of firepower, it could outduel the Mitsubishi Zero and helped make legends of skilled pilots like Maj. Richard Bong of the 49th Fighter Group, who became America's top ace with 40 kills and received the Medal of Honor personally from General MacArthur before plummeting to his death while testing a jet fighter a few days

before the war ended. Capt. Thomas Lynch scored 20 kills and won a DSC for leading a dozen P-38s against 40 Japanese fighters and bombers over Buna in December 1942 and shooting down two enemy aircraft while others in his squadron destroyed ten more. "All you gotta do is see them first," he said of his Japanese opponents. "If you see them first, you can get in position. If you see them coming up on your tail, it's too bad—you've seen them last." Promoted to lieutenant colonel, Lynch saw his last battle in March 1944 over Aitape Harbor in northern New Guinea, where he died in action.

By then, MacArthur's American and Australian troops were wrapping up their arduous conquest of New Guinea and preparing to retake the Philippines. Halsey's forces had advanced in late 1943 from New Georgia to Bougainville, near the northern end of the Solomons. That move forced Japanese warships to abandon Rabaul and neutralized the armed forces remaining at that once formidable base. Taking Rabaul—which at its peak harbored dozens of warships, scores of warplanes, and more than 100,000 troops—could have cost the Allies far more casualties than they suffered at Buna and Guadalcanal combined. Instead, they pinched it off and blasted it from the air, reducing that dwindling garrison to impotence.

Japan was no longer capable of offensive action in the Pacific and faced the grim task of defending its home islands with a weakened navy, which had lost its top strategist in April 1943 when a plane carrying Admiral Yamamoto from Rabaul to Bougainville was shot down by a P-38 pilot flying from Henderson Field with guidance from naval code breakers. Even more devastating for Japan was the death in battle of hundreds of expert naval airmen, who had trained for years and were replaced by less capable fliers. The Japanese Imperial Army remained formidable, but many of its troops were mired in China. Army commanders were reluctant to transfer them to the Pacific theater, and the Imperial Navy was losing the capacity to safeguard shipments of troops and supplies. Halsey was delighted to hear of enemy transports going down with Japanese soldiers aboard and referred to one such sinking as a "rich, rewarding, beautiful slaughter." Lest any of his subordinates ease up on their faltering foes, he often closed dispatches with the words, "Keep 'em dying."

THE STRUGGLE FOR CHINA

When Japanese troops invaded China in 1937, Emperor Hirohito was told that his Imperial Army had the situation in hand and the war "could be finished up within two or three months." Four years later, nearly one million Japanese troops were engaged in China, and no end to the conflict was in sight. Gen. Hideki Tojo rejected the option of withdrawing those troops and coming to terms with the United States—which

Top Ace Maj. Richard Bong (center) stands proudly in front of his Lockheed P-38 Lightning, named *Marge* after his fiancée. Bong, who served with 49th Fighter Group, was the Army's top-scoring ace with 40 aerial victories and was awarded the Medal of Honor at left in December 1944.

Gallant Gunner Cpl. George Papageorge of the 476th Anti-Aircraft Battalion, 41st Infantry Division, leans on a Quad 50 gun near an airfield on Biak Island, where his gallant unit helped repel Japanese air attacks in June 1944, shooting down 29 enemy planes. By securing Biak Island, off the north coast of New Guinea, MacArthur moved a step closer to his long-cherished goal of retaking the Philippines.

was aiding opposing Chinese Nationalists led by Chiang Kai-shek—and embarked on a sweeping offensive against America and its allies that was supposed to secure Japan's grip on China but failed to do so. Soon after the attack on Pearl Harbor, Japan invaded Burma to stop the Allies from funneling troops or supplies from that British colony to bolster the Nationalists in China. When the Burma Road between those two countries was sealed off,

supplies were airlifted to Chiang's forces and Allied commanders made plans to retake Burma and reopen the road. Their main objective was to keep the Nationalists fighting and tie down Japanese troops who might otherwise be sent to oppose American advances in the Pacific. But some strategists had a more ambitious goal: to use Nationalist air bases in China to bomb Japan into submission.

The fate of China was so closely linked to that of Burma and India during World War II that the U.S. Army lumped them together under the acronym CBI (China-Burma-India). Commanding in that theater was Lt. Gen. Joseph Stilwell, known as "Vinegar Joe" for his quick temper and sharp tongue. Stilwell escaped from Japanese-occupied Burma in 1942 by leading soldiers and civilians on a long, harrowing trek to India, where reporters touted him as a hero and expected him to celebrate his feat. "I claim we got a hell of a beating," he said bluntly. "We got run out of Burma, and it is humiliating as hell." He vowed to go back and retake that country.

Stilwell never had many Americans serving under him. To retake Burma, he would need help from British and Indian forces and from the Chinese troops he trained in his dual role as Chiang's chief of staff. That assignment caused him much aggravation, because Chiang was reluctant to commit his forces to battle in Burma. As China's generalissimo, he claimed to have nearly four million soldiers under his command, but many of them were not combat worthy. Others who were fit to fight were led by officers he distrusted. Chiang preferred to remain on the defensive against the Japanese and preserve his strength for a postwar showdown with his Communist rival, Mao Zedong, who had reached a fragile truce with the Nationalists to keep both sides from being drained by a bloody civil war and crushed by the invaders.

Out of Burma Lt. Gen. Joseph Stilwell, U.S. commander in the China-Burma-India theater, leads his staff along a jungle trail during the evacuation of Japanese-occupied Burma in May 1942. Stilwell, whose campaign hat and battered shoes appear above, led a mixed force of Allied troops and civilians on a rugged, 140-mile march over jungle-covered mountains to safety in Imphal, India.

Stilwell thought that Chiang was holding out on the Allies who aided him and referred to him in writing as a "stubborn, ignorant, prejudiced, conceited despot who never hears the truth except from me and finds it hard to believe." As Stilwell's relationship with him deteriorated, Chiang and his influential wife grew closer to Maj. Gen. Claire Chennault, who was Stilwell's subordinate but challenged his plan for a renewed ground war in Burma by proposing to use air power to supply the Nationalists and defeat the Japanese. A veteran of the prewar Army Air Corps, Chennault had recruited American volunteers in 1937 to form the "Flying Tigers," who flew combat missions for the Nationalists against the Japanese. When the U.S. entered the war, he rejoined the U.S. Army and organized the airlift from India to China, carried out by daring pilots who went "over the Hump," flying in turbulent skies above the towering Himalaya to land their overloaded cargo planes on primitive runways. More than a thousand airmen died in crashes on that perilous route during the war.

In March 1943, Chennault was named commander of the 14th Army Air Force, which targeted Japanese forces and their supply lines with fighters and medium-range bombers. His ultimate objective was to blast Japan itself with long-range B-29 bombers, launched from new airstrips he was building for that purpose. Stilwell warned that Japanese troops would respond to that threat by overrunning those bases, but Chennault forged ahead, dismissing the CBI commander as a hidebound old soldier who disdained air power and distrusted "any weapon more complicated than a rifle and bayonet."

Stilwell hoped to reclaim all of Burma but had to settle for a pared-down offensive whose purpose was to secure the northern part of that country and funnel troops and supplies to China along a new road from Ledo in India that would connect with the old Burma Road and supplement the airlift. He used his authority over the shipment of goods to the Nationalists as leverage to persuade Chiang to commit two Chinese divisions to the offensive. Trained by Stilwell and his officers, those soldiers were better fed and better equipped than

> "I claim we got a hell of a beating. We got run out of Burma, and it is humiliating as hell."
> Lt. Gen. Joseph Stilwell

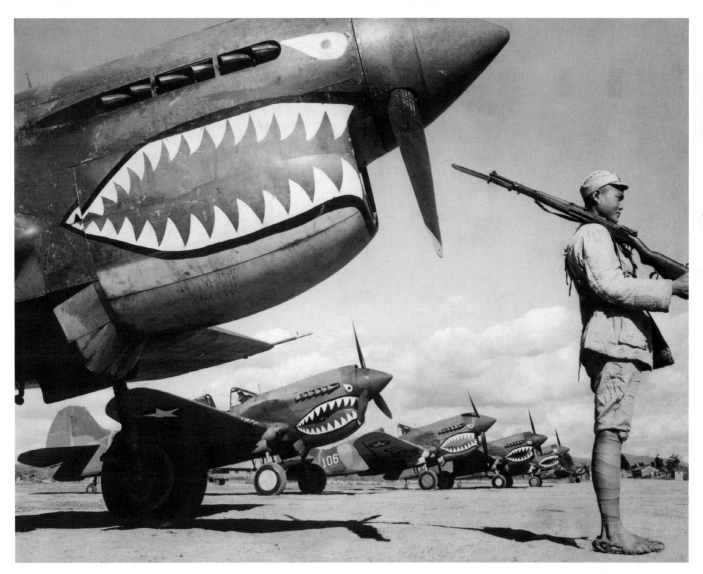

Flying Tigers A Chinese soldier at an airfield in Kunming guards Curtiss P-40K fighters of the U.S. 23rd Fighter Group, painted with the Flying Tiger emblem of Claire Chennault's prewar American Volunteer Group. Some of those volunteers later joined the 23rd Fighter Group of General Chennault's 14th Army Air Force in China.

LT. JOHN RUSSELL
FLYING OVER THE HUMP

*In 1944, 19-year-old Lieutenant Russell, with the First Combat Cargo Group, flew American-trained
Chinese troops over the "hump" of the Himalayas to fight in Burma against the Japanese.*

They overloaded us with fifty Chinese soldiers, who, fortunately, were not very well equipped with guns and other supplies so didn't weigh much. I was really shocked by the poor condition of these Chinese soldiers. They were not at all what we expected of American trained troops. We had to climb rather high and the coldness filled the plane. We had some heat up front, but they had none in the back. Consequently, the body lice left them and crawled all over our controls . . . we found a solid layer of clouds in all directions . . . there were no radio devices to bring us in to landing fields, most of which were located in small valleys surrounded by mountains, so when clouds settle down over a field, that field is closed.

This day our delivery of the Chinese soldiers to the fighting front came to a stop, as we heard the voice from the field tower tell the plane ahead of us that the field was socked in and landing was not possible. We were then told to divert to another field not too far away, but as we approached them, I radioed that tower for landing instructions, and received that same reply, "socked in." Remember, the Chunking deal was no gas from them for our return trip, so that didn't allow much time to circle around and wait for the clouds to blow away. We were

> **"I saw the upraised wing brush against tree tops on the side of the hill which caused me to pull back instantly on the stick to get us back on top again."**

Comrades **Lt. John Russell embraces a buddy at their training camp in India's eastern province of Assam.**

now down to 50 gallons and choked back as much as safely possible, and even that allowed for only 25 minutes of flying time.

At this time we were on top of the overcast at thirteen thousand feet and could see the peaks of many mountains sticking up through. After much conversation, we knew that running out of gas sitting up here would eliminate all choices to land thereafter, so in a desperate move, we chose an area where we thought maybe

the clouds didn't have hard centers. Henry, flying on instruments through the clouds, would put the plane in a very tight spiral while descending at a very slow rate, and I would put my face against the glass trying to see anything at all. And indeed I did, as I saw the upraised wing brush against tree tops on the side of the hill which caused me to pull back instantly on the stick to get us back on top again . . .

The contact with the tower was good, but there was such a disturbance that the compass fluttered and spun, giving us little direction at all. We had been warned of misdirections brought on by the placement by the Japanese of radio devices on the hillsides. A quick-thinking control operator told me to change frequency, and he would talk to us from a radio in a plane on the ground. He would home on our signal, and we would home on his. They worked together perfectly and brought us right over the field, which lay under a blanket of clouds. Then a most amazing thing happened: we saw a circular hole in the overcast exactly over the landing strip. Henry cut the engines back to idle and dove through the hole and onto the ground. We knew every second was critical and once parked, I had the crew chief drain the tanks. All that was left was two gallons: one minute of flying time. ∎

most Nationalist troops, many of whom were shortchanged by corrupt commanders who profited at their expense. Supporting Stilwell's Chinese recruits were Indian troops called Chindits, led by Maj. Gen. Orde Charles Wingate, an unconventional British officer born in India who drilled his men relentlessly in harsh conditions to prepare them to operate behind enemy lines in the dense Burmese jungle. Wingate's tough Chindits were models for a special unit of three thousand American commandos recruited to fight in Burma by Brig. Gen. Frank Merrill, a staff officer under Stilwell. Known as Merrill's Marauders, many were veterans of jungle warfare in the Pacific and all were volunteers—although some chose to join Merrill rather than serve time for offenses they committed in uniform.

Among those with good records who volunteered freely for what the War Department called this "particularly hazardous, self-sacrificing mission" were more than a dozen Nisei who had enlisted as translators and interrogators in the Military Intelligence Service. After joining Merrill's Marauders, they did more than translate. Unlike most Nisei in uniform, who served in Europe, they went into combat against Japanese troops, often creeping up on enemy units at great risk to assess their strength, listen for commands and other clues as to their plans, and report back. Some of those volunteers had

Air Power A Curtiss C-46 Commando transport plane skims over the rooftops of a Chinese village as it comes in for a landing. Such missions were often flown by pilots of the Air Transport Command, which hauled troops and supplies for U.S. and Allied armed forces. Combat missions in the CBI theater were flown by the 14th Air Force, which adopted the Flying Tiger as its insignia *(inset)*.

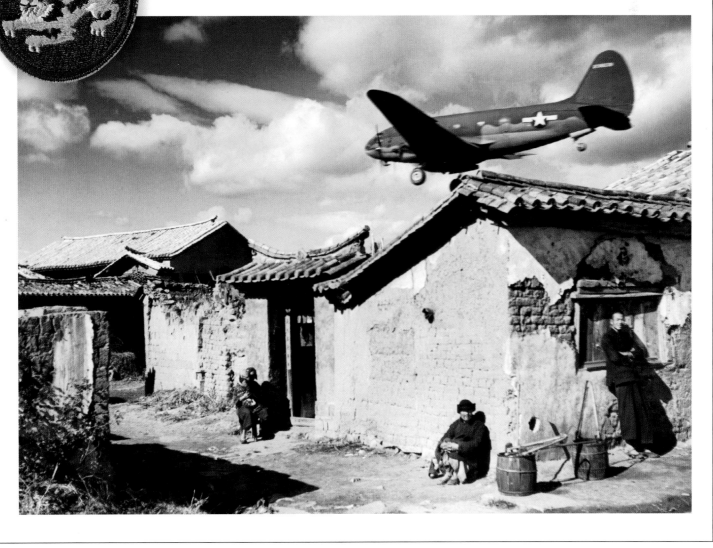

"Mud, mud, mud, typhus, malaria, dysentery, exhaustion, rotting feet, body sores."

Lt. Gen. Joseph Stilwell, on conditions in Burma

Jungle Fighters Chindits of the 77th Indian Infantry Brigade—a mixed force of British and Indian troops who fought as commandos—tend a wounded comrade during a deep raid into Japanese-occupied Burma in 1944.

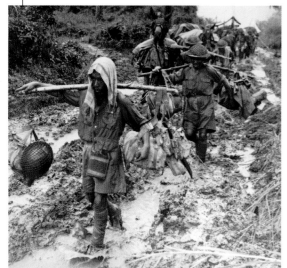

Allied Lifelines Above, heavily loaded troops of an Indian unit trudge along the muddy Ledo Road, which connected with the Burma Road, linking Allied bases in India with Burma and China. To haul more supplies to Nationalist forces opposing the Japanese in China, engineers improved the Burma Road, including a spectacular stretch near Annan, China, known as "21 curves," shown opposite with an Allied truck convoy wending its way upward.

relatives in Japan. Sgt. Roy Matsumoto, for instance, was born in California and remained there as a young man after his parents and siblings returned to Japan and settled in Hiroshima, where they later survived the atomic blast that obliterated much of that city on August 6, 1945. Fighting against men from their ancestral homeland was a sacrifice that Matsumoto and other Nisei Marauders who had been sent to internment camps in the U.S. made to show that they were true Americans. As one of them said, "Each of us in our own way looked beyond the 'barbed wires' [of the war relocation camps] to a better America."

Stilwell's offensive, launched in late 1943, inaugurated six months of furious action in the CBI theater, during which the momentum swung back and forth. In early 1944, the Japanese counterattacked, crossing into India in a drive that threatened to cut off Allied forces operating in Burma and stem the flow of supplies to Nationalist China. Many Indian troops remained loyal to Britain and opposed that invasion, but some sided with Japan against their British rulers, who had jailed Mohandas Gandhi and other advocates of Indian independence when they refused to support the war effort. Pilots who had been flying over the Hump to China shifted their efforts to keep stranded Allied forces fighting while hard-pressed Japanese troops ran out of food and ammunition and withdrew from India in the spring.

Meanwhile, Stilwell's multinational forces were closing in on their objective in northern Burma: Myitkyina, a vital town near the Chinese border where the Japanese maintained an air base and were reinforced by rail. Merrill's Marauders led the advance and took the runway there in May, but were stalled by Japanese troops holding the railhead and settled in for a siege. Many of the Marauders were sick and had to be evacuated. Meanwhile, monsoon downpours mired Stilwell's Chinese troops and held them back. "Rain, rain, rain," he wrote glumly as his campaign bogged down. "Mud, mud, mud, typhus, malaria, dysentery, exhaustion, rotting feet, body sores." One thought consoled him: "If we are so badly off, what about the Japs?" In fact, they were in even worse shape. Chindits cut the railroad below Myitkyina and denied aid to the Japanese defenders there, who lost more than half their men to disease and battle wounds within a few months before the survivors escaped and their commander committed suicide. "Myitkyina over at last," Stilwell wrote in August. "Thank God."

Allied gains in Burma were offset by simultaneous losses in China, where the enemy offensive Stilwell had predicted unfolded, driving Nationalist troops back hundreds of miles and reducing the threat posed to Japan by Chennault's air campaign. By mid-1944, the Joint Chiefs in Washington had concluded that islands in the Pacific would serve better than China as platforms from which to bomb and, if necessary, invade Japan. Future opera-

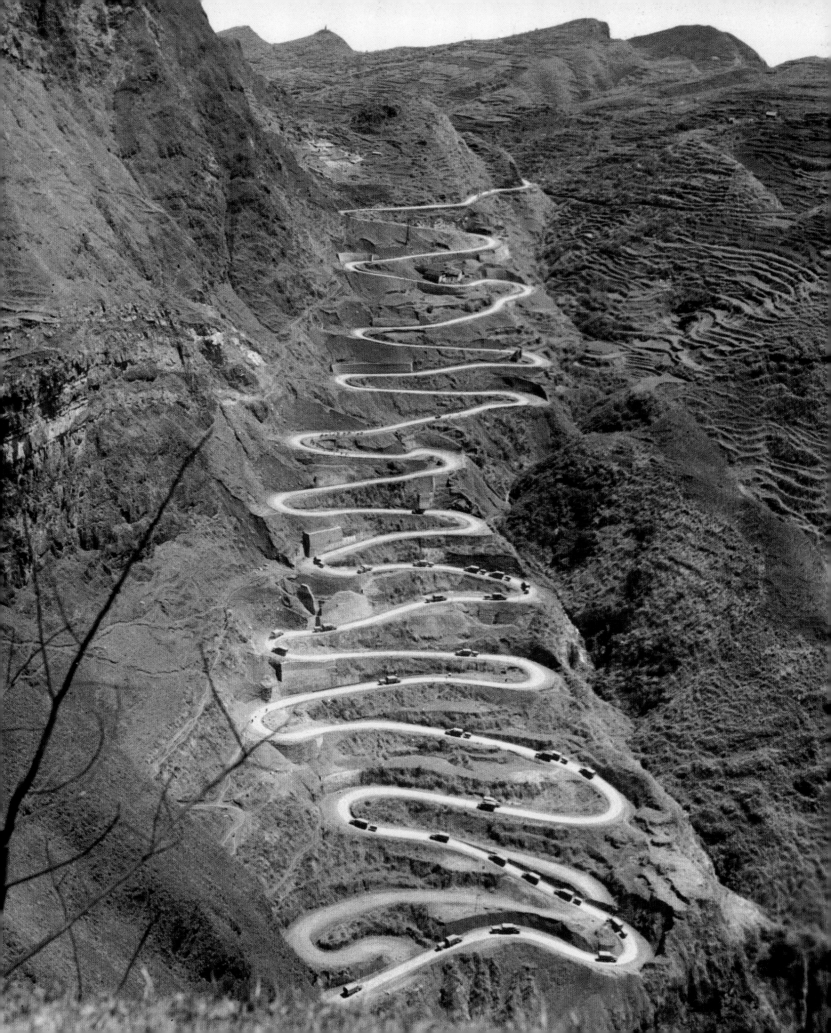

tions in CBI would focus on securing Burma and providing enough aid to the Nationalists to keep the Japanese from conquering all of China and redeploying their troops elsewhere. That strategy proved successful. Before surrendering, Japan had nearly two million soldiers on the Asian mainland, most of them in China and countries bordering it. Having gone to war with the Allies rather than withdraw from China, Japan ended up squandering much of its strength there, without achieving victory in Asia or averting disaster in the Pacific.

UNDERWATER WARFARE

The war in the Pacific placed a heavy burden on Japan—defending its maritime supply lines, on which it depended for oil, rubber, iron, and other essential commodities that were scarce or nonexistent on its home islands. That burden grew even heavier as the U.S. Navy achieved supremacy both above and below the waves. During the war, American shipyards with secure and abundant sources of raw materials outproduced Japan by a ratio of nearly ten to one in aircraft carriers, cruisers, destroyers, and other surface ships. The American edge in submarine production was smaller, and it took nearly two years for the Navy to refine its tactics and technology and achieve mastery underwater. Once it did so, however, Japan was in a terrible bind, for subs rivaled and often surpassed bombers as strategic weapons, inflicting severe economic damage and stifling the enemy's capacity to wage war. In the Atlantic, German submarines, known as U-boats, came close to severing the maritime supply line between the U.S. and Britain on which Allied hopes for victory rested (see pages 232–41). In the Pacific, American subs sank more than 1,000 merchant ships and reduced the flow of oil to Japan by 80 percent, throttling its war effort. "Tankers—those were the ships we wanted most to sink," wrote Vice Adm. Charles Lockwood, who took charge of all submarine forces in the Pacific in 1943.

Lockwood did much to increase the effectiveness of those forces and raise their morale, which was near rock bottom when he received his first combat assignment in 1942. After serving as a staff officer in Washington and London, he reported to Fremantle, Australia, that April to command submarines in the southwest Pacific, where captains and crews had been prowling intently for Japanese ships since the war began but had little to show for their efforts. Even when firing at slow-moving freighters or warships that had been crippled in combat and were sitting ducks, they often missed their marks. One captain launched 15 torpedoes at various targets and scored just one hit, and others fared little better. They blamed the newly introduced Mark 14 torpedo, which one skipper insisted was simply "no damned good," but their complaints fell on deaf ears until Lockwood arrived. Heeding their objections, he conducted target practice using Mark 14s armed with live ammunition— something the cost-conscious Navy Bureau of Ordnance had chosen not to do because such tests ruined those expensive torpedoes. He found that they were running at least ten feet deeper than their settings indicated, which meant that many torpedoes fired in combat were passing harmlessly under their targets. Further examination revealed that the Mark 14's detonating device, designed to trigger an explosion when it entered the magnetic field

"Tankers—those were the ships we wanted most to sink."

VICE ADM. CHARLES LOCKWOOD

Proud Predator The battle flag of the submarine U.S.S. *Seawolf* bears a wolf astride a torpedo and 18 red hash marks, each representing a successful attack on a Japanese vessel. *Seawolf* conducted 15 war patrols and sank more than 97,000 tons of enemy shipping before it was sunk by an American escort destroyer due to a communications error on October 3, 1944, with the loss of all those aboard.

of a ship's iron hull, was also defective and that the torpedo worked properly only when rigged to explode on contact.

The weapon's glaring defects were not fully remedied until Lockwood was called to Pearl Harbor to command the entire Pacific submarine fleet. One of his first moves in that capacity was to fly to Washington to demand that the Bureau of Ordnance "provide us with torpedoes that will hit and explode." His blunt words offended the bureau's chief, but Lockwood did not back down. "If anything I have said will get the bureau off its duff and get some action," he declared, "I will feel that my trip has not been wasted."

Lockwood won that bureaucratic battle and returned to the Pacific to combat the enemy with effective torpedoes, innovative tactics, and a strategic emphasis on targeting Japan's maritime supply lines. Earlier in the war, American submarine commanders had given enemy warships priority as targets over merchant ships, but Lockwood recognized that subs were most effective when used to destroy the vulnerable freighters and oil tankers that kept Japan's armed forces and war industries running. Those vessels were slower than submarines and more susceptible to attack than aircraft carriers, battleships, or cruisers, which were faster and often shielded by destroyers equipped with sonar to detect subs and depth charges to sink them. Like Allied merchant ships in the Atlantic, Japanese freighters sometimes traveled in convoys with destroyers as escorts to defend against submarines. Lockwood responded by adopting the tactics of German U-boats, which hunted together in so-called wolf packs to increase their chances of success against convoys and their escorts. The chief drawback of those large German wolf packs was that commanding and coordinating them generated considerable radio traffic, which could betray their location. So Lockwood sent out small packs of three subs and minimized radio contact between them.

Hunting in packs improved the odds that one or more subs would penetrate the convoy's defenses and make kills. But doing so was still risky, as Capt. Samuel Dealey discovered in November 1943 when his submarine U.S.S. *Harder* became separated from the two others in its pack and encountered a Japanese convoy in the mid-Pacific. Dealey attacked on his own and sank two freighters before submerging to avoid their armed escort, which dropped more than 60 depth charges. Shaken but unscathed, Dealey and crew resurfaced several hours later and dispatched a third freighter. Under Dealey's command, the *Harder* became one of the fleet's deadliest sea wolves, sinking more than a dozen other ships, including three destroyers sent down within the span of a few days in June 1944 before he returned to base at Darwin, Australia. His boss there thought that the five grueling war patrols Dealey had completed was enough for any captain and urged him to relinquish command of the *Harder*. But much of its crew was being replaced, and Dealey felt obliged to make one more outing and bring the newcomers up to speed before entrusting his sub to another captain. "I've got to lead this patrol," he insisted. Two months later, off the coast of the Philippines, the *Harder* submerged under attack and never resurfaced. Dealey and his crew were lost at sea, but they were not forgotten. He was one of eight U.S. submarine captains to receive the Medal of Honor, awarded to him posthumously, and he and his men were later memorialized in a book by Admiral Lockwood, *Through Hell and Deep Water*.

Submariners formed an elite corps within the U.S. Navy, all of them volunteers and rigorously trained for their hazardous duty. Roughly one man in every five died in action—a

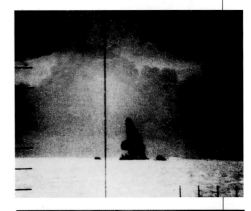

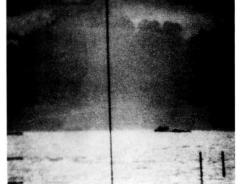

Wounded Prey This sequence of photographs, taken through the periscope of the *Seawolf* by its captain, Lt. Cmdr. Royce Gross, shows Japanese Patrol Boat No. 39 sinking after being torpedoed near Japan's Bonin Islands on April 23, 1943.

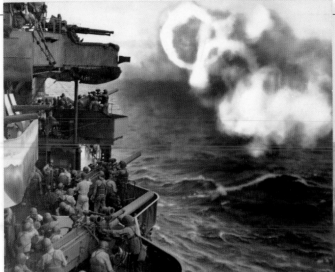

Storming Makin Smoke rings billow from a 5-inch battery aboard the cruiser U.S.S. *Minneapolis,* firing at Japanese positions on Makin Atoll in the Gilbert Islands on November 20, 1943. The naval bombardment preceded the landing by U.S. troops, including soldiers of the 165th Infantry Regiment, shown below wading ashore as Japanese oil dumps smolder in the background.

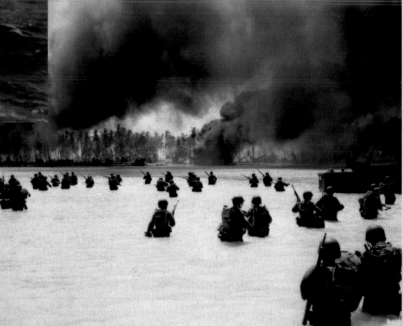

Daring Rescue Lt. Walter Chewning, catapult officer aboard the U.S.S. *Enterprise,* climbs to the cockpit of a burning Grumman F6F-3 Hellcat to aid the pilot, Ens. Byron Johnson, who escaped after his plane crashed on landing. The accident occurred on November 10, 1943, as the carrier was on its way to the Gilbert Islands to support the assaults on Makin and Tarawa Atolls.

higher percentage than in any other American branch of service during the war—but losses were even steeper among their foreign counterparts. Japanese submariners spent much of the conflict stalking Allied warships at great risk or conducting covert missions, including a daring but futile foray in February 1942 when a Japanese sub surfaced off Santa Barbara, California, and shelled an oil refinery there, inflicting little damage. Later that year, after Japanese warships lost the Naval Battle of Guadalcanal, more than a dozen submarines were diverted from offensive operations to carry food and other supplies furtively to soldiers holding out against U.S. Marines on that island. "We must help them," Vice Adm. Teruhisa Komatsu said of those troops, "no matter what sacrifices must be made." Two subs were lost in that desperate relief effort, which failed to avert defeat on Guadalcanal; another was damaged and ran aground, killing many of the crewmen. Overall, Japanese submariners suffered a much higher casualty rate than Americans did in that same capacity while inflicting far less damage on opposing warships or merchant ships. As casualties mounted, one Japanese commander responded to an officer's complaint that lives were being sacrificed in vain by declaring fatalistically: "No matter what the difference may be between our capability and that of the enemy, we must still carry out our orders, mustn't we? That has always been the battle spirit of Japanese submarine men, has it not?"

ADVANCING ON SAIPAN

In June 1943, Admiral Nimitz received permission from the Joint Chiefs in Washington to proceed with an ambitious offensive that he believed offered the quickest route to victory in the Pacific. Since defeating the Japanese fleet at Midway a year earlier, he had awaited the opportunity to advance westward toward Japan across tiny islands in the Central Pacific—a term used operationally during World War II to refer to the tropical zone above the Equator. Those islands lay closer to Tokyo than large islands in the South Pacific such as New Guinea and the Solomons. Nimitz had given priority to the Solomons campaign in 1942 because the Japanese threat to Australia and its supply lines was too great to be ignored and because the U.S. Navy needed more ships, landing craft, and troops before it could operate effectively across the vast distances separating the island chains of the Central Pacific.

First to be targeted would be Japanese bases on the Gilbert and Marshall Islands, located near the Equator some two thousand miles southwest of Pearl Harbor. Another thousand miles beyond that lay the Japanese-occupied Caroline and Mariana Islands. Invading those Central Pacific islands, many of which were part of atolls, involved navigating treacherous coral reefs and landing on desolate shores offering little or no cover for troops exposed to furious fire from entrenched defenders. Once captured, however, coral islands could readily be converted into U.S. naval and air bases to support the next leap forward across the Pacific. Seizing Saipan in the Marianas would bring B-29 bombers within range of Tokyo and U.S. troops within striking distance of Iwo Jima and Okinawa, the last bastions shielding Japan's home islands.

Nimitz entrusted this offensive to Vice Adm. Raymond Spruance, of Midway fame. Thanks to the prodigious output of American shipyards, Spruance's Fifth Fleet alone was larger than the entire U.S. Pacific Fleet had been before the attack on Pearl Harbor. At

"Gentlemen, we will not neutralize; we will not destroy; we will obliterate the defenses."

REAR ADM. HOWARD KINGMAN, PREPARING TO BOMBARD TARAWA ATOLL

Eagles for "Gators" This eagle patch was authorized by the U.S. secretary of the Navy on June 15, 1944, for all naval amphibious forces, such as the crewmen of landing vessels. Those forces became known as "Gators" for the speed with which they moved from water to land.

his command were ten big aircraft carriers and seven smaller ones designed to escort and protect amphibious forces as they landed, 12 battleships, a similar number of cruisers, and more than 60 destroyers. Yet despite that formidable display of sea and air power, the 35,000 Marines and soldiers who came ashore on the Gilbert Islands in November 1943 struggled desperately to overcome foes who were vastly outnumbered but deeply entrenched and fiercely determined. On Makin Atoll, it took four days for 6,500 attackers to root out several hundred Japanese troops while the escort carrier *Liscome Bay* and its crew stood by offshore, exposed to attack. On November 24, a Japanese submarine torpedoed the ship, which sank at a cost of more than 600 lives.

Victory came at an even steeper price on Tarawa Atoll, where four thousand defenders were holed up in pillboxes dug out of coral and reinforced with steel, concrete, and logs from coconut trees felled to provide Japanese gunners with clear lines of fire as Marines came ashore. Rear Adm. Howard Kingman planned to pulverize those fortifications with a devastating naval and aerial bombardment that would end the battle before Marines hit the beach. "Gentlemen," he vowed, "we will not neutralize; we will not destroy; we will obliterate the defenses." But nothing went as planned when the attack unfolded at dawn on November 20. Ineffective air strikes were followed by thunderous naval barrages that cheered the Marines but failed to dislodge their foes. "There aren't 50 Japs left alive on that island," one officer reckoned, shortly before the resilient defenders unleashed concentrated artillery and machine-gun fire on Marines as they approached the beach. Many were stranded in water several feet deep when their landing craft ran aground on a coral reef. Other troop carriers called amtracs (amphibious tractors) kept churning forward when they reached the reef but exploded when shots punctured their fuel tanks. One Marine saw an amtrac ahead of his "burst into flames, with men jumping out like torches." His own vehicle stalled, and he was one of the few men aboard who leaped out and waded ashore without being hit by the Japanese, who were "laying lead to us from a pillbox like holy hell."

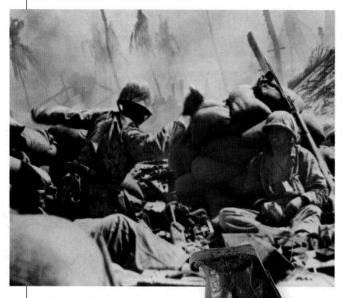

Close Combat A Marine prepares to hurl a hand grenade at a Japanese position during the fiercely contested invasion of Tarawa Atoll. The 20-ounce Mk II fragmentation grenade at right was the standard hand grenade used by American forces during World War II.

Of the seven hundred Marines in one battalion, only a hundred reached the beach intact, where they remained pinned down through the night with other survivors. Not until the tide rose the following day and allowed landing craft to cross the reef with reinforcements and heavy weaponry were the Marines able to advance in force and blast the enemy with tanks, grenades, and flamethrowers. More than a thousand Americans died and nearly 3,000 were wounded before resistance was wiped out. Only a dozen or so Japanese troops survived the battle as prisoners. An official account called it "the bitterest fighting in the history of the Marine Corps," but horrific contests loomed that would challenge Tarawa for that dubious distinction.

"There aren't fifty Japs left alive on that island."

AN AMERICAN OFFICER, AFTER TARAWA WAS BOMBARDED BUT BEFORE U.S. TROOPS LANDED

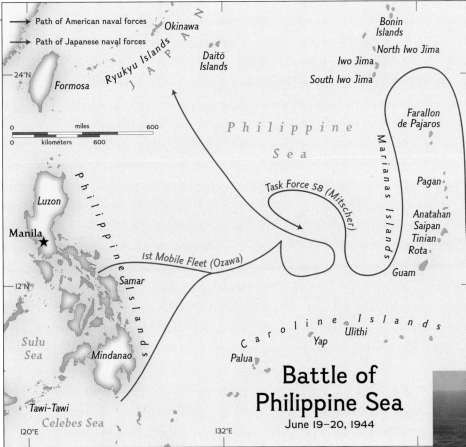

Battle of Philippine Sea
June 19–20, 1944

Path of American naval forces
Path of Japanese naval forces

JAPAN

Okinawa
Ryukyu Islands
Daitō Islands
Formosa
Bonin Islands
North Iwo Jima
Iwo Jima
South Iwo Jima

Philippine Sea

Task Force 58 (Mitscher)

Marianas Islands
Farallon de Pajaros
Pagan
Anatahan
Saipan
Tinian
Rota
Guam

Luzon
Manila ★
1st Mobile Fleet (Ozawa)
Samar
Philippine Islands

Sulu Sea
Mindanao
Tawi-Tawi
Celebes Sea

Caroline Islands
Ulithi
Yap
Palua

Carrier Battle American landings on Saipan and elsewhere on the Marianas in June 1944 set the stage for the Battle of the Philippine Sea, waged by U.S. and Japanese aircraft carriers in waters west of those islands. As shown on the map at left, Vice Adm. Jisaburo Ozawa's First Mobile Fleet advanced from the Philippines toward Vice Adm. Raymond Spruance's Fifth Fleet, which was shielding American forces as they came ashore on the Marianas. Spruance sent Rear Adm. Marc Mitscher's fast carrier task force to confront the enemy fleet and its warplanes. On June 19, the Japanese launched disastrous attacks, losing some 300 aircraft in clashes with American fighters like F6F-3 Hellcat below, shown landing on the U.S.S. *Lexington*. On June 20, Mitscher's aviators struck back. Among their targets was the Japanese aircraft carrier *Zuikaku* (bottom, at center), pictured with two Japanese destroyers turning to evade American bombs.

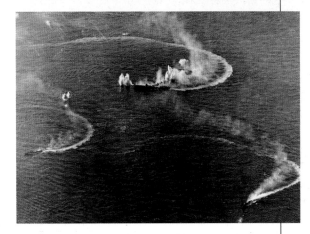

Hard lessons learned in combat on the Gilbert Islands made later assaults more effective. Amtracs were sheathed in heavier armor, and naval aviators were trained in precision bombing using bunker-busting rockets. Like MacArthur and Halsey, Nimitz and Spruance bypassed some Japanese outposts, which were left to "wither on the vine," and targeted others that had greater strategic value as naval or air bases. But nothing commanders did to strengthen or speed the offensive did much to lessen the terrors of island fighting in the Central Pacific, where the great fear was not being enclosed in jungle, as troops were on the Solomons and New Guinea, but being exposed to attack on open water or bare sand.

When Spruance advanced on the Marshall Islands in early 1944, warships and bombers did a better job of softening up Japanese defenses there, and landing craft brought heavy artillery ashore to support the Marines. They remained woefully vulnerable, however, to opposing gunners who survived the bombardment and to the volcanic impact of their own big guns on enemy blockhouses, packed with explosives. One such eruption on Namur, a tiny island within Kwajalein Atoll, cost a Marine battalion as many casualties as were felled there by Japanese bullets or shells. "An ink-black darkness spread over a large part of Namur such that the hand could not be seen in front of the face," one officer reported after the blockhouse exploded. "Debris continued to fall for a considerable length of time which seemed unending to those in the area who were all unprotected from the huge chunks of concrete and steel thudding on the ground about them . . . Men were killed and wounded in small boats a considerable distance from the beach by the flying debris."

Young Victim A Navy medic carefully lifts a severely injured infant found in the mountains on Saipan during the fighting there in June 1944.

The Japanese navy was spread thin across the Pacific and hard pressed to contest the advance of Spruance's mighty Fifth Fleet. After securing the Marshall Islands, Spruance sent a fast carrier task force led by Rear Adm. Marc Mitscher to attack Truk in the Caroline Islands, which served as the main base for the Japanese fleet. Yamamoto's successor, Adm. Mineichi Koga, withdrew aircraft carriers and other big warships from Truk rather than risk losing them to the oncoming Americans, who blasted the base in mid-February, destroying many vessels left behind there and more than 200 aircraft.

After falling back before the American onslaught, Koga resolved to wage a decisive naval battle against his foes—code-named Operation Z—but died in March in a plane crash off the coast of the Philippines before he could put his plans into action. Lost in the crash was a briefcase containing documents detailing Operation Z, which fell into the hands of Filipino guerrillas, who turned them over to an American agent. What those documents revealed was not one plan of attack but various proposals for securing Japan's "last line of defense"—which encompassed the Marianas and the Philippines—and achieving the great naval victory that both Koga and his successor, Adm. Soemu Toyoda, hoped for. One proposal involved luring U.S. carriers assigned to protect amphibious landings into a reckless pursuit of Japanese carriers, whose aircraft would then join with other warplanes launched from Japanese bases on land to shatter the American fleet and halt any further advances toward the home islands by U.S. Marines or soldiers.

Spruance learned of Operation Z as he was preparing to oust Japanese forces from Saipan and other Mariana Islands in June 1944. Furnished with that intelligence, he reacted cautiously when he learned that a powerful enemy fleet was approaching the Marianas from the west. "The Japanese are coming after us," he told officers aboard his flagship U.S.S. *Indianapolis* on June 16. Spruance sent Mitscher's task force to fend off the approaching fleet—which included nine aircraft carriers and more than 400 warplanes— but instructed Mitscher to remain close enough to Saipan to keep his aircraft within range of that island. Spruance did not want his carriers drawn into a hazardous pursuit that would divert them from the Fifth Fleet's primary mission—protecting the troops who had landed on Saipan a few days earlier and would soon invade nearby Tinian and Guam. Mitscher found himself on the defensive because his aircraft had a shorter range than warplanes launched by the Japanese fleet, which struck first. Radar gave the American pilots ample warning of that attack, however, and their opponents were not nearly as well prepared as Japanese naval aviators had been in 1941, when they were among the best in the world. Many now had only a few months' training,

Teamwork Two Navajo code talkers—one communicating by radio and the other decoding and transcribing a message—act as signalmen on the embattled Pacific island of Bougainville in 1943.

Navajo Code Talkers

American forces fighting in the Pacific found that their radio and field phone communications were all too often intercepted by the Japanese, who proved adept at deciphering coded messages spoken in English or other languages they understood. A solution to the problem was offered by Philip Johnston, a World War I veteran who had grown up as a missionary's son on Navajo reservations and was fluent in the Navajo language. Recalling that the Army Signal Corps had experimented with using Choctaw-speaking signalmen during World War I, Johnston believed that the complex Navajo language would be unintelligible to anyone who was not a native speaker.

In early 1942, Johnston persuaded Maj. Gen. Clayton Vogel of the U.S. Marines, commander of the Pacific Fleet's Amphibious Corps, to begin recruiting Navajo signalmen to encode, transmit, and decipher messages. That spring, the first 29 Navajo recruits began training at Camp Elliott, California, where they created a code that used Navajo words to represent military terms. Tank became "tortoise" (*chay-da-gahi*), artillery was "many big guns" (*be-al-doh-tso-lani*), and a fighter plane was a "hummingbird" (*dah-he-tih-hi*). Other English words were encoded using a Navajo word to stand for each letter. The Navajo words for ant (*wol-la-chee*), apples (*be-la-sana*), and axe (*tse-nill*) all stood for the letter "A." Thus the word "Marine" might be spoken as *na-as-tso-si* (mouse)—*tse-nill* (axe)—*gah* (rabbit)—*yeh-hes* (itch)—*tsah* (needle)—*dzeh* (elk).

By war's end, 375 Navajos were serving with the Marines, transmitting battlefield communications by radio in a code the Japanese found impenetrable. Six of those code talkers were at Iwo Jima, where they conveyed more than 800 messages. Maj. Howard Connor of the Fifth Marine Division said afterward: "Were it not for the Navajos, the Marines would never have taken Iwo Jima." ∎

PFC. HENRY KAGAN
LETTERS HOME FROM SAIPAN

Kagan, a heavy equipment operator with the 805th Engineer Aviation Battalion, landed on Saipan
in June 1944, soon after the invasion began there, to help build an airfield for B-29 bombers.
On August 24, he wrote home describing a Japanese air raid on his first night in Saipan.

Dear Honey,

Just got some interesting news over the radio, that we are now in Paris and going strong. It looks very close for the end of the European war. Then we can all look for big things to happen. The end of this whole war will come soon after that. I think there will be peace on Earth and I will be coming home to you and our son . . .

I grew my mustache back and it is shaping up pretty well. Last night was the first beautiful night I can remember in a long time. When I say night, I mean the sky was beautiful, the stars were shining in the heavens as I lay in my cot looking upward, and that is the only way I want to go through life, with my head up.

> **"I lay in my cot looking upward, and that is the only way I want to go through life, with my head up. Right now I am sort of between Heaven and Earth and when I say the Heavens were beautiful I also wish I could say the Earth was . . . But I'm afraid that beautiful day won't come until I set foot on good old U.S. soil."**

Right now I am sort of between Heaven and Earth and when I say the Heavens were beautiful I also wish I could say the Earth was also beautiful, the grass and the mountains etc. But I'm afraid that beautiful day won't come until I set foot on good old U.S. soil.

I think I have changed a great deal. I believe in the right things and I fight for what is right, and I will admit I'm wrong. Also you might be interested in knowing I have sworn, that night, that horrible night when we first set foot on Saipan and I was awakened by a roar of a Jap motor and a tremendous burst of bombs all around me, I crawled out of my pup tent like a scared rabbit, my teeth were chattering and my knees were shaking and my eyes were three times their size. I was so scared I didn't know where to go, not having a foxhole. I started to dig with my hands and feet. The sweat was rolling off me like a fountain. I was in a daze. I was ready and I thought, that was the end. I prayed and prayed to God and asked him to forgive me for all my sins and I swore if I ever got home alive and safe I would never gamble again and as much as I like to gamble, that is my promise. Just as soon as I step on home ground. You may not believe this but it is true, every word of it. This is just a little chapter of my experience on Saipan Island.

By the way I meant to ask you, do you save these letters? I hope so!

Here is hoping for a wonderful New Year . . . Answer soon.

Love always,
Your Henry

Far From Home Russian-born Henry Kagan, shown in the photo below, immigrated to America as a child and joined the U.S. Army to fight for his country in May 1943, leaving behind in New York his wife Bella and infant son Leonard— shown together in a photograph Kagan kept *(opposite, bottom)*. An experienced driver and mechanic, he was assigned to an Army airfield construction unit and served in the Pacific, building airstrips for B-29 bombers on Hawaii, Saipan, and the Ryukyu Islands. A faithful correspondent who wrote letters home almost every day, Kagan asked Bella to save them as a record of his service.

and their lightly armored Mitsubishi Zeros—once dreaded for their prowess in combat—were now fatally vulnerable to faster, sturdier fighters like the Grumman F6F Hellcat. In a rout remembered as the "Great Marianas Turkey Shoot," nearly 300 Japanese warplanes were downed on June 19, many of them by seasoned American pilots from the task force, who lost just 30 of their own aircraft. Mitscher's ships emerged intact while submarines dispatched by Admiral Lockwood attacked the Japanese fleet and sank two carriers.

Plowing ahead, that battered fleet was spotted 250 miles from Mitscher's task force on the afternoon of June 20, putting it within range of his aircraft. Although his pilots had no chance of returning to their carriers before nightfall, Mitscher received permission from Spruance to launch an attack, during which Americans sank a third aircraft carrier, damaged two more, and shot down 65 fighters before turning back at dusk. Many were running out of fuel when they glimpsed their own carriers in the distance, lit up at night like cruise ships to guide them home. Some ditched in the sea or crashed on deck, but most landed safely, amid what one pilot dazzled by the light show described as "a Mardi Gras setting fantastically out of place here, midway between the Marianas and the Philippines." Having lost nearly all its warplanes, the Japanese fleet withdrew. Some critics faulted Spruance for not taking greater risks to destroy it. But in this crucial Battle of the Philippine Sea, he had in fact turned Operation Z—the desperate Japanese pursuit of a decisive victory at sea—into a staggering defeat for his foes, while fulfilling his primary task of landing troops on the Marianas and shielding them until their task was fulfilled.

Captured Relic
Cpl. Donald Smith wears a battle-damaged Japanese helmet, shown at right, for a snapshot taken on Tinian in the Marianas on Christmas Eve, 1944. Smith helped secure the island as a gunner with the 17th Marine Anti-Aircraft Defense Battalion. His unit remained on Tinian to help defend newly constructed U.S. airfields.

Saipan was defended by some 25,000 Japanese troops, and they did not yield easily. The Marines who launched the assault there on June 14 faced an ordeal that would prove far longer and costlier for them and the Army troops who followed in their wake than the bitter battle for Tarawa. "We looked at each other, and our glances formed a common pool of anxiety," recalled Sgt. David Dempsey, whose Marine platoon landed in one of more than 700 amtracs amassed for this operation. "In a few minutes, our tractor grumbled up onto the reef. Lurching tipsily we crawled over it, giving us the feeling, for the moment, that we were very naked and exposed."

Casualties were steep on that first day, but the sheer weight of the invasion overwhelmed the defenders. By nightfall, 20,000 Marines held a beachhead nearly a mile wide. Within a week, the Japanese were outnumbered nearly four to one and had fallen back to Mount Tapotchau, midway up the island. By month's end, Marines and soldiers had clawed their way around that mountain, seizing Tanapag Harbor to the north and isolating Lt. Gen. Yoshitsugo Saito and several thousand of his surviving troops on the high ground. Six days

"We deeply apologize to the Emperor that we cannot do better."

LT. GEN. YOSHITSUGO SAITO, WHO DIED BY HIS OWN SWORD ON SAIPAN WHEN FACING DEFEAT

later, Saito sent his last message to Tokyo: "We deeply apologize to the Emperor that we cannot do better." Then he died by his own sword in a ritual called seppuku, or hara-kiri, long performed by samurai who faced defeat. His troops met death the next day by launching a hopeless, banzai charge on their foes at Tanapag Harbor. "The Japs just kept coming and coming," one soldier there said afterward. "I didn't think they'd ever stop." In the final act of the tragedy on Saipan, several hundred Japanese civilians who had settled there before the war and had been told that Americans would treat them brutally leaped from cliffs at the northern end of the island and drowned rather than submit to the enemy.

The defeat of Japanese naval forces in the Philippine Sea and the fall of Saipan—followed by the capture of Tinian and Guam—left Japan's leaders with little hope of averting disaster unless they surrendered. Shortly after the Marines landed on Saipan, Emperor Hirohito warned General Tojo that if his troops lost that island, "repeated air attacks on Tokyo will follow. No matter what it takes, we have to hold there." Indeed, American construction crews soon transformed Saipan and Tinian into launching pads for B-29s that posed a mortal threat to Tokyo and other Japanese cities. Tojo resigned, but Hirohito was not ready to admit defeat and end the deadly struggle. Instead, he and his chiefs remained intent on achieving a "decisive victory" and prolonged a conflict that was becoming suicidal for Japan.

Destined for Japan Ground crewmen load 500-pound bombs into a Boeing B-29 Superfortress, dubbed *Dauntless Dotty*, at Isley Field on Saipan. The aircraft was flown by men of the 869th Bomb Squadron, which led the first raid sent from Saipan against Tokyo on November 24, 1944, targeting the Nakajima aircraft engine plant there.

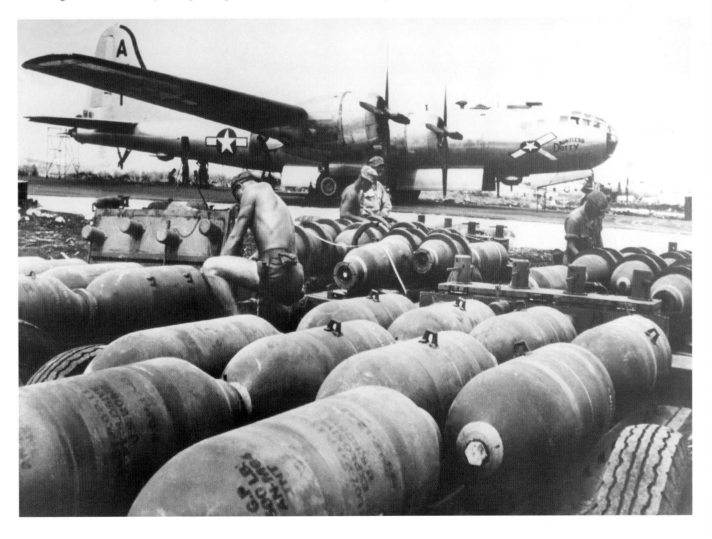

Like Japan, the island nation of Great Britain was heavily dependent on imported goods and highly vulnerable to attacks on its maritime supply lines. Winston Churchill was keenly aware that wartime shipments of food, fuel, and munitions from America helped keep his country fighting, and he feared defeat if German submarines severed Britain's transatlantic lifeline. "The U-boat attack was our worst evil," wrote Churchill in later years. "It would have been wise for the Germans to stake all on it." ✶ Fortunately for the Allies, Hitler did not invest heavily in submarines until after the war began. Much of Germany's industrial might as war loomed went to producing tanks, aircraft, and impressive but vulnerable naval blockbusters like the battleship *Bismarck,* which lasted only a few weeks in the open Atlantic in 1941 before succumbing to warships and carrier-launched warplanes of the Royal Navy's superior surface fleet. Meanwhile, Germany's submarine force, which entered the conflict with only 55 U-boats, was surpassing expectations under the keen direction of Vice Adm. Karl Dönitz, who deployed them in groups directed by radio—dubbed "wolf packs" by the British—to attack Allied convoys. "The Battle of the Atlantic has begun," declared Churchill in March 1941 as Germany stepped up submarine production. "The U-boat at sea must be hunted, the U-boat in the building yard or the dock must be bombed." ∎

The Battle of the Atlantic:

WOLF PACKS ON THE PROWL

Wolf Hunt Crewmen on the deck of the U.S. Coast Guard Cutter *Spencer* watch as a depth charge explodes during an attack in the North Atlantic on the German submarine *U-175* on April 17, 1943. U-boat commanders like the officer portrayed opposite, peering intently through his periscope in a sketch by a German war artist, had to be wary of such assaults as they pursued Allied ships.

Operation Drumbeat

A nation was officially at war. In April 1941, President Roosevelt extended the Pan-American Security Zone—in which the U.S. Navy protected merchant ships against attack—far across the Atlantic to the vicinity of Iceland, where the Royal Navy took charge of escorting convoys to Britain and wolf packs gathered to attack them. In October 1941, two American destroyers escorting merchant ships were torpedoed near Iceland: the U.S.S. *Kearny,* which lost 11 men but stayed afloat; and the U.S.S. *Reuben James,* which went down with most of its crew after being hit by the German sub *U-552.* "America has been attacked," declared Roosevelt, who continued to aid Britain and uphold America's right to navigate the Atlantic freely.

Soon after Germany declared war on the United States in December 1941, Admiral Dönitz ordered his U-boats to attack ships along the Atlantic and Gulf coasts and in the Caribbean. The offensive,

Leader of the Packs Adm. Karl Dönitz commanded Germany's U-boat fleet for much of the war.

code-named Operation Drumbeat, was launched by five long-range Type IX U-boats, which set out from Lorient, France, and wreaked havoc off American shores, where authorities had failed to organize coastal convoys or order blackouts, leaving ships dangerously silhouetted against city lights. This was a "happy time" for U-boat captains and a fearful time for those they targeted. The captain and several crewmen of the tanker *Cities Service Empire,* torpedoed off the coast of Florida, perished when their life raft was consumed by burning oil, reported a survivor, who "last saw the captain going into a sheet of orange flame."

In May 1942, Dönitz reinforced Operation Drumbeat by sending out large Type XIV subs, known as "milk cows," that were designed to refuel and resupply other U-boats and extend their patrol time. By then, the U.S. Navy had begun to run convoys along the East Coast, but the losses continued. In six months, Drumbeat sank 397 ships at a cost of just seven U-boats. ■

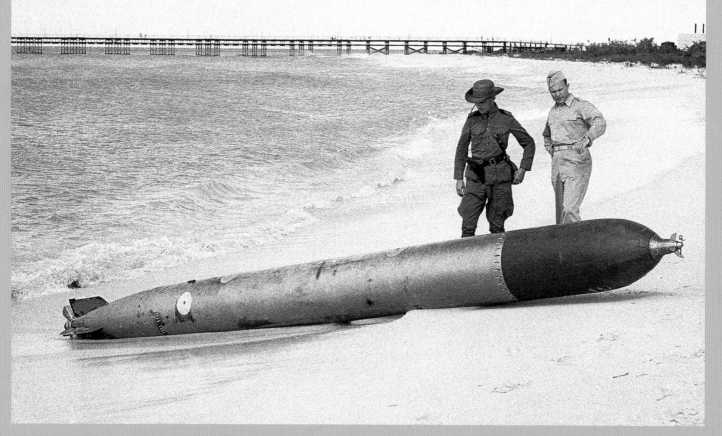

Deadly Flotsam A Dutch marine and a U.S. Naval officer examine a German torpedo that washed up at Aruba after being fired by *U-156* at the tanker *Arkansas* in early 1940.

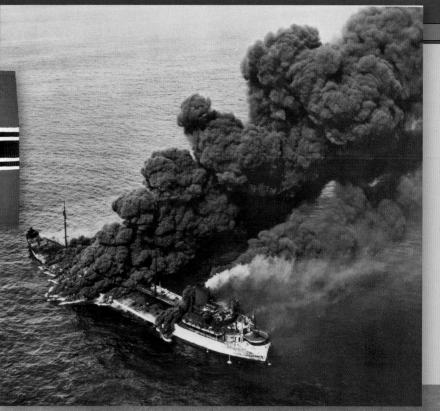

Cruel Seas At right, the American tanker *Pennsylvania Sun* burns after being torpedoed off Key West, Florida, by *U-571* on July 15, 1942, at a cost of two lives. Officers remained aboard after the crew abandoned ship and extinguished the flames with help from the minesweeper U.S.S. *Willet* before bringing the tanker to port for repairs. Submarines made speed by running on the surface, like the two Type VIIC U-boats pictured below during wolf-pack operations in the Atlantic in mid-1942. The Reich war flag above was flown by German subs.

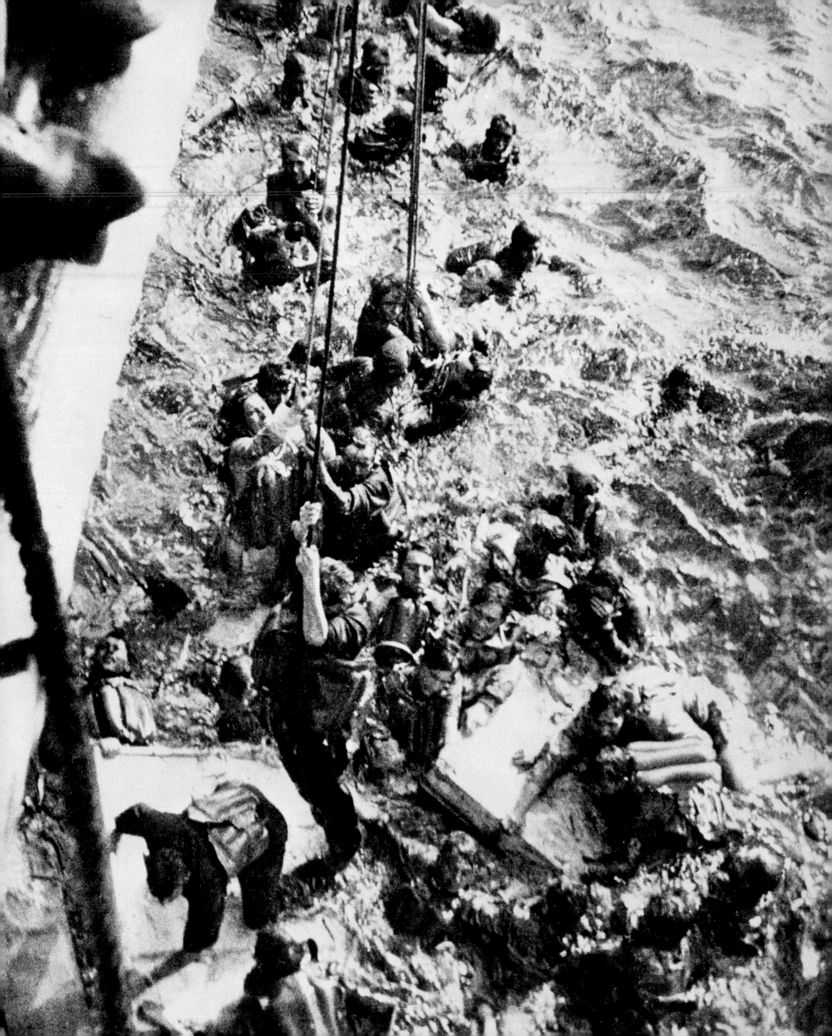

Rescued From a Watery Grave

The Battle of the Atlantic claimed many victims, including sailors who survived attacks at sea but died in the water or in lifeboats before help arrived. Under international law, naval forces were supposed to aid opposing sailors who survived shipwrecks. The British did so by rescuing German survivors of the sunken battleship *Bismarck* in May 1941. Admiral Dönitz officially abandoned such rescue efforts by his U-boat fleet, however, following an incident in September 1942 when the submarine *U-156* sank the British troopship *Laconia* off West Africa and then came to the aid of survivors—many of them Italian POWs—along with other U-boats and a Vichy French cruiser. During that rescue effort, an American plane bombed *U-156*, killing survivors from the *Laconia* in a lifeboat towed by the submarine and forcing it to submerge, which doomed other survivors clinging to the U-boat's deck. Afterward, Dönitz prohibited U-boat captains from making any further efforts to aid survivors of ships they torpedoed—a policy of unrestricted submarine warfare like that pursued by the U.S. and Japan in the Pacific.

The chief victims of U-boat attacks were Allied merchant mariners. Their chances of being rescued if a torpedo or mine wrecked their ship were poor even before Dönitz issued his order. Many who abandoned sinking vessels drowned, burned or suffocated in clinging fuel oil, or died from exposure in the icy North Atlantic. Those who managed to reach a lifeboat or raft were by no means assured of survival. Allied merchant ships risked being torpedoed if they stopped to help survivors, and Allied warships escorting convoys had to concentrate on seeking and destroying U-boats. Not until late in the war were rescue ships assigned to convoys to aid survivors.

For all the perils merchant seamen faced, few abandoned their task. "Those who have been torpedoed and rescued ship right out again as soon as they can get out of the hospital," one reporter noted. "That takes plenty of nerve, but the merchant seamen have it." The ranks of American merchant mariners swelled from about 55,000 to 250,000 by the end of the war—despite casualties amounting to nearly 20,000 men killed, wounded, or missing in action. ■

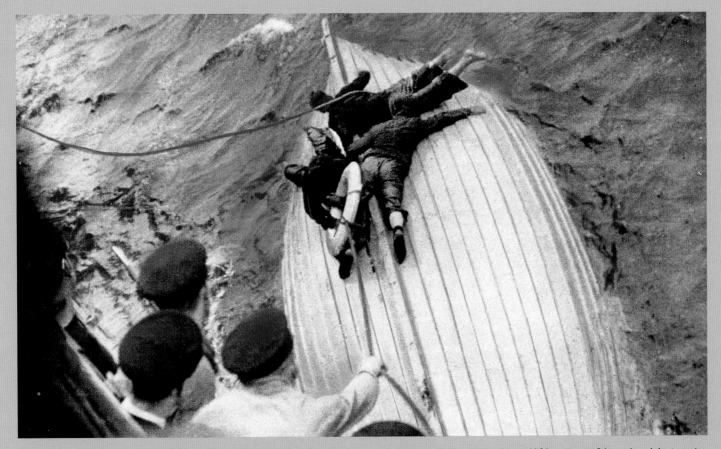

Lifelines Above, crewmen aboard the French cruiser *Gloire* aid survivors of the British troopship *Laconia,* clinging to an overturned lifeboat. Most of those aboard the *Laconia* were saved, but of more than 2,000 German crewmen aboard the doomed *Bismarck,* only 115 were rescued, including the men shown at left being hauled aboard the British cruiser H.M.S. *Dorsetshire.*

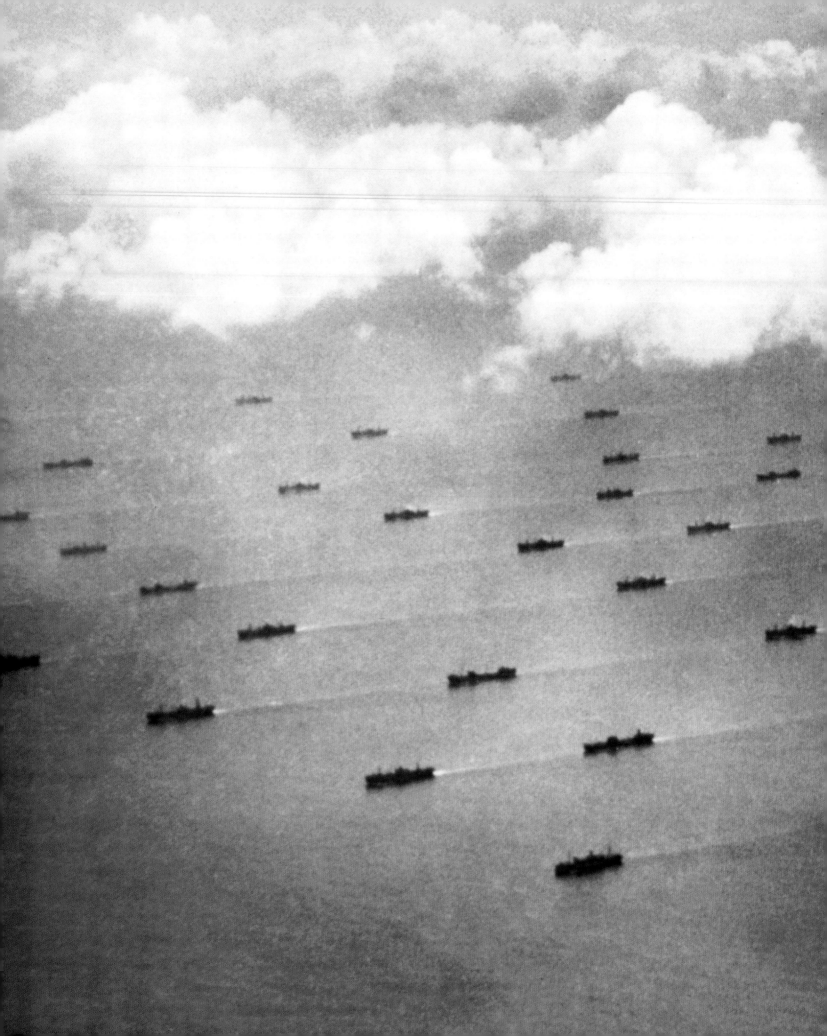

Safety in Numbers

Adopting a tactic developed during World War I to reduce depredations by German U-boats, Allied naval commanders organized convoys of merchant ships escorted by warships. At any one time, there were about a half dozen fully loaded outbound convoys destined for Britain and a similar number of empty convoys returning to America. They sought to avoid wolf packs, whose movements were often revealed by intercepted radio messages between U-boats and German naval headquarters, encoded on Enigma machines and deciphered by Allied cryptanalysts (see pages 142–43).

Normally a convoy sailed in a rectangular formation, with escort ships at the perimeter, seeking to detect U-boats before they came within torpedo range. The workhorses of convoy defense were the Royal Navy's Flower-class corvettes. Adopted by both the U.S. and Canadian Royal Navies, they were tough, compact, and lightly armed, using depth charges to force an attacking submarine to dive and remain down. Kills were usually made by warships that were somewhat larger and more heavily armed, such as the Royal Navy's River-class frigates and the U.S. Navy's destroyer escorts, which had sonar detection equipment and both stern- and side-launched depth charges. As the war progressed, convoys were also protected by escort carriers, whose aircraft searched for surfaced U-boats and attacked them.

A merchant ship in a convoy was far safer than one traveling alone, but convoys had drawbacks. It took time for them to assemble, and they traveled at the speed of their slowest ships, taking from 15 to 20 days to make crossings that fast ships could make in five. Upon reaching their destination, convoys clogged ports, causing delays in unloading cargo. The greatest problem was that wolf packs penetrating convoy defenses had a wealth of targets. When the Kriegsmarine (German Navy) equipped its U-boat fleet with an improved Enigma in early 1942 and code breakers lost track of wolf-pack movements, Allied losses in the Battle of the Atlantic increased alarmingly. As Churchill recalled: "I was even more anxious about this battle than I had been about the glorious air fight called the Battle of Britain." ∎

Straight Ahead Steaming in neat columns, an Allied convoy crosses the Atlantic in June 1943. Sailors guarding convoys were constantly on the lookout, like the Royal Navy reservist above, keeping watch on the bridge of the American-built escort carrier H.M.S. *Tracker.* The Allies offset merchant marine losses in the Atlantic by launching new Liberty ships, turned out rapidly by American shipyards, whose efficient workers received production badges *(top).*

Scattering the Wolf Packs

The Allies owed their ultimate victory in the Battle of the Atlantic in part to quick work by British sailors aboard the destroyer H.M.S. *Petard* in the eastern Mediterranean. On the night of October 30, 1942, they boarded the German submarine *U-559* after forcing it to the surface with depth charges and retrieved keys to Enigma settings as the U-boat sank, taking two daring British crewmen down with it. It was the second such coup by the Royal Navy (the first occurred in May 1941 when *U-110* was forced to the surface and boarded) and enabled Allied code breakers to solve the advanced Enigma adopted by the U-boat fleet in early 1942.

Service Badge **This German Submarine War Badge was awarded after two sorties against the enemy.**

That was a big intelligence breakthrough, but Allied tactical and technological advances also helped overcome the U-boat peril and scatter the wolf packs. High-frequency direction finders—designated HF/DF, or "Huff Duff"—allowed radio listeners at Allied stations to plot the positions of U-boats without decoding their messages. That helped convoys take evasive action and provided guidance for long-range B-24 Liberator reconnaissance bombers, which closed a gap in the mid-Atlantic left uncovered by earlier land-based bombers. Those and other Allied gains, including improved radar and depth charges, more than offset German increases in submarine production and the launching of larger Type IXC U-boats with greater range and torpedo capacity.

Allied shipping losses in the Atlantic fell from over seven million tons in 1942 to three million tons in 1943. Meanwhile, U-boat losses were mounting. In May 1943—"Black May" for the Germans—34 U-boats went down, causing Dönitz to suspend anticonvoy operations and withdraw U-boats from the North Atlantic, where his hunters had become the hunted. Attacks on convoys later resumed, and improved U-boats were introduced, but as Dönitz conceded: "We had lost the Battle of the Atlantic." By war's end, 785 of 1,162 U-boats had gone down, along with more than 30,000 crewmen—the highest casualty rate of any armed service in World War II. ∎

On the Hunt **A convoy escort fires a depth charge from a K-gun during an attack on a U-boat in the North Atlantic. The K-gun, introduced in 1942, could fire depth charges about 45 yards from an escort's side or stern, laying down a broad sweep of six to ten charges.**

Game Over Depth charges explode beneath the stern of *U-625* in a picture taken from a Royal Canadian Air Force Short Sunderland III flying boat, which targeted the sub in March 1944 and forced its captain and crew to surface and abandon the stricken U-boat. Allied vessels sometimes rescued U-boat survivors like the exhausted man at right, helped along the deck of a U.S. Coast Guard cutter by two of its crew in September 1943.

AFTER HITLER INVADED RUSSIA IN 1941, THE ALLIES RESOLVED to open a second front on Germany's western flank—a task not fully accomplished until troops landed in Normandy in June 1944. Yet Allied offensive action on that front began as early as 1940 when British bombers struck Berlin and intensified in 1942 when the U.S. joined the punishing air campaign, which continued until Germany lay devastated and defeated. ✶ Advocates of strategic bombing had long argued that wars could be won by sending masses of bombers against enemy cities and industries. Critics questioned the morality and utility of that doctrine, and Britain entered World War II with a policy of attacking only military targets. But after German bombers blasted cities such as Rotterdam, attacked in May 1940, Allied leaders came to view strategic bombing as justifiable. Beginning with the Battle of Britain, both the Royal Air Force (RAF) and the Luftwaffe conducted deadly raids on enemy cities. Air Marshal Arthur Harris, chief of the RAF Bomber Command, stated his goals as "the destruction of German cities, the killing of German workers, and the disruption of civilized life throughout Germany." Allied air strikes alone—delivered nightly by the RAF and daily by the U.S. Army Air Forces (USAAF)— did not win the war or deprive the enemy of the will to fight. They did, however, weaken the Reich and clear the way for the invasion of France and Germany by gutting the once mighty Luftwaffe. ■

Air War Over Europe:

BOMBING AROUND THE CLOCK

Aerial Armada B-17s of the U.S. Eighth Air Force's 390th Bombardment Group, based in Britain, head out to blast German war industries on August 12, 1943, accompanied part of the way by fighters at higher altitude, leaving contrails in their wake. The damage done to Germany's military capacity by American bombers was compounded by losses inflicted on the Luftwaffe by avid fighter pilots like Capt. Fred Christensen, shown waving from the cockpit of his P-47 Thunderbolt, with 22 swastikas painted on its fuselage representing German warplanes he downed.

Light Show A British Lancaster bomber, photographed from above, is silhouetted against antiaircraft fire and burning buildings during a night raid on Hamburg, Germany, on January 30, 1943.

The British Night Bombers

Early in the war, before focusing on strategic bombing, the RAF often struck at precise military targets such as German battleships or U-boat bases. Precision bombing had to be carried out in daylight, increasing the risk that aircraft would be spotted and shot down. Lack of support from RAF fighters—which were busy defending Britain against German attacks—made such daytime raids even costlier, and poor bombsights rendered them largely ineffective even when visibility was good.

By the time Air Marshal Harris took charge of Bomber Command in February 1942, the RAF had shifted its emphasis to strategic bombing at night, a path he pursued enthusiastically. Instructed to destroy the "morale of the enemy civil population," he mounted massive nighttime air raids on German cities involving as many as 1,000 bombers. The first such attack was launched on May 30, 1942, against Cologne, where more than 4,500 people were killed or wounded and 13,000 homes were destroyed. The British had suffered similar losses during German air raids on London, Coventry, and other cities and felt that such reprisals were warranted. Aside from scourging the populace, attacks on cities disrupted the German economy and war effort by damaging factories, government offices, ports, and other facilities.

The workhorses of Harris's command were the heavy Handley Page Halifax bomber and the heavier Avro Lancaster, which was introduced in 1942 and had greater range and a larger bomb load. Technology kept pace with the requirements of nighttime bombing. Radar beams from two stations were used to pinpoint British bombers in flight and guide them to their targets in the dark. Chaff in the form of foil strips, code-named Window, was dropped from aircraft to jam German radar that guided antiaircraft batteries. Pathfinders in twin-engine Mosquito fighter-bombers led the way during attacks, dropping flares or incendiaries to mark targets for bomber pilots, one of whom recalled that his illuminated target looked "like a huge shovelful of hot ashes which someone had flung on the ground." ∎

Fearsome Flak **Radar-directed German antiaircraft batteries like this one, shown firing its 88-mm guns in unison, could make nighttime bombing raids harrowing and nearly as hazardous as daytime raids. RAF airmen were heroes at home, celebrated by British magazines like the *Picture Post*, which featured a flier on its cover in August 1941 *(above)*, shown after he returned from a daring daylight attack on the German battleship *Scharnhorst* at Brest, France.**

Flying Fortress A B-17 of the 94th Bombardment Group targets the Focke-Wulf fighter assembly plant at Marienburg, Germany, on October 9, 1943. By war's end, more than 12,000 Flying Fortresses had been built. "Without the B-17," observed Gen. Carl Spaatz, the first commander of the U.S. Eighth Air Force, "we might have lost the war."

Americans Seize the Day

The U.S. Eighth Air Force began flying from Britain against German targets in France in May 1942, marking the opening of the American daylight precision-bombing campaign. Commanders hoped that masses of heavily armed B-17 Flying Fortresses and B-24 Liberators, flying in formation with each bomber providing cover to its neighbors, could overcome German air defenses and wreck German war industries. On their first missions over France, American bombers were escorted by RAF fighters. But Maj. Gen. Ira Eaker, who took charge of the Eighth Air Force in December 1942, wanted to attack Germany's industrial heartland, beyond the range of fighter escorts—and to do so daily while the RAF blasted German cities by night. "By bombing the devils around the clock," he wrote to an appreciative Winston Churchill, "we can prevent the German defenses from getting any rest."

Eaker's airmen conducted their first raid on Germany in late January 1943, bombing naval yards at Emden and Wilhelmshaven.

Mighty Eighth This shoulder sleeve insignia was worn by personnel of the Eighth Air Force.

By mid-1943, they were delving deep into Germany, far beyond the range of fighter escorts, and suffering heavy losses to German fighters. The toll would have been even higher had they lacked stout defenses of their own. Their mainstay was the Boeing B-17, which was manned by a crew of ten and bristled with .50-caliber machine guns. Unescorted B-17s flew in tight formations of squadron "boxes," staggered vertically so that their machine guns could provide overlapping fields of fire. Their secret weapon for precision bombing was the Norden bombsight, a gyroscopically stabilized telescopic sight linked electronically to the B-17's automatic pilot to deliver bomb loads on target. Conditions in those unpressurized bombers at altitudes approaching 30,000 feet were brutal, forcing crewmen to don oxygen masks and wear bulky flight suits. "We were always afraid when we flew missions, every one of us," said a B-17 tail gunner, who added that without that fear, "I think every one us would have been lost." ■

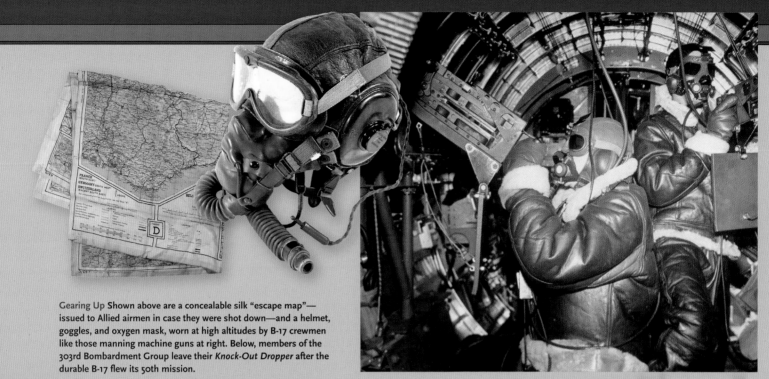

Gearing Up Shown above are a concealable silk "escape map"—issued to Allied airmen in case they were shot down—and a helmet, goggles, and oxygen mask, worn at high altitudes by B-17 crewmen like those manning machine guns at right. Below, members of the 303rd Bombardment Group leave their *Knock-Out Dropper* after the durable B-17 flew its 50th mission.

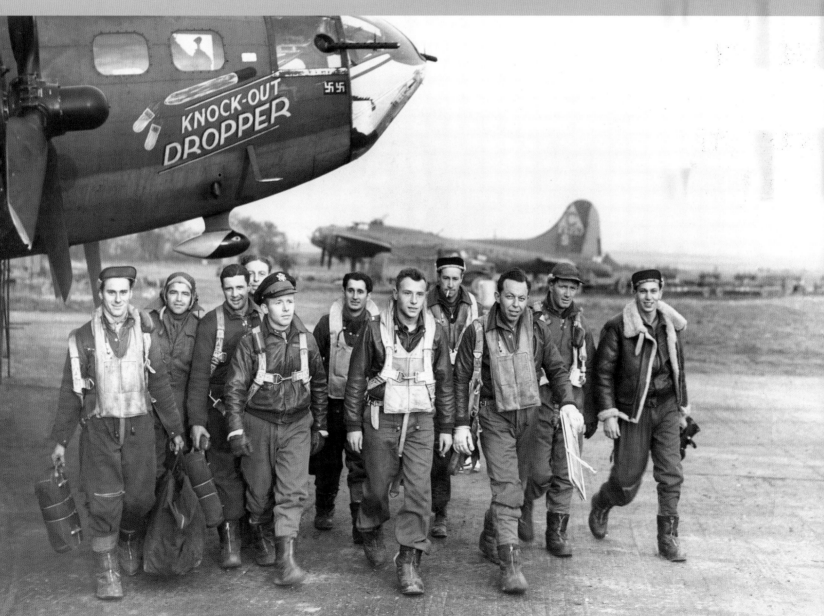

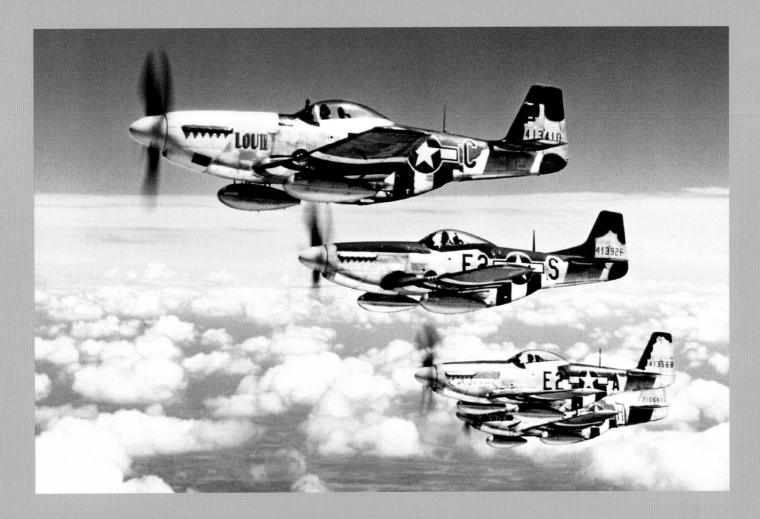

Mustangs to the Rescue

In August 1943, the Eighth Air Force launched raids on targets essential to the Luftwaffe and closely guarded by its fighters, including Messerschmitt plants in Regensburg and ball-bearing factories at Schweinfurt. During one raid on Schweinfurt, 60 of 250 B-24s went down. The Mighty Eighth could not afford such losses and sorely needed fighter escorts. But even advanced Allied fighters like the P-47 Thunderbolt and the RAF's Spitfire lacked the range to accompany bombers deep into Germany.

The aircraft that came to their rescue was a splendid example of Anglo-American teamwork, commissioned by the British Air Ministry and designed by the North American Aviation Corporation. Known as the Mustang and designated Mark I by the RAF and P-51 by the USAAF, its streamlined frame and advanced wing design reduced drag and eliminated the control problems plaguing earlier high-performance fighters. The

P-51s on Patrol
North American P-51 Mustangs of the Eighth Air Force's 375th Fighter Squadron fly escort duty on July 26, 1944. USAAF officers wore the winged prop collar badge above. By war's end, P-51s had destroyed nearly 5,000 Luftwaffe aircraft.

P-51B, introduced in December 1943, had a Packard-built version of the Spitfire's Rolls-Royce Merlin V-12 engine and a top speed of 445 mph. Its exceptional range of 2,200 miles, facilitated by 150-gallon drop tanks that could be jettisoned when empty, made it an ideal escort for long-distance bombers.

Mustangs outmatched German fighters in the air and pounded them on runways. "If they wouldn't come up into the air," said Capt. Don Salvatore Gentile, he and other Mustang pilots would "shoot them up on the ground . . . kill them, trample them down." Bolstered by P-51s, the Eighth Air Force and the 15th Air Force, based in Italy, dealt a crushing blow to the Luftwaffe during "Big Week"—seven days of relentless attacks in February 1944 that disrupted German aircraft production and downed nearly 600 enemy fighters, ensuring Allied air supremacy when troops landed in Normandy in June. ■

Dazed Survivors A shocked couple and child are helped through a rubble-strewn street by a German soldier following an air raid on the city of Mannheim. Allied bombing raids killed more than 300,000 German civilians, wounded 780,000, and left 7.5 million homeless.

Shock and Annihilation

Although USAAF bombers focused their attacks on German war industries, they also joined the RAF in conducting saturation bombing raids on German cities that caused massive civilian casualties. Some American commanders objected, including General Eaker, who warned that such assaults would convince "Germans that we are the barbarians they say we are." But Allied leaders were committed to the strategic bombing of cities in Germany as well as Japan until those opponents surrendered. Incendiaries dropped by Allied bombers on Hamburg, Germany, in July 1943 and Dresden in February 1945 kindled horrendous firestorms—hurricanes of flame that incinerated or asphyxiated tens of thousands of people. Other German cities like Berlin suffered similar losses over months as a result of repeated bombing raids. "It was very still in the city after these attacks," recalled Horst Sinske of Berlin. "The concentration

camp inmates took the dead away . . . they threw them on the ruins. And the mountain got higher and higher."

The deadly Allied bombing campaign forced Luftwaffe and German civil defense commanders to divert scarce personnel, antiaircraft batteries, and fighter planes from military to civilian targets. Allied airmen who blasted Dresden and other German cities in the war's last months did not know how long the struggle would last and were prepared to keep up the pressure until it ended. "We thought we had a lot of fighting left to do," one of them said. Ultimate responsibility for prolonging Germany's suffering lay with Hitler, who refused to yield even after Allied troops overran his borders. "We may be destroyed," he said, "but if we are, we shall drag a world with us—a world in flames." Hundreds of thousands of civilians died in the flames and rubble as he dragged Germany down with him. ∎

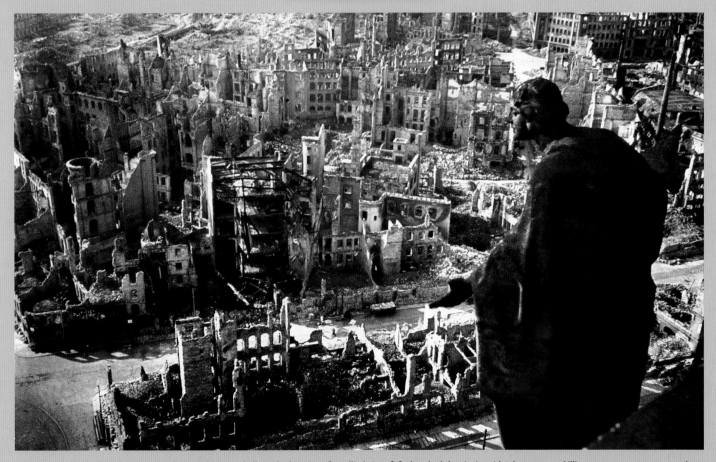

Devastation A blackened statue atop the Dresden town hall overlooks ruins after Allied aircraft firebombed the city in mid-February 1945, killing as many as 25,000 people. Allied air raids on strategic industrial targets like the oil refineries in Livorno, Italy, shown under attack on the cover of *Life* in 1944 *(top)*, also caused many civilian deaths.

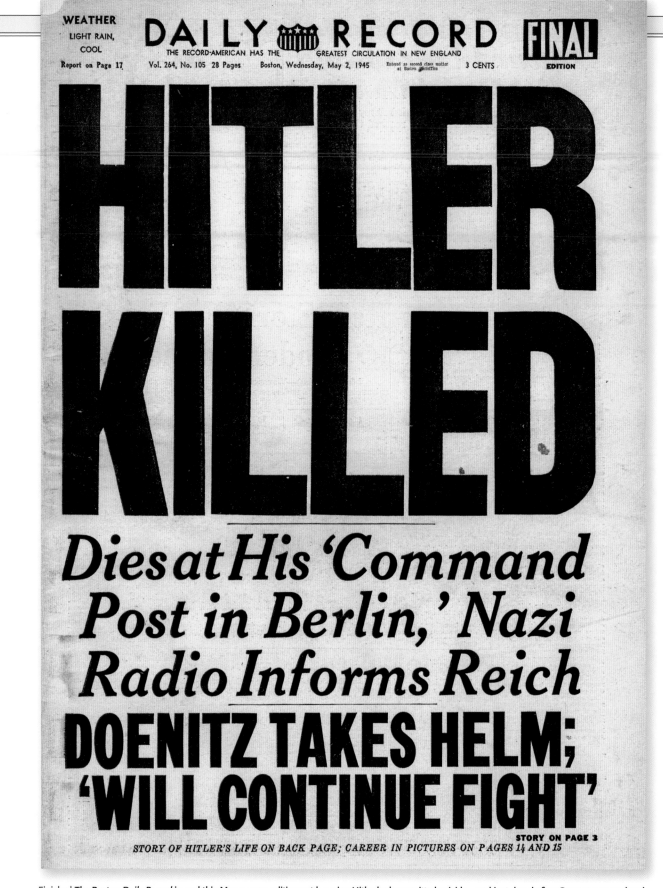

HITLER KILLED

DAILY RECORD

THE RECORD-AMERICAN HAS THE GREATEST CIRCULATION IN NEW ENGLAND

FINAL EDITION

Vol. 264, No. 105 28 Pages Boston, Wednesday, May 2, 1945 Entered as second class matter at Boston Postoffice 3 CENTS

Dies at His 'Command Post in Berlin,' Nazi Radio Informs Reich

DOENITZ TAKES HELM; 'WILL CONTINUE FIGHT'

STORY ON PAGE 3

STORY OF HITLER'S LIFE ON BACK PAGE; CAREER IN PICTURES ON PAGES 14 AND 15

Finished The Boston *Daily Record* issued this May 3, 1945, edition not knowing Hitler had committed suicide—and just days before Germany surrendered.

B Y THE SPRING OF 1944, A MILLION AND A HALF AMERICAN SOLDIERS WERE STATIONED ON BRITISH SOIL, preparing for what Allied Supreme Commander Dwight Eisenhower called "the greatest amphibious assault ever attempted." That fateful landing in Normandy, code-named Operation Overlord, would set the stage for the liberation of France and the invasion of Germany. Some in Britain complained that their own country had already been invaded—by the boisterous Yanks, caricatured as "overpaid, oversexed, and over here." But Eisenhower was careful not to let resentments at high levels threaten the Anglo-American alliance on which the success of Overlord depended. Even stern critics like British army chief Alan Brooke gave him credit for promoting that transatlantic partnership. As D-Day approached, Brooke wrote privately that Ike was "just a coordinator, a good mixer, a champion of inter-Allied cooperation, and in those respects few can hold a candle to him." What Brooke considered a small matter—nurturing and strengthening the alliance—was in fact the supreme task of the supreme commander, a job demanding military, diplomatic, and executive skills that were rarely combined in one war leader as they were in Eisenhower. Among the strong-willed subordinates he had to harness and hold in line were talented and troublesome generals like his countryman George Patton and Britain's Bernard Montgomery, whom Winston Churchill called "indomitable in retreat, invincible in advance, insufferable in victory." ✶ Monty could indeed be insufferable, but he was a logical choice to command Allied troops in Normandy until they broke

Victory Over Germany:

FROM D-DAY TO THE FALL OF BERLIN

CHRONOLOGY

- **June 6, 1944** Allied troops land in Normandy.

- **July 25, 1944** Allies break out in Normandy and begin advancing toward Paris.

- **August 15, 1944** Allied troops land on the French Mediterranean coast.

- **August 25, 1944** Germans abandon Paris.

- **December 16, 1944** Battle of the Bulge begins.

- **March 1945** Allied troops cross the Rhine and advance into Germany.

- **April 30, 1945** Hitler commits suicide as Soviet troops overrun Berlin.

- **May 7–8, 1945** Germany surrenders and Allies celebrate victory in Europe.

out of their beachhead and Eisenhower set up headquarters in France. Ike recognized that the British were entitled to have one of their own serve as field commander under the American supreme commander—and that Monty's arrogant and abrasive manner toward men of high rank was outweighed by his proven ability to inspire soldiers and lead them to victory. He earned the respect of his troops by planning operations meticulously and mustering all the strength he could before placing their lives at risk. His thorough, deliberate approach to battle had been vindicated in late 1942 at El Alamein, where he defeated Erwin Rommel, who was now responsible for defending the northern coast of France between Normandy and Calais, where the English Channel was its narrowest. Although the German High Command considered Normandy a less likely target for the Allies than the area around Calais, which offered invaders both a shorter crossing and a shorter path to Germany, Rommel recognized that Normandy was vulnerable to attack and was strengthening its coastal defenses. "We'll have only one chance to stop the enemy," he said, "and that is when he is in the water. Everything we have must be on the coast. The first 24 hours of the invasion will be decisive. For the Allies as well as Germany, it will be the longest day."

Montgomery was well suited to plan and implement the landing at Normandy because he respected Rommel without being intimidated by him. Rommel was an "energetic and determined commander," Monty remarked, and he had made "a world of difference" since taking charge of the coastal defenses. But Allied commanders had no reason to fear defeat, he insisted, if they strengthened their attack in response to Rommel's measures and instilled in their troops "infectious optimism, and offensive eagerness. Nothing must stop them. If we send them into battle in this way—then we shall succeed." Montgomery and Eisenhower agreed that the original plan for Overlord—which called for landing three divisions across a 30-mile-wide front—was inadequate to overcome Rommel's defenses. The revised plan broadened the front to 50 miles and boosted the initial assault force to five infantry divisions, three divisions of paratroopers, and several brigades of commandos and other forces. In all, more than 150,000 soldiers would land in Normandy in the first 24 hours, a feat requiring a prodigious armada of 5,000 warships, transports, and landing craft.

Over There An American soldier and his English girlfriend embrace in London's Hyde Park in a picture taken for *Life* by photographer Ralph Morse on May 1, 1944, as the D-Day invasion loomed.

Obstructions placed along the beaches by Rommel's engineers prevented landing craft from reaching shore at high tide, which meant that the first wave of troops would have to land when the tide was lower and advance farther under fire from German artillery and machine-gun posts overlooking the beaches. Demolition squads operating at great peril would have to clear obstructions and mines before landing craft could safely disgorge tanks to join in the attacks. Monty wanted armor up front during the invasion and turned to his innovative countryman, Maj. Gen. Percy Hobart, who designed floatable tanks called Duplex Drives (DDs), driven by propellers in water and by tracks on land. Some of Hobart's tanks were rigged with devices that could clear mines, allowing armor to lead the way in assaults and shield oncoming infantry. American commanders were skeptical of Hobart's "Funnies," as those strange vehicles were known, and made less use of them on D-Day than the British did, but Eisenhower later doubted that his "assault forces could have firmly established themselves without the assistance of these weapons."

Nothing in the Allied arsenal could have averted disaster if German generals—who commanded 11 armored and 50 infantry divisions in France—had anticipated the landing at Normandy and concentrated forces there. To keep German troops tied down around Calais, Allied intelligence officers conducted a deception campaign indicating that a fictitious First U.S. Army Group (FUSAG), under the command of General Patton, was massing near the Strait of Dover (Pas de Calais). False radio signals from Dover and misleading reports from double agents who had turned against their German spymasters sustained that illusion and portrayed the Normandy landings, once they occurred, as diversions meant to draw defenders away from Calais, where the big blow would soon fall. Patton's presence in England was publicized to bolster the hoax, but he nearly lost his commission as the phony leader of FUSAG—and the real commander of armored forces slated to land in Normandy after D-Day—when he gave a foolish speech in April stating that it was "the evident destiny of the British and Americans to rule the world." Ike was furious, but kept him on after sending a public relations officer to shut him up. That officer translated Ike's curt message into more polite language, but Patton insisted on knowing what his boss really said, to which the messenger replied: "He said that you were not to open your goddamned mouth again publicly until he said you could!"

As Patton well knew, Eisenhower's genial exterior masked the gritty determination of a leader who had grown tougher and more demanding as his responsibilities increased. Earlier in North Africa, he had in fact been "just a coordinator," in Brooke's words, overseeing a

> ## "We have only one chance to stop the enemy and that is when he is in the water."
>
> FIELD MARSHAL ERWIN ROMMEL

Brain Trust Top Allied commanders meet in London on February 13, 1944, to plan for D-Day. Seated from left to right are Lt. Gen. Omar Bradley, U.S. First Army; Adm. Bertram Ramsay, Allied Naval Expeditionary Force; Air Marshal Arthur Tedder, deputy supreme Allied commander; Gen. Dwight Eisenhower, supreme Allied commander; Gen. Bernard Montgomery, 21st Army Group; Air Marshal Trafford Leigh-Mallory, Allied Expeditionary Air Forces; and Lt. Gen. Walter Bedell Smith, chief of staff, Headquarters Allied Expeditionary Force.

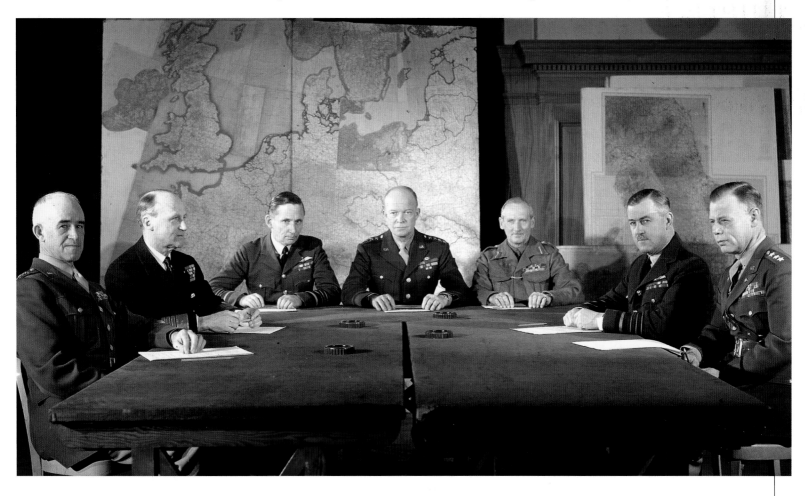

Tricked by Magic

Lt. Gen. Hiroshi Oshima, Japan's ambassador to Germany, was described by correspondent William Shirer as "more Nazi than the Nazis." A confidant of German foreign minister Joachim von Ribbentrop and top German generals, he was allowed to tour the Atlantic Wall, which guarded the west coast of occupied Europe against an Allied invasion. In late 1943, Oshima reported to Tokyo by radio that Normandy was lightly defended by the Germans. What this friend of the Reich did not know was that by encoding his dispatches on the cipher machine at the Japanese Embassy in Berlin, he was informing the Allies.

The cipher machine employed by Oshima and other Japanese diplomats was similar to the German Enigma, but instead of rotors it used electromechanical stepping switches of the type used in telephones. Unlike cryptanalysts at Bletchley Park—who had an Enigma machine at hand when the war started—William Friedman's team at the U.S. Army's Signal Intelligence Service (SIS) had to reconstruct their own version of the Japanese cipher machine by analyzing the Japanese diplomatic code, labeled Purple. The machine "spewed sparks and made loud whirring noises," recalled one officer, but it allowed the SIS to decipher Japanese diplomatic signals and supply Allied commanders with top-notch, top-secret intelligence reports, code-named Magic. Oshima's deciphered dispatches confirmed the success of Allied efforts to make the Germans expect an invasion at Calais and concentrate forces there. The unwitting Oshima, stated U.S. Army chief George Marshall, was the Allies' main informant "regarding Hitler's intentions in Europe." ■

Purple Prose Ambassador Hiroshi Oshima, pictured at top beside Hitler raising his hat, sent messages from Berlin in the "Purple" code on the Type 97 cipher machine, whose circuits are shown above. American cryptanalysts intercepted and deciphered the messages, producing a treasure trove of intelligence dubbed Magic.

campaign managed by his more experienced subordinates. Now he was fully in command. On issues of vital importance, he bowed to no one—not even Churchill, who opposed drawing troops away from Italy to launch Operation Anvil, an invasion of southern France that was supposed to coincide with the landings at Normandy. Eisenhower preserved Anvil over Churchill's objections by agreeing to delay the operation until after Overlord, which allowed the Italian campaign to achieve a major objective—the capture of Rome, on June 5.

Another high-level dispute arose when Churchill joined top Allied air commanders in opposing Ike's plan to shift the brunt of their bombing campaign from Germany to France, where railways, depots, and bridges would be targeted to isolate enemy troops in Normandy and block efforts to reinforce them. Inevitably, many French civilians would die in those air raids, and Churchill denounced such "cold-blooded butchering" of people whom Overlord was meant to rescue. Churchill urged Franklin Roosevelt to intervene, but the President trusted in Eisenhower and the plan went ahead. Among those who backed the supreme commander's decision was Maj. Gen. Pierre Koenig, whose Free French forces in England were preparing to join Allied troops and members of the French Resistance in liberating their country. "This is war and it is expected that people will be killed," Koenig said of the air raids. "We would take twice the anticipated loss to be rid of the Germans."

No call made by the supreme commander was more difficult or fraught with peril than his final decision to proceed with the invasion. Originally planned for early May, Overlord was put off until June 5 to allow for a larger assault, which required more landing craft and other equipment. Stormy weather over the English Channel in early June then forced Eisenhower to postpone the launch until June 6. His chief meteorologist, Group Capt. R. M. Stagg of the Royal Air Force, predicted that the weather would improve that day. Seas would remain rough, and clouds might obscure targets for pilots, but waiting longer for ideal conditions could be costly. If the invasion was not launched during the lull that Stagg forecast, it would have to be postponed for at least two weeks, when there would once again be a bright, moonlit night—required for operations by airborne troops—followed by a low tide at dawn for the amphibious assaults.

The consequences of such a lengthy postponement, wrote Eisenhower, were "almost too bitter to contemplate." The greatest risk was that secrecy would be lost, allowing the Germans to mass forces at the point of attack.

Weighing the hazards of delay against the danger that conditions would prove worse than predicted and doom the landings, Eisenhower chose to trust in Stagg and his staff, who had proven accurate in trials when asked to forecast weather over the landing zone. After one last briefing before dawn on June 5, Ike confirmed the decision he had reached the night before. "OK. We'll go," he announced. Later that day, he drafted a press release to be issued if the invasion failed. "The troops, the air force and the navy did all that bravery and devotion to duty could do," he wrote. "If any blame or fault attaches to the attempt it is mine alone."

Like Eisenhower, tens of thousands of troops who embarked for Normandy by sea and by air on the eve of D-Day were hoping for the best but preparing for the worst. Pvt. Harold Baumgarten and other men of the 116th Infantry Regiment, 29th Infantry Division, had already been informed by their colonel that they would be among the "first forces into the second front in Europe, and that two out of three of us aren't expected to come back." At a briefing before they shipped out, they learned that their target was the beach code-named Omaha, the most heavily defended of the five amphibious landing sites in Normandy. They were shown aerial reconnaissance photos of "Germans preparing the defenses," recalled

"He said that you were not to open your goddamned mouth again publicly until he said you could!"

GENERAL EISENHOWER'S WARNING, AS RELAYED TO GENERAL PATTON

Atlantic Wall In this color-enhanced photo, a massive Krupp 380-mm coast artillery gun juts from a newly constructed concrete casement on the French coast, one of hundreds of coast artillery batteries placed on the Atlantic Wall.

Arming the Resistance

In July 1940, British authorities created the Special Operations Executive (SOE), a shadowy organization assigned to strike back at Germany by conducting a secret war in Axis-occupied territories. The SOE worked in close cooperation with Lord Mountbatten's Combined Operations Headquarters, an organization tasked with harassing the enemy through commando raids and combined naval and army amphibious operations. While the commandos of Combined Operations raided enemy outposts in coastal areas, ranging from islands off Norway to German radar sites on French beaches, highly trained SOE teams were dropped behind enemy lines to conduct sabotage operations and organize guerrilla units.

The SOE's American counterpart was the Office of Strategic Services (OSS), created by President Roosevelt in June 1942 and directed by Col. William "Wild Bill" Donovan. The OSS was meant to be America's primary intelligence-gathering organization, and its field teams also worked closely with the SOE to penetrate occupied Europe.

Technicians and scientists working for the SOE and OSS devised unique weapons and equipment for clandestine operatives. The SOE pioneered the use of plastic explosives, and both the OSS and SOE developed compact short-wave transceivers—the SOE version weighed less than 40 pounds and looked like an ordinary suitcase.

Efforts to prepare for Operation Overlord behind enemy lines began in 1943. Royal Air Force bombers dropped weapons and supplies to the French Resistance, providing arms for nearly a half million fighters. OSS and Free French agents formed two-man "Sussex" teams to gather intelligence about German troop movements. Coinciding with the invasion, "Jedburgh" teams made up of OSS, SOE, and Free French officers launched a guerrilla campaign throughout France. General Eisenhower later praised those secret efforts, stating that the disruption of enemy communications and the "increasing strain placed on German security services throughout occupied Europe by the organized forces of Resistance, played a very considerable part in our complete and final victory." ■

Col. William Donovan

Lord Louis Mountbatten

Tools of Their Trade
Teams from Donovan's OSS and Mountbatten's Combined Operations Headquarters augmented efforts by the SOE and the French Resistance to break Nazi Germany's grip on Europe, using an array of weapons designed for special operations behind enemy lines, some of which are shown here.

OSS single-shot FP-45 Liberator pistol

SOE "Paraset" clandestine radio

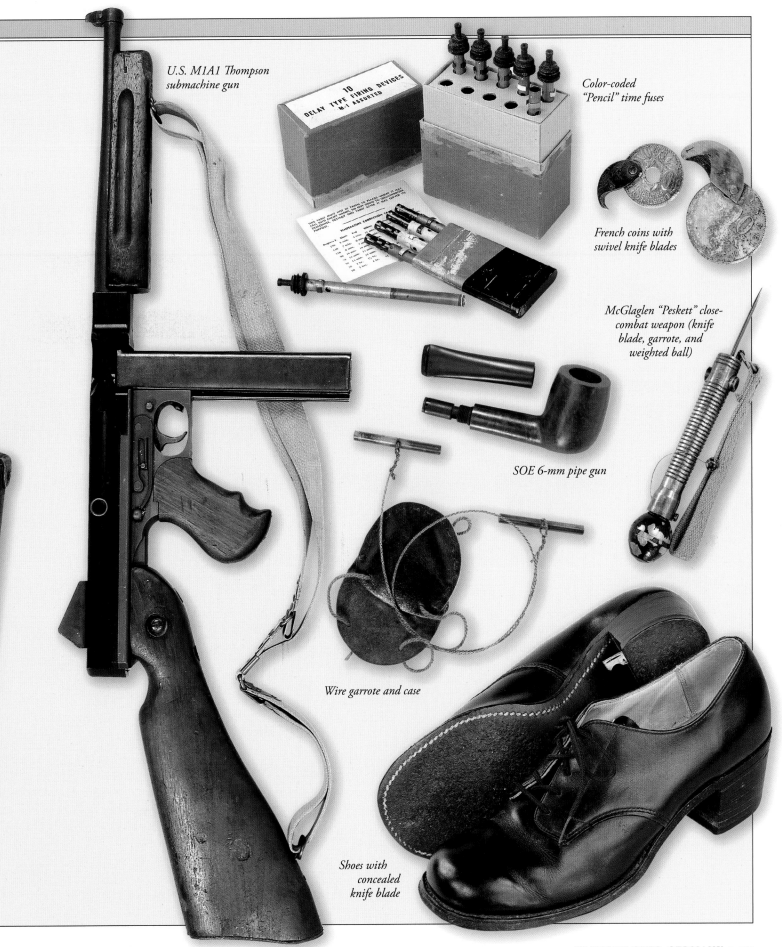

*U.S. M1A1 Thompson
submachine gun*

*Color-coded
"Pencil" time fuses*

*French coins with
swivel knife blades*

*McGlaglen "Peskett" close-
combat weapon (knife
blade, garrote, and
weighted ball)*

SOE 6-mm pipe gun

Wire garrote and case

*Shoes with
concealed
knife blade*

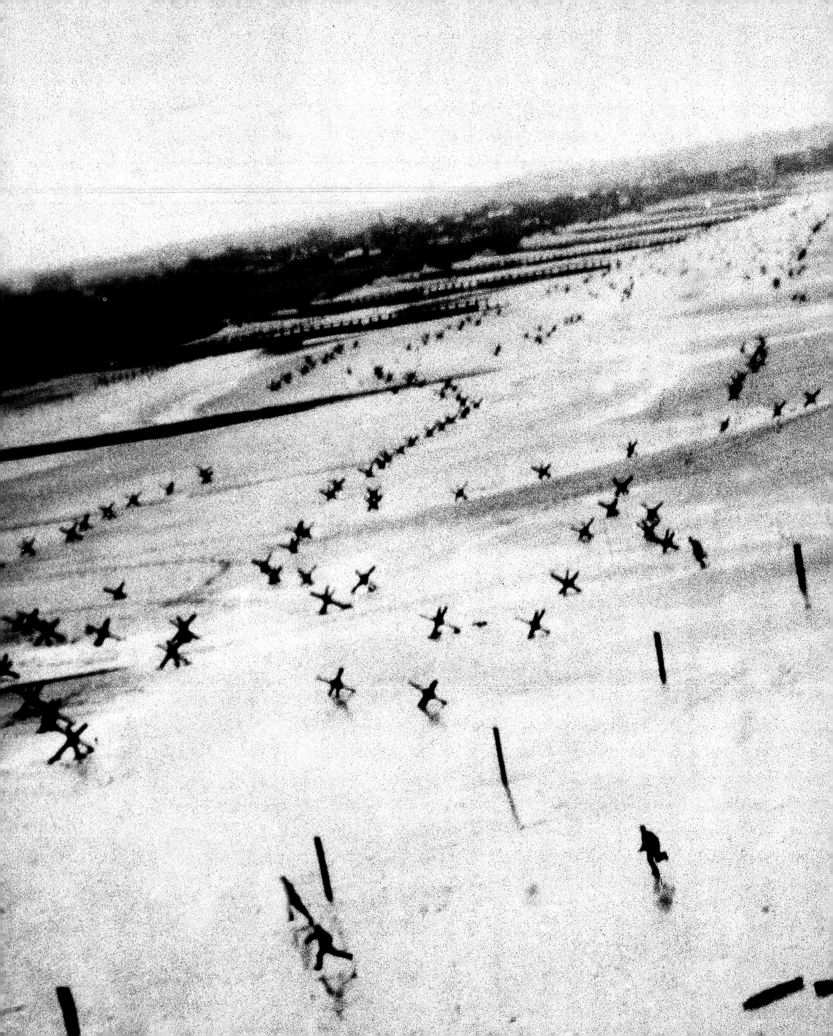

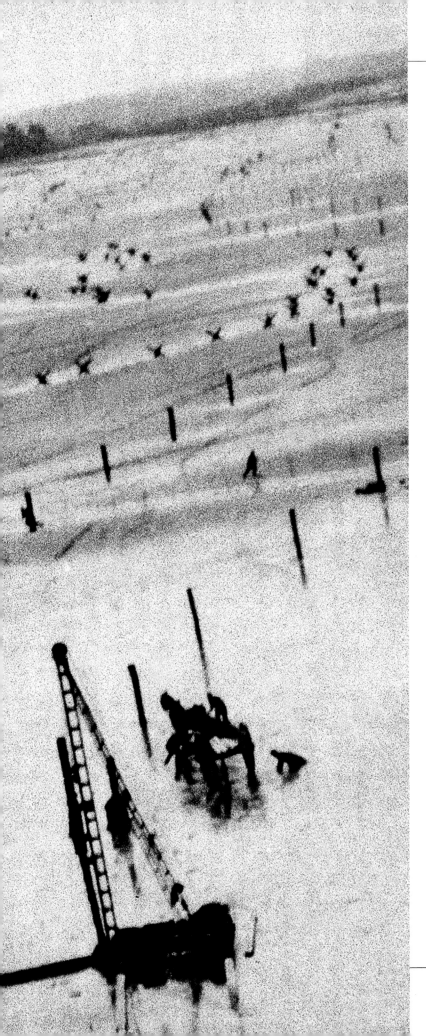

"If any blame or fault attaches to the attempt it is mine alone."

GENERAL EISENHOWER IN A PRESS RELEASE
TO BE ISSUED IF THE D-DAY INVASION FAILED

Baumgarten. Afterward, he wrote to his sister in New York City, asking her "to get the mail before my parents, and to break the news gently to them when she received the telegram that I was no longer alive."

DAY OF DECISION

Shortly before midnight on June 5, hundreds of planes filled with airborne troops—their faces blackened to avoid being spotted at night and loaded with equipment weighing 70 pounds or more—began taking off from runways in southern England. Civilians roused from sleep by the roar of engines overhead realized that a momentous new day in their long struggle against Germany was about to dawn. "It seemed as if every aircraft in the world was in flight, as wave followed upon wave without intermission," recalled John Keegan, who witnessed that stirring scene as a boy and went on to become a military historian.

Troops involved in this massive airborne assault faced a rough landing in Normandy, whether they parachuted from C-47 transports or descended in gliders that plowed into fields with a bone-jarring impact that could leave men dazed and battered before they even began to fight. Their targets lay at either end of the Allied landing zone, bounded by Utah Beach to the west and Sword Beach to the east—between which lay Omaha, Gold, and Juno Beaches. The U.S. 82nd and 101st Airborne Divisions came down behind Utah Beach, which like neighboring Omaha Beach would be assaulted around dawn by American troops arriving by sea. The British Sixth Airborne Division landed behind Sword Beach, which like Gold and Juno Beaches would be stormed by British Commonwealth forces, including two brigades of Canadians.

Close Encounter In a picture taken from a low-flying Allied photoreconnaissance plane in early 1944, a German work party on a French beach scatters to avoid the aircraft. Such flights helped produce maps of landing sites showing German obstructions like those visible here, designed to prevent landing craft from reaching shore at high tide.

Deception and Double Cross

After selecting Normandy as the landing site for Operation Overlord, Allied officers conducted elaborate deceptions to keep the Germans guarding other possible targets across a wide area—from the Mediterranean to Norway—before leading them to the conclusion that the invasion would most likely occur at Calais. Collectively, those deceptions were labeled Operation Bodyguard for a remark made by Winston Churchill: "In wartime, truth is so precious that she should always be attended by a bodyguard of lies."

Among those who helped guard the truth by feeding lies to the enemy were agents recruited by the Abwehr (German military intelligence) to spy on the British, who then turned them against their German handlers. That high-stakes spy game began in 1939 when MI-5 (British counterintelligence) arrested Arthur Owens, a Welsh agent working for the Abwehr. Owens helped MI-5 catch other German spies who parachuted into Britain

> ## "In wartime, truth is so precious that she should always be attended by a bodyguard of lies."
>
> WINSTON CHURCHILL

in 1940. By 1941, they had all been turned by MI-5 and were feeding false intelligence to the Abwehr by radio from a secret detention center in London. The operation was so sensitive that a top-flight committee of British intelligence officers called Double Cross (XX) was formed to handle it.

As the landings at Normandy loomed, double agents controlled by the Double Cross Committee played a big part in the ultimate Allied deception, dubbed Operation Fortitude, designed to reinforce German expectations that invasion forces would cross the Strait of Dover (Pas de Calais). "Never did we say anything directly about the Pas de Calais," remarked one double agent afterward. Instead, they offered vague hints of a buildup of men and materiel around Dover.

Anticipating that the Germans might try to confirm those reports by conducting reconnaissance flights, the Allies placed dummy aircraft, inflatable rubber tanks, and other props that looked suitably convincing from a distance on airfields and bases near Dover. Radio operators there broadcast false signals from imaginary divisions of the fictitious FUSAG (First U.S. Army Group), and hundreds of soldiers were given sleeve insignia for those divisions to wear on leave. As a final flourish, General Patton—well known to the Germans after his hard-charging advance across Sicily—was put in charge of the phony FUSAG. Meanwhile, the real commander of the Normandy invasion forces, General Montgomery, was impersonated by an actor, who made appearances around the Mediterranean to conceal Monty's whereabouts and intentions.

Operation Fortitude fooled the Abwehr and the German High Command. On D-Day, German forces in France were concentrated around Calais. Long after the invasion of Normandy began, Hitler believed that it was a diversion and held back panzer divisions to meet the anticipated threat at Calais, which never materialized. ∎

Optical Illusions **As part of Operation Fortitude, American and British intelligence services created dummy weapons to fool aerial observers, such as the cutout plane above and the inflatable M4 Sherman tank at right, hefted by soldiers at a camp in Yorkshire.**

Monty's Double Actor M. E. Clifton James *(below)* impersonated Gen. Bernard Montgomery *(above)* and appeared in North Africa and Gibraltar to suggest that the Allies were planning something big in the Mediterranean while the real Monty prepared to invade Normandy.

"It seemed as if every aircraft in the world was in flight."

JOHN KEEGAN,
OBSERVING ALLIED PLANES BOUND FOR NORMANDY

Men of the Sixth Airborne, led by Maj. John Howard, were assigned to seize two vital bridges situated between Sword Beach and the city of Caen, an enemy stronghold that General Montgomery hoped to capture on the first day of the battle. Descending in gliders around 12:30 a.m. on June 6, they were the first Allied troops to enter battle on D-Day. "Crash-landing was the big fear," Howard remarked. "My other worry was that we were all carrying grenades that were already primed. If one of those went off and exploded, it would have blown all the ammunition in the glider." Fortunately, no such blasts occurred, but hard landings killed some of the pilots—who came down remarkably close to their targets—and wounded others. Most of the troops emerged intact and took the bridges by storm before their startled foes could detonate charges and demolish the spans.

Few Allied paratroopers who landed in Normandy were as quick to achieve their objectives as Howard's men. The weather improved, as predicted, but their task remained daunting. In the American sector behind Utah Beach, much of the terrain consisted of marshes or fields that had been flooded by the Germans to impede landings. Accuracy was essential, but pilots of the C-47 transports had difficulty maintaining formation as they flew in and out of cloud banks over the English Channel and drifted farther apart when they encountered heavy flak over the coast of Normandy and began ducking and weaving. "We could see tracers coming up from many angles," recalled one pilot. "There was a tremendous racket such as experienced when flying through hail." Unnerved by the flak, some pilots sped up before reaching their drop zones, subjecting paratroopers to a dangerous "prop blast" that stunned them as their parachutes jerked open. Many landed far from their intended targets. Robert Flory of the 82nd Airborne looked down after jumping and "went into a state of shock. I was over water. My first thought was that the SOB pilot had dropped us over the English Channel. I looked to the right and saw a herd of dairy cows grazing. About that time I landed in water up to my chest. I was in a salt marsh." Weighed down by cumbersome gear, many paratroopers who landed in water as he did drowned, but Flory managed to reach dry land.

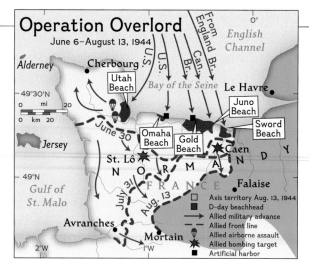

Operation Overlord
June 6–August 13, 1944

English Channel

Alderney

Cherbourg

Utah Beach

Bay of the Seine

Le Havre

Juno Beach

Sword Beach

Omaha Beach

Gold Beach

Caen

June 30

Jersey

St. Lô

N O R M A N D Y

Gulf of St. Malo

F R A N C E

Falaise

July 31

Aug. 13

Avranches

Mortain

☐ Axis territory Aug. 13, 1944
◻ D-day beachhead
→ Allied military advance
┅ Allied front line
Allied airborne assault
★ Allied bombing target
■ Artificial harbor

Target Normandy Preceded by airborne troops, Allied infantry landed on the beaches of Normandy on the morning of June 6, 1944. U.S. forces landed at beaches code-named Omaha and Utah; British and Canadian forces landed at Gold, Juno, and Sword Beaches.

"All this time, the gunfire was deafening, and the planes kept going over," he remarked." I saw one plane take a direct hit and explode in midair."

The main objective of the 82nd Airborne was the town of Ste.-Mère-Église, a vital crossroads a few miles inland from Utah Beach. Some ill-fated paratroopers drifted down in the center of town, where the glare from a burning building made them easy targets for German troops stationed there. One American was incinerated when he fell into that "flaming building, chute and all," related a fellow soldier: "He was burnt up so bad that he broke in two." After killing or capturing a few dozen other paratroopers who descended in their midst, the Germans holding Ste.-Mère-Église mistakenly concluded that the battle was over. In fact, hundreds of men with the 505th Parachute Infantry Regiment had landed safely near the town along with bundles containing bazookas. Those heavy weapons were handled by two-man teams, including Bill Dunfee, a veteran of the Sicily campaign, and his partner, Jim Beavers. "By the time Jim joined me I had the bundle unrolled and the bazooka and ammo out," Dunfee related. "We loaded up and headed for Ste.-Mère-Église. It was easy

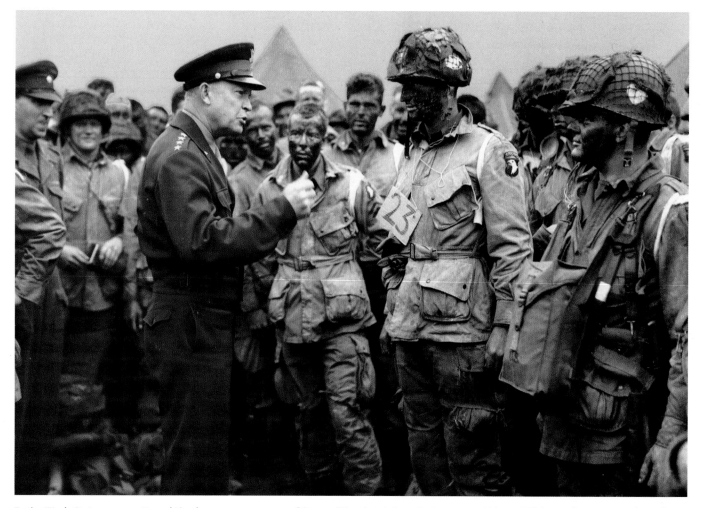

Parting Words On June 5, 1944, General Eisenhower encourages men of the 502nd Parachute Infantry Regiment, 101st Airborne Division, as they prepare to depart for a predawn descent on Normandy on D-Day.

to locate. That's where most of the fire was coming from." They were held in reserve while other paratroopers led by Lt. Col. Edward Krause overpowered the small German garrison there. Then they dug in at the outskirts of town "to await the counterattack that came all too swiftly," Dunfee recalled. "The enemy really socked it to us with 88s and Screaming Meemies," so-called for the shrill sound those rockets made. Among the victims were three paratroopers, one of whom had a grenade in his pocket when a rocket hit and was blown apart, as Dunfee looked on: "His head, chest, and right arm were all that remained intact. One of our men remarked, 'That's what you call going to hell in a hurry.' He wasn't being callous or unfeeling; his statement seemed appropriate at the time." Their commander, Krause, was wounded twice but refused to be evacuated and remained with his men until the Germans fell back and Ste.-Mère-Église was safely in hand.

For Maj. Gen. Maxwell Taylor, commander of the 101st Airborne Division, the battle for Normandy began as a frustrating search for his paratroopers, scattered across the countryside. "I landed alone in a field surrounded by the usual high hedges and trees with a few cows as witnesses," he related. His men were equipped with noise-makers called "crickets," whose clicking sounds helped them distinguish friend from foe in the dark, but it took hours for the far-flung paratroopers to gather in bands large enough to fight effectively. Taylor rounded up about 30 followers, many of them officers. "Never in the field of human conflict have so few been commanded by so many," he said ruefully. But their opponents were divided and distracted as well. Wide-ranging bombing raids, hit-and-run attacks by French Resistance fighters on phone lines and other means of communication, and artful Allied deceptions that included dropping thousands of dummies fitted with parachutes to simulate airborne assaults as far away as Calais confused German commanders, who did not expect the invasion to unfold at Normandy in the best of conditions—let alone in the wake of a severe storm. Rommel had discounted the possibility of an attack in such bad weather and had returned home to visit his wife on her birthday and to confer with Hitler, who was sleeping late this morning and would not be awakened until 10 a.m. Other German officers serving in France under Rommel were off conducting war games on June 6 in anticipation of an invasion in the weeks or months to come.

One notable exception was Gen. Erich Marcks, who remained at his headquarters in St.-Lô, 20 miles inland from Utah Beach. When informed that paratroopers were landing along the coast, Marcks promptly alerted the 352nd Infantry Division, whose troops guarded Utah and Omaha Beaches. They held strong positions at Omaha but were vulnerable to attack at Utah—and were not reinforced there on D-Day because large elements of Taylor's 101st Airborne coalesced before dawn and seized roads and causeways behind that beach, isolating the German defenders. Nearly 2,500 of the 13,000 American paratroopers who went into action on D-Day were killed, wounded, or captured, but their sacrifices enabled troops arriving by sea to take Utah Beach and secure the Allies' western flank at a cost of just 200 casualties—a toll that astonished planners who feared losing as many as 10,000 lives in the landings at Normandy.

Other factors contributed to the successful outcome at Utah, including good luck and dynamic leadership by 57-year-old Brig. Gen. Theodore Roosevelt, the eldest son of the late

Artful Dummies Before dawn on June 6, hundreds of dummy paratroopers known as "Ruperts" were dropped by British aircraft in an effort to confuse German forces as to the true location of Allied airborne landings.

"That's what you call going to hell in a hurry."

AN AMERICAN PARATROOPER, AFTER A FELLOW SOLDIER WAS BLOWN APART

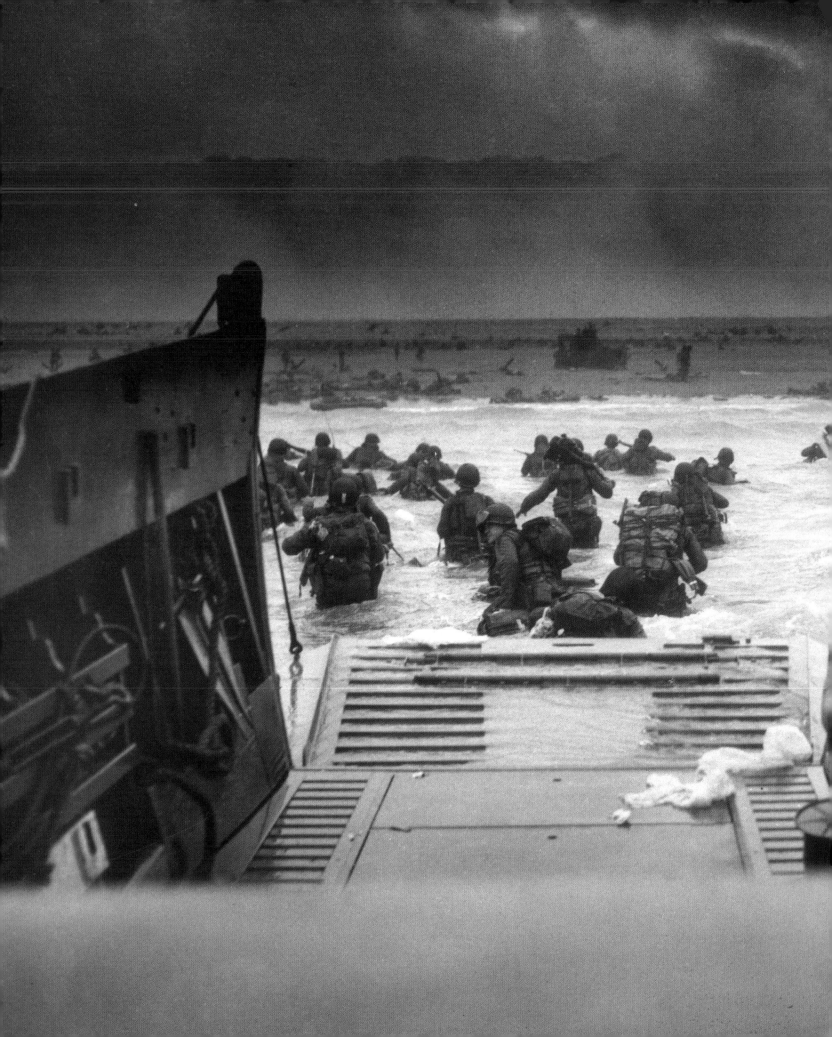

President Theodore Roosevelt. Although he walked with a cane and had a weak heart, he secured permission to land with the first wave from Lt. Gen. Omar Bradley, who led the American troops sent to Normandy as commander of the U.S. First Army. "It will steady the men to know I am with them," Roosevelt insisted. After wading ashore, he discovered that the first wave had landed more than a mile off course—a fortunate mistake, he realized, because the area was sparsely defended and close to a causeway held by the 101st Airborne. Rather than divert his troops laterally to their intended landing zone, he sent them rushing inland to link up with the paratroopers. "We'll start the war right here," he declared. Roosevelt's war would end a month later when he died of a heart attack, but what he accomplished at Utah Beach rivaled his father's celebrated charge up San Juan Hill in Cuba.

Schoolbook tales of heroism in battle did little to prepare troops of the U.S. First and 29th Infantry Divisions for the horrors awaiting them on Omaha Beach. Unlike most men of the 29th who were entering their first battle on D-Day, many in the Big Red One had fought in North Africa and Sicily. But none had faced an ordeal as trying as this assault, which proved deadly even before they came under fire from heavy German artillery on cliffs overlooking Omaha, or from machine guns and rifles protruding from slits in concrete pillboxes set in dunes along the beach, or from tanks half-buried in the sand with their barrels pointed menacingly at obstructions, minefields, and barbed wire through which troops would have to struggle before they reached shore.

The mayhem began far from land when Rear Adm. Alan Kirk anchored the transports before dawn a dozen miles from Omaha Beach—safely beyond the range of the big German guns there but perilously exposed to heavy seas—and troops on those ships piled into landing craft that were pitching wildly. Several of those craft sank before coming under fire, drowning hundreds of men.

Hard Landing Coming in with the first wave, heavily loaded soldiers of the 16th Regiment, First Infantry Division, wade ashore under fire at Omaha Beach on D-Day.

Ens. Joseph Vaghi

Beachmaster on D-Day

Vaghi landed on the "Easy Red" sector of Omaha Beach with Platoon C-8, Sixth Naval Beach Battalion, to serve as a beachmaster, directing the movement of men and equipment.

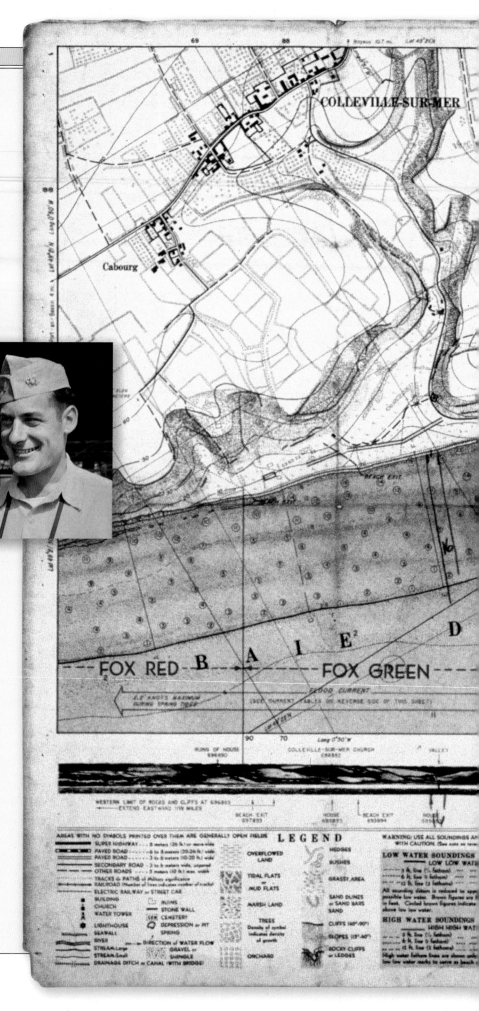

My first awareness that what we were doing was for real was when an 88-mm shell hit our LCI [landing craft] and machine-gun fire surrounded us. The Germans were in their pillboxes and bunkers high above the beach on the bluff and had an unobstructed view of what we were doing . . . the stench of expended gunpowder filled the air and rocket launchers mounted on landing craft moved in close to the shore and were spewing forth hundreds of rounds at a time onto the German defenses. The sea was rough. Purple smoke emanated from the base of the beach obstacles as the UDT [underwater demolition team] prepared to detonate another explosive in the effort to clear a path through the obstacles . . . Using the obstacles as shelter, we moved forward over the tidal flat under full exposure to machine-gun fire as we finally reached the dune line. All C-8s made the long trek, including Commander Carusi. God was with us!

Having reached the high-water mark, we set about organizing ourselves and planning the next move as we had done so many times during our training period. The principal difference was that we were pinned down with real machine-gun fire . . . Because the UDT had opened gaps through the underwater obstacles into Easy Red, most of the personnel and vehicles came ashore on my beach with the result that we were very crowded and became "sitting ducks" for the enemy fire. ∎

D-Day Map Beachmasters like Joseph Vaghi *(above)* were issued maps of the Normandy landing zones marked "TOP SECRET—BIGOT," a classification for documents that might reveal the location and timing of the invasion to the enemy. This map shows Easy Red, where Vaghi came ashore, and other sectors on Omaha Beach.

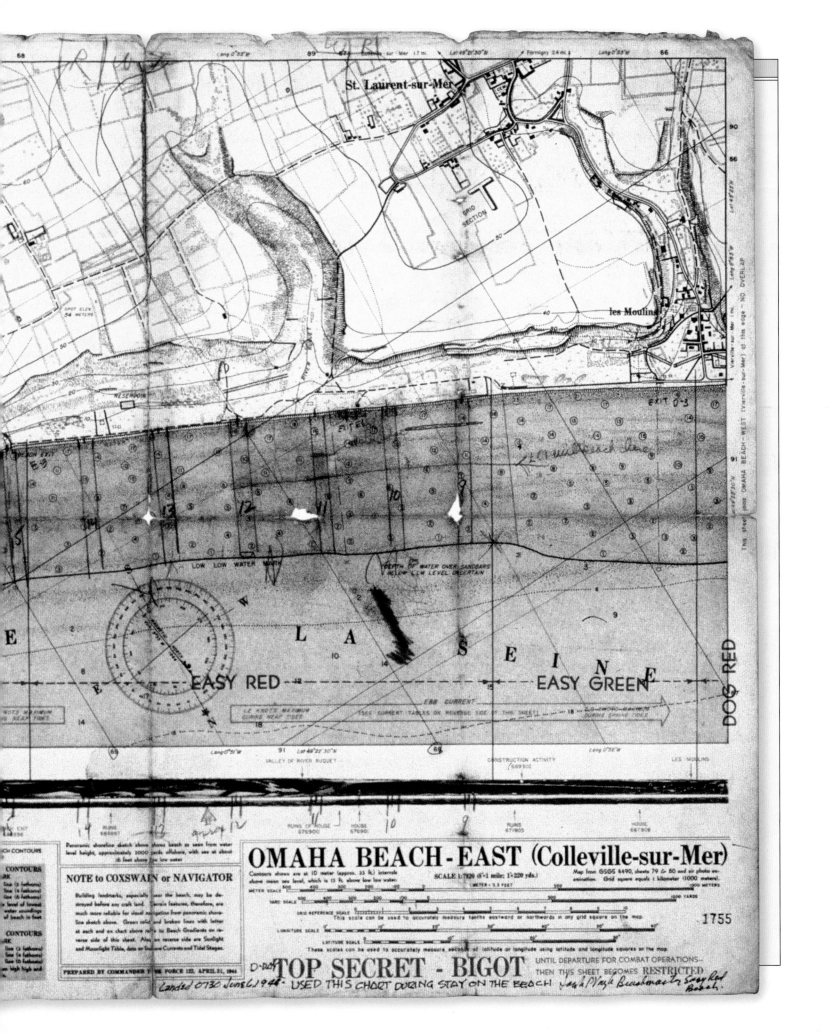

St. Laurent-sur-Mer

GRID SECTION

les Moulins

EXIT D-3

EASY RED LA SEINE EASY GREEN

DOG RED

LOW LOW WATER MARK

DEPTH OF WATER OVER SANDBARS BELOW L.W. LEVEL UNCERTAIN

EBB CURRENT

TIDE CURRENT TABLES ON REVERSE SIDE OF THIS SHEET

Long 0°51'W 91 Lat 49°22'30"N 66 Long 0°50'W

VALLEY OF RIVER RUQUET CONSTRUCTION ACTIVITY (669902) LES MOULINS

RUINS (668997) RUINS OF HOUSE (676900) HOUSE (675901) RUINS (671903) HOUSE (667906)

Panoramic shoreline sketch above shows beach as seen from water-level height, approximately 2000 yards offshore, with eye at about 15 feet above low low water

NOTE to COXSWAIN or NAVIGATOR

Building landmarks, especially near the beach, may be destroyed before any craft land. Terrain features, therefore, are much more reliable for visual navigation than panoramic shoreline sketch above. Green solid and broken lines with letter at each end on chart above refer to Beach Gradients on reverse side of this sheet. Also on reverse side are Sunlight and Moonlight Table, data on Tidal Currents and Tidal Stages.

OMAHA BEACH - EAST (Colleville-sur-Mer)

Contours shown are at 10 meter (approx. 33 ft.) intervals above mean sea level, which is 15 ft. above low low water.

SCALE 1:7920 (8"=1 mile; 1"=220 yds.)

Map from GSGS 4490, sheets 79 & 80 and air photo examination. Grid square equals 1 kilometer (1000 meters).

METER = 3.3 FEET

GRID REFERENCE SCALE — This scale can be used to accurately measure tenths eastward or northwards in any grid square on the map.

LONGITUDE SCALE

LATITUDE SCALE — These scales can be used to accurately measure seconds of latitude or longitude using latitude and longitude squares on the map.

PREPARED BY COMMANDER TASK FORCE 122, APRIL 21, 1944

1755

CONTOURS

NOTE to COXSWAIN or NAVIGATOR

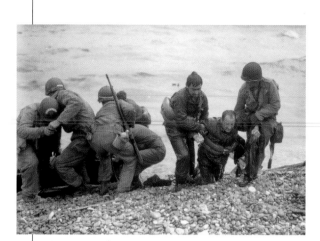

Bloody Omaha Men of a U.S. engineer special brigade rescue survivors of a sunken landing craft on Omaha Beach on D-Day.

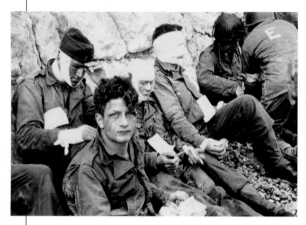

Stricken Survivors Wounded men of the 16th Infantry Regiment await evacuation to hospital ships on June 6.

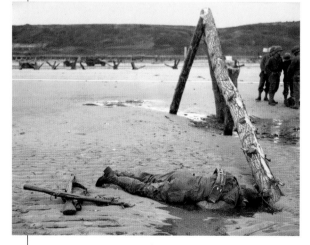

One Among Many Low tide on Omaha Beach reveals a dead American soldier lying at the base of a beach obstacle.

Landing craft that were carrying artillery or conventional tanks also went down, as did more than two dozen floatable DDs, which could not withstand high surf and sank with their crews. Few armored vehicles made it onto the beach to support the infantry in the first wave. "Everyone in my tank was praying," recalled J. C. Friedman whose battalion came under attack as it approached shore in a landing craft. "I kept thinking: is this the end of me? Will I ever see my family again? God give me strength to go on and see this day through. There was constant shelling and shrapnel flying off the tanks." Many crewmen who survived did so by abandoning their shattered vehicles and wading ashore on foot.

Preliminary bombardment of the German defenses had little impact on gunners in the sturdy pillboxes, many of them veterans of hard fighting on the Eastern Front. Unlike Friedman and his tank crew, infantrymen approaching Omaha Beach in landing craft had no armor to shield them. "About 200 to 300 yards from shore we encountered artillery fire," recalled Sgt. Bob Slaughter of the 116th Regiment, which led the way for the 29th Infantry. Shaken by the shelling, the sailor piloting the craft was reluctant to bring the troops any closer to shore. "These men have heavy equipment," Sgt. Willard Norfleet told him. "You *will* take them all the way in." When the sailor protested that they would all be killed, Norfleet drew his pistol, put it to the man's head, and shouted: *"All the way in."* Like many others in that heaving landing craft, Slaughter was seasick: "I had given my puke bag to a buddy who already had filled his. Minus the paper bag, I used my steel helmet." When the ramp went down, the water was still treacherously deep for soldiers wearing 60-pound packs. "Many were hit in the water and drowned," Slaughter said. "There were dead men floating in the water and live men acting dead, letting the tide take them in."

Demolition crews were among the first to land and the first to fall as they attempted to remove mines and obstructions on Omaha Beach. Sgt. Roy Arnn tried to unload his mine detector from its box "but couldn't because the lid was jammed. There was no place to hide in the open, and a sniper shot me." Moments later, he was hit by shrapnel in the leg and was unable to move as the tide rose around him. He was saved from drowning by a lieutenant who dragged him to the high-water mark and was wounded as he did so. As Arnn prayed to God for deliverance, he could hear another stricken soldier nearby "crying and asking for his parents." Private Baumgarten of the ill-fated 116th Regiment expected to die—and considered defeating the Nazis who were targeting his fellow Jews in Europe a cause worth dying for. But he survived several staggering wounds, the first of which occurred just moments after he descended from his landing craft: "Fragments from an 88-millimeter shell hit me in my left cheek. It felt like being hit by a baseball bat, only the results were much worse. My upper jaw was shattered, the left cheek was blown open . . . Blood poured from the gaping wound." Those who made it to the beach intact entered an arena of appalling carnage and chaos. "People were yelling, screaming, dying," said Sgt. Felix

"People were yelling, screaming, dying. Men were bleeding to death, crawling, lying everywhere, firing coming from all directions."

SGT. FELIX BRANHAM, 116TH INFANTRY REGIMENT, OMAHA BEACH

Branham of the 116th. "Men were bleeding to death, crawling, lying everywhere, firing coming from all directions."

Many of the three thousand casualties suffered by American troops at Omaha occurred in the first few desperate hours when the living huddled among the dead and the assault appeared doomed. The sparks that revived the attack and got those who were still able to fight moving came from officers who braved the terrors with their men and would not let them rest until they had achieved their goal—sergeants, lieutenants, and colonels like Charles Canham, who had warned his regiment that two of every three men might be lost here. "Colonel Canham was screaming at us to get across the beach," recalled Branham. "Back in training we used to call Colonel Canham everything not fit to print...We thought he would be another rear-echelon commander. After seeing him in action, I sure had to eat a mess of crow." Col. George Taylor, commander of the 16th Regiment, First Infantry, provided similar prodding to his men, pinned down at the far end of Omaha. "Two kinds of people are staying on this beach," he shouted, "the dead and those who are going to die. Now let's get the hell out of here!" Brig. Gen. Norman Cota of the 29th Infantry put it more bluntly to troops shuddering in the sand: "No sense dying here, men. Let's go on up the hill and die."

Some soldiers made daring assaults on German strong points, notably men of the Second Ranger Battalion who scaled a 100-foot-high cliff and seized a battery at great cost, only to discover that the massive 155-mm howitzers they were sent to capture had been removed by the Germans. More damage to enemy batteries and pillboxes was done by Navy destroyers that ventured perilously close to shore at midmorning and succeeded where the earlier bombardment had failed. That pounding helped clear the way for troops who had been trapped below the cliffs and dunes to push inland through ravines that were shrouded in smoke from blazes ignited by shellfire. By late afternoon, some units had advanced more than a mile and were battling Germans from house to house in the town of Colleville-sur-Mer. Behind them, reinforcements were pouring in by the thousands. "The entire beach was a mass of men, supplies, and equipment," one witness stated. Enemy guns continued to pound Omaha periodically, but the Germans would never again be as close as they were that morning to driving their foes back into the sea.

Most of the Allied forces who landed east of Omaha on Gold, Juno, and Sword Beaches fared better initially, with the exception of Canadian troops destined for Juno, who lost many of their landing craft to mines or artillery fire. Those low beaches were not as forbidding or

Welcome News First reports of the dawn landings in Normandy on D-Day reached the U.S. during the night of June 5 in time for editors at the *New York Post* and other American newspapers to break the news with banner headlines on June 6.

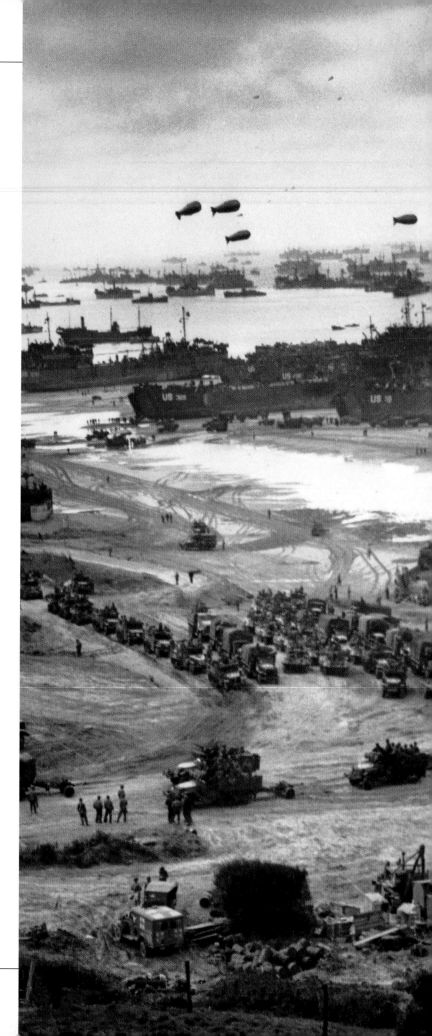

> ## "No sense dying here, men.
> ## Let's go on up the hill and die."
>
> BRIG. GEN. NORMAN COTA,
> 29TH INFANTRY DIVISION, OMAHA BEACH

as stoutly defended as the high ground above Omaha, and by midafternoon both the Canadians and the British troops who landed on either side of them had pushed several miles inland.

Commandos led by the Scottish nobleman Lord Lovat came ashore at Sword Beach marching to the tune of his piper, Bill Millen. Brigadier Lovat was "a typical aristocrat who would walk calmly with his head held high while the rest of us would be ducking and diving to avoid shells," Millen remarked. As they advanced beyond the beach, the shooting stopped, and French civilians gathered along the road to applaud the commandos, among whom were refugees from various European countries under Nazi rule. Entranced with Millen's bagpipe and kilt, one little girl tried to join the procession and had to be dissuaded by the piper, who knew that trouble lay ahead. Their assignment was to link up with Major Howard's Sixth Airborne paratroopers, who were fighting to hold the bridges they had seized long before dawn that morning. "The bridge over the Orne River was coming under sniper fire as we approached it," Millen said. "Lovat made a wave of his hand, telling us to go on and for me to continue playing." Some were shot as they crossed the bridge, but Millen and the bulk of Lovat's men came through unscathed and were heartily embraced by the battle-weary paratroopers.

Montgomery's hopes of occupying Caen on D-Day—the objective for which Howard's men had seized the bridges—were dashed a few hours later when the powerful 21st Panzer Division advanced from that city and drove a wedge between the British forces pushing inland from Sword Beach and the Canadians at Juno. "We were to make a strong thrust directly to the coast, wipe out the enemy, and take over the beaches to prevent further landings," reported Lt. Franz Grabmann, who had fought against the British in North Africa. "We met little resistance and drove on until we could actually see the sea, and then we met stiffening opposition." Late in the day, Grabmann learned that "some of

Expanding the Beachhead LSTs (landing ships carrying tanks and other vehicles) clog Omaha Beach on June 8, 1944, as an American tank-destroyer battalion moves inland in the foreground. Barrage balloons like those aloft here were moored by cables that deterred low-flying enemy aircraft.

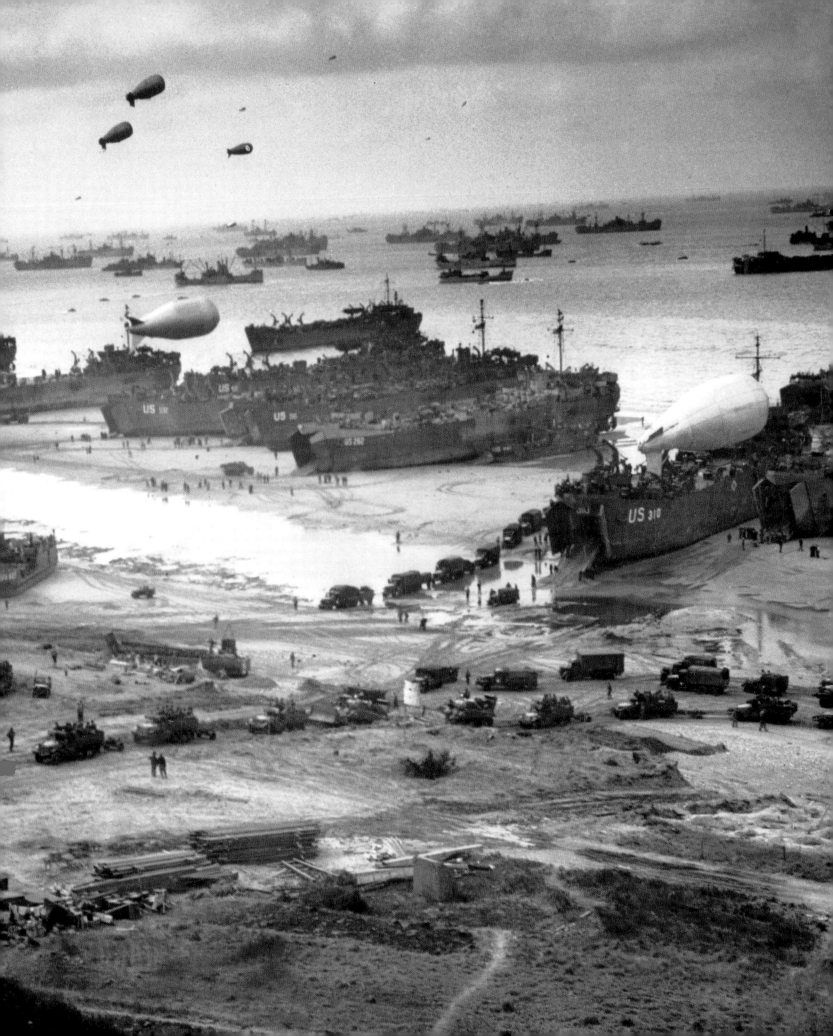

Deep Threat The 7.92-mm K98k Rifle was the standard German infantry rifle of World War II. When fitted with a telescopic sight, the rifle proved a highly effective weapon for snipers, who targeted Allied troops fighting in the hedgerows and small villages of Normandy.

"The fields were surrounded on all sides by immense hedgerows—ancient earthen banks, waist high, all matted with roots, and out of which grew weeds, bushes, and trees up to twenty feet high."

Ernie Pyle,
WAR CORRESPONDENT,
IN NORMANDY

our troops and tanks had actually reached the beach, which was heartening news. Then, like a thunderbolt from the sky, came a great aerial column of planes and gliders." That column consisted of 250 transport planes, towing gliders filled with reinforcements for the embattled British Sixth Airborne. Fighters shielded the transports and swooped down to strafe German tanks and antiaircraft batteries. By nightfall, Gen. Edgar Feuchtinger, commander of the 21st Panzers, had lost nearly half his tanks and decided to pull his forces back to Caen rather than have them pinched off by "heavily concentrated airborne troops."

Had the Germans brought more armored forces to bear against their foes on D-Day, they might have altered the outcome. But Hitler did not approve sending two panzer divisions to support the 21st until late that afternoon, and once they began moving toward Caen they were subject to air strikes that delayed them and did considerable damage. The decisive factor in the battle for the beaches was Allied air supremacy. While the battered Luftwaffe had little impact on the fighting, British and American airborne operations proved crucial in securing Sword and Utah Beaches and shielding the flanks of the amphibious assault forces. By the time Rommel returned to his headquarters in France late that night, he had lost his chance to stop his opponents in the water before they established a beachhead. The pivotal 24-hour struggle he called "the longest day" would be remembered as the finest day for those fighting to loosen Hitler's deadly grip on Europe.

BREAKING OUT

Allied commanders knew that landing on the coast of Normandy would be risky, but few anticipated how treacherous the next step in their campaign would be. Much thought was given to storming the beaches and less consideration to overcoming what lay beyond—forbidding country called bocage, consisting of low fields surrounded by hedgerows, mounds of earth covered with dense thickets in which snipers and machine-gunners could lurk unseen. "We were flabbergasted by the bocage," wrote Maj. Gen. Elwood Quesada. Infantrymen were "paralyzed" by small-arms fire from the hedgerows, he added, and tanks became snagged there and fell prey to artillery or rocket launchers. Stubborn German defenders exploited that terrain to the utmost and made breaking out of the beachhead in Normandy far costlier for the Allies than landing there.

The only way around the bocage for troops seeking to advance eastward to Germany lay through Caen, where Rommel concentrated the bulk of his armor. British and Canadian forces dispatched by Montgomery tried repeatedly to puncture German defenses in and around Caen before finally entering that city on July 9 after blistering Allied bombing raids that killed several thousand civilians there. "The dead lay everywhere," one witness reported, "not corpses, just the remains, fingers, a hand, a head, pathetic personal belongings." Many

soldiers on both sides perished as well in the attack, which forced the Germans back a few miles but failed to achieve a breakout. Monty was criticized for taking more than a month to seize an objective he had planned to capture on the first day of the campaign. Among his detractors was Churchill, who considered him overcautious and worried that "we were descending into a bitter 'trench warfare' situation similar to that of World War I."

Yet Montgomery's ponderous assault on Caen pinned down some the strongest German divisions in France while Bradley's American troops advanced westward up Normandy's Cotentin Peninsula against less formidable opposition.

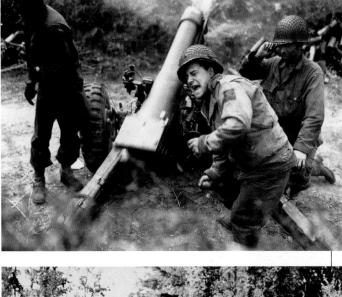

By late June, they had captured the port of Cherbourg, where Lt. Gen. Karl Wilhelm von Schlieben had orders from Hitler to "leave the enemy not a harbor but a field of ruins." His engineers wrecked the place so thoroughly that it took months to clear mines, sunken ships, and other obstructions and render the port fully operational. In the meantime, the Allies relied on two artificial harbors on the Normandy coast. Marvels of engineering, they helped boost Allied strength in Normandy to 1,500,000 troops and 300,000 vehicles by late July. But importing enough fuel and other supplies to keep those forces moving became a big concern as the campaign progressed.

Taking Cherbourg was no easy task for American forces. Although their foes included some demoralized recruits from Poland and other occupied countries who chose to fight for Germany rather than be sent to prison camps, strongholds like Fort du Roule, overlooking the harbor, were stoutly defended by German troops and were attacked at great risk by troops wielding grenades and other explosive devices. One officer, Col. Carlton McNeely, was devastated by the sight of the Americans who died taking that fort. "It tears me up to see so many of our fine young men being killed like that," he told Capt. George Mabry, who urged him to steel himself when fellow soldiers fell in battle by focusing on the enemy. "The only way I can do it," Mabry added, was to say: "You German SOBs killed my buddies, I'm going to get ten more of you for that."

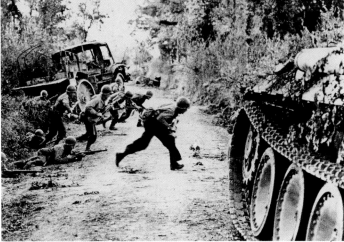

Tough Going At top, gunners manning a U.S. M3 105-mm light howitzer shell German forces on July 11, 1944, near Carentan, a town about five miles from Utah Beach. Faced with stiff resistance from enemies who used the hedgerows of Normandy's bocage to their advantage, Allied troops made little progress inland from their beachhead until July 25 when bombers blasted a hole in German defenses. That gap was promptly exploited by American troops like those shown above, crossing a road under fire near St.-Lô during the breakout on the 25th.

Men like McNeely who took the cruelties of war to heart soon became hardened to battle as the campaign intensified. After securing Cherbourg and the Cotentin Peninsula, American infantry and airborne troops—who advanced on foot after landing in Normandy—turned eastward toward the heart of France and entered the worst of the bocage, held by tough German veterans who yielded ground grudgingly. The struggle began in earnest on July 3 when Bradley's forces set out to seize the towns of Coutances and St.-Lô, beyond which lay open country that contained few barriers to armor and motorized infantry. If Americans broke out there, they could launch a blitzkrieg of their own and might bring the war to a swift conclusion. Mindful of that threat, Germans defended the bocage as if fighting for their home ground.

"My front lines looked like the face of the moon."

Maj. Gen. Fritz Bayerlein, whose panzer division was hit by Allied bombers on July 25

War correspondent Ernie Pyle described the combat: "The fields were surrounded on all sides by immense hedgerows—ancient earthen banks, waist high, all matted with roots, and out of which grew weeds, bushes, and trees up to twenty feet high. The Germans used these barriers well. They put snipers in the trees. They dug deep trenches behind the hedgerows and covered them with timber, so that it was almost impossible to get at them . . . They even cut out a section of the hedgerow and hid a big gun or tank in it, covering it with brush . . . Our men didn't go across the open fields in dramatic charges such as you see in the movies . . . They went in tiny groups, a squad or less . . . The attacking squads sneaked up the sides of the hedgerows while the rest of the platoon stayed back in their own hedgerow and kept the forward hedge saturated with bullets. They shot rifle grenades too, and a mortar squad a little farther back kept lobbing mortar shells over onto the Germans . . . This hedgerow business was a series of little skirmishes like that clear across the front, thousands and thousands of little skirmishes . . . Added up over the days and weeks, however, they made a man-sized war—with thousands on both sides getting killed."

Among the soldiers caught up in those deadly skirmishes was Sgt. Bud Warnecke, Company B, 508th Parachute Infantry Regiment, 82nd Airborne Division. On July 4, he and another sergeant were "standing behind a hedgerow being briefed" by Lt. Homer Jones when a German machine-gunner targeted them. One bullet grazed Warnecke, who "went down as if hit by a sledgehammer" but was not seriously wounded. Another hit Jones in the neck. "Blood was squirting out both sides and he was in terrible pain," Warnecke related. "We called for a medic. Jones was saying, 'Let me die! Let me die!' and Sgt. Roland Fecteau who was nearby, immediately stuck two fingers in the lieutenant's neck and plugged the holes."

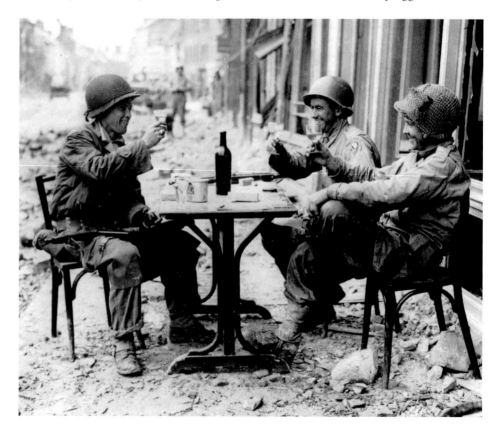

Brief Respite Three soldiers of the 79th U.S. Infantry Division raise their glasses in a toast at a sidewalk café in the rubble-strewn streets of La Haye-du-Puits on July 15, 1944. By taking this town, situated on the Cotentin Peninsula roughly midway between Cherbourg and St.-Lô, American troops severed German supply lines.

That prompt action helped save Jones, but he and many others in the company who were not killed outright while struggling through the bocage had to be evacuated. "By the time the fighting stopped for us on July 9," Warnecke said, "we in B Company, which started with 148 troopers, were down to 33."

By mid-July, Bradley's First Army had suffered more than 40,000 casualties and had yet to achieve its objectives. Coutances remained beyond his grasp, but his troops finally entered St.-Lô on July 18 after it was reduced to rubble. "We sure liberated the hell out of this place," one soldier remarked. As they did at Caen, Germans fell back to the outskirts of town but kept the Allies hemmed in. To shatter the enemy line and break out decisively, Bradley called for a massive bombing raid on German armor and infantry west of St.-Lô. Montgomery, who remained in command of all Allied troops in Normandy, approved Bradley's proposal and supported it by launching a preliminary attack by British and Canadian forces near Caen. Monty's enthusiastic reports as that offensive unfolded gave Eisenhower and his staff in England the impression that a breakout at Caen was imminent. When the attack there sputtered, pressure increased on Ike at headquarters to relieve Montgomery. Instead, he accepted Monty's assurances that his Commonwealth troops would continue to do their part by keeping powerful German forces tied down near Caen while Bradley prepared to deliver the big blow near St.-Lô.

Ike's forbearance allowed Montgomery to fulfill that pledge. Six of eight panzer divisions in Normandy remained engaged near Caen when Bradley's attack opened on July 25 with a terrific aerial bombardment by more than 1,500 B-17s and B-24s. American troops had pulled back from the front there to avoid being hit—but not far enough. Hundreds were killed or wounded when bombs went astray. Yet the carnage was far worse among the Germans, who had advanced when their foes pulled back and were dreadfully exposed. "My front lines looked like the face of the moon," reported Maj. Gen. Fritz Bayerlein, whose panzer division bore the brunt of the bombing. "At least 70 percent of my troops were out of action—dead wounded, crazed or numbed. All my forward tanks were knocked out, and the roads were practically impassable." Bradley's infantry poured through the gap, followed by tanks, some of which had steel blades attached up front to cut through hedgerows. Within days, the Americans had broken out of the bocage. To exploit that opening, Eisenhower

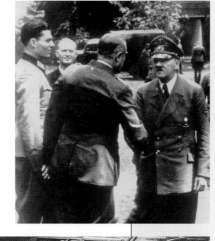

Narrow Escape At top, Col. Claus von Stauffenberg stands at attention at far left as Hitler arrives at the Wolf's Lair on July 15, 1944. Five days later, Stauffenberg planted a bomb that gutted the conference room there *(above)* but failed to kill Hitler.

Plot to Kill Hitler

Following the Allied invasion of Normandy and simultaneous setbacks on the Eastern Front, many high-ranking German officers concluded that their country was doomed. Aware that the Allies would never come to terms with Hitler, they plotted to eliminate him, take charge of the Reich, and open peace negotiations. An existing German contingency plan known as Operation Valkyrie called for the Territorial Reserve Army to impose order in the event of civil unrest. A group of senior army officers, including Gen. Friedrich Olbricht, Maj. Gen. Henning von Tresckow, and Col. Claus von Stauffenberg, chief of staff of the Reserve Army, planned to use those forces to disarm the SS and arrest the Nazi leadership once Hitler was dead.

On July 20, 1944, Stauffenberg attended a meeting with Hitler and others at the Wolf's Lair, the Führer's command post in East Prussia, and placed a briefcase containing a time bomb under the conference table before excusing himself. At 12:42 p.m., the bomb detonated, injuring Hitler and fatally wounding four others. Stauffenberg flew to Berlin to implement Valkyrie, but the plot collapsed with the news that Hitler was still alive. Stauffenberg and Olbricht were arrested and shot the same day. Hitler then eliminated proven conspirators as well as suspected enemies. More than 7,000 Germans were arrested, and nearly 5,000 were executed or forced to commit suicide. Hitler believed that he had been spared by fate for "the task imposed upon me by Providence" and continued with that ruinous task until he died by his own hand. ■

sent in Patton's Third Army, led by fresh armored divisions that raced eastward across open country and threatened to cut off German forces who were falling back from Caen toward the town of Falaise. Field Marshal Gunther von Kluge, who had taken charge of all Axis forces in France in July after Rommel was wounded and returned to Germany for treatment, warned Hitler that the situation was critical. "As a result of the breakthrough of the enemy armored spearheads," Kluge reported on August 1, "the whole Western Front has been ripped open."

That alarming news could not have come at a worse time for Hitler, who had narrowly escaped assassination on July 20 when a bomb exploded at the Wolf's Lair, his headquarters in East Prussia. The conspirators, who included several high-ranking officers, hoped to topple the Nazi regime and make peace with the Allies before they conquered Germany. Among those who paid with their lives after that plot collapsed was Erwin Rommel, who had met with conspirators beforehand and favored removing Hitler but not assassinating him. Rommel committed suicide in October 1944 to avoid being arrested and executed. Although few German commanders actively defied Hitler, many lost faith in him after D-Day as their country faced defeat on two fronts. A massive onslaught by two million Russian troops that summer pushed German invaders out of the Soviet Union and back toward their own border. Unable to shift any more divisions from his imperiled Eastern Front to repair his crumbling Western Front, Hitler ordered a desperate counterattack by forces caught in the Falaise pocket. Kluge dutifully complied, but his panzers were pounded by Allied warplanes and stopped dead in their tracks. "No matter how many orders are issued," Kluge informed Hitler in mid-August, German troops had no chance against such opposition and would be annihilated if not withdrawn from the pocket.

Garlands for de Gaulle Young girls with bouquets wait in the street of their war-ravaged town to welcome Free French leader Charles de Gaulle, who returned to France from exile in Britain on August 20, 1944, as Allied troops advanced toward Paris.

Kluge set that withdrawal in motion without Hitler's permission and began extricating tens of thousands of men who would otherwise have been killed or captured when the pocket closed around them. Suspecting Kluge of treachery, Hitler then recalled him to Germany. On August 19, Kluge committed suicide by swallowing a cyanide capsule after writing a letter to Hitler in which he urged him to end the war. "The German people have suffered so unspeakably that it is time to bring the horror to a close," he pleaded. Kluge praised Hitler for his "iron will" but pointed out that willpower alone could not turn defeat

"The German people have suffered so unspeakably that it is time to bring the horror to a close."

LETTER TO HITLER WRITTEN BY FIELD MARSHAL GUNTHER VON KLUGE
BEFORE HE COMMITTED SUICIDE

into victory. "If fate is stronger than your will and your genius, then that is destiny," Kluge wrote. "Show now that greatness that will be necessary if it comes to the point of ending a struggle which has become hopeless." His plea was futile, for Hitler lacked the greatness that Kluge attributed to him. Having thrust his forces into a disastrous war on two fronts, he had no intention now of surrendering to spare Germans or their opponents further suffering.

While German troops in the Falaise pocket were being battered and blasted, the Allies struck another blow against Hitler by landing in southern France. On August 15, the long-delayed Operation Anvil unfolded between Nice and Marseilles on the Mediterranean coast, where nearly 100,000 men came ashore by day's end. Commanding the assault was Maj. Gen. Lucian Truscott, who had distinguished himself in Italy and brought several American divisions from that campaign with him to Anvil. They were bolstered by Allied forces from many countries, including Frenchmen who were returning to their homeland after fleeing Nazi rule. They were among the first to land on the coast and enter Marseilles, a major port that would help supply Allied armies as they advanced.

French liberators were hailed in the city that gave birth to their national anthem, the "Marseillaise," but several thousand German troops remained holed up there for a week

Ultimate Penalty **A Frenchman who collaborated with the Nazis dies by firing squad in Rennes, France, in late 1944 after being condemned by a French Resistance tribunal.**

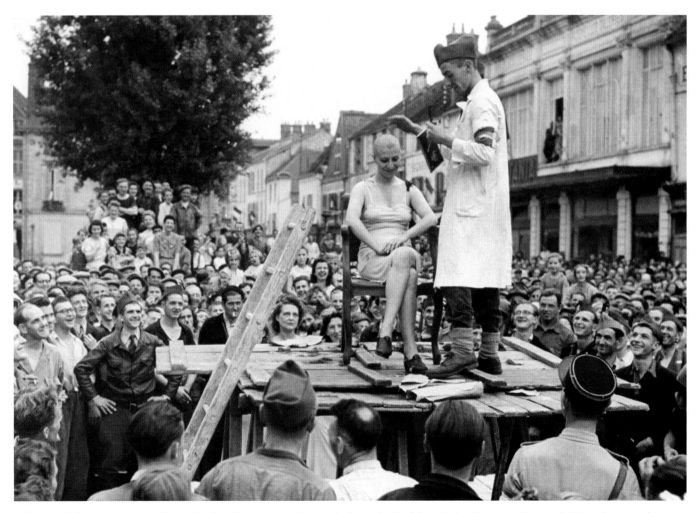

Public Humiliation **In a French town liberated by the Allies, a woman grimaces after having her head shaved, a humiliating punishment administered to some of those who had cooperated or consorted with German occupiers.**

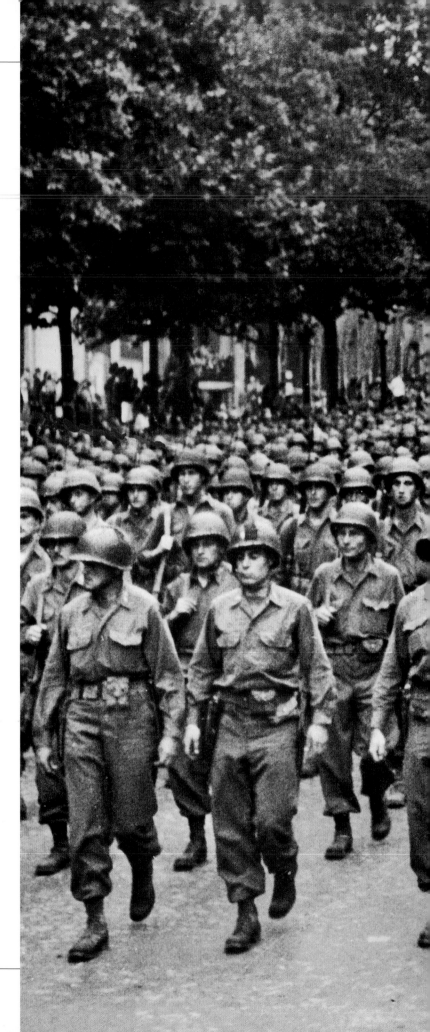

> ## "I have never seen in any face such joy as radiated from the faces of the people of Paris this morning."
>
> CHARLES WERTENBAKER, WAR CORRESPONDENT

before surrendering. As French tanks went from one street to the next, wrote their commander, he did not know whether they would be covered with flowers "by pretty, smiling girls or fired at by an 88mm shell." While the French took Marseilles, Americans hurried north to close a gap along the Rhône River through which Germans were squeezing to avoid being cut off. Some escaped there, as many did from the Falaise pocket, but tens of thousands were captured or killed on clogged roads below the gap. As one witness recalled, shattered tanks, trucks, and bodies formed "an inextricable tangle of twisted steel frames and charred corpses . . . through which only bulldozers would be able to make a way."

By late August, the infectious spirit of liberation had spread to the French capital, where Parisians were up in arms against the hated German occupiers. Eisenhower worried that sending Allied troops to secure Paris might have ruinous consequences. Indeed, Hitler had ordered Maj. Gen. Dietrich von Choltitz to destroy Paris if his forces could no longer hold it. "On the departure of the Wehrmacht, nothing must be left standing, no church, no artistic monument," Hitler insisted. Choltitz, a ruthless commander known to his men as "Hard Guy," found this order abhorrent and thought Hitler was crazy. Meanwhile, Gen. Charles de Gaulle and other Free French officers were urging Eisenhower to let their forces intervene in the ongoing uprising by the Resistance against the Germans in Paris and free that city. "I guess we'll have to go in," said Ike, who concluded that the danger of a bloody and chaotic rebellion was now greater than the risk of committing troops there.

Maj. Gen. Jacques Leclerc's French Second Armored Division led the way, followed by the U.S. Fourth Infantry Division. Choltitz tried to hold them off at the city's outskirts, but when Allied forces broke through and entered the capital in large numbers on August 25 he defied Hitler's order and surrendered

Liberators Massed ranks of the U.S. 28th Infantry Division march down the Champs-Elysées in Paris during an Allied victory parade through the city on August 29, 1944.

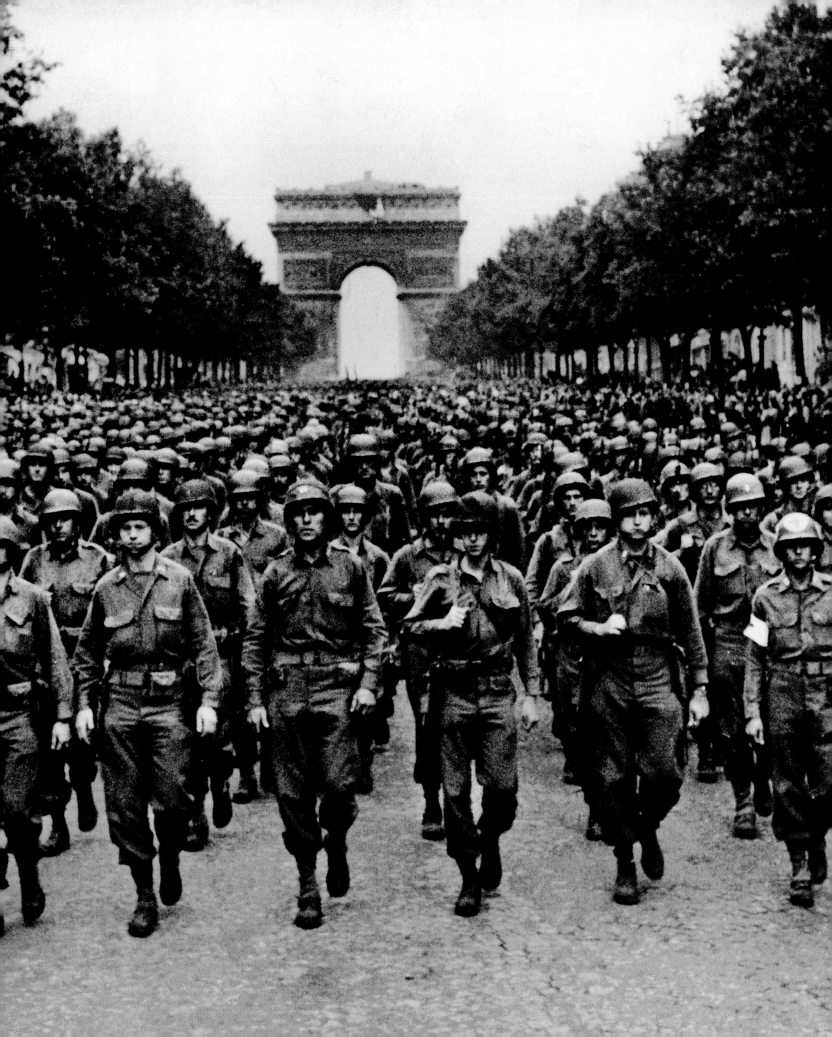

Paris intact. Bells tolled, wine flowed, and jubilant Parisians thronged the streets as the liberators marched in. "I have never seen in any face such joy as radiated from the faces of the people of Paris this morning," wrote war correspondent Charles Wertenbaker. Four days later, they were still celebrating when the U.S. 28th Infantry Division paraded down the Champs-Elysées. "My feelings as we marched along in the parade were that surely the war must be nearly over," remarked one soldier who took part, Ralph Johnson. "I could not have been more wrong. So many of my friends and comrades would be killed before that happy moment would arrive. Hitler just would not give up."

THE BATTLE OF THE BULGE

I have just made a momentous decision," Hitler informed his top commanders on September 16. "I shall go over to the counterattack!" Pointing on a map to Germany's border with Belgium and Luxembourg, he added: "Here, out of the Ardennes, with the objective—Antwerp!" The announcement startled Field Marshal Wilhelm Keitel, chief of the Wehrmacht, and others in attendance, who were struggling to defend their country against invasion by foes who appeared unstoppable. Since taking Paris, Allied troops had advanced northward into Belgium and seized the vital port of Antwerp, but it remained closed to shipping because the Schelde Estuary between Antwerp and the North Sea was mined and menaced by big German naval guns. Once the Allies secured that estuary, they could use Antwerp to supply troops preparing to invade northern Germany. Until then, supplies unloaded at more distant ports like Cherbourg and Marseilles moved slowly along roads that were heavily congested because the French rail network had been shattered by Allied bombers. Trucks hauling those supplies consumed precious petroleum, depriving tanks and other military vehicles of the fuel needed to continue advances made by armored divisions since the breakout in July. Hitler planned to exploit this situation by massing armor and infantry in the Ardennes and sending his forces barreling across Belgium to Antwerp. If successful, the surprise attack would recapture that strategic port and divide Allied forces to the south from those to the north.

Hitler's plan was reminiscent of the stunning German blitzkrieg in 1940, when panzers emerged from the Ardennes and raced to Dunkirk, stranding hundreds of thousands of Allied troops in Belgium and Holland and dooming France. Since then, however, Hitler had added two great powers, the United States and the Soviet Union, to his roster of enemies. His long war against formidable opposition had taken a heavy toll on the Wehrmacht and on Hitler himself, who was visibly shaken by the worsening military situation and the recent attempt on his life. Subject to insomnia and stomach ailments, he was now addicted to dangerous drugs administered by his physician, Theodore Morell. Hitler "had suddenly grown old," wrote his aide and diarist, Maj. Percy Schramm: "He often stared vacantly, his back was bent, and his shoulders sunken . . . The most frightening impression, however, was the tremble of his hands, which had become more pronounced during the last few months."

Yet Hitler was still capable of sizing up his foes and sensing their weaknesses, as he demonstrated by recognizing that Allied forces in France and the Low Countries were overextended and vulnerable to a counterattack. But his plan had an air of desperation that alarmed his

Freedom Restored A French poster depicts the spirit of Liberty freeing captives by lifting the lid from the sarcophagus of Nazi oppression.

"I have just made a momentous decision. I shall go over to the counterattack!"

ADOLF HITLER,
INFORMING TOP COMMANDERS
ON SEPTEMBER 16, 1944

commanders. To strengthen his offensive, he would drain German reserves of armor and manpower. All able-bodied males between 16 and 60 would be subject to military service. He even proposed shifting divisions temporarily from the Eastern Front to bolster the counterattack in Belgium. That would be inviting disaster, protested the army's chief of staff, Gen. Heinz Guderian, who had waged war on both fronts and knew that Soviet forces were not only more numerous than their Western Allies but also more dangerous, having suffered a cataclysmic invasion of their homeland that they were now poised to avenge. Hitler proposed to meet that threat by dealing the Americans and British such a crippling blow that he could then move the bulk of his forces eastward and repel the oncoming Soviets—a scenario his commanders considered fanciful, given Allied air supremacy. "This plan hasn't got a damned leg to stand on," said Field Marshal Walter Model when briefed by those who met with Hitler. Model proposed a limited offensive in Belgium by his Army Group B

Border War As shown on this map, Allied forces had swept across France and Belgium by the fall of 1944 and now faced German troops defending the Reich's frontier along a fortified line known as the West Wall. Operation Market Garden— an Allied airborne assault on enemy forces holding the border between the Netherlands and Germany—failed in late September. Hitler then launched a massive counterattack in the Ardennes region of Belgium and Luxembourg in December aimed at cutting the Allied armies in two and seizing their main supply ports along the North Sea.

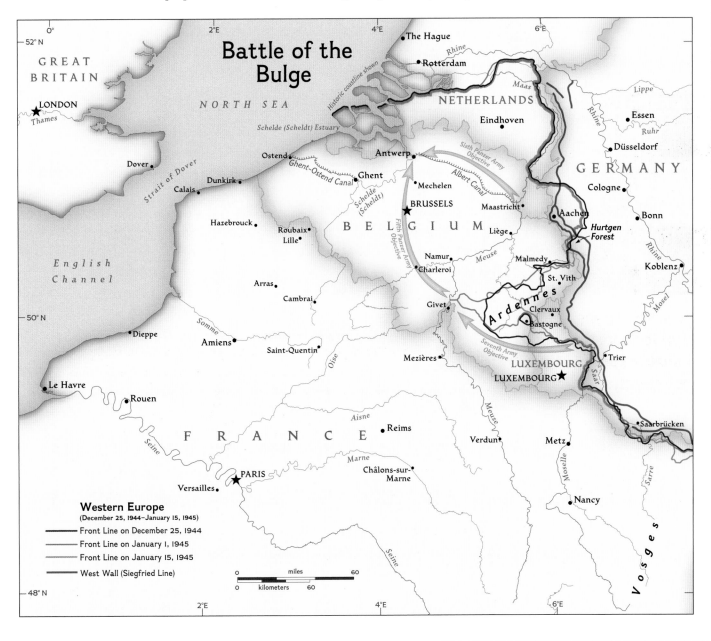

"My men can eat their belts, but my tanks have gotta have gas."

GEN. GEORGE PATTON

that promised smaller gains at less risk. Hitler would have none of it. He was prepared to stake everything—including the welfare of his nation, which faced a bitter reckoning in the east—on one last gamble in the west.

Three months elapsed before Hitler's decision could be translated into action on the battlefield. During that time, several factors combined to make Eisenhower's forces more vulnerable to attack. Ike's plan for invading Germany consisted of two thrusts—one northward through Belgium and Holland and across the Rhine into the Ruhr, Germany's industrial core; and the other eastward across the Moselle and Saar Rivers below the Ardennes. Shortages of fuel and other supplies meant that one of those thrusts would have to receive priority. Ike, who set up headquarters in France and assumed operational command there on September 1, gave priority to the drive northward because he needed Antwerp and was under pressure to capture German bases along the North Sea from which two fearsome new strategic weapons were being launched at Britain: the V-1 (a guided missile that flew around 400 miles per hour and could be shot down) and the V-2 (a much faster ballistic missile against which there was no defense). Montgomery led that advance into the Low Countries with British and Canadian forces and Lt. Gen. Courtney Hodges's U.S. First Army. Patton's Third Army was assigned to push eastward. But Patton, whose armored columns had made great progress since entering France in July, did not receive enough supplies to sustain that momentum. He railed against Ike for favoring Monty and pleaded in vain for more fuel, even if that meant reducing shipments of food. "My men can eat their belts," he said, "but my tanks have gotta have gas."

Vengeance Weapons **Moments before impact, a German V-1 flying bomb descends on a British town in late 1944. Beginning in June 1944, more than 9,500 of the guided missiles were fired against southeastern England. Nearly 2,500 more were directed at Antwerp after the Allies seized that vital port in Belgium.**

The controversy would soon have ended had Montgomery succeeded in punching his way into Germany that fall. But after taking Antwerp, he attempted to reach that goal in one quick leap by landing airborne troops in Holland in late September and capturing bridges over the Rhine. That overambitious plan, known as Operation Market Garden, went awry when two panzer divisions surprised the British First Airborne near the Rhine and tore up that division, which lost three-fourths of its 10,000 men. The failure of Market Garden was all the more bitter for Eisenhower because the operation delayed efforts to secure the Schelde Estuary and open the port of Antwerp, a task that Ike urged Monty to focus on more intently. Not until late November were the coastal batteries neutralized and the last mines removed, allowing supply ships to reach Antwerp. As the weather worsened, Allied troops in France and Belgium struggled to make dents in Germany's fortified western frontier, known as the West Wall or Siegfried Line. In a letter to his wife, Eisenhower disparaged premature claims of victory in Europe: "You can be certain that this war is not 'won' for the man that is shivering, suffering and dying up on the Siegfried Line . . . My whole time and thought is tied up in winning the bloody mess."

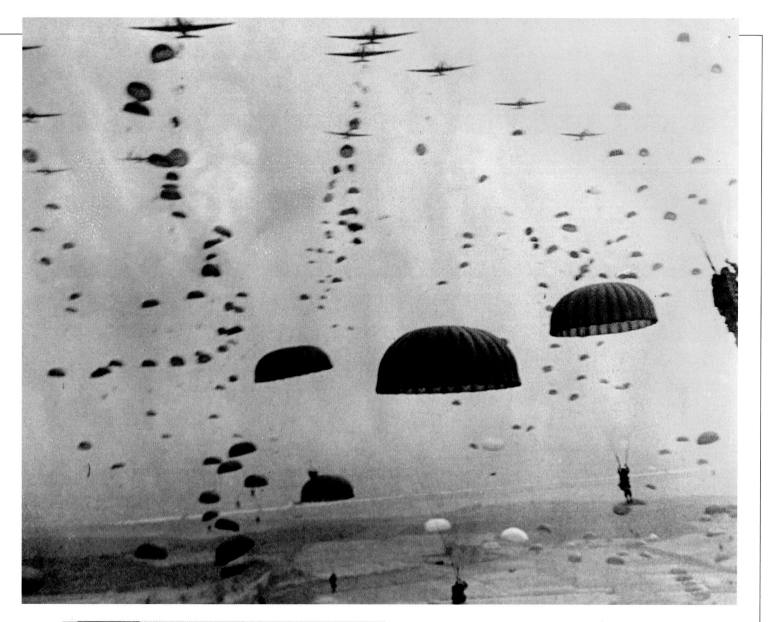

Airborne Army Parachutes fill the sky as Allied paratroopers land in Holland during Operation Market Garden in September 1944. U.S. paratroopers wore sturdy, high-laced jump boots *(left)*, designed to support their feet and ankles when they hit the ground. Injuries were common when paratroopers landed too hard or at an awkward angle like the soldier at far left, shown taking a dangerous tumble upon landing in Holland on September 24, 1944.

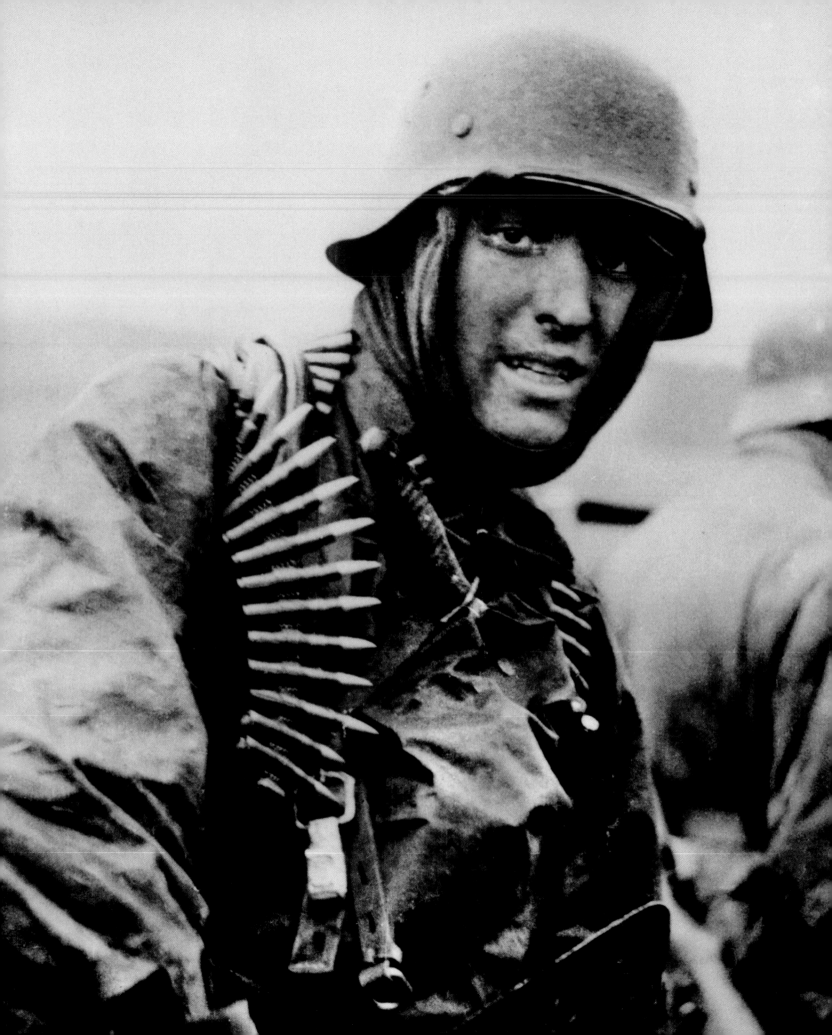

In fierce fighting that October, men of the U.S. First Infantry Division, heavily engaged in North Africa, Sicily, and Normandy over the past two years, enhanced the reputation of the Big Red One by penetrating the West Wall and blasting their way into the historic German border city of Aachen. Hitler was so attached to Aachen—the medieval capital of Emperor Charlemagne, touted by Nazis as founder of the first German Reich—that he instructed the commander there to hold out to the last man and, if necessary, "allow himself to be buried under its ruins." That officer ultimately surrendered, but not before Aachen was reduced to rubble. "The city is as dead as a Roman ruin," wrote one witness who walked through streets strewn with corpses, "but unlike a ruin it lacks the grace of gradual decay." Such gains were costly for Americans who would soon bear the brunt of Hitler's counterattack. Hardest hit were those fighting in the dismal Hurtgen Forest south of Aachen, where soldiers who eluded shots fired by entrenched Germans risked being impaled when trees struck by shells shattered explosively. One in every four Americans in action there was killed, captured, wounded, or hospitalized with "combat fatigue," a deceptively tranquil term for a condition that caused some men to go "berserk, screaming and yelling," as one sergeant put it. Soldiers of the 28th Infantry, who had marched in triumph through Paris a few months earlier, took such a beating in the Hurtgen Forest that the division was pulled out in November and sent to rest and refit in a quiet sector of the front where no trouble was expected—the Ardennes.

A few hours before dawn on December 16, U.S. troops holding an 80-mile-long line in the snow-covered Ardennes came under intense bombardment. "All hell broke loose with artillery shells landing all over," recalled Sgt. Ben Nawrocki of the 99th Infantry Division, who occupied a dugout with his platoon at the northern end of the line. "We could not stick our heads up. Trees and branches fell all over, and shrapnel whined around." When the bombardment ceased, German infantry attacked, guided by searchlights that allowed some men to find gaps in the American line but made others easy targets: "We kept mowing them down," Nawrocki said. "In many places, the Germans piled up on top of one another like cordwood."

Those attackers were hastily trained Volksgrenadiers (People's Infantry), including boys in their teens, men in their 50s, and transfers from the navy, air force, or noncombat duty who knew little about soldiering. Rushing forward recklessly, they suffered heavy casualties, but the sheer weight of their assaults wore down the outnumbered Americans, many of whom were new to combat or battle-weary veterans like those in the 28th Infantry Division who held the center of the line. As the day wore on, seasoned panzer divisions equipped with giant Tiger tanks moved in to exploit breakthroughs by the Volksgrenadiers. By December 17, panzers had pushed the 28th back five miles to the town of Clervaux, Luxembourg, where Col. Hurley Fuller's 110th Regiment was badly in need of help. "We've got twelve Tigers sitting on the high ground east of town, looking down our throats," radioed Fuller, whose corps commander, Maj. Gen. Troy Middleton, had issued a stand-fast order to prevent retreat from turning into a rout. "Sorry, Fuller, one battery is all I can give you," he was told. "Remember your orders. Hold at all costs. No retreat." Fuller and his troops—a few hundred men, including cooks and clerks armed for combat—were badly mauled by the oncoming Tigers but held out until the following day, when he and

"It was a case of every dog for himself. It wasn't orderly; it wasn't military; it wasn't a pretty sight. We were seeing American soldiers running away."

Maj. Donald Boyer, Seventh Armored Division, Battle of the Bulge

Hitler's Own An SS photographer snapped this picture of a well-equipped machine-gunner of the First SS-Panzer "Leibstandarte Adolf Hitler" Division, on the road near Poteau, Belgium, on December 18, 1944, the third day of the Battle of the Bulge. The death's-head cap device above, worn by all members of the SS, symbolized "loyalty unto death" to the Führer.

other survivors were captured. Heroic resistance by his regiment, which suffered casualties of over 80 percent, helped slow the enemy advance toward the city of Bastogne, where roads the Germans relied on converged. Without taking Bastogne or St.-Vith—another vital crossroads to the north—they would be hard-pressed to break out of the Ardennes.

Although many American troops fought hard and withdrew grudgingly before the enemy onslaught, some panicked and fell back in disarray. "It was a case of every dog for himself," remarked Maj. Donald Boyer of the U.S. Seventh Armored Division, whose tanks pushed forward through a chaotic mass of retreating Yanks to defend St.-Vith. "It wasn't orderly; it wasn't military; it wasn't a pretty sight," he added. "We were seeing American soldiers running away." Adding to the confusion and alarm were treacherous acts by Germans who had orders from Hitler to terrorize their foes. Lt. Col. Otto Skorzeny, leader of the daring raid that rescued Mussolini from prison in 1943, sent German commandos disguised as American soldiers to commit sabotage and sow panic behind Allied lines.

Worse deeds were committed by troops of the Waffen SS (the military wing of the brutal Nazi Schutzstaffel) who massacred American prisoners of war and Belgian civilians. The worst incident occurred on December 17 near the town of Malmédy, where more than 80 American POWs were slaughtered. Sgt. Kenneth Ahrens lay wounded there among the dead as SS troops fulfilled their grim task: "Each time they would hear somebody moan, they would shoot him . . . Every once in a while a tank or a half-track would roll by and turn their guns on us, just for a good time." Ahrens and others who feigned death got away and spread word of the massacre, which enraged U.S. troops and incited some to show no mercy to Germans who tried to surrender. "If they wore the black uniforms of the SS, they were shot," remarked one American soldier, who was seemingly unaware that black uniforms were worn by men in armored units of both the Waffen SS and the regular German Army.

Fighting the Elements Wearing waterproof boots called "shoepacs" to guard against trench foot, Sgt. Tommy Lyons (above) leans exhausted on a snowbank after a week on the front lines during the Battle of the Bulge. A less fortunate German soldier (right) lies frozen in a snowy field near Nefte, Belgium— one of more than 15,000 Germans killed during the Ardennes offensive.

On December 19, Eisenhower met with top Allied commanders. "The present situation is to be regarded as one of opportunity for us and not disaster," he insisted. Since September, they had been assaulting fortified German troops along the West Wall with little success. Now their foes were out in the open, where they would be highly vulnerable to attack when their advance faltered. "Hell," Patton burst out, "let's have the guts to let the sons of bitches go all the way to Paris. Then we'll really cut 'em off and chew 'em up." Ike would not allow the Germans anywhere near Paris and planned to stop them short of the Meuse River in Belgium. But he did give Patton the opportunity to cut them off at Bastogne, which lay at the heart of this bitter struggle—known as the Battle of the Bulge for the salient formed by the Germans as they dug deep into Allied territory.

Although bad weather prevented Eisenhower from launching air strikes against German forces bearing down on Bastogne or landing paratroopers there, he rushed 11,000 men of the 101st Airborne Division in by truck to hold that crossroads as a fortress with troops of the Tenth Armored Division until relieved. By December 21, they were surrounded by the enemy. Patton hurried armor north to break that siege, but his tanks were several days away. On the 22nd, German officers carrying a white flag delivered an ultimatum to Brig. Gen. Anthony McAuliffe of the 101st, demanding that he surrender Bastogne "to save the encircled troops from total annihilation." McAuliffe's one-word reply, delivered by Col. Joseph Harper, summed up the defiant spirit of embattled Americans: "Nuts!" "If you don't understand what 'Nuts' means," Harper told the Germans, "it is the same as 'Go to hell.' "

Desperate fighting ensued, culminating on Christmas morning in a predawn attack by German tanks, which crushed troops under their tracks and reached the outskirts of Bastogne before being blasted by antitank battalions laying in wait for them with artillery and bazookas. Although the weather remained frigid, the skies cleared, allowing supplies to be airlifted to the besieged city and dropped by parachute. When one of the C-47 transports was shot down, Schuyler Jackson of the 101st recalled, "I took a fleece-lined jacket from the body of one of the crew. It sounds terrible, but he had no more use for it. There was a bridge in front of us. We had planted explosives, but the detonator froze when they hit us on Christmas Day. Their infantry rode on the tanks and we were picking them off. I got myself a bazooka and hit one in the motor. The crew came out fighting. They did not surrender. We had to shoot them." Dead soldiers from both sides "lay frozen stiff where they had fallen," remarked another soldier defending Bastogne. "Burial details had problems putting them on stretchers . . . But in spite of the shells from the Germans, we managed to guide in enough supplies to fight off the enemy. It was great Christmas present delivered by air."

On December 26, Patton's Fourth Armored Division approached Bastogne. Heavy fighting the day before had cost the Fourth nearly a dozen tanks. But Lt. Col. Creighton Abrams—who would one day become chief of the U.S. Army—radioed headquarters and asked if Patton would authorize a risky end run into Bastogne around a German strong point south of town. "I sure as hell will!" Patton replied. Led by Lt. Charles Boggess in a Sherman M4A3 Jumbo tank nicknamed *Cobra King*,

PFC. JAMES MORRIS
FROZEN FEET AND SHELL SHOCK

Private Morris joined the 87th Infantry Division in 1944 and saw his first combat in grueling conditions when his division attacked the southern flank of the Bulge in late December.

Well, the ground was froze and there was snow on the ground in drifts sometimes knee deep. And the forest with all the roots in the ground . . . all you had to dig a hole with was this little G.I. shovel they issued you. There wasn't no way you could dig a hole so we had to just lay in the snow, in the road ditch, behind trees. The best coverage we could find was probably in this road ditch and we pinned down there for three days in that cold. And there was some of our men, I know of at least three, their feet froze and swelled in their boots to where they couldn't get their boots off. And others, their hands would get so cold you couldn't hardly work your rifle. I remember shaking so much from the cold that my chest was so sore I couldn't hardly touch it. And I might mention too that after we left there and went on into the Rhineland there were men that had been in battle there for—on that Rhine River—that had been shelled so much, even though they were coming back to the hospital to be treated, they were like wild men. They just looked wild out of their eyes. Their nerves were so bad they couldn't sleep. They said that they jumped out of bed at night just in a dream of what they'd been through. They were so nervous they couldn't sleep. I didn't get to that point but I have woke up during the night dreaming and have to get up and walk around to get over it. ■

"There was something ominous about the evening in the country. It echoed of faint screams and the crash of shell fire."

ONE VETERAN'S RECURRING ANXIETY AFTER THE BATTLE OF THE BULGE

the assault force left the main highway and dashed into Bastogne on a side road. "We were going through fast, all guns firing," Boggess recollected, "straight up that road to bust through before they had time to get set." At day's end, they lifted the siege by linking up with McAuliffe, whose refusal to yield Bastogne had been backed up triumphantly by his troops.

Some panzers skirted Bastogne and advanced to within a few miles of the Meuse River, where the U.S. Second Armored Division stopped them in their tracks in late December. Hitler's offensive was now literally running out of gas. Unlike the Americans, who airlifted fuel to Belgium to keep their tanks running, the Germans depended on capturing Allied fuel depots, most of which remained beyond their grasp. At the northern end of the bulge, they seized St.-Vith after a lengthy struggle but failed to reach Liège, a big Allied supply base on the west bank of the Meuse. As their tanks ran dry, they lost the protection of cloud cover and came under attack by warplanes. On New Year's Day, 1945, Hitler sent most of what remained of his Luftwaffe to target enemy air bases. That so-called Great Blow did significant damage to the Allies but greater harm to the Germans, who lost three hundred planes and were left without air support as the tide turned against their ground forces. In mid-January, Patton's armor drove north from Bastogne toward St.-Vith, forcing Germans to pull back toward their border to avoid being trapped. At month's end, Allied troops finally closed off the bulge and won the battle. For American forces, who did most of the fighting and suffered a staggering 80,000 casualties, it was a harrowing ordeal that would haunt veterans for years to come. One soldier who returned home to Maine afterward could not stand being in the woods there after dark. "There was something ominous about the evening in the country," he wrote. "It echoed of faint screams and the crash of shell fire."

The toll of battle would have been much worse without the merciful efforts of doctors, nurses, and medics who tended to the wounded and kept the vast majority of them alive. Most Americans who died in action during the war were killed instantly or perished before medical help reached them. Of those wounded who received treatment, just 4 percent died—half the death rate of World War I. Miracle drugs such as penicillin saved numerous victims, but their survival on the battlefield depended largely on medics who risked their own lives to deliver first aid and evacuate them to field hospitals. Nearly 2,000 medics were killed in the line of duty in Europe during the war. Doctors and nurses at field hospitals were at less risk, but some worked perilously close to the front lines at makeshift surgical wards. Dr. Henry Hills of the U.S. Medical Corps volunteered to parachute into besieged Bastogne in December 1944 but ended up landing there in a

German Buzz Saw The MG 42, shown here on a tripod mount, was the German Army's standard general-purpose machine gun. Robust and relatively inexpensive to manufacture, it fired a formidable 1,200 rounds per minute.

glider. He operated without a gown or mask in a dimly lit garage filled with eight hundred wounded men, many of them suffering from gangrene and requiring amputations. One officer objected that he was removing limbs "right and left" and questioned whether all those operations were necessary. "So I picked up a limb and handed it to him," Hills related. "He just about passed out. He never said another word."

U.S. Army nurse Mary Breeding worked at a French hospital that was overwhelmed with wounded during the Battle of the Bulge. Patients requiring extended treatment were transferred overseas. Those who remained under her care were given little respite once they recovered. "Much to my sorrow," she said, they were sent "back to duty." As the war drew to a close, most of her patients were wounded German POWs. They were in "terrible shape," she observed. "Severed cords, paralysis . . . Our boys did a number on them to be sure. We cared for them not as prisoners, but as we would take care of our own in hopes that their side was doing the same for our personnel." Those grateful POWs honored her daily in proper military fashion: "When I entered the ward every morning, I would hear this loud command in German, 'Achtung!' " All the patients would stand or sit upright at attention until she gave them the order "at ease" in German. "What a shock it was for me at first," she said, "not being used to this type of respect."

Perilous Passage Ducking to avoid enemy fire, men of the U.S. 89th Infantry Division cross the Rhine River in an assault boat near Oberwesel, Germany, on March 26, 1945. The Allied victory in the Battle of the Bulge set the stage for the crossing of the Rhine—the largest amphibious and airborne operation mounted since D-Day.

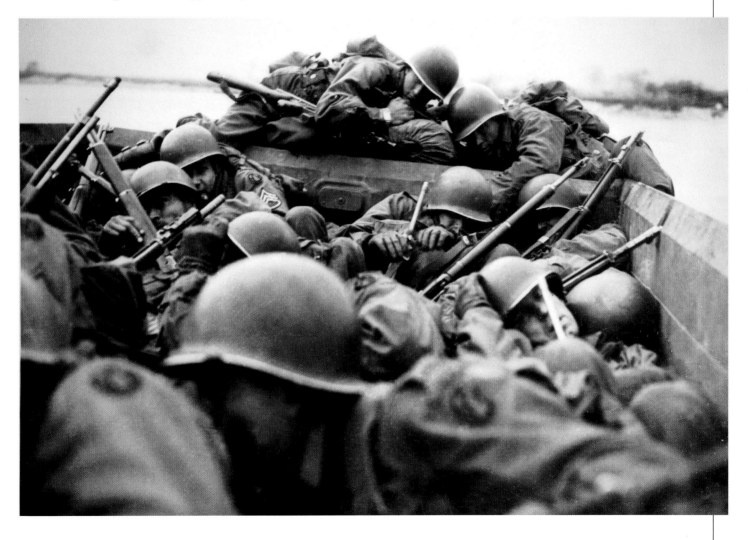

DIVIDED AND CONQUERED

Fleeing the Soviets **Frightened German civilians**, fearing reprisals by Russian troops advancing from the east, carefully make their way westward across the Elbe River on a damaged railroad bridge at Tangermünde, Germany, shortly before the war's end.

The Battle of the Bulge proved doubly disastrous for Germany. On the Western Front, Hitler's gamble succeeded only in delaying the Allied invasion for a few months while depleting German forces along the border and depriving them of reinforcements. On the Eastern Front, Russian troops exploited Hitler's decision to risk nearly all his reserves on a breakthrough in Belgium by sweeping across Poland in January 1945 and invading East Prussia, the first German state to suffer the terrors of Soviet occupation. After entering Germany, one Russian soldier wrote home: "We are proud to have made it to the beast's lair. We will take revenge, revenge for all our sufferings." Unarmed parties of German civilians fleeing westward were overtaken by the Red Army and attacked. Many women and girls were raped by Soviet troops, who continued those assaults as they advanced toward Berlin. In the town of Potsdam, near Berlin, young Ingrid Schuler was spared because her parents hid her from soldiers, but a baker and his wife who lived on her street were less fortunate. "The Russians had gone into their house intending to rape the baker's wife," she related. "Her husband, who happened to be at home, stood in front of her and tried to protect her." He was shot dead by the intruders, who then raped his defenseless wife. Some Russian officers tried to prevent such atrocities, but others looked the other way or took part in the mayhem.

The territorial gains made by the Red Army as the Western Allies were beating back Hitler's counterattack in the Ardennes had a profound impact on the Yalta Conference—the last meeting between Stalin, Churchill, and Roosevelt, who was in poor

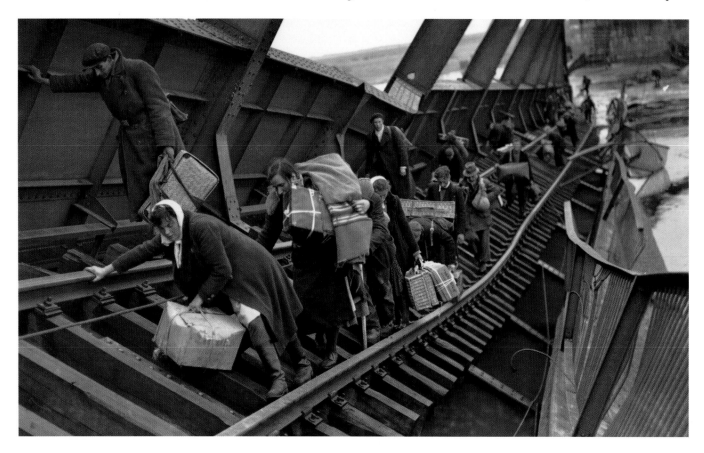

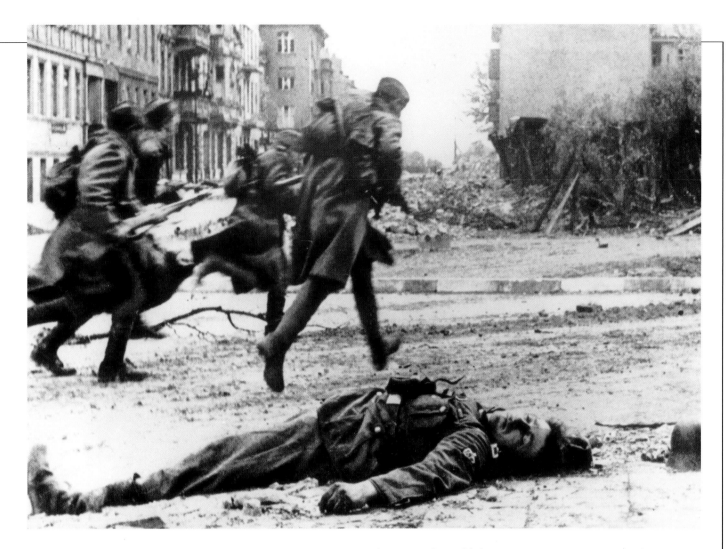

Final Push Russian infantrymen rush past the body of a fallen German soldier during the battle for Berlin, which began in mid-April 1945.

health when the Big Three convened at that Crimean city in February and would die two months later. The major Allied powers had already agreed in principle to divide conquered Germany into occupation zones. The Soviets would occupy eastern Germany and the eastern sector of Berlin, located within their zone. The Western Allies would occupy western Germany and western Berlin. What remained to be determined was the political status of countries occupied by the Red Army—notably Poland. The U.S., Britain, and France supported the Polish government-in-exile in London, which had launched an ill-fated uprising in Warsaw in 1944 while the Germans still held Poland. Stalin had withheld support from that uprising and waited until it was brutally crushed by the Nazis to invade that country and install Polish collaborators loyal to Moscow as the country's new rulers. "We drew the sword for Poland against Hitler's brutal attack," Churchill said. "Never could I be content with any solution that would not leave Poland as a free and independent state."

In the end, however, Churchill and Roosevelt settled for Stalin's empty promise that Poland would be "free, independent, and powerful." His pledge to allow democratic elections would not be fulfilled in Poland or in other Eastern European countries that were occupied by the Red Army and became Soviet satellites. Privately, Churchill may have suspected what the British diplomat Hugh Lunghi, who served in Moscow, already knew—that "there was not a chance in hell that Stalin would allow free elections in those

Comrades in Arms An exuberant Russian soldier greets an American GI with a bear hug to celebrate the meeting of Allied and Soviet forces along the Elbe River in April 1945.

Führerbunker Hitler spent his last days in this bunker beneath the Reich Chancellery in Berlin. After capturing the city, Russian troops ransacked the bunker searching for the remains of Hitler, whose body was burned by aides after he committed suicide on April 30, 1945.

countries when he didn't allow them in the Soviet Union." But Churchill and Roosevelt had little leverage at Yalta when Stalin's forces were within 50 miles of Berlin and their own troops were struggling to get beyond the West Wall. As U.S. diplomat James Byrnes put it: "It was not a question of what we would *let* the Russians do, but what we could *get* the Russians to do."

The big push into Germany by Eisenhower's forces began on February 8, while the Yalta Conference was under way. German engineers slowed the advance by opening dams on the Roer River and flooding large areas along the border. Punishing air raids by the British and Americans—who blasted Berlin and firebombed Dresden in February, killing tens of thousands of civilians—stiffened the resolve of German troops defending their western frontier. Yet they were now heavily outnumbered and outgunned, for Hitler had recently shifted most of his panzer divisions eastward to meet the dire Soviet threat. By early March, Allied troops had shattered the West Wall and reached the Rhine River, the last big natural barrier on their path to victory. Most of the bridges across that river were blown by retreating Germans, but one was captured intact at Remagen by troops of the First Army, whose commander Hodges reported that coup to his boss, Bradley, at Twelfth Army Group headquarters. "Hot dog, Courtney, this will bust 'em wide open," Bradley replied. "Shove everything you can across!" The bridge at Remagen, weakened by German attacks, lasted only ten more days before it collapsed. There and elsewhere along the Rhine, however, Allied engineers hastily built new spans to carry troops, tanks, and artillery into the heart of Hitler's doomed Reich.

Eisenhower likened the crossing of the Rhine to the invasion of Normandy and launched a massive airborne assault in late March that landed more than 20,000 troops on the far side of that river. One Allied pilot noted that German prisoners seized in that operation appeared resigned to their fate: "A short time before, when they had their weapons, they fought like hell trying to kill you. Now with no weapons they were as docile as cows and seemed to sense that they had lost the war."

By early April, Eisenhower's overwhelming forces had pushed all the way eastward to the Elbe River, within 60 miles of Berlin. Soviet troops were preparing to advance on that city, but nothing in the Yalta accord or other Allied pacts prohibited Eisenhower from crossing the Elbe and entering Berlin before the Russians got there. His reluctance to do so was based partly on his desire to eliminate pockets of German resistance in western Germany. He also knew that the political fate of eastern Germany had already been decided at high levels and that sending American and British troops to smash their way into Berlin would not alter that outcome. Bradley estimated the cost of seizing the capital at 100,000 casualties and called that "a pretty steep price to pay for a prestige objective . . . especially when we've got to fall back and let the other fellow take over." Churchill, now deeply concerned by Soviet advances and fearful that Stalin would renege on his promises, urged Ike to try for Berlin. "I deem it highly important that we should shake hands with the Russians as far east as possible," Churchill wrote.

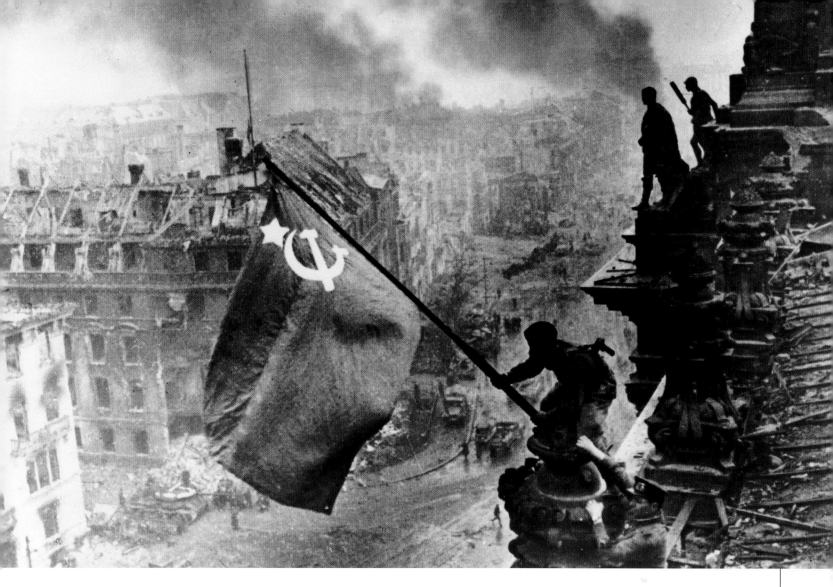

The question of whether Eisenhower should cross the Elbe and target Berlin became moot when the Soviets launched a massive offensive against that city on April 16. The battle for Berlin provided a brutal climax to a war that devastated Europe and left the continent in crisis for decades to come. The cost of seizing the capital was three times higher than Bradley estimated, and those Soviet casualties were matched by steep losses among the city's defenders, who included women and children. "They should be placed in the second line," advised Nazi propaganda minister Joseph Goebbels, "then the men in the front will lose all desire to withdraw." Goebbels remained with the Führer in his Berlin bunker to the bitter end and shared his fate. On April 30, Hitler committed suicide rather than face capture and punishment for his crimes—the worst of which were now fully exposed as Allied troops liberated the survivors of Nazi concentration camps and death camps. Soon Soviets troops raised their red flag over the ruins of Berlin.

On May 7, Hitler's successor, Adm. Karl Dönitz, surrendered unconditionally to the Allies. For many people on both sides of the Atlantic, V-E Day—celebrated on May 8—was a joyous occasion, but the mood at Allied headquarters was subdued. Eisenhower found it hard to savor victory in this great struggle, which he considered necessary and just but also found abhorrent. As he said afterward: "I hate war as only a soldier who has lived it can, only as one who has seen its brutality, its futility, its stupidity."

Red Triumph A Russian soldier waves the red flag of the victorious Soviets over fallen Berlin in a picture taken by photographer Yevgeny Khaldei, who re-created this flag-raising at the Reichstag on May 2, 1945, one day after that parliament building was seized.

"I hate war as only a soldier who has lived it can, only as one who has seen its brutality, its futility, its stupidity."

GEN. DWIGHT D. EISENHOWER, JANUARY 1946

As Allied forces advanced into Germany in 1945, they encountered appalling evidence of the evil that lay at the heart of Hitler's Reich. Horrified GIs liberated the emaciated survivors of concentration camps, most of them Jews seized throughout Nazi-ruled Europe and conveyed to those killing grounds in freight cars like cattle. Some survivors were so "weak and listless," said one soldier, "that they were difficult to distinguish from the dead which lay everywhere." The Allies uncovered a vast system of forced labor and mass murder, designed to enslave and ultimately eradicate all Jews under German authority and others who had no place in Hitler's malevolent New Order. ✭ The Holocaust (a word of Greek origin meaning "consumed by fire") was kindled in Nazi Germany—where concentration camps were established soon after Hitler took power in 1933—and reached full blaze when German troops invaded the Soviet Union in 1941. The gruesome slaughter of Jews by firing squads in Russia led to a more efficient and systematic program of genocide known as the Final Solution, which used gas chambers to achieve Hitler's publicly stated goal—the "extermination of the Jewish race in Europe." By war's end, six million of Europe's nine million Jews had been killed, along with hundreds of thousands of Roma (Gypsies), Slavs, Communists, mental patients, and others whom Nazis considered unfit to live. Including victims who died of mistreatment as forced laborers or POWs, Hitler's murderous regime claimed well over ten million lives. ∎

Holocaust:

THE SYSTEMATIC EXTERMINATION OF MILLIONS

Solemn Survivors Pictured in the spring of 1945 after Allied troops entered Buchenwald concentration camp, inmates there stare bleakly through barbed wire, haunted by their harrowing ordeal under the Nazis. Jews under German authority were forced to wear a Star of David emblem such as the one at left, issued to Dr. Henryk Fenigstein in the Warsaw ghetto.

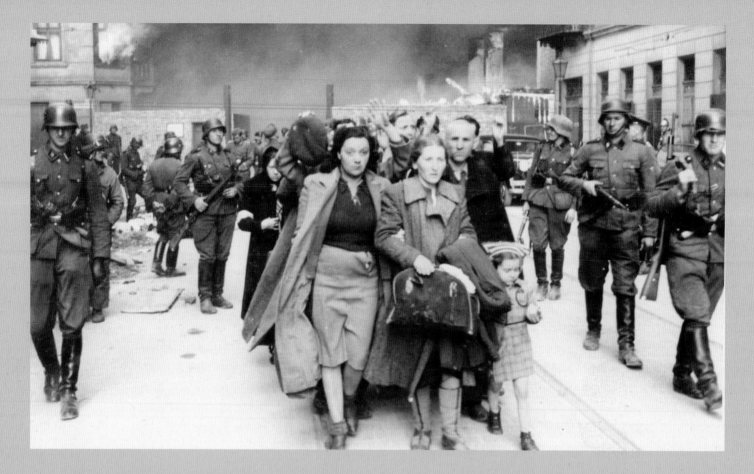

Nazi Terror

The conquest of Poland in September 1939 left millions of Jews and Slavs at the mercy of Nazi authorities, who terrorized the country. Thousands of Polish leaders were rounded up and shot to death, including government officials, teachers, and priests. Hundreds of thousands of Slavs were driven from their homes to make room for German settlers. Many of those evicted were forced to labor for the Reich, and some were sent to concentration camps. Polish Jews were uprooted and crowded into dismal ghettos in Warsaw (pictured above) and other cities, where they were subjected by taskmasters to a policy of "destruction through work" and died by the thousands of mistreatment, malnutrition, and disease. Hans Frank, the Nazi governor of Poland, remarked, "I ask nothing of the Jews except that they should disappear."

Ultimate responsibility for the Holocaust lay with Hitler and SS chief Heinrich Himmler, who left the task of implementing mass murder to his eager chief deputy, Reinhard Heydrich. Shortly

Agent of Death **Heinrich Himmler led the SS, the agency largely responsible for the Holocaust.**

before the invasion of the Soviet Union in June 1941, Heydrich formed SS Einsatzgruppen ("action groups") to execute Jews, Communists, and other presumed enemies of the Reich in occupied Russia as German troops advanced. German police were recruited to assist the SS in detaining, shooting, and disposing of thousands of victims at a time. Local civilians motivated by anti-Semitism or anticommunism also took part in those massacres.

Ukrainian collaborators helped German executioners round up more than 30,000 Jews living in and around Kiev, who were shot to death in a ravine called Babi Yar in late September 1941. "The corpses were literally in layers," one witness reported. "A police marksman came along and shot each Jew in the neck with a submachine gun." Hitler knew of such massacres and hoped that they would frighten and demoralize his Soviet foes. As he said to Himmler and Heydrich in October 1941: "It is good if our advance is preceded by fear that we will exterminate Jewry." ∎

Assaulted and Annihilated At right, a woman comforts a young Jewish rape victim in the Ukrainian city of Lvov after SS officers incited atrocities against Jews there by anti-Semitic residents. Below, a German police official executes the wounded during a massacre of Jews from the Mizocz ghetto in Ukraine on October 14, 1942. An uprising by Jews in the Warsaw ghetto in 1943 was crushed by German forces, who deported the occupants to death camps. Avraham Neyer—shown opposite in a dark coat being led away from the burning ghetto with female relatives—was the only member of his family to survive.

The Final Solution

On January 20, 1942, Reinhard Heydrich met with senior German officials at the Berlin suburb of Wannsee to lay out the Final Solution, as approved by Hitler, and implement the plan, which called for all Jews in German-controlled territory to be eliminated. Those fit for labor would serve as slaves until they collapsed and died or were put to death, ensuring that none would survive to "constitute the germinal cell for the re-creation of Jewry." Others, particularly women, children, and the infirm and elderly, would be promptly exterminated.

The Final Solution required a new kind of concentration camp—known as a death camp, or killing center—and a new method of extermination. At Auschwitz in Poland, three camps were in operation by 1942, one of which (Auschwitz-Birkenau) served as a killing center. Many prisoners were sent there soon after they arrived, told to remove their clothes for a shower, and put to death in one of four gas chambers, where as many as 6,000 people were killed each day using Zyklon-B tablets, which released an odorless gas containing cyanide. "We had two SS doctors on duty at Auschwitz to examine the incoming transports of

Condemned **Three identity photos for 14-year-old Czeslawa Kwoka—a Polish Catholic who was sent to Auschwitz with her mother in 1942 and died within months—were taken by Wilhelm Brasse, a Polish political prisoner there, moments after she was beaten by a guard. "She was so young and so terrified," he said. Camp inmates wore striped jackets like that above, with their identity number attached.**

prisoners," stated Auschwitz commandant Rudolf Höss. As prisoners marched by, those doctors "would make spot decisions," he added. "Those who were fit for work were sent into the [labor] camp. Others were sent immediately to the extermination plants."

Prisoners sent to labor camps lived in unheated barracks swarming with vermin. Diseases, overwork, and starvation combined to kill many inmates or so weaken them that they were sent to the gas chambers. "We used to search for a potato peel and fight over it," one prisoner recalled. Inmates were beaten, tortured, and experimented upon by SS overseers, whose aim, one survivor said, was "to destroy our human dignity, to fill us with horror and contempt for ourselves and our fellows." ■

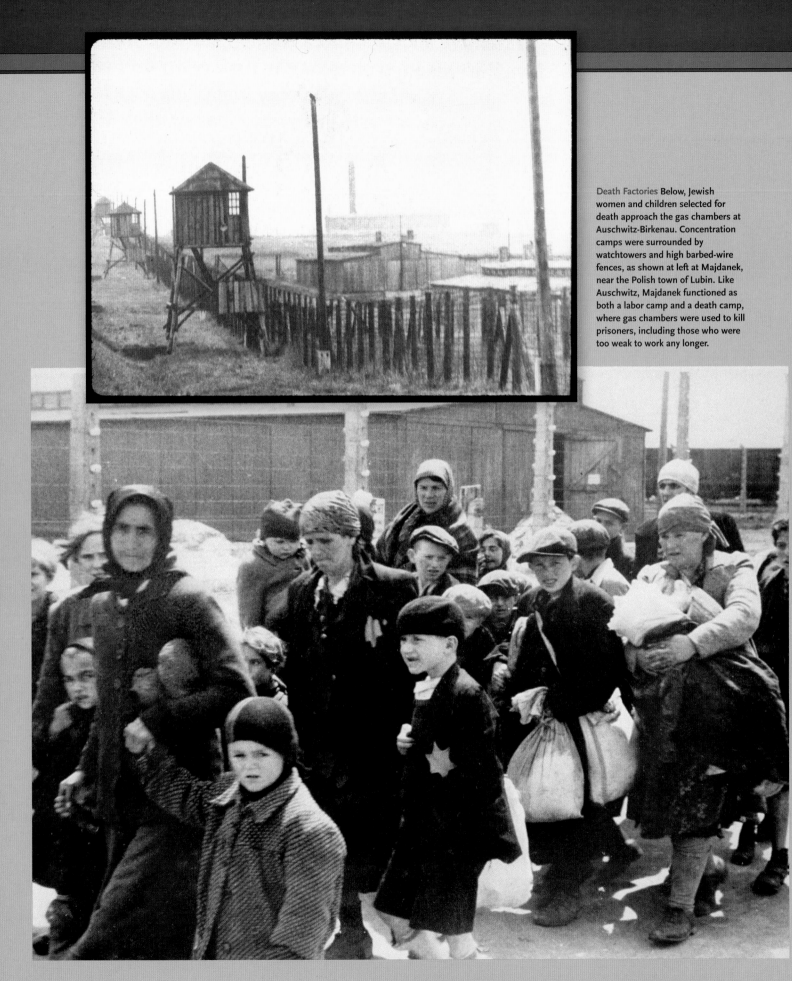

Death Factories Below, Jewish women and children selected for death approach the gas chambers at Auschwitz-Birkenau. Concentration camps were surrounded by watchtowers and high barbed-wire fences, as shown at left at Majdanek, near the Polish town of Lubin. Like Auschwitz, Majdanek functioned as both a labor camp and a death camp, where gas chambers were used to kill prisoners, including those who were too weak to work any longer.

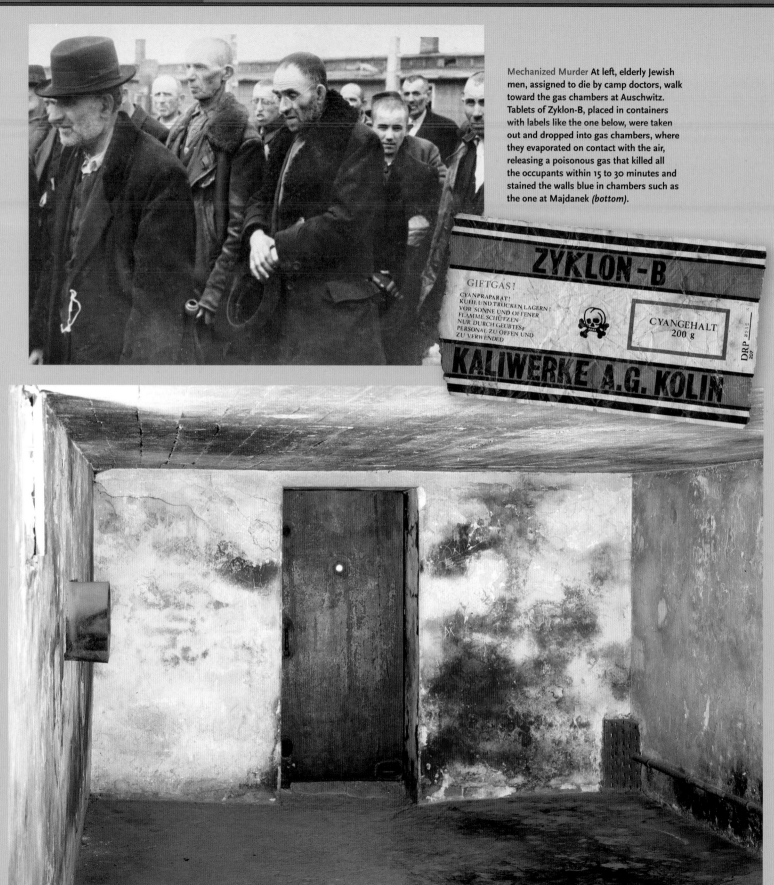

Mechanized Murder At left, elderly Jewish men, assigned to die by camp doctors, walk toward the gas chambers at Auschwitz. Tablets of Zyklon-B, placed in containers with labels like the one below, were taken out and dropped into gas chambers, where they evaporated on contact with the air, releasing a poisonous gas that killed all the occupants within 15 to 30 minutes and stained the walls blue in chambers such as the one at Majdanek *(bottom)*.

ZYKLON-B

GIFTGAS!
CYANPRAPARAT!
KÜHL UND TROCKEN LAGERN!
VOR SONNE UND OFFENER
FLAMME SCHÜTZEN
NUR DURCH GEÜBTES
PERSONAL ZU ÖFFEN UND
ZU VERWENDED

CYANGEHALT
200 g

KALIWERKE A.G. KOLIN

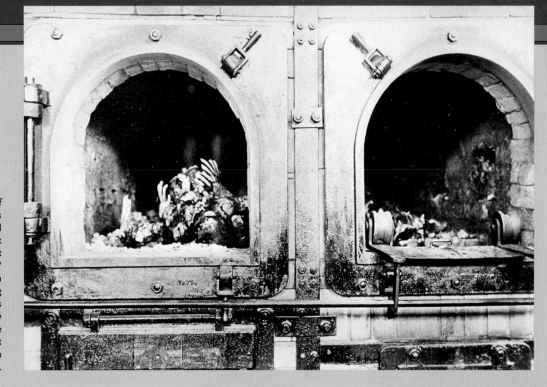

Last Exit At right, the skeletal remains of murdered camp inmates fill two ovens in the crematorium at Buchenwald in Germany. Inmates arriving at Auschwitz were told by guards that "the only exit is by way of the chimney," recalled survivor Primo Levi, who soon realized that the guards were referring to the crematorium. As Allied troops approached the camps in 1945, many dead inmates were left piled in those compounds like the victims below, at Dachau, the first concentration camp in Nazi Germany, established in 1933.

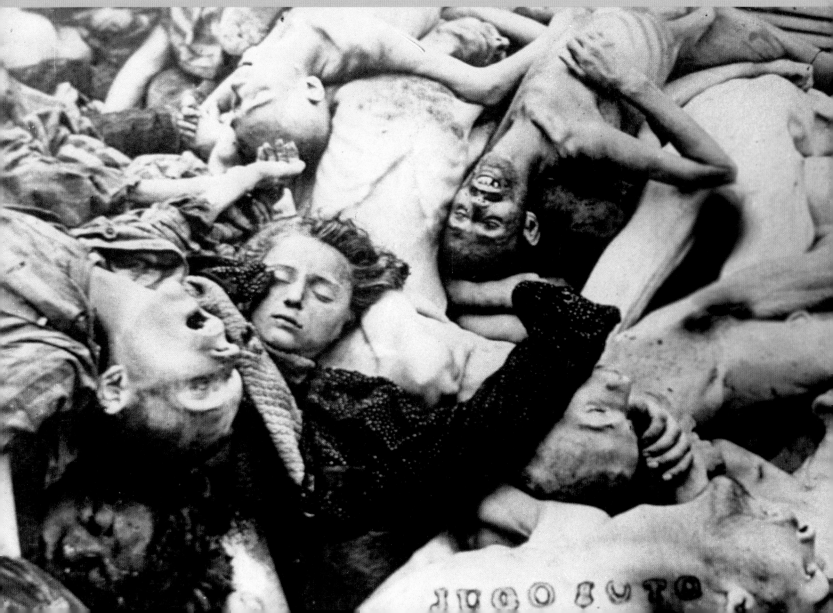

Liberation and Remembrance

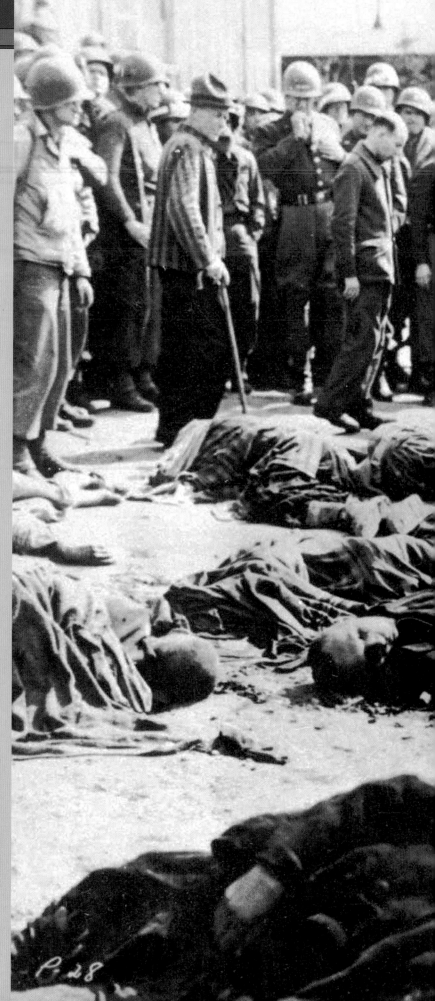

As Allied troops closed in on concentration camps, SS guards tried in vain to conceal evidence of mass murder by demolishing gas chambers and removing inmates. When Soviet troops advanced from the east and reached Auschwitz in January 1945, they found several thousand emaciated prisoners—left behind when most inmates were removed—and incriminating items taken from murdered victims, including huge piles of men's and women's garments and more than 14,000 pounds of human hair.

Allied forces who entered Germany from the west a few months later came upon massive evidence of genocide, including 10,000 unburied corpses at Bergen-Belsen, where prisoners evacuated from other camps recently had been held with little food or water. Another 13,000 people died there after the camp was liberated, despite the efforts of Allied doctors. Many survivors were scarred mentally as well as physically by their ordeal. As one doctor said: "It will take time for them to become human beings again." Soldiers who thought they had been through hell in battle confronted an even worse inferno, where innocent victims had been tortured and burned. After witnessing one camp, a U.S. Army chaplain wrote to his wife, "This was a hell on earth if there ever was one." ■

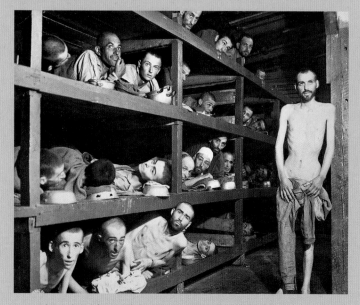

Lost and Saved At right, Eisenhower *(center)* views dead Holocaust victims at Ohrdruf, a satellite camp of Buchenwald, after its liberation in April 1945. Above, newly freed prisoners stare from their bunks at Buchenwald. Among the survivors here was author Elie Wiesel, who documented the Holocaust and won the Nobel Peace Prize.

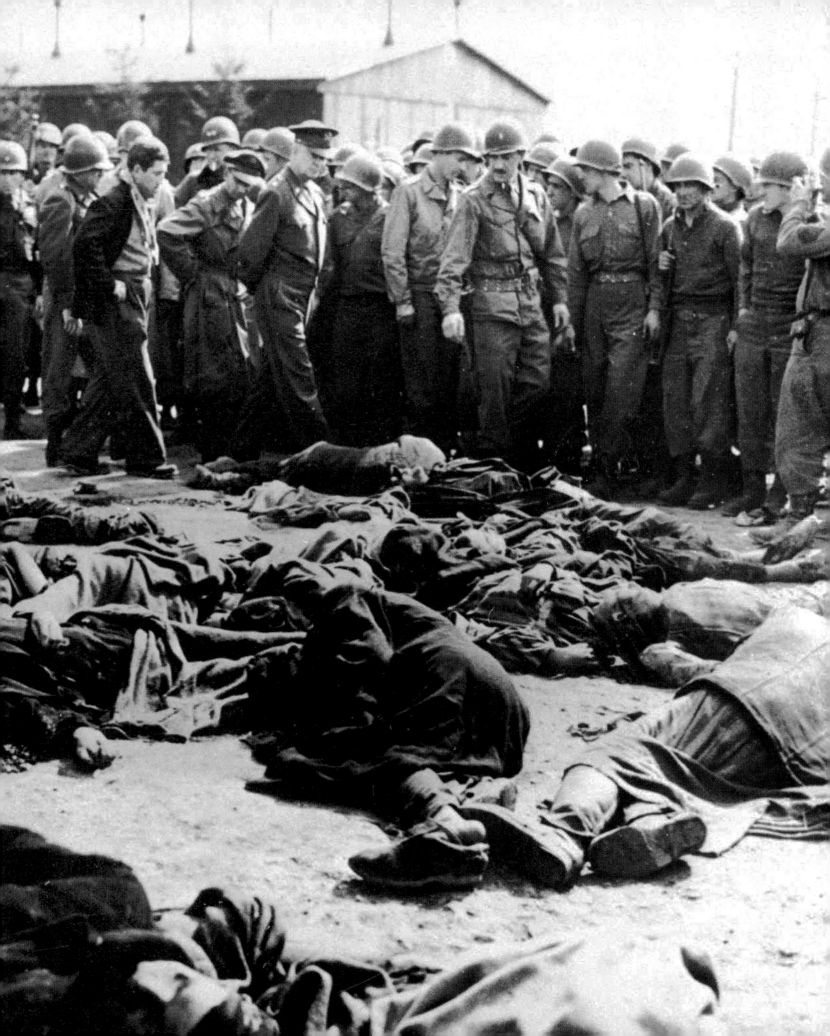

EJSZRSZKI 1933 R
BAR MICWA SOBOTA

A Close Community Destroyed
The photographs here, taken before World War II erupted, commemorate the close ties between family members and friends at gatherings such as bar mitzvahs *(upper left)* in the prosperous Jewish community of Eisiskes, Lithuania. On September 22, 1941, after German troops occupied the area, Lithuanian civilians and police collaborating with the SS drove Jewish residents from their homes and into the town's three synagogues, from which groups were then taken out and shot. Over three days, 3,446 men, women, and children were murdered, all but annihilating the Jewish community.

Relics of the Holocaust These personal possessions recall the lives of Holocaust victims and survivors. Some artifacts relate to Jewish religious life, such as the Kiddush cup at right, used in services, and the embroidered bag with the Star of David at upper right, which held a tefillin (or phylactery, containing prayers) and belonged to a concentration camp inmate who perished. Other items were cherished keepsakes like the accordion at bottom, owned by a Gypsy deportee, or the teddy bear beside it, named "Refugee," which belonged to Selma Schwarzwald, who found refuge in Poland during the war by assuming the identity of a Catholic.

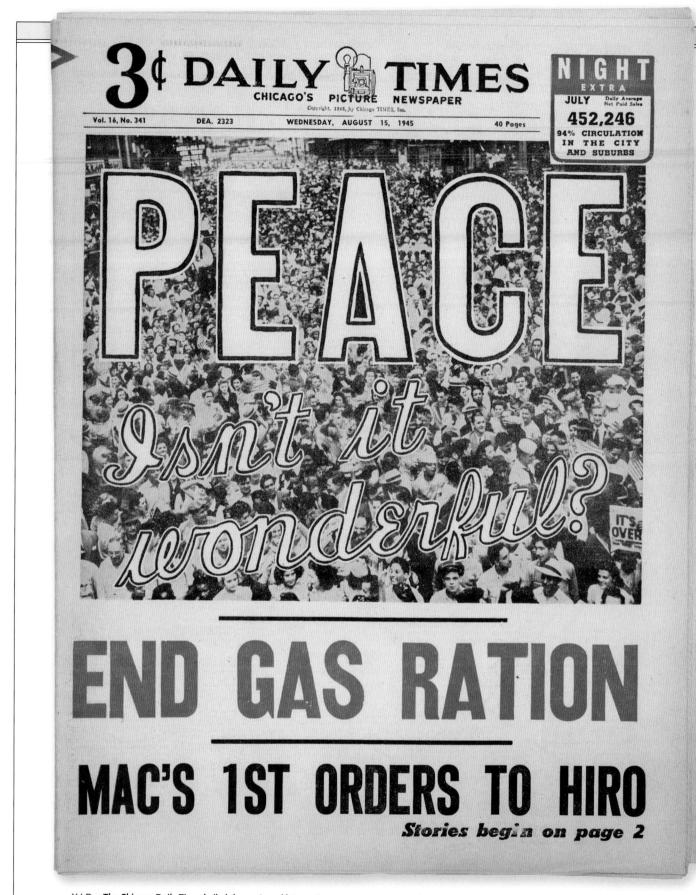

3¢ DAILY TIMES
CHICAGO'S PICTURE NEWSPAPER
Copyright, 1945, by Chicago TIMES, Inc.

Vol. 16, No. 341 DEA. 2323 WEDNESDAY, AUGUST 15, 1945 40 Pages

NIGHT EXTRA
JULY Daily Average Net Paid Sales
452,246
94% CIRCULATION IN THE CITY AND SUBURBS

PEACE

Isn't it wonderful?

IT'S OVER

END GAS RATION

MAC'S 1ST ORDERS TO HIRO

Stories begin on page 2

V-J Day The Chicago *Daily Times* hailed the war's end late on August 14, 1945, as gas rationing ceased and Hirohito came under MacArthur's authority.

O N OCTOBER 12, 1944, AS U.S. TROOPS COMMANDED BY GEN. DOUGLAS MACARTHUR PREPARED TO LAND on the island of Leyte and retake the Philippines, another event with potentially devastating consequences for Japan occurred on distant Saipan in the Marianas. Seized three months earlier at a cost of more than 16,000 American casualties, Saipan was now ready to receive the prize for which that island had been captured—the mighty B-29 bomber, whose exceptional range and capacity would enable it to reach Tokyo, some 1,500 miles from Saipan, and rain destruction on Japan's political and industrial core. Construction crews had been laboring mightily to complete the 8,500-foot-long runway required for takeoffs by fully loaded B-29s and were not quite finished with that task when the first of those Boeing Superfortresses arrived. Dubbed *Joltin' Josie,* it was piloted by Brig. Gen. Haywood Hansell, whose 21st Bomber Command would carry out repeated attacks on Tokyo and other Japanese cities. A boisterous crowd of servicemen gathered to greet Hansell and his gleaming aircraft, the largest, fastest, highest-flying bomber in America's arsenal. As they "surged across the coral rubble toward the new landing strip and the idling B-29," wrote one observer, a jubilant sergeant entranced by that imposing warplane shouted above the din of its four huge prop engines: "Look at 'er, look at 'er, look at 'er!" ✴ The B-29 was a potent symbol of America's military and industrial might, which had increased greatly since December 1941 when a nation still suffering the effects of the Great Depression and wary of foreign

Victory Over Japan:

FROM LEYTE GULF TO NAGASAKI

CHRONOLOGY

- **October 20, 1944** U.S. troops led by Gen. Douglas MacArthur land on Leyte in the Philippines.

- **October 24–25, 1944** Battle of Leyte Gulf

- **February 16, 1945** U.S. Marines land on Iwo Jima.

- **March 8–9, 1945** American B-29s launched from the Marianas firebomb Tokyo.

- **April 1, 1945** U.S. forces invade Okinawa.

- **August 6–9, 1945** Atomic bombs dropped by American airmen devastate Japanese cities of Hiroshima and Nagasaki.

- **August 14–15, 1945** World War II ends as Emperor Hirohito announces the surrender of Japan to the Allies on August 15 in Tokyo, prompting V-J Day celebrations on August 14 in the U.S.

entanglements was thrust reluctantly into a global conflict. Roused by that challenge, the United States was now capable of committing millions of troops to battle in both Europe and the Pacific while producing technological marvels on the home front like the Superfortress, a multibillion-dollar project that coincided with other defense programs requiring huge investments of capital, labor, and brain power.

When the B-29 entered service in 1944, few Americans were aware that it might eventually be used to deliver an awesome new superweapon—the atomic bomb, which was being developed in strict secrecy by some of the world's top scientists and a dedicated workforce of hundreds of thousands of people at various sites across the country. Military chiefs who were informed of that "Manhattan Project" had no way of knowing if it would succeed in providing them with a means to end the war. They proceeded on the assumption that Japan would have to be defeated by other methods, including conventional bombing raids launched from Saipan and other islands in the Marianas as well as costly amphibious assaults on Japanese troops holding occupied territory in the Pacific that shielded their home islands from invasion. Lt. Gen. Tadamishi Kuribayashi, commanding Japanese forces on Iwo Jima—located roughly midway between Saipan and Tokyo—vowed to defend that desolate island and its vital air base as he would his native ground. "Every man will resist until the end," he promised his superiors, "making his position his tomb."

How to overcome such fierce opposition and conquer Japan was a matter of intense debate among American commanders. Hansell and his boss, Lt. Gen. Henry "Hap" Arnold, chief of the U.S. Army Air Forces, believed that strategic bombing alone could win the war if enough B-29s were deployed against Japan and its air defenses were neutralized. They favored seizing Iwo Jima and its air base, which threatened their bombers. But they hoped to avoid further amphibious landings—which were sure to result in heavy casualties for

Triumphal Return This leaflet, produced by the U.S. Army's Southwest Pacific Area Psychological Warfare Branch, announced to Filipinos that General MacArthur had returned to the Philippines as promised in October 1944 along with that country's president, Sergio Osmeña.

American troops—by targeting Japanese cities and industries and forcing Emperor Hirohito to surrender or see his nation reduced to rubble. Adm. Chester Nimitz, in charge of all naval and ground operations in the Pacific except those in MacArthur's theater, proposed following up the assault on Iwo Jima with an invasion of Okinawa, situated near Japan's home islands and a potential staging ground from which to invade them.

MacArthur, for his part, saw no road to victory that did not run through the Philippines, having vowed to return there. During a meeting with President Roosevelt in mid-1944, he insisted that the U.S. had a moral obligation to free Filipinos from Japanese occupation and warned his commander in chief bluntly not to abandon them: "American public opinion will condemn you, Mr. President. And it would be justified." In targeting the Philippines, MacArthur and the admirals supporting him would bring only a portion of America's naval power to bear—but that would be enough to cope with the once mighty Japanese Imperial Navy, reduced now to desperate and often suicidal attacks.

Nations without America's vast resources had to make tough choices when considering how to defeat their foes. But the U.S. was capable of following various paths to victory and forcing the enemy to defend against multiple threats, as American troops did in Europe by continuing to fight in Italy while others landed in Normandy and southern France

and invaded Germany. In the Pacific, all options that might contribute to the downfall of imperial Japan were vigorously pursued, beginning with MacArthur's landing in the Philippines, continuing with a conventional strategic bombing campaign against Japan from the Marianas and amphibious assaults on Iwo Jima and Okinawa, and concluding with the use of devastating nuclear weapons against the cities of Hiroshima and Nagasaki.

That the U.S. could wage war successfully on various fronts in the Pacific while at the same time securing victory over Germany was something that few Japanese commanders anticipated when the fighting began—with the exception of shrewd observers like the late Adm. Isoroku Yamamoto who visited America before the war. Another officer who foresaw America's rise as a superpower was the ill-fated defender of Iwo Jima, General Kuribayashi, who toured the U.S. as a military attaché in the depths of the Depression, marveled at its resilience and resourcefulness during that crisis, and wrote prophetically in 1931: "The United States is the last country in the world Japan should fight."

"Every man will resist until the end, making his position his tomb."
LT. GEN. TADAMISHI KURIBAYASHI, JAPANESE COMMANDER ON IWO JIMA

Sinews of War During the landings on Leyte on October 20, 1944, soldiers form a human chain to lay sandbag ramps through the surf before unloading cargo from Coast Guard–manned LSTs, which carried tanks and other vehicles as well as troops and supplies.

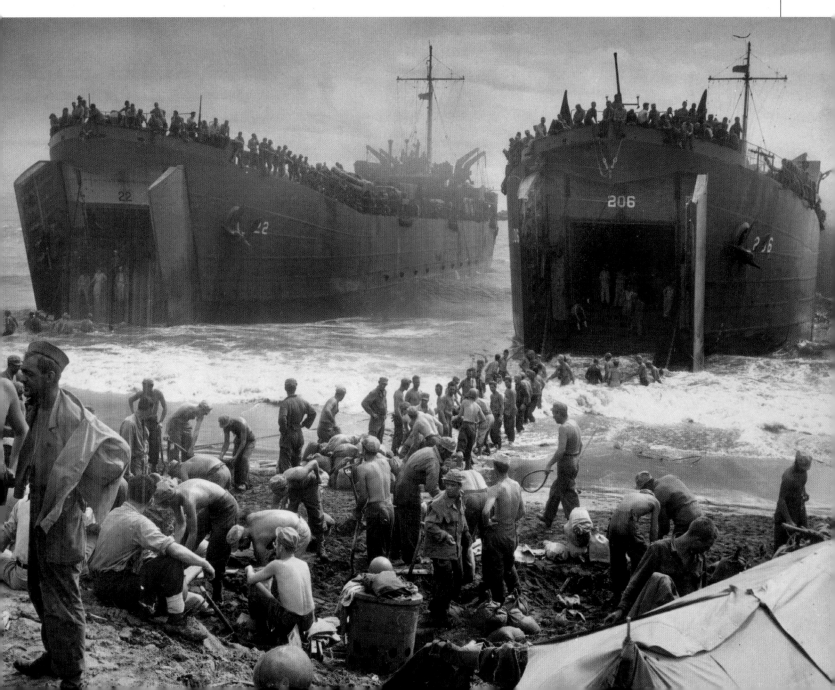

RETURN TO THE PHILIPPINES

On the morning of October 20, 1944, MacArthur's troops came ashore on Leyte, nestled between Mindanao, at the southern end of the Philippines, and the populous northern island of Luzon, MacArthur's ultimate objective. Japanese commanders had expected him to target Mindanao and had fewer troops on Leyte, most of whom withdrew into the island's rugged interior before the landings occurred. Facing little opposition on the beaches, MacArthur himself went ashore that same day. When his landing craft was prevented from coming all the way in to the crowded beach, he proceeded to wade in—a determined gesture that made a fine picture for cameramen on hand to record the event. Technicians of the U.S. Army Signal Corps set up a radio microphone on the beach to broadcast MacArthur's words to Filipinos, including thousands of guerrillas prepared to join American forces in ousting the Japanese. "People of the Philippines, I have returned," he proclaimed. "The hour of your redemption is here . . . Rally to me . . . As the lines of battle roll forward to bring you within the zone of operations, rise and strike."

By portraying this campaign as his personal crusade, MacArthur gave Filipinos a prominent figure to rally around. But the battle to reclaim the Philippines was in fact a massive undertaking by hundreds of thousands of troops and naval forces, some of whom were not under MacArthur's command. Nimitz sent the U.S. Navy's potent Third Fleet, commanded by Adm. Bull Halsey, to bolster Vice Adm. Thomas Kinkaid's less formidable Seventh Fleet, known as "MacArthur's Navy" because it was under the general's authority and covered his amphibious operations. Reporting to separate bosses, Halsey and Kinkaid did not communicate directly with each other. That nearly proved disastrous when Adm. Soemu Toyoda committed what remained of Japan's Combined Fleet to a crucial naval battle waged in and around Leyte Gulf, off the island's east coast, soon after MacArthur's forces came ashore there. Toyoda, whose objective was to cut off those troops and doom their invasion, was taking a huge gamble. But he and other Japanese naval commanders were determined to make a heroic last stand against the oncoming enemy. All they asked, stated one admiral, was the chance to risk everything for their homeland and emperor and "bloom as flowers of death."

Toyoda's plan of attack reflected what his subordinate, Vice Adm. Takeo Kurita, called the fleet's "suicide spirit." Kurita would approach Leyte from the west with a seemingly formidable task force, including the superbattleships *Yamato* and *Musashi,* encased in thick armor and equipped with monstrous guns that could strike targets more than 25 miles away. No battleship was invincible, however, when detected by aircraft carriers beyond the range of its guns and targeted by their warplanes. Halsey's fleet alone was far superior in air power to Toyoda's—so

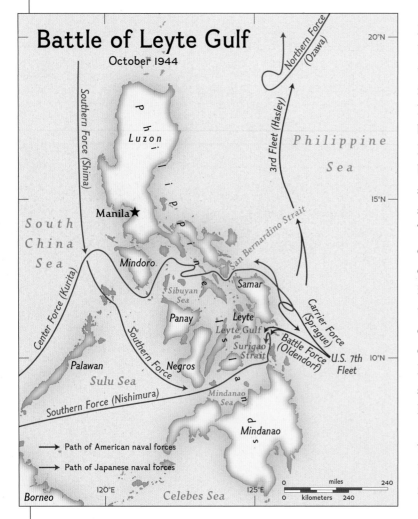

Battle of Leyte Gulf In October 1944, Adm. Soemu Toyoda divided the Japanese Combined Fleet into three forces, as shown on this map, and challenged the U.S. Third and Seventh Fleets, which were stationed in Leyte Gulf covering MacArthur's invasion of Leyte. Before the Center Force reached Leyte Gulf, it was attacked by U.S. submarines and carrier-launched warplanes of the Third Fleet on October 24. The Southern Force was battered that night by the Seventh Fleet in Surigao Strait and retreated. The Northern Force then lured the Third Fleet away from Leyte Gulf on October 25 and suffered heavy losses while the battered Center Force was repulsed by the Seventh Fleet off Samar Island, ending the Battle of Leyte Gulf, a crushing defeat for the Japanese Imperial Navy.

"I have been given a splendid opportunity to die... I shall fall like a blossom from a radiant cherry tree."

ISAO MATSUO, JAPANESE KAMIKAZE PILOT

much so that the Japanese commander decided to use his few remaining aircraft carriers as decoys, hoping to lure Halsey away from Leyte Gulf in pursuit of that Northern Force while Kurita's Center Force and a weaker Southern Force, commanded by Vice Adm. Shoji Nishimura, converged on Kinkaid's Seventh Fleet.

Even if Halsey took the bait and left Kinkaid exposed, Toyoda's fleet would require air support to have any chance of prevailing in battle. To that end, the Japanese prepared to launch warplanes from bases on Luzon and Formosa. Some pilots would employ a fearsome new tactic that epitomized the suicide spirit—kamikaze attacks, which called on them to crash planes loaded with heavy bombs into American warships and die in a blaze of glory. Devoted young pilots like 23-year-old Isao Matsuo felt honored to be chosen for that task. "Please congratulate me," he wrote his parents. "I have been given a splendid opportunity to die. This is my last day. The destiny of our homeland hinges on the decisive battle in the seas to the south where I shall fall like a blossom from a radiant cherry tree."

The showdown that loomed in Leyte Gulf would indeed prove decisive and historic—the last great naval contest of World War II and one of the largest battles ever fought at sea. Japanese hopes rested largely on the hefty Center Force of Admiral Kurita, who knew that the odds were against him but told his officers that desperate times required desperate measures. "Would it not be a shame to have the fleet intact while our nation perishes?" he asked them. "I think that Imperial General Headquarters is giving us a glorious opportunity... You must remember that there are such things as miracles. What man can say that there is no chance for our fleet to turn the tide of war in a decisive battle?"

Kurita needed a small miracle to escape detection as his hulking warships threaded straits above Leyte to reach that island's east coast, where the Third and Seventh Fleets stood guard. Straits through which Japanese ships passed frequently were favorite hunting grounds for U.S. submarines. In the early hours of October 24, the submarines U.S.S. *Darter* and U.S.S. *Dace* spotted Kurita's force, alerted Halsey by radio, and stalked the warships until dawn. At first light, they torpedoed two Japanese cruisers, including Kurita's flagship, *Atago*. "She was belching flame from the base of the forward turret to the stern," recalled Cmdr. David McClintock of the *Darter*, who watched through his periscope. "She was plowing ahead, but she was also going down by the bow... She was finished."

Kurita abandoned the *Atago* and resumed command aboard the superbattleship *Yamato*, but greater trials lay ahead for him. Halsey had yet to detect the Northern Force that was

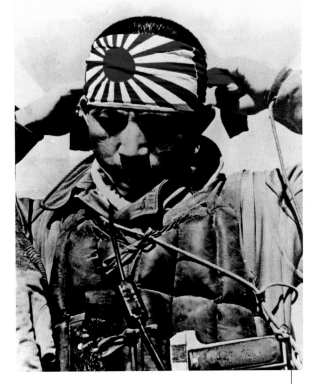

Determined to Die A kamikaze pilot wraps a *hachimaki* headband, ornamented with the Japanese Imperial Navy's rising sun insignia, around his head in a photograph taken in September 1944. The hachimaki was worn as a sign of determination and perseverance by Japanese civilians as well as servicemen.

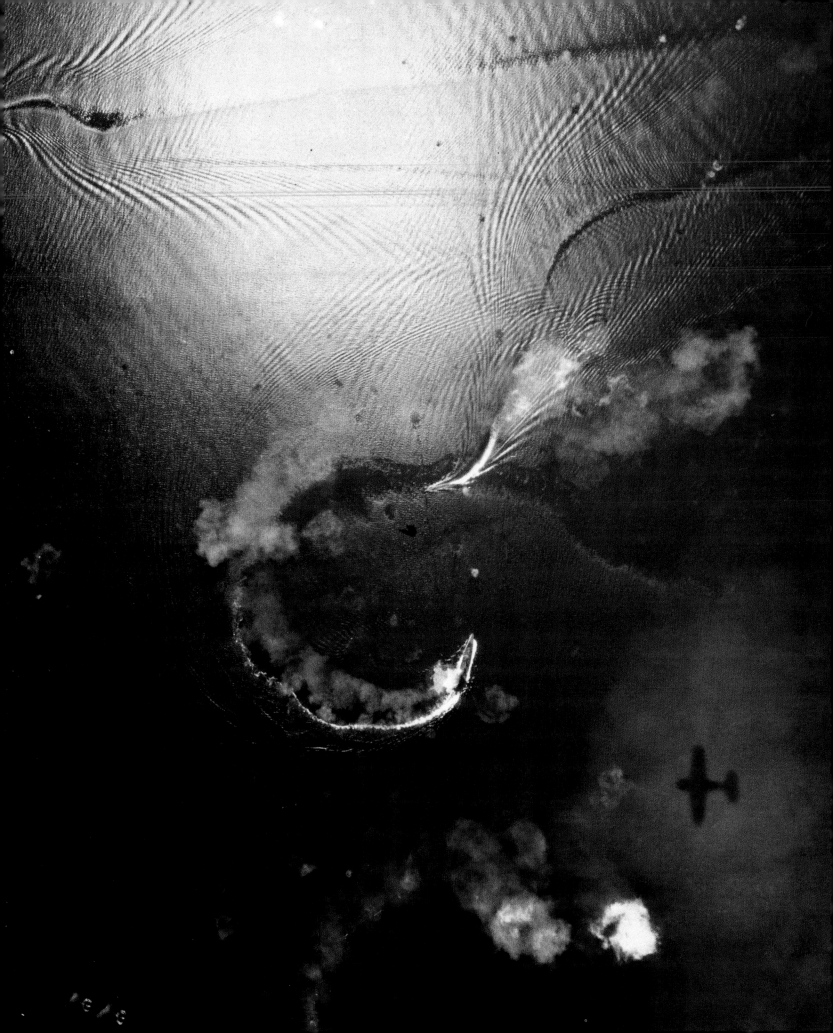

meant to decoy him. When he learned of the approaching Center Force, he launched most of his carrier-based fighters, dive-bombers, and torpedo planes against Kurita in the Sibuyan Sea. Crewmen aboard the *Yamato* and *Musashi* thought that their big ships could withstand anything the enemy threw at them. "The *Musashi* is unsinkable," sailors said. "If it sinks, Japan will sink with it." Like proud heavyweights in prime condition, those twin giants appeared invulnerable and emerged from the first round of their bout with Halsey's airmen unscathed, but warplanes attacking in the second and third waves delivered staggering blows. Around noon, a torpedo struck near the *Musashi's* bow, buckling its armor and sending water flooding into its forward compartments. Subsequent attacks compounded that damage and wounded the *Yamato,* hit by a 1,000-pound bomb that punctured its deck and detonated deep below the waterline. It survived that strike, but the *Musashi* keeled over and sank at day's end, a catastrophe that claimed a thousand lives and cast a pall over Kurita's battered force. As that great ship foundered, he reversed course and debated with his staff whether to prolong what looked increasingly like a hopeless suicide mission. Kurita concluded that he was duty-bound to proceed toward Leyte Gulf, and a message from Admiral Toyoda confirmed his decision: "Trusting in divine guidance, resume the attack."

Prospects for Toyoda's offensive went from bad to worse late that night when warships of Kinkaid's Seventh Fleet shattered Admiral Nishimura's Southern Force as it entered Leyte Gulf from the south through Surigao Strait. Toyoda's plan had called for Kurita to attack from the north at the same time. But when Kurita was delayed by the punishing air strikes Halsey launched on the 24th, Nishimura forged ahead and entered a trap laid for him by Vice Adm. Jesse Oldendorf, who crossed Nishimura's "T"—a classic maneuver in which a fleet lined up perpendicular to an oncoming column of warships and delivered converging fire on them with devastating impact. As one American officer who took part in that coup said afterward: "We were in the ideal position, a position dreamed of, studied, and plotted in War College maneuvers and never hoped to be attained." Nishimura went down with the stricken battleship *Yamashiro,* and the remnants of his force retreated.

Shortly before dawn on October 25, Kurita's Center Force emerged from San Bernardino Strait, north of Leyte Gulf. He fully expected to be challenged by Halsey's fleet and was startled to find the coast clear. During the night, Halsey had taken the bait and darted off in pursuit of the Northern Force, whose commander, Vice Adm. Jisaburo Ozawa, had finally succeeded in attracting his attention. Halsey did not know that Ozawa's carriers were decoys, with few warplanes on their decks, and he could not be faulted for pursuing them after receiving a report that Kurita had reversed course under fire. But he would indeed be faulted for not leaving a task force behind to guard San Bernardino Strait and the northern approach to Leyte Gulf.

Lacking direct communication with Halsey, Kinkaid knew only what he gleaned from a radio message he intercepted between Halsey and his fleet captains, which gave the false impression that Halsey had indeed left warships to guard the strait. Kinkaid had no inkling

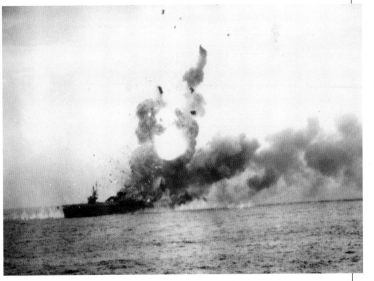

Perilous Waters The aerial photo opposite, taken over the Sibuyan Sea on October 24, shows the Japanese superbattleship *Yamato* completing a turn at bottom while another ship of Admiral Kurita's Center Force also takes evasive action nearby to avoid bombs dropped by U.S. carrier-based aircraft, one of which casts its shadow on a cloud at lower right. The sprawling Battle of Leyte Gulf continued the next day off Samar Island, where Rear Adm. Clifton Sprague's Seventh Fleet task force came under attack by Kurita's surviving warships and by kamikaze pilots, one of whom plowed into the escort carrier U.S.S. *St. Lo,* which exploded *(above)* and sank.

> ## "I intend to go in harm's way."
>
> CMDR. ERNEST EVANS, U.S. SEVENTH FLEET,
> QUOTING JOHN PAUL JONES

that his northernmost carrier group, commanded by Rear Adm. Clifton Sprague, was now exposed to attack by Kurita's oncoming force. "This was indeed a miracle," wrote Kurita's chief of staff. "Think of a surface fleet coming up on an enemy carrier group. Nothing is more vulnerable than an aircraft carrier in a surface engagement." What Kurita and his staff did not know was that Sprague's group contained the most vulnerable of all flattops—small escort carriers converted from merchant ships to support amphibious landings and officially designated CVEs, an acronym that sarcastic crewmen took to mean "Combustible, Vulnerable, and Expendable." Kurita had more reason than he realized for the hopeful message he sent to headquarters as battle loomed: "By heaven-sent opportunity we are dashing to attack enemy carriers."

Sprague and his men proceeded to demonstrate that the spirit of sacrifice was not confined to the Japanese. He threw everything he had into a battle that he expected to lose but had to fight to shield MacArthur's troops and their beachhead. The warplanes on his six escort carriers lacked armor-piercing bombs. Some delivered torpedoes, and others simply strafed or buzzed Kurita's warships in an effort to distract and deflect them. With no time to fuel up, Lt. William Gallagher took off from the carrier U.S.S. *Gambier Bay* with a nearly empty tank, released a torpedo at a Japanese battleship, and plunged to his death moments later.

Similar sacrifices were made by men on Sprague's destroyers, whose task was to protect the carriers at all cost. The captain of the destroyer U.S.S. *Johnston,* Cmdr. Ernest Evans, who hailed from Oklahoma and was part Cherokee, took as his motto the defiant words of Revolutionary War hero John Paul Jones: "I intend to go in harm's way." As Kurita's force closed in, Evans did just that. After first laying down a smokescreen to shield the carriers, he advanced under withering fire and unleashed torpedoes that crippled the cruiser *Kumano*. His own ship and crew emerged from that attack battered and bloodied, but Evans, who

Last Hurrah Crewmen on the listing Japanese carrier *Zuikaku* offer a final banzai salute to their flag and emperor after being attacked by aviators of Admiral Halsey's Third Fleet on October 25. *Zuikaku* sank along with other ships of the Northern Force as the Battle of Leyte Gulf ended.

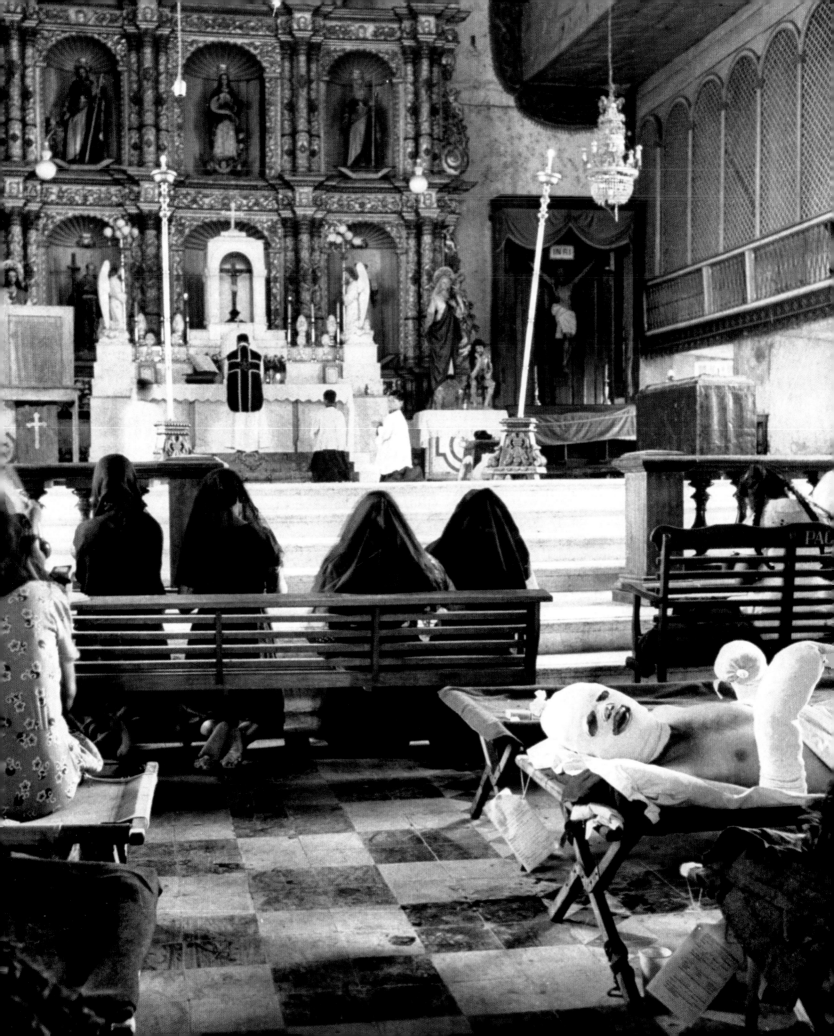

lost two fingers, remained at the helm and refused treatment. "Don't bother me now," he told the ship's doctor. "Help some of those guys who are hurt." He continued to fight—and draw fire away from the carriers—until the *Johnston* was pounded into oblivion. Evans and 60 of his 330 men went down with the ship, and only about half those who jumped overboard survived. Just one of the American destroyers and destroyer escorts assigned to protect the carriers survived this desperate battle.

Stunned by his determined foes, Kurita worried that he might soon face an even greater challenge from Halsey's Third Fleet, summoned to aid Sprague in an urgent, uncoded message that Kurita intercepted. Around 9:30 that morning, he withdrew, much to the astonishment of his adversary. "I could not believe my eyes," said Sprague, "but it looked as if the whole Japanese fleet was indeed retiring." Victory came as a shock for an admiral who had resigned himself to defeat if not death. "At best, I had expected to be swimming by this time," he remarked.

In addition to the destroyers that went down, Sprague lost the *Gambier Bay* to Kurita— and another escort carrier later that day when the U.S.S. *St. Lo* fell victim to a kamikaze attack. But American casualties were far outweighed by the massive damage inflicted on the Japanese fleet during the sprawling, two-day struggle known as the Battle of Leyte Gulf. Bull Halsey's all-out pursuit of Ozawa's Northern Force led to the destruction of the aircraft carriers *Zuikaku* and *Zuiho,* among other warships, in a rout dubbed the Battle of Bull's Run. The Japanese also lost three battleships in and around Leyte Gulf as well as 18 cruisers and destroyers. In pursuit of a miraculous victory, Admiral Toyoda had suffered a momentous defeat that all but demolished his fleet and left the U.S. Navy in command of the Pacific.

Prayer and Redemption Women kneel in worship *(opposite)* while a wounded American soldier lies behind them in Palo Cathedral on Leyte. Ignoring Japanese propaganda like the poster below, which urged revenge on Americans for casualties caused by their air raids, Filipinos aided U.S. troops against Japanese forces, led by Gen. Tomoyuki Yamashita, who did not come down from the Luzon Mountains and surrender *(left)* until the war ended.

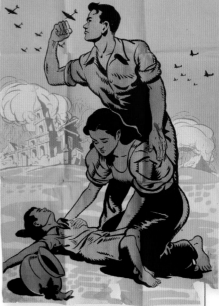

AMERICA CHALLENGED! THE PHILIPPINES ACCEPTED!

ADVANCING ON MANILA

Victory in Leyte Gulf sustained MacArthur's campaign by ensuring that his troops on shore would continue to receive supplies and reinforcements. But his opponents were bolstered as well by Japanese convoys arriving at the port of Ormoc on Leyte's west coast. Preoccupied with securing Leyte Gulf, U.S. naval forces were not in position to attack those convoys until November, by which time enemy strength on Leyte had increased from 20,000 to more than 40,000. To reach Ormoc and cut the Japanese supply line, American troops followed roads winding through treacherous mountain passes like Breakneck Ridge, fiercely defended by opponents who held the high ground. For several weeks, the U.S. 24th and 32nd Infantry Divisions battled the elite Japanese First Division there in torrential rains and deep mud. American casualties approached 1,500, but the toll on the Japanese, who came under heavy artillery fire, was far higher. Lt. Tatsuhide Yasuda lost three-fourths of his company and greeted two soldiers sent to him as replacements fatalistically. "We are glad you are going to die with us," he told them.

"We are glad you are going to die with us."

LT. TATSUHIDE YASUDA, ADDRESSING TWO SOLDIERS SENT TO HIM AS REPLACEMENTS ON LEYTE

As the year drew to a close, MacArthur's troops on Leyte gained the upper hand. On December 7, three years after the attack on Pearl Harbor, the U.S. 77th Infantry Division made a daring amphibious landing south of Ormoc, which fell to American forces three days later. Japanese troops on the island were now stranded, but they remained dangerous and defiant. That did not stop MacArthur from declaring that his foes had suffered "the greatest defeat in the annals of the Japanese Army." The campaign for Leyte was "closed," he announced, except for some "minor mopping up."

It was not the first time that MacArthur had proclaimed victory when there was still hard fighting to be done. "Often these pronouncements produced bitterness among combat troops, and with considerable cause," wrote Lt. Gen. Robert Eichelberger, whose Eighth Army was charged with "mopping up" Leyte. "I was told that there were only six thousand Japanese left on the island," he noted, an estimate that fell far short of the actual number: "It

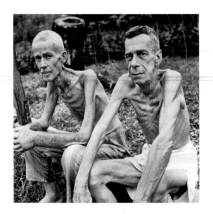

took several months of the roughest kind of combat to defeat this army. Between Christmas Day and the end of the campaign we killed more than twenty-seven thousand Japanese." Eichelberger's experience was much like that of Australian commanders whose troops were left to mop up on New Guinea when MacArthur moved on to the Philippines. "If there is another war," Eichelberger stated, "I recommend that the military, and the correspondents, and everyone else concerned, drop the phrase 'mopping up' from their vocabularies. It is not a good enough phrase to die for."

MacArthur's triumph on Leyte was not as quick or complete as he claimed, but he had good reason to press ahead promptly to Luzon and strike while the iron was hot. The Japanese Army commander on Luzon, Gen. Tomoyuki Yamashita, found himself in a plight similar to MacArthur's when the Japanese invaded that island and took Manila three years earlier. Yamashita had more than 250,000 men, but many were in poor condition,

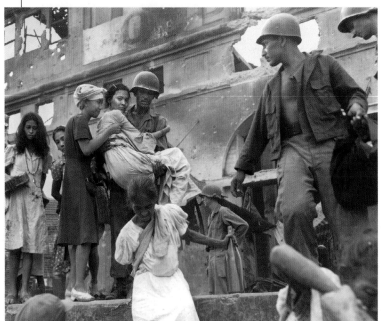

Liberated in Manila **Among the civilians freed by U.S. troops when they entered Manila in February 1945 were the two Americans at top, Lee Rogers (left) and John Todd. Emaciated by three years of Japanese imprisonment with other foreigners at Santo Tomás University, they were photographed by** Life **magazine's Carl Mydans, who was interned there with them for more than eight months. Later that month, American soldiers rescued weak and injured civilians held captive by Japanese soldiers in a church in the Intramuros (above), the old walled colonial center in Manila.**

and they would receive little support from Japanese naval or air forces. U.S. warplanes from Halsey's carriers and bases on Leyte and Mindoro—a small island near Luzon occupied by American forces in mid-December—pounded Clark Field and smashed enemy aircraft there in attacks reminiscent of those carried out by the Japanese in late 1941 when they appeared unstoppable. Now they were reduced to launching kamikaze assaults on MacArthur's fleet as it entered Lingayen Gulf, north of Manila, to clear the way for his invasion forces. On January 6, 1945, Japanese planes crashed into a dozen warships there and killed hundreds of sailors. But those desperate attacks failed to deter landings that brought 60,000 troops ashore on January 9, with many more to follow. MacArthur repeated his dramatic gesture on Leyte by wading onto the beach at Lingayen Gulf as photographers recorded the event. "The decisive battle for the liberation of the Philippines and the control of the Southwest Pacific is at hand," he declared.

Yamashita did not contest the landings. Many of his troops withdrew into the mountainous recesses of northern Luzon, where they would hold out for months. Others opposed

MacArthur's advance on Manila or defended Corregidor, the stronghold at the entrance to Manila Bay where he had come under siege before escaping to Australia. A combined assault there by U.S. paratroopers and amphibious forces in mid-February trapped several thousand Japanese soldiers, holed up in tunnels. That showdown ended explosively when they first tried to blast their way out and then detonated a massive powder keg in a suicide attack that killed dozens of Americans and most of the remaining Japanese. "I have never seen such a sight in my life," remarked an American officer who was sent sprawling by that eruption. "Utter carnage, bodies laying everywhere—*everywhere.*"

Worse sights awaited U.S. troops who fought their way into Manila. Yamashita ordered his forces to abandon the city as Americans closed in, but the Japanese naval commander there, Rear Adm. Sanji Iwabuchi, had more than 15,000 men and chose to resist to the bitter end. His defiant stand placed civilians at great risk. MacArthur's troops, who liberated emaciated prisoners of war left behind in the Philippines after most of the POWs were shipped to Japan, also succeeded in freeing four thousand American, British, and other foreign civilians held in squalid conditions at Santo Tomás University in Manila. Less fortunate were

> "I recommend that the military, and the correspondents, and everyone else concerned, drop the phrase 'mopping up' from their vocabularies. It is not a good enough phrase to die for."
>
> LT. GEN. ROBERT EICHELBERGER

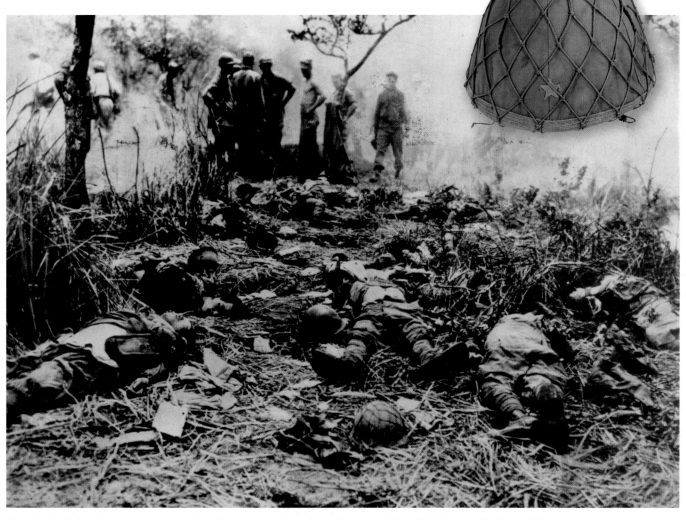

"Mopping Up" Following a desperate Japanese banzai charge on Mindanao in late May 1945, soldiers of Maj. Gen. Franklin Sibert's X Corps overlook a corpse-strewn hill. Among the dead are Japanese Type 90 steel helmets such as the one with camouflage netting above. This attack against X Corps, which was part of General Eichelberger's Eighth Army, came weeks after MacArthur declared victory on Mindanao.

<blockquote>
"We were bombing as high as they could get the airplane, practically in a stall, up to 31,000 feet, scared to death of the fighters."

PILOT DAVID BURCHINAL,
RECALLING HIS FIRST MISSION
OVER TOKYO
</blockquote>

Filipinos trapped in the embattled city, where as many as 100,000 residents perished. Some were killed by vengeful Japanese troops, retaliating for assaults by Filipino guerrillas. Others were caught in the crossfire as fighting raged from street to street and buildings collapsed.

The bodies of Filipino civilians and Japanese soldiers were "strewn over the streets, in gutters, on lawns," recalled Tom Howard, whose tank battalion led the way into Manila for troops of the 37th Infantry Division. Attempts to remove the dead "were met with sniper fire," he said, "so instead of removal, when dusk came the bodies were covered with quick-lime to hasten their deterioration and to stifle the smell." He and other soldiers found more Japanese casualties when they entered shattered buildings to clear out snipers: "To keep from being tricked by a sniper pretending to be dead, we pulled all the bodies to the wall and sat them up leaning against the wall. We proceeded to shoot each one in the forehead regardless of whether they were already dead . . . It was a grotesque, gruesome picture to see these row-by-row bodies along the walls. These were the day-by-day necessities to survive one day more."

The searing battle for Manila ended in March 1945 when U.S. troops stamped out the last embers of Japanese resistance in the capital. MacArthur's mission was still not accomplished, however. Fighting to secure Luzon and other Philippine islands continued until Japan surrendered. Much like the Allied campaign in Italy, which contributed indirectly to Germany's defeat by tying down and chewing up enemy forces, reclaiming the Philippines did not force Japan to yield, but helped achieve that outcome by sapping its strength and morale. "If we occupy the Philippines," one Japanese admiral had assured Emperor Hirohito before his forces attacked U.S. bases there in December 1941, "it will be easier for our navy to carry on the war." Three years later, that navy was crushed at Leyte Gulf, and the Philippines became a graveyard for Japan's hopes and hundreds of thousands of its troops.

Strategic Bomber Maj. Gen. Curtis LeMay, who took charge of the strategic bombing campaign against Japan in early 1945, urged the invasion of Iwo Jima to eliminate Japanese fighter bases there and reduce the risks his crews faced. In preparation for the invasion, the 64th Engineer Topographical Battalion produced detailed, top-secret maps of Iwo Jima like the one opposite. The blue grid denotes artillery target squares and the red annotations mark enemy activity and troop concentrations.

CLOSING IN ON TOKYO

The bloody toll paid by U.S. ground forces as they reclaimed one island after another from diehard Japanese soldiers made the prospect of achieving victory through the air all the more compelling. But the initial results of the strategic bombing campaign launched from the Marianas in November 1944 were discouraging. B-29s, equipped with pressurized cabins that allowed the crew to operate at an altitude of 30,000 feet without oxygen masks, flew above the range of anti-aircraft batteries but were subject to attack by Japanese fighters and buffeted by jet-stream winds that made hitting targets precisely almost impossible. One pilot, David Burchinal, recalled that on his first mission, directed against an aircraft-engine factory near Tokyo, "we were bombing as high as they could get the airplane, practically in a stall, up to 31,000 feet, scared to death of the fighters. At that altitude, we suddenly ran into these terrific jet winds that no one had run into before. They were well over 100 knots, sometimes you'd get up to 200 knots." Under those conditions, there was no way for the bombardier to get a fix on his target, Burchinal remarked: "The bombs would fly into the fields."

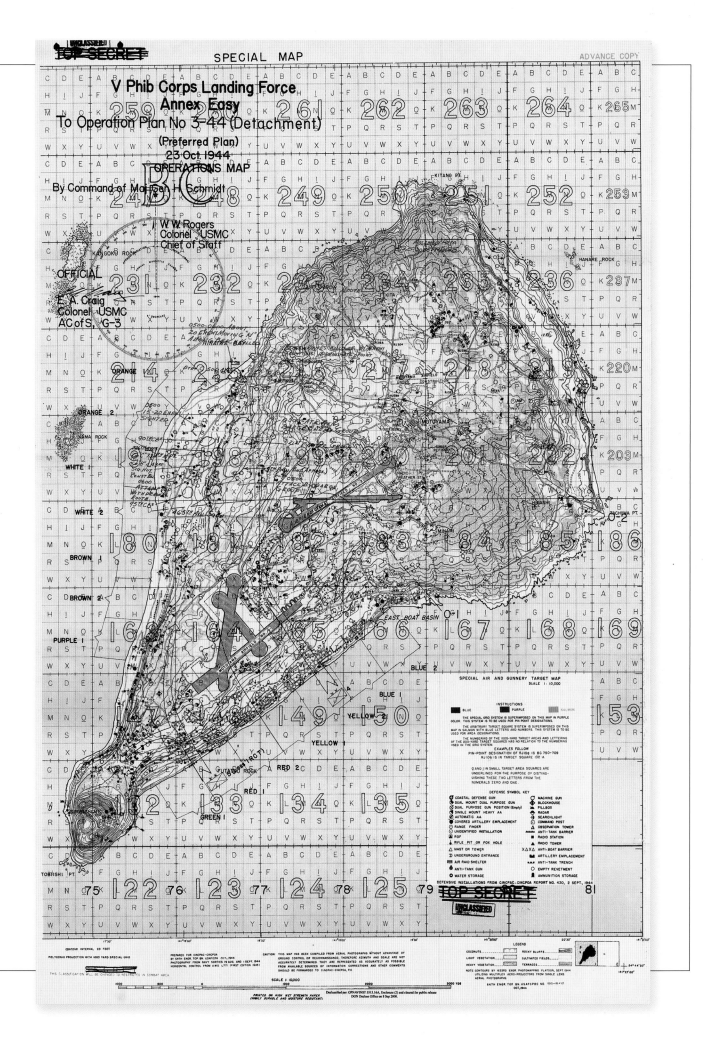

SPECIAL MAP

ADVANCE COPY

V Phib Corps Landing Force
Annex Easy
To Operation Plan No 3-44 (Detachment)
(Preferred Plan)
23 Oct. 1944
OPERATIONS MAP

By Command of Maj. Gen. H. Schmidt

W. W. Rogers
Colonel USMC
Chief of Staff

OFFICIAL

E. A. Craig
Colonel USMC
A C of S, G-3

SPECIAL AIR AND GUNNERY TARGET MAP
SCALE 1: 10,000

INSTRUCTIONS

BLUE PURPLE SALMON

THE SPECIAL GRID SYSTEM IS SUPERIMPOSED ON THIS MAP IN PURPLE
COLOR. THIS SYSTEM IS TO BE USED FOR PIN POINT DESIGNATIONS.

THE ARBITRARY TARGET SQUARE SYSTEM IS SUPERIMPOSED ON THIS
MAP IN SALMON WITH BLUE LETTERS AND NUMBERS. THIS SYSTEM IS TO BE
USED FOR AREA DESIGNATIONS.

THE NUMBERING OF THE 1000-YARD TARGET AREAS AND LETTERING
OF THE 200-YARD TARGET SQUARES HAS NO RELATION TO THE NUMBERING
USED IN THE GRID SYSTEM.

EXAMPLES FOLLOW
PIN-POINT DESIGNATION OF RJ106 IS BC 750-709
RJ106 IS IN TARGET SQUARE 132-A

O AND I IN SMALL TARGET AREA SQUARES ARE
UNDERLINED FOR THE PURPOSE OF DISTING-
UISHING THESE TWO LETTERS FROM THE
NUMERALS ZERO AND ONE.

DEFENSE SYMBOL KEY

COASTAL DEFENSE GUN MACHINE GUN
DUAL MOUNT DUAL PURPOSE GUN BLOCKHOUSE
DUAL PURPOSE GUN POSITION (Empty) PILLBOX
SINGLE MOUNT HEAVY AA RADAR
AUTOMATIC AA SEARCHLIGHT
COVERED ARTILLERY EMPLACEMENT COMMAND POST
RANGE FINDER OBSERVATION TOWER
UNIDENTIFIED INSTALLATION ANTI-TANK BARRIER
RDF RADIO STATION
RIFLE PIT OR FOX HOLE RADIO TOWER
MAST OR TOWER ANTI-BOAT BARRIER
UNDERGROUND ENTRANCE ARTILLERY EMPLACEMENT
AIR RAID SHELTER ANTI-TANK TRENCH
ANTI-TANK GUN EMPTY REVETMENT
WATER STORAGE AMMUNITION STORAGE

DEFENSIVE INSTALLATIONS FROM CINCPAC-CINCPOA REPORT NO. 430, 2 SEPT., 1944

CONTOUR INTERVAL 20 FEET

POLYCONIC PROJECTION WITH 1000 YARD SPECIAL GRID

THIS CLASSIFICATION WILL BE CHANGED TO RESTRICTED IN COMBAT AREA

PREPARED FOR CINCPAC-CINCPOA
BY 64TH ENGR. TOP BN. USAFICPA OCT., 1944
PHOTOGRAPHY FROM NAVY SORTIES 19 AUG. and 1 SEPT 1944
HORIZONTAL CONTROL FROM AMS L771 (FIRST EDITION 1943)

CAUTION: THIS MAP HAS BEEN COMPILED FROM AERIAL PHOTOGRAPHS WITHOUT ADVANTAGE OF
GROUND CONTROL OR RECONNAISSANCE, THEREFORE AZIMUTH AND SCALE ARE NOT
ACCURATELY DETERMINED. THEY ARE REPRESENTED AS ACCURATELY AS POSSIBLE
FROM AVAILABLE SOURCES OF INFORMATION CORRECTIONS AND OTHER COMMENTS
SHOULD BE FORWARDED TO CINCPAC-CINCPOA, RH

LEGEND
COCONUTS ROCKY BLUFFS
LIGHT VEGETATION CULTIVATED FIELDS
HEAVY VEGETATION TERRACES

NOTE: CONTOURS BY I63TH ENGR. PHOTOMAPPING PLATOON, SEPT 1944
UTILIZING MULTIPLEX AERO-PROJECTORS FROM SINGLE LENS
AERIAL PHOTOGRAPHS.

SCALE 1:10,000
1000 500 0 1000 2000 3000 4000 5000 YDS

PRINTED ON HIGH WET STRENGTH PAPER
(HIGHLY DURABLE AND MOISTURE RESISTANT)

Declassified per OPNAVINST 5513.16A, Enclosure (2) and cleared for public release
DON Declass Office on 8 Sep 2000.

64TH ENGR. TOP. BN. USAFCPBC NO. 1010-15-17
OCT., 1944

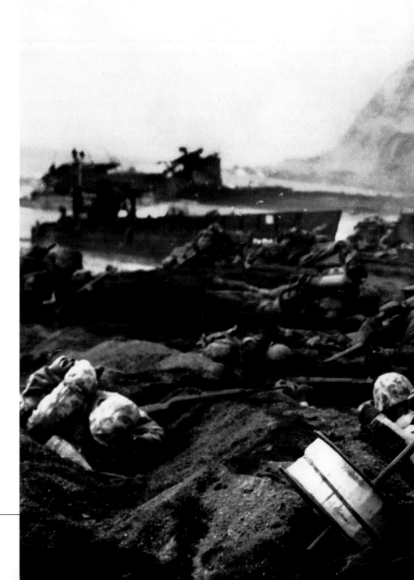

"If you don't kill at least one enemy soldier, you don't deserve to die!"

INSTRUCTIONS GIVEN TO JAPANESE GIRLS
IN PREPARATION FOR AN AMERICAN INVASION

Maj. Gen. Curtis LeMay, a tough veteran of strategic bombing campaigns in Europe and China who took command at Saipan in January 1945, concluded that so-called precision bombing from high levels was too imprecise and ineffective to bring Japan to its knees. He laid plans for low-level, saturation bombing of urban and industrial areas, using incendiaries of the sort that caused firestorms in Dresden and other German cities. Those raids would expose B-29 crews to greater risk of attack, and LeMay stepped up efforts to protect them and save those whose planes were too badly damaged to make it back to the Marianas. To that end, he urged the Navy and Marines to seize Iwo Jima, from which Japanese warplanes menaced B-29s in the air and on the ground. Once in American hands, that island could serve as a rescue station for stricken bombers and a base for fighters, which did not have sufficient range to escort B-29s to Japan from the Marianas but could do so from Iwo Jima.

The attack on Iwo Jima would be followed by a massive assault on Okinawa, which lay close to Kyushu, Japan's southernmost home island. If strategic bombing from the Marianas did not achieve victory, Okinawa would serve as a base for air strikes and amphibious landings on Kyushu, from which U.S. troops would then invade Honshu, the main island containing much of Japan's population and its capital, Tokyo. The cost of that ultimate invasion was almost too dreadful for American commanders to contemplate. Japan's home defense forces included three million soldiers of varying capabilities and vast numbers of civilians, who were being trained for combat in schools and workplaces using bamboo spears and other crude weapons. Girls were instructed to "guard their honor like samurai" when the Americans invaded and join in the suicidal defense of their country. "If you don't kill at least one enemy soldier," they were told, "you don't deserve to die!"

Japanese troops defending Iwo Jima were prepared to give their lives in exchange for a heavier toll in American blood. Their

Pinned Down U.S. Marines of the 28th Regiment come under intense enemy fire soon after the invasion of Iwo Jima began on February 19, 1945. Japanese artillery on Mount Suribachi, looming in the background, could target much of the island.

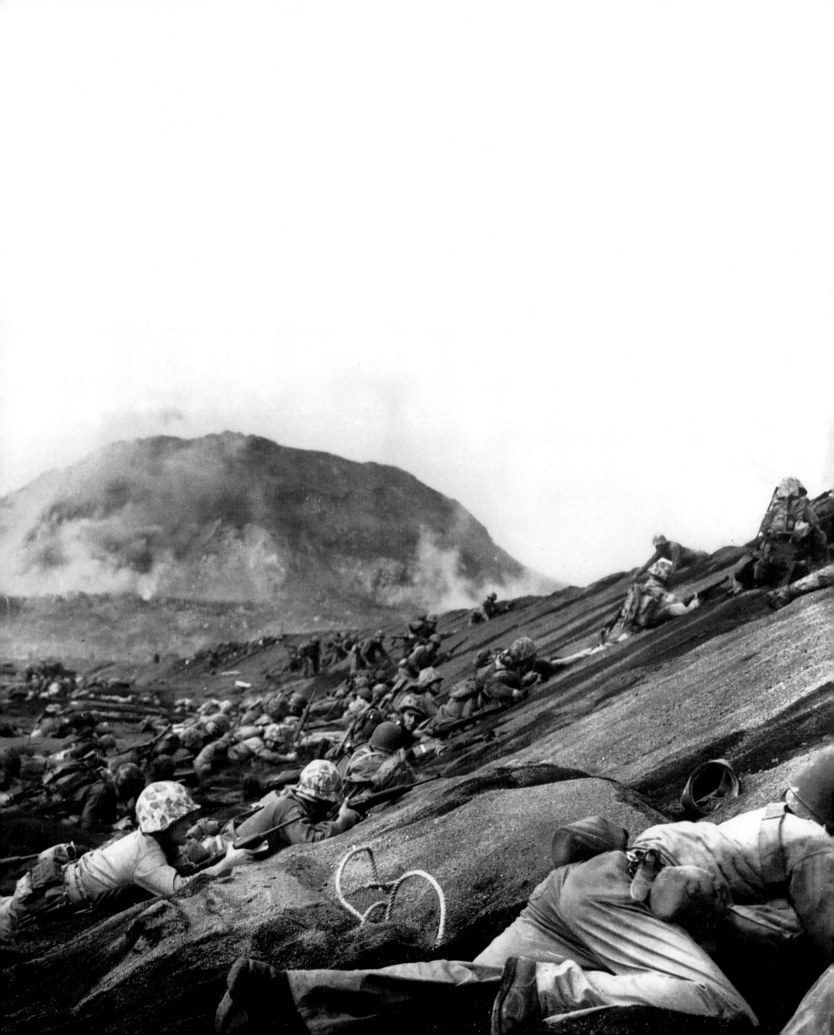

"One of the first sights I saw was a Marine blown in half."

Capt. LaVerne Wagner, at Iwo Jima

commander, General Kuribayashi, rejected suggestions from naval officers that he fortify the beach and try to repulse the landings. Reports of previous battles in the Pacific convinced him that American firepower, delivered by ships, planes, and artillery, would soon shatter coastal defenses, allowing U.S. troops to break through and score a quick victory. Instead, he planned a defense in depth, embedding his 20,000 men in pillboxes, tunnels, and caves throughout the island, which was only five miles long and two miles wide. His most imposing bastion was on Mount Suribachi, a 500-foot-high extinct volcano overlooking the beach, but dozens of other strongholds, covered in earth and sand and barely recognizable except for the guns protruding from them, awaited the oncoming Marines elsewhere on Iwo Jima. Kuribayashi hoped to prolong the battle and make it as costly as possible for his foes, but he did not expect to prevail or survive. "I am sorry to end my life here, fighting

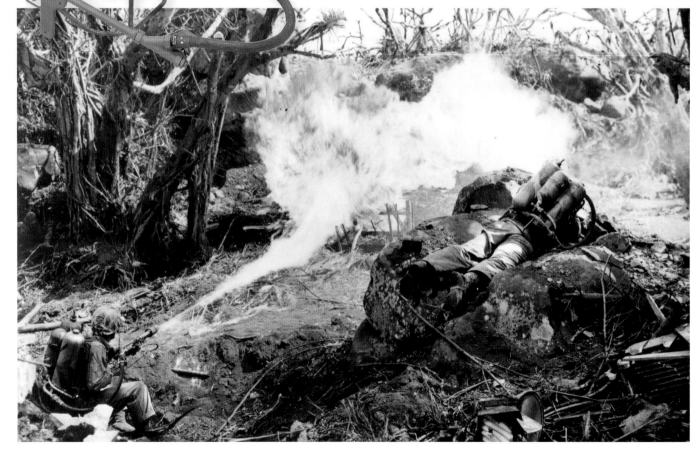

Storming Suribachi Above, Marines target Japanese troops on Mount Suribachi using flamethrowers like the M1A1 at top, which could shoot burning napalm up to 50 yards. On February 23, Marines reached Suribachi's summit and placed a small flag there—replaced later that day by a larger flag, raised by six Marines as photographer Joe Rosenthal took his memorable picture *(opposite)*.

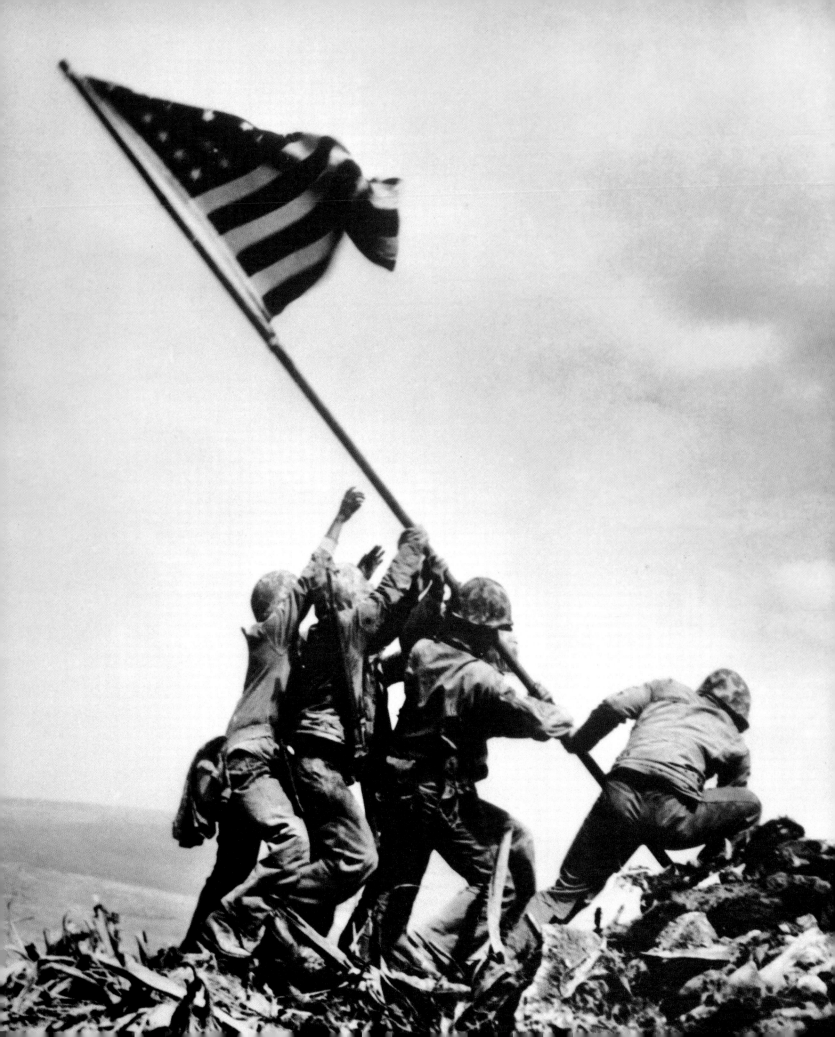

the United States of America," he wrote his wife, "but I want to defend this island as long as possible and to delay the enemy air raids on Tokyo." As invasion forces outnumbering his troops more than three to one approached Iwo Jima, he sent a parting letter to his son: "The life of your father is like a flicker of flame in the wind . . . There is no possibility of my survival. Therefore, you must be the central figure of our family and help Mother."

In keeping with Kuribayashi's orders, his troops allowed thousands of Marines to land on Iwo Jima on the morning of February 19, 1945, before targeting them with mortars and rockets. Caught under the deadly barrage in soft, black volcanic sand, men with heavy packs who tried to run had the nightmarish sensation of being stuck in place. Most clung to the beach, attempting to burrow into the sand and find shelter. "One of the first sights I saw was a Marine blown in half," recalled Capt. LaVerne Wagner, who landed with his company after the Japanese opened fire. "The beach was crowded with Marines as far as I could see. Enemy artillery fire was very hot and it seemed to me that almost half the men on the beach had been wounded and were waiting to be evacuated." Some units made inroads that first day, but for most it was a matter of hanging on desperately until they had enough men and machinery ashore to challenge their fortified opponents.

Here as at Omaha Beach on D-Day, the impetus to advance came from battle-tested officers like Lt. Col. Charles Shepard of the 28th Regiment, Fifth Division, who made it clear to his battalion that the only way out of the fix they were in was to press forward. "Secure this lousy piece of real estate so we can get the hell off it," he urged as they launched a harrowing assault on Mount Suribachi on February 20. "There probably wasn't a man among us who didn't wish to God he was moving in the opposite direction," said Cpl. Richard Wheeler. "But we had been ordered to attack, so we would attack . . . Our training had imbued us with fierce pride in our outfit, and this pride helped now to keep us from faltering."

For three days, Marines grappled up the slope at great peril, blasting their foes with grenades, TNT, and flamethrowers and turning their concrete pillboxes into coffins. Finally, on the morning of February 23, men of the 28th Regiment reached the summit and raised a small American flag. Barely visible from the beach below, it was replaced later that day by a larger flag, raised by six Marines—three of whom would die in action before the war was over—as photographer Joe Rosenthal captured the moment for posterity. "I took the picture," Rosenthal said of that famous image, "but the Marines took Iwo Jima."

For many Americans, that flag-raising summed up the fighting spirit of the Marines and their hard-won victory on Iwo Jima, but the battle was far from over when the Stars and Stripes rose over Suribachi. Thirty days of horrific fighting lay ahead before the last deep pockets of Japanese resistance on the island were cleaned out. One incident witnessed by a war correspondent typified that brutal struggle. As Marines took possession of two airfields in mid-island and advanced toward a third airstrip under construction at the north end of Iwo Jima, they came under fire from the entrances to caves occupied by Japanese troops.

Well Camouflaged The U.S. Marine Corps camouflage helmet cover at top was designed to match the inner lining of the M1944 pattern utility jacket above. Both the helmet cover and the jacket were reversible, with a green camouflage color scheme for jungle terrain.

Necessities Marine K-rations came in color-coded packages *(top)* and contained preserved food such as canned meat along with candy, cigarettes, and other items. A tin of instant coffee *(above right)* came with the more substantial C-rations. Many troops purchased nonreflective cigarette lighters *(above left)*.

2ND LT. IRVAN BAKER
SMOKING OUT THE ENEMY

Baker, who joined the Marines in 1943, commanded a rifle company at Iwo Jima that guarded against Japanese infiltrators on Mount Suribachi, who used tunnels from which Baker's company extracted prisoners for interrogation.

This fellow, Ray Duncan, hears voices and he said, "They ain't speaking English." I can't see anybody. It's just a little fissure in a rock wall and a big boulder. So, we moved the boulder, pried it but kept our distance and we could see steps going down, so, we got a satchel charge, it's a hundred forty-four sticks of dynamite, and we could hear it go bump, bump, bump, bump and then boom, and they were still chattering. They were down that deep. So, I called down to regiment, I said, "You better send us a smoke generator, we've got a bunch of people here and we can't get to them." So, we got a smoke generator, and we poked the hose down, and everybody did everything very gingerly, you know, you didn't want to look in, straight down, because you'd get killed, and so, we smoked them. We could see smoke coming out hundreds of feet away. This was like the headquarters of this particular area, like an octopus, and all of these tunnels, and that's where they were feeding those tunnels and coming up at night and shooting at us... You know, these guys a minute ago were killing, trying to kill your buddies, and so they came, eight of them came out and one of them was a corporal, or a sergeant, and he had his blouse out of his pants, and another guy was brown nosing him, by tucking [that] shirt in, and I was ready to shoot him, just on general principles... They were escorted down to the division intelligence and I hope they

> **"So, we got a smoke generator, and we poked the hose down, and everybody did everything very gingerly, you know, you didn't want to look in, straight down, because you'd get killed, and so, we smoked them."**

got a lot of information from them...

One day... we liberated a cave full of foodstuffs... they said, you know, "Don't touch the food, they probably poisoned it." There's a sealed can, I figured... why would they poison it?... so I opened it up with a bayonet, and little cubes of meat, evidently horse meat, had no fat, and we've been living on K rations, and so, this looked good and some of the kids said, "Lieutenant, you told us, you were a short order cook"... So, I got some plastic C-2, which is a plastic explosive, it burns... So, they found some scallions, and we rinsed them off with our canteen water, threw it in there, and the sergeant major was leaning against a rock... and I said, "Top, you get the first taste," and he leaned over, he took his taste, and then he keeled over. I mean, "My God, it was poisoned. I'm going to be court-martialed." Then I looked behind him, he had six bottles of sake, he got to the cave before we did, and disposed of all the sake. He was stone drunk. ∎

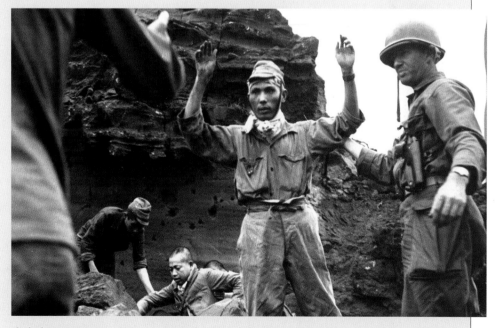

Flushed Out A Japanese soldier emerges with hands raised from a cave on Iwo Jima on April 5, 1945. Of the more than 22,000 Japanese soldiers defending the island, only 216 were captured alive.

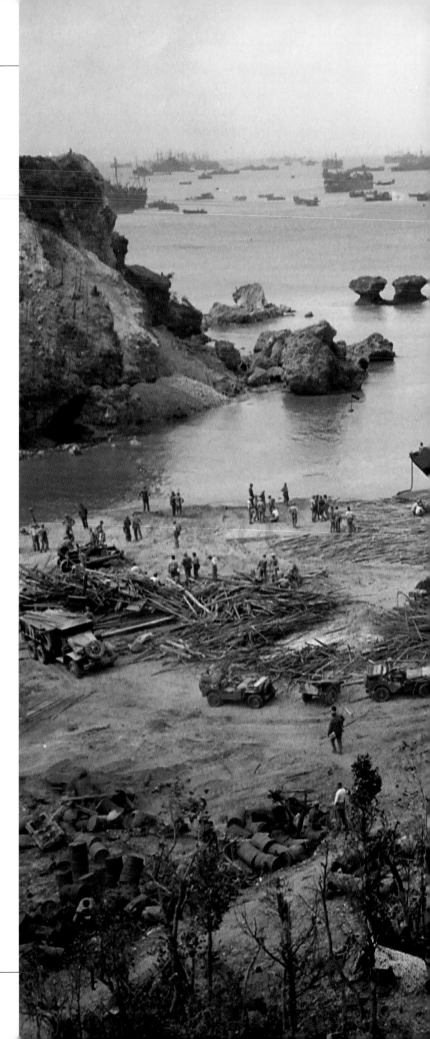

"This is the biggest thing yet attempted in the Pacific."

A NAVAL INTELLIGENCE OFFICER
DESCRIBING THE INVASION OF OKINAWA

After hurling grenades and calling in tanks to silence the gunners, Marines brought up flamethrowers and shot napalm—an inflammable gel that sticks to clothing and skin—deep into the caves, where soldiers lurked. "The Marines heard the Japs howling," the correspondent reported. "A few rushed out of the caves on fire. The Marines shot them or knocked them down and beat out the flames and took them prisoner." Japanese troops were seldom captured alive unless severely wounded, so the Marines were surprised when about 40 men who had escaped the flames emerged and gave themselves up. They turned out to be Koreans, forced to labor on Iwo Jima by the Japanese: "They said that everyone else in the caves had either been burned to death or had committed suicide." Groping through the rubble, the Marines found many bodies, "some burned into frightful black lumps . . . The smell was overwhelming and the men turned away in disgust."

Horror mingled with heroism as men on both sides made selfless sacrifices, including seven Americans who were awarded Medals of Honor after throwing themselves on grenades to save others. On Iwo Jima, wrote Admiral Nimitz, "uncommon valor was a common virtue." The battle ended in late March when Kuribayashi conceded defeat by committing suicide. Most of his men lay dead by then, with the exception of a few hundred who were captured and scattered holdouts who remained hidden in caves until long after the war ended. Kuribayashi had fallen far short of his stated objective, which was to kill ten Americans for every man of his own who died. In fact, the Japanese death toll was roughly three times that of American forces, who had six thousand fatalities. The Americans also suffered 25,000 wounded, however, making Iwo Jima one of the few battlefields where total U.S. casualties exceeded Japanese losses.

Medics and nurses flew in from Guam and airlifted the most seriously wounded back to hospitals there. "The worst thing

Beachhead Following the invasion of Okinawa in April 1945, U.S. Navy landing craft deliver fuel drums *(lower right)* and other supplies to the area designated Yellow Beach. A coral reef prevented large ships offshore from being unloaded at low tide until Seabees constructed pontoon causeways out to the reef.

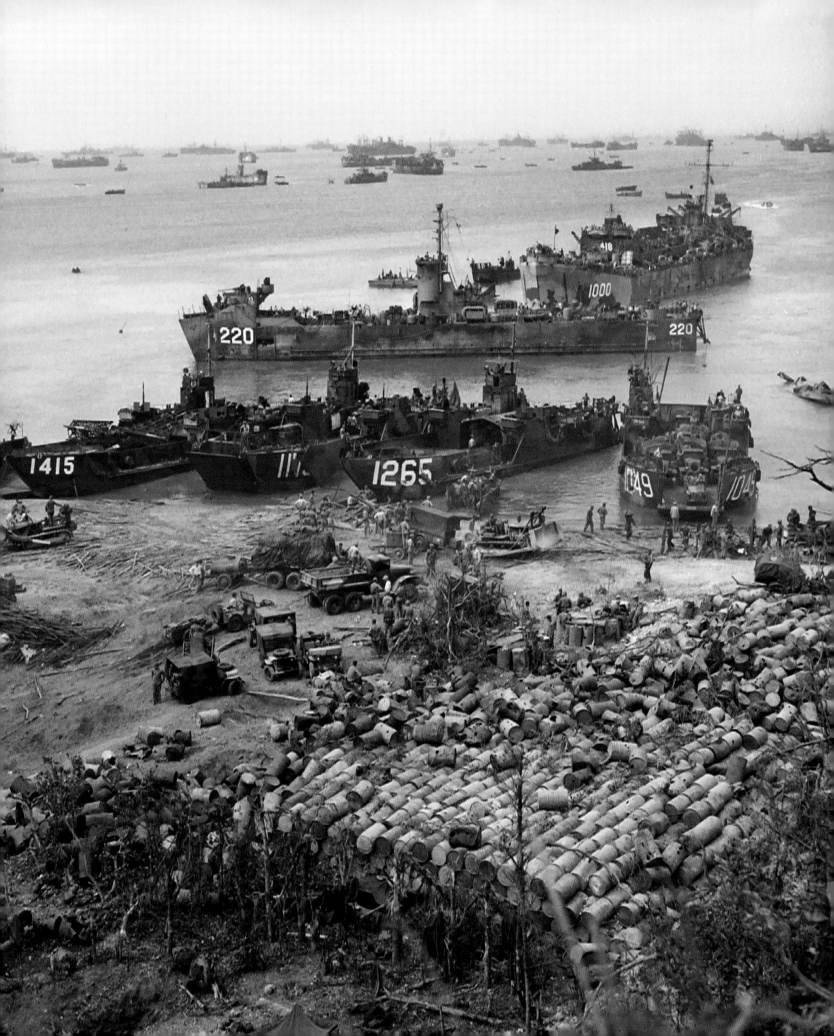

KAMIKAZE

Allied soldiers and sailors were shocked by the suicide missions carried out by pilots of Japan's Special Attack Corps, who launched their first strikes against U.S. warships off the Philippines in October 1944. Known as *kamikaze,* or "divine wind," for the typhoon that saved Japan from a Mongol invasion fleet during the 13th century, those pilots were sent to their deaths by Vice Adm. Takijiro Onishi, commander of Japan's First Air Fleet. Initially opposed to suicide tactics, Onishi changed his mind after the Imperial Navy lost hundreds of aircraft and pilots in the Battle of the Philippine Sea in June 1944. "In my opinion," Onishi stated, "there is only one way of assuring that our meager strength will be effective to a maximum degree. That is to organize suicide attack units composed of A6M Zero fighters armed with 250-kilogram [550-pound] bombs, with each plane to crash-dive into an enemy carrier." Kamikazes were volunteers, many of them university students, motivated by loyalty to country and reverence for the emperor. They were hastily trained for a task that required more resolve than expertise. According to Admiral Onishi, their "nobility of spirit" would be enough to save Japan.

Close Call A kamikaze narrowly misses the carrier U.S.S. *Sangamon* off Okinawa on May 4, 1945.

As Allied fleets closed in on Japan's home islands, kamikaze attacks increased. At Okinawa, waves of up to 300 aircraft menaced the Allied fleet. Many of the planes were shot down before they struck ships, but some did terrible damage. On May 11, 1945, the aircraft carrier U.S.S. *Bunker Hill* was attacked by two Zero fighters. The first released a bomb that smashed through the hull before the aircraft struck the flight deck. Moments later, a second Zero plunged into the flight deck near the control tower, igniting munitions and aviation fuel in a massive conflagration. The attacks killed 373 men aboard the *Bunker Hill* and wounded 264 more. Crewmen managed to control the blaze, and the crippled carrier returned to Bremerton, Washington, for repairs.

By the end of the war, the Special Attack Corps had sunk 34 Allied war vessels and damaged 368 others, inflicting 9,700 casualties at a cost of as many as 4,000 kamikaze pilots. Unlike the divine wind that saved Japan from the Mongols, these daring kamikazes failed to turn back the American onslaught. When Emperor Hirohito surrendered in August 1945, Admiral Onishi followed in the path of those doomed pilots by committing suicide in his quarters. ∎

Punctured This gaping hole in the flight deck of the *Bunker Hill* was caused by a bomb dropped by a kamikaze who then plowed into the ship.

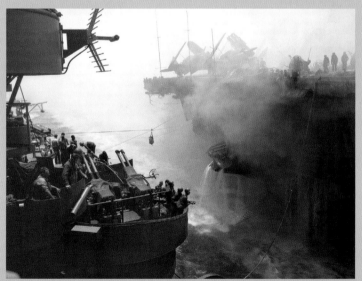

Help at Hand The cruiser U.S.S. *Wilkes Barre (left)* draws up alongside the *Bunker Hill* to help fight the flames and evacuate the wounded.

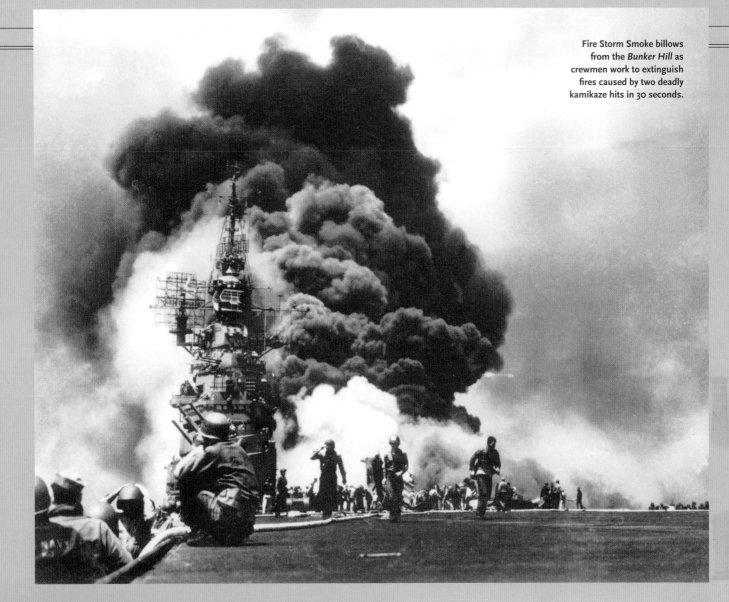

Fire Storm Smoke billows from the *Bunker Hill* as crewmen work to extinguish fires caused by two deadly kamikaze hits in 30 seconds.

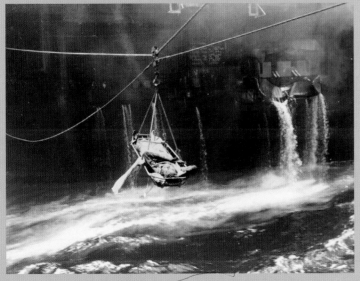

Deliverance A wounded sailor rides in a basket stretcher on a line strung from the *Bunker Hill* to the assisting cruiser *Wilkes Barre*.

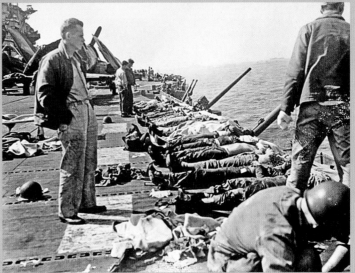

Counting the Cost After putting out the fire, crewmen on the battered carrier lay out the bodies of shipmates killed in the suicide attacks.

you would see were burns, and men who were torn up by shrapnel," recalled Nurse Norma Crotty. "The fellows were so much younger than us, 17 or 18 years old, and some looked younger than that . . . They wanted their mothers, and we sort of became their mothers and comforted them . . . The feeling of closeness to these boys I didn't have again until I had children." Many of her patients were fresh recruits, "right out of high school," she noted. "And now a lot of them were ruined for life."

The brutal struggle for Iwo Jima was barely over before an even deadlier battle erupted on Okinawa. "This is the biggest thing yet attempted in the Pacific," a naval intelligence officer said as the campaign there unfolded. General LeMay's bombers were called in to pound Okinawa before the invasion began on April 1, 1945, ushered in by the largest fleet ever assembled in the Pacific, consisting of four hundred troop transports and more than a thousand warships. Unlike tiny, desolate Iwo Jima, Okinawa was a populous island 60 miles long. Annexed by Japan in the late 1800s, it was defended now by some 100,000 troops, one-fourth of whom were Okinawans, who had been told that Americans would brutalize them. Their opponents consisted of U.S. Marines and Army troops under the overall command of Lt. Gen. Simon Bolivar Buckner Jr., son of the Confederate general who surrendered unconditionally to Ulysses Grant at Fort Donelson in 1862. A methodical Army man, Buckner possessed a numerical advantage over his foes of less than two to one and had to overcome formidable Japanese defenses at the southern end of Okinawa. That made for a slow, grueling bloodbath, which author William Manchester, a Marine lieutenant on Okinawa, likened to the punishing battles of World War I, when "two great armies, squatting opposite one another in mud and smoke, were locked together in unimaginable agony."

The landings on April 1 went unopposed, offering no hint of the ordeal that lay ahead. "Never before had I seen an invasion beach like Okinawa," wrote correspondent Ernie Pyle, who would die a few weeks later while covering this campaign. "There wasn't a dead or wounded man in our whole sector of it. Medical corpsmen were sitting among their sacks of bandages and plasma and stretchers, with nothing to do." The first few days of the operation were deceptively quiet because the Japanese commander, Lt. Gen. Mitsuru Ushijima, had pulled nearly all his troops back below his defensive line, south of the landing zone. On April 3, Vice Adm. Richmond Kelly Turner, in charge of the invasion fleet, signaled Nimitz: "I may be crazy but it looks like the Japs have quit the war at least in this section." Nimitz, who had better intelligence on Japanese intentions, fired back a message dismissing everything but Turner's first few words: "Delete all after crazy."

Fierce fighting loomed both on land and at sea as Japanese soldiers, sailors, and pilots prepared to die for their cause. On April 7, warplanes from American carriers sank the superbattleship *Yamato,* which survived the showdown at Leyte Gulf only to perish as it steamed toward Okinawa with orders to "fight gloriously to the death." That mission was thwarted, but a greater threat followed in its wake as entire squadrons of kamikaze pilots descended on Turner's fleet in the days and weeks to come. The Japanese, who used flowery terms to glorify suicide missions, called kamikazes who died together in mass attacks at sea "floating chrysanthemums." Their assaults were dreadful enough without the menacing presence of a

"We made eleven thrusts up that hill, and fell back each time with most of our boys dead or missing."

MARINE SGT. MIKE GORACOFF, AT SUGAR LOAF HILL ON OKINAWA

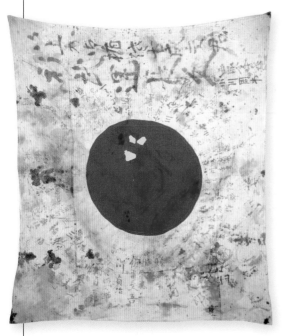

Captured Flag Seized by Marines on Iwo Jima, this blood-stained "good luck flag" was a traditional gift for Japanese soldiers heading overseas. Such small national flags were usually signed by family and friends with inscriptions wishing the soldier safety, good fortune, and victory.

new suicide weapon, which the Japanese called *oka* ("cherry blossom") and Americans familiar with Japanese slang dubbed *baka* ("idiot"). A small piloted rocket plane released from the belly of a bomber and packed with TNT, it plowed into ships at speeds of more than 500 miles per hour. In mid-April, the destroyer *Mannert L. Abele* was struck by a rocket plane shortly after being hit by a kamikaze and sank within minutes. The destroyer *Laffey*, blasted by six kamikazes a few days later, was left a smoldering wreck but managed to stay afloat. In May, Vice Adm. Marc Mitscher's flagship, the aircraft carrier *Bunker Hill*, barely survived twin strikes by kamikazes that killed or wounded six hundred crewmen. The attack came out of the blue "like summer lightning without any warning rumble of thunder," a reporter wrote, and left the flight deck looking like "the crater of a volcano."

U.S. forces on shore, meanwhile, were locked in a ferocious battle as they challenged Japanese forces deeply entrenched on ridges and hilltops and bolstered by heavy artillery. "Progress was being measured in yards, then feet," recalled Manchester. It was "Iwo Jima all over again, but to the nth degree." As the Americans bogged down, General Ushijima launched a futile counterattack in early May that left six thousand Japanese soldiers dead within a few days. General Buckner then renewed his advance, but progress remained painfully slow amid drenching rains. Marines who clambered up the muddy slopes of heavily

Father's Loss Marine Col. Francis Fenton, an engineer with the First Marine Division, kneels by the flag-draped body of his 19-year-old son, Pfc. Michael Fenton, a scout-sniper who was killed in action on May 7, 1945, while serving with the First Battalion, Fifth Marine Regiment, on Okinawa.

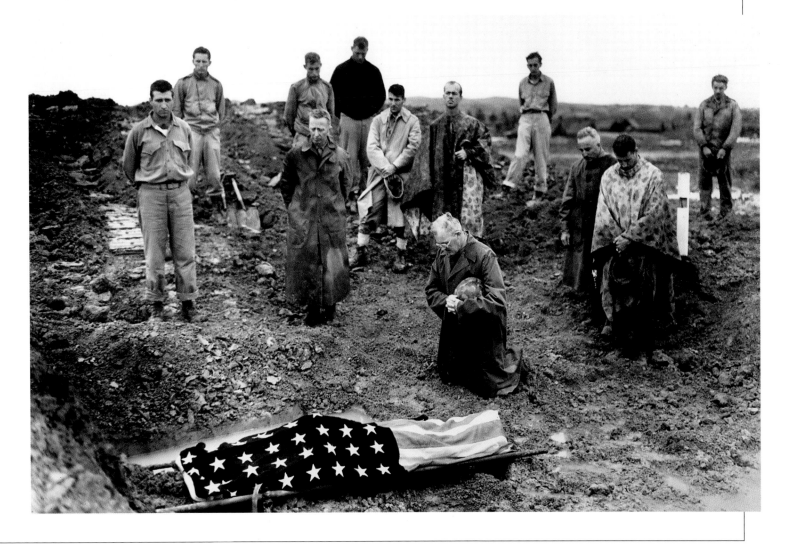

defended Sugar Loaf Hill were beaten back repeatedly. "We made eleven thrusts up that hill," reckoned Sgt. Mike Goracoff, "and fell back each time with most of our boys dead or missing." Neither side in this fiercely contested sector was able to remove their dead while the fighting lasted. "We threw mud on the corpses with our entrenching tools," one Marine recalled, but "shells came in and blew the corpses apart. There were body parts all over the place. We called it 'Maggot Ridge.' "

By late May, U.S. forces had secured that ridge and Sugar Loaf Hill and were targeting Shuri Castle, where Ushijima had his headquarters. Having lost more than half his troops, he fell back to a shorter defensive line near the southern tip of Okinawa and fought to the bitter end like General Kuribayashi on Iwo Jima. Many civilians died in that war zone before Ushijima committed hara-kiri in late June and the last of his troops took their own lives or surrendered. More than 170,000 Japanese and Okinawans perished in this calamitous battle, which left 12,000 American sailors and soldiers dead—including General Buckner, one of the highest ranking Americans killed in the war—and brought the total number of U.S. casualties on Iwo Jima and Okinawa to 80,000. Based on that steep toll, it was estimated that conquering Japan's home islands could cost as many as a million American casualties. "Victory was never in doubt," said Maj. Gen. Graves Erskine of the Marine Corps, which had paid a heavy price in the Pacific and faced ever greater sacrifices as it closed in on Japan. "What was in doubt, in all our minds," he added, "was whether there would be any of us left to dedicate our cemetery at the end, or whether the last Marine would die knocking out the last Japanese gun and gunner."

BOMBING JAPAN INTO SUBMISSION

By the time fighting ended on Okinawa, B-29 bombers had been blasting Japan's major cities with incendiaries for more than three months. That campaign began in earnest on March 9 when more than 300 B-29s took off from the Marianas for Tokyo. To maximize their impact, General LeMay stripped the Superfortresses of nearly all their guns and gunners and reduced the fuel load, enabling each aircraft to carry twice the usual bomb load. They would need less gas because they would not be flying in thin air at high altitudes. They would approach Tokyo just a mile or two above the ground, which would increase the accuracy of bombing but also make the B-29s more vulnerable to antiaircraft fire. "We'll get the holy hell shot out of us," one airman predicted, but LeMay shrewdly calculated that Japanese gunners would be surprised by the low-level raid and would have difficulty hitting his fast-moving bombers at night.

Pathfinder planes reached Tokyo around midnight and dropped napalm canisters that marked the target area with a blazing "X." Then each succeeding B-29 added fuel to the fire by dropping up to six tons of incendiaries. A brisk wind fanned the flames, which spread quickly across a city made up largely of wooden buildings. Soon downtown Tokyo was engulfed in a monstrous firestorm. "This blaze will haunt me forever," said one pilot. "It's the most terrifying sight in the world and, God forgive me, it's the best." Down below, terrified civilians prayed in vain for deliverance. Robert Guillain, a French journalist, described their plight: "In the dense smoke, where the wind was so hot it seared the lungs, people struggled, then

"In the dense smoke, where the wind was so hot it seared the lungs, people struggled, then burst into flames where they stood."

ROBERT GUILLAIN, DESCRIBING THE FIREBOMBING OF TOKYO IN MARCH 1945

burst into flames where they stood." Thousands of men, women, and children sought refuge in the city's canals, but the water was "so hot that the luckless bathers were simply boiled alive," reported Guillain, who called the blaze "a real inferno out of the depths of hell itself." The official death toll in Tokyo was nearly 84,000, surpassing the number killed in Dresden or other German cities set ablaze by Allied bombers as the war in Europe drew to a close.

Civilian losses in later firebombings of Japanese cities were not as steep, in part because some urban areas were evacuated. Within a few months, however, LeMay's campaign devastated the Japanese populace, leaving more than ten million people homeless, and gutted Japanese industry, which relied heavily on small factories and workshops that were heavily damaged when the fires spread. By June 1945, the prime targets on LeMay's list had been bombed out, and he began targeting smaller cities. Several were placed off-limits to his 20th Air Force. One was Kyoto, which was spared because of its historic significance. No reason was given to airmen for setting aside four other cities, including Hiroshima and Nagasaki. Nor were they told the purpose of a new unit called the 509th Composite Group, which arrived on Tinian in June and trained in B-29s for a secret mission. Only the commander of that group, Col. Paul W. Tibbets, and a few other officers knew that their mission was to deliver an atomic bomb. Tibbets was told that it would detonate with the destructive force of 20,000 tons of TNT—roughly twice the tonnage of all the bombs dropped by hundreds of B-29s on Tokyo on that catastrophic night in March. "That's going to be a damn big explosion," he replied.

The atomic bomb was six years in the making. In August 1939, renowned physicist Albert Einstein sent a letter to President Roosevelt warning that German scientists were seeking ways of triggering "a nuclear chain reaction in a large mass of uranium," a process that could

Blast Site Above, Maj. Gen. Leslie Groves, director of the top-secret Manhattan Project, stands beside physicist Robert Oppenheimer at Ground Zero in Alamogordo, New Mexico, where the atomic bomb developed by Oppenheimer's team was tested on July 16, 1945, reducing the tower that held the bomb to twisted steel rods. Below are three pictures of that blast taken through a telephoto lens during the first tenth of a second *(upper row)* and three pictures taken through a normal lens between the first second and the sixteenth second *(lower row)*.

.006 second

.025 second

.100 second

1 second

8 seconds

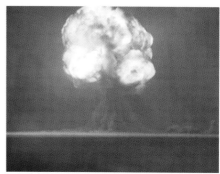
16 seconds

result in "extremely powerful bombs." Roosevelt decided that something must be done "to see that the Nazis don't blow us up." If a superbomb was indeed possible, America would have to build one before its enemies did. A government committee was established to fund nuclear research, much of it conducted initially at Columbia University in New York. That inspired the code name Manhattan Project for what became a huge, nationwide effort after the U.S. entered the war. The top-secret program, supervised by Gen. Leslie Groves, involved processing uranium to produce two isotopes: uranium-235 and plutonium-239. Both were highly fissionable, meaning that they could be used to fuel nuclear chain reactions, during which atoms would split apart and release vast amounts of energy. A team of scientists at Los Alamos, New Mexico, led by physicist Robert Oppenheimer designed a bomb that would compress nuclear fuel into a critical mass and trigger an explosive chain reaction.

As Oppenheimer's team prepared to test that bomb in July 1945, President Harry S. Truman—who learned about the Manhattan Project only after he was sworn in following Roosevelt's death in April—debated with advisors whether to issue a warning and urge Japan to surrender before deploying the weapon. Some officials believed that Japan would soon yield without being subjected to a nuclear attack if the U.S. modified its demand for unconditional surrender to allow Hirohito to remain as emperor. Before Truman met with other Allied leaders at Potsdam, Germany, in mid-July, Assistant Secretary of War John

> **"We call upon the government of Japan to proclaim now the unconditional surrender of all Japanese armed forces... The alternative for Japan is prompt and utter destruction."**
>
> Proclamation issued at Potsdam by President Harry Truman and other Allied leaders

McCloy drafted a proclamation that laid out strict terms for Japan's surrender, including complete disarmament, war crimes trials, and military occupation, but promised that those occupying forces would be "withdrawn as soon as there has been established a peacefully inclined and responsible government," which could include "a constitutional monarchy under the present dynasty." Truman preserved the pledge to withdraw forces from Japan when a peaceful government was in place, but eliminated any reference to a constitutional monarchy under Hirohito, who had approved Japanese aggression and would be allowed to remain on the throne after his country was defeated only as a ceremonial figure with no real power. The official proclamation that Truman and other Allied leaders issued at Potsdam concluded with a stern warning: "We call upon the government of Japan to proclaim now the unconditional surrender of all Japanese armed

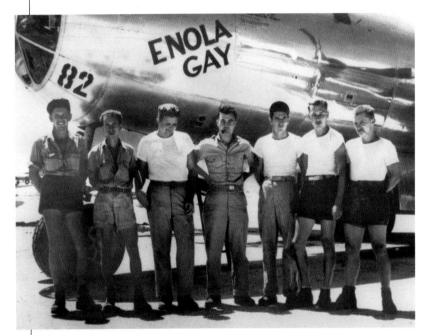

Destined for Hiroshima Col. Paul Tibbets (center), pilot of the B-29 *Enola Gay*, stands with his ground crew on Tinian Island in July 1945, a few weeks before he piloted this Superfortress over Japan and dropped the atomic bomb called "Little Boy" on Hiroshima.

forces ... The alternative for Japan is prompt and utter destruction."

Truman was at Potsdam when a veiled message arrived there signaling that an atomic bomb had been tested successfully in the desert near Alamogordo, New Mexico, before dawn on July 16: "Operated on this morning, diagnosis not yet complete but results seem satisfactory and already exceed expectations ... Dr. Groves pleased." A week later, Truman told Stalin that the U.S. had "perfected a very powerful explosive which we are going to use against the Japanese, and we think it will end the war." Stalin replied that he hoped America would "make good use of it against Japan." In fact, he already knew of the Manhattan Project, which

Nuclear Warfare At right, a mushroom cloud rises nearly 30,000 feet above Hiroshima in a photograph taken from the *Enola Gay* when it circled back to record the impact of the atomic bomb dropped there on August 6, 1945. The hands of this wristwatch were fused there at the moment of the blast—8:16 a.m. As shown below, the explosion leveled downtown Hiroshima, leaving only portions of a few reinforced-concrete buildings standing.

"My God, what have we done?"

CAPT. ROBERT LEWIS, COPILOT OF THE *ENOLA GAY,* OVER HIROSHIMA

had been penetrated by Soviet spies whose disclosures would help the U.S.S.R. produce its own nuclear weapons.

By the time the conference ended on August 2, Japan had dismissed the surrender terms and Truman had authorized the 20th Air Force to deliver its "first special bomb." As he wrote later: "I regarded the bomb as a military weapon and never had any doubt that it should be used." No alternative means of ending the war other than easing the surrender terms appeared less horrific. LeMay predicted that six more months of conventional strategic bombing would force Japan to surrender, but that meant destruction on a scale that might rival if not surpass the use of the two nuclear weapons that were ready for delivery.

Second Strike A mushroom cloud rises over Nagasaki, Japan, in a photo taken from the outskirts of the city moments after an atomic bomb dubbed "Fat Man" descended from a B-29 piloted by Maj. Charles Sweeney and exploded over the city on August 9, 1945.

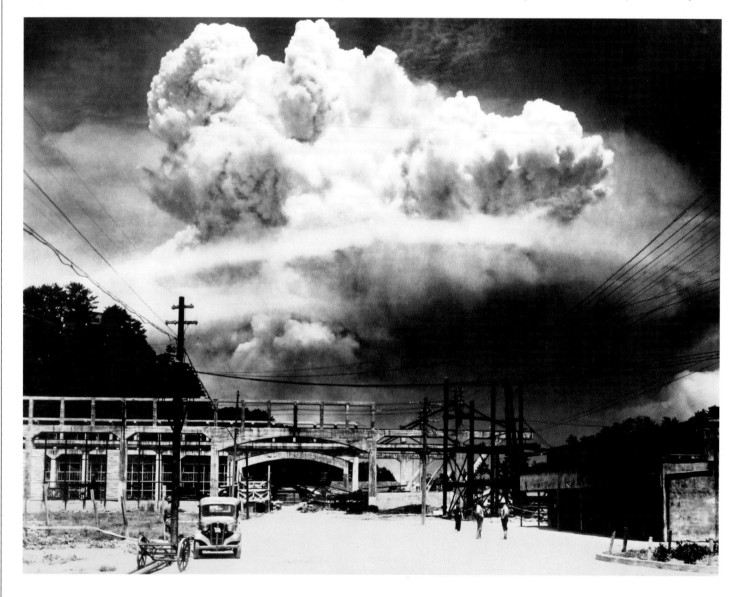

An invasion of Japan's home islands threatened to be costlier in lives on both sides than any punishment inflicted on that country from the air.

Several hours before dawn on August 6, 1945, Colonel Tibbets and his crew took off from Tinian in his B-29. Christened *Enola Gay* for his mother, it carried a single, 9,000-pound bomb dubbed "Little Boy," fueled with uranium-235. Capt. William Parsons of the U.S. Navy armed the bomb after takeoff to avoid a catastrophe if the plane crashed on Tinian. Hiroshima was the primary target, and clear skies there ensured that the city and its 245,000 inhabitants would not be spared in favor of a secondary target. Japan's air defenses were now negligible, allowing Tibbets to approach Hiroshima unchallenged at 31,600 feet and target the city in broad daylight. At 8:15 a.m., Little Boy plummeted from the plane's bomb bay and exploded a minute later in a blinding flash 2,000 feet above the city. Wearing dark goggles to shield their eyes, Tibbets and his crew saw a mushroom cloud billow from the lurid fireball and felt a violent shock wave rock their plane. "The city we had seen so clearly in the sunlight a few minutes before was now an ugly smudge," recalled Tibbets. "My God," said his copilot, Capt. Robert Lewis, "what have we done?"

In Hiroshima, a thermal blast hotter than the surface of the sun, followed seconds later by a supersonic shock wave, killed nearly everyone within a half mile of Ground Zero and leveled most buildings within a mile or two. Kinue Tomoyasu, a 44-year-old widow who lived three miles from where the bomb fell, saw a dazzling light, which she described as "a thousand times brighter than a camera flash bulb," and was knocked to the floor unconscious. When she came to, she went in search of her daughter—who had gone to work that morning in downtown Hiroshima—and came upon a stricken girl who was naked and whose skin was peeling off. She was calling for her mother and begging for water. "I thought she might be my daughter, but she wasn't," said Tomoyasu. "I didn't give her any water. I am sorry that I didn't, but my mind was full, worrying about my daughter." Prevented from a crossing a bridge into downtown Hiroshima, Tomoyasu was returning home when "the black rain started falling from the sky." That radioactive fallout burned her exposed skin as she ran for shelter. Late that night, she learned of her daughter's whereabouts and found her near death, so disfigured that she was recognizable only by her voice. "Her face looked terrible," her mother recalled. "She still appears in my dreams like that sometimes." She was one of more than 100,000 people who perished in the explosion or soon after. Tens of thousands fell ill later from exposure to radiation, as Tomoyasu did, many of whom died or never fully recovered.

On August 9, a second atomic bomb, fueled with plutonium-239, was dropped on Nagasaki, which had about 200,000 inhabitants but suffered roughly half as many casualties as Hiroshima because the bomb did not explode over the most densely populated area. Most of the victims in both cities were civilians—as were at least 25 million of the 50 million or more people killed in World War II. On the same day Nagasaki was bombed, Soviet forces entered the conflict against Japan. Its fate was sealed, but some war leaders

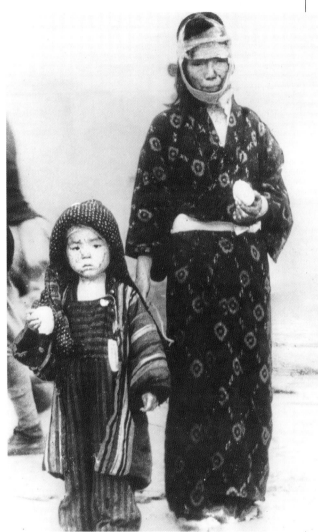

Seared Survivors An injured mother and her son hold boiled rice balls given them by emergency workers the day after Nagasaki was bombed. Photographer Yosuke Yamahata recorded this and other images of the destruction and suffering in his city on August 10, 1945. "It was truly a hell on earth," wrote Yamahata, who was relieved that Japanese authorities finally admitted defeat after this attack and did not use his photographs "in one last misguided attempt to rouse popular support for the continuation of warfare."

> ## "We have had our last chance. If we do not devise some greater and more equitable system, Armageddon will be upon us."
>
> GEN. DOUGLAS MACARTHUR,
> AFTER JAPAN FORMALLY SURRENDERED

in Tokyo remained defiant. When Prime Minister Kantaro Suzuki proposed accepting the terms laid out at Potsdam, Japan's war minister, Gen. Korechiki Anami, protested. "Who can be 100 percent sure of defeat?" he said. "We certainly can't swallow this proclamation."

Finally, Emperor Hirohito overruled the militants who sought to prolong Japan's hopeless struggle and prevailed on the Cabinet to accept defeat. "I cannot bear to see my innocent people suffer any longer," he said. On August 15, following a failed coup attempt against Suzuki by militants who hoped to pressure the emperor into backing down, Hirohito announced that the government was surrendering to prevent the "ultimate collapse and obliteration of the Japanese nation."

The end of the largest and most destructive war ever waged was a joyous moment for some people and a somber one for others. Soldiers on Okinawa who were preparing to invade Japan received the news "with quiet disbelief coupled with an indescribable sense of relief," recalled Eugene Sledge of the First Marine Division. "Except for a few widely scattered shouts of joy, the survivors of the abyss sat hollow eyed and silent, trying to comprehend a world without war."

General MacArthur, who joined Admiral Nimitz in accepting Japan's formal surrender on September 2, spoke for millions when he expressed his hope that "a better world shall emerge out of the blood and carnage of the past." Afterward, he warned that rival powers could no longer afford to resort to armed conflict as the ultimate solution to their disputes. "The utter destructiveness of war now blots out this alternative," he declared. "We have had our last chance. If we do not devise some greater and more equitable system, Armageddon will be upon us."

Victors and Vanquished Gen. Yoshijiro Umezu, chief of the Imperial Japanese Army General Staff, signs the surrender document before General MacArthur *(standing at right, facing Umezu)* during a ceremony held aboard the U.S.S. *Missouri* in Tokyo Bay that formally ended the war between the Allies and Japan on September 2, 1945.

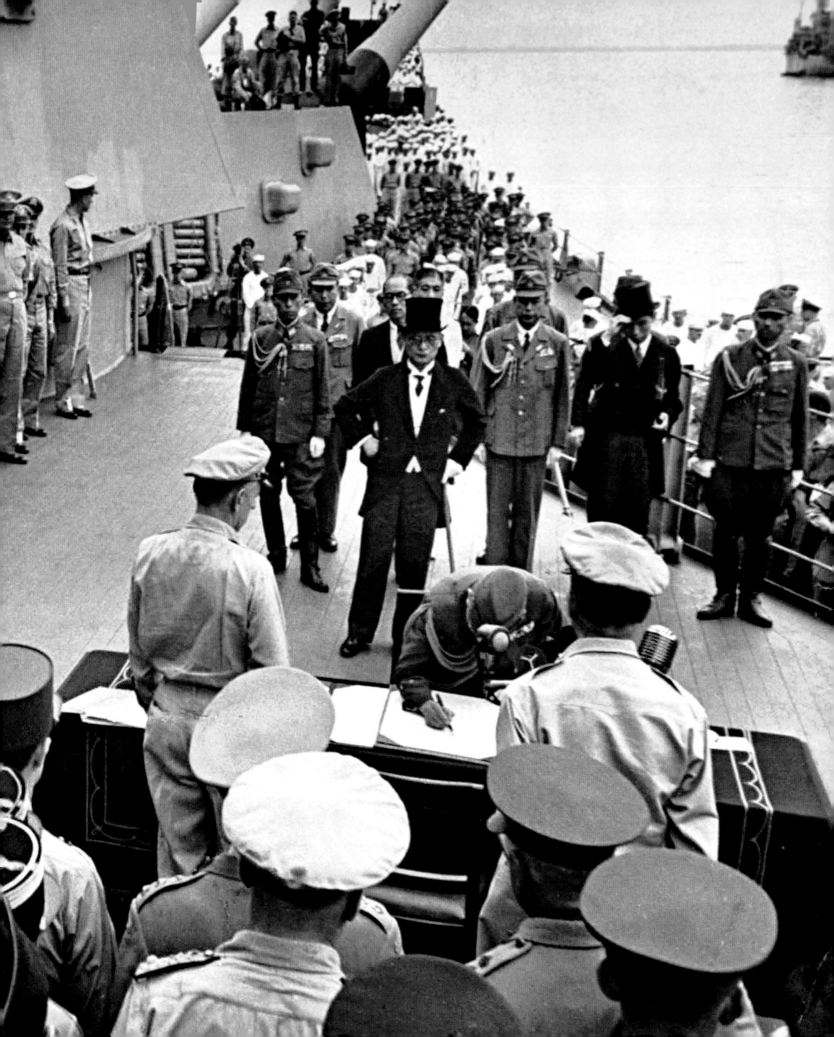

Ambrose, Hugh. *The Pacific.* New York: NAL Caliber, 2010.

Ambrose, Stephen. *Band of Brothers: E Company, 506th Regiment, 101st Airborne, from Normandy to Hitler's Eagle's Nest.* New York: Simon & Schuster, 1992.

Astor, Gerald. *The Greatest War: Americans in Combat, 1941–1945.* Novato, Calif.: Presidio Press, 1999.

Atkinson, Rick. *An Army at Dawn: The War in North Africa, 1942–1943.* New York: Henry Holt, 2002.

———. *The Day of Battle: The War in Sicily and Italy, 1943–1944.* New York: Henry Holt, 2007.

Bastable, Jonathan. *Voices from D-Day.* Cincinnati: David & Charles, 2004.

Bix, Herbert P. *Hirohito and the Making of Modern Japan.* New York: Perennial, 2001.

Costello, John. *The Pacific War, 1941–1945.* New York: Harper Perennial, 2009.

De Lee, Nigel. *Voices from the Battle of the Bulge.* Cincinnati: David & Charles, 2004.

D'Este, Carlo. *Eisenhower: A Soldier's Life.* New York: Henry Holt, 2002.

Miller, Donald L., and Henry Steele Commager. *The Story of World War II.* New York: Simon & Schuster, 2001.

Overy, Richard. *Russia's War.* London: Allen Lane, 1998.

Rees, Laurence. *WWII Behind Closed Doors: Stalin, the Nazis and the West.* New York: Vintage Books, 2010.

Roberts, Andrew. *The Storm of War: A New History of the Second World War.* New York: HarperCollins, 2011.

Sewell, Patricia, ed. *Healers in World War II: Oral Histories of Medical Corps Personnel.* Jefferson, N.C.: McFarland, 2001.

Thomas, Evan. *Sea of Thunder: Four Commanders and the Last Great Naval Campaign, 1941–1945.* New York: Simon & Schuster, 2006.

Time-Life Books, eds. *World War II.* 39 vols. Alexandria, Va.: Time-Life Books, 1976–1983.

Toland, John. *The Rising Sun: The Decline and Fall of the Japanese Empire, 1936–1945.* New York: Modern Library, 2003.

Travers, Paul Joseph. *Eyewitness to Infamy: An Oral History of Pearl Harbor.* Lanham, Md.: Madison Books, 1991.

Weintraub, Stanley. *15 Stars: Eisenhower, MacArthur, Marshall—Three Generals Who Saved the American Century.* New York: NAL Caliber, 2008.

Boldface indicates illustrations. If illustrations are included within a page span, the entire span is **boldface.**

A

Aachen, Germany 287
Abrams, Creighton 289–290
Abwehr (German military intelligence) 148, 262
African Americans
 industrial workforce 78, **79**
 military service 66, **169**, 172
Afrikakorps 124, **124–125, 126, 127, 129**
 see also Panzer tanks
Ahrens, Kenneth 288
Akagi (Japanese aircraft carrier)
 Battle of Midway 107, 108–109, **109,** 110, 113, 117
 Pearl Harbor attack 50
 telegrapher 98
Alamogordo, New Mexico **337,** 338
Aleutian Islands 105, **106,** 107
Alexander, Harold
 Italian mainland campaign 171, 177
 North African campaign 130, 144–145
 opinion of American soldiers 147
 Sicily invasion 148, 151, 155, 157
Allen, Terry 155
Allied alliance
 internal conflict 139–140, 157
 Potsdam conference 338, 340
 Tehran conference **167,** 167–168, 171
 Yalta Conference 292–294
 see also specific battles and combat locations
Amache internment camp, Colorado 95
American Red Cross 76
Anami, Korechiki 342
Anders, Wladyslaw 172
Anderson, Kenneth 147
Antwerp, Belgium 282, 284, **284**
Anzio, Italy **172,** 176
Ardennes (region), Luxembourg 20, 282, 287, 288, **288**
Arizona, U.S.S. **52,** 55–56, 57, **57**
Army Corps of Engineers 96–97
Army Nurse Corps 74
Arnim, Hans-Jürgen von 145, 150
Arnn, Roy 270
Arnold, Henry "Hap" 310
Astoria, U.S.S. 117, 195
Atago (Japanese ship) 313
Atlantic, Battle of the 232–241
Atomic bombs
 development 310, 337–338
 German efforts 337–338
 Hiroshima bombing 311, **339,** 341
 Nagasaki bombing 311, **340,** 341, **341**
 testing **337,** 338
Auchinleck, Claude 124, 130
Augusta, U.S.S. 135–136
Auschwitz-Birkenau concentration camp, Poland 300, **301**

Auschwitz concentration camp, Poland 166, **166,** 300, **302,** 303, 304
Austria, annexation by Germany 16
Avro Lancaster bomber **244,** 245
Axis alliance 14, 31
 see also specific battles and combat locations

B

B-17 Flying Fortress **64–65,** 246, **246, 247**
B-24 Liberators 246
B-25B Mitchell bombers **100,** 100–101, 212
B-29 bomber **231,** 309, 310, 322, 324, 336
 see also Enola Gay
Ba Maw 87
Babi Yar, Ukraine 298
Badoglio, Pietro 160
Baker, Irvan 329
Balkans, Axis conquest of 26, 27, **27**
Bardia, Libya 120, **122–123**
Bastogne, Luxembourg 289–291
Bataan, Philippines
 Battle of (1942) 83–85
 Death March 6, 88, **91,** 91–93
 map 87
Baumgarten, Harold 257, 261, 270
Bayerlein, Fritz 277
Beardsley, Charles 158
Beavers, Jim 264–265
Beer, Len 198
Bel Geddes, Norman 109
Belgium, invasion by Germany 20
Belov, Pavel 46
Benton, Thomas Hart 145
Bergen-Belsen concentration camp, Germany 304
Berlin, Germany
 battle for **293,** 294–295, **295**
 bombings 24, 242, 251, 294
 post-war division 293
Berlin, Irving 72
Biak Island, Indonesia 213, **213**
Bingham, Billy 146
Bismarck (German battleship) 232, **236,** 237
Bizerte, Tunisia 140, 150
Bletchley Park, England 142, 143, **143,** 148
Blitz, London, England 24, **24,** 25, **25**
Bluemel, Clifford 88
Bocage 274, **275,** 275–276
Bock, Fedor von 40
Boggess, Charles 289–290
Bombings
 equipment **79,** 246, **247**
 Europe **242–251**
 nighttime **244,** 245, **245**
 precision bombing 245
 skip-bombing 212
 strategic 24, 242, 245, 251, 322
 see also specific places
Bong, Richard 212–213, **213**
Bottcher, Herman 208, 211
Boy Scouts **71**
Boyd, Betty Warwick 142
Boyer, Donald 288

Bradley, Omar
 Berlin advance 294, 295
 Normandy advance **255,** 267, 275, 277
 North African campaign 147, 150
 on Patton 159
 Rhine River advance 294
 Sicily invasion 155, 157, 159
 II Corps command 147, 150
Branham, Felix 270–271
Brasse, Wilhelm 300
Brauchitsch, Walther von 40
Breeding, Mary 291
Brewster F2A-3 Buffalos 108
Britain, Battle of (1940-1941) 24, **24, 25**
British forces
 codebreaking 142
 as prisoners of war 23, **23**
 uniforms and insignia **167**
 see also Royal Air Force (RAF); Royal Navy; specific battles and combat locations
Brodie, Howard 204, **204**
Brooke, Alan 139, 144–145, 253
Browning, Miles 112
Broz, Josip 26
Buchenwald concentration camp, Germany **296–297, 303,** 304
Buckmaster, Elliott 106–107, 114, 115, 117
Buckner, Simon Bolivar, Jr. 334, 335–336
Bulge, Battle of the (1944) **282–292**
Buna, New Guinea 208, 211, 213
Bunker Hill, U.S.S. 332, **332, 333,** 335
Burchinal, David 322
Burma
 Allied campaign 214–215, 216
 Japanese occupation 87
Burns, John 93
Byrnes, James 294

C

Caen, France 272, 274–275, 277
Calais, France 254, 255, 262
California, U.S.S. 61, **61,** 99
Camp O'Donnell, Philippines 91, **91,** 92, 93
Canadian forces
 Aleutian Islands 106
 Atlantic battles 239, **241**
 Dieppe, France 144, **144**
 Italian mainland 172
 Low Countries 284
 Normandy 261, 264, 271–272, 274, 277
Canham, Charles 271
Canopus, U.S.S. 86
Carlson, Evans 199, **200,** 202
Caroline Islands 223, 227
Casablanca, Morocco 136, 144
Cassin, U.S.S. **60,** 61
Cassino, Italy **173,** 176, 177
CBI *see* China-Burma-India (CBI) theater
Cenne, Giuseppe 212
Central Pacific campaign **223–231**
Chaku (Coastwatcher) **203**
Chamberlain, Neville 16, **16**
Chaparuka (Coastwatcher) **203**

Chennault, Claire 214–215, **215**
Cherbourg, France 275
Chewning, Walter **222**
Chiang Kai-shek 14, 214, 215
Chikao, Yasuno **208**
China
 Japanese occupation 14, 218, 220
 struggle for **213–219**
China-Burma-India (CBI) theater **214–220**
Chindits (Indian troops) 217, 218, **218**
Chochalousek, W. G. 110
Cholmondeley, Charles 148
Choltitz, Dietrich von 280, 282
Christensen, Fred **242**
Chuikov, Vasily 186
Churchill, Winston **24**
 Berlin advance 294
 Casablanca meeting 141, **141**
 on codebreakers 142
 confidence in British air power 24
 conflicts with Eisenhower 256
 defiant attitude 24
 Germany bombings 246
 Italian mainland campaign 176, 256
 Japan, war with 35, 61
 on Montgomery 253, 275
 National Geographic maps 200
 North African campaign 120, 124, 130
 as prime minister 24
 Singapore loss 87
 Tehran conference **167,** 167–168, 171
 on U-boat attacks 232
 on wartime deception 262
 Yalta Conference 292–294
 Yugoslavia defenses 26
Cities Service Empire (tanker) 234
Clark, Mark Wayne 160, 163–164, 171, **171,** 174, 176, 177
Clemens, Martin 203, **203**
Coastwatchers 192, 195, 203, **203**
Codes and codebreaking 34, 37
 Bletchley Park, England 142, 143, **143,** 148
 Enigma coding machine 142, **142, 143,** 239, 240
 Midway 98, 99, 105–106, 107
 Navajo code talkers 227, **227**
 Pearl Harbor 98, 99
 prisoners of war 92
 Purple (code) 34, 37, 256
Cologne, Germany 245
Colorado River Relocation Center, Arizona **95**
Colossus (computer) 142, **143**
Combined Operations Headquarters 258
Concentration camps
 death camps 300, **301, 302**
 deportation from Italy 166
 Italian Jews 165
 labor camps 300
 liberation 304
 survivors 296
 transport trains 166, **166**
Connor, Howard 227
Coral Sea, Battle of the (1942) 102, **102, 103,** 105

Corregidor, Philippines 84–85, 86, **86,** 88, **89,** 321
Cota, Norman 271
Coutances, France 275, 277
Cregan, Ruth **70**
Croats, conflicts with Serbs 26
Crotty, Norma 334
Cyr, Rosario 138
Czechoslovakia, German occupation 16, **16**

D

D-Day *see* Operation Overlord
Dace, U.S.S. 313
Dachau concentration camp, Germany 303, **303**
Daladier, Édouard 16
Darby, William 164
Darlan, Jean-François 135–136, 139
Darter, U.S.S. 313
Davis, Benjamin 172
Dawley, Ernest 161
De Gaulle, Charles 23, 139, **278,** 280
Dealey, Samuel 221
Dempsey, David 230
Denniston, Alastair 142
Dieppe, France 144, **144**
Dignan, Art 198, **198**
Distinguished Service Cross (DSC) 211, 213
Dixon, Robert 102
Donahue, Cass **198**
Donahue, James A. 198, **198**
Dönitz, Karl 232, 234, **234,** 237, 240, 295
Donovan, William "Wild Bill" 258, **258**
Doolittle, James **100,** 100–101
Dorsetshire, H.M.S. **236,** 237
Double Cross (XX) Committee 262
Downes, U.S.S. **60**
Draft, U.S. 66, **66**
Drake, Thomas 145–146
Dresden, Germany 251, **251,** 294
DSC (Distinguished Service Cross) 211, 213
Duncan, Ray 329
Dunfee, Bill 264–265
Dunkirk, France 20, **23**
Dutch Harbor, Unalaska Island **106,** 107

E

Eaker, Ira 172, 246, 251
Eastern Front, map 38
Eastern Solomons, Battle of the (1942) 202, **202**
Eden, Anthony **120**
Edgers, Dorothy 34
Edson, Merritt 197
Egypt, battle for 118, 120, 124, 130, **130, 131, 132–133, 147,** 254
Eichelberger, Robert 208, 211, **211,** 320
Einstein, Albert 337–338
Eisenhower, Dwight D.
 as Anglophile 140
 Battle of the Bulge 284, 289
 Berlin advance 294–295
 commendations for WAACs 74
 in concentration camp **304–305**

conflicts with Churchill 256
diplomacy 253
Italian mainland campaign 160
Kasserine Pass, Tunisia 146
leadership 255–256, 277
liberation of Paris 280
on MacArthur 84
on Nazi war crimes 165, 167
North African command 136, **139,** 139–141, 144–145, 147
Operation Anvil 256
Operation Husky 150–151
Operation Overlord 171, 253–258, **255, 264,** 277–278
praise for Resistance 258
silencing Patton 255
Eisiskes, Lithuania 306, **306**
El Alamein, Battle of (1941) 130, **130, 131, 132–133,** 254
Elbe River, Czechoslovakia-Germany **292, 294, 294**
Emmons, Delos 96
Enigma coding machine 142, **142, 143,** 239, 240
Enola Gay **338,** 339, 341
Enterprise, U.S.S. **front endpaper**
 commander 106
 Eastern Solomons 202, **202**
 Gilbert Islands **222**
 Guadalcanal 197
 Midway 49, 105–106, 109–110, 112, 113
 Tokyo attacks 101
Erskine, Graves 336
Espionage 104, **104,** 262
 see also Codes and codebreaking
Ethiopia, invasion by Italy 10, **10**
Europe, bombings **242–251**
Evans, Ernest 317, 319

F

Falaise, France 278–279
Faulkner, Melvin 56
Fecteau, Roland 276
Feldt, Eric 203
Fenigstein, Henryk 297
Fenton, Francis **335**
Fenton, Michael **335**
Feuchtinger, Edgar 274
Fitch, Alva 91–92, 93
Flagg, James Montgomery 66
Fletcher, Frank 106–107, 109, 112, 113, 117, 192, 202
Flory, Robert 263–264
Ford Island Naval Air Station, Oahu, Hawaii 53, **54–55,** 55
Fort Des Moines, Iowa **74,** 75, **75**
Foster, Henry 128
France
 Allied bombings 256
 avoidance of war 16
 declaration of war 19
 German collaborators **279**
 Germans control 20, 23
 liberation poster **282**
 Vichy-based administration 23
Franco, Francisco 13
Frank, Hans 298
Fredenhall, Lloyd 145, 146–147

Free French
 leadership 23
 liberation of France 256, 258, **278,** 280
 North African campaign 139, 174
French Expeditionary Corps 171–172, 174
French Foreign Legion 138, **138**
French Indochina, Japanese occupation 31–32
French Resistance
 D-Day 265
 execution of Nazi collaborators **279**
 liberation of France 256
 liberation of Paris 280
 Operation Overlord 258
 weapons 256, **258, 259**
Friedman, J. C. 270
Friedman, William 34, 256
Fry, Philip 85
Fuchida, Mitsuo **52**
 Midway 108–109, 113
 Pearl Harbor 48–49, 52–53, 55, 59
Fujitani, Yoshiaki 93, 96–97
Fuller, Hurley 287–288

G

Gallagher, William 317
Gambier Bay, U.S.S. 317, 319
Gandhi, Mohandas 218
Gas, poison 14, **14**
Gaulle, Charles de 23, 139, **278,** 280
Gavin, James 151–152
Gay, George **112,** 113, **113**
Geneva Convention 101, 165, **208**
Gentile, Don Salvatore 249
German forces
 equipment 232
 insignia **163, 240**
 weapons **274, 290**
 see also specific battles and combat locations
Germany
 atomic bomb efforts 337–338
 blitzkrieg tactics 19
 Condor Legion 13
 declaration of war against U.S. 63
 Enigma coding machine 142
 League of Nations withdrawal 10
 Nonaggression Pact (1939) 19, 44
 Operation Barbarossa **38**
 post-war divisions 293
 prisoners of war (held by) 23, **23,** 41
 punishment of Italy and Italians 164–165
 see also Hitler, Adolf; SS security forces; U-boat attacks; specific battles and campaigns
Ghormley, Robert 192, 197
Gilbert Islands **222,** 223–224
Gloire (French cruiser) **237**
Goebbels, Joseph 295
Gold Beach, Normandy 261, 271
Gona, New Guinea 208, 211
Goracoff, Mike 336
Göring, Hermann 155
Grabmann, Franz 272, 274
Grashio, Sam 88
Graziani, Rodolfo 118, 120

Great Britain
 avoidance of war 16, **16**
 declaration of war 19, 61
 defense of Greece 26
 see also British forces; Royal Air Force (RAF); Royal Navy; specific battles and campaigns
Greece, invasion by Italy 26
Gross, Royce 221
Groves, Leslie **337,** 338
Guadalcanal **191–199, 202–207**
 body parts as trophies 199, **207**
 casualties **199,** 223
 Coastwatchers 192, 195, 203, **203**
 eyewitness accounts 198, 206
 Japanese defenses 202, 206, **206,** 207
 map 195
 Naval Battle 197, 199, 202, 223
Guam 61, 85, 87, 330, 334
Guderian, Heinz 40–41, **142,** 283
Guernica, Spain **12,** 13
Guillain, Robert 336–337
Gumu (Coastwatcher) **203**

H

HA-19 (Japanese submarine) 37, 72, **73**
Haile Selassie, Emperor (Ethiopia) 10
Halder, Franz 28
Halfaya Pass, Egypt 118, 120, 124
Halleck, Henry 171
Halsey, William "Bull"
 Guadalcanal 197, 199, 203
 Leyte Gulf 312–313, 315, 317, 319
 New Guinea 211–212, 213
 relationship with MacArthur 207
 replacement 106
 retaking of Philippines 320
 South Pacific command 197
 Tokyo bombings 101
Hamburg, Germany **244,** 251
Hansell, Haywood 309, 310
Hara, Yoshimichi 32
Harder, U.S.S. 221
Harding, Edwin 208
Harmon, Ernest 146–147
Harper, Joseph 289
Harris, Arthur 242, 245
Hart, Charles 150
Hashizume, Sato 94
Hawaii, Japanese Americans 93, 96
Hawker Hurricane (British plane) 24
Henderson, Henry Clay 86
Henderson Field, Guadalcanal 192, **194,** 195, 197, 203, 213
Hewitt, Henry 135–136, 155, 163
Heydrich, Reinhard 298, 300
Hills, Henry 290–291
Himmler, Heinrich 41, 298, **298**
Hirano family **95**
Hirohito, Emperor (Japan) **33**
 air raid defenses **35**
 Indochina occupation 35, 38
 Saipan defenses 231
 surrender 332, 338, 342
 V-J Day 308
 war conference (1941) 31–32
Hiroshima, Japan 311, 337, **339,** 341
Hiryu (Japanese aircraft carrier) 107, **111,** 115, 117

Hite, Robert 101, **101**
Hitler, Adolf
 assassination plot 277, 278
 assumption of power 8
 attachment to Aachen 287
 Austria annexation 16
 Axis alliance 159, 161, **256**
 Balkans conquest 26
 Battle of Britain 24
 Battle of the Bulge 282–283, 290, 292
 bunker **294**
 D-Day 265, 274
 death **252**, 294, 295
 declaration of war 63
 France invasion **22**, 23, 280
 health 282
 Holocaust 28, 298, 300
 League of Nations withdrawal 10
 Mediterranean Arena 140
 military decision-making 40
 military service 8
 Normandy defenses 278
 North African campaign 120, 124, 145
 Operation Alaric 159, 160
 Operation Citadel 188
 peace accord (1938) 16
 Poland invasion 8, 19
 rally **8–9**
 refusal to surrender 251
 Rhineland invasion 16
 scorched earth policy 275, 280
 Soviet Union invasion 26, 28, 39–41, 44, 46, 48, 186
 Spanish Civil War 13
 warfare beliefs 8
 Wolf's Lair 40, 277, **277**, 278
 Yugoslavia invasion 26
Hobart, Percy 254
Hobby, Oveta Culp 74, **74**
Hodges, Courtney 284, 294
Holland, invasion by Germany 20
Holocaust **296–307**
 Final Solution 296, 300
 gas chambers 296, 300, **301, 302**
 Lithuania **42**
 relics 307, **307**
 Soviet Union 41
 Ukraine 43, **43**
 victims 296
Homma, Masaharu 85, 91
Hong Kong, invasion by Japan 87
Hopkins, Harry 38
Hornet, U.S.S. **100**, 100, 101, 106, 109–110, **111**, 112, **112**, 113, 197
Höss, Rudolf 300
Hoth, Hermann 188
Howard, John 263, 272
Howard, Tom 322
Hull, Cordell 32, 34, 38
Humphrey, Roy **154**
Hurtgen Forest, Germany 287

I
Ichiki, Kiyano 195, 199
India *see* China-Burma-India (CBI) theater
Indian forces
 CBI theater 214, 217, 218, **218**

Mediterranean Arena 172, 174, 177
 North African campaign 120, **120**
Indianapolis, U.S.S. 227
Ingelsby, Leo 138
Inouye, Daniel 93, 97
Internment camps 94, **94, 95**
Iron Bottom Sound 193, 195
Italian mainland campaign
 Allied forces 160, 171–172, 174
 German defenses 163, 171, 176–177
 map 162
 Salerno, Italy 160–161, 163–165, 167
 Winter Line 171, 176, 177
Italy
 deportation of Jews 165, 166
 invasion of Balkans 26
 invasion of Ethiopia 10, **10**
 invasion of Greece 26
 North African campaign 118
 surrender **134**
 see also Italian mainland campaign;
 Sicily, Allied invasion
Iwabuchi, Sanji 321
Iwo Jima
 Allied assault **4**, 310, 311, **322–330, 326, 327**
 casualties 329, 330
 eyewitness account 329
 Japanese defenses 5, 310, 324, 328–330, **334**
 map 323
 Navajo code talkers 227
 prisoners of war **329**

J
Jackson, Schuyler 289
James, M. E. Clifton **263**
Japan
 air raid defenses **35**
 Axis alliance 31, **256**
 Burma invasion 214
 China invasion 14, 218, 220
 French Indochina occupation 31–32
 Geneva Convention violations 101
 imperialism 87
 Nanking massacre 14, **15**
 overconfidence 99, 105, 193, 195
 poison gas preparations 14, **14**
 prisoners of war (held by) 6, 87–88, **91**, 91–93, 101, **208**
 strategic bombing of 311
 surrender terms 338
 U.S. relations (pre-war) 14, 32
 victory over **308–343**
 war conference (1941) 31
 see also specific battles and combat
 locations
Japanese Americans
 as enemy aliens **93**, 93–97
 internment camps 94, **94, 95**
 military service 93, 95, 96–97, **171**, 217–218
Japanese forces
 codes 98
 good luck flags **334**
 uniforms **49, 108**
Jenkins, James 56

Jews
 deportation to concentration camps 165, 166
 pogroms against 29, **29**, 296
 see also Concentration camps;
 Holocaust
JN-25 (Japanese code) 98
Johnson, Byron 222
Johnson, Ralph 282
Johnston, Philip 227
Johnston, U.S.S. 317, 319
Jonelis, Frank G. 92
Jones, Homer 276–277
Juin, Alphonse Pierre 171–172, 174
Juneau, U.S.S. 202
Juno Beach, Normandy 261, 271–272

K
Kaga (Japanese aircraft carrier) 107, 110, 113, 117
Kagan, Bella **228**, 229
Kagan, Henry 228–229, **229**
Kagan, Leonard **228**, 229
Kakuta, Kakuji 106
Kamikaze 313, **313, 315**, 332, **332, 333**, 334–335
Kasserine Pass, Tunisia 146–147
Kearny, U.S.S. 234
Keegan, John 261
Keitel, Wilhelm 180, 282
Kenney, George 207, 212
Kesselring, Albert 145, 147, 155, 157, 160, 171, 176–177
Khaldei, Yevgeny 295
Kharkov, Soviet Union 188
Kiev, Ukraine 298
Kimmel, Husband 49, 52, 53, 97
King, Edward 91
King, Ernest 191, 197, 207
Kingman, Howard 224
Kinkaid, Thomas 312–313, 315, 317
Kirby, Billy 176
Kirk, Alan 267
Kiska Task Force 106, **106**
Kluge, Gunther von 278–279
Koenig, Pierre 256
Koga, Mineichi 227
Komatsu, Teruhisa 223
Kovshove, Natasha 182
Krause, Edward 265
Kumano (Japanese cruiser) 317
Kuribayashi, Tadamishi 310, 311, 326, 328, 330
Kurita, Takeo 312–313, 315, 317, 319
Kursk, Battle of (1943) 188, **188–189**
Kwoka, Czeslawa 300, **300**
Kyoto, Japan 337
Kyser, Kay 78
Kyushu, Japan 324

L
La Hayedu-Puits, France **276**
Laconia (British troopship) 237, **237**
Laffey, U.S.S. 335
Langabaea, Andrew **203**
Laval, Pierre **138**
Lavarack, John 124
Layton, Edwin 97, 98, 99, 105, 107
League of Nations 10

Leckie, Robert 192
Leclerc, Jacques 280
Leese, Oliver 172
Leigh-Mallory, Trafford **255**
LeMay, Curtis **322**, 324, 334, 336, 337, 340
Leningrad, Soviet Union 46, **183, 184**, 185, **185**
Lester, Clarence "Lucky" 170, **170**
Levi, Primo 166, 303
Lewis, Robert 341
Lexington, U.S.S. 49, 102, **102, 103**, 105, **225**
Leyte Gulf, Battle of (1944) 309, **311–319**
Liscome Bay, U.S.S. 59, 224
List, Wilhelm **26**
Lithuania, Holocaust **42**
Livorno, Italy **251**
Lockard, Joseph 53
Lockheed P-38 Lightning fighter 212–213, **213**
Lockwood, Charles 220–221, 230
London, England
 Blitz 24, **24**, 25, **25**, 245
"Loose Lips" poster 104, **104**
Lovat, Lord 272
Love, John 91
Lucas, John 176–177
Lunghi, Hugh 293–294
Luxembourg
 Allied advance 20, 287, **288**, 288–291, 292
 German invasion 20
Luzon (island), Philippines 87, 91, 320
Lviv (Lvov), Soviet Union 29, **29**, 299, **299**
Lynch, Thomas 213
Lyons, Tommy **288**

M
Mabry, George 275
MacArthur, Arthur 84
MacArthur, Douglas **85**
 awarding Medal of Honor 212–213
 character 84, 211, 320
 hat and pipe **84**, 85
 "I shall return" pledge 88
 Japan's surrender 342, **342–343**
 New Guinea campaign 191, 207–208, 211–213
 Philippines command 61, 83–85, 88
 relationship with Halsey 207
 retaking Philippines 309–322
 V-J Day 308
Madrid, Spain 12, **13**
Maginot Line 20
Maguire, Dorothy 76, **76–77**
Majdanek, Poland **301**
Makin Atoll, Gilbert Islands **222**, 224
Malay Peninsula, Japanese advance 61
Malaya, Japanese occupation 87
Malmédy, Belgium 288
Manchester, William 334, 335
Manhattan Project 310, 337–338, 340
Manila, Philippines 83–85, 319–322, **320**
Mannert L. Abele, U.S.S. 335
Mannheim, Germany **250**
Manstein, Erich von 41, 186, 188

Manzanar Relocation Center, California **94, 95**
Mao Zedong 214
Maps
 Bataan, Philippines 87
 Battle of Leyte Gulf 312
 Battle of Midway 107
 Battle of the Coral Sea 102
 Battle of the Philippine Sea 225
 D-Day 268–269
 Eastern Front 38
 Guadalcanal 195
 Iron Bottom Sound 195
 Italian mainland campaign 162
 Iwo Jima 323
 Japanese air assault on Oahu 49
 Mediterranean Arena 141
 National Geographic 200–201
 Operation Barbarossa 38
 Operation Husky 150
 Operation Overlord 264
 Pearl Harbor 37, 49, 58
Marcks, Erich 265
Mareth Line, Tunisia 146, **146**
Mariana Islands **223–225, 227–231, 230**
Marriages and relationships 68, **68, 69**
Marseilles, France 23, **23,** 279–280
Marshall, George
 as chief of staff 168, 171
 and Eisenhower 139, 145
 interservice rivalries 207
 Japanese attack threat 34–35
 and MacArthur 84–85, 88
 Mediterranean campaign 139–140
 Operation Overlord 168, 171
 on Oshima as informant 256
 Sicily invasion 141, 144
Marshall Islands 223, 225
Martin, William *see* Michael, Glyndwr
Matsumoto, Roy 218
Matsuo, Isao 313
Matsushita, George 95
Mauldin, Bill 155, 156, **156**
Mayo, U.S.S. 160
McAuliffe, Anthony 289–290
McClintock, David 313
McCloy, John 338
McClusky, C. Wade 110, **110,** 113
McKennon, William 197
McMillan, Oden 53, 55
McNeely, Carlton 275
McQuillin, Raymond 145–146
Mead, Harry 53
Medal of Honor 212–213, **213,** 221, 330
Mediterranean Arena **134–177**
 see also North African theater
Merchant ships *see* Atlantic, Battle of the
Merrill, Frank 217, 218
Merrill, Herbert 108
MI-5 (British counterintelligence) 148, 262
Michael, Glyndwr 148, **148**
Middleton, Troy 287
Midway, Battle of (1942) **105–117**
 codebreaking 98, 99, 105–106, 107
 eyewitness account 110, 114
 map 107
 newspaper account **82**
Mikuma (Japanese cruiser) 107, **111**

Millen, Bill 272
Miller, Doris "Dorie" **59**
Mindanao (island), Philippines **321**
Minidoka internment camp, Idaho 94
Minneapolis, U.S.S. **103, 222**
Missouri, U.S.S. **342–343**
Mitscher, Marc **100,** 225, 227, 230, 335
Mitsubishi Zeros 108, **109,** 113, 230, 332
Miwa, Yoshikawa 105
Mizocz, Ukraine **299**
Model, Walter 283–284
Montagu, Ewen 148
Montgomery, Bernard "Monty" **263**
 Battle of the Bulge 284
 Caen campaign 274–275
 on Eisenhower 139
 El Alamein 254
 Italian mainland campaign 160, 173
 Normandy invasion 277
 North African campaign 130, **130,** 136, 139, 142, 150
 Operation Overlord 253–254, **255,** 262, 263, 272
 personality 253
 Sicily invasion 150–151, 155, 157
Morell, Theodore 282
Morimura, Tadashi *see* Yoshikawa, Takeo
Morris, James 289
Morriss, Mack 204
Moscow, Soviet Union 39–40, **44,** 45–46, **47**
Mountbatten, Lord Louis 149, 258, **258**
Murata, Shigeharu 53
Murrow, Edward R. 24, 61, 139
Musashi (Japanese battleship) 312, 315
Mussolini, Benito 160, **161**
 collapse 159–161
 disdain by Italians 155
 execution 161
 on horseback **11**
 invasion of Ethiopia 10
 invasion of Greece 26
 North African campaign 118, 120
 overview 10
 as puppet dictator 161
 Spanish Civil War 13
 views on warfare 11
Mydans, Carl 320

N
Nagasaki, Japan 311, 337, **340,** 341, **341**
Nagumo, Chuichi **48**
 Midway 107–109, 112, 113, 117
 Pearl Harbor 33, 48, 50, 53, 59
Namur (island), Kwajalein Atoll 225
Nanking (Nanjing), China 14, **15**
Naples, Italy **164,** 164–165
National Geographic Society
 wartime maps 200–201
Nautilus, U.S.S. 113, 117
Navajo code talkers 227, **227**
Navy Cross recipients **59,** 110, **110**
Navy Nurse Corps 74
Nawrocki, Ben 287
Nazis
 collaborators **279**
 pogroms 29, **29**
 storm troopers **8–9**

supremacism 28
 see also SS security forces
Neame, Philip 124
Neosho, U.S.S. 102
Nevada, U.S.S. **52,** 53, 55
New Georgia 212
New Guinea campaign **207–213**
Neyer, Avraham **298,** 299
Nimitz, Chester
 Central Pacific campaign 223–225, 227–231
 Guadalcanal 200, **200**
 intelligence staff 98, 99–102, 105, 107
 interservice rivalries 207
 Iwo Jima 330
 Japan's surrender 342
 Life magazine portrait **97**
 Midway 98, 101–102, 105–108, 113, 117
 Okinawa invasion 310, 334
 Pacific Fleet command 97, 99–102, 105, 197
 retaking Philippines 312
 Saipan advance 223–225, 227–231
 Solomons campaign 223
Nishimura, Shoji 313, 315
Nomura, Kichisaburo 38
Nonaggression Pact (1939) 19, 44
Norfleet, Willard 270
Normandy (region), France *see* Operation Overlord
North African theater 118–133
 see also Mediterranean Arena
Norway, German invasion 20, **20–21**

O
O'Connor, Richard 120, 124
Office of Strategic Services (OSS) 258, **258**
Ohrdruf concentration camp, Germany **304–305**
Okinawa
 Allied assault 311, 324, **330–336**
 casualties 6, **7, 335,** 336
 kamikaze attacks 332, **332,** 334–335
 Yellow Beach **330–331**
Oklahoma, U.S.S. 50, **51,** 55, 56
Olbricht, Friedrich 277
Oldendorf, Jesse 315
Olorere (Coastwatcher) **203**
Olson, John 92
Omaha Beach, Normandy 257, 261, 265
 D-Day landing **266–267,** 267, 268, 270, **270,** 271, **272–273**
 map 268–269
Onishi, Takijiro 332
Operation Alaric 159, 160
Operation Anvil 256, 279
Operation Avalanche **163**
Operation Barbarossa 28, 29, **29, 38–47**
Operation Blue 186
Operation Bodyguard 262
Operation Citadel 188
Operation Compass 120, **121, 122–123**
Operation Crusader 124
Operation Drumbeat 234
Operation Fortitude 262, **262**
Operation Husky *see* Sicily, Allied invasion

Operation Market Garden 283, 284, **285**
Operation Mincemeat 148, **148,** 149, **149,** 154
Operation Overlord (D-Day/Normandy invasion) **253–276**
 assault force 254
 casualties 263–264, 265, **270,** 270–271
 deception campaign 255, 262, **262**
 eyewitness account 268
 German defenses 255, **257,** 262, 274, **275,** 275–276
 maps 264, 268–269
 news reports **271**
 Omaha Beach **266–267, 270**
 photoreconnaissance **260–261**
 planning 167–168, **255,** 258
 timing of 167–168, 256–257
Operation Torch 136, **136,** 141
Operation Valkyrie 277
Operation Z 227, 230
Oppenheimer, Robert **337,** 338
Oran, Algeria **137**
Ormoc, Philippines 319, 320
Orschiedt, Helmuth 128
Orwell, George 13
Oshima, Hiroshi 33–34, 256, **256**
Osmeña, Sergio 310
OSS (Office of Strategic Services) 258, **258**
Otus, U.S.S. 86
Outerbridge, William 52–53
Owens, Arthur 262
Ozaki, Hotsumi 40
Ozawa, Jisaburo 225, 315, 319

P
P-51 Mustangs **170, 248,** 249, **249**
Palermo, Sicily, Italy 150, 157, 158, **158,** 159
Pan-American Security Zone 234
Pančevo, Yugoslavia 27, **27**
Panzer tanks 130, **132–133,** 136, **140,** 146
Papageorge, George **213**
Paratroopers
 awkward landings **285**
 D-Day 263–264, **264**
 Operation Husky **151,** 151–152
 "Ruperts" (dummies) 265, **265**
 uniforms **151, 285**
Paris, France 20, **22,** 23, 280, **280–281,** 282
Parsons, William 341
Patton, George S.
 on African Americans 66
 Battle of the Bulge 284, 289–290
 criticism of Eisenhower 140
 eagerness for combat 135, 136
 Italian mainland campaign 163
 Mediterranean Arena 135–136, 139, **139,** 140
 Operation Fortitude 262
 Operation Husky 151
 Operation Overlord 255, 278
 personality 159, 253, 255
 scandals 159, 163
 Sicily invasion 155, 157
 II Corps command 147

Paulus, Friedrich 186, **186**
Peace accord (1938) 16, **16**
Pearl Harbor, attack on **48–61**
 advance warnings 33–34, 52–53
 attack force 32–33, 48, 52–53
 casualties 56, 59, 93
 defenses 52–53
 eyewitness account 57
 maps 37, 49, 58
 newspaper account **30**
 photography 50
 planning model **36**
 spy **36,** 36–37
 vengeance for **99,** 117
Pearl Harbor, cryptanalysts 98, 99
Pennsylvania, U.S.S. **60**
Pennsylvania Sun (American tanker) **235**
Pétain, Philippe 23
Petard, H.M.S. 240
Philippine Sea, Battle of the (1944) 225,
 227, 230
Philippines
 Allied retaking of (1944) 309–322
 army insignia **87**
 battles (1941-1942) 82–93
 eyewitness account 86
 Japanese bombing (1941) 61
 Japanese propaganda 87–88, **88, 319**
Phraner, George D. 57
Piper, Robert 151–152
Ploesti, Romania 172–173
Pogroms 29, **29**
Poison gas 14
Poland
 codebreakers 142, **142**
 German invasion 8, 19, **19**
 Nazi atrocities 298
 post-war government 293
Pollard, Joseph 114
Port Moresby, New Guinea 101, 105,
 207, 208
Potsdam, Germany 292, 338, 340
Prague, Czechoslovakia 16, **16**
Prince of Wales, H.M.S. 87
Prisoners of war
 coded messages 92
 Corregidor, Philippines 86, **86**
 Dunkirk, France 23, **23**
 held by Japanese 6, 87–88, **91,**
 91–93, 101, **208**
 inhumane treatment 6, 41, 88, **91,**
 91–93, 101, 288
 Iwo Jima **329**
 medical care 291
 North African campaign 120,
 122–123
 number of 23
 Sevastopol, Soviet Union **28,** 29
 Tunisia 146
Propaganda
 American **99, 104, 104,** 145, **145**
 German **41,** 172
 Japanese 50, 87–88, **88, 319**
 Soviet **46, 178, 188**
Pule, Daniel **203**
Purple (code) 34, 37, 256
Purple Heart **113**
Pye, William 49
Pyle, Ernie 150, 154, 276, 334

Q
Quesada, Elwood 274
Quezon, Manuel 84
Quincy, U.S.S. 195, **195**
Quintos, Antonio 61

R
Rabaul, New Britain 207, 213
RAF *see* Royal Air Force (RAF)
Rampley, John 56
Ramsay, Bertram **255**
Rationing and embargoes **70,** 71
Red Cross 76, 92
Rejewski, Marian 142, **142**
Remagen, Germany 294
Rennes, France **279**
Repulse, H.M.S. 87
Reuben James, U.S.S. 234
Rhine River, Europe 291, **291,** 294
Rhineland, German invasion 16
Ribbentrop, Joachim von 256
Ridgway, Matthew 164
Robalo, U.S.S. **80–81**
Robinett, Paul 145, 147
Rochefort, Joseph 98, **98,** 99–100, 105
Roesle, Major 42
Rogers, Lee **320**
Rome, Italy **176,** 177, **177,** 256
Rommel, Erwin 124, **124–125**
 France occupation 20, 23, 254,
 265, 274
 Italy occupation 160
 North African campaign 127, 130,
 136, 145, 146, 147, 150, 254
 suicide 278
 wounding 278
Roosevelt, Franklin D.
 Casablanca meeting 141, **141**
 confidence in Eisenhower 256
 declaration of war 61–63, **62, 63**
 "Europe First" policy 191
 on home front 64
 Japanese threat (pre-war) 14,
 33–35, 38
 letter from Einstein 337–338
 Mediterranean Arena 139
 meeting with MacArthur 310
 National Geographic maps 200
 OSS creation 258
 Pacific theater 88, 97, 191
 Pan-American Security Zone 234
 scrap drive 71
 Tehran conference **167,** 167–168, 171
 on war mobilization 64
 Yalta Conference 292–294
Roosevelt, Theodore 265, 267
Rosenthal, Joe 326, 328, 330
"Rosie the Riveter" 78, **78**
Rotmistrov, Pavel 188
Royal Air Force (RAF) 24, **24,** 167, 242,
 245, **245**
 see also specific battles and combat
 locations
Royal Australian Navy Coastwatchers
 203
Royal Navy 120, 124, 234, 239, **239,** 240
 see also specific battles and combat
 locations
Różycki, Jerzy **142**

Rubber collection 71, **71**
"Ruperts" (dummy paratroopers) 265,
 265
Russell, John 216, **216**
Ryder, Charles 150

S
Saipan **2, 223–231**
 as bombing base 231, **231,** 309
 civilian casualties **226,** 231
 eyewitness account 228
 newspaper account **190**
Saito, Yoshitsugo 230–231
Salerno, Italy 160–161, **163,** 163–165,
 167
Sangamon, U.S.S. **332**
Saratoga, U.S.S. 49, 101
Savo Island, Battle of (1942) 195
SBD Dauntless dive-bombers **111,** 212
Schlieben, Karl Wilhelm von 275
Schlüsselburg, Soviet Union 184, **185**
Schramm, Percy 282
Schuler, Ingrid 292
Schutzstaffel *see* SS security forces
Schwarzwald, Selma 307
Schweinfurt, Germany 249
Scrap collection 71, **71**
Seabees 195, 330
Seawolf, U.S.S. **220**
Selective Training and Service Act
 (1940) 66
Senninbari 95, **95**
Seraph, H.M.S. 148
Serbs, conflicts with Croats 26
Sevastopol, Soviet Union **28,** 29
Shanghai, China 14, **14**
Shaw, U.S.S. **54–55**
Shepard, Charles 328
Shirer, William 256
Shokaku (Japanese aircraft carrier) 51,
 101–102, 105
Short, William 49, 52
Sibert, Franklin **321**
Sicily, Allied invasion **148–159**
 beach landing **152–153**
 casualties **154,** 155
 deception campaigns 148, **148,** 149,
 149, 154
 eyewitness account 158
 German defenses 154–155, 157
 impact on civilians 155, **155**
 map 150
 paratroopers **151,** 151–152
 planning 141, 144
 size of force 154
Sidi Barrani, Egypt 118, 120
Sidi bou Zid, Tunisia 145–146
Siegfried Line *see* West Wall
Siffleet, Leonard **208**
Signal Intelligence Service (SIS) 34,
 38, 256
Singapore 61, 87
Sinske, Horst 251
Skip-bombing 212
Skorzeny, Otto 288
Slaughter, Bob 270
Sledge, Eugene 342
Smith, Donald **230**
Smith, Kate 72

Smith, W. Eugene 6
Smith, Walter Bedell **255**
Smolensk, Soviet Union **29**
SOE *see* Special Operations Executive
Somme River, France 23
Sorge, Richard 40, **40**
Soryu (Japanese aircraft carrier) **51,**
 107, 113
South African troops **121,** 147, 172,
 173, 174
Soviet forces
 atrocities 292
 prisoners of war 41
 uniforms 45, **45,** 167
Soviet Union
 Holocaust 41
 invasion of East Prussia 292
 invasion by Germany 28, **28,** 29, **29,**
 38–47, 178–189
 Nonaggression Pact (1939) 19, 44
 occupation of Poland 19
 propaganda **46, 178, 188**
Spaatz, Carl 246
Spanish Civil War 12, **12,** 13, **13**
Special Attack Corps *see* Kamikaze
Special Operations Executive (SOE)
 258, **258**
Speer, Albert **22,** 23
Spencer, U.S.C.G.C. **232–233**
Spies *see* Codes and codebreaking;
 Espionage
Sprague, Clifton 315, 317, 319
Spruance, Raymond
 Battle of Midway 109, 112–113,
 117
 Central Pacific campaign 225, 227,
 230
 Central Pacific offensive 223–224,
 225
 character 106
SS security forces
 atrocities 41, 42, 43, **43,** 288, 298
 recruitment poster **41**
 uniform **286**
St. Lo, U.S.S. **315,** 319
St.-Lô, France 265, 275, **275,** 277
St.-Vith, Belgium 288, 290
Stage Door Canteen, New York, N.Y.
 76, **76–77**
Stagg, R. M. 256–257
Stalin, Joseph **28**
 Battle of Stalingrad 186
 German invasion of Soviet Union
 44–45
 Manhattan Project knowledge 338,
 340
 Moscow defenses 40, 46
 occupation of Poland 19
 scorched-earth policy 180, **180**
 Spanish Civil War 13
 Tehran conference **167,** 167–168,
 171
 Yalta Conference 292–294
Stalin, Yakov 45
Stalingrad, Battle of (1942-1943) **178–**
 179, 186, **186, 187**
Stark, Alexander 146
Stars and Stripes 156, **156, 157**
Station Hypo, Pearl Harbor 98, 99–100

Stauffenberg, Claus von 277, **277**
Ste.-Mère-Église, France 264–265
Steinbeck, John 161
Stibbard, Geoffrey 92
Stilwell, Joseph **214,** 214–215, 217, 218
Stuka dive-bombers **18,** 19, **127,** 141
Submarine warfare
 Atlantic theater **232–241**
 Pacific theater 220–221, **221,** 223
 wolf packs 221, 232, 234, **235,** 239, 240
Sudetenland, Czechoslovakia 16, 17, **17**
Sullivan brothers 202, **202**
Suribachi, Mount, Iwo Jima **324–325,** 326, **326,** 328
Suzuki, Kantaro 342
Suzuki, Suguru 37
Sweeney, Charles 340
Sword Beach, Normandy 261, 263, 271, 272, 274

T
Tanaka, Raizo 199
Tangermünde, Germany **292**
Tank warfare
 African-American battalion 66
 Ardennes 287–288
 Battle of the Bulge 289–290
 decoy tanks 262, **262**
 Dieppe, France **144**
 Guadalcanal 195
 Mediterranean Arena **140,** 140–141, 145, **146,** 147
 Normandy invasion 154, 254, 270, **272–273,** 274, 277
 North African campaign 118, 120, **132–133**
 Panzer tanks **26,** 130, **132–133,** 136, **140, 146**
 Sicily invasion 155, **158**
 Soviet invasion 39, 46, 188, **188–189**
 U.S. production 78
Tarawa Atoll 224, **224**
Taussig, Joseph 55
Taylor, George 271
Taylor, Maxwell 265
Tébourba, Tunisia **140**
Tedder, Arthur **255**
Tehran, Iran **167,** 167–168, 171
Tibbets, Paul W. 337, **338,** 341
Tinian, Mariana Islands 230, **230,** 231
Tito (Josip Broz) 26
Tobruk, Libya 120, 124, 130
Todd, John **320**
Togo, Heihachiro 48
Tojo, Hideki 31–32, 213–214, 231
Tokyo, Japan
 bombings 100–101, 231, 309, 322, 324, 336–337
Tolischus, Otto 19
Tomonaga, Joichi 108
Tomoyasu, Kinue 341
Toyoda, Soemu 227, 312–313, 315, 319
Tracker, H.M.S. 239, **239**
Tresckow, Henning von 277
Truk (island), Caroline Islands 227
Truman, Harry S. 338, 340
Truscott, Lucian 177, 279

Tulagi, Solomon Islands 192
Tunis, Tunisia 140, 150
Tunisia campaign 140, 141, 144–145, 146, 150
Turing, Alan 142, **143**
Turner, Richmond Kelly **194,** 334
Tuskegee Airmen 170, **170,** 172
Tyler, Kermit 53

U
U-boat attacks
 avoiding through convoys **238–239,** 239
 commanders **232**
 defenses **232–233, 240**
 German casualties 240
 impact on British 232
 Operation Drumbeat 234
 rescue of sailors **236,** 237, **237, 241**
 surface running **235**
Ukraine, German invasion of 41, 42, 43, **43,** 298
Umezu, Yoshijiro **342–343**
Uncle Sam **66**
Underground, London 24, **24**
Uniforms and insignia
 American **56, 88, 136, 154, 168, 223, 285, 328**
 British **167**
 Japanese **49, 108**
 Soviet 45, **45,** 167
United Nations (WWII) 171, 174, **175**
United Service Organizations (USO) 76
United States
 declaration of war 61–63
 home front 64–83
 mobilization for war 64–83
 war production 64, 78, **78,** 79, **79, 80,** 220
 see also specific battles and combat locations
U.S. Army
 growth in numbers 64
 inductee **66**
 nurses **165**
 Parachute Regiment 138
 recruitment poster **66**
 segregation 66
 uniforms and insignia **88, 136, 154, 168**
 see also Army Nurse Corps; Women's Army Corps; specific battles and combat locations
U.S. Army Air Forces 242, **242–243,** 246, **246, 249**
 see also Women Air Force Service Pilots; Women's Auxiliary Ferrying Squadron; specific battles and combat locations
U.S. Marine Corps
 rations **328**
 uniforms **328**
 see also specific battles and combat locations
U.S. Medical Corps **154,** 290–291
U.S. Military Intelligence Service 97
U.S. Navy
 number of sailors 67
 protection of merchant ships 234

 recruitment poster **64**
 segregation 66
 uniforms and insignia **56, 223**
 see also Navy Nurse Corps; Women Accepted for Volunteer Emergency Service; specific battles, combat locations, and ships
U.S. Office of War Information 104, 145
Ushijima, Mitsuru 334, 335, 336
USO (United Service Organizations) 76
Utah Beach, Normandy 261, 263, 265, 267, 274

V
V-1 (missile) 284, **284**
V-2 (missile) 284
V-E Day 295
V-J Day **308, back endpaper**
Vaghi, Joseph 268, **268**
Vandegrift, Alexander 192–193, **194,** 195, 197, 203
Vichy government
 British attacks on 136
 collaboration with Allies 135–136, 139, 171
 collaboration with Axis 135, 138, **138**
 collapse 171
 confined to southern France 23
 governance of French colonies 23
 Mediterranean Arena 135–136
 submarine rescues 237
Victor Emmanuel III, King (Italy) 159–160
Vitebsk, Soviet Union **39**
Vogel, Clayton 227

W
WAAC (Women's Army Auxiliary Corps) 74, **74, 75**
WAC (Women's Army Corps) 74
Wagner, LaVerne 328
Wainwright, Jonathan 84, 91
Wake Island 61, 85, 87
Waldron, John 112, 113
Wannsee, Germany 300
War bonds 72, **72, 73**
War Manpower Commission 80
Ward, U.S.S. 52–53
Warnecke, Bud 276–277
Warsaw, Poland **19,** 298, **298,** 299
WASPs (Women Air Force Service Pilots) 75, **75**
Wavell, Archibald 120, 124
WAVES (Women Accepted for Volunteer Emergency Service) 74
Welchman, Gordon 142, **143**
Wertenbaker, Charles 282
West Virginia, U.S.S. **59**
West Wall (Siegfried Line) 284, 287, 289, 294
Western Desert 118, **121, 126**
Weygand, Maxime 23
Wheeler, Richard 328
White, Harvey **154**
Wiesel, Elie 304
Wilkes Barre, U.S.S. **332, 333**

Willet, U.S.S. 235
Wilson, Henry Maitland 171
Wingate, Orde Charles 217
Winter Line 163, 171–172, 173, 176, 177
Wolf packs (submarine groups) 221, 232, 234, **235,** 239, 240
Wolf's Lair 40, 277, **277,** 278
Women
 industrial labor 64, **68,** 78, **78,** 79, **79,** 182, **183**
 military service 74, **74,** 75, **75, 143,** 182, **182**
Women Accepted for Volunteer Emergency Service (WAVES) 74
Women Air Force Service Pilots 75, **75**
Women's Army Auxiliary Corps (WAAC) 74, **74,** 75
Women's Army Corps (WAC) 74
Women's Auxiliary Ferrying Squadron 75
Women's Royal Naval Service (Wrens) **143**
World War II
 causes 8–29
 remembrances 6
Wrens (Women's Royal Naval Service) **143**

Y
Yalta Conference 292–294
Yamaguchi, Tamon 117
Yamahata, Yosuke 341
Yamakaze (Japanese destroyer) **116–117**
Yamamoto, Isoroku
 Aleutian Islands attack 107–108
 Battle of Midway 105, 106, 117
 death 213
 estimation of American capabilities 32–33, 311
 fleet 101–102, 105
 Pearl Harbor attack 32–33, 48, 59, 61
 retreat 202
 Time magazine portrait **96**
 on Tokyo bombings 101
Yamashiro (Japanese battleship) 315
Yamashita, Tomoyuki **319,** 320, 321
Yamato (Japanese battleship) 312, 313, **314,** 315, 334
Yank (U.S. Army magazine) 204, **204**
Yasuda, Tatsuhide 319
Yorktown, U.S.S.
 Battle of Midway 107, 112, 113, 114, 115, **115,** 117
 Battle of the Coral Sea 102, 105
 transfer from Atlantic Fleet 100
Yoshikawa, Takeo 34, **36,** 36–37
Yugoslavia, resistance to Germany 26, 27, **27**

Z
Zaragoza, Spain 13, **13**
Zeros (Japanese planes) *see* Mitsubishi Zeros
Zhukov, Georgi 46, 178
Zuikaku (Japanese aircraft carrier) 101–102, 105, **225, 316–317,** 319
Zygalski, Henryk **142**

Eyewitness to World War II

Edited by Neil Kagan
Narrative by Stephen G. Hyslop

Published by the National Geographic Society
John M. Fahey, Chairman of the Board
and Chief Executive Officer
Timothy T. Kelly, President
Declan Moore, Executive Vice President;
President, Publishing and Digital Media
Melina Gerosa Bellows, Executive Vice President;
Chief Creative Officer, Books, Kids, and Family

Prepared by the Book Division
Hector Sierra, Senior Vice President and General Manager
Jonathan Halling, Design Director, Books and
Children's Publishing
Marianne R. Koszorus, Design Director, Books
Lisa Thomas, Senior Editor
R. Gary Colbert, Production Director
Susan S. Blair, Director of Photography
Jennifer A. Thornton, Director of Managing Editorial
Meredith C. Wilcox, Director, Administration and Rights Clearance

Created by Kagan & Associates, Inc.
Neil Kagan, President and Editor-in-Chief
Sharyn Kagan, Vice President and Director of Administration

Staff for This Book
Neil Kagan, Editor, Illustrations Editor
Stephen G. Hyslop, Author, Text Editor
Carol Farrar Norton, Art Director
Harris J. Andrews, Historical Consultant, Editor, Eyewitness Accounts;
Contributing Writer
Uliana Bazar, Illustrations Researcher
Maura Walsh, Text Rights and Permissions
Carl Mehler, Director of Maps
Michael McNey, Map Research and Production
Gregory Ugiansky, Map Research and Production
Marshall Kiker, Associate Managing Editor
Judith Klein, Production Editor
Lisa A. Walker, Production Manager
Galen Young, Rights Clearance Specialist

Manufacturing and Quality Management
Phillip L. Schlosser, Senior Vice President
Chris Brown, Vice President, NG Book Manufacturing
George Bounelis, Vice President, Production Services
Nicole Elliott, Manager
Rachel Faulise, Manager
Robert L. Barr, Manager

The National Geographic Society is one of the world's largest nonprofit scientific and educational organizations. Founded in 1888 to "increase and diffuse geographic knowledge," the Society's mission is to inspire people to care about the planet. It reaches more than 400 million people worldwide each month through its official journal, *National Geographic,* and other magazines; National Geographic Channel; television documentaries; music; radio; films; books; DVDs; maps; exhibitions; live events; school publishing programs; interactive media; and merchandise. National Geographic has funded more than 10,000 scientific research, conservation and exploration projects and supports an education program promoting geographic literacy.

For more information, please call 1-800-NGS LINE (647-5463)
or write to the following address:

National Geographic Society
1145 17th Street N.W.
Washington, D.C. 20036-4688 U.S.A.

Visit us online at www.nationalgeographic.com

For information about special discounts for bulk purchases, please contact
National Geographic Books Special Sales: ngspecsales@ngs.org

For rights or permissions inquiries, please contact National Geographic
Books Subsidiary Rights: ngbookrights@ngs.org

Library of Congress Cataloging-in-Publication Data
Eyewitness to World War II : unforgettable stories and photographs from history's greatest conflict / Neil Kagan, Stephen G. Hyslop.
p. cm.
Includes index.
ISBN 978-1-4262-0970-3 (hardcover : alk. paper) -- ISBN 978-1-4262-0983-8 (deluxe)
1. World War, 1939-1945--United States. 2. World War, 1939-1945--Personal narratives, American. 3. World War, 1939-1945--Pictorial works. I. Kagan, Neil. II. Hyslop, Stephen G. (Stephen Garrison), 1950-
D769.E94 2012
940.53'73--dc23

2012024945

This 2013 edition printed for Barnes & Noble, Inc. by the National Geographic Society.

ISBN: 978-1-4351-5302-8 (B&N ed.)

Printed in Hong Kong

15/THK/3

Contributors

Neil Kagan, editor, heads Kagan & Associates, Inc., a firm specializing in designing and producing innovative illustrated books. Formerly publisher/managing editor and director of new product development at Time-Life Books, he created numerous book series, including the award-winning *Voices of the Civil War, Our American Century,* and *What Life Was Like.* Recently he edited *Great Battles of the Civil War, Great Photographs of World War II,* and for National Geographic the best-selling *Concise History of the World, Eyewitness to the Civil War, Atlas of the Civil War,* and *The Untold Civil War.*

Stephen G. Hyslop, author, has written several books on American history, including National Geographic's *Eyewitness to the Civil War* and *Atlas of the Civil War.* A former writer and editor at Time-Life Books, he contributed to many volumes on the Second World War, including *Great Photographs of World War II, Lightning War,* and *Barbarossa.* His articles have appeared in *American History, World War II,* and the *History Channel Magazine.*

Harris J. Andrews, military historian and consultant, specializes in American military history and material culture. He is a historian and artifact consultant for the National Museum of the United States Army Project and has extensive experience researching historical artifacts and military maps for numerous publications. He has contributed to many military history projects, including Time-Life Books' landmark series *World War II* and the arms and equipment volumes of *Echoes of Glory.* He was a contributing editor to National Geographic's *From the Front: The Story of War,* by Michael S. Sweeney, *Eyewitness to the Civil War,* and *Atlas of the Civil War.*